MAKING THE
MODERN

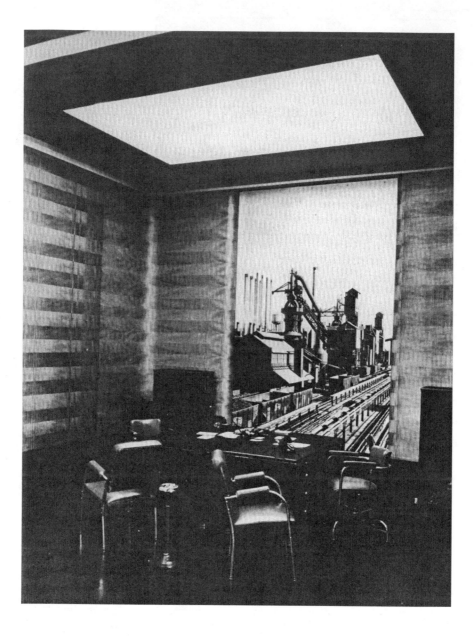

Albert Kahn, architect, Interior of Ford Pavilion, Century of Progress
Exposition, Chicago, 1933–34, then office in Rotunda, Ford Motor Co., River
Rouge, Dearborn, Mich., 1936–52. (Ford Archives, neg. 66122B)

TERRY SMITH

MAKING THE
MODERN

INDUSTRY, ART, AND
DESIGN IN AMERICA

THE UNIVERSITY OF CHICAGO PRESS
CHICAGO AND LONDON

Terry Smith is associate professor in the Department of Fine
Arts at the University of Sydney.

The University of Chicago Press, Chicago 60637
The University of Chicago Press, Ltd., London
© 1993 by The University of Chicago
All rights reserved. Published 1993
Printed in the United States of America

02 01 00 99 98 97 96 95 94 93 5 4 3 2 1

ISBN (cloth): 0-226-76346-3

Library of Congress Cataloging-in-Publication Data
Smith, Terry (Terry E.)
 Making the modern : industry, art, and design in
America / Terry Smith.
 p. cm.
 Includes index.
 ISBN 0-226-76346-3
 1. Modernism (Art)—United States. 2. Art,
American. 3. Art, Modern—20th century—United
States. 4. Art and industry—United States. I. Title.
N6512.5.M63S63 1993
709′.73′09041—dc20 92-935
 CIP

⊗ The paper used in this publication meets the minimum
requirements of the American National Standard for
Information Sciences—Permanence of Paper for Printed
Library Materials, ANSI Z39.48-1984.

CONTENTS

ILLUSTRATIONS

ACKNOWLEDGMENTS

The concepts underlining this book first took shape in 1979 at the Centre for Contemporary Cultural Studies at the University of Birmingham, United Kingdom. They formed the basis my dissertation, "Making the Modern: The Visual Imagery of Modernity, U.S.A. 1908–1939," for which I was awarded my degree at the University of Sydney, Australia, in 1986. Subsequent visits to the United States resulted in major revisions. I am grateful for the opportunities offered by periods as a postdoctoral visiting fellow at the National Museum of American Art, Smithsonian Institution, Washington, D.C., and as a Hagley Fellow at the Hagley Museum and Library, Wilmington, Delaware.

Twelve years of work earns many debts. The project would have been impossible without the kind cooperation of the following people, who have my deepest gratitude.

At the University of Sydney: Associate Professor John Burnheim, Professor Virginia Spate, and my colleagues in the Department of Fine Arts, students in my course on American art and design; John Spencer and staff of the Power Research Library, staff of the Fisher Library. Staff of the State Library of New South Wales were also of assistance.

At the University of Birmingham: Richard

Johnson and members of the Visual Arts/Ideologies Group, particularly Michael Green, Andy Lowe, Phil Goodall, and Tony Fry.

At the Detroit Institute of Arts: Linda Downs, Nancy Jones, Marylin Ghausi, Cheryl Wagner, Dolores S. Slowinski, and George Tysh; Marylin Florek and Jeanne Zanke of the Archives of American Art, Midwestern Division; Cynthia Read-Miller, David R. Crippen, and other staff of the Henry Ford Archives, Edison Institute Dearborn; Thomas P. Kish, Lee Kollins, and Michael W. R. Davis of the Ford Motor Company, Dearborn, and Adrian Ryan of Ford Australia; Peggy Butzu of the Automotive History Archive, Detroit Public Library; Carl F. Kemp of Albert Kahn Associates, Detroit; Thomas Featherstone of the Archives of Labor and Urban Affairs, Wayne State University.

In Washington, D.C., Garnett McCoy and staff of the Archives of American Art; Lois Fink, Office of Research, National Museum of American Art, and curatorial staff of the museum; Pete Daniels, National Museum of American History; Alan Fern, National Portrait Gallery; staff of the NMAA Library, the Library of Congress, the National Archives and the Archives of the Federal Bureau of Investigation.

In New York, Clive Phillpot and Rona Roob of the Museum of Modern Art Library; staff of the New York Public Library and the Cooper-Hewitt Museum of Design; staff of the Commonwealth Fund, Harkness House.

In Mexico City, Alicia Azuela of the Instituto de Investigaciones Esteticas, Universidad Nacional Autonoma de México, and staff of the Palacio des Belles Artes, México D.F.

At the Hagley Museum and Library, Wilmington, Delaware: Glenn A. Porter, Patrick Nolan, Ella Phillips, Laurie Schad, Jon Williams, Barbara Hall, Martin W. Kane, Diane Partnoy, imprint and archives staff. At the University of Delaware: Emeritus Professor Eugene S. Ferguson and Professor David A. Hounshell.

Fellow scholars made wonderful and critical colleagues, and friends of the same order, each one invaluable to my project in different ways: Patricia Hills, Alan Wallach, Maren Stange, Allan Sekula, Sally Stein, Howard P. Segal, Frances V. O'Connor, Marshall Berman, Bernard Smith, W. J. T. Mitchell, John Heskett, Jeffrey Meikle, T. J. Clark, Linda Nochlin, Irving Sandler, Susan Fillin Yeh, Laurence P. Hulburt, Helen A. Harrison, Shelley Rice, Lucy Lippard, Joyce Kozloff, Whitney Chadwick, Lisa Tickner, Jon Bird, Mary Kelly, Ruth Oldenziel, Max Kozloff, David Hay, Glen Mannisto, Veronica Young, David Bindman, and Frances Carey.

For their help in bringing these ideas into readable form I thank Elgin Barker, Christine Dixon, Suzette Markwell, and Myra Katz at the University of Sydney. At the University of Chicago Press I am grateful to

Karen Wilson for her expertise and enthusiasm throughout and to Janet Moredock, Candace Rossin and Kathryn Gohl. This book is dedicated to my family—Tina, Keir, and Blake—for their support over the long haul.

Versions of the chapter on Frida Kahlo were published in *Block* 8 (1983): 11–23, and 9 (1983): 34–47, and in *Lip* 8 (1984): 39–59. I am also grateful to Patricia Hills and Wanda Corn for inviting me to lecture on Rivera at the Luce Foundation Seminar on American Art at the Institute of Fine Arts, New York, in 1986, and to Patricia Hills and Allan Wallach for inviting me to deliver a paper on Rivera at the College Art Association Meeting, Houston, 1988, assisted by the Kress Foundation.

I should also like to thank the following institutions for permission to reproduce photographs: Albert Kahn Associates, Detroit, Michigan (AKA); the Detroit Institute of Arts (DIA); Dame Dolores Olmedo of the Frida Kahlo Museum, Coyoacan, Mexico; the Ford Archives of the Henry Ford Museum, Dearborn, Michigan (FA); the Centro de Informacion y Documentation des Artes Plasticas, Mexico City; the Library of Congress, Washington, D.C. (L of C); and the Museum of Modern Art, New York (MOMA).

INTRODUCTION: THE VISUAL IMAGERY
OF MODERNITY

Only the Newest Structures

"But he himself built only the newest structures, and his attitude to the old could be defined in one scathing word: survivals." Thus spake Kirill Izvekov—old Bolshevik, worker-engineer, party loyalist and, for years, senior official in the Department of Heavy Industry—as he walked for the first time around provincial Tula in a scene from Fedin's *The Conflagration.*[1] He had just been arbitrarily banished to this remote town, described as scarcely changed since the nineteenth century. Stunned by the sudden fragility of the principles that have sustained his life, he defiantly reasserts them. His intense commitment to modernity would have found echoes throughout the world in the 1930s, when the novel is set; indeed, in many countries modernity had settled into orthodoxy. A similar outlook, although in very different forms, was still prominent around 1960, when the book was written. Now, however, such commanding dreams seem absurdly anachronistic. What has changed? What was modernity then? What is it for us now? And, within these questions, another: why has the past been so persistent? Indeed, in Reagan and Bush's America, Thatcher's Britain, and in the new (dis)order in central Eu-

rope and what was the USSR, it might be said that the past has come back—not just into fashion, but into power.

Such concerns shape much current debate in domains as apparently diverse as academic epistemology and (the often scarcely less esoteric) deciding-what-to-wear-tonight. They are just as pertinent in differently related spheres, for example, the writing of history in great metropolitan centers and the efforts in Third World nations to independently determine their own conditions of day-to-day survival.

In joining the interrogation of modernity, I hope to contribute toward discussion of what kind of entity it was, what elements of it remain. I do not attempt an overall mapping of modernity, as if it were some kind of totality, nor even chart its history as a discursive figure. Instead, I pose the very question of modernity to a particular time and place, one of the acknowledged moments of its most brilliant appearance—in the United States in the 1920s and 1930s. The picture that emerges is quite different in its general structure and movement from those proposed in prevailing historical accounts of the period, while consonant with them in many lesser ways. Much of this difference follows from my concentration on the operations of what I call the visual imagery of modernity. The exceptional prominence during this period of the symbolic (in visual and other forms) has been widely acknowledged, and a variety of its manifestations have been explored, from glamor photography to exhibition architecture, new refrigerators to abstract art. But something more connects this diversity with the other, more pervasively powerful historical currents of the time, something like an ensemble of processes of visualization, with seemingly systematic regularities of its own. It is this ensemble, rather than any one or two parts of it (such as its penchant for shining surfaces, or for images of machines), that significantly altered the way Americans saw themselves, saw others, and were seen by others.

I explore the emergence, shaping, transformation, and then normalization of this visual order in a series of connected case studies, ranging from the first Ford Motor Company plant at Highland Park, Detroit, commenced in 1910, to the New York World's Fair of 1939–40. The connections describe a single, obvious aspect of the ensemble: the evolution of visual images of American industry from an increasingly prolific picturing to a central theme within the iconology of modernity. And, again, while there is much that overlaps with current research in art, design, and photography history, a range of different readings arises. I conclude with some reflections on the regularization of this new visual order in American society during World War II.

Kirill's Anxiety

To return to the exiled bureaucrat: his declaration exhibits, in extreme form, most of the elements fundamental to standard understandings of modernity's drive to perpetual renovation. In moving about the town, he is taking the first modernist step: surveying the world, classifying it according to the simplest—indeed, only possible—division, that between the old and the new. He makes this distinction instantly, at a glance, judging by how the buildings look, in themselves and as ensembles, as embodiments of the resources used to build them, of the costs absorbed in their maintenance. He sees how they form townscapes, how their disposition relates to the provision of services, how the town is positioned in local, regional, even national networks of supply and control. Before him confusion, wastefulness, petty detail, and fussy ornamentation—an anachronistic disorder inimical to the way people should live now. All around him, on every surface, in every space, the marks of class—privilege and deprivation, ownership and exploitation. No mere symbols these, but the material fact of historical injustice. He has seen all he needs to know and is revolted.

More basic than raging over matters of taste, Kirill's modernity is activist, boldly interventionist: it moves quickly from the classifying gaze to an insistence on the obliteration of the past—the removal of its physical presence, its appearances, even, when pressed, its memory. All have to go. Anything left standing is scorned as a "survival," with, presumably, a limited life expectancy. Someone, somewhere, has failed to recognize the historical inevitability of modernity; they deserve only contempt. The same would doubtless apply to retrograde thoughts or beliefs, old-fashioned mementoes, reactionary actions—all these become part of the hated past, destined to disappear from sight, from usage, and from thought.

Into this utter emptiness Kirill's type of modernity projects the equally totalizing presence of "only the newest structures." The world organized in all its relations according to a complete clarity of articulation, the always evident logic of rational planning, functional form and efficient design, a distribution of services through channels of such transparency that the equity of their flow is everywhere observable—thus securing an ideal of human behavior open to all, in the best interests of all. A vision of progress, of the new endlessly renewing itself, a permanent revolution, a perpetual renovation. A dream, utopian in its reach through time, global in its stretch through space, complete in its desire to enlist the public and the private in all men and women.

Nor was this dream held in extreme forms only in Russia. Henry Ford, no friend of political radicality of any stamp, authored the most famous formulation of modernity's hatred of the past in a remark of 1919: "History is more or less bunk. We want to live in the present and the only history that is worth a tinker's damn is the history we make today."[2] That the technology of modernity readily crossed political boundaries otherwise heavily defended is evident in Lenin's exhortation of 1918: "The possibility of building socialism depends exactly on our success in combining the Soviet power and the Soviet organization of administration with the up-to-date achievements of capitalism. We must organize in Russia the study and teaching of the Taylor system and systematically try it out and adapt it to our ends."[3] In practice, this occurred with the most spectacular success just over ten years later, when the Ford Motor Company led other U.S. and European corporations in establishing the vast Soviet tractor industry.

The unified vision of modernity, seen as progressive from most of those political perspectives dominant in the first half of this century, was demonstrably successful in most of its undertakings, evidently capable of innovating and diversifying within its focused body, and increasingly confident of fulfilling its own prophecies of immanence. It thereby recruited more and more people and places to its project of making over the world into the "only new." By the 1920s, in the United States at least, who could doubt its triumph? What was the jazz age but a stylish party celebrating the historic victory of modernity? Who dared spoil the fun? Who dares now?

If, however, we introduce history—this time as a critical interrogation—the dream becomes a set of clichés. Why were there so few people at the party? Who wanted to keep dancing, anyway, after the self-inflicted wound of the 1929 crash? And by the mid-1930s, Kirill, like modernists everywhere, was feeling the chill of anachronism as the singular, all-conquering paradigm seemed, invisibly, to shift. He must stride about insisting that he "built only the newest structures"—proudly, angrily, like someone defending an inheritance. Could it be that the town of Tula was not simply bypassed by modernity, but that it (whichever powers that be there) chose to resist change—passively perhaps, yet nonetheless firmly? Maybe it preferred to fight for another model of persistence, not just counterrevolutionary conservatism, but possibly one based in the evolutions of a regional culture, a national route through those complex times (the last months of 1989, and the current disintegration of the Russian state, are prefigured here). Or had the central party, in concert with the powers that be in all major social formations through the world, realized that the people would no longer subscribe

to the simple version of modernity Hope of the World? Were the image brokers now eager to discard the well-matched ensemble in a cynical scramble for a more complex, freshly persuasive ideological package?

We can, with hindsight, see that Kirill's commitment to a singular party-line modernity was exceptional in its reductive extremity. Most modernizers were prepared to work steadily toward goals always deferrable by expediency. It has become almost a commonplace in studies of the art and architecture of the period that modernism was always in dialectical dialogue with, if not the classicism that Baudelaire, when coining the contemporary usage, characterized as its "other half," then at least some figure if the past as Other.[4] This is one of the themes I have occasion to explore below. Nor has cultural modernity been consistently on the side of economic and political progressives; it served fascism well, in both Italy and, we can now increasingly see, Germany.[5] And the reactionary codification of the arts as Socialist Realism in Stalinist Russia played havoc with critical tendencies which were, in capitalist countries, already in ambiguous relation to it.

Despite its own presumptions of clearing the slate to enable the wholly, unimaginably new, a universal state both in and beyond time and place, modernity now seems—as the last remarks on Kirill's puzzlement at Tula imply—to have been variously invented, adopted, and adapted at different times and places, achieving such distinctive forms that the level on which we might be dealing with a global phenomenon will need careful specification. Of great interest, too, are the various ways in which the prodigiously innovative energies so evident in the early phases of modernity became institutionalized: the Ford Company stilted up in the 1930s (some say mid-1920s); the artistic avant-garde turned into official culture in New York during the early 1960s. If we are, these days, still in a phase of modernity, then it is one that lacks hope of a glorious, even shared future, that cannot posit any unity other than an uncertain reflex toward survival, that sees cycles and calamity rather than progress, that increasingly venerates the past while recognizing it as a museum of completed options, that notes the rising tide of anger around the world at the inequities of unequal development and the undignified yet cold-blooded scramble by the privileged to hold onto their increasingly isolated, yet still growing, riches. Each of the great modernist markers has fallen, turned into its opposite, or something other. We live, apparently, in modernity's aftermath.

Despite such a gloomy general picture, we continue to live and work in our specific worlds, struggling against their imbrication into the larger insanities—working, too, one hopes, to lessen the power of these dominating orders. To help maintain at least this political possibility, it seems

of relevance to accurately map the terrain that brought us to this pass, particularly the "lives" of the early regimes of modernity. A set of questions emerge, determining the shape of the enquiry. What is—or was—modernity? How does history appear in it? What have been its internal histories? What impact has it had on other discursive formations, for example, on the presence of the past? Why does a certain variety of modes of visualization seem to play such an important role within it? How does such visualization change its regularities; what impels these changes? What place do specialist discourses, such as modernism in the visual arts, have in the broader imagery of modernity? Are we still subject to the same general network of powers, the same modes of visualization? If there has been a major shift, to a postmodernist condition, what light can the above throw on an analysis of it?

The Argument

My main focus is on the role of visual imagery within the so-called second industrial revolution in the United States, that is, during the rise of mass manufacturing, linked to mass consumption. This revolution marked a new phase in the history of modern societies. Certain parts of the world were dramatically transformed, actually and figuratively. The Ford Motor Company plants in Detroit, Michigan, installed new methods of production on an unprecedented scale, quickly becoming not only striking examples of innovative manufacture but also symbolic models of a desirable kind of modernization.

Fresh images of industrial progress were generated and widely distributed, particularly photographs in public media. Mass production reproduced images of itself on a massive scale for mass consumption. At the same time, within the plants and in the neighborhoods dependent on them, seeing itself was being organized differently. This, too, spread until it became a normality. How these realities and representations were connected is the object of this study.

A distinctive machinery of representation emerged in the United States during the 1920s and 1930s. It shaped a set of images of both past and future into a diverse but coherent imagery of a modern present. Some of its manifestations have been previously studied—for example, Precisionist painting, Art Deco fashion, Moderne skyscrapers, streamlined industrial design—and rather vapid generalizations about the "style," or "styles," of the two decades have been advanced. But the particular character, and the powers, of the new way of seeing cannot be fully understood unless it is examined in action across a variety of visualizing domains. Further, these domains need to be located pre-

cisely within the psychosocial economies which were, in turn, con-
structing them.

Broadly speaking, a new imagery of modernity evolved during the
massive shift from entrepreneurial to monopoly capitalism which began
in most industrial countries in the 1880s and came to dominate the social
order by the 1920s. There is, however, no simple, deterministic equa-
tion between entities such as the Machine Age and Modernism. On the
contrary, the visual regime of early twentieth-century modernity is as
complex as the social change of which it is a constituent part. Nonethe-
less, a certain iconography seems fundamental; six images constantly
occur, separately or in couplets: industry and workers, cities and
crowds, products and consumers.

Is there an iconology of modernity? I take this question in two related
but distinct senses. The question Can there be a systematic study of the
visual imagery of modernity? is answered one way or another by this
entire study. The other question is Did the imagery of modernity itself
constitute an iconology, that is, actively produce meanings and knowl-
edges in its social reception? A proposal follows.

By the later 1920s the iconography of Modern America seems to
coalesce into a limited, loose, but nonetheless flexible and effective en-
semble of images. Its elements, so constantly repeated, varied, approxi-
mated, so rarely violated, are readily listed: (1) the industrial plant and
manufacturing worker (for example, the River Rouge and the assembly-
line worker); the agricultural site and the farm worker (the wheat silo
and the sharecropper); (2) the vertical city and the crowd (almost always
New York City and the Wall Street/Broadway crowd on the pavement);
(3) the stylized product and the consumer (a burgeoning number of ex-
amples of great structural similarity).

This ensemble figures—in its internal relationships, its productivity,
its dominance over other structures—a "regime of sense" of consider-
able power. It indicates the presence of a visual order which organizes
seeing in particular ways, despite the limited scope of its imagery and
its structural fragility. It not only reproduces in visual terms the devel-
opment of what I argue is a new "regime of truth" in the United States
in the 1920s and 1930s—that is, the new corporations/New Deal consen-
sus—but it was an active, constructive constituent of this regime and of
the social formation on which it, in turn, was based. It grew from being
an iconography—a repetition of images—to become an iconology in the
sense adduced in the second question above. That is, these images and
couplets, in their accelerating repetitions and predictable diversifica-

tions, secured increasingly ordered patterns of reading from those consuming them, while at the same time modifying other modes, even displacing them, until the new regime of seeing became itself the norm.

The Corporate State was spasmicly formed within the social wounds which surfaced so dramatically between 1929 and 1934. One important way in which it shaped itself was around a new set of relationships between signifier and signified, a particular modern rhetoric of the word/image. The terms in which this relationship was worked out—and which lead through World War II to the corporate consumerism, the industrial-military state of the 1950s and 1960s—construct a particular modernity as American, and construct a certain reading of U.S. society as modern, actively attempting to exclude other readings. Visual shaping occurs within the new set of rhetorical relationships. The most evident paradox is that, at a moment when the operations of the sign measurably increase in social power, the elements of this growth are so restricted, so confining: three couplets between six object/place/person figures seem implausibly few. Nor is it simply a question of significant omissions, structural absences, withheld silences. Rather, it is just this movement of constant internal contradiction, of infinite reaching combined with self-erasure, which I hope to show to be typical of the imaging of modernity. It is both a source of its devastating strength and one of the causes of its inevitable failure. Other pressures came from the resistances it provoked and the pasts which it kept stirring into renewed life. Yet these contrary tendencies were themselves ineluctably intertwined with the modernizing forces: modernity, between the wars, exists essentially in the play of flow and blockage between imagined futures and echoing pasts. Occurring on such a scale, and with such internal scope, the visual imagery of early twentieth-century modernity seems to amount to a distinctive phase in those modern economies of seeing that had emerged a century before, in the years around 1800.

This study traces one trajectory through the 1920s and 1930s: the imagery of industry from the Ford Motor Company factory at Highland Park, Detroit, in 1910, to the New York World's Fair of 1939–40. It is argued that the imagery of modernity works alongside other social forces in the new corporatism's prodigious efforts to separate production from consumption, and to simplify and regulate both. This occurs always in specific ways; thus the trajectory is followed through a series of case studies, one chapter being devoted to each. The studies are grouped in four parts.

The first part explores certain relationships between the modernization of work and industrial themes in modernist art during the 1910s and 1920s. In chapter 1 it is argued that certain revisualizations of ma-

chine functions, productive labor, and their organization were at the core of the first, full-scale system of mass production—the assembly line at the Ford Motor Company in 1913–14. Vision was equally important to the extension of this system of surveillance outside the factory, shaping the social relations of work as corporate "welfare." Chapter 2 shows how, in the buildings of Albert Kahn Associates, the spatial demands of line production engendered a radically functionalist architecture, contrasting sharply with the symbolic functionalism of the European Modern Master architects of the period, themselves partly inspired by a romantic perception of these same buildings as spontaneous, vernacular structures. Business then mass advertisement projected images of these new "cities of industry," updating public perception of the inventor-entrepreneur, personified by Henry Ford, while also pushing the Ford car upmarket. These processes are examined in chapter 3. Crucial to them were the aestheticizing powers of the most "advanced" painters and photographers, such as Charles Sheeler and Margaret Bourke-White. By the later 1920s, a merger between the economic and social forces of modernization and the modernist artists must have seemed inevitable. But modernity was not to shake off its "other" so easily: the past was constantly reasserted, often as a preindustrial pastoral. The most striking instance occurred in the midst of the Ford domains at Dearborn: in chapter 4 the Henry Ford Museum and Greenfield Village are read as examples of this modernistic archaism.

The apparently predestined matching of modernization and modernism, their spectacular creation of a dominant visual order, was thrown into disarray by the conflicting forces which created and followed the Great Depression and by opposition from competing visions of industrial society. Part 2 of this volume examines some pivotal attempts to impose a view from above, and certain crucial resistances to that effort. Henry Luce's drive to modernize business's self-image drew on the services of modernist aestheticists of industry, such as Bourke-White and Sheeler, but *Time* and *Fortune* magazines also evolved an extraordinarily successful ensemble of signifying practices; their power is the subject of chapter 5. In chapters 6 and 7, Diego Rivera's epic murals and Frida Kahlo's private *retablos*, particularly those made in New York and Detroit, are examined as examples of two utterly different kinds of opposition to this push by the new corporatism to install its view of modern America. In his *Detroit Industry* murals, Rivera's modernity draws Mexican—indeed, world—history into a heroic exchange between man and machine, all in the service of a Pan-American, communist future. It is also shown how, in 1933, these murals became the centerpiece in a risky, but essentially modern, exercise in corporate promotion. In contrast,

Kahlo painted the marginalized world of women, victims of modernity. Other Mexican artists, also working in the United States, see the clash of cultures in different terms.

Social Realism in the United States during the 1930s is marked by ambiguity. Revolutionary anger appears rarely, reforming zeal much more often. On a national level, recovery from the shocks of the early 1930s meant a forced alliance between the new corporations and the welfare state—one which still prevails, however precariously. Social Realists and Surrealists were impressed by the potential of the new industrial order, while also alert to its destructions of valued skills and people. They were attracted to the liberal promises of Roosevelt's New Deal, but suspicious of its limitations. Chapter 8 sketches the responses of artists to their new relationships with government agencies, particularly photographers such as Lewis Hine and the remarkable group who worked under Roy Stryker at the Farm Security Administration. In chapter 9 I show how a number of government agencies called on photographers in efforts to publicize the agencies' reform programs. Parallels are drawn between these efforts and the address of the popular photomagazines, such as *Life*. A positive picturing of demotic multiplicity wells up in the later 1930s: the dissent of critical realism is gradually absorbed into an imagery of diversity, individualistic but shared, and somehow specifically, even naturally, American.

What about the overtly modern, the imagery of the absolutely up-to-date, of the clean-lined future; what happened to that during the 1930s? Part 3 addresses this question, following its scattered evolution through product design, art museums, and the expositions. Chapter 10 looks at the emergence of the industrial designer and the stylistic shift from late 1920s modernistic Art Deco to a streamlined Moderne in the 1930s, arguing that the priorities of advertising prevail throughout. In chapter 11 the purist modernism of the Museum of Modern Art, which celebrated the European Modern Masters and the skills of American engineers, is shown to be a kind of aesthetic policing of the "tasteless excesses" of local industrial designers. MOMA's enormous impact on architectural taste is also explored, particularly the invention of the International Style, and the role of the photomodern within it. The popular triumph of the streamlined Moderne is traced in chapter 12—a study of the symbolic destination of the Fordist factory, its evolution into a sign for mass production at the New York World's Fair of 1939–40. The crowd of people teeming through the "white city" on Flushing Meadow is a symbol of a future desired, courted, but available only as a sign of itself: the spectacle of pure consumption.

Pure, symbolic modernity was a culmination, yes, but also a fragile

dream, collapsing quickly into the practicalities of wartime demands, a furtherance of the mid-1930s fusion of corporations and state. By 1940 the documentary picturing of the seemingly limitless variety of everyday life which animated the Farm Security Administration and *Life* magazine alike merged with the obviously modern imagery of the new industries and their products. Chapter 13 analyzes an Office of War Information photomural and a series of paintings by Charles Sheeler for *Fortune* magazine to show the result: modernity made normal.

THE MODERNIZATION OF WORK: DETROIT, 1910–1929

FORDISM: MASS PRODUCTION AND TOTAL CONTROL

Nothing original, yet everything new. Henry Ford did not invent the industrial processes so closely associated with his name—neither mass production in general nor the mobile assembly line. Not one of thousands of engineering and other tooling discoveries which attended the success of the new processes was his creation. The inventive genius represented by his name was above all an organizational one: elements developed elsewhere were shaped into a productive system of incessantly self-refining functionality in which nothing was original except the system itself, particularly its capacity to constantly redefine, simplify, and proliferate—that is, to make new—its own parts. Is this quality distinctive of early twentieth-century modernity: an unprecedented concentration on the replication of a single, ever narrowing, more reduced product through a system which was itself constantly diversifying? The Industrial Revolution shifts into a higher gear, entailing a new phase in the development of the factory system. That a major change occurred is widely acknowledged; that its novelty consisted importantly in transformations of the given is less accepted. I argue that the revolutionary productivity of corporate capitalism, as exemplified in Ford-type domains of invention, consisted es-

sentially in the dynamic of apparent contradictions of this type.

The Ford Motor Company plants at Highland Park, Detroit, and the River Rouge, Dearborn, drew together processes which had been developing over two centuries, many of which were operative in partial ways elsewhere in the United States and, to a lesser extent, in Europe. The "Ford way" was quickly adopted by other manufacturers, and the entire system rapidly exported globally, becoming known as Fordism. The Ford Motor Company emerged at the conjuncture of entrepreneurial capitalism with the new corporations which still dominate the world economic order. It exhibits, therefore, features both unique and typical, enabling scrutiny of the new processes in their transitional and early formations. The novelty of these developments was recognized at the time, and recorded in some detail, both within the company and externally.

These conditions secure Ford Motor Company as an obvious starting point for any study of twentieth-century modernity. Much has been written about the Ford family, the company's management, and the engineering of its products and productive processes. My emphasis is on the other elements in the system, primarily the symbolic ones, stressing that these form as much a part of the productive machinery as more overtly material practices. Indeed, the integration of what had been seen as quite distinct "levels" of activity constitutes much of the system's modernity. This has yet to be adequately acknowledged. I examine in turn six representational practices—the spatial organization of work, surveillance, architecture, advertising, photography and painting— through case studies of particular instances of integration, exploring how certain image makers worked for Ford Company, then how Ford Company was obliged to work to the demands of the image. In this way, an archaeology of the construction of a very powerful imagery of modernity is set out.

Fordism's First Phase: Highland Park, 1910–1914

> And I came in fact to a group of great squat buildings full of windows, through which you could see, like a cage full of flies, men moving about, but only just moving, as if they were contending very feebly against Heaven knows what impossibility. So this was Ford's? And then all above one, and right up to sky itself, the heavy many-sided roar of a cataract of machines, shaping, revolving, groaning, always about to break down and never breaking down. . . . One was turned by force into a machine oneself, the whole of one's carcass quivering in this vast frenzy of noise which filled you within and around the inside of your skull and lower down rattled your bowels, and climbed to your eyes in infinite, little, quick

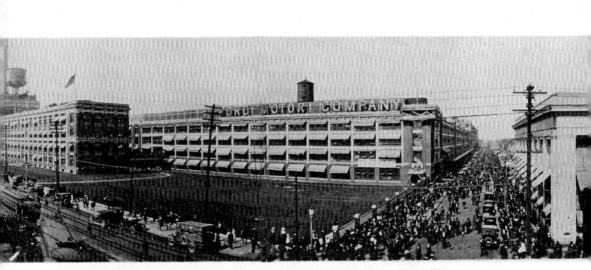

1.1 Panorama of Ford Motor Co., Highland Park, 1910s. From the collections of Henry Ford Museum and Greenfield Village. (Ford Archives, P.O.3139)

unending strikes. . . . The workmen bending solicitously over the machines, eager to keep them happy, is a depressing sight; one hands them the right-sized screws and still more screws, instead of putting a stop once and for all to this smell of oil, and this vapour which burns your throat and your eardrums from inside. . . . You've become old, all of a sudden—disgustingly old. Life outside you must be put away; it must be turned into steel, too, into something useful. You aren't sufficiently fond of it as it was, that's why. So it must be made into a thing, into something solid. By Order.

On his first day at the Highland Park plant, Louis-Ferdinand Céline's autobiographical persona enters one of the cul-de-sacs which constitute *Journey to the End of the Night* (1932), experiencing the full horror of Ford Company modernity.[1] His account adds the power of sound—in this case of overwhelming noise—to the still silence that usually accompanies historical recall, especially that exercised through visual imagery. While Céline's literary skills and his training in medicine make him exceptional among the thousands who passed through the factory, in other ways he had endured much in common with other Ford workers: a brutalizing war, the displacements of immigration, desperate poverty, and the systematic, often violent, erosion into abjection of whatever idealism, hope, and self-respect he may have had.[2]

What about the view from the other side? *The Ford Industries: Facts about the Ford Motor Company and the Subsidiaries*, a well-illustrated book published by the company in 1924, devotes many pages to defending its industrial relations record. Under the heading "Repetitive Work," this justification is advanced:

The monotony of repetitive work has often been discussed as an unfortunate phase of factory life. It is true that repetitive work could almost kill some men, but others prefer it to anything else. Several years ago an executive order that every man was to change his job every three months was put into effect. To the surprise of everybody this order was fiercely resisted by the majority of men on these monotonous jobs. As a matter of cold fact, the majority of men dislike working their brains more than is absolutely necessary and if they find that a job may be done almost automatically a surprisingly large proportion prefer sticking to it than to learning anything new.[3]

This is very much the language of Scientific Management as the natural panacea for securing industrial harmony and progress. The words of Frederick Taylor echo in the advice given to Céline's antihero: "You haven't come here to think, but to go through the motions you'll be told to make. . . . What we need is chimpanzees." The publicist's soothing words do not square with the Ford Company's by then well-established track record of tying any increases in wages or improvements in working conditions to relentless speedups and massive sackings, or with the persisting necessity to hire many times the desired work force in order to absorb the enormous rate of attrition.

These contrasting characterizations reveal much about Fordism in its mid-1920s phase. But the key components of the system were being put in place by 1908, when Henry Ford commissioned Detroit architect Albert Kahn to build the Highland Park plant. Ford had secured a sound market position for the Model T, and an adequate distribution network, but saw the potentialities for a massive expansion in both. More importantly, he had decided to freeze this car's engineering and to produce no other car.[4] He had employed many extraordinarily inventive mechanics and administrators and directed them to focus on rationalizing the processes entailed in producing as many of these cars as possible, preferably through the high-volume production of interchangeable parts which could be rapidly assembled. He did not formally employ the services of Taylor or any other Scientific Management company, but many such principles and procedures were well known at Ford Company.

The conjunction of these components at Highland Park, especially during the years 1913–14 when the assembly line was created, led to a shift in the nature of machine production which was quickly recognized as fundamental. In a famous *Encyclopaedia Britannica* entry of 1926, Ford himself (or his publicist, William J. Cameron) defined it rather abstractly: "Mass production is not merely quantity production, for this may be had with none of the requisites of mass production. Nor is it merely

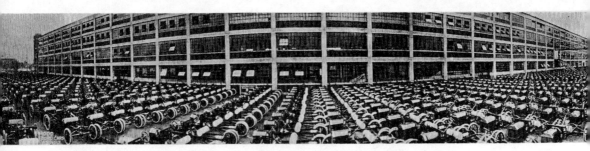

1.2 One day's output, Ford Motor Co., Highland Park, 1914. From the collections of Henry Ford Museum and Greenfield Village. (Ford Archives, P.833.682)

machine production, which also may exist without any resemblance to mass production. Mass production is the focussing upon a manufacturing project of the principles of power, accuracy, economy, system, continuity and speed."[5] The generality of these remarks should not obscure the primary emphasis on quantity production for the maximum number of consumers—that is, the connotations of the term *mass* are not at all ambiguous; they are of its essence. Massive amounts of products for the masses was precisely the aim. Yet how original was this? Had it not been the object of manufacturers for most of the nineteenth century, and had not many of them achieved it, in their areas of operation, using engineering devices well in advance of those assembled at Highland Park? Have not historians, and public opinion in general, been misled on this point by the prodigious publicity efforts of the Ford Company in the years during and after World War I? More generally, is not mass consumption, rather than mass production, the definitive drive of modernity in the first half of this century?

In the most thorough recent study of these questions, David Hounshell concludes that there were remarkable continuities between the evolutionary American System of Manufactures and mass production, but that there were also fundamental differences between the two systems, differences which came first, and most strikingly, into form at the Ford Motor Company, Detroit. The continuities include a persistent desire to achieve total interchangeability of parts in machine manufacture, a drive for maximal production, and an increasing restrictiveness as to variety of product models. Key enabling factors were the accumulation and transmission of skills and knowledge among manufacturers and machinists in the armaments, ordinance, sewing machine, and bicycle industries as well as the mobility of these men, particularly within the northeastern states. Like scientists, they were attracted to where the major challenges were: key figures put in crucial time at Ford.

Differences between the two systems are just as significant. Major

nineteenth-century manufacturers such as Singer and McCormick, contrary to legend, directed their products to the top end of the market, as opposed to the lower-order masses targeted by Ford from 1905 to 1927. Despite every effort, no earlier manufacturer of "multicomponent consumer durables" achieved a full interchangeability of parts in the making of their products, while Ford eventually achieved in it the elements of both the car and the men and materials of the production process itself. Nor were any of the great names of nineteenth-century industry, with the exception of Singer, capable of annual production figures in the hundreds of thousands regularly achieved at Ford and those who quickly followed its revolutionary methods.[6]

It was a particular transformation of the spatial organization of the work process that brought all these forces together in their most dynamic configuration to date and literally set them in perpetual motion. This was, of course, the assembly line. Much fabled, often described, the subject of many and variable reminiscences, the assembly line is celebrated as a symbol of industrial revolution and bitterly hated as the chief weapon of systematic oppression. Much dispute reigns as to the nature of its invention at Highland Park in 1913. There were precedents in the conveyor systems in the Westinghouse air-brake foundry, the Chicago "disassembly" slaughterhouses (made infamous in Upton Sinclair's *The Jungle* in 1906), and in various brewery grain elevators, flour mills, and food-canning factories throughout the United States. All of these were directly known to one or more of the engineers working at Ford.

Hounshell contrasts the *Encyclopaedia Britannica* abstractions about mass production with the recollections of the chief engineer Charles Sorensen: "Henry Ford had no ideas on mass production. He wanted to build a lot of autos. He was determined but, like everyone else at the time, he didn't know how. In later years he was glorified as the originator of the mass production idea. Far from it; he just grew into it, like the rest of us. The essential tools and the first assembly line with its many integrated feeders resulted from an organisation which was continually experimenting and improving to get better production."[7] This extract places the assembly line in the correct context: Ford Company is best seen as a site onto which enormous inventive and repressive energies were concentrated around the goal of quite literal mass production. It all began at the Piquette Avenue plant soon after 1904 but took emphatic shape in the planning for the move into Highland Park in 1910. Key elements were the creation of a full range of special-purpose tools; an emphasis on the interchangeability of parts; the placement of both materials and machines at strategic, sequential manufacturing points rather than traditionally, according to their type of function; a meticulous materials purchasing system and a carefully timed delivery system. While

production of the early Ford models increased from 1,745 in 1904 to 8,250 in 1907, when the Model T was introduced in 1908 the figure rose to 13,840 for 1909. When all these systems were applied to the single model during the first year in the new building at Highland Park, production shot up to 20,727. It more than doubled in the following year, reaching 82,388 in 1912. Even before the emergence of the assembly line in 1913, the Ford Company plant was already an astonishing, exceptional domain of invention. The American System of Manufactures had been developed to its ultimate form.

The assembly line was not a simple process wherein the car, as it were, accumulated its forms as it moved slowly forward through the factory. Nor was the line created around a simple, clearly prefigured concept, however transparently obvious it seemed soon after the event. Whereas, in later years, the final stages of assembling the chassis and attaching the body to it became fixed as the most popular image of the assembly line, these were, in fact, the culmination of a variety of prior processes, both in sequence of operation and moment of invention, none of which presumed the idea of continuous flow from raw materials to final product. Total line production took years to evolve—or, more accurately, to happen—as a cumulative effect of many, quite specific and often quite contradictory, design decisions. The archaeology of this occurrence will repay some excavation: it is, after all, both a much fabled and an actual figure of early twentieth-century modernity.

Origins on Line

The search for the origin of the assembly line began immediately after the event: it was instantly obscure and has remained elusive ever since. While it seems to be a paradigm of imposed instrumentality, the invention of the assembly line has resisted the descriptive efforts of both the pragmatists who created it and those, equally committed to objectivity, drawn to elaborating its history. Ford production engineers were working so close to the limits of their own ingenuity that they did not keep diaries: their reminiscences, however, range from Superintendent Charles Sorensen's claim that he and others experimented with a crude chassis assembly-line in mid-1908, to quite detailed recollections of the many foremen and machinists involved, gathered as part of a company oral history program in the early 1950s.[8] From these accounts it is clear that the first subassembly line was installed in the flywheel magneto department on April 1, 1913, and that within a year almost every other assembly operation in the plant was put onto a moving line of some kind, including that of the entire engine (by November) and the chassis (between August 1913 and April 1914). Records and reminiscences conflict as to just which part of the magneto—the coil, the permanent mag-

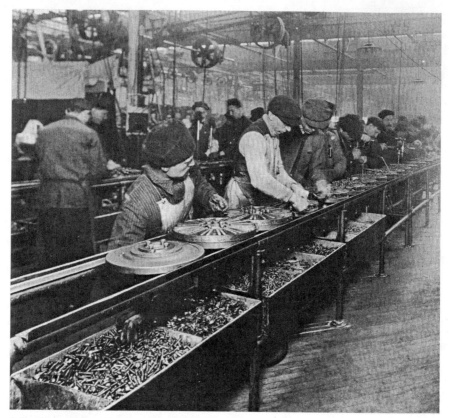

1.3 Assembling the flywheel magneto, Ford Motor Co., Highland Park, 1913. From the collections of Henry Ford Museum and Greenfield Village. (Ford Archives, P.833.167)

net, or the transmission—was set in motion first, and as to the precise dates on which other processes were transformed, as well as to the exact steps through which the changes occurred.

Despite his claiming of credit—through the use of the proprietor's "we"—there is no evidence that Henry Ford himself conceived of total continuous assembly prior to its emergence in his workshops. As I show in the next section, Albert Kahn was not briefed to anticipate it in his designs for the original buildings at Highland Park. Ford's ghostwritten *My Life and Work* relies entirely on the account given by Arnold and Faurote.[9] And Ford did not wait until after the invention of the assembly line to give long-awaited permission for engineering and industrial reporters to enter his plant; he opened up the company to inspection and publicity toward the end of 1912, convinced that his overall approach—then popularly known by the loose but encompassing term *Fordism*—was working. The Model T production figures for 1912, cited

above, would have seemed sufficient evidence. Arriving at the beginning of 1913, technical journalist Fred Colvin carefully noted the significance of electrical motors in distributing power throughout the factory, although he could hardly anticipate its subsequently fundamental role in line assembly, through both driving belts and chains and in controlling the speed of the line through switching. Electrical power also permitted great flexibility in the mobility of machining tools and, through electrical light, in the disposition of fixed machines. More generally, we tend to forget that electricity had as profound a role in the birth of mass production as it is widely acknowledged to have had in the provision of objects for mass consumption. As Thomas Hughes has recently argued, the basic principles of Fordism—constant flow, mass demand, and mass supply—also draw on the metaphor of electrification: Samuel Insull, creator of the Commonwealth Edison Company, was a "system builder" of comparable significance to Henry Ford.[10]

Colvin's articles in *American Machinist* during 1913 concentrated on the machines used at Highland Park.[11] Henry Ford's decision to still the engineering of the Model T itself and concentrate on increasing the quantity of its production allowed his engineers to devote all their inventive energies to the machinery used in manufacturing. They adapted many existing machines, sent out unprecedented specifications for new ones, and built some of their own. To all of these they applied three factors that extended impulses implicit in the approach to machinery of Frederick Taylor, himself an expert tool cutter—accuracy, speed, and simplicity of operation. Multiple operations were sought whenever possible—in spindle drilling, head milling, reaming of the engine block, for example, with an entire block, or set of blocks, being treated at once, then quickly released for the next block or set. These machines were also designed to be worked by semiskilled, and eventually unskilled, operators—with all the consequences for economy, speed, and control imagined by employers for decades. Even before the assembly line began to accelerate these advances, Highland Park represented the triumph of the machine shop at the heart of manufacturing in ways only dreamed of by Frederick Taylor. These multiple-purpose machines embodied the skills that had, for centuries, been the province of craftsmen. The machines were not expert systems like those encoded today into certain computer programs as imprints of particular human professionalisms. Rather, they concentrated on quite particular partial skills, certain moments in what used to be a sequence of creative labor, the frozen sections susceptible to separation, reduced to a simple motion, untiringly, infinitely repeatable. Whereas Taylor's system treated all elements in the factory, including the work force, as functions in regular motion, the

Highland Park machine shop was obsessed with realizing the machinist's formal imperative: the interchangeability of parts leading to a manufacturing system consisting of machines which are perfectly calibrated to make, incessantly and with minimal human intervention, other machines. In the case of the Model T, this meant a component of another machine, over and over. Something of this quality of mechanical autonomy is apparent in the photographs, by local Detroit firm Spooner and Wells, with which Colvin illustrated his articles. This is particularly evident in the original prints, in that the backgrounds around the machines are dropped out of focus. It is even more striking when they were subject to airbrushing and marking up for reproduction.[12]

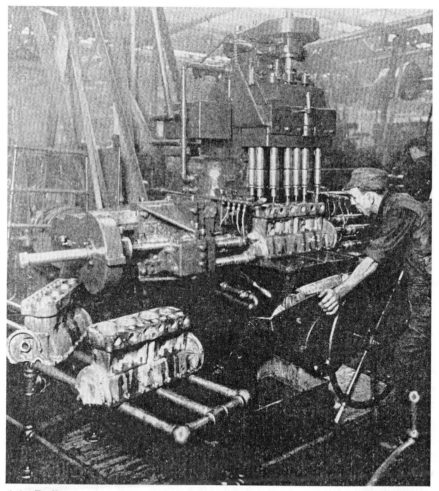

1.4 Drilling and reaming the engine block, Ford Motor Co., Highland Park, 1913. From the collections of Henry Ford Museum and Greenfield Village. (Ford Archives, P.833.219)

Such an intensity of concentration, on the part of both machine engineers and photographers, enabled their originality but disabled their capacity to visualize their contribution within larger organizational structures. In the early months of 1913, time was still being spaced at Highland Park in essentially the same ways it had been for decades at the major batch-producing manufactories, such as Bethlehem Steel and Baldwin Locomotive. Production engineers had removed from workers their ability to prefigure the dovetailing of any complex set of processes, but they still envisaged single workers or groups servicing individual machines. Conveying materials, tools, or partly finished products was also conceived as measurable motion through a two-dimensional plane. Even assembly—newly prominent as a result of the machinists' inventions of ready-made parts and soon to be acknowledged as close to an imperative in and of itself—was done, as it had been for some years, at benches or at stands, isolated in rows, stretching as long as covered space would permit.

The acceleration of machine production at Highland Park had wrought changes of degree in the spatial organization of work. Engineering writers Arnold and Faurote, in their series of articles in *Engineering Magazine* during 1914 and their book *Ford Methods and the Ford Shops*, note many remarkable changes in work practice throughout the entire company organization. A typical illustration caption reads, "General Views of the Ford Machine Shop Showing the Exceptionally Close Grouping of the Machines."[13] The fantastic speeding up of machine production was carried out in increasingly confined conditions, with safety provisions themselves being made up ad hoc. These reports and photographs attest to the contraction of work space, almost to the point of its disappearance, which the blinkered obsessiveness of the machine engineers promoted. Assembly benches and stands were also stacked as closely together as possible, allowing only for the movement of trolleys full of parts between them. The rate of production remained limited by the capacity of the individual workman at each stand, indeed, by the slowest of such men. Major assemblies, such as the engine, the chassis, the dashboard, and the axles, were all put together in one stand, as were major subassemblies, such as the magnetos, on single benches. All that was repeated was the stand or bench, the workman bending over it, and the trolleys and teams servicing him. These fundamental structures were reduced to simpler and simpler units, and their interaction regulated as far as time and motion systematicity could allow. Certain operations, such as the threading of radiator fins and tubes, were evidently Taylorist in their time-saving simplicity,[14] but the basic components of the labor process were still essentially static, even if moving, each in their place, at hyperspeed.

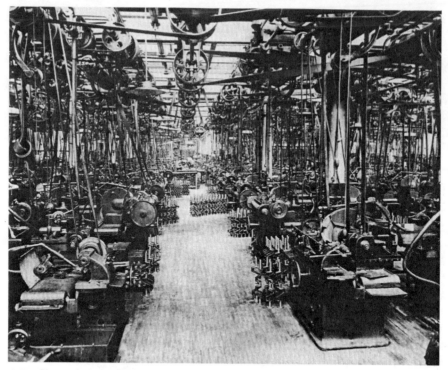

1.5 General view of Ford Machine Shop, Ford Motor Co., Highland Park, 1915. From the collections of Henry Ford Museum and Greenfield Village. (Ford Archives, P.833.2296)

Was not the assembly line, as Sorensen recalled, the "natural" outcome of these pressures: the company's drive for ever-increasing production allied with the machine engineers' desire to fulfill the ultimate goals of their profession? Drawing on Arnold and Faurote, and many of the oral history reminiscences, leading Ford Company historian Allan Nevins paints an engrossing picture of a logical, if rapid, development from the machining innovations to the introduction of gravity slides and conveyor systems at various points in the factory to the installation of the assembly line throughout the factory.[15] Hounshell stresses the priority of the production engineers' inventiveness, certainly much underrated in earlier accounts, and carefully demonstrates the difficulties in discovering anything other than mutually stimulating simultaneity in the emergence of the conveyor belts and gravity feeds, on the one hand, and the assembly line itself, on the other. He inclines to giving precedence to the assembly line, arguing that it provoked the search for smaller servicing systems of similar speed and control ability.[16] He also

asserts that Nevins's metaphor of the conveyors and gravity feeds as rivulets flowing into streams of machines which were then organized into great rivers (the assembly lines) is inappropriate: "With the speed, magnitude and impact of change at Ford, this was the Deluge, the Great Flood, which wiped out all former notions of how things ought to be moved and assembled."[17]

It is important to distinguish here between an accurate characterization of the near-spontaneous combustion of the assembly line (and all its related phenomena) at Ford and the nature of the system itself once in operation. The evidence taken as a whole points to the scarcely coherent conjunction of many factors, variously shaped by many drives, some contradictory, some convergent. But a regulatory system *was* put in place on an unprecedented scale. The crucial factor in need of explanation is the revolutionary step of reversing the previous relationship between a worker and the work to be done. What, at Highland Park, precipitated this change? What pushed Taylorist rapid running-on-the-spot into a three-dimensional continuity, for which "flow" seems a quite accurate figure? What kinds of pressures accumulated to turn static, one-point assembly, which entailed a relatively, although decreasingly, complex set of skills—however much it was being increasingly fed by synchronized deliveries of ever-smaller parts—into its opposite, the passage of parts past workers whose job became the touch which adds

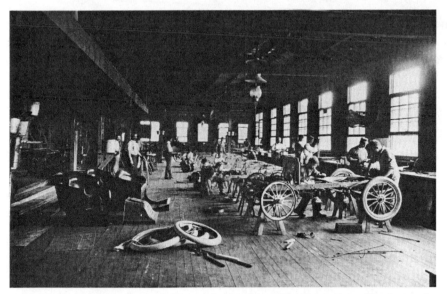

1.6 Static assembly, Autocar Co., n.d., Ardmore, Pa. From the collections of Henry Ford Museum and Greenfield Village. (Ford Archives, P.O.3845).

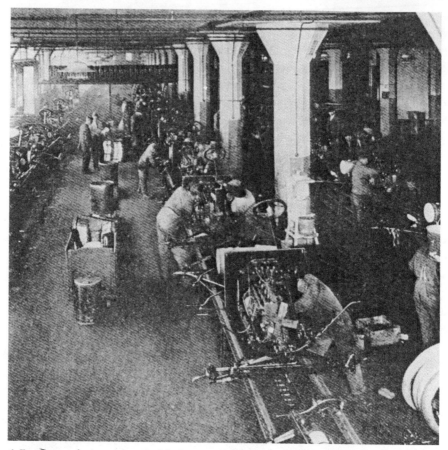

1.7 General view of assembly line, connecting motor to chassis, Ford Motor Co., Highland Park, 1914. From the collections of Henry Ford Museum and Greenfield Village. (Ford Archives, P.833.3987)

to that of others in the accumulation of the whole product? However much one describes the two kinds of approaches to the same task in (almost) interchangeable terms, they represent contraries, as a glance at the photograph of magneto coil assembly will reveal. The workbench has disappeared, to become a mobile surface—a frame in space—across which one's task slides. In other parts of the factory, the stand vanishes to become a similar frame upon which the worker's task appears to be performed, then again and again. And the task is now much reduced from a gathering together, however regulated, to a passing touch, utterly controlled.

The most particular kind of explanation could refer this fundamental reconceptualization to a moment of local myth: to the ingenuity of the

machine engineer—in this case, Martin, Sorensen, Emde, or Klann—suddenly grasping a simpler way of getting the particular job done. Its implications became clear to others at Ford, in charge of other workshops, so they applied the idea to their task. The Ford Company assembly line becomes the ensemble of their efforts, an overall effect of its roughly related parts. Why these men saw their task so differently can only, on this reading, be referred to the engineer's proclivity to be always imagining new solutions, that is, to the inexplicability of "pure" invention. Hounshell, whose argument rests on something like this assumption, is nonetheless genuinely puzzled by it. After describing in detail the momentous day in the flywheel magneto assembling department, he muses: "Martin, Sorensen, Emde and others had designed what may have been the first automobile assembly line, which somehow seemed another step in the years of development at Ford yet somehow suddenly dropped out of the sky."[18] There is no doubt that nonscientific, even nonverbal, thought plays a crucial role in all invention, including that of engineers: "thinking in pictures" is fundamental, as Ferguson and others have pointed out.[19] This seems self-evident in relation to particular machining problems, but was not the assembly line less an imagined variation of an ensemble of given elements and more a sudden shift to a different kind of picturing altogether? A change, that is, in the framing of space, in spacing time, which enabled the realignment of certain existing elements, thus also enabling, in turn, recognition of its applicability to other realignments, ad infinitum. The assembly line was the key move in the emergence/appearance of a new paradigm of production.[20]

Another kind of miraculous explanation would attribute key agency to Henry Ford's evident, and often-attested, desire for unity. Yet no matter how much his organizational genius is acknowledged, it did not, as we have seen, predict or even desire the assembly line. Are we then left with Highland Park, 1913, as the site on which various modernizing forces—such as those of factory organization, production engineering, labor management, the drive for profits, the migration of peoples, the development of new technologies, the growth of rapid communications, and the emergence of the professions—achieved an unprecedented expression, unleashing a whole unimaginable from a combination of these parts? Many theories of modernity take precisely this form. They leave the concept of modernity as an inferred essence, almost as mystifying as if it were conjured up by Henry Ford himself. Nevertheless, a reading of this sort may take us closer to modernity as it was being redefined at Highland Park. How much further generalizable it may be must await the unfolding of studies across many other sites.

Political economy has something to contribute to the unraveling of our

puzzle, however. If the theses as to the essential contradictions driving capital have any validity, where else but at this time and place would we expect to find them in evident, even naked operation? In 1857–58, in the *Grundrisse*, Marx graphically highlighted the alienation of workers from the control of their labor which automation was introducing.[21] He also saw clearly how essential to the capitalist system was the extraction of surplus value from workers' labor. While he predicted increases in both areas if capital was permitted to flourish unchecked, he could not have foreseen their exponential acceleration at a place such as Highland Park. The worker, suddenly, became adjacent to the production process; the machine became central. Furthermore, the revolution at Ford is predicated on the assumption that machines also "work." It is no large step—in the profit-driven circumstances ruling at Ford Company—to the reconstitution of machines, particularly through the application of technical and scientific information, such that surplus value is extracted from them. Indeed, with hindsight it seems obvious that this had been a governing force in the design and disposition of machines for some decades and that the Highland Park machine shops represent a specific advance in the development of this tendency.[22] The surplus value generated by such unprecedented automation could be graphically measured by the amount of human skill redundancy it caused, but to those in control, it was best proved in greatly increased productivity matched with proportionally greater reductions in costs (not just material costs, but including those of technological application)—that is, pure surplus value, translatable into profits.

Here, too, is a further key to the timing of this takeoff. Surely Henry Ford's decision to build Highland Park illustrates an axiom of capitalist development: that innovation will be adopted only when it offers the prospect of lowering production costs such that it increases significantly the profits to be gained from investing in it. In Ford's own words, "Our policy is to reduce the price, extend the operation and improve the article. You will notice the reduction of price comes first. We have never considered any costs as fixed. . . . One of the ways of discovering what a cost ought to be is to name a price so low as to force everybody in the place to the highest point of efficiency. The low price makes everybody dig for efficiency. We make more discoveries concerning manufacturing under this forced method than by any method of leisurely investigation."[23] Yet Ford Motor Company grew so rapidly along these lines that Henry Ford could afford to establish a domain dedicated to productive innovation, to unenvisagable developments that demanded adoption. Again, a passage from one stage to another, to another marker of a new modernity: from choosing to finance and use the innovations of others,

Ford Company began to structure itself to produce its own inner transformations. This suggests a step beyond our opening slogan: nothing original, yet everything new. How far, and how, Ford actually progressed beyond this point emerges in what follows.

In sum, the assembly line was clearly the key invention. Yet it was neither a predictable nor even a necessary outcome. But occur it did, less as one huge, singular solution, more as an accumulation of culminations of many inventions within a variety of different discourses. It was the fact and the figure which enabled mass production to be recognized as the new paradigm that it was. Moreover, the assembly line expressed unequivocally Ford's larger organizational structures and satisfied its overriding purposes, above all the imperative as to economy. Had it been a more costly alternative to the outstandingly successful operations already in place, it is doubtful whether it would have been adopted. Mass production would have been a lesser thing, if it occurred at all. The Ford Company courted risk taking on the shop floor and within the flow of supplies, but was extremely conservative on the level of speculative capital. During the 1920s, as we shall see, Ford was forced to be flexible in both its manufacturing methods and its finances. Fordist mass production had only a short life in its first "pure" form.[24] Its persistence as a symbolic paradigm, however, was of much longer duration.

"A Great Productive Machine"

On January 21, 1914, Charles B. Going, editor of *Engineering Magazine*, wrote to Horace L. Arnold in Detroit, responding to the suggestion, supported by Henry Ford and his chief engineer, Edward Gray, that the Ford experiment was of "extreme interest" and worthy of book-length treatment. Going preferred a series of articles in the first instance and set out the following scheme: "First, an article taking the Ford shops in their entirety under the concept suggested by a phrase in your letter of the 19th, as a great productive machine, showing how the idea of coordination for economy of production is carried out by the arrangement and equipment of the plant as a whole, and showing the ideals of management, and the relations between manufacturer, employees and public by which the establishment is animated." The second article was to deal with the foundry as a specific example of "specialized installation and equipment for production at the least possible cost," and the third with the power plant as "physically speaking, the energizer of the entire plant."[25] Arnold and Faurote went on to elaborate this schema considerably, but maintained its structure. The first article was presented in the May 1914 issue, the cover of which shows an image of the original Highland Park building, with the four chimneys of the power plant

prominent, bursting through pages of text to arrive fully formed in front of the reader. In the context of the magazine's usually rather sedate design, this visual eruption, or tearing away the pages to read the vital news about Ford, signifies the sensational.

"A great productive machine," Arnold's metaphor of "the plant as a whole," has disappeared from our increasingly microscopic pursuit of the origin of the assembly line. But is not this what we find there, in the depths of particularity? Machines came to dominate Highland Park during 1913; reshaping them so they could work with maximum precision, efficiency, speed, and economy became the priority; servicing machines in the cheapest, most direct fashion became an obsession; distributing their output in the most obvious way became imperative. Space was organized around these demands; human activity became a simple function of them. Conveyors, gravity feeds, the subassembly, and the long assembly lines were each more and more elaborated ways of establishing circulation between machines. In this sense, workers making simple, repetitive gestures of assembly were also performing machinelike functions: analogies to robotic behavior were quickly drawn. Human space disappeared at Highland Park; machine logic allowed no agency for workers except as operatives, no territorial initiative, none of the "fallow" space still possible at other plants. Toilets were installed close to the line; rest time was excluded, banished to outside the plant. Individual control over time within the job itself was also reversed: from actively anticipating the future—the sequence of steps to make the product—the assembly-line worker waited passively in expectation of what was conveyed to him.[26] In sum, workers were adjusted to fit machine requirements or discarded: machines, not people (however regularized by time and motion standardization), set the pace at Ford.[27] Yet the assembly line was itself a machine, or more accurately, the internal circulatory system of an additative machine laid out and open. From this perspective "the plant as a whole" becomes "a great productive machine."

Did the concept of machine itself undergo a change, matching that happening in the system of production as a whole? Or was the metaphoric becoming literalized, like so much else in Highland Park's relentless drive toward the utterly instrumental? Within the discourse and actions of those concerned, there was the orthodox sense of a machine as an apparatus in which the action of several parts is combined for the applying of mechanical force to a purpose. But most dictionaries also cite the larger sense of controlling organization—in politics, say—even machinery as the framework of a story or play.[28] But there was also, in the situation at Ford and elsewhere of the time, the machinist's prag-

matism toward his apparatus as itself a construction, which can be made differently (by applying other machines). At the same time, engineers were coming to see their machines increasingly as simply the most practical imaginable method of serving a given purpose, usually the transforming of certain materials into something with another use. If one removes, as Taylor strove to do, the expertise of machine operators and their specialist limitations, any functionality can become machinery. Highland Park did not go quite that far, whatever the drives of its production engineers. It did achieve a revolution in the conception of machine production by giving such priority to assembly over basic manufacture that the production of parts, and therefore all machines engaged in making them, had to be reshaped to produce parts that, while functional in the Model T, were most suitable to rapid assembly. The accelerating output of Ford machines in the years before 1913 was phenomenal enough, but the increases from 1914 were staggering.[29] This drive toward the priority of assembly over the production of parts absorbs the achievements of the production engineers (and, as we shall see, of the almost equally important office management) into a larger system, that of the plant as a whole: a machine using machines to produce machines in such ways that each of these terms was being rapidly redefined. It could be said that machinic surplus value has fused with that being so brutally extracted from the worker, himself fast vanishing into invisibility, to become a bursting dam of pure productivity.[30]

Thus the appeal of the "great productive machine" metaphor to those controlling these operations. *Engineering Magazine* proudly declared its dedication on its front cover: "Specially devoted to the interests of proprietors, engineers and managers." Small wonder that Highland Park shone forth with such force of revelation, and that a unitary, if flexible, description of Ford phenomenon was preferred. In Arnold and Faurote's text, the assembly line is accorded much attention, but only as part of a larger and extremely varied set of operations, both administrative and material. These are treated as ultimately coherent, everywhere innovative, and essentially beneficial. Yet there are various indicators in their account that the accelerating obsession with assembly was creating contradictions that threatened to disrupt, even overturn, the flow. The generalizing drives of Fordism were already meeting particular resistances; the tension here is explored in the sections that follow. I emphasize the politics of seeing and of space, but do so within the framework of the overall development of Ford Company during the 1910s and 1920s.

Phase Two: Global Fordism at the Rouge, 1917–1927

In the preface to his laudatory write-up of a long series of interviews with Henry Ford, preparatory to Ford's unsuccessful campaign for a U.S. Senate seat, Bensen stresses that the chief difference between the "kindly" labor philanthropist, the conqueror of the secrets of mass production of 1914, and the new Henry Ford of 1923 is the latter's total commitment to "order"—not just in matters concerning Ford Company, but in the practical, efficient, and just organization of key relationships in the world at large.[31] What kind of order was being called for? Was it the naïve generalization of Yankee know-how or part of the orchestration of the internationalizing of Ford Company's interests? The shift from isolationism to global antiwar sentiment, represented by Ford's funding of the 1915–16 Peace Cruise, has the same components as the shift from these positions to all-out support for the war when it was officially declared in December 1916. Ford Company was important in the mechanization of the war, but more important to the propaganda line that mass production was on the side of the Allies than the reality of its actual contribution, given the company's difficulties in meeting its targets. To Benson (and many others), Ford's ambition became mythical, godlike—a vision of ultimate power, bringing labor, social, and natural relationships into ordered harmony. He has Ford moving mountains, diverting rivers, saving the world. Not machinery but Ford himself has become the "New Messiah."[32]

At Highland Park in 1915, 18,000 people worked in dozens of buildings, on 5,500 machines, fifty miles of belting, one and a half miles of conveyor track—the nucleus of an empire of twenty-five plants in the United States, others in Canada and England, with headquarters in seventeen countries and over 7,000 dealers in the United States alone.

In 1915, planning began on a plant at River Rouge, Dearborn, Michigan, which would dwarf Highland Park in all these respects. Between 1915 and 1925 the Rouge plant developed in ways which have had profound consequences for both the imagery and the "base structures" of twentieth-century modernity. In seeking to expand and liberate the "organic flow" of Highland Park, and to join it to a system of transportation which brought raw materials from sites owned by the company to the Rouge and then distributed the processed product to selling/consumption points, Ford Company effected a system of centralization both intensely local (treating all other time and space as subservient to the place of production) and global (evacuating the local as a minimal through-put point in the network as a whole). The metaphor of the productivity

of money, circulating in patterns of finance, producing ever more capital in its incessant exchange movement, was materialized in the network of which the Rouge was the most visible junction. The product remained constant, single—the Ford Car. The "purity" of mass production glimpsed at Highland Park was now envisaged without the distractions of awkward containers, "old-fashioned" labor relations, or reliance on other manufacturers and suppliers. This purity was projected as sheer movement, both within the plant, now broken up into separated functional sites joined by rail lines, and within the system as a whole, also broken up into sites of extraction, loading, transport, unloading, then redistribution, which were joined by railways and shipping. The fact of the railway junction replaced the metaphor of the river. The Rouge itself became less a productive machine (the whole system was now that) than a city in which machines reproduced themselves, a utopia of robotized workers kept submissive by high wages and welfare/coercion. Ford Company entered the centuries-long struggle between the city and the plan; the triumph of the latter is a further index of its modernity.[33] Above all, the local/global scale of the system was the first concrete manifestation at a significant magnitude of that Other which many commentators have recognized as haunting laissez-faire, competitive U.S. individualism—the planned society, the government of resources, needs and growth, albeit by private enterprise. River Rouge, Dearborn, Michigan, became a model for Lunar City (a midcentury model of modernity as persistent, if not as celebrated, as New York City). And the Ford Company mass production network became a natural order, the new Nature, a man-made machine for controlling both Nature and Man.

The continuous assembly production of Highland Park had necessitated not only the fitting of feeder lines to the main lines in logical sequence but a precision of timing, of coordinated human/machine action unprecedented in industrial work, indeed, in nearly all organized behavior. The Rouge network instituted this on a massive scale: it assumed that the synchronized flow could be generalized not only to the whole plant, but to all elements of the network which fed the plant. Eventually, Ford was to see it as the essence of a universal philosophy: all other relationships become subordinate to maintaining the Flow. (Huxley waits in the wings.) But at this stage, all Ford Company sought to do was buy up vast supplies of the raw materials of which cars were made—iron and steel, lumber, coal, limestone, silica sand (for glass)—and organize for their extraction and transportation to the huge bins on the riverfront at the Rouge, where they would be processed to the next stage. Economies of scale then applied to the entire network.

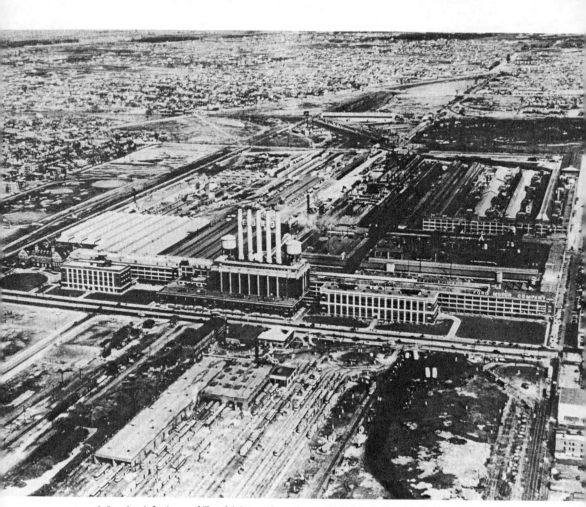

1.8 Aerial view of Ford Motor Co. plant, Highland Park, c. 1920. (Albert Kahn Associates, Architects & Engineers, Detroit, Mich.)

In this way the network aimed to be largely self-sustaining. (It did not as yet consume its own product, although the lively repair and spare parts business predicated this; secondhand cars were just beginning to appear.) It became so in a way different from certain nineteenth-century empires, as was soon noted: "As a result of the high degree to which fabrication has been mechanized, the attention of management is turning now to the transportation of materials. . . . The biggest cost savings of today and tomorrow are likely to come from moving rather than making."[34] That is, movement around the network became the priority; the very circulation of the system became constantly self-replenishing.

The overall layout of the Rouge appears puzzling at first, as does the intermittent, even haphazard fashion of its development. Perhaps it was

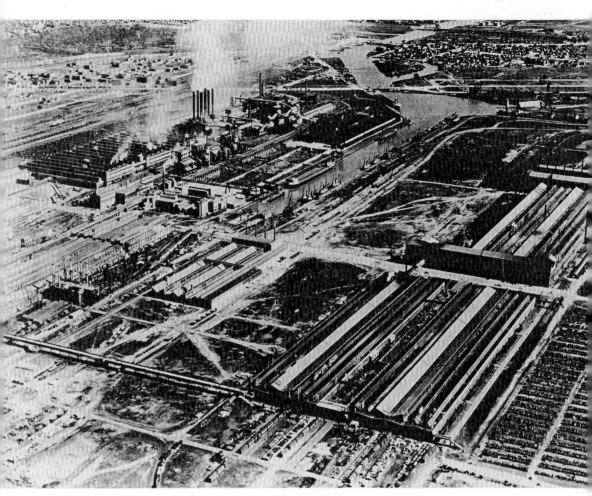

1.9 Aerial view of Ford Motor Co. plant, River Rouge, Dearborn, 1930.
(Albert Kahn Associates, Architects & Engineers, Detroit, Mich.)

initially conceived as a feeder site to Highland Park, then as the site for
the Fordson tractors, and then, with the old plant failing to contain the
new processes, as the place for them: the moving assembly line itself
was not brought to the Rouge until 1927. There is, however, the leap to
the local/global network already indicated. The first clear sign of it is
that, instead of the continuous, *contingent* placement of each step in the
process, converging always on the central production line and tending
always toward assembly, the major functional sites quickly step out of
Building "B" (the Eagle Building) and are divided into *separate* structures
all over the site.

But this separating should not surprise us. It came from a commit-
ment to the division of labor so evident in the minutest breakdowns of

1.10 Eagle ("B") Building, Ford Motor Co. plant, River Rouge, Dearborn, 1917. (Ford Museum, Forster Studio, M4567-35; Albert Kahn Associates, Detroit, Mich.)

human and machine motion still continuing in all Ford work, different only in that it was expressed on a large scale. And the urge to growth which was the other side of the same obsession was expressed in this very scale, the plant as a whole, which was all assembled on north-south axes, with railway lines running throughout, the curving river feeding the storage bins and the high line distributing their materials into the plant proper. Basically, the plant can be conceived as a single structure of one-story, roof-lighted buildings able to be extended horizontally in any way determined, all constructed out of standardized materials on a common module and tied into a clear circulation matrix which is itself part of a larger system of supply and removal. It is this which leaps beyond the essentially additive nature of Highland Park and industrial plants of comparative magnitude overseas, such as the Krupp plant at Essen. Its modernity is its commitment to infinite growth, its ability to extend in directions yet to be perceived, its declaration of a fundamental order which can both contain and productively harness any future change.

To be able to see this clearly, to stand over a model and move pieces about, to envisage the ways the Rouge locked into the Michigan iron and steel reserves and the Fordlandia rubber plantations in Brazil, Ford needed to achieve an absolutism of power which, while it might seem feudal in some of its trappings and language, contains in it the seeds of

the abusive dominance which characterizes later multinational capital. In 1919, Ford assumed total control of the company by threatening to withdraw from the business and then secretly buying out the minority shareholders. He unleashed major purges of the management by Sorensen and Liebhold. He announced the $6 day and then promptly increased the speed of production. He squeezed his franchized dealers by overloading them with a hundred percent more cars than they had ordered. Two years later he tightened the screws even harder, boasting in *My Life and Work* how he managed to gain the same number of cars from the labor of 40 percent fewer men in 1921 by a speedup of savage ferocity.[35] As part of the same move, he adjusted the wage scale down 20 percent, sacked 20,000 men, purged 75 percent of foremen and managers, and closed down the Sociological Department as "wasteful." The 1921–22 profit was $200 million. Ford company's clarity of vision depended crucially on the exercise of power unchecked, on the exclusion of any ameliorating structures so totally that nothing remained but the abstract elements of mass production itself, enshrined in continuous motion, the basis of a new, ordered world system. It is hardly surprising that the Ford example appealed to apostles of planned societies, both socialist and fascist, in the years following.[36]

These repressions were not unusual, nor were they without consequence. Political economy shows us how these moves by Ford fit the implacable drive toward total production and how they are, at the same time, its crippling limitation, precipitating constant crisis. Marx tells us that "The contradiction, to put it in a very general way, consists in that the capitalist mode of production involves a tendency towards absolute development of productive forces, regardless of the value and surplus-value it contains, and regardless of the social conditions under which it takes place, while, on the other hand, its aim is to preserve the value of existing capital and promote its self-expansion to the highest limit (i.e. promote the ever more rapid growth of this value)."[37] There is a double movement here between an unstoppable drive to expand beyond its present limits, and to put everything at risk in so doing, and an equally implacable containment within the specific base of operations, a confining insistence not just on concentrating profits but also on the core value of the particulars of original person and place. In this sense, Marx goes on to say, "The real barrier to capitalist production is capitalism itself."[38] Ford Company exemplifies these observations par excellence, in the organization of Highland Park and the Rouge, in the daily adventure of innovation and inflexibility within both plants, and its tempestuous history of change and resistance to change over three decades. Deleuze and Guattari point to these contradictory processes as part of a "capitalist flow" aimed at creating a "surplus value of flux," and consisting of con-

stant internal struggle between drives toward generative "deterritorialization" and constraining "territorialization."[39] These can be seen in action in the machine shops in 1913–14: a schizophrenic irruption at the moment of maximum rational flow is as acute a reading as any of the fourth-dimensional reversal at the heart of the invention of the assembly line. On a quite different scale, a war between center and peripheries occurs within global Fordism during the years following.[40]

Explanatory models such as these, which stress the necessity, continuity, and fluidity of apparently contradictory forces, seem most responsive to the volatility of early twentieth-century modernity. I have tried to apply them in my descriptions of the spatial organization of work at Highland Park and the River Rouge. But the account remains partial: the shaping of space inside the factory was continuous with efforts to control the social spaces "beyond" its thin, transparent walls. Fordist modernity spread fast, far, and wide.

Different Ways of Watching

Three distinct but related forms of surveillance were operative within the Ford domains of invention; indeed, they were key products of its inventiveness. It follows, typically, that they were also means constitutive of this inventiveness, of its endless diversification, of its constant reproduction. One was quite traditional; the other two became modern in their form, their excessiveness, their risk taking, their thrust for totality. *Spying* on fellow workers was one method. It is emphasized briefly here in its orthodox forms of bullying, threatening, cajoling, coercing information about workers likely to engage in dissidence or sabotage, particularly during the struggles to unionize the plants throughout the 1930s. Estimates of the proportion of workmen (apart from foremen) holding such watching briefs vary, but some are as high as one in four.[41] Yet even this traditional means of maintaining control was changed by its incorporation into the other two, more distinctively modern methods: constant *inventory* of the stasis and movement of every element, material and human, in the entire plant (which redefined management as above all monitoring), and *inspection* of workers' behavior away from the plant in forms which varied from the welfarism of the Sociological Department in the 1920s to the more direct, criminal coercion of Ford Service in the 1930s.

We have seen that in its purest form, line production demands precision timing for the arrival of materials, parts, tools, and machines at the relevant part of the line. Continuous flow allowed the greatest economies by reducing the movement of workmen to the absolute minimum (implying the dream of total automation impossible in a manufacturing industry but nonetheless figured at the time in the frequent references

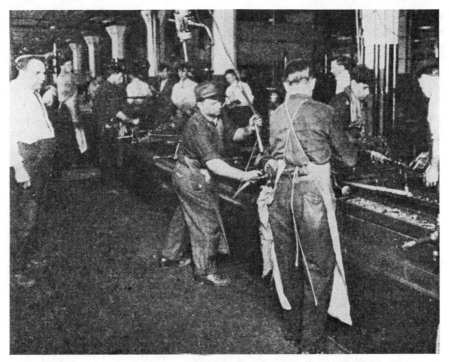

1.11 Foreman and workers, front-axle assembly line, Ford Motor Co. plant, Highland Park, 1913–14. From the collections of Henry Ford Museum and Greenfield Village. (Ford Archives, N.O.19505)

to robots). Inclined trays, conveyor belts, monorails, trolleys, and human lifting were all practical servants of the line. But what astonished early observers of the plants in action even more was the extension of the domain of management at the expense of the worker and the reshaping of management around stock control.

Fordism was based on the assumption that the demand for Model Ts was insatiable, so that the single purpose of the plant was to process incoming materials into product at the maximum rate. Although the River Rouge plant gradually moved toward entirely encompassing every stage of this processing, at Highland Park it was still the case that many major and minor components were supplied from outside: "the bodies, wheels, tires, coil-box units, carburetors, lamps, 90 per cent of the car body painting, all drop forgings, all roller and ball bearings, grease cups, spark-plugs, electrical conductors, gaskets, hose connections and clips, horn, fanbelt, muffler pipe, and part of the bolts."[42] As it expanded, the Ford Company took over many of these manufacturing functions, but when this list was compiled in 1914, the plant made only the major engine components (cylinder block, the distinctive magneto flywheel) as well as most of the interior fittings and the lower body (chassis, axles,

wheels, etc.). As argued, its primary emphasis was on assembly, on reducing all functions to approximations to assembly. In effect, this exported manufacturing to those who supplied the plant, and it did so under cut-throat conditions. (Two mistakes, delays, or faulty orders meant cancellation of the contract.) At the other end of the system, Highland Park boasted no storage space, except on rail cars ready to roll. Ninety percent of cars manufactured were already sold; the remaining 10 percent were immediately distributed to local retail outlets which were "merely removed members of the Highland Park plant."[43] These, along with the economic imperative of maximum cost reduction in every aspect, on every level, constituted the basic framework within which management became an essential part of Ford Company modernity, inseparable from its technical revolution.

The Visible Hand: Management as Observation

The commercial planning of production flow at Highland Park would seem a matter of textbook simplicity, given the stability of steady, apparently insatiable demand for the Model T. Charting production levels and scheduling the fixed components needed to supply them would seem a matter of standard budget control, the plotting of conveniently increasing, converging curves—albeit on an unprecedented scale. That this does *not* fully characterize Ford Company procedure reveals more of the modernity of Highland Park.

In recent interpretations of modernity, the "organizational revolution" has taken up a place in the list of modernizing forces, alongside electrification, changes in transport and communications, new industries, and the great social changes such as urbanization and the migrations of people within and between nations. To some, the emergence of a new managerial class is as significant as technological advances of the sort we have been discussing. The managers' organizational skills, knowledge, and perspectives became crucial to the evolution of mass production, mass distribution, and mass consumption into practical, commercial and, to a degree, socially viable systems: they became, on this argument, foundational to the "second industrial revolution."[44] Chief chronicler of these changes Alfred D. Chandler has claimed that the new technologies of the mid-nineteenth century—the railroad, telegraph, steamship, and cable—and the new methods of mass distribution they enabled, required a new type of organization to coordinate the flow, at unprecedented volumes and speeds, of goods, passengers, and messages. First appearing within the railway and telegraph systems in

the 1850s and 1860s, the new managers became essential to the mass retailing establishments, such as the big stores and mail order firms like Sears Roebuck, then to the mass production enterprises, where they were crucial to the emergence of both cartel-like trusts in the oil industry and to the oligopolies of the machine-manufacturing and the food-distributing industries.

Certain companies came to dominate their fields of activity not only because they controlled the relevant technology—usually only a temporary advantage—but also because they could maintain a level of *throughput* that enabled them to produce and sell a given range of products much more cheaply than other, usually smaller, competitors. *Throughput* meant that technological advantage became a matter of not just material but economic scale. The new managers—working to their own conceptions of the flows of capital in the economy (or at least the relevant sector) as well as to the details of movement within the plant and through the system—became "the visible hand" controlling the movement of men, money, machines, and products, as opposed to the invisible hand of market forces that Adam Smith saw as the key regulator during the first phase of capitalism.[45]

"Hour by hour, with endless toil and pains, an absolutely correct record is kept of Ford component production and of the Ford factory output."[46] Between 1,000 and 4,000 separate pieces of each element of the Model T moved through Highland Park each day in 1914, emerging as 1,400 finished cars. In such a system, total tabulation and constancy of flow become inextricable—the control of the visible becomes all-important. Motion in space becomes the key indicator of use. Each element appears, in motion then stilled, just as it is consumed by the circulatory system. Exact, complete record-keeping seeks to display throughput with utter transparency, to enable the imposition of a two-dimensional flowchart onto the three-dimensional actuality of men, machines, and things, to set out a structure which makes quickly apparent any mismatching between its graphic ideal and the factory floor, or the performance of the suppliers and distributors. It applies also to worker and machine labor, except that it does so in reverse. When the flow dominates, a still workman, or one making an inappropriate movement, is immediately noticeable in his nonproductivity, his consumption of surplus value (a reverse visibility, an organic-mechanical exchange). The same holds for machines which fail to perform properly. Material components delivered at the wrong time, stored in the wrong place, being made the wrong way, or being assembled wrongly stand out as "wrong" because of their difference from the systematic string of mul-

1.12 Office at the clearinghouse, Ford Motor Co. plant, Highland Park, 1913–14. From the collections of Henry Ford Museum and Greenfield Village. (Ford Archives, N.O.833.697)

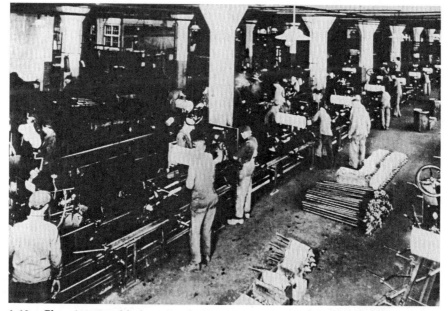

1.13 Chassis assembly line, Ford Motor Co. plant, Highland Park, 1913–14. From the collections of Henry Ford Museum and Greenfield Village. (Ford Archives, P.833.985)

tiple simplicities. Tabulation is a constant searching of the similar for the different, of motion for immobility which instantly becomes an oddity, an aberration, a threat unless it is quickly put "right."

None of this was new to Highland Park. By the mid-1880s, Singer Sewing Machine Company plants in New Jersey and Glasgow produced eight thousand machines a week, satisfying two-thirds of world demand. This required a greater degree of tight scheduling of flow of materials into, through, and out of the plant than was common in other industries at the time, even those producing much simpler goods or packaging processes.[47]

By 1900 the Taylor System was so regularized that owners could purchase the services of those practiced in installing it in different kinds of plants. We have noted the ways elements of it were absorbed into Highland Park's rage for invention. A detailed account of its installation at a smaller motor manufacturer shows how the system had moved beyond the notorious "planning and routing the work through the shop" and "rate-setting by means of slide-rules and time-study" to an equal insistence on "our cost system" and "our general accounting methods."[48] By 1910, "unremitting record-keeping" was being urged as essential to all efficient management, the core of the services which the "production engineer" could provide to businesses; for example, it occupies over two-thirds of Diemer's textbook, *Factory Organization and Administration*.[49] It was the site of a fundamental shift in power, control, and responsibility within the work process from the worker to the manager, and was recognized as such by all concerned at the time.[50]

There were, nevertheless, certain conditions specific to Highland Park that lent the shifts there a local inflexion, and an intensity which gave them, rather than others, the power to become paradigmatic, to become "Fordism." Chandler's model distinguishes between upper and middle management, but it tends, at the same time, to merge them into an abstract set of organizational functions. At Ford, however, all levels of management were subject to the increasingly eccentric will of Henry Ford himself: their proposals for improving the flow had to match his conception of how the parts of his empire best fitted to together at that time. Moreover, few Ford company managers, especially before the 1920s, fit the model of "organization men" bent over flowcharts, distant from the factory floor. Most of them were mechanical engineers who became production men, as they redefined the nature of their trade by their own innovations. Indeed, their increasingly unusual closeness to the material forces of production, allied with the imposition of a set of demands modeled on the distributive industries, arguably enabled their drastic transformation of those forces.[51] Nevertheless, these men contributed greatly to the destruction of the expert foremen and skilled ar-

tisans who had been so central to the work process, and to their replacement by a range of specialist managers, working between the top management and the deskilled worker, dedicated to maintaining and accelerating the flow. This was their input into the creation of the new factory system in the United States.[52]

Another difference at Ford is that, for reasons which will soon emerge, few Ford Company managers joined "the revolt of the engineers"—the double drive toward both professional recognition and social reform which characterized the "progressive" engineers of the period.[53] Yet the major differences at Highland Park were matters of degree that turned themselves into differences of kind. We have already rehearsed them: although it may be theoretically irrelevant, the sheer scale of Ford Company production was unmatched in any other industry at the time, and it was combined with a degree of reductive instrumentalism and a measuring gaze applied so relentlessly to every person and thing in the system that all relationships, understandings, and perceptions were thrown into a disarray from which—it must have seemed to many at the time—only Fordism itself seemed capable of rescuing them.

But matching these quantitative excesses was an excess of quite the opposite kind: at every moment this entire mobile edifice of factory organization was at risk of failure, collapse, closing down. Prudent management—and, indeed, official statement at the plant—placed the safety factor of component supply at one month's supply in reserve. Highland Park typically operated at a maximum of *three days'* supply in reserve. This necessitated new kinds of managers (for example, the "shortage chaser") and a constant acceleration of demand on workers; it also deeply affected Ford suppliers and sales branches, as it was to them that Ford shifted the burden whenever the system failed. We are, these days, familiar with how the postwar Japanese car manufacturers have refined "just-in-time" production supply methods into a fine art. The astonishment of contemporary observers at Highland Park was founded on their assumption that "the ideal factory condition is undoubtedly that of perpetual tranquility, all operations balanced and coordinated."[54] The modernity of Ford Company was, on the contrary, its creation of a domain of excess, in which extreme regulation courted chaotic disorder, a world dedicated to the incessant, lively invention of means for the reduction of its components to a dull similarity, aspiring to a perfect clarity of vision which had almost nothing to see except itself.

From Sociology to Service

What forms did this regime of constant watchfulness take "outside" the factory? It attempted to wear down externality by efforts to institute the "Ford way of life" among its employees. Like earlier English capitalists such as Colgate and Rowntree, Henry Ford was deeply interested in the "spiritual" lives of his workers. Many moves were made in welfare terms: factories were well lit and ventilated compared to others; some care was taken with methods of hiring and firing; examples were set by hiring some black and handicapped workers as well as former convicts; the *Ford Man* exhorted pride in the company; and, from 1914 to 1921, the Sociological Department surveyed the attitudes and behavior of the men on and off the job. Humanitarian ideologies are evident here, certainly inspiring Ford and those close to him, although each can also be seen as equally obsessed with maximizing productivity. Company welfare programs expanded along with, and as part of, the burgeoning of "the great productive machine." What was the relationship at Ford between these two apparently contradictory drives toward economy and humanity?

Prior to Highland Park, Ford production was typified by what were, in effect, a number of craft-based workshops within the plant as a whole. From 1910, as the innovations leading to the assembly line accelerated, as expert foreman and skilled artisans were increasingly replaced by dedicated machines and unskilled laborers, the company's thirst for raw labor exploded beyond the bounds of Detroit's available labor force. Most workers were recently arrived southern and eastern European immigrants, mostly of peasant origin, as were many unemployed from around the States, and few had much experience of industrial work.[55] This combination of factors led to chaos within the plant, in stark contrast to the brutal rationality of the machine system that was evolving but echoing the implicit anarchy of its high-risk supply servicing. In 1913, labor turnover was 370 percent; to maintain a work force of 14,000, the company had to hire 52,000 people.[56] Keeping workers committed to their jobs, despite the conditions, was the task of a directly coercive disciplinary apparatus of hard-driving supervisors and foremen (increasing from 1 in 53 in 1914 to 1 in 15 by 1917). Their efforts were directed by the swarms of clerical work-in-progress chasers, front-liners of the new flow managers just discussed.

The final element in what Ford later celebrated as his grand plan of high volume, high wages, and low prices was the introduction, in January 1914, of the famous $5 day. A drastic, perhaps desperate effort to solve the 1913 labor shortage, it doubled the wage rate for automobile

workers in the area, quickly filled available places in the factory, and, along with the other measures already mentioned, assisted further huge leaps in productivity.[57] Although it was presented as profit sharing, it came, for workers, at a price. In order to qualify for the astronomical wage, workers had not only to submit to workplace discipline, but they had to pass a series of checks on the nature of their home life. They were then categorized in various ways and, if passed, became "acceptable," in company language.[58] A Sociological Department was set up in January 1914 to conduct these checks; it consisted initially of about one hundred men, mostly Ford middle management and physicians. By the end of the year it had grown to nearly two hundred, but its numbers gradually reduced thereafter. In response to a Senate Commission on Industrial Relations in 1915, Henry Ford set out the objectives of the Sociological Department. They were to "explain opportunity, to teach American ways and customs, English language, the duties of citizenship . . . counsel and help unsophisticated employees to obtain and maintain comfortable, congenial and sanitary living conditions, and . . . exercise the necessary vigilance to prevent, as far as possible, human frailty from falling into habits or practices detrimental to substantial progress in life. The whole effort of this corps is to point to life and make them discontented with mere living."[59] Sociological Department photographs show employees in their homes before and after the attentions of inspectors: they contrast as pointedly as Dr. Barnardo's famous images of slum children, and they reinforce Meyer's point about Ford welfare's middle-class perspective on the home as universally central to moral and social values. They tend to contrast *How the Other Half Lives* exposés of desperate people in degenerate hovels to (unpeopled) homes freshly constructed, in isolated spaces, with a Ford parked in front of them.[60]

A less charitable view of the activities of the Sociological Department inspectors is that they were "empowered to go into the workers' homes to make sure that no one was drinking too much, that everyone's sex life was without blemish, that leisure time was profitably spent, that no boarders were taken in, that houses were clean and neat."[61] These were the criteria of "acceptability" to the company and of citizenship in the community. It was both a benevolence without bounds (an excess of zeal) and a crude attempt to achieve total control over the worker as a productive unit. In one sense, it merely used the new "science" of human management to clothe the barbarous coercion of workers on and off the job, which was common (in fact, typical both earlier and later than this moment) everywhere. It was an attempt by the old boss to impose on everybody the dedication to hard work, thrift, and decency which he believed motivated him, a set of values which his organiza-

tion's own productive innovations had rendered redundant. He could not see how people could live otherwise, yet the organization was making it impossible for them to do so. He was insisting on a nineteenth-century work ethic, while also insisting on a work practice irrecoverably of another order. Both this and the marketing practices discussed below incline me against the often-expressed view that Ford's moves were simply old-style entrepreneurial capitalist, whereas the new corporate managers were those with a large vision of national markets and of broad social control over the people both as workers and consumers. These *are* the distinctive desires of monopoly capitalism; I am simply arguing that in Ford's case we see them in contradiction with earlier elements, and, precisely because of the contradictions, we see them as "pure."

It should not surprise us that the range of enquiry by the Sociological Department inspectors has a familiar echo: it is welfare pure and simple, welfare as aid, as recuperation (of workers), and as surveillance (of workers). Its archaic flavor is an imposition from more recent periods when the state typically takes on such tasks; then there was no oddity, from the company's perspective, in such a commitment. The Sociological Department was not, in itself, a major Ford concern; its interest to us is that it may indicate a further aspect of the modernity of Ford's strategy: in so far as it was welfarist, it joined the growing discourse of surveillance, of studying the body of the working class for symptoms of diseases—sicknesses, ideas, attitudes, temperamental proclivities to sensual excesses—so that reforms might be enacted, police might be loosened, to curb them, to channel them into productive work or quiescent idleness, as the need may be. This transposes the obsessive internal monitoring within the plant to the worker's life outside; indeed, the worker's body becomes a site for obliterating the distinction between inside and outside, between work and leisure, for instituting the One Man, One Car, One Process regime.

It is of interest that the Sociological Department's reports were not confined to the "unsophisticated" raw laborer but rather were gathered on all Ford employees, with the exception of top management. All were profiled according to their biography, the economic and financial situation of themselves and their family, along with portraits of their morality, habits, and lifestyle. Women were excluded from individual profiles, it being assumed that they were not heads of households.[62] But how far did this surveillance go; when did it become inefficient? Céline's persona becomes a machine slave at the Highland Park "Crystal Palace," but the following passage marks the transition to another side, to a recovery of humanity, however abject: "So by dint of renunciation, bit by

bit I became a different man—a new Ferdinand. All the same, the wish to see something of the people outside came back to me. Certainly not any of the hands from the factory; my mates were mere echoes and whiffs of machinery like me, flesh shaken up for good. What I wanted was to touch a real body, a body rosy and alive, in real, soft, silent life." [63] Ferdinand becomes the habitué of a local brothel, falls in love with Molly, a warm-hearted girl, and switches from being a Ford company trolley-pushing dogsbody to the handyman at a house of ill fame. Every fear of Henry Ford fully realized, a prime subject for the Sociological Department, a personification of perfidity! Yet, for a moment, Céline's text breathes a simple warmth, which disappears soon after money re-enters the scene.

To Gramsci, work and its social relations were very much products of each other. Concerned above all with the corporatization of the fascist state in Italy—the state's role as a legitimizing front and as a police force against old reaction and new revolt, for the new, industry-based finance capital—he perceived the American expression of this capital (free from many of the feudal and bourgeois forms it carried in Europe) with a clarity which attests, among other things, to the lucidity of its own projection. His insight also emerges, obviously, from his position within the labor movement: other workers and revolutionaries were quick to see the threat in Fordism, thus the U.S. strikes of 1919, the Brisbane General Strike of 1917, sparked off by the introduction of time cards on the railways. Gramsci's ideas were expressed in his brilliant "Americanism and Fordism" essay of 1929–30. [64] Two of its terms of reference are immediately relevant: "the question of sex" and "psychoanalysis and its enormous diffusion since the war, as the expression of the increased moral coercion exercised by the apparatus of State and society on single individuals, and of the psychological crisis determined by this coercion." They are brought together at many points in the essay, particularly: "One should not be misled, any more than in the case of prohibition, by the 'puritanical' appearance assumed by this concern. The truth is that the new type of man demanded by the rationalization of production and work cannot be developed until the sexual instinct has been suitably regulated and until it too has been rationalized." This "rigorous discipline of the sexual instincts (at the level of the nervous system)," these efforts "by some firms to control the morality of their workers," are "necessities" to Americanism. Having just discussed Trotsky's militarization of labor in the USSR, Gramsci characterizes "the American phenomenon" as "the biggest collective effort to date to create, with unprecedented speed, and with a consciousness of purpose unmatched in history, a new type of worker and man." While the in-

spections may be, in fact, the fumbling efforts of a few firms, they could become state ideology "inserting themselves into traditional puritanism and presenting themselves as a renaissance of the pioneer morality and as the 'true' America." This can be most clearly seen in the case of Prohibition, which certainly did not restrict the drinking habits of the wealthy.

In the new "Fordized" man, the active use of at least some intelligence, fantasy, and initiative in professional work is broken by redefining work as physical, mechanical exclusively. The mental and the imaginative are split two ways: at the plant they become the preserve of management, and within the New Man they are placed in abeyance until he goes home. Thus the necessity to control home life through either prying inspectors or the inculcation of moralistic ideologies. Workers, at least the valuable ones, had to be watched so that the psychophysiological consequences of mechanized work would not take too great a toll. They also had to be watched in case the "trained gorillas," in Taylor's words, having conquered their relatively simple new jobs, might look around and realize that this is what they are being obliged to become and grow angry, resistant. And finally, they had to be watched in order to contain their "animal" cravings for alcohol and for excessive or at least irregular sexual activity. "The exaltation of passion cannot be reconciled with the timed movements of productive motions connected with the most perfected automatism."[65] Although, as we shall see, for many who knew nothing of productive work directly, just this apparent impossibility was enormously exciting, appealing especially to rich dreamers about the times and to artists.

The New Man was not an invention; labor had been progressively more and more abstracted at different rates in different jobs for some centuries. Rather, it was an intensity, an acceleration, a tying of the new worker to a mechanical process which was so different, so modern. Ford Company was conceiving its workers as robots on the job, will-less automata, whose minds off the job, activated while their bodies were recovering, being fed, or resting, needed to be watched for signs of revolt or collapse or failure to recuperate, for independences which had to be replaced with nonthreatening thoughts, to be "educated."

It was Ford Company's failure in this regard, its failure to go far enough in terms of social control, a failure amounting to "myopia," which, Ewen argues, made it clear to the more advanced corporate contemporaries that more subtle and widespread forms of ideological persuasion were necessary to the continuance of their interests.[66] "For capital cannot at one and the same time present free market consumption as being the very essence of freedom itself, promoting it as the sym-

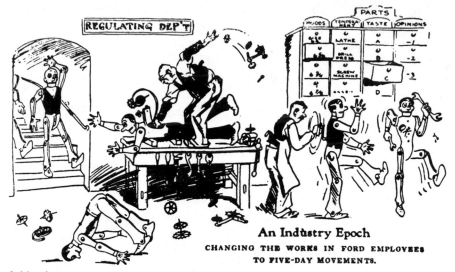

1.14 Anonymous cartoon of Ford assembly line, c. 1913. (From *Left Curve* 5 [1975]: 54)

bol of advanced liberalism, and openly manifest its desires in this domain."[67] The contradiction between the imagery of free choice and the fundamental coerciveness of the system is just too evidently a matter of everyday experience. And if reality cannot be changed, then the perception of it had to be. Thus the construction of the worker's family as consumers, above all through advertising. On this argument, failure is most evident in the labor unrest of the later 1910s and in the brutal repressions of 1921. The pressure of factory organization, tying the worker to the machine, the coercion by foremen, scabs, thugs, and police, and the off-work surveillance efforts were not enough to produce the docile work force required by the new industrialization. The true move to modernity, then, was the move to consumerism. The true site was not the factory but the creation and circulation of market imagery.

Against this, Gramsci, like Arnold and Faurote before him, drew attention to Ford's *economies*, an obsessive feature of his enterprise. Thrift, yes, but they were a different type of economy, a new type: they aimed to atomize all the elements of engineering, supply, manufacture and, as far as possible, the distribution of the car as such, and to concentrate it within one system—indeed, as far as possible, in one place. As we have seen, that place was the River Rouge, an icon of modernity not just for functionalist buildings, its utterly industrialized "look" (this was to come), but above all for its priority in achieving the physical form of monopoly in its economy of scale in terms of both production and hegemony. The Rouge itself became a totalizing, modernizing machine—a machine for the constant reproduction of its own modernity, of moder-

nity as such. At the River Rouge, Ford Company did not merely elaborate entrepreneurial conceptions of work; it prefigured a new social order. This occurred not only in the direct productive processes but in the indirect, persuasive usages, such as in the wages policy, the destruction of unions, the obliteration of competitors, the domination of the market and in the local ideological propaganda regarding morality, sexuality, and alcoholism just outlined. It was all of these together, organized by the economy of scale, which is so striking. Gramsci comments: "Hegemony here is born in the factory and requires for its exercise only a minute quantity of professional political and ideological intermediaries." Compared with Europe, the economic rationalization (the base structure) dominates the superstructures "more immediately" and the latter are also "rationalized" (simplified and reduced in number).[68]

To the degree that there was a "thrust to totality" in Ford Company hegemony, its failure is marked (and perhaps more obvious to American observers without the fact of fascism-in-power to contend with). At most, probably no more than 5–10 percent of Ford workmen were barred from the $5-a-day profit-sharing scheme between 1914 and 1919. Perhaps they constituted the "minute quantity" necessary to be a lesson to others. (Although, in real terms, this was a lot of bodies: Highland Park employees averaged 12,880 in 1914, 18,892 in 1915, 32,702 in 1916).[69] Yet they were just one of the many aspects of system which, as we have described it, is inherently coercive in all its relations. Specific, overt, aggressive forms of control would seem an irrelevance, but they became increasingly necessary as workers, distributors, and suppliers failed to submit to the grip of Ford Company monopoly, ever-tightening because of the logic of its own expansion and because of the contractions caused by broader economic forces, such as competition, recession, and eventually, depression. Some of this failure was politically motivated, taking the form of sabotage and efforts to unionize the plant. Whatever the formal beauty of the Highland Park domain from the viewpoint of management, working there was hell, and protests, resignations, resistances, and, eventually, strikes were frequent. Sociological Department investigators were rejected as snooping pimps. Although invisible to investigators, certain local (and imported) working-class cultural patterns were in existence, and were tenuously maintained, because they were preferred to the lifestyle being imposed. The expansion of management and the degradation of labor exacerbated class, racial, and ethnic divisions inside and beyond the plant. After many false starts, irresolution and sabotage, automobile workers' unions began to form in the early 1930s. Ford Company became notorious not only for the increasingly intolerable conditions of work, but also because of the extremity of its resistance to unionization. In the broadest sense, the company's re-

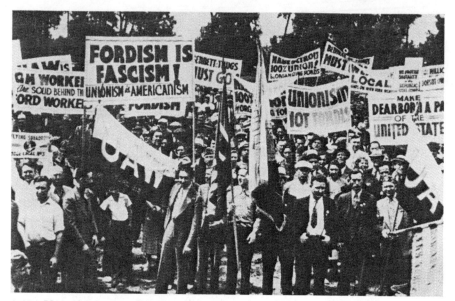

1.15 United Automobile Workers members at a union rally in Monroe, Michigan, June 1937. (Archive of Labor and Urban Affairs, Wayne State University, Detroit)

version to brutality can be seen as a direct consequence of its most fundamental innovations. Replacing the skilled machinist with multiskilled machines, and transforming all labor within the plant into the automatic, coglike actions of a "great productive machine," so threatened an entire generation of workers that they bitterly resisted change and sought other forms of collectivity, provoking the Ford engineers to ditch their visions of the factory as a domain of invention and to take up the tools of tyrants.[70]

These conditions account for the transition from welfare sociology to rule by force within the plants and the surrounding municipality between the 1920s and 1930s. The Ford Service Department, in Sward's words, "stamped by Ford's temperament and moulded by Bennett's genius," was twenty years in the making. It constituted, when fully spun, a web of spies and private police which the *New York Times* designated in 1937 as "the largest private quasimilitary organization in existence."[71] Sward goes on to detail the significantly criminal composition of this force, its relentless intimidation of employees, its links with the Dearborn and Detroit police and underworlds, its state political influence, and above all, its violence against the thrust to unionize the plant, especially between 1937 and 1941. After years of refusing to honor the conditions of the Wagner Act, broken by a crippling strike in early 1941, Ford Company was obliged by the National Labor Relations Board to

hold a plebiscite on the form of representation Ford workers wanted, in which 97 percent voted for unionization, mostly in the United Auto Workers. Ford Service was transformed into Plant Protection and the battles continued, albeit somewhat muted by demands of war production. Sward's account, that of a union official who was a victim of the Ford Service Department's activities, is doubtless loaded against the company. But on all essential points it is supported by the findings of the National Labor Relations Board inquiry in the May 1937 beatings of UAW officials, in general accounts, frequent press reports, as well as magazine articles from the period.[72]

However much reference to Ford Service tells us about the nature of the Ford Company "way," it adds to our account of the domain's inventiveness only the element of brutality, the final coercion behind the persuasion. More pertinent to completing the picture of Ford Company's variety of surveillance is reference to the Service as one of the agencies through which the company controlled the surrounding district in its image, updating the efforts of the Sociological Department, and doing so much more effectively. Yet, again, in perspective, such controlling needs to be placed alongside other means, especially the control of reserve work forces in the area (and thus all the commercial and political effects of large bodies of people) through astute manipulations of both taxes and relief.[73] Thus was the new intensity of Ford's "internal vision" externalized: terrorizing a neighborhood, threatening a major city and a state, positing—if writ large—a *Brave New World*.[74] My point is that its power flowed not only from its brutalizing and its brutality, its projections of inevitability, total control, sweet reason and a "model" leader, but importantly also from its contradictions, its constantly self-revolutionizing reinvention of constraints. This dynamic, and the ways it structured the variety of disciplinary gazes which we have been discussing, seems to point to something essential in the nature of modernity.

We have traced how Ford's "ways of watching" transformed Taylor's takeover of the spatial organization of work into a system of flows, itself manifest in constant monitoring, and shown how coercive surveillance within the plant extended to welfarism, then power broking, beyond it. The Ford-type drives to modernity are also distinctively marked in two other areas which have visualized space at their core: architecture and advertising. Innovations matching those of machinists and the managers occurred in both domains, and at the same time as those already examined. We take each in turn in the following sections, beginning by returning to Highland Park in 1910 to explore the role of architects and building engineers in the combustion known as Fordism.

ARCHITECTURE AND MASS PRODUCTION: THE FUNCTIONALISM QUESTION

Albert Kahn and Actual Functionalism

With the Austin Company of Cleveland and a very few other firms, Albert Kahn Associates of Detroit came to dominate U.S. industrial architecture from the 1920s until the 1950s.[1] While the quantitative preeminence of Kahn Associates is everywhere recognized, only specialist publications acknowledge the inventiveness and the quality of much of the company's work. It is argued here that Kahn Associates exemplifies to a high degree the inventiveness typical of twentieth-century modernity—that which I have indicated by the phrase "Nothing original, yet everything new." Indeed, I show that, in the extremity of its commitment to the functional, the firm's output transforms the conditions for architectural originality in ways which challenge the evaluative assumptions upon which studies of modern architecture are based. This transformation occurs in the work Kahn Associates did for manufacturers in the northeast particularly that done for the Ford Motor Company, which obliged all those working in relation to its evolving system to change their productive procedures to service its demands. In both its design and its office organization—in the structure of its practice—Kahn Associates modeled itself on Ford Company manufacturing and management techniques. It is in these structural ways that

modernity in one "sphere" shapes modernity in another, that a discursive formation evolves across a variety of otherwise not necessarily connected sites, until we can begin to pick out the outlines of a regime of modernity.

The association between Ford Company and Kahn Associates began in 1908, when the first large Ford Company plant was commissioned. Speaking to a journalist in 1929, Kahn recalled that moment in terms which submerge his own creativity to the designing will of Henry Ford: "When Henry Ford took me to the old race course where the Highland Park plant stands and told me what he wanted, I thought he was crazy. No buildings such as he talked of had been known to me. But I designed them according to his ideas. Ford's big contribution to industrial building is the covering of many activities with one roof and thus saving expense in building, heating and upkeep."[2] This personal reminiscence graphically documents the meeting of the two men, but it is misleading in several ways. In general terms it assumes that ideas, including design ideas, are entities authored entirely by individuals, exchanged between them, and then given physical form by some lesser method of translation. But as we have seen, Henry Ford no more authored the sites of line production than did a single person invent the great board games such as chess or go.

Nor was Albert Kahn a simple translator: by 1908, he had already designed two automobile factory buildings of the sort Highland Park turned out to be, and the idea of collecting functions under one roof was as old as the Industrial Revolution itself; indeed, it is effectively part of the definition of a factory as a concentration of functions and functionaries in one place. Perhaps, twenty years on, Kahn had fallen victim to the rhetoric that Henry Ford originated all that occurred in his name. Perhaps it was an example of Kahn's businesslike refusal to promote himself as an individualistic—and therefore, to the practical men with whom he dealt, potentially unreliable—creative genius. Certainly Kahn's posture as an architect was that of an engineer of buildings, an organizer of all the processes necessary to present the required building as a completed package to the client quickly, efficiently, and economically. There is a modernity of approach here that seems quite specific to the U.S. experience, to be inflected differently from the strong fascination for functionalism of the European modernist architects. Interestingly, Kahn's modernity seems contradictory: a careful conservativism governs his architectural thought overall, yet the office's organizational procedures, and certain sorts of designing, especially industrial work, were radical in the extreme. This chapter is devoted to a detailed exploration of the elements of Ford and Kahn's modernity.

Ford presumably chose Kahn because he had, after training with leading Detroit architects Mason and Rice, set up a practice which varied between large houses for the new rich (for example, Henry Joy, 1908), university buildings, (Engineering School, University of Michigan, 1903), clubs for the new rich (Country Club of Detroit, 1907), and factory buildings, particularly as architect to the Packard Corporation. He was to continue this varied practice, expanding it to include the downtown Detroit administrative headquarters of many of the new companies (for example, General Motors, 1922), banks (Detroit Trust, 1915; National, 1922), newspapers (*Detroit News*, 1916; *Detroit Free Press*, 1923), and even municipal buildings (Police Headquarters, 1923). Over seventy buildings by Kahn are illustrated in W. Hawkins Ferry's *The Buildings of Detroit*,[3] a selective reflection of the prestigious output of his office and of his influence on Detroit building, totally eclipsing that of all other local and visiting architects. The buildings vary in style and size, from the Arts and Crafts cottage manner applied on a large scale to encrusted New York skyscrapers, from Beaux Arts palazzi in the McKim, Mead, and White mode, to utterly unornamented industrial frameworks. Variation and separation were conventional in late nineteenth-century architectural practice; Kahn began in this way and continued in it throughout his long association with Ford Company.

There is a functionalism in this variety of specialization, this willingness to "give people what they want," to design within the language, the style, the specifications deemed most appropriate. There is nothing here of the obsessive insistence of the architect committed to personal expression, nothing of the dream of forms and structures universally able to meet all the functions of the New World. Rather, people lived in houses more or less like castles or cottages, whereas machines "lived" in buildings more or less like machines. Le Corbusier's call of 1923, "the house is a machine for living in," would have occasioned dismissive laughter; it entailed a crossing of categories reprehensible to men quite capable of smashing convention in other ways. Indeed, in a 1931 lecture, Kahn derided the work of Le Corbusier, Lurçat, and Mallet-Stevens as "startling," "notoriety-seeking," and "inexplicable": "Theirs is functionalism to the 'nth' degree," thereby using the term in a way which, I argue, belies the implications of his own practice.[4]

Ford would have been interested in the fact that Kahn shared his practice with his engineer brother, Julius Kahn, designer of a bar truss system for reinforcing concrete. Their joint offices were at Kahn's Trussed Concrete Steel Company building (1907). Together they built ten works buildings for Packard, Plant No. 10 (1905) being the first reinforced concrete structure in the automobile industry, notable for its lengths of open

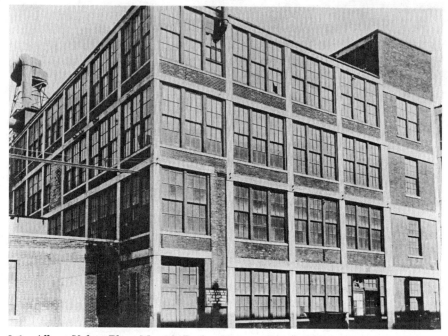

2.1 Albert Kahn, Plant No. 10, Packard Motor Car Co., Detroit, 1905. (Albert Kahn Associates, Architects & Engineers, Detroit, Mich.)

space between columns and the good lighting from near-floor-to-ceiling windows. They also built the far more complete Geo. N. Pierce Plant in Buffalo, New York, in 1906. Speedily designed and constructed, it contained large open floor spaces and the glass wall lighting of Packard 10, as well as overhead cranes, and sawtooth roofs, with railhead links to deliver and collect materials, setting up a flow through the factory along the ground floor. Indeed, the plant contained in miniature all of the key elements at which Ford Motor Company painstakingly arrived, after some years, at Highland Park. Kahn's Chalmers Motor Car Company, Detroit, of 1907 continues on the Packard rather than the Pierce model. It is exactly this kind of building that Le Corbusier celebrates as unauthored, "vernacular" architecture in *Vers une architecture*.[5]

To the Beaux Arts traditionalist, buildings like these so lacked ornament, and served such pedestrian purposes, that they scarcely qualified as architecture. To modernist purists such as Le Corbusier, they so lacked style that no professional architect could have designed them; rather, they could only be spontaneous products of the American System of Manufactures, or the Machine Age. It did not occur to the European modernists that here were buildings fulfilling already the conditions for modern architecture which they were only then devising, and doing so in directly functional, rather than symbolically functional,

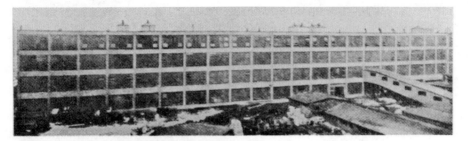

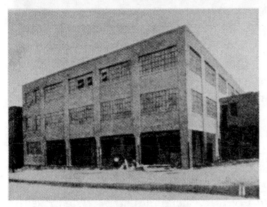

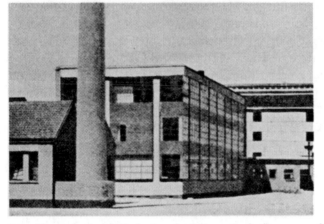

2.2 Unattributed U.S. factory buildings (including one of Kahn's, *top*), as reproduced in Le Corbusier, *Towards a New Architecture* (New York: Praeger, 1946), 38

ways. Certain misreadings of the achievement of the industrial architects have resulted from these presumptions, distorting the history of twentieth-century architecture. These are discussed at the end of this chapter. It is the terms of debate themselves which require prior examination. What is specifically modern about these buildings?

The earliest factories were sparsely—and, to those who labored in

them, brutally—functional structures. As early as 1718 in England the basic constituents of the factory were in place: John Lombe's Silk Mill in Derby was a regular, framed skeleton construction of five stories, in which operatives serviced spinning machines driven by a waterwheel. Arkwright and Strutt's mills later in the century began to include steam-driven engines, and by 1797, in the Benyon, Marshall, and Bage Flax Mill at Shrewsbury, iron columns and beams throughout predict later steel framing, as does the Sheerness Boathouse of 1858–60, entirely iron-framed, including H and I section beams. Others, such as Watt and Boulton, and Fairbairn, soon applied these principles on a massive scale, while still others refined construction techniques in buildings other than factories. Throughout the nineteenth century, the mill model of the factory changed little in fundamentals, while being constantly refined and elaborated in machinery and in the range of products it could produce and reproduce. Even the single-story, roof-lit industrial structure had evolved by midcentury, in the railway repair sheds at Swindon, and by 1900 a four hundred by two hundred foot steam-powered weaving shed had been built at Cromer Mill, Middleton.[6]

Twentieth-century mass production emerged, as we have seen, from the innovations of the nineteenth-century metal industries. The drive to interchangeable parts manufacture was pursued most avidly by small arms and machine producers, as were new systems of supply and distribution. In the United States, machinists and system builders were key creators of mass production. They were also the first to see the limitations of the traditional mill buildings, especially in the steel industry, where the demands to increase production of large-scale, specialized items, such as armor and locomotives, led to major innovations in factory design. Alexander Holley designed steel mills, such as that for Edgar Thomson in 1885, around the Bessemer convertor, making it the basis of a continuous flow of iron into the plant, where the processing stages were aligned to "convenient railroads with easy curves: *the buildings were made to fit the transportation.*"[7] For batch manufacturers in the heavy industries, the introduction of overhead cranes was also a significant step toward the open-space factory, controlled as it were by its plan; machine shops were built around them at the Midvale Ordnance, Bethlehem Steel, and Baldwin Locomotive companies in the 1890s. Yet while key seeds of rationalized planning were being hatched in these shops— the first two were run by Frederick W. Taylor in the 1870s and late 1890s, respectively—batch production, however accelerated, was not the basis of mass production. The conceptual leaps traced in the last chapter were essential to line production as a technological advance. A structurally homologous set of inventive reconceptions was necessary for the factory itself to become an architectural machine.

It was in the automobile industry, before, during, and after World War I, that the eighteenth-century British multistory mill was most influentially displaced as the basic industrial form. The exceptional complexity of operations required, their diversity, their separation yet interdependence, and the vast quantity of them demanded a new form. This was the single-story shed, internally open to a variety of usages and tied to external service systems. It was the factory conceived as itself a machine, a shell for the shaping of production. Kahn Associates is typical of the industrial engineer-architects who pioneered this fundamental shift, and it did so in the building, and the constant adaptation, of the Ford plant at Highland Park, Detroit. On a scale unmatched elsewhere, the fundamental conditions of industrial production were being changed at this plant: the reorganization of the nature of work traced in the previous chapter precipitated a revolutionary change in all of its contextual conditions, including its housing. The reconception of work space was not, of course, a simple switch from one mode to another. It was, rather, a matter of a new architecture of power evolving out of a set of yet-to-be-integrated demands, at an unprecedented speed, and with an overall effect of stunning simplicity. This ex post facto lucidity is one of the hallmarks attending breakthroughs celebrated as modern.

By 1908, when he commissioned Kahn, Ford had secured the Model T's market position and its distribution, and had decided to freeze its engineering and produce no other car (the Fordson tractor being a separate, and lesser, saga). He had turned the inventive powers of his organization to rationalizing the processes entailed in producing as many as possible of these cars. Ford workers had been subjected to their first intensive motion analysis—by Walter E. Flanders, employed to secure the output of ten thousand cars in twelve months. The Highland Park plant was conceived as a conduit of the productive process, a structure for organizing the flow, a machine in itself. But the plant did not instantly become one extensively serviced, internally flexible, single-story shed. None of the Ford plants took this form. Rather, individual buildings became more and more open and simple in structure, and the plants as a whole, in all its various elements, began increasingly to be interrelated in this way. How did it happen?

Kahn's first building for Highland Park (known as the Original Building) was a 75-foot wide, 865-foot long, four-story reinforced concrete structure. Floor and column spacing was in equal units, filled with glass, and articulated only slightly by ornamental brickwork and some doubling of exterior verticals at long intervals in order to vary slightly the long facade. In contrast to the still labor-intensive methods used to build it, the structure embodied a commitment to manufacture on a massive scale, a belief that mass production could be rationally organized in

some sort of sequence. It was not a shed, or stack of sheds, within which functions could be executed almost anywhere, as long as there were no obvious obstructions. It did more than merely facilitate certain purposes. It *began* to organize them into the flow referred to above and described by a Ford official: "The design of the building was such that raw material was hoisted as near to the roof as possible, letting it work down in the process of manufacture. Thousands of holes were cut through the floor so that parts that started in the rough on the top floor gravitated down, through chutes, conveyors, or tubes, and finally became a finished article on the ground floor."[8]

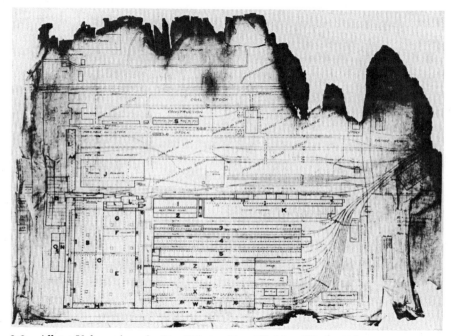

2.3 Albert Kahn, plans for Ford Motor Co., Highland Park, 1909–10. From the collections of Henry Ford Museum and Greenfield Village. Ford Archives, P.O.8291)

2.4 (*top right*) Albert Kahn, Original Building, Ford Motor Co., Highland Park, 1910. (Albert Kahn Associates, Architects & Engineers, Detroit, Mich.)

2.5 (*middle right*) Albert Kahn, interior of Original Building, 1910. (Albert Kahn Associates, Architects & Engineers, Detroit, Mich.)

2.6 (*bottom right*) Albert Kahn, Original Building under construction, 1909–10. From the collections of Henry Ford Museum and Greenfield Village. (Ford Archives, P.188.5258)

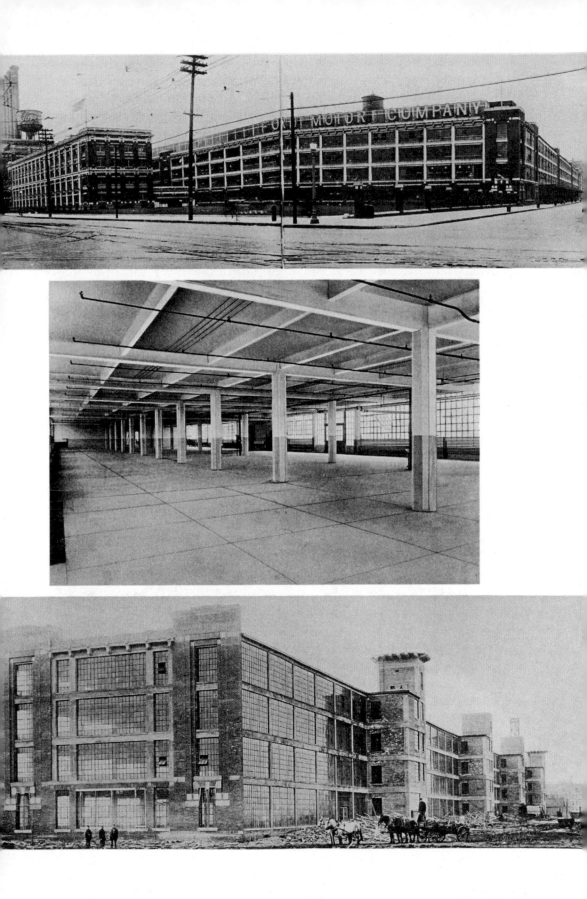

Hydraulic lifts took heavy materials and externally supplied parts to the top floor for the departments concerned with finishing fenders, tanks, hoods, radiators, and upholstery. A poignant old/new image is the photograph of the horse-drawn dray delivering Fisher bodies to the chute. On the third floor the body was painted and wheels, tires, lamps, floorboards, and tool boxes readied for passage to the second floor (first above the ground) where the body was assembled. On the ground floor the elements of the chassis were machined. This floor, in effect, continued beyond the Original Building into the single-story, sawtooth-roofed machine shop, 840 feet by 140 feet, which ran alongside it. In fact, as the demands for productive space grew, the Original Building was itself extended along Manchester Avenue, and then again along John R. Street. Within two years, the machine shop filled the space formed by these buildings. The same official just cited describes the setup:

> The buildings were unique and different from the previous factory construction. They had a craneway between each pair of buildings, the roof of the craneway being glass, so that there was a continuous well of light into the building. It was not necessary to put sides in these buildings, other than the street side, so that the buildings were not encumbered with walls or partial walls. . . . Galleries were built on either side of the craneway, to enable workmen to unload a car of material or a car of finished products from any point in the gallery.

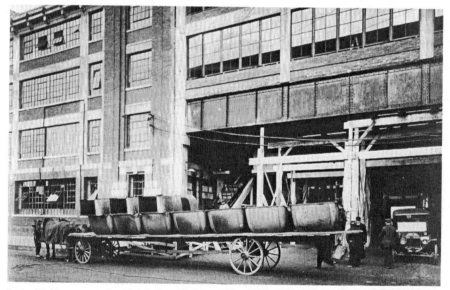

2.7 Fisher motor bodies being delivered by horse-drawn dray, Ford Motor Co. plant, Highland Park, 1913–14. From the collections of Henry Ford Museum and Greenfield Village. (Ford Archives, P.833.407)

In the machine shop, cylinders, heads, pistons, rings and gears were made, and the various components (motor, transmission, axles) were assembled into the complete chassis, to which was added the body.

It is obvious from these descriptions that the compartmentalizing of functions quickly outstripped the buildings. The idea of gravity flow was too general, and the crucial importance of assembly was not fully perceived. Functionally, it was clearly necessary to concentrate machining functions on the ground, yet this necessitated raising the heavy materials in the air (indeed, to the top floor), after they had already been machined to a considerable degree. An effective relationship between the weight of raw materials and the increasing weight of the gradually accumulating car had not yet been worked out. Prior to 1913, the chassis was machined and assembled on the ground, with the three above-ground floods feeding the body down onto it—in a way analogous to a stationary overhead crane. The basic concept of processing the entire car, from beginning machining to end assembly, through the floors from top to bottom, was never put into practice. Filtering down from the top applied only to the bodywork, the superstructure of the car. And it seems to have been, initially, a filtering more akin to wholesale soaking than a conduiting along narrower and narrower paths to a more focused finish. What is impressive about the building is its *length* of floor space unimpeded by columns: parts were worked at in stands along these narrow "galleries," then passed down to the next stage to a stand on the floor immediately below. There were, thus, thousands of replications of the same process occurring side by side, organized overall into a movement downward from floor to floor. The machine shop was, at the same time, feeding in *sideways*. No wonder the most striking feature of Highland Park was the remarkable closeness of the machines and the assembly stands, as is attested by reports, layouts, and many photographs.

An illuminating comparison is Giaccomo Matte-Trucco's Fiat plant in Turin of 1920–23—the penultimate image in Le Corbusier's *Vers une architecture* of 1923, an attraction at the Exposition des Arts Décoratifs in Paris, 1925, and celebrated by Reyner Banham as "the most nearly futurist building ever built."[9] Its planning, structure, and even many details replicate Highland Park with one major difference: it turns the Ford sequence upside down, so that raw materials enter at the ground level and are processed progressively up the five floors until the completed car emerges on the roof, where it speeds around a testing track and descends down a helix to the ground. This testing track/racetrack declares a rhetoric of speed, of display, inconceivable to Ford Company's modernity. It is architectural ostentation of a high order, repellant to pragmatists who would reject it immediately because of the extra expenses of installation (compared to an orthodox roof) and expansion (it

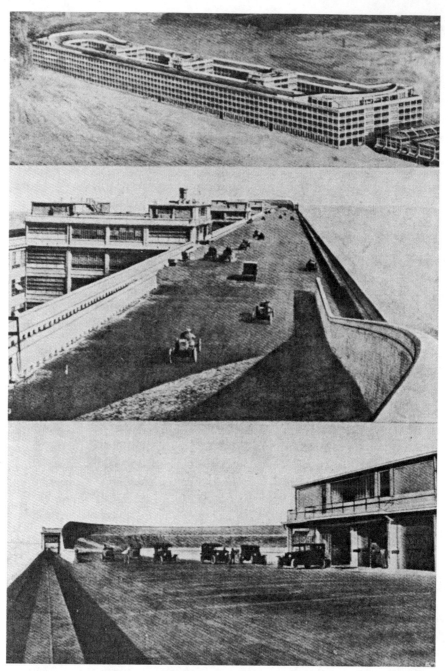

2.8 Giaccomo Matte-Trucco, Fiat plant, Turin , 1920–23, as reproduced in Le Corbusier, *Towards a New Architecture*, p. 267

could only be enlarged by adding on stories below, whether they were needed or not). It is, however, a wonderfully symbolic form, expressing the purpose of an otherwise anonymous building—or at least a building whose size, facade, and social presence declare industrial production of an unspecific sort. It advertises its purpose as clearly as any neon sign and loudspeaker (compare Ford advertising below). It literalizes the organic metaphor of production more so than Ford does: the tree of production bears its fruits upon itself for all to see and hear; the product is not, initially, separated from the process. And finally, it celebrates the car in itself as an attractive, useful machine and as a key to the increased tempo of the machine age. In contrast, the Highland Park plant, as River Rouge after it, came to celebrate less the product than the process, less the car than mass production itself as the key to the new age. We approach closer to Ford's modernity.[10]

The Original Building was updated by the new Six-Story Building on Manchester Avenue of 1914. The same principle of working from above down was applied to the same parts, mostly the body, but the structure was turned inside out; it was built around a railway, from which a mobile crane lifted materials to the myriad balconies cantilevered from each level. Its inside-facing wall was unclad, making it perhaps the most bare structure of the period. Hawkins Ferry compares the balconies to those of the student quarters of the 1926 Bauhaus, although this is entirely a coincidence of appearances.[11] Gropius's real debt probably goes deeper— thus the "American" model for his Fagus shoe-last factory, in Alfred an der Leine (1911–14), including inspiration from U.S. open-office plan-

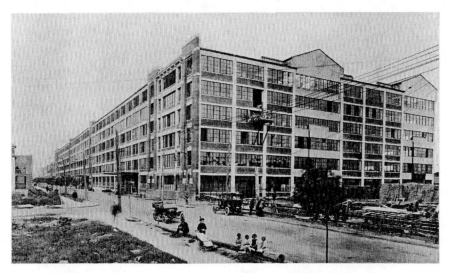

2.9 Albert Kahn, Six-Story Building, Ford Motor Co., Highland Park, 1914. (Albert Kahn Associates, Architects & Engineers, Detroit, Mich.)

2.10 Albert Kahn, interior of Six-Story Building, 1914. From the collections of Henry Ford Museum and Greenfield Village. (Ford Archives, P.O.4156)

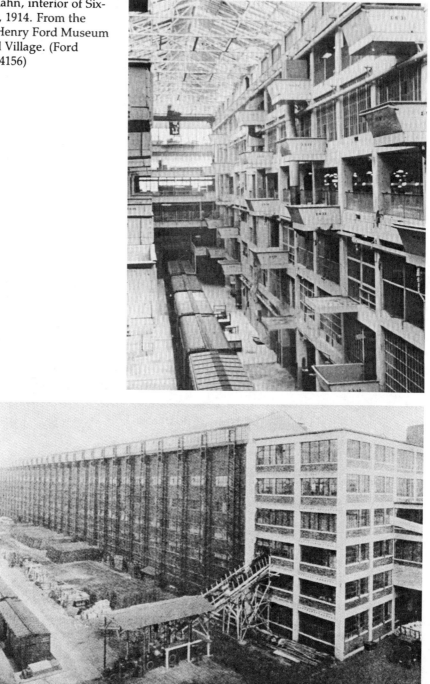

2.11 Albert Kahn, northside exterior of Six-Story Building showing delivery chute and railhead, 1914. From the collections of Henry Ford Museum and Greenfield Village. (Ford Archives, N.O.19506)

ning, something Kahn had yet to develop.[12] A closer parallel is Behrens and Bernhardt's high tension factory (1909–10) and the assembly hall (1911–12) for AEG Farben, Berlin, both of which were oriented to railway tracks. But two fundamental differences from Kahn's line-production buildings are obvious: the AEG factories were using machines to manufacture machines (mostly large electrical generators and other motors) in a static fashion, and, for all the elegance of Bernhardt's engineering design, Behrens remained concerned to organize the abstract planes, textures, and surfaces of his buildings into masses which evoked a classical order however much they also questioned it. The railways materials building on the site is a clear example.[13]

In contrast, the 1914 Six-Story Building becomes an inverted shelving/filing/classifying/treating/shifting system of a precision which makes it impossible to separate architecture from engineering. Something of this marks Arnold and Faurote's fresh, excited account of how each purpose of the building is carried out. It is almost as if the building, and the machinery within it, does the work, with human intervention important only in feeding the materials in. At the same time, the building is, as it were, an assembling of its purposes, the movement of its machines, the spaces in which materials are stored and in which jobs are done, *but nothing more*. Nothing is "left over," nothing is inexplicable in functional terms (by two literalist, instrumental engineers). This is the key to the difference between Kahn's functionalism and that of his European contemporaries such as Behrens and Gropius, themselves exceptional enough at the time.

We return now to the effects of the transitions to full-scale line production in 1913–14. While the Original Building was overtaken in functionality by the Six-Story Building, a more general effect was evident in the plant as a whole: its horizontal extension—its spread along ground level until it covered 180 acres. The significance is that the plant itself, rather than any one building, became the container, the shaper, the conduit of the assembly-line flow. The plant had its own powerhouse: the five chimneys with FORD spaced between them (see fig. 1.9), which Kahn placed across the front of his original building, declaring the company's face, of which Ford was inordinately proud.[14] Furthering this self-containedness, the functions of the plant were organized more and more around an internally circulating monorail, and around conveyor belts which connected the sectional assembly lines. At the same time, however, an opposite effect was occurring: the plant buildings became more and more orientated to the local railway system, implying a continuous flow within a much larger network of raw materials coming in and completed, saleable Fords going out. Actually, by 1913, Highland Park was exporting itself: assembly plants were established in Buffalo,

Portland, Dallas, and elsewhere. With no manufacturing processes, they were pure mass production sites. They are not deemed worthy of illustration or discussion by most writers.[15]

But the overriding point is that, while few buildings would be expected to accommodate such rapid change and then such fundamental reconception, it was this reconception itself which declared a new, modern parameter of function: that buildings did, from now on, have to not only accommodate but anticipate such fundamental changes, often. This was the new functionalism of radical flexibility itself. Highland Park was obsolete in four years exactly: on January 1, 1910, the plant began operations; by January 1914 the continuous assembly line was in full swing.

Functionalism is essential to modernity, not just as a design expression of the rhetoric of rationality, efficiency, and simplicity, but as the bottom-line materialization of the organization of the productive process itself. In architectural discourse, functionalism means that, within the limits of materials and technology, the relationships between given purposes dictate the form of the built structures, the spaces between them, and their relationships to subsidiary and contingent purposes. In consequence, the other major approaches toward architectural inventiveness (for example, skillfully deploying integrated structural and decorative languages or massing the building into a symbolic form) become secondary or accidental. Functionalism in engineering, by contrast, is not an internal, divisive ideology at all; it is the condition of the practice itself. I am proposing that, at this moment of the birth of a different kind of modernity, Kahn has transposed the values of engineering into those dominating architectural discourse. But may this not be, rather, a brusque banishing of "architecture" by an unusually strong client, causing a relaxation of architectural pretension such that it sinks into its engineering base?

Two statements interestingly attest to the congruences of this moment. Speaking in a court hearing about certain of the later buildings at Highland Park ("W" and "X" buildings), Ford Company chief construction engineer in 1909–15, Edward Gray, said: "The architectural publications throughout the world gave Mr. Kahn credit for building these buildings, and he had absolutely nothing to do with it until the time arrived when we, the Ford organization, had the specifications and plans all out in detail."[16] Alongside this, these remarks of Albert Kahn, although made as late as 1940, refer to a principle already obvious in his work in the 1910s: "We plainly tell our clients that we can advise as to the type of building that will best suit their requirements but we are not process engineers. We, of course, are glad to help with suggestion and can explain how others in the same work carry on, but we do not pre-

tend to make layouts for machinery or other equipment."[17] Kahn is here, and in practice, disclaiming the role of process engineer but accepting the position of construction engineer. He is asking the client to list the functions, set out their dimensions, plan their placement in relation to each other, determine the flow of mechanical and human movement. From this point he will develop a structure: it is an earlier point than that at which other architects, up to this time, would have declared their competence. It is a point at which Gray, for example, would enter the picture as a construction engineer and beyond which he would see that very little of engineering significance would need to be done. It is the point of functionalism, the point at which Kahn came to realize that he—as a functionalist industrial architect—was relevant, due, I would argue, to the experiences of Highland Park.

Highland Park was not, obviously, the birthplace of architectural functionalism. Such spectacular achievements by engineers as the Crystal Palace and the Eiffel Tower, as well as many bridges, factories, hangars, warehouses, and even cities such as Garnier's projected *Cité Industrielle*, attest to its prominence, its fundamentality, and to the variety of architectural expression it supported—in, for example, the New York and Chicago skyscraper. Rather, the functionalism I am seeking to describe differs from these because it was shaped to contain a moment of transformation in the forces of production which was so exceptional that it established typicality for decades.

Yet we have seen that the Highland Park Original Building housed a vague and, soon, inappropriate productive metaphor. Its repetitive structure allowed for expansion in any direction—the decorative brickwork, especially toward the public front corners, was easily expandable. Nothing stood in the way of this unit extending itself in any direction up or sideways. But it could only repeat its own modules, and while this possibility became essential to many other types of factories and to mass housing, for example, it was quickly redundant in the spontaneous combustion of mass assembly. This grew, as we have seen, in ways which went against the structure containing it: both human and physical organization was constantly stressed by the changes. An accident on the first dray assembly line in late 1913 piled nearly finished cars into a wall, threatening to collapse it, and such dangers became more acute on the continuous assembly line. The often-reproduced photograph of car bodies being dropped onto the chassis in the open courtyard in 1914 was not an elaborately set-up photo opportunity. The wooden scaffolding was an extension of a building no longer adequate to its purpose: other photographs show a hole broken into the first-floor wall, through which the finished bodies are being pushed.

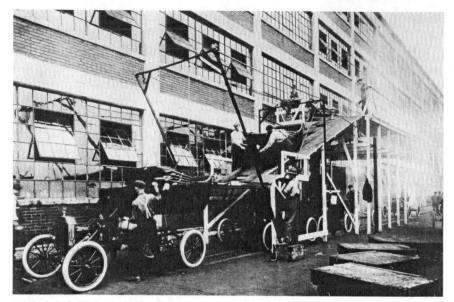

2.12 Model T body being dropped onto chassis, Ford Motor Co., Highland Park, 1913–14. From the collections of Henry Ford Museum and Greenfield Village. (Ford Archive, P.833.915)

The newer, more precisely engineered buildings at Highland Park were themselves rapidly outpaced. The pressure toward dividing operations more and more minutely, the close packing of machines servicing and passing subassemblies in order to save lifting and time, the conduits for bringing the appropriate tools and materials to the necessary place at the exact time, the positioning of inspectors, the pathways permitting managerial surveillance—all these incessant refinements began to fill the spaces even in new buildings, producing impressively clear sequences as well as overloadings of elaborate complexity: "Like a railroad system with its stations, sidetracks, depots and terminals, the body painting and upholstering process line wends its way over three successive floors of the new, big six-story building on Manchester Avenue, now running straight for 850 feet at a time, turning right-angle corners, now going down-grade to the floor below, back and across until finally the terminal is reached—the 'chassis-body assembly bridge' outside."[18] Designing was, obviously, design for specific functions; process sequences were being tried out at such a rapid but uneven rate (at least one significant machining change was occurring somewhere in the plant *each day* in 1913–14) that they take on the character of constant *additions*, however huge in size. The River Rouge plant was being forced into existence.

A machine shop need not take its shape from the machines within it, any more than an assembly shed need be a kind of (plaster) "cast" of the movements within it. Is not the very idea of functionalism threatened by the enormous tolerance in the relation between specific purposes and such simplicities as keeping the weather out, but the light in, while they are being pursued? In 1929, at the end of an extraordinarily successful decade in which Albert Kahn Associates came to dominate industrial architecture in the United States and elsewhere, Moritz Kahn contentedly observed:

> For general purposes, a standardized plan of building will prove to be of advantage. This refers particularly to such buildings as are used for motor assembly plants, or for the manufacture of bodies, motor parts, machine tools . . . and the like. In this type of factory the architect need only familiarize himself with the general method of manufacture, and the building need not be designed for any particular installation of equipment. There are other types of factory buildings, such as foundries, forge shops, cement plants and the like which must be designed to fit particular schemes of equipment installation.[19]

The design focus here is shifted to processing the materials and services necessary to construct an *enveloping shed*, a standardization of architectural practice itself, a repertoire of forms and procedures which adapts itself to the requirements of any job. This is indeed the way Kahn Associates developed, and, in this as in so much else, they predict the corporate architects of the 1960s. But my point here is that the actual record of Highland Park and River Rouge is less magisterial, more experimental.

This record emerges when we look closely at the base line of functionalism, the effectiveness of the buildings as assemblages of materials and as environmental conditioners in use. As to the latter, Kahn was as meticulous as possible, both in the general design (the heating plants on the roof of the Original Building and around the machine shop heated but also cooled the buildings, while waste air heated the craneway at, importantly, no extra expense) and in the details (the hollow ductwork for air distribution in the concrete columns of the 1914 Six-Story Building referred to above). As assemblies of materials—in terms of efficiency in getting the building constructed—the Highland Park work was remarkable for its period, but it did not approach the speed which Kahn later achieved because only a certain amount of building materials and construction processes were standardized. Those that were, were skillfully deployed by the architect: they were preferred, used in the most direct

way possible—with some exceptions, such as the elegant, exaggerated monument to the overhead crane, the 1911 Packard Forge Shop.[20]

Between 1908 and 1916 the eighty members of the Kahn office were designing for eight car manufacturers, as well as Goodrich Tires and Mack Printing, in Detroit, and many other firms elsewhere. The office organization was described in 1918:

> The various departments occupy approximately 14,000 feet of floor space. . . . There are two large drafting rooms, separate structural and mechanical engineering rooms, one for the specification writers and a separate room for the typing and assembling of specifications, chief superintendent's office and field superintendent's room, estimating room for contractors, two filing rooms for contracts, correspondence, etc. The grouping . . . works out particularly well. It brings these closely related departments into easy communication with one another. . . .
>
> All departments have graphical progress reports on their work. At the beginning of any work the estimated progress is indicated by a curve in black ink on coordinate paper, and the actual progress recorded from day to day in red ink. Any marked divergence in these curves indicates serious delay and daily inspection of the records enables prompt action to be taken to remove it. The Superintendent reports his progress in this way and also by means of daily and weekly reports. Thus a general and detailed supervision of all work is possible from the executive offices.[21]

I have cited this account in detail not only for what it reveals about the size of Kahn's enterprise, but because it tells us, by analogy, much about the way Highland Park was organized as a productive site. Arnold and Faurote's excitement at the productive inventiveness of the plant is matched only by their enthusiasm for the complex system for *charting* stock inventory, the transfer of materials, job routing, and the precise state of each assembly line at every given moment. The connection is obvious: Kahn's Ford Company work in the service of mass production led him not merely to the adoption of various time-saving devices, but toward the standardization of architectural practice itself, toward the dream of an office, supervised by an elite managerial group (himself, brother Louis, and Ernest Wilby), orchestrating a "throughput" of production, particularly the skills of analytical management: "The average architect, without the assistance of men who can deal with the structural problem, the sanitary, power, sprinkler, heating and ventilating, and cooling problems, is apt to fail. . . . All must work in close touch with each other to gain the desired results expeditiously; wherefore, the combination must exist at the outset."[22]

Arguing that no one would possibly be efficient in all these fields, Kahn drew the obvious conclusions: "the tag of the individualist, the temperamental artist has passed. . . . Most important of all and contrary to all precedent, the architect today needs must be a businessman, for who would care to entrust the expenditures of millions to one not thus endowed?"[23] The ultimate expression of Kahn's functionalism was just this office organization, to which, like Ford, he gradually devoted more and more of his creative, inventive energy. Like Ford Company itself, the office became a machine for the production of even more refined, technically beautiful, economically efficient, and abstractly inhuman machines. And above all, like Ford Company, Kahn Associates was exceptionally and typically modern, not so much in any one of the elements of functionalism here distinguished, but in their combination, their scale of operation, their exclusion of other possibility, and their commitment to infinite mass-reproduction of a singular type. Working for Ford, Kahn gradually modified his practice until it paralleled Ford's. This is an efficacy effect of two sorts: first, echoing Ford's organizational structure made servicing Ford easier (indeed, this was forced on Ford's suppliers by the company; it would be surprising if they treated Kahn Associates with the same conform-or-ship-out, close-up directness, but it would also be surprising if the lesson was lost on such a survivor); second, it defined architectural practice in the "new age" which—it was widely, rhetorically perhaps, assumed at the time—Ford Company represented. The myth of Ford Company as magically combining humanitarian working conditions and a high wage with unparalleled productivity led many, including, doubtless, Albert Kahn, to believe that "the Ford Company was something more than a successful manufacturing enterprise. It was an exemplar, almost miraculous in its swift rise, of forces that were reshaping the world."[24] Kahn wanted to be the architectural servant of this new world. And this was, to a significant extent, what he became. More importantly, Kahn Associates became the model of a new kind of architectural modernity—not only in their design solutions but in their organizational practice. Much of this was a direct response to the new demands made of them by clients such as Ford Company, but what Kahn Associates did was also shaped by the same combination of forces which determined the structures of Ford Company itself.

Building the USA

I have been arguing that Kahn's response, in the moment of the birth of line production, was to transpose into architectural practice the priorities of engineering practice. Indeed, *response* inadequately expresses the strength, and the complexity, of the relationship. Like all other Ford

Company suppliers, Kahn was obliged to adjust his practice radically to the demands of the evolving Ford Company system, or go under, be replaced, retreat from the field, leaving it to others. But his office became part of the team, orchestrated by Ford, which *invented* line production—the buildings, the two plants, the network of extraction, processing, assembly, and sales; all the structures of these complex circuits were part of the system's machinery, the system of mass production devoted above all to its own reproduction. Kahn's office became a machine for the reproduction of mass production as a mode of industry; it was party to the birth and helped set the main patterns for industrial architecture for the next fifty years, as well as predicting the shape of corporate architecture as such. Both the built structures and the office organization, inseparable products of each other, need to be further explored in order to substantiate these claims. At the same time, the rather general characterization of transposing engineering and architectural practice—already, I hope, made specific in the discussions this far—needs to be fully articulated.

In the late nineteenth, early twentieth century, the U.S. building industry was "fragmented from top to bottom."[25] There was little attention to technological economy in building methods (unlike many other productive forms, they remained largely handicraft-based); unionization was achieved by 1900, but in terms of each distinct craft, skill, and trade; and productivity was low, wages and costs high, compared with other industry. The highly visible energy of the building site and the spectacular moves of contractors and real estate speculators were illusory. The economic pressures led to a paring away of architectural amenity, often to the extent of doing without an architect; they led to a slow development in building methods and materials, a localization of the practice. Clearly, few of the conditions for a rationalized industry capable of producing standardized parts and fast, efficient methods of construction were present, although most of its elements were available, for example, machine production, steel framing of great variety, skills in concrete construction, the interest of inventors, the drive throughout the economy toward increasing productivity, as well as highly organized transport systems.

Industrial building, particularly, "remained purposefully utilitarian and incidentally ugly,"[26] bursting out of crowded, expensive, inappropriate sites. There were, however, exceptions, developing into a tendency which generates Kahn's work from within the practice itself. The paternalism of Cadbury, Rowntree, and Lever indicated to many manufacturers a path through mounting labor unrest while increasing productivity and profits. Various "improvements" were added—lavatories, rest rooms, better ventilation and lighting, sometimes even libraries, hospi-

tals, and garden settings. The National Cash Register Company of Dayton, Ohio (c. 1885), is a famous example: on its well-landscaped site, elegant brick buildings carried large windows, ventilation ducts, and stirring mottoes in bold lettering—"Labor is a Girdle of Manliness" and "Improved Machinery Makes Men Dear, Their Products Cheap."[27] Often these improved amenities amounted to little more than tacked-on sheds, but by the 1890s sufficient factory-owners engaged enough architects to enable a tendency toward "Realistic Design" to be discerned, especially in warehouses such as those of Richardson's Marshall Field and Adler and Sullivan's Walker in Chicago, and in the work of less known architects.[28]

Minor changes in building technology—the simplification of steel structures, improvements in construction, in materials (concrete, brick, and especially glass), and in tools (bulldozers, polishers, sprayguns)—as well as early work on air conditioning and improvements in electric lighting all created pressures toward the rationalizing of building practices and, consequently, of architectural practice which still, effectively, led it. Large projects consumed so many elements that they were, in real terms, their own productive plants: they set the modules, standards for their own unique production. The Empire State Building of 1932–33 is the outstanding example of using all available building and architectural resources to the full without advancing technically beyond that already achieved in, say, the Woolworth Building of twenty years earlier. Mass production was entering architectural and building practice mainly as a consequence of its application to consumer goods and to service industries such as the movies; windows, radiators, ducts, panes of glass were achieving standardized sizes and shapes. But these were only individual parts of buildings; the architect, usually, refused to draw any lessons as to overall design from this. Rather, the standardized elements were usually massed into idiosyncratic shapes and then decorated with signs from quite other languages. Only in the lower reaches of the architectural hierarchy was standardization making an impression: in factories and warehouses, that is, on the sites at which mass production itself occurred.

Burchard and Bush-Brown compare the more alert responses of the European architects and conclude that "on balance" it seems that the architects of 1913–33 in America failed their times.[29] Kahn and others like him, however, did *not*, in this regard. Such a judgment manifestly excludes their achievement. It does so in ways which lock them into a double bind: in effect, it disqualifies them as "real" architects because they did not create "high" architecture as beautifully as the masters of the period (thus their qualitative inferiority), and because they did not insist on applying the imagery of their industrial work to their official,

commercial, and domestic buildings (therefore their immoral, weak subscription to "double standards" and innovative inferiority compared to European modernists). Being so disqualified, their industrial architecture, however fulsomely praised, becomes invisible, incidental, exceptional, not part of a definitive tendency in architectural history. The "truly modern" awaits the arrival of the Europeans in the 1930s and, especially, the 1950s and 1960s. Even the reappraisal of Kahn, which was a part of the 1970s breaking of International Style hegemony by those seeking complexity and contradiction as well as local (American) content, kept to the same double bind. Only now, promoters of the popular such as Venturi *celebrated* Kahn's "inconsistency": "Mies van der Rohe looked only at the backs of Albert Kahn's factories in the Midwest and developed his minimal vocabulary of steel T-sections framing industrial sash. The fronts of Kahn's sheds almost always contained administrative offices, and, being early twentieth century creations, were graciously Art Deco rather than historical eclectic. The plastic massing up front, characteristic of this style, grandly contradicted the skeletal behind."[30]

Kahn and His Critics: The Brokerage of Architectural Reputation

What is at stake here in this categorical brokerage of architectural reputation? On one level, clearly, competition for current contracts infects every architect's perspective on desirable style. But the case of Albert Kahn touches on the ways architectural history itself is constructed in the United States, and with it, much about the pasts and futures of living in cities and the housing of productive work. In unpacking the architectural ideologies so fiercely competing, we find few innocent players, not excluding Albert Kahn.

At no stage did Albert Kahn even contemplate living in spaces which shared anything with his industrial architecture. His own Detroit house of 1909, with additions in 1928, is a scaled-down version of the ambience of heavily paneled, decorative ceilings, marble fireplaces, and medieval furniture complete with tapestries and loudly framed paintings which he provided for clients such as the Dodges, Newberrys, and Fords. Photographs show a liking for the popular paintings of Brittany, especially peasant women—a taste shared widely in Europe at the time—and one or two ballet studies by Degas.[31] Kahn designed in such a variety of styles that only a certain simplicity of massing and a regularity of surface resulting from a preference for the use of standardized materials indicates, however faintly, the continuity of authorship. The variety of styles is not unusual for the period, particularly for United States architecture; the consistencies lie within each of them.

There is, however, a quality in Kahn Associates' approach to architecture which is not captured by the standard dichotomy between Beaux Arts eclectic pluralism and modernist singularity, autonomy and integration. A different aesthetic is signaled in Kahn's response to an interviewer in 1908: "But so long as the lines of the building indicate that there is behind them a sustaining skeleton, and so long as they do not mask the reality and pretend to be themselves the sustaining material there is no offence." So far, spoken like Gropius himself, or Le Corbusier: an early assertion of truth to materials. But in response to the puzzle as to the "natural form" of a material as arbitrary as concrete, he adds: "We must learn to treat concrete as concrete, but to construct concrete pillars and cornices, concrete walls and buttresses so that they will advertise the fact that they are concrete and so that they will still be beautiful."[32] Fresh from the reinforced concrete expanses of the Packard shops, Kahn is reaching for a purity of structural expression fundamental to later European modernism. But prior to the decorative elements on the Administration Building at the Ford plant at Highland Park, he is also leaving the way open for a vocabulary of tradition-referring forms to be part of the new language. This mix would culminate in the later 1930s and 1940s, in post–Art Deco Moderne, of which Kahn—along with the Austin Company and other system builders—was to become a master.

Kahn's own public pronouncements on architecture betray an instinctive traditionalism and frequently contradict the case I am trying to build for the radicality of his industrial architecture. "Architecture is the art of building, adding to the mere structural elements distinction and beauty." This definition begins his 1931 lecture "Architectural Trend," the most complete statement of his architectural credo (see n. 4). Speaking, as he often did, against modernistic excesses, Kahn retreats here to a conception of architectural art as consisting of refined additions to the building process. Kahn begins by celebrating the "restrained modernism" of the German architects Wertheim, Hoffmann, Olbrich and Kreis, especially their official buildings in the cities (108–9) and acknowledges a deep debt to the industrial work of Behrens and Bruno Paul (111). The Chicago World's Fair of 1893 is placed firmly at the center of American architectural "reawakening," and Charles F. McKim is fullsomely praised for his "re-use of well-tried forms . . . invigorated by a strong personality" (114). Kahn disputes claims that Louis Sullivan and Frank Lloyd Wright created "a truly American architecture . . . even though hailed as such," pointing to their lack of influence on other American architects—"To many of us it appears exotic"—and concludes shrewdly: "Strange as it may seem, in our own most modern work, Wright is fol-

lowed via the European rendition of his precepts rather than his own direct" (118).

The main part of the lecture is reserved for an all-out assault on modernism, repeatedly characterized as "strange and bizarre." Kahn objects strongly to the "radical abandonment of all that has served hitherto," finds inconceivable any architectural parallels to the experiments of "Modigliani, Picasso, Matisse, Derain and their ilk" (120). While admitting that skyscrapers can be overdressed, the "fuller expression of contemporary life and thought . . . need not mean ugly buildings entirely of steel and glass" (121). He distinguishes between simplicity and "stark nakedness," seeing the latter as "affected," and acutely notes that it often entailed complicated and costly construction (121). Admitting that the evolution of the automobile design "has indeed taught us the importance of simplification," he objects to the banishment of all ornament: "Modernists present us with box-like forms, with windows unconventionally placed at corners or in long horizontal slots, with structures devoid of cornices, flat roofs surmounted by pipe railings, and ask us to accept these as the last word in Architectural design" (123). Mendelsohn, Poelzig, and Gropius are ridiculed as creators of "Shaven Architecture" (124); Le Corbusier, Lurçat, and Mallet-Stevens as having taken "functionalism to the 'nth' degree" (125). In the Soviet Union, "their new architecture is just as difficult to understand as their new economic system," and Kahn is shocked by the young Russian architect on an American visit who "found architectural merit only in our alley fronts, our steel and cement mills" (128). He deplores the impact of modernist "stunts" on current New York architecture, finding the Chrysler Building "an architectural failure," the Radio City proposals "bizarre," and Raymond Hood's Radiator Building "a novelty." In contrast, he praises the restraint of Holabird and Root's Palmolive Building in Chicago, and the "imposing mass," the "dignity" of the new Empire State Building (128–32). His most general pronouncement on style is that "Today is heralded as the Machine Age, the day of the railroad, the steamboat, the automobile, the airplane and the radio. We find beauty in a machine, for the absence of all not absolutely required for the performance of its work. The same functionalism, however, applied to architecture, and many today believe this is the ultimate in modernism, would make for a very sad community architecturally" (122).

The irony here is that Kahn had, for over twenty-five years, been applying just this machinist functionalism to his industrial building, and to his approach to architectural practice. Indeed, the lecture ends with an emphasis on the pragmatics of the latter, particularly the need for architects to follow the model of corporate management. All of Kahn's

comments are bracketed under the heading "Architecture as Art"; all are subservient to the definition cited above, wherein the "art" of architecture is conceptually separated from the business of building. Some parts of his critique follow from his actually functionalist pragmatism—thus the objection to "windows unconventionally placed at corners or in long horizontal slots." But mostly it would seem that, in his public pronouncements as in the internal logic of his practice when it came to non-industrial building, Kahn could not penetrate the rhetoric of traditionalism. As the impact of the European modernists began to be felt in the United States in the late 1920s, antipathy provoked both black and white exaggerations and confused retreats. But it also led to a set of indirect incorporations which, added to the increasing subtlety and the spreading influence of U.S. industrial architecture itself, laid the foundations for the post–Art Deco Moderne mix which was to become the prevailing style in U.S. architecture in the later 1930s and 1940s.

It was just this mix that was featured in *Architectural Forum* in a special issue of August 1938. Trumpeted as "The One Man Building Boom," the editors celebrated Kahn's 800 million dollars worth of contracts and the quality of his architecture as "that small but sure step ahead of the parade."[33] Frequently heralded in the Detroit press as an immigrant boy who made good, Kahn achieved national prominence for the practice of Kahn Associates during World War II. Subsequently, however, he has received curious treatment at the hands of authors of textbooks on U.S. architecture.

James Marston Fitch, alive to questions about the "American" in U.S. architecture, the impact of technology, and the importance of engineering, does not mention Kahn at all, although he cites Ford as an example of how American industry can commit itself massively to a type of production but then find itself too rigidly tooled up, thus restricting architectural invention compared with less industrialized societies.[34] While this may have a general validity, it is, as I have shown, the opposite of the truth in this case. Kahn's outspoken opposition to modernism, expressed in the 1931 lecture, was to cost him dearly as modernist historians began to take hold in U.S. museums, education, history writing, and art criticism. H. R. Hitchcock mentions Kahn less as an architect than as a phenomenon and reproduces not one of his buildings but a map showing locations of factories built by Kahn Associates in Europe and Africa.[35] To Wayne Andrews, Kahn excels at "impersonal" buildings which were "often works of art" but seems somehow to disqualify himself by failing to assert that his methods amounted to "an intellectual system," unlike Gropius, whose responses to United States architecture Andrews is concerned to picture in the reference to Kahn.[36] In the most

thorough treatment, Burchard and Bush-Brown point to Kahn's "genuinely colossal" achievement in industrial architecture *and*, on two occasions, to his failure to "universalize" such achievements because of his subscription to the predominant "hierarchical" attitude which dressed culturally superior buildings such as governmental offices, churches, and universities in historical languages while factories and warehouses barely qualified as architecture at all. In this other work, including the administrative buildings, the "public" face of industry, Kahn fell victim to style as such, with the result that "his skill fell away."[37] Typical of Kahn's general reputation among architectural tastemakers is Ada Louise Huxtable's remark, in the course of a 1969 *New York Times* review of a book by Vincent Scully: "One really resists packaging seventeen and eighteenth century New England Houses and Albert Kahn factories in the same box."[38] In the crowning insult to this modern master, his work appears in William H. Jordy's *American Buildings and Their Architects: The Impact of European Modernism in the Mid-Twentieth Century* only in the form of a photograph of the interior of the Glenn L. Martin Bomber Plant of 1937. And it only appears there because Mies van der Rohe used it as a backdrop on which to superimpose some cutout planes and a Maillol female nude in a rather silly *Project for a Concert Hall* (1942).[39]

Kahn has been treated thus because his major achievements are excluded from the main currents of twentieth-century United States architecture. These currents are assumed by all to be the refined Beaux Arts eclecticism of McKim, Mead and White, the skyscrapers of Chicago and New York, the native modernity of Frank Lloyd Wright's houses, and, finally, the influence of the European Modern Masters, directly or through disciples such as Philip Johnson, with some recent, "postmodern" revisions, even reversions to nineteenth-century eclecticism. Certain regional variants of these key tendencies are sometimes permitted into the canon (the California houses of the Greene brothers, for example), but nothing from the lower orders of the hierarchy.

Here we discern one major element of such self-limiting histories: that the focus is architectural tradition, the social institution of exclusive architectural practice, recognizing only work within its frame of reference, employing only its symbolic languages, at the higher reaches of the profession. Skyscrapers unavoidably enter history, despite their crass commerciality, because they are so prominent, distinctively American, the bread and butter of many architects otherwise demonstrably competent, and because many of them are fine buildings. But are not all these factors relevant in the case of industrial building?

Just as striking is the assumption that genuine modernity (as opposed to the raw energy of the skyscrapers) comes from Europe and is Ameri-

can only because European masters built in the United States or influenced U.S. architects. The great exception is, of course, Frank Lloyd Wright, who is credited with alerting the Europeans to modern space, mass, and planning. The iconic works here are Walter Gropius and Adolf Meyer's Fagus factory, Alfeld, 1911–13, and their Werkbund Pavilion, Cologne, 1914. But the earlier, and from the viewpoint of planning, more radical Pierce Plant, Packard, and Highland Park buildings, and the contemporary, quite as aesthetically impressive Packard Forge Shop, are noted only as the "type of thing" which influenced the Europeans. They are neither valued in themselves nor, surprisingly, valued as *modern*. It is an enormous condescension to see such work, and the often superb work produced by the Kahn office during the next thirty years, as somehow beyond the discourse of modern architecture. Although not an American text, Reyner Banham's purported revision of the Eurocentric Pevsner's *Pioneers of Modern Design*, his *Theory and Design in the First Machine Age*, does not even bother to mention Kahn or other key industrial architects of this machine age.[40] I hope I have shown enough to restore to the achievement of these men the importance it deserves, and to their complex legacy the seriousness with which we need to take it. The modernism of Behrens, Gropius, and Mies emerged from a parallel but different closeness to another colossus of rationalizing industry, the AEG Farben combine.[41] Nor was Poelzig's factory work, or Taut's promotions of steel and glass, so distant from this energy. It is the force of this energy at work upon architectural practice, different though it proves to be in different societies, that is the proper starting point. The reverse perspective—that the Modern Masters created modern architecture out of their own inventiveness—is laughably unrealistic, yet surprisingly often taken.

What was Kahn Associates actually building during the period when its reputation was being so actively, and variously, brokered? In the 1920s, apart from the River Rouge work, Kahn's office built fifty major factories for the new manufacturers as well as many non-industrial structures, especially Renaissance palazzi for the Detroit financiers and skyscrapers for the downtown administrative offices of the manufacturers. By 1929, the four hundred staff members were producing one million dollars worth of construction per week. The firm survived the depression of 1929–32 mainly because 521 plants of various sizes, including a forty million dollar tractor plant, were built in the Soviet Union during those years, many of them as part of the deal made with the USSR by Ford Company.[42] From 1933 the automobile industry revived, then boomed, with many smaller firms going to the wall but the larger ones committing more to the cheaper car and Ford Company being

eased out of dominance by Chrysler and General Motors. The aircraft industry boomed also. By 1938 Kahn Associates employed six hundred people and was directly responsible for 18 percent of all industrial architecture in the entire country. During World War II, work by the office actually increased. It was at this moment that Kahn became publicly identified with industrial architecture per se. In a *Life* feature on Detroit (October 23, 1939), the aerial views of the Rouge plant and Greenfield Village shift to a page of photographs of four prominent Detroit businessmen, not including either Ford. The caption reads: "Albert Kahn is the architect of the automobile industry. He has designed Packard's buildings for 35 years, Ford's for 30, Chrysler's for a dozen years, has planned more than 125 buildings for General Motors. In his long career he has laid out more than $800,000,000 worth of factories, ranks as the No. 1 U.S. industrial architect. He shocks fellow architects by saying: 'Architecture is 90% business and 10 % art.'" This celebration of the staggering success of the unorthodox but ordinary artist-entrepreneur, the brilliant plain man, parallels the terms in which, as we shall see, the legend of Henry Ford was constructed. It also both courts and defies rejection by the architectural profession: the photograph shows Kahn behind his blueprint-covered desk so engrossed in dealing that the telephone seems to swallow his head.

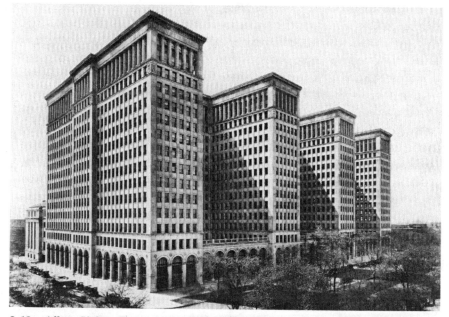

2.13 Albert Kahn, General Motors Building, Detroit, 1922. (Albert Kahn Associates, Architects & Engineers, Detroit, Mich.)

The office organization refined that of c. 1918, described earlier. Kahn and his brothers Louis and Moritz (the latter having main responsibility for the European work) were served by a secretarial staff. All other staff worked in either the technical or the executive division. The technical division was divided into design, architectural, structural, and mechanical sections, with further subdivisions (of the architectural into industrial and commercial, the structural into steel and concrete, and mechanical into sanitation, heating, air conditioning, electrical, and process engineering). The executive division had two departments—for internal office management and for field supervision; its overall job was to secure the materials and supervise the construction. Kahn maintained control, knowledge of, and influence on the work of the office through his constant presence—a leadership style very like Henry Ford's, except that Kahn encouraged the development of projects from the design concepts to the final executive details by the firm as a whole through the form of intra-office seminars. These seminars were the productive sites of the office's work. (He did not employ a graduate architect until 1935 in fear of disrupting this process.) The result of this team approach to each project was that, while full use of accumulated experience was made, along with constant reuse of the standardized concepts, materials, and methods, the resultant building in each case varied at least to the degree that the demands of the client were different.

The basic refusal to take on the design of the work process itself persisted throughout: all the buildings are containers, envelopes, condensers of functions specified by their owners. Yet the fundamental organizational form remains the same as that of Ford—the tendency toward "one man, one product, one process"; the subservience of all concerned with the process to the process, to its continuance and growth. Kahn's office could not have achieved its phenomenal speed in designing massive, complex projects without a vocabulary of forms, a set of knowledge of materials, a whip-tight office organization, a total control over contractors and, through them, over the work force. Nor without a commitment to quantifiability. All the elements in the process could be and were separated, costed, and trimmed to their most effective, both in the circulation of the design through the office and in the stages of construction and use. It was this machine that produced a range of buildings matched by few individual architects and by no other groups of the period. Compare the contemporary history of The Architect's Collaborative.

Among those few writers who do take Kahn's achievement seriously, Hildebrand's *Designing for Industry* contains the best account of the buildings, following them through as design solutions with critical

closeness. Interestingly, however, the terms in which the buildings are conceived and executed gradually come more and more to structure his language, turning it into an exposition of almost inevitably self-resolving solutions, at once pragmatic and beautiful. Few mistakes or misjudgments, no bad or even ordinary performances appear as what may be forty or so exceptional buildings come to stand for the hundreds, even thousands. This may be fair; but in such a case especially, we need to be able to grasp the character of the majority practice—not only to make value judgments but because the point of mass production is efficient, speedy production in numbers, and we need to be able to gauge performance on this sort of scale. Nor do we discover from any of the publications much about conditions of work in these structures, how they were perceived by those who most used them.

Kahn clearly led the field in the provision of light and ventilation. Indeed many of the most convincing structures go beyond minimal service to function in their glass sheetings, their striking roof profiles, their generosity of overhead space: the Packard Forge Shop; the Ford Glass Plant; the De Soto Press Shop, 1936; the Export Building of the Chrysler Dodge Half-Ton Truck Plant, 1937, and the Tank Arsenal, 1941; the Amertorp Corporation Torpedo Plant, 1942. But it is difficult to argue that these shapings result more from concern for the workers than from the abstract criteria so far adduced. Indeed, the engagement with the processes of creating such structures is so profoundly rationalized and controlled that it establishes its own standards of "beauty": by repetition, by evoking innumerable other similar and successful solutions, by gradually supplanting all other solutions to similar problems, by setting out its own typical "excesses," "indulgences," and "refinements." To Henry Ford, more light at Highland Park meant that "you can put the machines closer together,"[43] the harmful effects of which, Hildebrand and others say, cannot be attributed to the design of the buildings.[44] Yet there is no evidence in the plans, the records of office organization, in statements or, most importantly, in the buildings themselves that Kahn saw the workers in any more sympathetic light than Ford himself. Machines and processes dictated size and shape; workers meant mostly sufficient light to see and be seen by, and regularly spaced toilets (to reduce walking distance and time away from the machines and supervision).[45] The entire tendency of Kahn's practice is in this sort of direction, as would be expected of an architecture of mass production. Indeed, much of the buildings' power, their clarity as structures, depends on their total disregard of human scale, anthropomorphic reference, and workers' needs, and on local or regional relationships. They

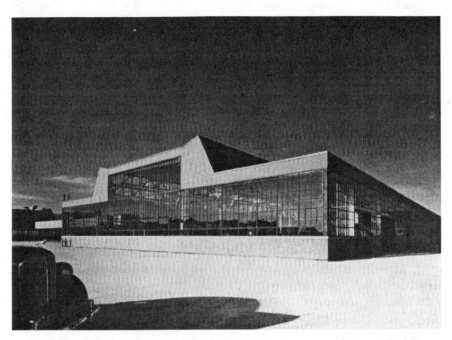

2.14 Albert Kahn, Chrysler Half-Ton Truck Plant, exterior of Export Building, Detroit, 1937. (Photo Hedrich-Blessing, courtesy Albert Kahn Associates, Detroit, Mich.)

declare a world quite beyond such concerns; they are the products of a revised practice which regards such factors only when fed into it in the form of data by experts on the needs of the average user.

After the Rouge, Kahn Associates' design principles became more and more formal. The initial rules of thumb, the insights developed at Highland Park, were based on principles surprisingly close to the "organicism" of Louis Sullivan. Despite his doubts and Sullivan's modernism cited above, Kahn affirmed the Chicago architect's innovations in skyscrapers. In a famous 1896 talk, "The Tall Office Building Artistically Considered," Sullivan sets out the "commonsense": the ground floor commercial, the repeated modular office levels, and the attic top, as well as the verticality, height, the growth upward of it all. That is, physical functions are declared through organic expression. On this model, we can read the Highland Park "hopper" as a mechanized river within various enclosures. Then at the Rouge, the circulating system, still somewhat "organic," demanded envelopes at its crucial junctions: Eagle, "B" Building, took shape from the production lines within it, and extended its half mile as expressively as Sullivan's Wainright and Prudential buildings were "lofty." But from the mid-1920s onward, Kahn made his

qualitative leap onto the plane of mass production in architectural-engineering terms: designs become ensembles of elements from a repertoire established by the possibilities of the progressive rationalizing of architectural, engineering, and building practice. The outstanding buildings are so because they are consummate solutions within this new practice, not because they look Miesian (indeed, the power flows in the opposite direction). There are no longer any organic or anthropomorphic structural metaphors, nor more echoes, however distant, of the "classical language of architecture" (unless the bases usually ruled off by the concrete floor, the stretch of glass curtain wall, and the monitored roof structure, often clad with sheet iron and edged, are said to echo the base, columns, and entablature of the temple). Both the use of asymmetries whenever necessary and the conception of each structure as infinitely extendible in any direction are antithetical of any classical design. Similarly, the overall plant designs go beyond previous large-scale planning, including the Rouge, in their abstract formality: namely, the Chrysler Plymouth plant, Detroit, 1928; the tractor plants at Stalingrad and Cheliabinsk, Russia, 1930 and 1933; the Chevrolet Body Plant, Indianapolis; the Willow Run Bomber Plant for Ford, Michigan, 1943; and the Dodge Chicago Plant for Chrysler, 1943.

Writing in the mid-1950s, Wayne Andrews reproduces Kahn's Chrysler Dodge Half-Ton Truck Plant (Detroit, 1937) next to the Styling Building at the General Motors Research Center (also Detroit), part of the complex designed by Eero Saarinen and other Detroit architects in 1949–56. The latter is a private campus, a hymn to the intellectual work—here a separate, "advanced" activity—of automobile engineering, design, and styling. It owes most to Mies van der Rohe's Illinois Institute of Technology, Chicago, in general layout, in the approach to structure, and in refinement of detail, indeed, the end walls are composed of brightly colored glazed ceramic bricks, the glass tinted, the foyers as dazzling as concert halls.[46] Yet the Center also comes out of Kahn, in the use of standardized units, in the car materials (steel, aluminum, and glass), in the "stretch" and "run" of the horizontal structures. But they gain their energy in this regard from Kahn's industrial work: they place the most refined productive work on the automobile within buildings which look like what are recognized, in the mid-1950s, to be the most refined structures of automobile mass production. In contrast, when Kahn himself designed the equivalent structure to Ford Company in 1922, he produced a long, low structure with concrete base and steel frame monitor, both of which, remarkably, were shaped such that they echo masonry moulding and arches, even to evoking corbels, but with a firmness and gravity which make this interior Engineering

Laboratory space look like what the interior of Behrens's famous AEG Turbine Factory could have been, but was not. Yet the exterior of this building carried masonry-encased repetitive columns, including the four Doric columns in the center-entrance, and a tiled, gabled roof. As well as being the site of Henry Ford's private office, this building was also the site of Ford Company's major propaganda organs: *Ford News*, the *Dearborn Independent*, and the Ford radio stations. It was required to express their reactionary purposes, and it did.[47] Yet when called upon later to express modernity in a public space which demanded it, Kahn adopted the modern as a style, quoting the Turin Fiat plant in the Ford Pavilion at the 1939 New York World's Fair. We return to this fine tangle of apparent contradiction later, when we discuss the later 1930s convergence of an imagery of modernity.

By the mid-1950s, certain major changes had occurred, enabling Saarinen to design in quite different relationships to the productive process. Mass production was the dominant industrial mode, and it now had the additional capacity to reproduce itself by making the minimum adjustments required by the logic of style change and obsolescence. The corporate state was no longer prefigured; it was the dominant force. The separations, the abstraction of River Rouge were now the norm; advertising was built into the system; labor was pacified. Building materials and practices were not entirely standardized, but they were further along, and the General Motors engineers could deal with any difficulties (which they did, inventing "sandwich panels" for the walls and a fifty-foot triangular steel truss). Designing in this changed situation, Saarinen turned away from the residual symbolic languages of the nineteenth century, from the Arts and Crafts style of his father, to a fusion of the major tendencies in twentieth-century architecture—the symbolically functional aesthetic of Kahn. But while he is speaking a Miesian language, he is quoting Kahn: the Research Center buildings draw their automobile, industrial reference not from Kahn's service buildings, but from his industrial architecture—the structures enclosing machine shops, presses, dies, assembly lines. Saarinen's is a "factory aesthetic" because it depends on formal transference, on allusion. In the terms of reference of the first phase of modernity, the Machine Age, it is symbolic rather than functional. But the terms change by the 1950s: perhaps all becomes symbolic in corporate architecture; even the "actually functional" exists mainly as historical quotation.

The 1960s see further ironies, indicative of the weakening of these debates and distinctions under the ideology of corporate state "Great Society" and U.S. economic-military imperialism. In our particular case, in 1960 Eero Saarinen designs the confused concrete classicism of the

U.S. Embassy in London, very much in traditions of hierarchical eclecticism for which Kahn was pilloried, as well as the overtly organic TWA terminal at Kennedy Airport, New York, a symbolic shaping of sheer obviousness. At the same time, Kahn Associates transforms the work of its founder into a practice which soon echoes Saarinen (the Avon Products complex at Springdale, Ohio, 1966), even sometimes attempting the Miesian (the Administrative Office of the Chevrolet-Saginaw Iron Foundry Division, for General Motors, Michigan, 1968).[48]

The burden of my argument amounts to this: Kahn became the first architect, the chief designer of mass production in that, while refusing to apply the symbols of mass production to his official, commercial, and industrial building, he developed a designing procedure, expressed above all in his office organization, which applied the principles of mass production to *all* of the categories in the hierarchy of architectural practice. It was this which, eventually, destroyed the power of style to define the hierarchy, not the aesthetics of an imported modernism. Yet it also preserved the class powers of the hierarchy, something modernism appeared to threaten. Kahn refused European modernism because he had developed his own distinctively American one—specifically, the modernity of Ford Company writ into architectural practice, a practice evolved out of the demands which created mass production. In a parallel way, the Austin Company was precipitated into its systematizing by the demands of the light bulb manufacturers—of, that is, the other great system-building industry, electrification. Kahn's initiative evolved from Realistic Design, but its success, its power as part of the power of mass production, forced the pace of mass production in the building industry. The industry had been subservient to the needs of the eclectic architects and the commissioners and contractors, and was thus fragmented, but not entirely, and less and less so following the growth of Kahn and other architect-engineers. If rationalization of the building industry in Europe awaited the success of the Modern Masters (if it did, which I doubt), it did not await them in the United States—it waited on Kahn, the Austin Company, et al. Kahn's disclaimers, antimodernism, modesty, personal preferences for failures such as the Detroit Athletic Club notwithstanding, his modernity was of this unique and far-reaching sort: it implied that all architectural practice, whatever its style and subject, could be put on a mass production basis. It also meant a transformation in U.S. architecture whereby mass production demanded an imagery which would echo in all buildings, from factories to film lots. It got that imagery in the modified modernism of post-Art Deco Moderne.

HENRY FORD AND CHARLES SHEELER: MONOPOLY AND MODERNISM

By the mid-1920s, Henry Ford was known throughout the world as the inventor of the Model T, the provider of transport for the people, the model of a self-made man. Behind this legend stood something less personal—a revolutionary modernization of the system of manufacture. Mass production, regular wages, and consumerism were creating a new social order. Fordism was not merely an often-cited symbol of the modern world, it was a set of forces visible within the new way of life. How did Fordist modernity become visible? Obviously, information about such a massive undertaking spread through observation, experience, and reportage. But the imagery of the Ford Company and its products was also manufactured, like that of other social institutions and their services, through various systems of publicity. Two fine studies have charted the multitude of Ford Company representations: Keith Sward's *The Legend of Henry Ford* (1948) and David L. Lewis's *The Public Image of Henry Ford* (1976).[1] Both go beyond the figure of the founder to the company itself, although neither concentrates on the emergence of the public image in visual terms. Nor do they thoroughly relate the company's variable attempts to shape information circulating around it and its products to

the controlling of information flow *within* the company, especially within the factory itself. The depth of the modernity of Ford Company, and all similar new corporations, can only be grasped when this relation is fully seen.

One Man, One Car, One Process

The Henry Ford story has been told often enough to need no repetition here. However, I review aspects of it so that the role of the Henry Ford legend in Ford Company advertising can be discerned. We will see that what is presented both in Ford publications and in social and business histories as a somehow "natural" growth is, in fact, a set of strategies to expand and then dominate a particular market. All of the broader implications we have drawn depend on the incisive successes of these maneuvers.

The Ford automobile was preceded into the mass market—and large-scale production—by the cheap, single-cylinder Oldsmobile, made at Lansing, Michigan, in quantities of four thousand per annum between 1903 and 1905. The Detroit Automobile Company, for which Henry Ford worked between 1895 and 1901, also made a cheaper car before turning to the luxury market more typical of the industry as a whole. Hire purchase and mail order also began to open out the market for cars. Ford's seventeen hundred 1903 Model As declared his approach toward this pocket of the market: $850 was not cheap but the car was small, not the huge, often customized models that dominated car ownership in both the United States and Europe. Between 1903 and the introduction of the Model T in 1908, Ford Motor Company made a variety of types each year, improving their ease of handling and reliability (so that owners, rather than chauffeurs, could drive them) but displaying considerable ambiguity about the targeted market. This continued after the introduction of the fabled but mechanically undistinguished Model T: in 1910, for example, the price of the range was lifted from $950 to $1,200, but a commercial Roadster was then introduced for $680. The Model T signaled a shift to cost reduction (for 1911 the Torpedo Runabout was reduced to $590), to simplification (black only from 1914), and to a marketing approach based on blanket availability and ease of purchase.[2] By 1913, in every U.S. town of more than one thousand population, Ford dealerships were established. Allied with the productive innovations already discussed, this network allowed constant shifting of the price of the car as a means of manipulating not only salesmen and customers, but also suppliers and competitors. Its greatest public moment came when, along with the $8-a-day offer to workers, Ford Company offered $50 to each purchaser of a 1914–15 Model T, both under the populist

rubric of profit sharing. Although only a small part of the year's profits were shared (1.5 of 30 million) and the wage hedged with qualifications, this twinned gesture secured Ford Company's enormous reputation for "industrial democracy." It became the symbol of successful, modern business, of U.S. enterprise, and gained prodigious space for maneuver in all its operations. In Arnold and Faurote's words: "Thus the commercial serpent of the Ford car trade is seen to have its tail in its mouth, making the circle complete and endless, and, so far as can now be seen, impregnable."[3]

Behind this gesture was a more complex strategy, one which integrated all Ford operations within the broader framework of competition. Whether it was plotted by Henry Ford or by his managers, whether it was a planned operation or a set of instinctive reactions, is irrelevant to its net effect. The successful sequence need only be sketched here. A proven, marketable product was promoted as "essential"—the fastest, the most versatile, the most basic, the cheapest. Eventually, its very quantity demonstrated its "democracy." Second, the unit cost of producing each vehicle was reduced in the ways we have explored, particularly by freezing the engineering of the product and by transferring inventiveness to the processes of producing and distributing it. Third, supply and sales networks were controlled through dependence and coercion. Fourth, upper management was destabilized and management expanded down the hierarchy. Fifth, a volatile labor market was cornered and contained by doubling the going rate to $5 a day, after which workers were locked in place through deskilling, repression, inspection, and more coercion. Finally, all other elements of the industry (for example, competitors, neighborhoods, related economic and political agencies) were obliged to replicate these conditions or go out of business, or lose office.

The Model T was no marvel of modern engineering, nor was it distinct in appearance from any other cheaper car of its period. It was certainly an advance on the motorized bicycles of the 1890s, but it belonged to the first age of the automobile, the moment of the trial-and-error *bricoleur* tinkering of the backyard mechanic and the engineer-inventor. It looked like a slightly dressed-up version of the kind of machine which could have many uses, which a farmer could use for sowing, pumping, and running other machinery as well as transporting produce and passengers. In short, there was nothing "modern" about the Model T itself, and it was not strongly promoted as such. Indeed, early advertisements for Ford cars, the Model T especially, tended to embed them unequivocally in the utilitarian, the local, and even the traditional. Does this counteract the thrust of the argument to date?

Prior to 1923 there is no discernible "house style" in Ford advertising, nor any particular coherence in its address to the differing markets for the range of Ford cars.[4] Indeed, between 1917 and 1923, the company did no advertising at all. In 1904, Leroy Pelletier was hired to run an advertising department of less than ten; it seems not to have grown much before he left in 1914. Dealers were asked to advertise themselves, the Detroit office assisting with copy and formats as well as doing the national advertising. Much of the energy seems to have been devoted to instructing dealers on sales ideas and in promoting the activities of Ford and Couzens to the media.[5] Certain slogans were inaugurated, such as "Watch the Fords Go By." Display advertisements ranged from the illustrated classified (the "first" is usually given as the one in *Frank Leslie's Popular Monthly* of July 1903: "The Latest and Best, Boss of the Road") to a top-of-the-market address to the market influence of the owner, showing the Model A driver in his glaring goggles, illustrating its slogan, "In the eyes of the chauffeur," with "Ford" on the top of his cap.[6] Mostly, however, a standard set of elements was assembled: an image of the car, the logo "Ford," an attractive female model, and a short text bringing out a "sales point," usually ease of handling, reliability, availability, and/ or price. They stand out from other car advertisements of the period in their simplicity, their directness, their basic "lack of style." Presumably this was a way of distinguishing Ford advertisements from those for more expensive cars, and thus assisted in positioning the car in relation to the desired, "lower" market.

The stylistic mobility of the early Ford advertisements can be seen in the house/club magazine, *Ford Times*, "devoted to the automobile public in general and the Ford owner in particular." The January 1915 issue, for example, opens with a homily to courage, embroidered by a Blakean

3.1 Ford Motor Co. advertisement in *Frank Leslie's Popular Monthly*, July 1903. From the collections of Henry Ford Museum and Greenfield Village. (Ford Archives, P.O.3146)

nude. Its editorial surveys world confusion and retreats to the "privilege of being a citizen of the U.S.A." The features include a tour of Ottawa via photographs of Fords doing that, a demonstration that the Model T is "Every Woman's Car," testimonials from ex-President Taft after his visit to Highland Park, and diagrams showing oiling points of the car. There is no consistency in medium, coloration, or illustrative style. The central, double-page image shows a New Year baby, adorned by a sash embossed "Ford Salesman," driving off confidently in a Model T, while from the clouds above springs a radiating angel holding a "profit-sharing check."

Whatever reinforcing effects early advertising might have had, Ford differed from other car companies—and, indeed, from the general tendency of U.S. business at the time—in its lack of commitment to it. Exceptions occurred only when the strategy itself was threatened—during the Selden patent case, for example. Many reasons have been suggested, but the most obvious seem that the company had two major assets which unfailingly brought its single product limitless free publicity: price-cutting itself (particularly the $5-a-day strategy), and the growing legend of Henry Ford.[7]

Legend to Lincoln

Following the success of the Model T, particularly as expressed in their 1914 $5-a-day and $50 profit-share promise, Ford—the company, then its head—came quickly to symbolize a new industrial order. During the 1920s, the company worked assiduously to harness the economic and the ideological potential of this symbolizing effect, to create a legend around the figure of Henry Ford himself. Disentangling genuine symbol from manufactured legend is no easy task, particularly when a major purpose of advertising which uses identifiable individuals is precisely to conflate the two in the process of attributing potent agency to the individual. Of importance here is deciphering this process of conflation. Until Henry Ford was well into his dotage in the later 1940s, company publicity insistently attributed every advance of whatever sort to his personal initiative. This was the major device for picturing Ford Company as a "family concern" in an age of increasingly faceless, soulless, harsh, and exploitative corporations. Ford was, of course, all those things. Much of the potency of the Ford figure derives from its mobility across contradictions we have been noticing throughout; it is a figure not just of *transition* from one order to another, but of constant movement back and forth between them. The legend is woven in this double shuttle.

Ford's autocracy, his ruthless exclusion of the other early stockholders in 1915–19, the Sorensen-Liebhold purges of the 1920s, the idiosyncratic

decisions of the 1930s (support of Bennett, pressures on Edsel Ford, relocation of the power station, $3 million cash on hand), as well as the insistence on fluidity of functions among top executives were all entrepreneurial capitalist in style and spirit. Yet these same elements created a management structure which, when allied to the rationalization of lower management and of production as described, became widely recognized as not only the best in the car business but as outstanding in any business of the period. The structure became the very model of modern management for other corporations (at least until the mid-1920s, when a quite different model—the team management approach, personified by Alfred P. Sloan of General Motors—emerged). Similarly, the basic conception of the Model T as a typicalizing modern commodity depends not just on the matching of a mass market and a cheap car but rather on a selective revolutionizing of the ordinary, while changing no other values and relations of power—indeed, of reversing what many would have regarded as their steady improvement. The "universal" motor was linked to a chain of universals: the "common family man" in city and country, the "typical American." While men as workers were reduced to machines, men as consumers were trained, by the salespeople, in simple mechanics. The process consumed men in producing itself, but promised to liberate them as consumers by selling them freedom of movement, ownership of their mobility. The selectivity came in with the Model T's targeting: economically independent workers—farmers, small businessmen, skilled tradespeople. Despite the huge volume of sales, and publicity pictures of the River Rouge employees' parking lot crammed with Fords, only rarely did the Model T come within reach of most factory workers. All aspects of Ford Company were based on the continual double shuttle.

Commentators agree that such contradictions abound in the beliefs and behavior of Henry Ford himself. For example, two widely shared traits, populism and anti-Semitism, inspired his often-stated hatred of "Wall Street profiteers and monopolists," despite the fact that the Ford Company was the foremost industrial banker of the age, involved in both local and international finance capital on a large scale (playing a major role, for example, in the Michigan Bank collapse of 1933). Ford's personality, or lack of it, continues to exert some of the enormous fascination felt at the time. His innovations leading to the success of the Model T have been interpreted in part as "one man's unique version of the search for the father."[8] Another revives Sociological Department head Samuel Marquis's metaphor fusing the mind of Henry and the body of the Model T: "The Ford car is Henry Ford done in steel and other things . . . power and endurance in engine and chassis, but somewhat ephemeral in its upper works."[9] More seriously, it is argued that

Ford's initiatives led toward the creation of an organization which was shaped by the need to resolve key contradictions of the moment. Especially the double track of *progress* figured in the visible transformation of natural materials and relationships in time in contrast to the opposite idealization of a pastoral *retreat* from civilization. Ford Company modernity opened up both tendencies, exaggerated them, gave them new forms. In apparently matching mass production with mobility within the countryside, it suggested an illusory synthesis not only of old and new technologies (down-home American ingenuity and modern methods) but of both with a newly accessible Nature. The history and the philosophy of Henry Ford himself made him a mediating figure, indeed, the outstanding symbol of "industrial pastoralism." Just how these interpretations might be grounded is open to question, but there is no doubt that during the 1920s they formed the basis of the public image of Ford, structuring Ford publicity and advertising, and they were successfully inserted into the "commonsense," "the collective consciousness" of the period.[10] To Warren Susman, such fabrications parallel Hollywood's star making and mark a shift in the United States from "a culture of character to a culture of personality."[11]

The myths of Henry Ford as the successful plain man, the engineering genius, the farmer-mechanic who worked hard and got lucky, the social prophet and philanthropist, the conservative visionary, the man whose doctrine of high wages and low prices makes capitalism work for all (that is, achieves socialism) were both wish-projections of people in a variety of political and ideological positions and the carefully cultivated imagery of Ford Company. Their effectiveness is attested by the frequency with which Ford's words on almost any subject were reported, especially between the wars, in the press—Ford gave "innumerable interviews"—and by the letters written to Dearborn.[12] It is demonstrated also by union organizers' difficulties selling their case to those who had not directly experienced conditions at Ford. Upton Sinclair's propaganda novelette *The Flivver King* goes to some pains to separate the revolutionary inventiveness of both Henry himself and Ford Company production methods from the acts of the despot and the exploitations of the system.[13] Such distinctions were essential to a strategic analysis of modernity of the Ford type, a necessary prelude to successful unionization. No small purpose of Ford publicity was the counteracting of this kind of analysis, aimed at re-fusing the contending elements.

The legend was manufactured through a series of books in the 1920s, usually written up from interviews, through ghostwritten statements on radio, to the press, in the Ford-owned newspaper, the *Dearborn Independent*, and in advertisements featuring the kindly figure of Henry alongside some homily which led to a practical remark about the relevant

model of car then available. This last form became standardized only in the later 1920s, and ubiquitous in the embattled 1930s. Less and less active since 1911, the advertising department was closed down in 1917 for five years (Ford characterizing it as "useless"). Dealers, however, could not ignore the need for local representation and were obliged to continue advertising, at their own expense, at a rate of about $3 million a year. Productivity, profits, and market share continued to grow (the last, for example, peaking in 1923 at 57 percent). Ford remained constantly in the news; indeed, the company put significant resources into making news, literally. In April 1914, a Motion Picture Department was established, initially to create films such as *How Henry Ford Makes One Thousand Cars per Day*. But by 1916 it had a staff of forty-five and was producing weekly newsreels for audiences between three and five million.[14]

Indeed it may have been the need to keep demand ahead of supply, rather than competition from the more stylish and comfortable Chevrolet, which prompted the return to national advertising in 1923 with a $7 million campaign, one-third spent by the company, two-thirds spent locally. It was the first attempt by the company to *standardize* advertising, as others were doing. Part of this thrust was the $5-a-week purchase plan, launched with a colorful campaign of advertisements associating the car with the jobs of spring and the delights of family life. Probably owing to the acquisition of the Lincoln Company and its upmarket car in 1922, some effort was made in 1924 to upgrade the entire range and the company's image in full-color double-page advertisements in the *Saturday Evening Post* and the *Country Gentleman* as well as in forty-three metropolitan newspapers. At one stroke, Ford became the biggest advertiser in the United States. The Lincoln advertisements adopted the most refined style of the period—delicate wash drawings floating in the page, featuring the car as a vehicle of expensive pleasure, and a short text which made a point of attributing aesthetic authorship to the body designer. A 1926 Ayer agency advertisement for *Harpers* read: "In the two-passenger coupe, Judkins has admirably interpreted the fleetness and power of the Lincoln in the sweep and symmetry of the body lines." The failure of the weekly purchase plan to tap the $2,000-a-year earners' market, due to the company's refusal to supply the car until fully paid, and of the lack of success of the $2 million corporate image campaign in the newspapers (whereas it did succeed in the more expensive publications) are the first indications of a change of direction at Ford Motor Company. The advertisements of the campaign of 1924 declared its aims: "to familiarize the public with the Ford industry, its vast facilities for the manufacture of products on a production basis and to point out

that by owning and controlling its own sources of raw materials greater value can be passed on to the consumer."

No longer did simply the car itself, a few ordinary slogans, and publicity around price-cutting suffice. The company began to sell itself in its two most generative figures: the legendary Henry Ford and the now-to-be fabled domains of productivity, the Highland Park and the River Rouge plants. Although there were, of course, earlier images of both Henry Ford and the plants (for example, the explanatory feature in *Ford Times*, April 1915, 310–15), it was at this point that the company sought to control the patterns of its representation, to organize the imagery of the competing aspects of its modernity.[15] Its reaching for an imagery to match its modernity was nowhere more striking than in the culmination of these changes of the mid-1920s: the campaigns around the introduction of the Model A in 1927.

By 1927 the imagery of Ford Company modernity no longer stood in arbitrary, equivocal, and variable relation to the car, to its factory organization and its managerial network. This was the moment when the company, creator of modern "cities of industry" at Highland Park and the Rouge, generator of new imagery of modernity almost as a by-product, began to respond consistently to the new demands of the image. Like other major corporations, Ford both contributed to the conditions for and was drawn into the implosive rush toward the appearance of coherence, clarity, and simplicity which came, in the later 1920s, to mark the consumption of the "modern." Both products and producers were obliged to participate in this "new look" or fall into the invisibility of anachronism. The revolutionary demands of mass consumption were now being felt by the originators of the revolution of mass production.

The Model A Campaign: Ford Fails

The Ford Company's campaign to launch the Model A in 1927 excited enormous interest at the time and has come to be regarded as a classic within modern advertising. For us it signals the encounter of Ford Company modernity with three distinct but related, signifying practices: industrial design, the Moderne as subcultural fashion, and avant-garde art. The encounter occurred around both the design of the car and its marketing. The result was a transformation of the imagery of industry—indeed, of the imagery of Modern America as circulating both within the country and abroad. Ford Company was not the first major company to engage other modernities, nor did it do so in ways precisely similar to others, such as General Motors or Chrysler. Its typicality was, however, established by the scale, thoroughness, and impact of its modernization. Its massive social weight secured certain of the conditions by

which "the Modern" became visible. But it did not command the field, and the command which it did assume was, as we shall see, unexpected.

Celebrated by the Advertising Club of New York as "the most soundly co-ordinated campaign in American advertising history," the Model A launch both related to and activated enormous public interest.[16] From May 26, 1927, when the fifteen millionth (and last) Model T rolled off the end of the line at Highland Park (actually 15,458,781 were manufactured), until December 1 of the same year, when the Model A was unveiled, stories about the secret car abounded in all kinds of publications. After plans were stolen from the offices of Ford's advertising agency, N. W. Ayer of Philadelphia, in June, this interest was astutely fueled. The company had not only to maintain customer loyalty and whet the appetites of new purchasers; it also had to keep in readiness the services of suppliers, agents, and laid-off workers, all of whom were obliged to maintain themselves for seven months. The economic consequences of this production vacuum were newsworthy enough in themselves. The formal side of the campaign was designed by N. W. Ayer, an agency chosen by Edsel Ford for the "quality of its presentation."[17] The campaign's climax was the daily series of full-page advertisements in two thousand English-language newspapers between Monday, November 28, and Friday, December 2, at a cost of $1,300,000. The first described the concept of the new car in general terms, the second and third stressed its cheapness and mechanical innovations—all these featured the bust of the legend, the smiling face of Henry Ford—the fourth revealed the look of the car, and the fifth summed up. Millions of people jammed showrooms all over the country, and within a fortnight four hundred thousand orders had been placed.

In response to the increasing preference for some elegance of line and variety of model choice, attributed usually to the growing affluence of the U.S. middle classes in the mid-1920s and the influence of women customers as tastemakers, Edsel Ford had been permitted to make what were called "cosmetic" changes in the Model T, particularly in 1920 and 1923. Similarly, a number of mechanical improvements were introduced. A full-page advertisement in the November 1924 issues of *Ladies' Home Journal* and *Good Housekeeping* shows well-to-do mother and nurse-housekeeper delivering a befurred daughter to school, under the rubric "Ideally adapted for women's personal use." The text stresses reliability, comfort, ease of handling, good looks, and, above all, "the prestige of high success in the motor world." When taken together with the image, the class coding of this last phrase is evident. Such coding was to become overt with the Model A. Said advertising director Fred L. Black:

3.2 Ford Motor Co. advertisement, "First Pictures of the New Ford Car," 1927. From the collections of Henry Ford Museum and Greenfield Village. (Ford Archives, D-829)

"With the advertising for the Model A came in this concept that if you sell the classes, the masses will follow. The trouble had been with the Model T that the Grosse Pointers didn't want it, not even for a second car . . . thus the advertisements in *Vogue* and *Vanity Fair*. . . . That was a conscious effort to put the Model A into the best garages and best

families."[18] The Model A was trumpeted as reaching new heights in body design and mechanical dexterity—stressing both equally but reversing the Model T emphases. In style terms it was reaching for the designed elegance of luxury-coach building, which peaked 1927–31.[19] For its size, price, and class, it appeared as a generously endowed "people's car." Further, the switchover itself was heralded then, as it has been since, as testimony not only to the flexibility of enterprising capital but also to the new social power of design itself. Thus, in a feature titled "Color in Industry" in the first issue of the business magazine *Fortune* (February 1930), color photographs of the Models T and A are contrasted above the caption: "Mr Ford clung to black, but Chevrolet sales continued to mount, until with the new Model A, Mr Ford made a complete surrender to color trend."[20] Color is, of course, regarded here as the key feature of "the modern," as a shaping element within the design, not as applied ornament (indeed, some products illustrated were Art Deco modernistic).

There would seem, then, to be a simple passage from the acknowledged success of the campaign—of the power of this meeting of Ford Company modernity and industrial design—to one aspect of the campaign of especial interest to art history, the role of artist-photographer Charles Sheeler. Ayer agent Vaughn Flannery distributed copies of Sheeler's 1927 photographs during the early months of the campaign. The encounter of three different modernities would seem to be in place, with only the task of describing its dynamics remaining. But in doing so, we need to recognize the volatility of the situation once again. The Model A campaign can be read in quite the reverse way: as signaling the *failure* of the earlier type of Ford Company modernity, built as it was around the universalizing of a single commodity, the globalizing of its productive-distributive network, processes in which (as we saw) deep contradictions became energizing and fertile. Further, if we recognize that the subsequent history of the Model A fell between the two stools of being an updated Model T which could be reproduced ad infinitum and being the basis of major, annual model changes, it becomes clear that Ford Company failed to move wholly to the slightly, but nonetheless significantly, different model of industrial modernity represented by General Motors. Indeed Ford Company never recovered the dominance of production, market share, profits, and social power which it had achieved in the mid-1920s. It could not do so, I submit, because forces within the company, and others operative on it at this conjuncture, prevented it from developing *domains of representation* as generative as its productive/managerial *domains of invention*.

When the Rouge plant was retooled for the Model A in mid-1927, and

F. M. 67

This full page advertisement appears in the November issues of *Ladies' Home Journal* and *Good Housekeeping.*

IDEALLY ADAPTED

FOR A WOMAN'S PERSONAL USE

The woman who has many demands on her time requires a car on which she can always depend for timely use. It must be handled easily; it must assure her of instant and unfailing control; and it must be both good-looking and comfortable—ready for strenuous wear and service. Above all, it must possess the prestige of high success in the motor world. These demands explain why so many thousands of women drive Fords.

TUDOR SEDAN, $590 · FORDOR SEDAN, $685 · COUPE, $525 · (All prices f. o. b. Detroit)

Ford

CLOSED CARS

3.3 Ford Motor Co. advertisement, "Ideally Adapted for Women's Personal Use," 1924. From the collections of Henry Ford Museum and Greenfield Village. (Ford Archives, D-983)

the assembly line was transported from Highland Park in September of that year, then the engineering, manufacturing, and assembling processes were all concentrated at one point in the network. Retooling for the 5,580 parts of the Model A (nearly all new) in a few months was a prodigiously inventive effort, echoing the introduction of the line assembly fifteen to sixteen years before, matched only by the swing to war production as many years later. And it was achieved at considerable human cost. It was made particularly desperate by the lack of planning and preparation, by the prior decimation of key senior engineers and managers, by poor coordination between different parts of the organization, and by a deep policy division within the company (usually personified as an oedipal struggle between Henry and Edsel Ford) around whether to give priority to engineering and productive capacity or to design and rationalized distribution.[21] The strength of these divisions was everywhere manifest—perhaps never more strongly than when, after the campaign announcing the Model A climaxed, it became apparent that there were only a few hundred cars available for purchase! Into this space drove Ford Company's greatest rival, General Motors, producing over a million Chevrolets in 1928 (24 percent of industry production compared to Ford's 15.4 percent). Its strategy was to hold prices at about a hundred dollars above the Ford, imitate the styling of more expensive cars, and introduce at least one significant engineering change every year. Its corporate structure was built around consensus among top executives who had independent control of their divisions within coordinated campaigns.[22] For example, after three years' preparation, it nailed the Model A by introducing a six-cylinder Chevrolet early in 1928. General Motors was forcing Ford upmarket, into terrain which it sought to control. By obliging Ford Company to exchange the modernity it had pioneered for a newer type which General Motors had developed from the Ford model (and others), it was attempting to force Ford to fail. Chrysler broke its way into this market by similar methods—and, significantly, with the backing of eastern finance capital. Thus each of the big three had different internal economic elements. Although Ford briefly resumed leadership in 1929, their battles forced Ford into third place between the mid-1930s and the 1950s.

The reach for maximal monopoly never succeeded in achieving totality (antitrust laws, directed at an earlier capitalism, set upper limits anyway). Instead small business went to the wall, while adoption of Ford-style modernity turned many industries into oligarchies controlled by a few companies large enough to command sufficient resources to mass produce. Thus the "rationalization" of oil, steel, railroad, banking, radio, and newspapers. Many industries were also divided into

"luxury" and "mass" markets, with smaller companies mainly confined to supplying the former. The Model A signals Ford Company's decision to retreat from attempts to expand the market (following the inadequacy of the 1923 Weekly Purchasing Plan) in favor of movement upmarket.

Within the means of millions

Automobile parking grounds adjacent to factories may be seen today in every American industrial center. They offer a striking proof of the better standard of living that workers in this country enjoy.

Here Ford cars usually outnumber all others. Their low cost and operating economy bring them within the means of millions; and in families where the cost of living is high even in proportion to income, the purchase of a car is possible with little sacrifice through the Ford Weekly Purchase Plan.

Runabout $260	Tudor . $580
Touring . $290	Fordor . $660
Coupe . $520	All Prices F. O. B. Detroit

On Open Cars Starter and Demountable Rims $85 Extra Full-Size Balloon Tires Optional at extra cost of $25

FORD MOTOR COMPANY ∴ DETROIT, MICHIGAN THE UNIVERSAL CAR

M A K E S A F E T Y Y O U R R E S P O N S I B I L I T Y

3.4 Ford Motor Co. advertisement, "Within the Means of Millions," 1925. From the collections of Henry Ford Museum and Greenfield Village. (Ford Archives, D-801)

Advertisements such as that in the *Saturday Evening Post* of May 16, 1925, "Within the Means of Millions," showing Ford workers driving their Coupes ($520) out of the River Rouge gates at knocking-off time, reflect the intentions of the Purchasing Plan but neither its actual effects nor the drift of company policy.

A similar ambivalence is evident in the design of the Model A. For all of its loudly promoted "beautiful new low body lines," it varies in no significant way from the late Model Ts, except in the wide range of color options. "There is nothing radical about the new car. In fact, it is more conventional than the Model T," Edsel Ford admitted.[23] Only in its openness to color does it partake of industrial design modernity. Similarly, the quality of drawing, tone, and color in the Ford advertising over the next six years (before it was cut again in 1933) is that of a restrained contemporaneity, up to date but not "modernistic." The connotations of different modern design styles are thoroughly explored in part 3 of this volume, but my point here is that on all levels, the Model A acknowledges the economic force of another modernity, but only partially joins it, a reticence which cost the company dearly. While the River Rouge plant and most of the productive networks allied to it were reaching unprecedented kinds of integrative power, the product and its "life" as a representation were settling for a kind of pleasant ordinariness. Ayer and Son, a distinguished agency (in fact, the second oldest in the United States, established in 1869), was reaching past the dynamism of General Motors and Chrysler advertising and styling, for a higher market position. But in its general advertising, this too failed, locking the Ford cars into worlds of gentle aspiration, a kind of bland normality, a quintessentially middle-class imagery at a time when this class was being buffeted, reformed, threatened, and revived.

Yet this failure was a powerful one: its contradictions continued to exert enormous influence on U.S. society in general, and on various domains of representation, right through the 1920s. Failure, for such an enterprise, does not mean retreat from the stage, a slipping out of sight. On the contrary, it means holding as much else as possible in place while the company adapts as much as it can. Yet the gap between productive genius and representational timidity exerted a distorting influence not only within the company, but also on everything associated with it. Such a gap seems essential to the continuing generation of an imagery of normality—and as such, we return to it often.

In this situation, what happened to those images already established as the imagery of productivity, of the "universal" force of Ford Company production processes, the pictures of the plants? Powerful panoramas of Herculean men and machines wrestling with raw materials

hardly fitted the pleasantries of N. W. Ayer's campaign and seem not to appear in that form in Ford advertisements of the late 1920s and 1930s. But the plants do appear in another form, one in which they, rather than the Model A, were modernized. This was Sheeler's job at the Rouge in 1927.

Raphael of the Fords?

Charles Sheeler's 1927 Rouge photographs, and particularly his paintings *American Landscape* (1930) and *Classic Landscape* (1931), have become a paradigm of the meeting of art and industry, archetypal images within American art and even icons of American history. As such, they have become almost opaque as created images. What was the genesis of their apparent inevitability? What brought together a company, revolutionary in its productive and organizational forms yet conservative in cultural matters and ambivalent about the demands of the "public image" and consumerism, with a member of a tiny band of New York avant-garde artists? Was this a distinctively modern kind of patronage?

Sheeler's connections with the New York Dadaists might have triggered a more radical representation of Machine Age America. Until his death in 1918, Morton Schamberg worked closely with Sheeler, sharing the same house and studio. Like Sheeler, Schamberg was an academically trained painter whose contacts with early French modernism caused him to revise his approaches fundamentally. Both were represented in the Armory Show of 1913, with competent examples of adopted Modernism—Cubist in form, Fauvist in color, both mildly but clearly declaring allegiance to French intentions in a way known broadly as "modernistic," a phrasing we will encounter again, one which aptly indicates the adoptive character of the style. Sheeler was revising the light-touch, bravura, near-Impressionist manner he learned from his Philadelphian teacher, William Merritt Chase.[24] He was revising it through the more "advanced" French connections of the Arensberg salon, also Philadelphia-based. Here, the local, even neighborly, is linked with the international modern.

After the widespread impact of Cubism and Fauvism, the subsequent internal developments of the Parisian avant-garde failed to make an equally uniform impact in other countries. In Sheeler's case, however, the Arensberg circle made directly available a special imaging of Machine Age modernity—the ironic symbolism of Marcel Duchamp and Francis Picabia. Perhaps Schamberg's humorous found-object sculptures, such as the well-known piece of toilet plumbing entitled *God* (1916), reflect Picabia's scatological, blasphemous jolliness or Duchamp's frequent descents into crudely obvious puns and schoolboy humor—the

obvious parallel being his *Fountain*, the inverted urinal signed with the name of its manufacturer and exhibited at the Independents' Exhibition in New York, 1917. If this kind of humor is absent in Sheeler's work, so too is the complex mythology of the mechanomorph which obsessed Duchamp in his paintings of the 1910s and his symbolist projects such as *The Bride Stripped Bare by Her Bachelors Even (The Large Glass)*, 1915–23.[25] Nonetheless, certain of Duchamp's preoccupations with the paradoxes of perception enter Sheeler's work at this time, particularly in his photography. *Stairwell* (1915), a detail of the Doylestown, Philadelphia, house he shared with fellow photographer Schamberg, depends on strong lighting and close focus to produce broad contrasts and subtleties of detail—that is, it is a subject which consciously isolates certain properties of photography and throws them into conflict with each other. It alludes to Picasso and Braque from the same distance as Duchamp's *Nude Descending a Staircase* (1912) cause célèbre at the Armory Show, and it predicts such drawings as *Open Door* (c. 1932), which in turn echoes Duchamp's photographs of his studio, particularly *Door: 11 rue Larrey* (1927).

Another modernity, this time mostly American, claims Sheeler briefly, around 1920: New York City itself as a site for the transfiguration of entrepreneurial into finance capital. Along with the other Precisionists (and in this kind of connection, a school-based style term can mean something, however introductory), the New York skyscraper becomes a focal subject for photographs, paintings (such as *Church Street El*, 1920), and even a film, *Mannahatta* (1920). The theme of this work is usually light falling on a dense field of shapes, organizing them within exaggeratedly mechanical perspectives. *Mannahatta's* nine minutes is a succession of such shots, with intercut extracts from the poetry of Walt Whitman. (That it was shown in Paris within three months indicates the symbolic potency of New York as a European dream city of the Modern, as Metropolis). The city's luminous, intense light as a cohering, guiding, revealing force is a theme common to the work of John Marin, Georgia O'Keefe, Joseph Stella, Paul Strand, and Sheeler at this time, and in Louis Lozowick's images of the towering rational city, its positivity is made explicit.[26] They contrast with the city as a site for the desperate struggle of an alienated individual which was so prominent in German art of the period, and with the ambiguity of the city as prison and carnival in English art of the time, although Lozowick and others were to arrive at a more critical reading of the city in the early 1930s.[27]

Within the avant-gardist enthusiasm for the potential utopia of the Machine Age, the figure of Henry Ford was frequently cited. In the October 1923 issue of *Broom*, editor Matthew Josephson featured Sheeler's paintings and photographs as well as a mocking, but nonetheless awestruck, paean to Henry Ford:

Mr. Ford, Ladies and Gentlemen, is not a human creature. He is a principle, or better, a relentless process. Away with waste and competitive capitalism. Our bread, butter, tables, chairs, beds, houses and also our homebrew shall be made in Ford factories. There shall be one great Power-House for the entire land, and ultimately a greater one for the whole world. Mr. Ford, Ladies and Gentlemen, is not a man.

Let Ford be President. Let him assemble us all into a machine. Let us be *properly* assembled. Let us all function, unanimously. Let the wheels turn more swiftly. . . .

> Ford means action
> Ford means higher wages
> Ford means standardization
> Ford means Wheat markets
> Ford means lower freight rates

Vote for the people's candidate. A veritable crusade has sprung up spontaneously throughout the vast and effective Ford organization, and every city and every hamlet of the continent is behind it.[28]

Sheeler was to figure forth these values in his art, and to echo these words, often and without irony, during the next two decades. Editor of the *Little Review*, Jean Heap, was the most active promoter in New York of the idea of bringing artists and engineers together. This drive culminated in May 1927, in the Machine-Age Exposition, held in a commercial building in midtown Manhattan.

Photographing the Rouge

Sheeler did not treat the city as a preeminent subject. Although he moved to New York to live in 1919, his art concentrates on close studies of the female body, and on rural forms, particularly the arts, crafts, and constructions, all seen as artifacts. His approach to the River Rouge, then, does not simply entail a transposition of the avant-garde modernity of the cityscape. The city as a machine of forms recedes before a concentration on machines in themselves (and eventually, their new world). As well, he draws in some conscious archaisms, particularly in the paintings done subsequent to the 1927 visit. Of greatest relevance to the photographs Sheeler took at the Rouge, however, was his "flourishing business in free-lance advertising photography."[29] His most important client was N. W. Ayer of Philadelphia, whose art director, Vaughn Flannery, was "particularly diligent about seeking commissions for him to photograph such mundane subjects as spark plugs, typewriters, movie projectors, flatwire and tires. He also arranged for Sheeler to make photographs for the Lincoln automobile, Canada Dry beverages

and Koehler plumbing."[30] During this same period, from 1923 to 1929, Sheeler did studio portraiture for Condé Nast publications such as *Vogue* and *Vanity Fair* at the invitation and under the direction of Edward Steichen. Sheeler would have, at the time, accepted Steichen's often-repeated claim that no contradictions existed between aesthetic and commercial purposes in their type of photography—that, indeed, the very convergence of such demands itself created the possibility for a great and effective photography.[31] Yet we should recognize that these photographers were importing into commercial work an aesthetic which had been developed in "art" photography—in Paul Strand's experiments, in the Neue Sachlichkeit tendency in Germany. Sheeler did much record photography of works of art for dealers such as Knoedler, patrons such as Albert Barnes, and museums such as the Metropolitan, as well as buildings for architectural firms. His work was valued because he photographed spark plugs, cars, and society ladies as if they were works of art. He applied, in a measured way, many of the modernist techniques of isolating, cropping, bold lighting, contrasting sharply different with even surfaces, thereby transforming the advertised subjects into things in themselves, possessing the look of objects of a valuing gaze.

It was just this quality which Flannery wished to add to the 1927 Model A campaign. As we have seen, the aim of this campaign was not only to sell the car as a more refined, aesthetically pleasing, and thus "modern" model; it sought also to reshape consciousness of Ford Company modernity itself, to update it, adjust it to the shift toward the newer modernity of the dominance of the gaze. Susan Filin Yeh has explored the Sheeler-Flannery connection in detail, concluding that the art director "sought to create a glamorous image for the Ford Company by touting the aesthetic side of industry . . . he came up with the idea of special photographs of the Ford plant which recorded industrial architecture and machines, photographs which, when seen as a group, might be an artistic record of the industry because they could be associated with the name of a known creative photographer."[32] Flannery contended that "in modern automobile advertising, good design and popular taste are rapidly approaching each other."[33] The Model A campaign was part of the orchestration of this meeting. Within it, however, we might assume the Sheeler photographs to be directed more specifically, at least in the first instance, to "the classes"—as Ford advertising manager Fred L. Black called them—to the rich, to professionals, to tastemakers who, while they probably would not buy the car, at least might pause before ruling out Ford products as belonging only to "the rest."

Flannery distributed a select portfolio of prints, and they quickly appeared in upmarket magazines, such as *Criss-Crossed Conveyors* in *Vanity Fair* (Feb. 1928, 62).[34] They also received prominent treatment in local and international photography magazines, such as *Transition, Creative Art*, and in exhibitions, including the famous Film und Foto traveling show, opening in Stuttgart in 1929. This has led to the polite fiction that these photographs are primarily "noncommercial" in character, that Sheeler was acting quite independently, intent on creating a "portrait of industry" untied to specific use.[35] While there is no suggestion that Flannery directed Sheeler around the plant (indeed, Sheeler warmly recalled his freedom of movement during his six-week visit),[36] the context of the "invitation" has been shown to be overriding enough for it to be clearly a commission with an explicit object: the aestheticizing of the Rouge. Essential to this, of course, is the maintenance of the figure of the independent "known creative artist." The point holds, notwithstanding Sheeler's own deep, genuine, and persistent enthusiasm for Ford and his works. The photographs were also distributed to wider audiences in magazines such as *Life* and *USA*, where they became part of a broader tendency toward aesthetizing the new corporatist stream in American industry as a whole. How this occurred is traced in parts 2 and 3 of this volume.

What of the photographs themselves? How were they shaped by the demands of the situation? Technically and stylistically they mark an advance in refinement, particularly in the treatment of graduated light, compared with much earlier industrial photography. There are precedents, in both anonymous and signed work, for most of Sheeler's close-ups, perspective groupings, and vistas.[37] What distinguishes them is their presentation as a set, the sense of precision, and an unexpected richness of surface variation—that is, they insist on the priority of aesthetic considerations in looking, on the fit of a certain complexity of reading to the subject, which amounts to the insertion of a distinct order of beauty into the seeing of the subject. This attempt was made in two contrary ways, by an enriching *inclusion* and by an *exclusion* of much content.

What excited Sheeler in the interior shots, the close-ups of machines, was their materiality, the fact of their being shaped metal directed at relentlessly shaping other metal. In photographs such as *Metal Shear*, it is clear that lighting has been organized to pick out the raw, tactile surfaces of the machine casing, relegating to flat shadow all else, including the function of the machines.[38] Most of the interior shots were taken in the Open Hearth Building—a part of the plant which, however mechanized, remains tied to the raw struggle with materials at the core of

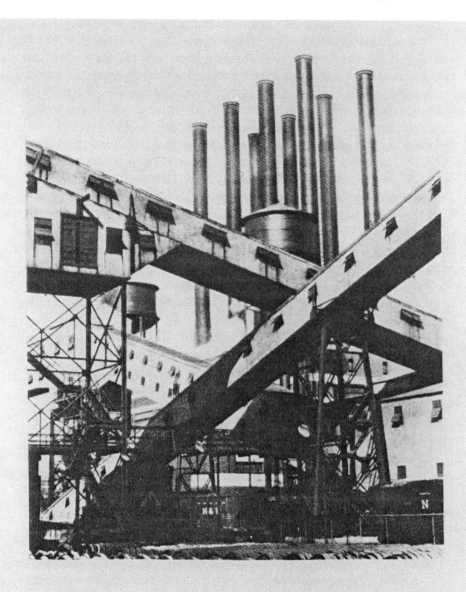

By Their Works Ye Shall Know Them

THE Ford automobile factories in Detroit, of which the view above shows a segment of its chutes, elevators and power-house stacks, may justifiably lay claim to being the most significant public monument in America, throwing its shadow across the land probably more widely and more intimately than the United States Senate, the Metropolitan Museum of Art, the Statue of Liberty, or even the novels of Harold Bell Wright. In hyperbole and anathema, it has been compared, lyrically, reverently, vindictively, to the central ganglion of our nation, to an American altar of the God-Objective of Mass Production. But it is simply one man's monument to his own organizing and merchandizing genius. The gross magnitude of that achievement is a national by-word: 9,000 cars per day of the old Model "T" Ford; 12,000 cars per day, it is expected, of the new Ford; 40,000 employees in Detroit and the total to be doubled in the coming year; and a vast hive of fully developed corollary industries. Surely Henry Ford, the name or the man, does not seem terrible or fabulous, yet to millions of Americans he is the present-day Colossus of Business, an almost divine Master-Mind. In a landscape where size, quantity and speed are the cardinal virtues, it is natural that the largest factory turning out the most cars in the least time should come to have the quality of America's Mecca, toward which the pious journey for prayer

3.5 *Vanity Fair*, February 1928, p. 62 (including Charles Sheeler's *Criss-Crossed Conveyers*, 1927). (Courtesy of the Lane Collection, Museum of Fine Arts, Boston)

heavy manufacture since the eighteenth century. Of those presently known to be part of the Rouge series, only one interior shows part of the line-assembly process, the *Stamping Press*. Yet it is isolated, a gargantuan shape-in-itself.

The effect of precision in these photographs is conveyed not just by Sheeler's fine calibration of light, but by the intensity of cropping—to the edge and, in the middle-distance shots, into the subject. The middle-distance shots, especially exteriors, form the majority of images. Astonishingly, there is no picturing of the mass-production process at all, even by implication. Sheeler not only ignores the workers except when they happen to be present within the frame (*Forging Die Blocks* is an exception), but he fails to register any sense of movement between key points in the plant taken as a whole. Above all, there is nothing about the unique, much-celebrated assembly line being installed at this plant from September 1927. The exterior shots seem concerned to picture the complex otherness of this new industrial environment as a sequence of subtle spaces, as surprising shifts of sight. This may be read as an abstract formal equivalence to the productive presses; it certainly was not a picturing of them.[39] Sheeler's separation of parts of the plant was paralleled in their presentation as publicity; for example, his picture of the Model A in the *New York Times* (Sunday, Dec. 18, 1927) showed it utterly isolated, a designed object. This departs from the more usual product-at-the-plant—the plant shot—and from the typical advertising image of the car in some situation of use.

These exclusions effect deep ruptures in key relationships structuring industrial photography up to this point. What Allan Sekula calls "engineering realism"—an accuracy of rendering based on explicit use value (such as we saw in the photographs used by, for example, Arnold and Faurote)—is rejected in favor of views of parts so abruptly cropped that they convey continuity outside the frame, but only in the most general way. The overriding order is absent, but no less important for that. It is this rejection which energizes Sheeler's entry for the 1932 Museum of Modern Art photomural competition of 1932: his *Industry* cuts *Stamping Press* in half and montages *Criss-Crossed Conveyors*, *Power House No. 1*, and *Pulverizer Building* into an abstract, totally self-referencing surface. Similarly, the radical displacement of human labor as a subject worth noting to the peripheries of service to the machine is a rejection of social realism, increasingly a concern of photography of industry, as in Lewis Hine's work of the preceding two decades. Above all, Sheeler's portfolio breaks the tendency toward fusing elements of these two approaches, which Sekula argues is to be the overriding direction of this kind of photography.[40] An industry without producers, process, or product—this is Sheeler's promise—an industry of image, look, an abstract do-

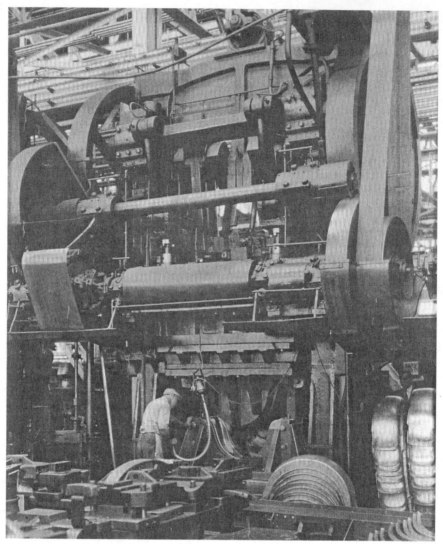

3.6 Charles Sheeler, *Stamping Press*, 1927. Photograph. (Lane Collection; Photograph courtesy, Museum of Fine Arts, Boston)

main, a suitably clear background for the pure act of consumption of the sign to be sold, the Model A.

Painting the Rouge

Two paintings of the Rouge by Sheeler have come to symbolize American Industry triumphant. Although they are both relatively small (24 × 31 inches and 25 × 32 1/4 inches respectively), *American Landscape* (1930) and *Classic Landscape* (1931) attempt something major—indeed, the

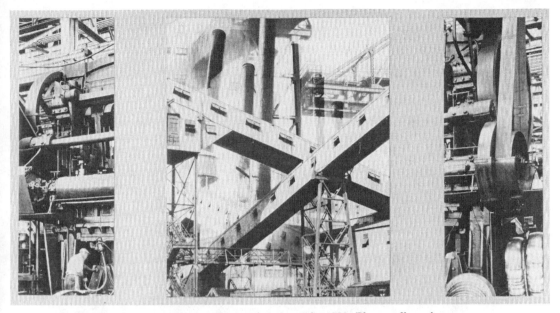

3.7 Charles Sheeler, *Industry* (design for a mural), 1932. Photocollage from negatives of Ford River Rouge Factory taken in 1927, silver gelatin print triptych, 20 × 70 cm *(left and right panels)*, 20.1 × 16.2 cm *(center panel)*. (Julien Levy Collection, gift of Jean and Julien Levy, 1975.1146a–c, overall view; photograph © 1991 The Art Institute of Chicago. All rights reserved)

iconic force stated in their titles. "Landscape"—each is a view of a section of the world in which everything perceivable has been created by man or is controlled by man. Sheeler's extreme consciousness of this is evident particularly in the framing of the sand, earth, lime, and coal by barges, a concreted waterway, the angular railway lines. The paintings present this new world, unassimilable by previous genre such as cityscape, even by the view from an airplane, and, just in their titling, they attempt to replace previous landscapes in as resolute a way as Ford processing transforms the raw materials of nature. A new, different, but equally total, natural order is proclaimed. "American"—this new order is a national one (particularly in the painting in which Sheeler added the Ford logo to three of the railway trucks);[41] only the United States has such a radical transformation occurred. "Classic"—the transformation is an aesthetic one as well; it has produced a kind of calm harmony equivalent to that of Greek art, reminiscent of the grandeur and changelessness of Egyptian monuments.

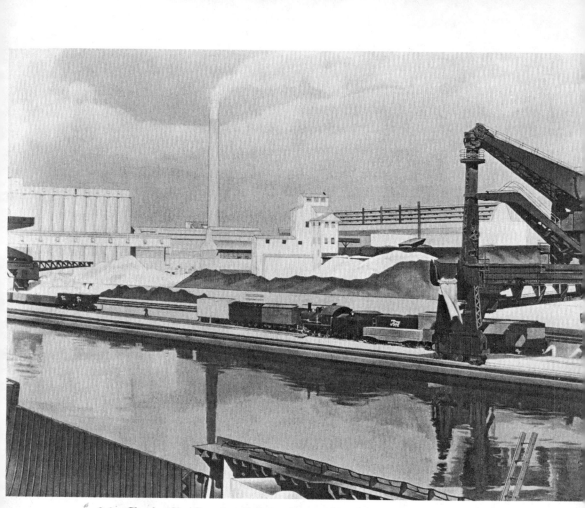

3.8 Charles Sheeler, *American Landscape*, 1930. Oil on canvas; 24 × 31 in. (Collection, The Museum of Modern Art, New York, gift of Abby Aldrich Rockefeller)

These inferences may be crude and naïve, but they are obviously intended by the artist and accepted by his patrons and many of those who have reacted to these paintings since. Their anthology role in histories of art in America, indeed, in text and picture books on twentieth-century America, is precisely their constant representation as constituting these values. Painted three and four years after his visit to the River Rouge plant, and not directly commissioned (although many of Sheeler's later industrial paintings were), there was little overt obligation on the artist to operate such an elevated yet bland mode. His commercial photography was, on his own admission, concerned with "getting the job done" within the going expectations. All his statements on his paintings

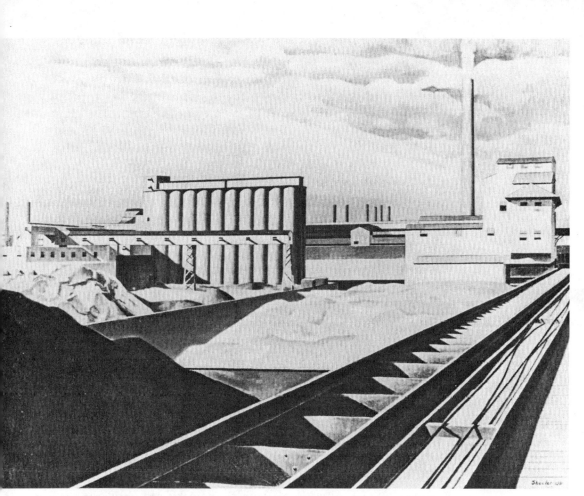

3.9 Charles Sheeler, *Classic Landscape*, 1931. Oil on canvas; 25 × 32¼ in. (From the collection of Barney A. Ebsworth)

evoke the independence-of-an-artistic-vision rhetoric typical since early nineteenth-century Romanticism. Yet these paintings present a picture of industrial America more conservative, restricted, and uninformative than Ford Company itself.

How did this occur, specifically, in this case? We need to put aside the internally coherent but hopelessly reductive and trivial readings engendered by the titles, as sketched above, and look again at the paintings and the related discourses. Compositionally, they are orthodox layouts of foreground incident, which then shifts across middle ground to an advanced background and an apparently mobile sky which closes off the movement and concentrates it across the central band of the picture.

Color is additive, supportive of the linear movements, subtly hinting at changes of plane but not contradicting the tonalities. Into these structures, typical for rolling hills dotted with lakes or tracks across grassland, Sheeler has fitted the industrial elements. This fitting in supports a generalization about a new Nature, but in an old-fashioned way (akin to Rococo images of new machinery, to the earliest English Romantic elemental images of the new manufacturing, the iron foundries of the seventeenth century), sacrificing the chance for a "new form—new content" equation, refusing the implication raised earlier, that the "structures of modern technology" demanded a different "expressive artistic language." While the mobile crane-loaders are a major framing feature (compare the 1928 watercolor) of *American Landscape*, the cement plant cylindrical storage bins of *Classic Landscape* locate it not too far from the grain elevators of an agricultural landscape—a connection with an older transformation of the natural which adds to the eternal, "classic" connotation of the painting. These conventionalities, constantly tracking back to given knowledges, are, perhaps, the antimodern movements of the paintings. Responding to them, writers such as Constance Rourke, in a book for Sheeler's gallery based substantially on his own long biographical text of 1938, celebrates his "clarity of revelation" of "the broad subject" but opens her account of the two paintings with "Hart Crane was later to say that the poetry of the machine age is no different from the poetry of other ages: and these paintings exist to prove it."[42] For Martin Friedman, writing in the 1968 Smithsonian catalogue, the same qualities produce quite the opposite judgment: "In certain works of the 30's, Sheeler sacrificed abstract structure to complex literalism. The River Rouge factory paintings, for example, are technically brilliant but, at most, are idealized industrial vistas, more concerned with description than with strong plastic qualities. Unfortunately, he was too often overwhelmed by such complex subjects, and his best results were simpler configurations, whether buildings or objects in a room."[43]

But if these conventionalities are containing strategies, they are holding back other kinds of forces which are very much present in the subject. The paintings may be the relatively simple ideological whitewashing which their titles claim; they may also display a failure of nerve, of imaginative power before a complex subject which Friedman regrets. Yet their compression is tentative, even tremulous—it is more interesting than it seems. *American Landscape* is spatially activated when we realize that our viewing position is in the empty hold of a huge steel barge floating on the Rouge River, approaching the dockside before us. We shift, that is, from a slippery, hollow emptiness to the water's reflective opacity, to the sharp, concreted river's edge, on which artificial mountain ranges of raw materials have been stacked, delivered by barge,

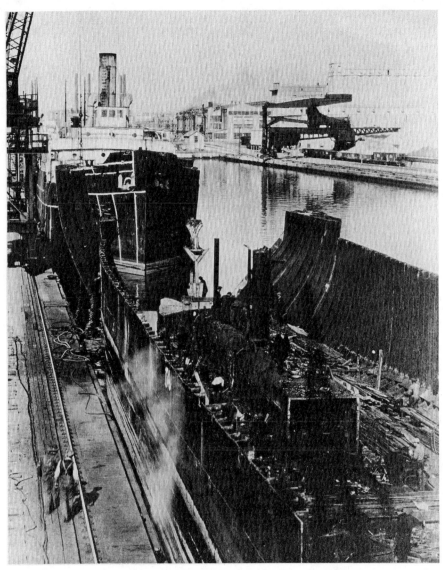

3.10 Charles Sheeler, *Salvage Ship*, 1927. Photograph. From the collections of Henry Ford Museum and Greenfield Village. (Ford Archives, P.189.6575; Courtesy of the Lane Collection, Museum of Fine Arts, Boston)

being sorted by the crane-loaders moving across them like mobile harvesters to be redistributed by the trains into the factory buildings which enclose the horizon. Indeed, the barge has been floated into the slip to be wrecked as raw material for the foundry.[44] A similar movement of radical entry gradually contained by a ruled-off horizontality is obvious also in the railway track diagonals of *Classic Landscape*.

The paintings also repress, like most of the 1927 photographs, the labor power which is working the plant being pictured. The fugitive figure scurrying along the railway line does not contradict the anger of the *Daily Worker* writer at this absence, or his obvious conclusion: "pure and uncontaminated by any trace of humans or human activities, an industrialist's heaven where factories work themselves."[45] The creator of this man-made landscape is Man; but the first to concretize the abstraction are, on this kind of reading, Henry Ford in particular and industrialists in general, followed by their architect-engineers, their managerial planners. The *Daily Worker* writer is quite right: undeniably, a class-dominant way of seeing structures these pictures. This did not prevent their publication in the social reformist magazine *The Survey*. Its February 1, 1931, "Graphic number" reproduced *American Landscape* as its frontispiece. Interestingly, the two versions of another major treatment of a River Rouge–based subject, *City Interior* (1935 and 1936), show him to have pulled back from a close view of a railway switch enframed by overhead piping to a more general view of that whole section of the yard. The broader view works much more effectively as analogous to a city streetscape; the closer view almost demands that we understand the kind of work going on, which we cannot, as there are insufficient indicators.[46] Clearly, the presence or absence of images of workers is not the factor at issue here. A tremendous variety of social relations crosses such complex sites: for example, conveying equal respect for the human labor process and the power of machinery (only one, and already an allegorized, perception) does not necessitate their equivalence of presentation of the kind Lewis Hine foregrounded so well. It is just as well conveyed by, for example, Paul Strand's close-up of the cutting area of a machinist's lathe, in which nothing moves and no machinist can be seen— *The Lathe, Akeley Shop* (1923).

The worker banished, is the factory working itself? Perhaps so, although the indicators of even machine movement are faint in *American Landscape* and nonexistent in *Classic Landscape*. If it is working, it produces nothing, no identifiable product, no Ford car. Would that not be too crass an expectation, too close to advertising, to the domain of the brand image, for it to remain art, to retain its transcending potentiality? Or perhaps this simply obtains, signifying Sheeler's own consent to such industry as good, with the value of such imagery to Ford Company being precisely its indirection. Thus Rourke: "Since 'American Landscape' was painted its title has been applied by others with bitterness and disgust. Sheeler's use of the title carries irony but the world which he reveals produces no dismay. Nothing of grime or human waste appears here. He might say that these do not tell the whole story, that they

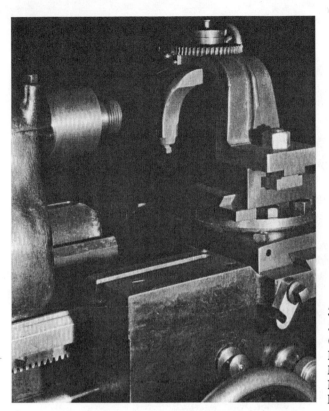

3.11 Paul Strand, *The Lathe, Akeley Shop*, 1923. Photograph. (Copyright © 1971, Aperture Foundation, Inc., Paul Strand Archive; photograph International Museum of Photography, George Eastman House, Rochester)

may be ephemeral, that the enduring fact is that the vast mechanism has its own life, its own conquests and future. He has accepted industrialism and renders what he sees as its essential forms."[47] Presumably Rourke has in mind a contrast with paintings such as Phillip Evergood's *American Tragedy* (1937), in which police brutally assault workers in front of a landscape made up of a pristine oil refinery, echoing the newspaper imagery of strikebreaking by police and such agencies as Ford Service, which was so much a part of the Ford story at the time Sheeler was visiting and painting but had become more overt during the UAW campaigns of the mid-1930s.[48] Although Sheeler's cool acceptance might be preferred by Ford Company et al. to Evergood's heated opposition, we do not expect Sheeler to become a Social Realist or a news photographer, nor do we halt more than passingly over his obvious "acceptance of industry" as a biographical truth, significant to the shaping of his unique sensibility. Rather, I am interested in the indicative character of the conditions, the nature and the social circulation of such acceptances, because they weave together, organizing the societal pathways of visual images, securing and losing meaning as they travel.

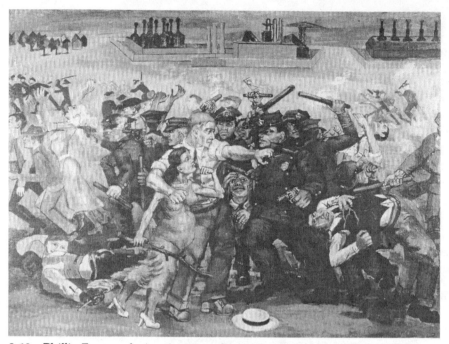

3.12 Phillip Evergood, *American Tragedy*, 1937. Oil on canvas; 29½ × 39½ in. (Private collection; Photograph Terry Dintenfass Inc., N.Y.C.)

"The enduring fact is that the vast mechanism has its own life, its own conquests and future": a condition of submission, but, yet again, the full vastness of the River Rouge mechanism is not shown. Not the labor power, not the product, not the productive process famous every-where—the assembly line. Rather, Sheeler has selected two different views of the same area of the plant, the huge storage bins at the loading docks of the River Rouge next to the factory buildings. The manufacturing processes take place in the buildings at the horizon line: the elegance of Kahn's profiles are given their due but they are at the edge of our vision; they rule it off. Sheeler clearly found these buildings less interesting, less essential to the form-character of industrial America than the cranes, chimney stacks, overhead piping, and railway lines. But he has rendered these latter not with the attention to "grime and human waste" or to their "muscular" power, both of which interested many nineteenth-century artists, but rather with the precision, elegance, and spareness characteristic of such simple but accurate enclosures as Kahn's buildings. Perhaps information about manufacturing processes was omitted because, again simply, the paintings aim to be images of industry in general rather than manufacturing industry or Ford Company specifically. Perhaps this is their distance from the 1927 photographs. American industry as a whole is the "vast mechanism" introduced here.

If this is so, then Sheeler has chosen exactly the right subject for his apparently banal, generalized theme. He has sensed—or it has stamped itself on his consciousness, persisting in his memory beyond the specifics of this-or-that machine, this-or-that sight—something which we arrived at in our analysis of the architecture and design of the River Rouge plant, the "higher order" of modernity which this plant represents. I argued that in seeking to expand and liberate the "organic flow" of Highland Park, and to join it to a system of transportation which brought raw materials from sites owned by the company to River Rouge, whence they were processed into products which were themselves redistributed for assembly, sale, and consumption at other owned outlets, Ford Company affected a local/global system of centralization, singularity, and dominance. The plant becomes the junction of a network, a new kind of organization of power. The entire system becomes a machine for reproducing mass production, for circulating elements around it in determinative patterns which exclude other possibility, but which suggest a different, more regulated and "rational" social order.

American Landscape (1930) which at first appeared as a distant view from across the river, placing us *outside* the plant itself, separating, externalizing us as spectators, in fact positions us at the most visible point of conjunction in this network. Not at the "front door" locations of the Administrative Building or any of the sales offices, but at the point where raw materials are assembled, just as the High Line—the largest crane structure then built and thus a dramatic figure—begins the distribution to the "mini-city" glass and steel plants. We are, in a real sense, being delivered up to this processing; we are already in its network; we are approaching the maw of the huge, transforming machine which fills all the space we can see. In *Classic Landscape* we have entered the plant, and our view is at right angles along the other side of the storage bin, along a track on which we can see rail trucks passing in *American Landscape*. An abstract order prevails. Our slightly disturbed entry has been calmed. Light is clear, delineating useful differences. The only clouds in the sky are those made by chimney smoke. It is a perfect day.

So perhaps *American Landscape* and *Classic Landscape* do carry more than the anthology values of their overwheening titles. Landscape vistas were available elsewhere in the plant and at points on two sides of the plant perimeters. By choosing just this junction, Sheeler has released the general readings of his titles, but he has also responded directly to the specific way in which Ford Company constituted these generalities. The paintings begin from Ford and return to Ford. If, as I have argued, the architectural practices (office organization and design processes) of Kahn Associates were produced/determined by Ford Company, then Sheeler's approaches in this case were also determined in ways both

quite direct and less direct. Like Kahn, Sheeler, along with countless others, including many in the New York avant-garde close to him, believed that Ford Company was something more than a prodigious manufacturer of cars: "It was an example, almost miraculous in its swift rise, of forces that were reshaping the world."[49] It was just these forces of transformatory modernity that Sheeler, in these two paintings, placed himself to visualize. His ideological consent generated the conservative containment of the paintings but also, in the same moment but by contra-movement, their chief value to Ford Company: they display the new, "rational," controlling power of Ford Company not as something being striven for against all sorts of odds (the "absences"), but as *achieved*. The tensions of the paintings, on all levels, are contained; equilibrium is reached; everything is in place; the new order is one of constant stasis. It is absolutely modern. It is, also, eternal.

The achieved stasis of Ford Company eternality was conferred by Sheeler, ultimately through his reduction of the elements (the "essential forms") of the River Rouge to objects of contemplation. This is what ties together all of his work for Ford, from the 1927 photographs to these two iconic landscapes as well as the later images. His procedures parallel those exercised by Ford at Greenfield Village: the past is evoked but replaced by a drastically limited reading of the present through a process of appropriation. It is the slow refinement of the tasteful, discriminating gaze that aestheticizes the Ford Company system, epitomized by River Rouge, its ascension into *art*.

Not showing identifiable productive processes, as noted above, permits the paintings to stand as signs for American industry in general terms. But it also, and I submit more strongly, permits the Ford Company way to stand for American, indeed modern, industry in general terms. And in case anyone missed the point, Sheeler added the Ford logo to the railway trucks in *American Landscape*.

What ultimately binds Ford Company, Kahn Associates, and Charles Sheeler to each other at this moment is their mutual willingness to change their creative practices in the construction/representation of mass production as the core logic of a new social order. Each does so not in the same way, but in structurally homologous changes within their own, partly independent practices. I have shown how Ford Company and Kahn Associates did so, and indicated already some analogous moves by Sheeler. The final one is the "offering" to Ford Company of pictures of its own plant as entry points, the gateway to this new order, within a language of legitimacy which is the nearly exclusive province of art. The River Rouge plants not only become a respectable subject for art—they can, at last, be spoken within civilized discourse—but they become themselves the material of a new civilization with its own

beauty, its own art. By the ways he shows them in his art, Sheeler shows them *as art*. And the plants themselves stand, as we have seen, for mass production, the basis of this new order, hovering at the horizons of these two paintings, emanating the regularity, the control which has organized what we see so efficiently, the central motor of modernity, powering away, benignly, just out of sight.

To Sheeler's expressed pleasure, Edsel Ford bought *Classic Landscape* soon after its completion, as did Mrs. Abby Aldrich Rockefeller *American Landscape*.[50] In the March 1931 issue of the relatively new journal of the new corporatism, *Fortune*, the latter painting appeared as a full-page color illustration entitled "Section of the Ford Plant at Dearborn, Michigan." Its caption makes a fitting end to this discussion of these paintings, for it makes explicit the values being formed in this aesthetic-industrial crucible:

> An artist, observing a factory, usually finds in it some symbol of industrial grandeur, oppression or monotony. Charles Sheeler, whose calm and meticulous Fordscape appears on this page, has another approach. He looks at the Ford plant as it is; enjoys its patterns, shades and movements; and is careless of deductions. Yet not entirely careless. Let him speak for himself: "The plant is perhaps as good an illustration as could be found of the belief, which prevails amongst some artists, that forms created with the idea of functioning in the most efficient manner carry an abstract beauty that could not be achieved as convincingly were they to be conceived with the primary intention of making beautiful shapes. From the huge machine which cuts steel plates at a pressure of a thousand pounds to the square inch to the gauges which measure thousandths of inches, efficiency of function and its accompanying beauty is evident. Here is to be seen the machine working with an infallibility which precludes human competition. Noticeable is the absence of debris. Everything in the path of the activity is in the process of being utilized . . . it becomes evident that one is witnessing the workings of an absolute monarchy. It confirms a preference for that type of government with the proviso that the monarch be of the calibre of Henry Ford." (57)[51]

Making Modernity Visible

Was this meeting of different modernities—Ford Company, industrial design, upper-class fashion, and avant-garde modernism, however well defended, localized, and limited—a chance congruence, never repeated, and without issue? Or can we see it as an example of the kind of encounter that produced a very particular imaging of modernity which

came into prominence, if not dominance, as the decade progressed? By February 1940, in its special review issue "The United States of America," *Fortune* began its feature on the "U.S. frontier" with a reproduction of Bingham's *Fur Traders descending the Missouri* (c. 1845) and ended with Sheeler's *City Interior* (1936), under which this caption appeared: "A train of cars winds down a corridor of the River Rouge plant of Henry Ford. The River Rouge is more than the biggest factory in the world, emblem of the industry that pushed America up through the bursting twenties. It is the assembly-line technique, the concept of the mass market, the philosophy of high wages and of low price, the projection of U.S. industrialism into an era of consumer potency" (104).

Not only has the Rouge become a mythical icon, but Sheeler's visualization of it has become iconic. At least for this audience. When a textbook author claims thirty years later that "Sheeler's series of paintings and photographs, made in 1927 and 1930, of the River Rouge plant of the Ford Motor Company, probably more than any other work opened the eyes of his generation to the severe beauty of functional engineering design," [52] we need to ask: how does he know? Is he assuming that artistic innovation will have a widespread social effect, or is he referring only to a "generation" of artists and "art lovers"? How consequential was Sheeler at the Rouge, Margaret Bourke-White at Otis Steel? If their kinds of representation did come to define the subject during this period, how did this occur, what were the structures of its dissemination, how stable were the meanings being established in this spreading?

As we have seen, the company consistently documented its activities photographically, not just the car and the Fords, but the engineering inventions and the continually changing faces of the plants. Progress in every sphere, from the smallest machine to the broadest landscape of the Rouge, was recorded in straightforward fashion. The plants were also subject to the recording eye of others, like Arnold and Faurote, who aimed to convey as much information to other engineers as they could, or like Detroit real estate and insurance brokers Murphy Brothers, who commissioned local photographer O. Rotch to produce a panorama from the river in 1925, presumably for local publicity purposes. As an object of national interest, the plants became a subject for the ubiquitous postcard, recording a visit to the new industrial shrine or some degree of wonder at it.[53] The plant buildings were also recorded as instances of completed industrial architecture, commissioned by Kahn and others. One or two of the photographs of new buildings at Highland Park, particularly the interiors of the Original Building and the Six-Story Building of 1916, coincide with aspects of Sheeler's aesthetic. As well they might, given the argument above concerning concrete functionalism of the

3.13 O. Rotch, *Panorama of Ford Motor Co., River Rouge* (section), 1925.
(Courtesy, National Automotive History Collection, Detroit Public Library)

buildings. That a photographic reading of this functionalism was not
instantly developed is obvious from the majority of shots, especially the
exterior views.

Photographic functionalism was, however, very much the approach
in record photographs of Kahn's Open Hearth Plant, and the Glass
Plant, both being built in 1924–25. In November 1927, at the very time
of Sheeler's visit, the latter was photographed for the architect in a man-
ner not unlike the aesthetic developing in Europe around the imaging of
Modern Master architecture. Was Sheeler's impact immediate, even
anticipated? Had elements of this aesthetic already influenced the un-
known local photographer? Or have we here the beginnings of a func-
tionalist photography developing in response to its local conditions of
production, quite independently of external style?

Sheeler's 1927 photographs, and possibly the subsequent paintings,
had a measurable effect on the internal imaging of the Ford plants, par-
ticularly the Rouge. They were widely used in Ford publications, in both
Ford News and company publicity. A 1929 booklet, *The Ford Industries*,
illustrates the shifting style at a glance: on one page a sprawling pan-
orama at the top contrasts to the tight and subtle repeats of Sheeler's
Criss-Crossed Conveyors below. On other pages, however, Sheeler images
are cropped into the usual narrative overlays. Sheeler's vision trans-

3.14 Albert Kahn, Glass Plant, exterior, Ford Motor Co., River Rouge, built in 1925, photographed 1927. (Albert Kahn Associates, Architects & Engineers, Detroit, Mich.)

3.15 Albert Kahn, Glass Plant interior, 1927. (Albert Kahn Associates, Architects & Engineers, Detroit, Mich.)

formed the way the Rouge was subsequently photographed by Ford photographers and others, drawing them away from direct functionalism. His vision was, for all its demonstrative reticence, a symbolizing one. His only photograph taken at the Rouge which approximates the plain precision of the 1927 Glass Plant photographs is *Production Foundry*. It is one of the few which concentrates on the exterior of one building (although it certainly emphasizes the diagonal in a way which goes beyond the strictly functional). Sheeler focused on single machines at the expense of their place within the productive flow; on the complex conjunctions between buildings and conveyors which created such rich spaces rather than on the buildings as structures functional with regard to the processes taking place within them; and, in his vistas, on the transformed pastoral, instead of the engineering photographers' typical emphasis on circulation "from ore to car." Documentary and publicity photographs had to have high explanatory value with regard to all that Sheeler ignored.

Sheeler's impact can be seen particularly in the middle-range subjects and in records of the conjunctures between buildings. Here, a marked shift in Ford imagery occurs, from the descriptive to the dramatic. It becomes the visual language in which the Rouge is projected as an icon of modern industrial power: the precision of the present harnessing the raw energy of the past. Mary Jane Jacobs has skillfully shown how profoundly photographers employed by Ford Company were influenced by Sheeler's approach. *Classic Landscape* and *American Landscape* were closely followed by George Ebling in 1945, as was *City Interior* in the same year. Similarly, the famous *Criss-Crossed Conveyors* are echoed in an official photograph, *Conveyors* of 1938.[54] Descriptive demands obviously constrict the pictorial energy of most of these, but the weakness of exaggeration which follows from the too-distant view of the official *Conveyors* of 1938 does not hold for another, closer view of the same subject from another angle taken in the same year by Forster. Similarly, there are the general views of the Open Hearth Plant, perhaps marred by the obvious picturesque framing by the steel electricity pylons, but the perspective does convey the structuring of the building around the railway feeding-in. Sheeler's *Ladle Hooks* invests the interior of this building with a cathedral-like gravity. A 1938 photograph *Blast Furnaces* again emphasizes the dramatic contrast of steam escaping from the dark, looming mass of the structure.[55] The other highly significant area where Sheeler's aesthetic had little impact was in the representation of skilled work at the machines and unskilled work around the plant. Here the influence of Diego Rivera can be traced, as we shall see in chapter 6.

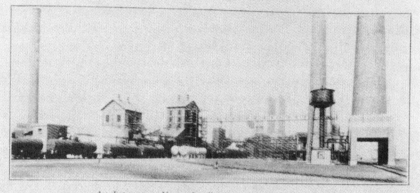

An Interesting View of a Portion of the Rouge Plant

CONTROL OF PRIMARY NECESSITIES

Years ago Henry Ford realized that the transportation needs of America must be satisfied largely through the production of more motor vehicles, and that this situation would cause an ever-increasing demand for Ford cars. Even when the Company was breaking all records with a production of 200,000 cars a year, Mr. Ford appreciated that ten years hence nine or ten times as many Fords would find a ready market. This, however, would render necessary a better control over the sources of raw materials, particularly the primary necessities—coal, iron, wood, steel and glass, as well as more complete protection against non-supply from any source or for any reason—high prices, transportation difficulties or labor troubles resulting in non-production.

With this in mind Henry Ford visualized the gigantic Rouge plant with its coke ovens, blast furnaces, and steel mills, which would convert raw materials into finished products with the minimum waste and expense. This plant was to be the enormous machine which would perpetually insure low prices for Ford products. But before long it was found that

Coke Conveyors and Power Plant

the Company would have to go even further in its control of raw material.

Iron and coal form the backbone of the automotive industry; iron because it is the principal component of a motor car and coal because it is necessary both in the manufacture of iron and the production of power. The cost of iron and coal delivered at a plant largely governs the selling price of the product. No matter how efficiently or economically a manufacturing organization may be operated, the fluctuating market prices of raw materials are beyond its control. The only way to avoid price fluctuations is to control the source of raw material.

The Ford Motor Company protected itself against outside market influences besides rendering itself and its customers independent of price fluctuations, by acquiring vast coal reserves, iron properties and timber lands. These are coördinated under one general management and the materials meet at the Rouge plant where they are converted into finished products.

The coal properties lie in Kentucky and West Virginia. The iron and timber lands are located in Northern Michigan. The Rouge plant lies between them,

[11]

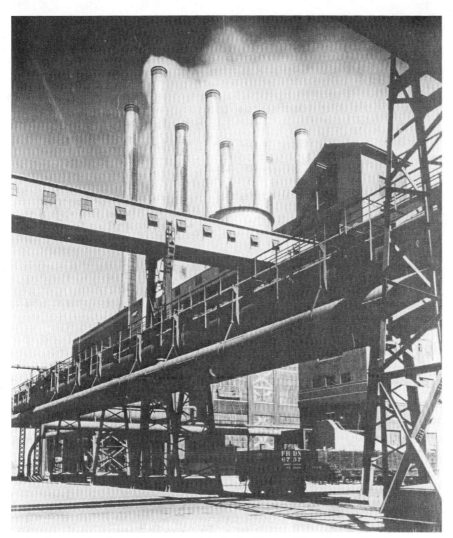

3.17 Forster Studios, *Conveyers, Main Power House, River Rouge, Dearborn, Michigan*, 1938. (Albert Kahn Associates, Architects & Engineers, Detroit, Mich.)

3.16 (*facing page*) From *The Ford Industries* (Detroit: Ford Motor Co., 1923), 11. From the collections of Henry Ford Museum and Greenfield Village. (Ford Archives, N.O.19503)

Sheeler's vistas were organized around the contrast between the movement of the sky and the permanence of the new industrial city. Something of this toadying vision influenced Ford photography, although most of the general views are more dynamic; indeed, they are aerial views. But Sheeler's perspective proved influential in the effort to assert Albert Kahn's prominence as an industrial architect. Thus Ebling and others created elaborate, carefully printed portfolios of the buildings, long views and close-ups of details, which were used in features prepared for *Architectural Forum*.[56] The net effect, however, was a "classicizing" one, relating Kahn to a careful "modernizing" rather than the European-based modernism which the *Forum* had been promoting during the previous decade. This moves away from Sheeler's more purist, modernist aesthetic toward the emerging "modern trend" (in Kahn's own words).

Yet, as we might expect with Ford Company, consistency was more an advertising manager's ideal than an achieved realization. The Henry Ford legend found its willing illustrators in magazines and books and, in a curiously feudal way, in the retention by the family of artist Irving Bacon, who painted episodes of Henry Ford's life, portraits of the family, and great moments in American history.[57] Norman Rockwell was also commissioned for the same purposes. On the other hand, Edsel Ford developed a commitment to a consistent modern aesthetic which affected a relocation of the mass market Ford cars, as we have seen with the Model A, but was much more strongly expressed in the design of the Lincoln range.[58] It was part of the culture being constructed in Detroit by his generation of the new rich, and was projected in public ways through the Detroit Society of Arts and Crafts. Like the shift from the Model T, like the basic move within design itself, this group negotiated a passage from applying "art" (decorative devices, elaborate ornamentation) *to* industrial products toward seeing "art" *in* them (their "natural" simplicity, "precise" beauty, their matching of "form" and "function"). This implied the possibility of designing art *into* them, of controlling the matching so skillfully that the result would be "a work of art." The transition is marked in ways we will return to, but here it can be signaled by comparing the launching of a new Hudson range by Detroit distributor Bemb-Robinson Company, in 1915, to the exhibition Art in the Automobile Industry staged by Chrysler, Ford, Lincoln, Hudson, and Packard executives at the Detroit Society of Arts and Crafts in January 1933. In contrast to the frames and potted plants of the earlier era, the 1933 exhibit featured models, drawings, advertisements, but no actual cars. Rather, twenty-five years of Ford hubcaps, radiators, and dashboards were mounted separately, one above the other, on black velvet.[59]

The year 1933 also saw the first Detroit International Salon of Industrial Photography, a worldwide competition held at the Institute of Arts, attracting many entries and much interest. Under the headlines "Photographic Artists Find Beauty Interest in Machine" and "Camera's Lens seeks out the most Striking Aspects of Era of Smoke and Steel," a staff writer of the *Detroit Free Press* poured out such resounding dreams of unity as these:

> The artist looked at the Machine Age and, working with a product of that age, found the beauties inherent in the machine, and became an industrial photographer. The exhibit of what these modern artists have found will not only be the first international salon in Detroit but the first anywhere. This is as it should be, for Detroit, of all of the world's cities, was the forerunner in the enshrining and ennobling of the machine. This new art form already has its old masters. Dr. Max Thorek and E. O. Hoppe were amongst the first to see beauty in the dynamo, the plunge of the piston, the rhythmic pattern of steel girders, and the curl of the plumes of smoke and steam. Leonardos of the lens, their work will be on display at the Institute.[60]

Behind the hyperbole lies the hope that artists can help secure acceptance of an industrial-social order which, although so recently evolved, in so few places and with such drastically transformatory consequences, seeks consent as "natural," "beautiful," "noble," and, in case none of these absolutes work, as powerful and inevitable anyway. Artists such as Sheeler had already supplied the desired imagery, and it was flooding business magazines. The new corporations seemed well on the way to finding the imagery most appropriate to projecting their modernizing order, to both their managements and their customers. This imagery seemed flexible enough to accommodate the diverse demands on it, yet fundamentally coherent enough to be everywhere, evidently new.

Grand prize, medal of honor, and gold medal
at the 1915 Panama Pacific International Exposi-
tion, San Francisco, went to the various Ford
Motor exhibits. These included scale models of
the Highland Park plant, the film *How Henry
Ford Makes One Thousand Cars per Day*, and a
welfare display by the Sociological Department.
But the most spectacular part of the show was
the scaled-down assembly line, which actually
turned out eighteen Model Ts each day, in the
Palace of Transportation: "people never seem to
tire of watching a rear axle go though the vari-
ous processes until with its additions it grows
into a complete motor car," observed a photo-
graph caption. Above this wonderment were
scenes of America's vast rural spaces, dotted
with Ford cars, serviced by Ford machines.
These country places also introduced a theme
which was to parallel the other half of a bal-
anced way of life, an ethos valid not only in
America but worldwide. Henry Ford enthusias-
tically sponsored successful experiments into
using, for example, soybeans to make plastic
parts, and insisted that the Ford Exhibition
Building at the Chicago Century of Progress Ex-
position in 1934 prominently display a model
industrialized American barn complete with
soybean patch and processing equipment.[1] Two

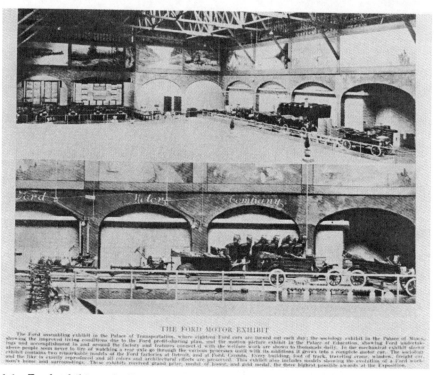

THE FORD MOTOR EXHIBIT

The Ford assembling exhibit in the Palace of Transportation, where eighteen Ford cars are turned out each day; the sociology exhibit in the Palace of Mines, showing the improved living conditions due to the Ford profit-sharing plan, and the motion picture exhibit in the Palace of Education, showing Ford undertakings and accomplishment in and around the factory and features connected with the welfare work are shown to thousands daily. In the mechanical exhibit shown above people seem never to tire of watching a rear axle go through the various processes until with the addition it grows into a complete motor car. The sociology exhibit contains two remarkable models of the Ford factories at Detroit, and at Ford, Canada. Every building, foot of track, traveling crane, window, freight car, and the like is exactly reproduced and all colors and architectural effects are preserved. This exhibit also includes models showing the evolution of a Ford workman's home and surroundings. These exhibits received grand prize, medal of honor, and gold medal, the three highest possible awards at the Exposition.

4.1 Ford exhibit at the Panama Pacific International Exposition, San Francisco, 1915. From the collections of Henry Ford Museum and Greenfield Village. (Ford Archives, P.O.3392)

years earlier, during the depths of the depression, Ford had presented three messages—"Unemployment," "Self-Help," and "Farm and Factory"—to the people of America in nationally run newspaper advertisements. In the last he opined that "With one foot in industry and another foot in the land, human society is firmly balanced against most economic uncertainties."[2]

How does this desire for equilibrium square with Ford's equally notorious risk taking, with slogans such as "If you stabilize anything it is likely to be the wrong thing," boldly asserted inside the Ford Rotunda at the Chicago Exposition?[3] Is this a change of heart, a maturing, even humanizing, of the vision that pushed the Highland Park "hell" into global Fordism at the Rouge? While some evolution of Henry Ford's views can be demonstrated, the impulses at work here are, arguably, larger than one man, however influential. We have arrived at a further, driving contradiction of twentieth-century modernity: its tendency to project its future, to a significant extent, through what amounts to a cannibalizing of its own prehistory and by the consumption of any available, usable past.

Global Fordism depended on centralized control of an international network, vertically integrated from the points of supply of the points of sale and service, the model of the modern corporation. Yet from the mid-1920s, and strongly from a decade later, Ford set out on a program which seems to go in exactly the opposite direction—a decentralizing of automotive production not in further off-shore versions of Highland Park, but through a distribution of manufacturing functions into the countryside—in fact, all over it: "I am going to . . . establish plants for manufacturing parts of Ford cars and Ford tractors in places where they will be in easy reach of farming districts, and provide employment for farmers and their families in winter. And these plants are going to be operated by water power."[4] Nineteen "village industries" were established within sixty miles of the Rouge plant. Although they were varyingly successful, and depended greatly on financial and logistic support from the Ford Company central offices, they were innovations in decentralized technology and in small-scale manufacture.[5]

What inspired this change of direction, if that is what it was? Ford sought an epochal shift, equivalent to that inaugurated by the era of mass production: "It is far from impossible that with automatic machinery and widespread power the manufacture of some articles may be carried on at home. The world has proceeded from hand work in the home to hand work in the shop, to power work in the shop, and now we may be around to power work in the home."[6] Human history, here, is firmly grounded in the work process as the absolutely basic generator of social structure. No hint of anything superstructural and, of course, no social conflict enter the picture. Just a man and his work, a machine to tinker with, and his house around him. Such statements employ populist rhetoric, evoking an eighteenth-century village communality as the most desirable utopia. Yet at the same time they seek to relocate the colossus of mass production into utterly antithetical settings, as if its massive monument to throughput, its critically quantitative accumulations, and its ruthless speeds of circulation were immaterialities that could be spread like dandelion spores, then grow up here and there, at their own pace (probably a steady trot). Henry Ford may have been indulging a youthful dream, or searching for popularity at a time when worship of him was sharply on the wane, or wistfully hoping for a more stable, less concentrated and dangerous work force. Cottage industry manufacture of small automobile parts in the environs of the big assembly plants became a key to Toyota's takeoff in the 1950s and 1960s; perhaps Ford foresaw such a necessity. But if we take the village industries as part of his revival of traditional values and practices such as square

dancing, they can be seen as elements within a plan, albeit very vaguely conceived, to engineer a different sort of post-mass-manufacturing society.[7]

The Henry Ford legend of the essentially simple man draws in these homiletic resolutions, like a white hole of benign banality. More generally, the impulses at work here express dramatically the contested, warped birth of the Modern, garnered from the womb of the traditional. Like many of his fellow grand entrepreneurs, certain aspects of the irresistible, seemingly destined shift into a corporatist maturity repelled him, driving him back to a birthing scenario, precipitating a primal urge to naturalize his network, to see the Ford Company power system as organic, close to the earth—indeed, as powered by natural forces such as water. Dispersing fragments of the Rouge—mechanical flowers bursting forth in every valley, as they did at the beginning of the Industrial Revolution (or so it might seem, in a nostalgic haze)—implies social engineering on a grand scale. It is a dream of modernity as a seamless merging of industry and farming, a pastoral which plants machines in the garden as benign presences, powering away quietly, industriously, harmoniously, as if they had always been there. It is Sheeler's vision of the Rouge itself—in reverse, to be sure, but to the same, positive purposes.

In his acute study of technology and the pastoral ideal in America, *The Machine in the Garden*, Leo Marx recognizes this quality in Sheeler's paintings, and that Nick, F. Scott Fitzgerald's narrator in *The Great Gatsby*, experiences the contrary movement of the same sensation; Nick's vision, no longer "imposing the abstract residum of the pastoral dream on the industrial world . . . instead discloses the past by melting away the inessential present." He sees this "gift of hope" as a reliving of the discovery of America.[8] It may be that at least some Americans have been, ever since, condemned to repeat this originary enactment, tied to an always-beginning, and ever-optimistic renewing. Sentimentality and naïveté attend closely. But modern pastoralism is complex, not simple, in the hands of men like these; it is linked not to bucolic retirement but to aggrandized transformations of the earth. The great weakness of Ford's fantasy lies in his imagining that the meeting of industry and farming can take place in the absence of that other great machine of modernity—the city. Attacking its "evil concentrations" will not—and did not—drive it away.[9] The potential strength of Ford's fantasy lies in its glimpse of another, more and more necessary, and still absolutely modern, ecology. At the beginning of his epilogue on the city's hollow triumph over the pastoral, "The Garden of Ashes," Leo Marx cites a passage from Mark Twain's *A Connecticut Yankee at King Arthur's Court*,

written in 1889. It remarkably prefigures the rise of Fordism and seems a blueprint for Ford's one-foot-in-each balance: "In various quiet nooks and corners I had the beginning of all sorts of industries under way—nuclei of future vast factories, the iron and steel missionaries of my future civilization. In these were gathered together the brightest young minds I could find, and I kept agents out raking the country for more, all the time. I was training a crowd of ignorant folk into experts—experts in every sort of handiwork and scientific calling. These nurseries of mine went smoothly and privately along undisturbed in their obscure country retreats."

The specter of fascism also haunts these words. It found its historical reality with a vengence, as did Fordism. But Ford's "village industries" faded quickly with the coming of world war, to which global Fordism was much more suited. Gatsby's valley of ashes—the industrial dumping ground at Flushing on the way to his Long Island estate—also flourished under later regimes of modernity. In 1939 it became the site of the New York World's Fair, and thereafter one of the elements within the ringing of the city and its environs with freeways, bridges, and parkways by "Detroit's man in New York," Robert Moses.[10]

Archaism and Architecture

Neither the Henry Ford Museum nor Ford's House, Fair Lane (1915), was built by Albert Kahn. The former was built by Robert O. Derrick, a Detroit architect who specialized in early American revival work,[11] the latter by a young pupil of Frank Lloyd Wright and a Philadelphia interior decorator! We might have expected the contradiction of Ford commissioning his industrial architect to exercise another side of his practice and to do for Ford what he was so successfully doing for the other new rich of Detroit, and for Ford's management and clients, that is, provide a palace on Grosse Point. This is indeed how things began, but Ford changed his mind, moved the project out of town and almost out of the architectural profession altogether. The small saga of Fair Lane is another instance of the play of contraries which shaped the parameters of modernity in architecture.

Declaring that he did not wish to become involved in the social life of the "parasites" of Grosse Point, where integration of new into old rich was actively pursued during these years and was expressed in a plethora of historicizing, ostentatious structures, Ford bought two thousand acres at Dearborn, on the River Rouge, where he and Clara Ford had played as children and where they had weekended since. Near the site of the Rouge plant, Fair Lane does not overlook it with quite the directness of a baronial castle or the owner's mansion at such industrial

4.2 Willard van Tine, *Fair Lane*, Dearborn, Mich., 1915. From the collections of Henry Ford Museum and Greenfield Village. (Ford Archives, P.O.130)

sites as Merthyr Tydfill, Wales, but the feudal character of house, plant, museum, and later, schools, is obvious. It lacked worker housing, but this soon appeared in the colonization of the town of Dearborn during the 1920s and 1930s (albeit in the form of accommodation for the middle management).

Edsel Ford's pleas to his father to commission Frank Lloyd Wright to design Fair Lane were successful. This is remarkable, indeed, exceptional: few other of the new manufacturers, pioneers of modern industry, were prepared to entrust the housing of their private lives to the acknowledged leader of the moderns. Ford may have been attracted to the open planning of Wright's houses, paralleling the flexibility of the machine shop and the later buildings at Highland Park, but equally, he may have read Wright's love of large textures of stonework and well-crafted furniture as a kind of economical, minimal rustication, an updating of the archaism of his fellow rich. He could have been presented with enough of Wright's writings and statements to respond favorably to the architect's often-stated "organicism," his emphatic individualism, his loud Americanism, his praise of the businessman as more likely than the "cultured" to have "unspoiled instincts and untainted ideals," his defiant celebration of Midwest virtues—that is, the conservatism of this master of the architectural modernity.[12]

In the event, Herman van Holst, head of Wright's office since 1909 when the latter eloped to Europe with the wife of one of his clients, was commissioned, and began work in 1913 on the residence and the accompanying buildings, such as the four-story power-plant garage, a laboratory and a dam, all set in the huge grounds, well away from roads. The main buildings were thickly clad with gray, chunky Kelly limestone, articulation of windows was regular, the planning horizontal and spacious. But the striving for simplicity of effect in the massing of the whole is contradicted by its gargantuan size, its random irregularities, its obvious expense; it is clearly an overscaled cottage, straining against the palace inside which seems to be struggling to get out. This contradictory effect—of English Gothic breaking out of enlarged Wrightian spaces—was assisted by Ford's dismissal, in 1914, of van Holst and his replacement by decorator W. H. van Tine, who completed the construction and the landscaping as well as suffusing the interior with mahogany and marble in the usual Grosse Point style and quantity. Ford's "simple," "country" dwelling also matched the most lavish of the "parasites" in cost: the house over $1 million, the rest another million.[13] The initial reach toward (perhaps) modernizing his private life was soon replaced, in the event, by the opposite: a revulsion to tradition typical of his class. The result, however, lacks even the bravura extravagance of 1920s Grosse Point as well as much of the architectural refinement within the noisy parameters evident in many of these houses, such as Kahn's John S. Newberry House of 1915.[14] Fair Lane is at best undistinguished, at worst actively ugly in a way not evident in any other structure commissioned by Ford. In refusing the pretentious, over-signed, often erudite, and sometimes subtle—but also "inauthentic" and "inorganic"—aristocratic revivalism of his compeers, Ford reached for signs of modesty, the rural, the natural which he could not maintain without also refusing the totalizing, even megalomaniacal, urges which led to the inflated confusions of the final structure.

Was it this aesthetic catastrophe which led Edsel Ford to return, in 1926, to Albert Kahn for his own house? Henry Ford holidayed in Worcestershire, then in 1931, added a shepherd's cottage from Lower Chadworth to Greenfield Village, brick by brick. The Edsel Fords sent Kahn to the Cotswolds to "Study . . . and to make sketches and photographs of a myriad of details. He had noticed that many of the larger of such dwellings of this type consisted of an original building to which many additions had been built for years and centuries, resulting in that characteristic rambling appearance."[15] This Kahn reproduced with some skill, employing English workmen and materials both for the stone walls, mullions, doorways, and roofs and for the reassembled fireplaces

4.3 Albert Kahn, Edsel B. Ford House, Grosse Point, Mich., 1926. (Albert Kahn Associates, Architects & Engineers, Detroit, Mich.)

and stairways inside. Such translation of the "authentic" was not unusual for the rich of the period: the Cloisters in New York and San Simeon in California are the most extreme examples, while Kahn was to build another Cotswold cottage-mansion for Alvan Macauley, president of Packard Motor Company, a neighbor at Grosse Point Shores. Thus the Arts and Crafts movement, partly inspired by the socialist humanism of William Morris, the craftwork creativity and the morality of the Gothic celebrated by Ruskin, was revived in "Dynamic Detroit" by a restatement of its sources, by possession of them, by their reproduction. Thus they are modernized—torn from their point of growth, their embedment, then cited, isolated, in a new context of use, by the princes of another kind of modernity.[16]

Apprehending Time: The Future Anterior

"Nothing historical, yet everything old": another, quite contrary principle seems to be emerging to take its place alongside the "Nothing original, yet everything new" which, as we have seen, drove Ford Company modernity through its first phases. Nowhere is this more strikingly evident than in the most spectacular embodiment of Ford archaism: the Henry Ford Museum and the contingent Greenfield Village.[17] Its position within the Ford domain at Dearborn, Michigan, not only exemplified the great nineteenth-century American dichotomy but also gave it a particularly twentieth-century twist, a fascinating reversal. The museum and the village at Dearborn are a simulation of the pastoral ideal

which mass production was relentlessly rendering redundant. The garden inside the Ford Company machine of modernity was the ghost of things past.

The search for a usable past was widespread throughout the nineteenth century and remains so today. Most of the international expositions since 1851 had installed historical reconstructions, centering usually around craft work of a regional, and often vanishing, character. William Morris's *News from Nowhere* (1890) imagines a utopia in precisely these terms. In an opposite social and political space, some of the new rich in the United States sought out the past on a major scale: Ford shares something of the antiquarianism of the Rockefeller family at Williamsburg, and something of the obsessive hoarding of Hearst at San Simeon.[18] But while they modernized, respectively, financing and news distribution, Ford Company modernized manufacturing itself—and then sought to implant, literally, within its confines, a living museum of outmoded manufacture. What can this play of ambivalences tell us about the imaging of modernity?

Greenfield Village opened in 1929 on a 252-acre site a few kilometers from the central Rouge plant, but within the Ford precinct at Dearborn—indeed, next to the Kahn-designed Engineering Laboratories (1925), where Henry Ford located his workshop and where such publications as the *Dearborn Independent* were based. In architectural terms, the most striking element is the central museum building itself, the facade of which was fashioned by fitting together three famous early landmark buildings: Independence Hall, Congress Hall, and the old Philadelphia City Hall. This telescoping of signs evokes both the dynamism of past revolutionary independence and the patriotism of subscription to it as a possibility lost to the present. There is a resemblance here to the consciously artificial, deliberately minimal sets used in historical plays and movies, albeit on a Cecil B. deMille scale: it is a necessarily generalizing irreality, evoked by selective specifics. As a facade, the museum could not be more different from the functionality of the Highland Park and the Rouge buildings. Yet it is tied to them, in the garden-machine dichotomy, by its very oppositeness. With the Ford plant looming all around, such a facade declares mass-production modernity as the irresistible present by embodying the finality of the past in a brand-new, but also overtly artificial, simulation of that past.

Greenfield Village, laid out in grounds next to the museum, evokes in a general way a "typical" late eighteenth-, early nineteenth-century American rural community. Into this framework has been inserted a compound of building types from many times and places, which are peopled with craft workers whose skills were being rapidly outdated by the demands of the network centered on the nearby Rouge plant. In a

4.4 R. O. Derrick, exterior of the Henry Ford Museum, Dearborn, Mich., 1929. From the collections of Henry Ford Museum and Greenfield Village. (Ford Archives, P.O.19502)

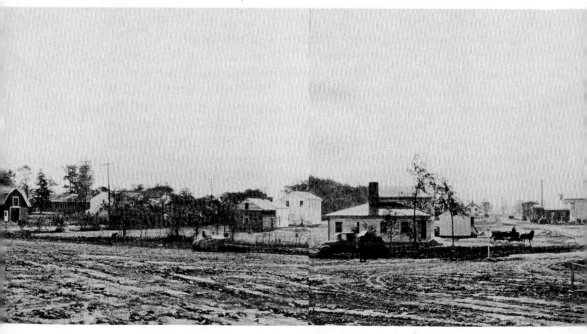

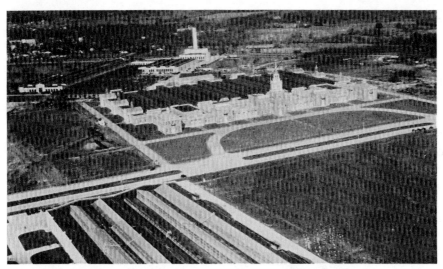

4.5 R. O. Derrick, aerial view of the Henry Ford Museum, 1929. From the collections of Henry Ford Museum and Greenfield Village. (Ford Archives, P.188.3135)

4.6 Panoramic view of Greenfield Village in the 1930s. From the collections of Henry Ford Museum and Greenfield Village. (Ford Archives, P.O.5968.A–D)

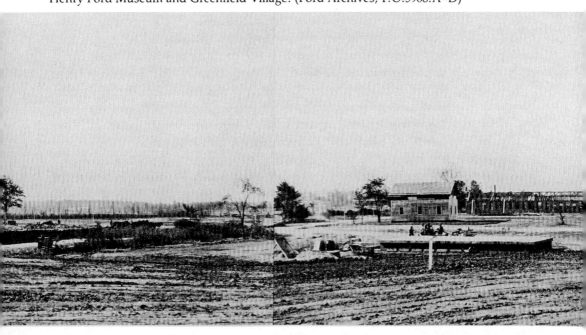

hazy way, the village celebrates continuous, hard, and happy work at and by machinery of many kinds. As well, the houses, shops, laboratories, and schools of famous Americans were recovered and are represented: that of Edison, authentically; that of the schoolhouse supposedly immortalized in the rhyme "Mary Had a Little Lamb," and the birthplace of Stephen C. Forster, doubtfully. More strikingly, the museum was stuffed with multiple specimens of "something of everything":[19] "Airplanes and steam engines compete for attention with dolls, churns, hearses, china, washtubs, muskets, bedsteads, zithers and music boxes, baby jumpers, sleighbells, hoopskirts and covered wagons. . . . Lifesized railroad cars adjoin a prolific display of dolls and trundle beds and a random series of cigar store Indians. . . . The floors are stuffed with an acre of clocks. Tucked end to end, antique dressers stretch as far as the eye can reach."[20]

What kind of relationship to the past is implied in Greenfield Village and in the Ford Museum? Ford's famous remark that "History is bunk" has the popular connotation of a statement of freedom from constraint, conservatism, defeatism, and a defiant assertion of the power of individual initiative. It was made to a reporter when, in 1916, Ford sued the *Chicago Tribune* for labeling him an "ignorant idealist" and an "anarchist" for opposing war against Mexico. It appeared at a time when sections of the press were exposing Ford's lack of learning and he was reveling in the popularity which that lack, combined with his prodigious success, was affording him. He actually said: "History is more or less the bunk. We want to live in the present, and the only history that is worth a tinker's damn is the history we make today."[21] Yet the antiquarian gargantua perpetuated in his name at Greenfield Village seems to indicate a respect for history of some depth and detail.

The contradiction here is, however, more apparent than real. The nostalgic rhetoric of populism was not locked into pitched battle with the modernizing rhetoric of progress; on the contrary, it was a duet of combination and alternation. Within this dance of mutuality, however, both past and present are being irredeemably transformed: certain processes of contrast, detachment, and restatement are under way. In short, the past is being modernized, the present rendered past. Arguably, this is a major function of the modern museum. It may also be one of the purposes of private collecting, albeit enacted differently. Greenfield Village and Henry Ford exemplify this processing, which seems everywhere to have at least three major forms.

The first follows from an overriding rhetorical effect of modernity itself: that the entire past is rendered separate, other, because it has been irrecoverably finished by the fundamental changes which constitute the

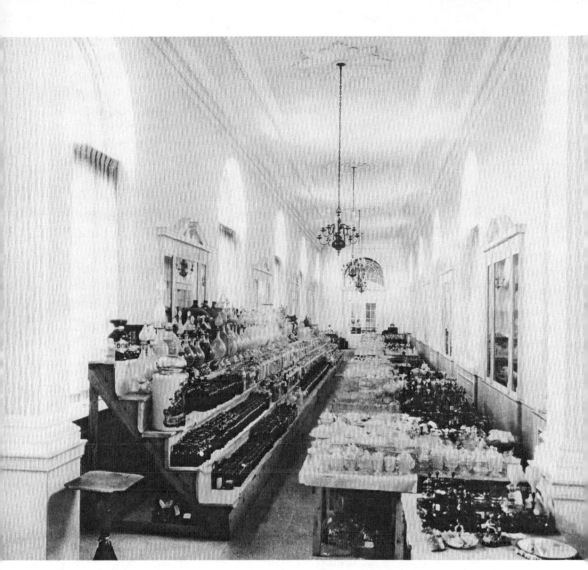

4.7 Interior of Henry Ford Museum. From the collections of Henry Ford Museum and Greenfield Village. (Ford Archives, P.188.12067)

present. The modern is distinguished as Modern by what it has closed out; it may have no form other than this closing out; it may be a new era of change as such, a future without limit, never to end and therefore beyond history. When this basic shift is registered through artifacts, it tends to project the past, all of the known past, as immobile, as somehow equally available for scrutiny from a single position in the shifting

present. It amounts to a kind of imperialism of the appreciative gaze, a tyranny of listing, a reduction of history and sociality to things, and their completion by cataloging. The past becomes available to the present above all as the subject of a process of separation then appropriation. At this time, ethnographic museums were changing in character: each collected object was now more precisely identified than before, yet the preferred mode of response to it became less contextual, more a matter of exercising a supposedly universal aesthetic taste.[22] The same process underlies the jumbled prodigalities of Ford's village-museum.

Greenfield is also modern in that it renders the past incoherent. It does not do so only by its lack of labeling, of the chronological arrangement of declared, limited purpose; it does so more deeply: it represents a desperate wish to obliterate the past, to consume it in use, to fix it by a celebration of each and every aspect of it. Ford did not buy the finest or the most historically important or even the most representative items of a type; he attempted to buy all the tokens of the type, that is, "everything." Asked why Ford bought things in such fabulous quantities (only to discard much of them), the dealer-collector Voorhess replied: "I don't know why he bought them unless it was so that he would have what there was, and there would be no more left."[23] Again we should not dismiss this idea because of its obvious practical impossibility: it is structurally congruent with the global character of the mass-production network as a world order, and as a ruralized social order. It is also, on the other hand, an extreme expression of the collector's ultimate fantasy: that all becomes one, and I possess it.

The modernity of Greenfield Village and particularly the Ford Museum is evident not only in that it renders the past as a whole separate and incoherent, but that it does so in order to legitimize a certain limited reading of the present, specifically the present as the age of machine power, presided over by Ford Company. What differentiates it from previous attempts at legitimization is, again, its totalizing scope: not just certain tendencies in history lead to the present (as in inheritance or ancestry), but all history, all of the past, leads to this, and only this, present. It parallels the tendency, in formulating histories of Modern art, to reduce all previous art to that of the Old Masters, all previous architecture to historicist eclecticism.

Thus the reproductions of the three American monuments in the facade of the museum were made with an antiquarian meticulousness made possible by the techniques for replication typical of the American system of manufactures, replaying (and literally museumizing) the immediately preceding phase of modernity. Exactly the right stones were procured for each section: Harvard handmade red brick, Cold Springs

gray granite, a blue-gray Georgian marble and soapstone. Yet behind the facade stretches out an exhibition hall of Highland Park dimensions (450 by 800 feet) and construction, with a steel frame, modular columns, and glass roof monitors in the manner of the adjacent Engineering Building, but also echoing the profile of the facade. Inside this space, the past becomes the early age of industrialization; the present is the modern machine age, creator of some distinctive products but mostly defined by its power to fill the world with limitless reproductions of the same things. While some of the machines, and many of the products, of mass production were featured, the assembly line was absent. Indeed, like all museums of industrialization, the central, revolutionary core of the Industrial Revolution—the factory system—was invisible. Astonishingly, at Dearborn this meant leaving out Ford Company's own revolutionary transformation of the factory system—and still does today.

A Place of Grace?

How conspicuous an omission would this have seemed? After all, the Ford airport was spread out in front of the museum, various sections of the plant were being built nearby, and the Rouge colossus was growing only three kilometers away. With the plant itself, they became part of the stable backdrop of photographs of company products and personalities. Ford was not averse to creating mock-ups of the line at temporary expositions—thus the 1915 display at San Francisco. Albert Kahn updated the idea for the General Motors Exhibit at the Chicago World's Fair of 1933–34. But a re-creation of the assembly line within the museum, or a mock-up factory in the village, would have been as symbolically uncontrollable as situating a garden literally within the Rouge plant. It is as a fictional dream of the past that Greenfield Village and the Ford Museum functioned most precisely in the present: they implied that mass-production modernity was still rooted in (and would one day return to) an Eden populated by men and machines living in harmony; it became a visible goal of an abstract, arm's-length redemption.

Was reparation at the basis of Henry Ford's exercises in historical preservation? They were, partly, attempts to rescue some reputation from the ridicule heaped upon the ignorant idealism of his "History is bunk." They certainly aimed at asserting a different, more accessible relationship to history itself: "I'm going to give the people an idea of real history. I'm going to start a museum. We are going to show just what actually happened in years gone by."[24] Perhaps, too, Ford was touched by irrefutable evidence of the negative effects of modernization, including that of which he was agent, and sought a degree of atonement. The desire for "a place of grace," free from the impact of modernity, inspired

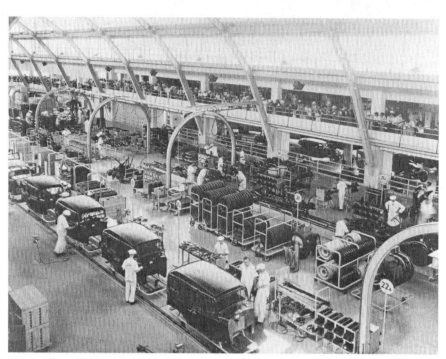

4.8 Albert Kahn Associates, model assembly line, General Motors Exhibit, Century of Progress Exposition, Chicago, 1933–34. (Albert Kahn Associates, Architects & Engineers, Detroit, Mich.)

much antimodernist sentiment around the turn of the century.[25] Perhaps Greenfield Village was Henry Ford's penitent gift to the people whose lives he had transformed—hopefully, now, not irredeemably. If so, his plea was quickly answered: the village-museum soon became a source of great enjoyment to himself and others.[26] It resolved the contradictions inherent in its siting by submerging them in the simultaneity of personal experience, that is, past and future were absorbed in the enjoyment of their immediacy as the present. To Henry Ford, the village-museum rendered history autobiographical: it recorded the forces that shaped him—his own birthplace was included—and, in the most general and sanitized of terms, it asserted the historical importance of Ford and his great friends, such as Thomas Edison. These gentle fables made their reassuring impact on the visitor, who absorbed them, usually, as surrogate, sentiment, interest, admiration, or awe.

The creation of industrial history as part of the national heritage soon turned itself into the "heritage industry."[27] Many of the techniques now used to turn declining Britain into a vast open-air museum of its lost industrial glory were prefigured at Greenfield Village. The main trick was the supreme sleight of hand, the wisking away of the central, mo-

tive power (the drive for profits) and its most potent industrial forms (the factory system in Britain, the assembly line at Ford). Another was the downplaying, in Dearborn to the point of invisibility, of conflict and contradiction, of the other historical forces aimed at generating a different order of social power. At Greenfield Village, Ford banished not only all conscious class, ideological, and political perspectives toward workers; he also excluded the aristocrats and their professional "parasites" from his humble pantheon. Indeed, he stole a march on the patriarchs of the previous generation by transforming their nostalgic preservation of a hierarchical order of patrons and the folk (vide Williamsburg) into an unalloyed celebration of the common, practical, and simple virtues of "the people."[28] This was tourism of the modern but with a reverse, and doubled, inflection.[29] By absenting the assembly line, and the urbanized present and all its attendant disharmonies, Ford could have it both ways: Greenfield Village represented "the good old days," while at the same time and place the Ford Museum proved that, due to the capitalist machine, the amenity of human life had been measurably progressing. "The two messages together—life had been better in the old days and it had been getting better ever since—added up to a corporate employer's vision of history."[30]

This vision was in the ascendant in the later 1920s. Ford's elisions of the future back into the past then forward again, the selective shaping of popular memory—even the fact that, as history, Greenfield Village was bunk—none of this seemed obvious. Or maybe it was, and perhaps this is a further clue to its power. One face of modernity at the apogee of its mass-production phase was, as we shall see, its massive investment in imagery, in the symbolic language of mass consumption. If capitalist history is destined to repeat itself as tragedy or farce, then an essential element of its incessant reproduction of itself is surely the creation of these domains of simulacra, wherein it can reenact its own "history" in ways—such as time machine–like reversals—that seem to banish history altogether.[31] And a key to successful performance is managing the audience, not as naïve innocents deceived by the naturalistic totality of the illusion, but as victims made even more susceptible by their complicity in what is evidently a fabrication, in something that falls so far short of its crude but engaging goals that these goals seem all the better, more pure and natural, indeed, achieved, for that. Is not this the typical experience of modern tourism, irrespective of the simulation being visited?

If Greenfield Village conjured a precapitalist paradise, and the Henry Ford Museum omitted any simulation of the assembly line, the factory system as transformed by mass production was rarely absent from the itinerary of the visitor to Dearborn. Many millions visited Highland Park

An ideal expressed in stone and steel. . . . A vision reduced to practical terms. The Rouge is another substantial proof of the soundness of Ford theories, the rightness of Ford products. In it there is but one unchanging rule: progress! It is a symbol of our day

AN *Invitation* —

Every day the Rouge plant is in operation, hundreds of visitors go through its buildings. Each of them gains a vivid and lasting impression of the plant's scope, its aims and its processes.

If you have made one or more trips through the plant, you carry a memory that will linger with you for a long time. If you have *not* visited the Rouge, you are cordially invited to do so.

The Rouge plant is more than a fabric of steel and brick; it is symbolic of the age in which we live. It is a symbol of progress — of greater freedom and a broader outlook for all mankind.

There is no inviolable rule at the Rouge save that of change and progress. What is best at the plant today may be supplanted tomorrow by something better.

Henry Ford's idea of his calling was summed up when he said; "Industry is mind using nature to make human life more free."

4.9 Ford Motor Co., "Invitation" advertisement in *From the Rouge to the Road, Dearborn*, Dearborn, 1935. From the collections of Henry Ford Museum and Greenfield Village. (Ford Archives, N.O.19504)

after 1914, and many more toured the Rouge plant from the mid-1920s to the 1960s. The wording of a 1935 advertisement is typical. Under the heading "An Invitation," and below a photograph inspired perhaps by Charles Sheeler's 1932 painting *River Rouge Plant* (Whitney Museum of American Art, New York), it reads:

> Every day the Rouge plant is in operation, hundreds of visitors go through its buildings. Each of them gains a vivid and lasting impression of the plant's scope, its aims and its processes.
>
> If you have made one or more trips through the plant, you carry a memory that will linger with you for a long time. If you have not visited the Rouge, you are cordially invited to do so.
>
> The Rouge plant is more than a fabric of steel and brick; it is symbolic of the age in which we live. It is a symbol of progress—of greater freedom and a broader outlook for all mankind.
>
> There is no inviolable rule at the Rouge save that of change and progress. What is best at the plant today may be supplemented tomorrow by something better.
>
> Henry Ford's idea of his calling was summed up when he said: "Industry is mind using nature to make human life more free."[32]

The assembly line was the highlight of the visit: special railings were installed so that tourists could view the final stage of chassis and body assembly. When we take in a whole day at Dearborn, with its stops at the museum, the village and the Rouge, and add to it the symbolic work done by saturation advertising of the Rouge as a site of unprecedented productivity, then we can see that, by the late 1920s, the interlacing of progressivism and archaism in Ford Company modernity was even more far-reaching and complex than has been thought. If Greenfield Village and the museum were gardens of nostalgia planted within the Rouge's symbolic precincts, then the huge plant and all its processes were also being museumized by tourism, becoming a colossal monument to themselves, a machine productive also of vast figurative capital, even as it went through its gigantic paces. Perhaps "the great productive machine" created by the engineers, managers, and architects at Highland Park, elevated to a global network of material distribution at the Rouge, became, with the addition of the village-museum, a set of interlocking domains for the representation of the double movements of twentieth-century modernity. As a whole, this amounted to a new kind of machine, one dedicated to the mass production not only of saleable things but also, and equally importantly, of consumable imagery.

MODERNIZATION AND NATIONAL DISSENSUS: IMAGERY OF REALITY IN THE 1930s

THE SHAPING OF SEEING: OUTRAGEOUS *FORTUNE*

Changes in the imaging of modernity after 1930 are so marked that they seem to constitute a major shift from the structures of the 1920s. The modernizing impulses in U.S. society were certainly visualized in a rich variety of ways during the 1930s. Obviously they were given form in other media, and equally, other impulses also achieved visual form. But a claim for an unprecedented prominence of visualization at this time can be made. And it can be shown that, of all the objects of this visualization, the effort to image the modern was most striking. We have traced the genesis of certain such efforts before and around 1930. The Ford assembly line, Kahn's functionalism, Ford Company advertising, Sheeler's aestheticizing, and, as we shall see, *Fortune*'s "business culture" and Rivera's Pan-Americanism were all astonishingly inventive, adaptable, and powerful; all had—to varying degrees—profound effects, yet all failed in their thrusts to universality. The limits of such imaging, and of the Ford Company type of modernity which activated them at crucial moments, are evident not only in their internal dysfunctionality but also in the voices of their victims. The values of other people, other nations persist—in the private domains of Frida Kahlo, for example, in the public hysteria of

Jose Clemente Orozco and David Alfaro Siqueiros. But in the aftermath of the Great Depression, generated by its trauma, the competing modernities of the 1920s seem to attempt a convergence, to seek compromises among apparent incompatibilities. By mid-decade, an imagery of coalition is emerging—many-sided and internally contending, to be sure, but nonetheless the energy is that of expanding consensus, dreamed or enforced, willed or submitted to under protest. This changes the terms of the processes developed in the 1920s and earlier: the imagery of modernity enters a new phase. The urges to disorder and totality of the competing modernities of the 1920s, dreams/projections then, seek generalization, institutionalization in the mid-1930s. They seek to control the social gaze—in short, to govern.

The obvious symbol of this change is the popularizing of the "business governments" of the 1920s in the welfare orientations of the New Deal from 1932. The Roosevelt administration attracted many reformist and radical currents, and released metaphors of healing, helping, binding, of revenge through regulation, security through support, rationalization through resettlement, of peace through planning. These had real roots in the struggles of many people and organizations, both inside and (mostly) outside of government. Yet behind the thin screen of encouragement for democratic dissension (of business versus government, the people versus profiteers), a "new deal" was being struck between the new-style, modernizing government and the new-style, oligarchic corporations. The U.S. ruling class was reforming itself and all its dependencies against the disaster of loss of control figured so blackly in the Depression. These enforced adjustments are traced through their swift shift from the commanding heights of *Fortune* magazine, then through governmental publicity (including the famous Farm Security Administration photography projects seen in context), to the imagery of teeming multiplicities of people in *Life* magazine.

The laissez-faire conception of the nation as a domain for unfettered experimentation by entrepreneurial capital and ungoverned individuals—long since made a fiction by the concentrated powers of both mass production and the stock exchange—was reshaped as a domain of regulation for the controlled manufacture of diversity. To employ our Ford Company metaphors: the invention to excess around the single object of Highland Park is changed into the ordered productivity of variety of post–Model A River Rouge. It is small wonder that the plant itself became an icon of the period. This suggests that, from the point of view of image management (like publicity and "humaneering," a "science" of the moment), the novelty of these shifts had to be welcomed for what it was—modern. And the otherness of this modernity had to be figured as something it was not, according to earlier ideologies—American. No

longer an imagery confined to the subcultures of the rich, to foreign fashion, to the enticements of unattainable luxuries, the mid-1930s shift entailed that modernity be quantified, popularized, and naturalized ("nativized"). It was, indeed, made in America. It had to look "Made in America."

The imperative of reestablishing the legitimacy of business-based government through popularization was one-half of the New Deal. The other half was the pressing need to regularize, but not regulate, the expanding markets for the consumables of reviving mass production. This, too, was organized around the domestication of the modern. The effort to "modernize every American home" meant, in the first place, making it new (with new products) and locating its novelty as part of a national drive (by reimaging the "typical American family" in this sort of space). Part of this thrust was the popularization of the unparalleled prowess and the patriotic commitment of U.S. industry—another reason why the biggest of them all, the River Rouge plant, became iconic during the period. But the successful (although partial) domestication of modernity also went deeper: by the 1940s and 1950s, the particular configuration of modernity which was developed at this moment became normal. This point is argued in part 4; it is raised here only to prefigure a consequence of the consensus building of the mid-1930s. A drag to compromise exerts a compelling force within New Deal dynamism. It indicates that a future subject is something rare in both modernity and art history: the ordinary—the infinite subtleties of its establishment and constant reconstitution. It haunts the outpouring energies of the productive centers we will study, it skirts the fringes of their fascinating battles, it awaits the inevitable collapse of their fantastic extremes, and it commands the field when the nation literally goes into battle in World War II.

In parts 2 and 3 of this volume, I reverse the procedure followed thus far. Instead of tracing the effects as various discourses/practices and individuals/agents cross the shifting, growing site "Ford," I begin from the figure of "Ford" as it appears on various national sites, agencies of the transformation of the 1930s. These includes magazines such as *Fortune*, the great public debates about the social purposes, and limits, of art (nowhere more emphatically experienced than in the controversies surrounding the Detroit and New York murals of Diego Rivera), governmental structures such as the New Deal (importantly including their publicity machines), new practices such as industrial design, and art institutions such as New York's Museum of Modern Art. In fact, the reversal cannot be symmetrical; the figure "Ford" merges quickly into the larger picture precisely because the iconological regime is forming on a broader scale. How this formation takes places is the focus of the

rest of this study, that is, the development from the rupturing around 1930 to the unity of 1939—and its almost instant collapse, revealing the ideologically concealed point of the entire movement: Modern America, not as a mechanized Futurama, but as an effect, a compromise, an expedient unsighting.

Time, Taken at the Flood

Henry Luce, in February 1929, submitted to the directors of Time Inc. a proposal for a magazine to be named *Fortune:*

> Business, the smartest, most universal of all American occupations, has no medium of expression except the financial pages of newspapers and the cheapest, least distinguished of magazines. . . .
>
> Unless we are prepared to believe that America's industrialists are chiefly concerned with the technique of sales departments, with the stale Get-Rich-Maxims of onetime errand boys, the subject matter of such a magazine as *Forbes* must be thought piddling and inexpressibly dull. Even the *Nation's Business* . . . is enslaved by the idea that any article by a great name (Ford, Schwab, Hoover, Farrell) is per se entertaining reading no matter what the Great Name may tell his ghost writer to say.
>
> We conceive that the failure of business magazines to realize the dignity and the beauty, the smartness and the excitement of modern industry, leaves a unique publishing opportunity. . . .
>
> We propose to become a national institution, perhaps the greatest of all institutions which are concerned with criticism and interpretation. The field which lies open is as immense and as rich as was ever offered to journalistic enterprise. We have wars to record, strategy to admire, biographies to write. The 20th Century trend in merchandizing, the growth of the chain store system, is no less significant in the century's development than the decline of the theory of state's rights. Industry is a world in itself, for which we must be critics, historians, biographers and secretaries.
>
> And this world is more macrocosm than microcosm, is in fact the largest of the planets which make up our system. . . .
>
> *Fortune* is primarily a conception . . . as follows:
>
> 1. It will be as beautiful a magazine as exists in the United States. If possible, the undisputed most beautiful.
> 2. It will be authoritative to the last letter.
> 3. It will be brilliantly written. It will have *Time's* bursting-with-fact, economical, objective merits, but the language will be more sophisticated. . . .

4. It will attempt, subtly, to "take a position," particularly as regards what may be called the ethics of business. Of course, business is not a profession, and so one cannot set up a definite professional code. Nor is it desired blasphemously to equate business with religion. But in a general way, the line can be drawn between the gentleman and the money-grubber, between the responsible and the irresponsible citizen. *Fortune* is written for those who have a sizable stake in the country and who ought, therefore, to yield to no other class in either the degree or the intelligence of their patriotism.[1]

This is the language of conviction which might well (will) become certainty. It calls for the celebration of an explosive, positive power—for that power to recognize and herald itself, to accept its triumph in a style appropriate to its continuous victory. The practice of business, in this text, falls short of moral, sensual, intellectual, and active perfection only in its failure to proclaim its perfection. Yet this failure secures perfection in an act of business, the "unique publishing opportunity," in metabusiness, the chance for a profit by inserting an "institution" for the continuous interpreting of business to itself. And further, it is a self-correcting discourse, affirming power, raising standards, watchdogging the mere "moneygrubbers" and "irresponsibles," setting limits. It will passionately persuade business of its current significance and future glory—for which it will be paid, a work productive of much surplus value, a model itself for further business. With *Fortune*, the "world" of business will be complete; it will be not just the "largest planet," but "the system."

Luce's proposal is a rarely available "internal" statement. It was intended not for publication but to persuade the directors of a seven-year-old company, successful in a relatively new field but entering a period of acknowledged instability, to take on a major commitment of a sort quite different from what they had developed, and to do so against the wishes of the cofounder of Time Inc., Britton Hadden. In the statement Luce shows that he knows a market for his product exists: his perception of it, and his insatiable desire to sell something to it, are "gut instincts" constantly referred to in commercial ideology. The accuracy of his "instinct" is what gives his language its passion; it is what will be celebrated as he constructs a company which goes on from one publishing success to another—and rightly, because, at this conjuncture, this construction is his special creativity.

The parallels with Ford twenty years earlier are there, but they are general ones—the interest for this account lies in the differences. Where Ford Company transformed the processes and relations of material pro-

duction, Time Inc. changed the processes and relations of information distribution. Where Ford Company changed the nature of "business," constituting a certain definition of modernity, Time Inc.'s modernity was its reordering of the internal relations of information distribution, its packaging of this information in a new way. *Time* magazine itself stands for this. But with *Fortune*, as Luce's prospectus so eloquently shows, Time Inc. modernity aims a crucial, and quintessentially 1930s, step further: it sells modernized "business" a new set of representations of itself. And they are a set in which media representation itself, the level of signs itself, is substantial, constitutive, indeed material—not for the first time, but on an unprecedented scale, with staggering scope. Producing representations, and new relations of representation, becomes in the 1920s and 1930s the innovative edge, the central energy, the definitive modernity, the future hope. It reshapes "business," most obviously in advertising in general, but also "internally," through reflexive agencies such as *Fortune*. Of the lessons taught by advertising during this period, Schudson says rightly, "Where buying replaced making, then looking replaced doing as a key social action, reading signs replaced following orders as a crucial modern skill."[2]

How did Time Inc. modernize information distribution? Again, by simple moves of market perception and organizational reductiveness reminiscent of Ford Company modernity—although, of course, massively different in terms of scale:

> *Time* is a weekly news-magazine, aimed to serve the modern necessity of keeping people informed. . . . From virtually every magazine and newspaper of note in the world, *Time* collects all available information on subjects of importance and general interest. The essence of all this information is reduced to approximately 100 short articles none of which are over 400 words in length. Each of these articles will be found in its logical place in the magazine, according to a FIXED METHOD OF ARRANGEMENT which constitutes a complete ORGANIZATION of all the news.[3]

Originating no facts, researching very little, *Time* began as a metamagazine, retailing digested news (inevitably laced with news about news, news gathering, others' news). Its "fixed method of arrangement," so heavily stressed, was a kind of line organization of not production but *consumption*. Yet these could not be (for long) an equivalent of Ford Company's fixity with regard to singular, invariable models. From within its regularizing structure, *Time* writers developed a prose language, modern in its constant bordering on excess: a dynamic syntax, a varying social tone, an edge of mockery within a profound conviction of its own global seriousness and significance.[4]

Who were the consumers? Both Yale graduates from "good" families, Hadden and Luce targeted their own generation and part of that immediately preceding them, the 250,000 or less college graduates, primarily from the East Coast and the North industrial centers, "an elite group which he hoped would include the most important people and young men and women on the way up."[5] *Time* shared, and formed, the language of this elite as it took confident power during the boom of the 1920s. Its appeals for advertisers frequently took the form of self-congratulation. In the January 3, 1938, issue a Rockwell Kent deco-elongated Mercury holds a delicate mirror above the slogan: "In mankind's youth, the market place was the appointed spot both for the bartering of goods and the exchange of news. This natural relationship between the selling of goods and the telling of news continues today in the pages of TIME, *The Weekly Newsmagazine*." This is followed by five pages listing *Time*'s 780 advertisers and describing their targets as "TIME's seven thousand families—with their stability of business position, of income, of ways of life—constitute an unmatched market whose importance to Business increases in bad times when less fortunate markets suffer sudden contraction" (48–54). Memories of c. 1930 still haunt a text written under the threatening shadow of war in Europe. *Time*'s position during the Depression is bitterly characterized in Alfred Kazin's memory that "*Time* was always documenting some great and successful and unparalleled American career with a show of inside knowledge. You saw the great man on his living room sofa, with his dogs; you hear the nickname by which only his fellow ambassadors or corporation executives knew him."[6]

Kazin describes one-half of a double effect—the making almost common of remarkable men, the normalization of the exceptionally powerful. The other half concerns us at the moment—the fabulation of the world of U.S. business. But both effects constantly operate simultaneously: populism and elitism fold in and out of each other, as we saw in the case of Henry Ford. *Time* and *Fortune* extend this elision to a whole class.

In a speech of March 1929, when he first began to think about *Fortune*, Luce claimed: "Business is, essentially, our civilization; for it is the essential characteristic of our times. That which controls our lives and which is necessary for us to control is the science and technology and the development of credit and the circumnavigability of the globe—in short, modern business. Long since has business ceased to be a low and private and regrettably necessary affair to be escaped when possible. Business is our life."[7] Lamenting the failure of U.S. tycoons to acknowledge their historic, international, and local significance, he went on to claim that they could afford to do so no longer: "the significant change is the incipient public curiosity as to the model and objectives and pro-

cesses and personalities of industry and commerce and finance." In the early 1920s this "curiosity" might be construed as a benign interest in the doings of one's betters, like perusing *Country Life* at the dentist. Yet the Red Scare of 1919 might have unsettled business sufficiently to expose such confidence as rhetorical. By 1929 the 1920s boom was showing every indication of bursting, as seen by the rapid acceleration of business failures in that year. Are Luce's stirring words the brave voice of fear—workers' fears for their livelihood, capitalists' fears for profits and of insurrection? Yet *Time* was incorporated November 1922, and *Fortune* was launched, after a month's pause while the New York stock market crashed, in February 1930.

Taking Care of Business: Old Manners, New Ideas

"If, with the help of *Fortune*, you come to know yourself better, to take yourself more seriously, to project a confidence you might not quite feel, if you set your house in a certain recommended order, then you will survive the current crisis, prosperity will return, and you will regain control as the natural rulers." This is what Luce was promising; this is where he hoped to profit: capitalism feeding off its own misfortunes in order to strengthen itself. The curious "public" is not at all broad: the intended audience is the business community itself. And Luce was under no illusions as to the fictive unity of this "community." His class perspective is quite clear in his March 1929 appeal to put away prejudice against the "low," "private," "regrettably necessary," and in his February 1929 distinction between "the gentleman and the money-grubber, the responsible and irresponsible citizen."

Yet *Fortune* argues, and evidences, more than a mere raising of *tone*, an appeal for a superior moral and aesthetic culture among business leaders and their agents, their professional servants (although it does this in abundance, as I will show). It also bespeaks, recognizes, and actively proselytizes a new, importantly modern *type* of business practice. When Luce, in his climatic trope, cries out to industrialists to "yield to no other class," he means more than holding the line against a working mass stirring restlessly under the yoke, disturbed by portents of catastrophe (to continue in his rhetorical vein). He is calling for business to purge itself of practices which, however recently instituted, are holding back development. His call is to face contemporary realities, as analyzed and displayed in *Fortune*, to update procedures—in short, to *modernize* all operations. With the defeat of organized labor following the years of struggle since the 1870s and 1880s, the chief obstacle to business progress is *within*—it is reactionary corporate style.

Correcting two standard but false characterizations of *Fortune* opens

out the depth of this assumption that Luce and Hadden's generation will save U.S. business from itself, for itself. The magazine was not simply a belated product of 1920s boom confidence which received a surprising setback during the Depression, obliging a strategic pulling in of triumphing horns until the recovery of the later 1920s. This is to impose the conventional view of the trajectory of business itself onto that of the magazine. Rather, I argue that *Fortune* was born from the spasmic contradictions of the moment of the Depression itself, during which period its mode of address was anything but reticent. It was aggressive, ironic, rarely defensive, ambivalent. I argue farther on that its voice in the *later* 1930s was not that of a triumphal restoration; it is shot through with the uncertainties of a social formation developing beyond that envisaged at the moment we are now discussing. Thus the opposite of the conventional view is shown to be the case. Second, while *Fortune* staff researched stories often against the wishes of certain industrialists, while it exposed certain procedures to ridicule, reported some historic cases of malpractice (especially financial), and while it rarely used corporate-prepared publicity material without extensive rewriting, particularly by such brilliant liberals-become-radicals as Dwight MacDonald and Archibald MacLeish, its much-vaunted independence was a qualified one. Some earlier successes were figured as epochal; some founding fathers became swashbuckling. But the deepest passions were engaged in finding evidence of, and stating the case for, the gearing up toward the oligarchic corporate organization of all forms of capital—manufacturing, finance, retail, mercantile, and now, increasingly, service. Obviously, this was a gradual process, occurring at different rates within these sectors. In the United States in general, however, it was a movement forward as significant as the double shifts in finance and mass production twenty to thirty years earlier. It visibly accelerated in the later 1920s, taking its first dominant shape in the 1930s. In *Fortune* we can trace both an agency and an effect of this shift. By 1930 the slightly abstract complacency of principle in *Time*'s 1921 prospectus had become unrealistically quaint: "A respect for the old, particularly in manners. An interest in the new, particularly in ideas."

Nowhere is this clearer than in the "corporate story," *Fortune*'s outstanding innovation within journalistic genre and the mainstay of each issue. A history of a given corporation is interlaced with descriptions of its present situation, including its position within its industry and the economy of the United States (and the world, where relevant). Based on documentary research, visits to plants and/or offices, and interviews: hard facts, eyewitness accounts, peoples' voices. And laced with highly colored graphics and strong, refined black-and-white photographs.

How this form evolved around *Fortune*'s commitment to corporatism is strikingly illustrated by comparing the treatments of Henry Ford of Ford Motor Company and Alfred P. Sloan, Jr., of General Motors.

The lead story of the December 1933 issue was a mocking, annoyed, almost angry profile of President F. D. Roosevelt, under the title "What's to Become of Us?" and its parenthetical "(Only He Knows—And He Is Not Telling)." The lead corporate story, similarly, announced that Ford Motor Company was going to lose $20 million that year, yet "Mr. Ford Doesn't Care." Without explicitly saying so, the article placed the blame for such an unconscionable loss at the door of an anachronistic attitude. Henry Ford is depicted as the unquestioned power at the core of Ford Company, running the vast corporation in too down-home a fashion (absenting himself continually at the museum in Greenfield Village, "living in the past"), past his prime, yet refusing to hand on the seal to his natural heir, Edsel, and thus undermining him. Yet Edsel is also questionable for not taking the law of the father by force. Thus Ford's security enforcer Harry Bennett appears as "a likable man," of undeniable toughness, leaping into the fray against Communist agitators who are shot down at this side (132 and 126, respectively). Another aspect of Ford's anachronism is what is portrayed as his obsession with product rather than process: "it is doubtful whether Mr. Ford ever thought to himself, 'I will make a million automobiles a year.' What he thought was 'I will make—within certain cost limitations—the perfect automobile. As a result of its perfection maybe a million people a year will want copies of it. Which I will be happy to let them have'" (64). This clearly contradicts my earlier analysis in its opposing of the singular, made object to the perfected process. Yet just such a shift from one to the other was often held to distinguish the two phases of capitalism; indeed, we will see it offered as definitive of the differences between design in the 1920s and the 1930s.

Against the image of the old man still dreaming of the perfect car, coming alive only when he can physically tinker with the shaping of a machine part, the writer places the "hard facts" of economic analysis—Ford's production and profit figures over the decades, against those of competitors. They show Ford eclipsed by General Motors and Chrysler, but also as internally wounded by the persistence with the Model T, the recovery through the Model A from 1927, and the decline of the last few years. Is this decline reversible with old Henry hanging grimly onto the reins of power?

This argument, in just this tone of surface reportage but covert undermining, is also made in the visual images which accompany the story. Both text and photos follow the narrative device of a-day-in-the-life, a walk around the property with the boss. The feature opens with a full-

page photograph of a breakfast nook at Henry's office far from the heart of the Rouge plant. Around the table of this American interior sit Edsel and the other chief executives, sometimes for hours a day. Discussion of anything but Ford Company is forbidden, especially reference to more successful rivals. Russell C. Aitkens uses a hand-held Leica, in the style of Salomon's peephole candid snapshots of the famous, to build up a sense of the boss meandering through his day. Ford photographer George Ebling appears in a cameo with Bennett (126). Sheeler's influence is evident in the long shot of the storage bins taken from between shops (131), and in the one posed, heroizing portrait: Henry and Edsel stand casually looking at each other, titans filling the foreground before the elevated conveyors and the massive chimneys of the Rouge power plant—the relaxed but conventional business portrait inserted in front of Sheeler's Museum of Modern Art mural of the year before. Ostensibly an orthodox celebration, there is a level on which the definitional gap between foreground and background, and the lesser lighting of the sub-servient Edsel, undermines the power surfaces (69).

Other potential scenes, sources of rich visual imagery, are treated in

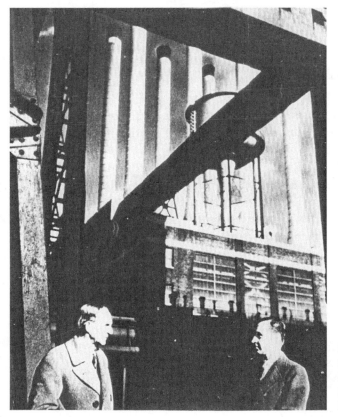

5.1 Henry and Edsel Ford at the Rouge, in *Fortune*, December 1933, p. 69. (Aikens for *Fortune* Magazine; Time Inc., New York)

small pictures late in the magazine or are confined to the text. "The workmen of the Rouge are so much less important than the machines they tend that the contrast is extremely depressing" (122), but only to the eyewitness observer; Ford is quickly praised as no "harder on his labor than are other automobile makers" (122), and photographs show at least some workers looking happy enough. Unemployment in hard times is treated as natural to the "technique of mass production" (124). There are also very few images of cars, only occasional glimpses of parts of them. Does this indicate a tacit reaction to Ford's refusal to advertise in *Fortune* either Ford Company itself or its luxury range? Ford had only appeared as a passing reference in previous issues of *Fortune*—too obvious, or the wrong business model?

But perhaps the most striking absence among the visual imagery is the River Rouge plant in operation. Ironically, a bowel-of-the-earth image of a furnace in expressionist scarlet appears in an advertisement for Republic Steel part way through the story. However, the famous progress from the boats arriving at the specially cut basin, through the huge storage pits to the blast furnaces, the foundry, then on through the machining and assembly processes is detailed in the text in terms uncannily close to Rivera's organization of the stages in his two main panels (122). Rivera's murals in the Cortez Palace for former J. P. Morgan partner and then U.S. ambassador to Mexico Dwight Morrow were given a one-page illustration in the January 1931 issue. Six pages of full color were devoted to the Detroit Institute of Art murals in the February 1933 issue (48–53), featuring full-page images of the top corner panels, with knowing commentary on Rivera's barbs at war research and at the commercialized chemist. Yet his Communism is declared disavowed, and the article does not show the main panels; rather, he is photographed, in black and white, just beginning work on them. They were, indeed, not finished until March 1933, yet neither they nor the Rockefeller vandalism were ever to appear in *Fortune* (despite its otherwise detailed reporting on Rockefeller Center). It should be noted, however, that Rivera had been called upon to do a front cover for the March 1932 issue on the Soviet Union; he produced a brilliantly cryptic sea of cloth caps carrying red flags and floats through Red Square during the May Day parade.[8]

The written description of the plant in operation is a fine evocation, concluding with the following:

> The Rouge is the Industrial Revolution and the Factory System and the Machine Age all compactly assembled into one neat parcel which is, to all practical purposes, the work and property of one man. This is the last and final fillip to the sensation of viewing the River Rouge—that it was created by and belongs to this curious, quiet gentleman who walks be-

side you. True, Mr. Ford says that the Rouge is so big that it is no fun any more. He spends most of his time at the Engineering Laboratory, which is about four miles deeper into Dearborn. But the Rouge remains a universe, and you can go look and shake hands with its creator. (122)

Such monotheism—awe before the wondrous works of an idle god—does not prevail in the new corporation. Early in the April 1930 issue, McCann sought advertisers with the bold slogan "FASCISTI ALL!" and the bundle of sticks and axes, pointing out the relevance of the motto "Strength in Union" (4). In the lead story, necessary business individualism was channeled by the heading "A Panel of G.M. Executives" and the division of the pages into vertical boxes featuring a portrait photograph topping a career profile which precisely identified the contribution of each manager to the corporation, as well as their salaries and what they made from the shares held among the hundred top management of the company. "G.M. is not greased to the Napoleonic individualism of Fox Film[9] or Ford Motor"; rather, the individually strong heads of each of the brilliantly conceived divisions of G.M. are kept in productive balance by the ideal new manager, Alfred P. Sloan, Jr., whose greatest skill—"genius"—is this kind of manipulation.

Yet if we examine the writers' interpretive moves, we see quickly a fundamental problem in the *Fortune* program at least at this early stage: beyond the facts and figures, beyond the efficient paring down of processes already in place, beyond the excitement of the interlocking networks of one rationalized industry servicing another, beyond these delights of the search for content, there seems to occur a stripping away, an elusiveness of that very content. Either *Fortune's* dream of the new corporatism, so readily eloquent in the Luce proposal and speech of 1929, is being overwhelmed by the all-too-human managers it seeks to celebrate or the writers' language is inadequate to the task of getting down to the unique novelty of these men:

> Someone has remarked that the gods of the ancients were "men writ large." The deities of modern industry are men geared high. They do not necessarily possess outstanding qualities of abstract mentality. But they do have ambition where the ordinary man has a discontent; the dominate their jobs where the ordinary man is dominated by a small job; they have confidence that they are moving up where the ordinary man has an apprehension that he may be moving out. It is not so much that they are bigger wheels as it is they rotate so much more rapidly. (64)

Hollow repetitions defeat the urge to fabulation. But the urge is there, and it produces some spectacularly inept prose during *Fortune's* early

"Advertising"... *says* FRANCIS H. SISSON

"is perhaps the Greatest Agency of Natural Selection in the Business World" . . .

FRANCIS H. SISSON
*President of the Guaranty
Trust Company of New York*

"It accelerates the process whereby the world's productive activity is becoming centralized in the hands of those who are best equipped to carry it on."

IN this statement Mr. Sisson points out with admirable clarity the rôle of advertising in the modern economic process.

Production facilities today are wonderfully efficient, but adequate and suitable markets are needed before the most effective organization of production can be achieved.

It is the function of good advertising service to locate and develop these necessary markets on the scale which modern industry requires, and with a selectivity which keeps costs at a minimum.

Many manufacturers, through the use of such services, maintain an active demand for their products — and keep in a position to profit by the economies of large-scale production and concentrated control.

In the cultivation of markets essential to this achievement, the J. Walter Thompson Company has successfully served many of the leading enterprises of this country, helping to work out practical market strategy based upon accurate research and wide advertising experience.

Two folders, entitled "Selling at Home" and "Selling Abroad," have been prepared briefly to show the scope of the services of the J. Walter Thompson Company.

Either or both of these folders will be sent to executives interested. Write to the New York Office and copies will be forwarded promptly.

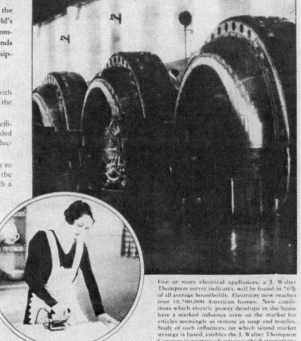

Five or more electrical appliances, a J. Walter Thompson survey indicates, will be found in 76% of all average households. Electricity now reaches over 19,700,000 American homes. New conditions which electric power develops in the home have a marked influence even on the market for articles seemingly as remote as soap and textiles. Study of such influences, on which sound market strategy is based, enables the J. Walter Thompson Company to prepare advertising which strengthens the position of its clients in their many markets.

J. Walter Thompson Company

New York • Graybar Building • 420 Lexington Avenue

Chicago, Boston, Cincinnati, San Francisco, Los Angeles • Montreal, Canada • London, Paris, Madrid, Berlin, Stockholm, Copenhagen, Antwerp, Warsaw • Alexandria, Egypt; Port Elizabeth, South Africa • Buenos Aires, Argentina; São Paulo, Brazil • Bombay, India • Sydney, Australia • Batavia, Java

5.2 J. Walter Thompson advertisement, in *Fortune*, June 1930, p. 117. (Time Inc., New York)

years. The above is followed by reference to their "fundamental simplicity": the Fisher brothers visit their old mother daily. In March 1930 the singularly dull A. R. Erskine, general manager of Studebaker, is heralded as "a strange but significantly modern phenomenon. The Great Age of Business begins to resemble the Great Age of Government— nineteenth century England" (104). Disraeli is evoked in a desperate attempt to deify this accountant! An updated Social Darwinism is implicit in the *Fortune* program. It is made explicit in statements such as Francis H. Sissons's testimony for J. Walter Thompson: "Advertising is perhaps the greatest agency of selection in the business world. It accelerates the process whereby the world's productive activity is becoming centralized in the hands of those who are best equipped to carry it on" (*Fortune*, June 1930, 117, analyzed further below). But at the same time, it is haunted by the possibility of failure, by the fear that capitalism might not survive the crisis of its own (or, at least, finance capital's) making, the eroding doubts that the new corporatism might not be strong enough to save capitalism as a whole. *Fortune* boldly fronts this nemesis, draws energy from the battle, yet the doubt remains (and grows during the New Deal period).

The Undisputed Most Beautiful

Fortune quickly became a leading "house journal" of the new corporatism (with the other Time Inc. publications, it led its field). But it is also a key example of a relatively new communicative form, one which was changing word/image relationships in significant ways, structuring the iconology of modern America. Having set out something of the magazine's perspectives, its immediate audience, and its difficulties, I now treat it primarily as an agency for organizing various prevailing discourses— particularly those of advertising, documentary, and design—into a configuration aimed at serving the new corporatism.

Taking the first issue as an unresolved repository of various inputs, of various possibilities for a magazine of this type, the extravagance of the format itself is most immediately striking. Indeed, it overwhelmed many (see excerpts from editorials, April 1930 issue, 137) by its fundamental category shift: use of the expensive style of an art publication—less magazines than folios of images and information around a theme (gentlemen's fine printing)—for a content entirely commercial. This was not a matter of "modern design" (as yet not clearly formed), it was unequivocally "art into industry," and Beaux Arts at that. Designed by artist-typographer Thomas M. Cleland, the 11¼-by-14-inch, 184-page book featured hand-sewn board covers, heavy paper, line printing, and color processing. The Baskerville type signaled elegance without archaism. It was an *as-*

sembled magazine, paralleling in all respects the production of the Model A. The cover drawing of the Wheel of Fortune showed the allegorical female, opening cornucopia before a busy, sixteenth-century port. Historical and historicist—the beginnings of capitalism, showing *our* history, our ancientness. This and the one-dollar cover price are the aesthetic and marketing equivalents of the class moves referred to earlier.

The advertisements filling the first fifty pages were almost entirely for luxury products (cars, holidays) or company promotions. Stylistically, Beaux Arts typography supported Post-Impressionist, even sometimes Fauvist color and brushing, although many major companies opted for the old-fashioned watercolor gem (Goodyear, 42–43; Packard, 52). Dissonant notes were struck by Bryant Gas Heating's protesting-too-much at the threat to profits and to the general well-being of energy oligarchies, so the company created a popular clamor with slogans such as "Down with the Gas Barons!" And Empire Bolts-Nuts-Rivets created the image of a gargantuan worker, muscles rippling as he pulls at the wrench tightening the nut screwing down the entire top of a New York skyscraper (27 and 37, respectively). In later issues, Bryant dropped its attempt to co-opt popular agitation in favor of cool picturings of its redesigned stoves, and the heroic worker fades away in favor of dramatically lit, high-contrast close-ups of stacks of bolts, nuts, and rivets. Some modernistic advertisements appear: the stacked and stripped silver lines of Alcoa office furniture (122), the Futurist explosion of lines on the speeding Marmon Big Eight (183, inside back cover).

Gradually, *Fortune* advertisements in the early issues settle into a range that extends from the old-fashioned through the Moderne to the modernistic, with the more expensive ads tending toward the old-fashioned and the majority toward the Moderne medium. Classics of the first type were William F. Wholey Company's efforts to deluge the personal offices of the top executives with massively elaborated turned wood and chintz under the aesthetic principle of "appropriateness," of fitting the taste of the client—an earlier, but nonetheless modern, flexibility which we noted in the Detroit practice of Albert Kahn. "Appropriateness" is the key copy word in Wholey's March 1930 advertisement (151); the effectiveness of such overdecoration for the personal spaces of the new tycoons, imitating the cultural bankruptcy of their predecessors, was demonstrated in a later feature on various leading businessmen's offices. At home, Crane offered modern plumbing, heavy fixtures but in new, bright colors—a calculated compromise typical of Henry Dreyfuss's design ethic (see ch. 10).

Beyond this personal culture of the rich, modernity found more purchase, particularly in the design of standardized office furniture and equipment, and in the presentation of certain of the relatively few ad-

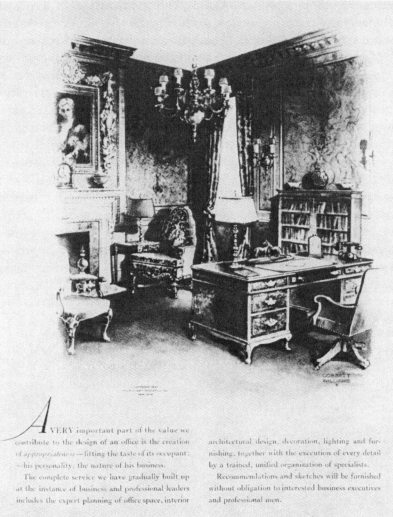

A VERY important part of the value we contribute to the design of an office is the creation of *appropriateness* — fitting the taste of its occupant — his personality, the nature of his business.

The complete service we have gradually built up at the instance of business and professional leaders includes the expert planning of office space, interior architectural design, decoration, lighting and furnishing, together with the execution of every detail by a trained, unified organization of specialists.

Recommendations and sketches will be furnished without obligation to interested business executives and professional men.

The William F. Wholey Co. Inc. [Equipment Specialists] 11 East 36 St. New York

5.3 Advertisement for William F. Wholey Co. Inc. office fittings, in *Fortune*, March 1930, p. 151. (Time Inc., New York)

vertisements for manufactured products. White Trucking persistently featured its services in bold color reversals (against white). Mostly, however, nonpersonal advertisements were directed at the imagery of office and factory organization, the nitty-gritty of the new corporatism. But, again, the odd abstraction prevails. Two striking early instances open campaigns which persist for years by these advertisers. Remington Rand typically took a double-page spread which opposed a large photograph of a businessman caught by some exaggerated disaster (robbery, fire, flood, accident) to an equally large stack of office equipment which

triumphed, restoring order and clarity. The text trumpeted, accurately, "a business force, never before available. . . . The best informed men in America on creating, filing and protecting the control records of business" (April 1930, 124–25). The Austin Company, Cleveland, engineers and builders second only to Kahn Associates in industrial construction, ran a similar campaign in which they sold the coordinated modernity of their own office organization in advertisements featuring sharp black-and-white woodblocks of a metropolis arising from Rouge-type power plants, but the company failed to mention that their material service was building factories! Their advertisement in the March 1930 issue is a classic: "Nineteen-Thirty, modernization year in industry" (101). The iconography of Modern America begins to converge here: industry becomes the basis of the vertical city; the Rouge plant supports the soaring growth of New York. This tame metropolis excludes the countryside as readily as it does the worker (who exists only as a contractual problem in the copy) and even the consumer. Business talks to business here. It is its own producer and consumer; it produces organizational forms to consume itself. Ford Company modernity spreads to the construction of business itself.

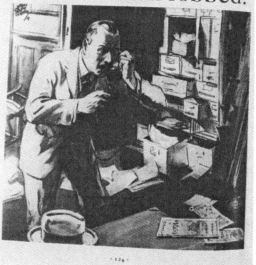

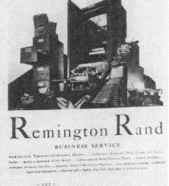

5.4 Advertisement for Remington Rand business service, in *Fortune*, April 1930, pp. 124–25. (Published with permission, Unisys Corporation)

NINETEEN N-THIRTY

modernization year in industry

Mighty buildings rear their heads into the clouds . . . sturdy ships of the air drone away to distant ports . . . new products appear overnight on counters and in sales-rooms everywhere.

It is a dramatic age in which industry plays a lead role, for back of all the romantic pageant are the wheels that must turn, ever faster, to set the pace of progress.

And so, *1930—Modernization Year in Industry*, marks a New Era in the design and construction of the Nation's plants . . . an Era in which Austin will be called upon to accomplish still greater achievements in producing plants to supply modern demands.

Austin's nation-wide organization is busy from Coast to Coast . . . designing and building a number of modern plants that herald the New Era in American Industry.

Executives in practically every field of business will find Austin literature, which deals with fundamentals as well as specific building problems, helpful. Wire, phone or write the nearest Austin office for the literature and approximate costs on any project you may be planning.

THE AUSTIN COMPANY

ENGINEERS AND BUILDERS · · · CLEVELAND

THE AUSTIN METHOD OF UNDIVIDED RESPONSIBILITY
Design, construction and building equipment . . . separate responsibilities ordinarily . . . become one unified responsibility under The Austin Method. One organization handles the complete project under one contract which guarantees in advance, total cost, time of completion with bonus and penalty clause if desired; and quality of materials and workmanship.

THE AUSTIN METHOD

New York Chicago Philadelphia Newark Detroit Cincinnati
Pittsburgh St. Louis Seattle Portland Phoenix
The Austin Company of California Ltd.: Los Angeles, Oakland and San Francisco
The Austin Company of Texas: Dallas The Austin Company of Canada, Limited

5.5 Austin Company advertisement, in *Fortune*, March 1930, p. 101. (Courtesy of the Austin Company, consultants, designers, engineers, and constructors)

In such cases, the imagery of modernity—the icons and the visual style of the American Modern—becomes unequivocally, plainly, and directly the imagery of the new corporatism, of the type of "business force, never before available." The administrative, the organizational, the managerial, the pressing logistics become the most significant activities of capital—or, at least, are seen to be the areas of most flexibility, and thus expansion, and thus profits. Such a clear matching of imagery and ideology is constant in the texts, frequent in the illustratory imagery and in the advertisements, but it does not dominate the latter. Its varying fortunes are significant.

Throughout the 1930s a broader process is occurring on this level, one which mobilizes the range of imagery from old-fashioned to modernistic, a process of *legitimation*. In itself, this is of course not at all new: it has been in action ever since the powerful sought to reproduce their subjects' subservience through symbolic, rather than overtly coercive, means. Nor is mobilizing the range of present imagery, rather than deciding among it, new. Such a looseness with regard to matching styles of imaged and social power was typical of nineteenth-century capitalism. What is so different here from the coexistence of heavy high Victorian mansions and the light precision of Crystal Palace factory architecture? Very little, except that as well as the old-fashioned residually aristocratic imagery blessing the new rulers, modern design does also—both in the modernistic updating the personal culture of the rich (the Marmon car, for example—Haddon and Luce's preference and a casualty of the oligarchies)[10] and in its dispersion through the broader visual culture. It is this dispersal that I am seeking to decipher—its very "naturalness," "inevitability," its gradual normalization, needs explanation.

But this democratization of modern seeing is precisely *not* evident on the pages of the early *Fortune*. Its readership was even more exclusive than that of *Time*: it consisted of those who could at least dream of a $10,000 custom-built Pierce Arrow, and buy one for between $2,595 and $6,250 (February 1930, 10–11), who could identify with the feature "A Budget for a $25,000 Income in Chicago" (116) or $50,000 a year in New York (April 1930, 104). Gatsby is evoked here—his patiently acquired style of living, his absent, elusive business, and the devastated ash-heap wasteland through which his domain was approached. The "general effect" of modernity is being organized by this class as a necessity not for its members but for the "new" class of consumers, the "mass markets" required by modernized economies of scale, rationalization of production and distribution, by the thrusting urge to monopolization which so fascinates the writers of *Fortune*. For this ruling class, all styles are radically provisional; none are necessities so long as they serve their legiti-

mizing purposes. Note the desires at work in an advertisement for the new Waldorf Hotel: "Citadel of the gracious art of modern living," its "old-fashioned" credentials established by its earlier history, its interior fittings, and its hierarchical social organization ("citadel," "gracious," "art"). Modernity is reached for by describing not its incorporation of the New York subway system into its basement, nor its ultraradical planning in the behind-the-scenes provision of services, but its architectural style: "twin towers of grey, whose chaste simplicity reflect harmoniously the vibrant spirit of our times" (April 1931, 155). But few of the advertisements in *Fortune* in these early years blended styles: Regency, Contemporary, and Futuristic appeared on different pages, giving a sense of lively competition within the same, heterogeneous world. In a parallel way, most of the advertisements retained internal structural distinctions, usually with some decorum: relations between copy and image were mostly straightforwardly illustrative, mutually reinforcing. Overall, design works in these advertisements as a *regulating ensemble*.

The "mass market" consumer appears in *Fortune* only as a victim. The twinned images of the stylized product and the domestic consumer were becoming common in publications with wider audiences, and, later in the decade, they merged into a couplet which still structures most advertisements as well as vast amounts of other public images. The broad basis for this observation has been put forward by Stuart Ewen in *Captains of Consciousness*.[11] I accept his analysis of the importance of advertising to modernization in the 1920s, the first efforts to create a consumer culture in reaction to the political threat to the ruling classes of workers protesting the degradation of labor under monopoly capitalist reorganization as well as in reaction to the need for a mass market to absorb the overabundance of mass production. His emphasis on everyday life as the site of this transformation is correct: work, the home, dreaming, the structures of consciousness were manipulated to create a new set of values. They located the release from labor and a disfiguring environment in the act of purchase, in the promise of excitement and gratification in the having (rather than the using) of a commodity. They disrupted the family by downgrading the father and by elevating youth, by releasing uncontainable sexual energies while promising to restore order through the mother's domestic consumption. They mechanized agricultural production, accelerating the internal migrations toward the chaotic cities, while promoting Americanization and modernization as the twin pillars of a new citizenship, a utopia of obedience. The consumer culture developed in fear of, and in contradiction to, the destructiveness of anticapitalist rebellion, on the one hand, and the persistent, microscale resistance of self-definition, self-help, nuclear and neighborhood productivity on the

other. This fraught mass culture was envisioned in the 1920s, was deferred by the 1930s Depression and World War II, then realized in the 1950s and 1960s as a normality, before disintegrating again in the 1970s.

My analysis supports, in a general way, this outline and this history. Ewan's approach is, however, somewhat reductive; it simplifies *agency* (ignoring entrenched capital, for example, as a reactionary force) and the nonsymbolic *modes* through which social power was organized. As well, in terms of historical patterning, I would emphasize the mid-1930s because I attribute more importance as a social generator to the corporate-state sector than to consumer culture, which I see more as a constellation of key agencies and effects of this social formation, but not its principal organization form. The 1920s dream of control over consumption had to fail—as did the later 1930s dream of control through modernist utopianism—because, I believe, such failure of the extreme was essential to the success of the compromise, of the institution of the ordinary.

There is, in much advertising's address to its readers during the 1920s, an implicit invitation to complicity, to share in the sense that this particular statement, this type of imagery, is exaggeration. Truth is not the point: sharing the illusion is the name of the game. But this is layered, depending on which sector of the market is being aimed at. As we have seen, *Fortune* advertisements showing product and consumer assumed an ease of ownership markedly contrasting to advertisements directed at a broader market. There, the new car typically thrust forward into space, carrying the exited family with it as they show it off. This motif, too, had a recent history. The class conflict implicit in it was the basis of Norman Rockwell's famous *Saturday Evening Post* cover of July 31, 1920, "Excuse My Dust!" in which a thrilled, cheeky family in a Model T overtakes an anonymous expensive car. Rockwell's technical brilliance resided in his use of freeze-frame cropping and exaggerated photographic mimeticism.[12] In a flourish of democratic rhetoric, the manic, gee-whiz driver suddenly achieves the improbable. But all readers recognize that it is a metaphor of Ford Company production and sales successes. Causing the reader to chuckle at this is the measure of Rockwell's success—and of the harmlessness of a dream of momentary resistance. The people gesture defiantly, delightedly, but foolishly; they need modern business, even for their dreams of freedom.

The middle- and lower middle-class consumer—for Ewen shows that the consumer society at most reached down only this far in the 1920s and 1930s, although it was a dream factory for many more—appears in *Fortune* as the targets of those who can afford the culture offered in the luxury goods advertisements, who control the business which Remington and others will help modernize. Especially, the consumer appears as

a figure in advertisements by advertising agencies, namely, the J. Walter Thompson advertisements of June 1930, in which the unmitigated Social Darwinism of Sissons joins with a close-up of huge electric turbines to dominate utterly the housewife innocently ironing, the encircled object of this raw, "natural" energy (177). By inserting commodities between the housewife and the turbines, Thompson helps position the new corporations in the appropriate markets (note the copy's language of big scale and control). The advertisement legitimizes new corporatist barbarism as a natural order; it modernizes it through the electrical imagery and Thompson's managerial scientism, and it reinforces corporate patriarchy by the positioning of Sissons and the housewife victim. In Ewen's words, "Corporate America had begun to define itself as *the father of us all*."[13]

Consumer culture is further examined during the discussion of design and modernity. In this domain of "business persuades business," *Fortune* displays certain further relationships of some interest, rarely brought out in analyses of advertising, particularly those to do with art.

Ars Brevis, Advertising Longa

Art enters *Fortune* in a variety of ways, from exaggerated independence to abject dependence, until a different kind of artwork becomes a normality. The variety can be collected under different usages, and these arranged on a scale, as follows.

Art as a sign of high culture and taste is signaled in full-color reproductions of works in the collections of the European business or hereditary aristocracy, or in works bought for the American public museums (usually with business endowment). Works of art in the collections of American businessmen (for example, Mellon) are actually rather rare. Hemingway on bullfights, illustrations by Goya, are also a rare sort of feature (March 1930, 83 ff.). Occasional features on American artists, in which they are celebrated for their independent perception, occur, but invariably the artists' interest is in picturing industry. A classic example is the March 1931 issue of *Fortune* in which more than one full-page image plus quotation is given to Sheeler. *American Landscape* is printed in color above that artist's approving remarks about Ford's "benevolent dictatorship." This is to be expected in a business magazine, but the strongest recognition of independence is given to artists who have it least, who consent most directly to the *Fortune* program. In the famous "This Is The U.S.A." special issue of February 1940, the final image in the art-illustrated survey of U.S. *history* (not culture) is, as we have seen, Sheeler's *City Interior* (1936), also with an approving caption about the

Ford Company. It is argued in part 4 of this volume that Sheeler's *Power* series (1939–40) is absorbed into this perspective.

Art is also evoked in the frequent reproduction of examples of highly skilled craftwork, usually in either business or royal collections, or recently created fine work (for example, Paul Manship's glass sculpture, bronze doors). Are these prominent because they are a more reliable, possessable, and reproducible indicator of civilized taste—one which shades more readily to the less civilized? Thus, perhaps, the feature on Hearst at San Simeon (May 1931, 56–68).

Thirdly, paintings are frequently used as illustrations to corporate stories and economic reports, thus giving the magazine a cultured look. This also increases the pleasure of reading and uses the color-printing processes efficiently. Yet the images have usually a rather general relation to the texts compared to the photographs, maps, and diagrams. A feature on the wine industry of Europe and the United States is illustrated by a Fauvist landscape by Emanuel Bénézit (May 1930, 50); Burchfield's *The Promenade*, owned by A. Conger Goodyear, is used to "record the American scene which is passing" (77f.); Thomas Hart Benton images drowsy black farm workers in a story on cotton (June 1930, 74f.); a Hopper lighthouse appears in a feature on electricity (June 1931, 53). The double drama of regret for a past banished by modernity and the need to nationalize modernity is constantly played out in the choice of artworks. The influence of the Museum of Modern Art on the culture of this class can be traced with some precision in these choices. They are a key indicator of its development.

Another artistic category was art directly applied to picturing businessmen. The *Time* cover portrait was well established; *Fortune's* portrait in each issue was usually the head of the corporation featured in the lead corporate story. British painter Sir William Orpen came over to accept commissions at $15,000 each, painting Mellon, Baker, Davidson, Atterbury, Kahn, Dr. Grace, General T. Coleman Du Pont. The caption to his portrait of Rufus L. Patterson, modernizer of cigar manufacture, in the June 1930 issue reads: "Of his American sitters he says they are the most model understanding sitters I have ever had. . . . It really is remarkable the wide range of subjects the average businessman can discuss with knowledge" (59).

More frequently the style of portraiture was a dynamic symmetry bust, a very mild Cubism, but clearly modern. This sort of work begins to cross to advertising artwork—a volatile borderline at the period, with many artists making their living doing advertising work, and with a reverse movement constantly going on. For example, in Chicago, Frank Hinder; in Melbourne and Sydney, Nutter Buzacott, Hera

Roberts, Adrian Feint, Thea Proctor; in New York, Steichen and Sheeler in photography. The commercial activities of these artists raises a further question: does the artwork in advertising evolve into a distinct, modern aesthetic at this time?

Works of art are sometimes cited in advertisements, either to indicate an expensive ambience or to initiate the visual idea of the advertisement. Often, in the color ones especially, company logo or product will be floated within the white space, separated from copy, so it can become a "picture," evoking a watercolor or an engraving and is often very finely done. More "modern" and "modernistic" agencies frequently set the logo or product in dramatic opposition to a highly colored, bursting background—the Firestone tiger in a Fauvist jungle, Lindberg flying a Lockheed over a Post-Impressionist Grand Canyon. It usually takes some time, however, before the artists conquer the technicalities of color printing to achieve the subtleties already achieved in poster making.

Nonetheless, new aesthetics are suggested by the possibilities of color printing during these years. This is also true in the photography, particularly that used in advertisements. Certain preferences in lighting, cropping, montaging, and airbrushing develop from individual mannerisms, from agency look to a widely shared style. For example, airbrushing photographic negatives produced a range of effects, from the sensuous, abstracted "glamor" shot, through which stars were manufactured in Hollywood,[14] to the homogenization of consumer and product in magazine advertisements. The merging of housewife and washing machine, of office girl and filing cabinets, as if both were made of the same substance, becomes one of classic indicators of modernity itself. The highly commercial value of newness as such ("brand new," so new you can see the brand) was signaled unmistakably by the passages within the image between the tactility of treated machine casing and the metallic sheen of bright flesh. At first confined to black-and-white photography, these effects spread to monochrome (grays, greens), then were gradually incorporated into color reproduction. It was not only these changes in the photographic image and its reproduction that marked the moment, but their relationship to the headlines, logos, and text of advertisements. These seem to vary from the tendency toward integration of tone, color value, and mode in the more expensive advertisements to the greater volatility, even clash of elements which tended to rule in advertisements for larger market goods and in publications with less specialized readerships. But these observations as to audience address remain subject to detailed testing. Can we conjecture that the art of advertising design, which had been developing its own conventions for decades, now goes beyond the use of artworks within adver-

tisements, beyond the application of visual ideas from the other arts to advertising, to the point where it actively develops an aesthetic drawn largely from its own purposive and technical constraints?

Such a degree of self-determination seems evident in "high-class" advertising in the 1920s, ostentatiously in Art Deco and modernistic styles. In the mid-1930s, however, it would have been reinvigorated by the urge to consensus, and spread through the popularizing thrusts of the moment. It would also be conditioned, in advertising related to the industries of mass production, by the decimation of smaller producers during the 1920s and the Depression. Did this cut down the variety within the same market range—in car advertisements, for example? Some claim the contrary, pointing to the eminence of designers such as Cassandre and E. McKnight Kauffer in the early 1930s in contrast to the typically overloaded mass circulation advertisement of the late 1930s, replete with selling points, mixed media, and abrupt shifts of typeface.[15] But the differences here reflect the class directedness of the advertisements, and I would guess that a study of a larger number of examples would probably reveal the power of regulation to limit certain sorts of variety while manufacturing others.

Another major conditioning factor is that, by the mid-1930s, advertisements designed primarily by an individual artist were becoming rare enough in the United States to be remarkable, exceptional, and expensive. A high degree of specialization in each phase, from market research to artwork, had become common in the 1920s with the application of scientific management principles in this field, too. J. Walter Thompson, for example, would doubtless display a history not dissimilar in structure to that of Kahn Associates. Small wonder, then, that the standard format advertisement, produced by experts divided as to technique and place within the production process, became the rule. But while we might expect this organization of production to limit the inventive and innovative scope of the advertisements, it would contradict their market-expanding purpose if it also produced an overall effect of sameness. On the contrary, the structural principle of superficial diversity effected by a reductive underlying order appears again. Yet, too, it is not a static one: it is a regulating system precisely in its constant establishment, then destabilizing, of points of definition. Advertising in the United States in the 1930s becomes, perhaps, one of the clearest cases of this system at work.[16]

Can we accurately say that advertising art achieved a distinct form, one shaped "naturally" by its functional obligations and technical limits, at this boom time for the practice itself (accelerated by the need to "move" accumulated production during the Depression, and then lead-

ing the "Recovery"—it is, of course, the imagery of Recovery that we are focusing on here)? This would be to privilege modernity of style as "natural," to accept at face-value its implied claims for functionality. Entailed here is a question in the history of modern art, and of modernism: What are the implications for our understanding their art of the fact that many modern artists of the period were professional advertising artists? Sheeler's positioning has been explored, but generalization is difficult in this scarcely studied area.

The main point is that the accelerating thrust toward market expansion in the 1920s and 1930s crossed the boundaries of class and region which largely shaped advertising until then, despite the inroads of catalog sales, chain stores, and time payment. Specialization of labor was well entrenched, in the form of craft skills specific to different technical processes. But there was also a hierarchy of creativity within the industry tied to degrees of design independence. By 1900 at least three figures appear: the professional artist commissioned to supply imagery, which was then processed into reproducible form by others; the commercial artist, working professionally for an agency, commanding a variety of skills in preparing artwork of his or her own design for reproduction; and the copy artist specializing in particular kinds of rendering or treatment of artwork, screens, negatives, and so on. These divisions reflect something of the practices which converged to produce advertising art as itself distinct. They vary greatly as to time and place—thus these 1918 remarks by an Australian artist employed within a studio specializing in luxury publications: "It is the versatility of the Australian commercial artist which has impressed the American specialist. Most of us are thankful we do not spend our time putting in heads and hands on fashion catalogue figures, or in airbrushing drawings of machinery."[17] The modernizing of advertising on the mass-production, scientific management model in the 1920s, however, began to fulfill these fears. The opening up of mass markets, and the capacity of newspapers to print half-tone photographs, greatly increased the quantity of copy artists, while the vitality of modernism in the subcultures of the rich, and selected waves of fashion, drew in many professional artists who had come to work in a modern manner. In the later 1920s, the efforts of key producers to move up-market—such as the Model A campaign, and much of the flood of fictive depiction of upper-class life which appeared in advertisements and films during the Depression years—boosted this hierarchized division of labor.

These distinctions persisted during the 1930s, but a standardization of the design of advertisements and of the organization of the profession seemed to proceed apace. Commercial artists became specialist copy art-

ists, or primarily assemblers of the work of others. Professional artists increasingly experienced a divorce between the relationships obtaining within their commercial and private work. Specifically, their agency work was subject to drastic transformation to fit standardized formats (for example, the montaging of photographs, color changing of wash drawings). The 1920s possibility of professional artists with an independent self-conception working full time as commercial artists for an agency which valorized their conception was roughly displaced during the 1930s in all but "quality" agencies. This possibility had been an important basis not only for the spreading of modernist imagery but, in view of the number of artists working this way, arguably, for its creation. The centrality of the Smith and Julius studio in Sydney in the 1920s has been pointed out, but this kind of connection has been rarely studied elsewhere.[18] The accounts of Sheeler at Ford, of the subsequent use of his imagery there, and of his continuing role in supplying elaborations of its connotive force are intended to plot the movement from the 1920s possibility through to the tensions and divorces in the 1930s art-advertising relationship. But it remains only one case, however suggestive it might be. Margaret Bourke-White's tie to *Fortune* and then to *Life* made her more directly effective and widely influential.

In a magazine such a *Fortune,* art had to be distinguished from advertising because the class being addressed valued art as a domain for transcendent experience, for the exercise of a disinterested taste, for the recognitions of skills deployed independent of the exigencies of the domains in which they worked and made their money. Thus we have the usages noted above—features on collections, examples of outstanding craftwork, and illustrations to corporate stories. Yet even these show a constant tendency to point toward the "business culture" being developed. And in the design of advertisements, the reach toward the visual culture of the class is also imperative, given the advertiser's desire to sell to these people. Modern artists had a double role here: not only to modernize the subculture of the rich through updating its tokens of taste (paintings, sculpture, architecture) but also to modernize the advertising directed at them. Thus the continuities across a variety of signifying practices, between image makers and certain consumers.

It was perhaps this relationship which led Meyer Schapiro, in a talk to the first American Artists' Congress (1936), to assert: "The content of the great body of art today, which appears to be unconcerned with content, may be described as follows . . . elements drawn from the professional surroundings and activity of the artist; situations in which we are consumers and spectators; objects which we confront intimately, but passively or accidentally, or manipulate idly and in isolation—these are the typical subjects of modern painting. They recur with surprising regu-

larity in contemporary art." This kind of treatment, he adds, excludes much—especially it eliminates the "world of action." He is rejecting the modernist assumption that these subjects are incidental, arbitrary, irrelevant to the real concern with formal innovation and self-expression. At this point he refuses the capacity of some of these formal innovations to powerfully either disrupt or reinforce expected readings.[19]

Schapiro goes on to explicitly stress the class connections, the transpositions being argued here. Speaking of the *"rentier* leisure class in modern capitalist society," he argues: "A woman of this class is essentially an artist, like the painter whom she might patronize. Her daily life is filled with esthetic choices; she buys clothes, ornaments, furniture, house decorations; she is constantly rearranging herself as an esthetic object. Her judgements are esthetically 'pure' and 'abstract,' for she matches colors with colors, lines with lines. But she is also attentive to the effect of these choices on her unique personality."[20] Relationships become a formal matter of interaction between separated, isolated things. For Schapiro all this amounts to a betrayal of the potential of modern art, and of current necessities. Proof of the alienated passivity of this modernity is, precisely, the modern woman of this class, no longer scorned for a *nouveau riche* lack of taste, but acknowledged as exercising modern aesthetic judgment more successfully, more completely, than most artists.

But the convergence could not be complete, art could not be utterly commercialized without endangering its valorization, thus the continuing production of differences. For modern artists, this took the form of both accelerated experimentation *and* "conservative" retreats. (Incidentally, this double-sidedness, rather than cultural lag, could contribute toward an explanation of differences between modernism in, say, France and Australia, during this period and in its relationships to other tendencies in art in those countries.) Thus also the importance of artists such as Sheeler whose work and statements constantly attest to an independent artist so impressed by the powers of Industrial America that he willingly consented to become one of its visualizers. As we shall see, this interpretation was also given to Rivera's frescoes, and their defense was organized around it in Detroit in 1933.

The continued effort to relate these contending demands shaped not only the advertising in *Fortune* but its layout, design, and editorial structure. From the mid-1930s, especially, it was the entire ensemble of elements within the magazine which regulated the ways it reads. The energy of the ensemble rather than the power of any one of its elements is the driving force. This applies not only to *Fortune* magazine, but to the imagery of modernity in advertising and other publicity.

To address the question with which this section began: advertising

artwork, then, develops a distinct, modern aesthetic only as one element in the mix, unless one wishes to stretch the term *modern* to cover the whole ensemble. Such a finding contradicts the view of, for example, James Sloan Allen, historian of the design efforts of the Container Corporation of America. Allen states that in the 1920s, "modernist graphic designs soon became the chief models for the printing and advertising professions" and that, in the 1930s, this tendency continued until

> the alliance of the consumer economy and modernism was made. Modern life and modern art had demonstrated affinities not to be denied or dissolved. And these affinities helped install a culture in which personality would be increasingly shaped by public imagery, and the gulf between high and popular art would all but disappear. This culture was not only modern, or up-to-date: it was modernist, that is, impatient with functional constraints, attuned to elemental realities and desires, responsive to abstract forms, and entranced by technological ingenuity.[21]

While this reading touches on key forces of the period, it fails to see the double drives toward future and past in early twentieth-century modernity, it exaggerates the modernist elements in imagery, and it generalizes the modernizing aspects of high business culture as if they were universally distributed and accepted. Advertisers were, as we have seen throughout this chapter, quite smart at mobilizing multireferential imagery, at targeting audiences on a class basis, and at trimming their messages to the shifting winds of opinion and desire. I take, as a final illustration, a declaration of emphasis quite other than that celebrated by Sloan—the Getchell Agency's response to the demands of the Depression, uttered in *Time-Fortune* syntax: "We believe people want realism today. Events portrayed as they happen. Products as they really are. Human interest. People. Places. Told in simple photographs that the eye can read and the mind can understand."[22]

Again, the implication arises of realist impulses at one pole, modernist ones at the other, and various specific compromises in between. But a close historical reading shows a complex ensemble, forming and changing through the two decades in response to certain technical possibilities and limitations in available modes of representation and, more importantly, in response to the social demands upon it. Exiled members of the Frankfurt school, Adorno and Horkheimer, vividly display their horror:

> Advertising becomes art and nothing else, just as Goebbels—with foresight—combines them: *l'art pour l'art*, advertising for

its own sake, a pure presentation of social power. In the most influential American magazines, *Life* and *Fortune*, a quick glance can now scarcely distinguish advertising from editorial picture and text. The latter features an enthusiastic and gratuitous account of the great man (with illustrations of his life and grooming habits) which will bring him new fans, while the advertising pages use so many factual photographs and details that they represent the ideal of information which the editorial part has only begun to try to achieve.[23]

Written around 1940, these remarks record the victory of the regulating order initiated in 1930 and shaped in the mid-1930s. But the power of the transposition pointed to here comes not from the forcefulness of magazines themselves, but from their complicity in the construction of the corporate state. And their contribution was not only the dynamism of their projection of the new business culture, but their embedding of its imperatives in larger class cultures. If Ford Company and others spread the imagery of privilege as part of their efforts to profit from the boom by moving upmarket in the late 1920s, the Depression demanded both the creation of fictive dream-pictures of prosperity *and* legitimation through popularization. This *down*market move was reinforced by the "democratization" of the imagery of Recovery. Thus, in the mid-1930s, the social mobility of imagery is multiple, but the major shift is downward and outward. With exceptions, the modernist artists who joined/ were drafted into the advertising boom of the 1920s found it necessary to adapt/subsume their work or be displaced. In this sense, advertising art commanded its own productivity to an unprecedented degree, positioning independent artists primarily as dependent suppliers of changes in style *and* as followers of fashions set by advertising.

Industrial design was being shaped in similar ways, as is shown in chapter 10. The key movement was from applied ornamentation, decoration, even applied "styling," to design "from the inside out." Much mystery and obviousness attended this shift. The phrase "art in industry" refers to both phases in the 1920s and 1930s, until the latter was widely seen as the key to industrial design as the decade progressed. "Art in industry" means, in the first place, the shaping of industrial machinery, products and promotions, *not* representations of them—and this differs from the representation previously discussed. Yet, as we have seen in many spheres, during the 1920s many products *became* their representations—or, more accurately, their relationships to the realm of representation became the most significant ones. *Fortune* became one of the key promoters of the values of this shift.

Fortune and Photography

So far, I have concentrated on photography within *Fortune* advertising, but the remarks by Adorno and Horkheimer cited above alert us to the role of photography within the overall ensemble, which I argue is the crucial regulating system of this magazine of corporate modernity. They claim that advertising and editorial matter had, by the end of the decade, become essentially indistinguishable: both were constructing the reader in similar ways simultaneously. At the beginning of the decade, we can discern the genesis of this regime, its birth at a point when its elements were dynamic precisely because they were tending in contrary, contradictory directions. If, by 1940, Time Inc. magazines were working to standards that were "striking yet familiar, easy yet catchy, skillful yet simple," whose "object is to overpower the customer, who is conceived as absent-minded or resistant,"[24] ten years earlier the mode of address was much more volatile. I sketch it here as a way of recalling the powers which excited Luce to become the voice of the East Coast and northern new corporate technocracy and to point to the complexities of "documentary expression" which are of concern in the next chapter.

The core creative energy of *Fortune*, the internal structure which probably grasped and shaped its readership more than any other, and which, while not quite new, was better developed here than elsewhere, was the combination of the realist, eyewitness corporate story and the modernist, documentary photo-essay. This combination appears in the very first words and images published in *Fortune* (February 1930, 54ff.): "Swift and Co., butcher for 20,000,000 persons, buys no raw materials. Its cattle, its sheep and its logo are finished products. Year after year it spends some $500,000,000 for these beautifully assembled mechanisms and proceeds at once to disassemble them. By countless individual acts of destruction, Swift & Co. paradoxically increases the value of products which are the results of countless individual acts of creation." Modernist rhetoric, thrilling to the drama of modernization, exalting in its contradictions. The first image, a comic wash drawing of a huge hog strung up by the legs and marked according to the major markets for its various parts, replaced the expected editorial. But the immediately following images introduced the definitive coupling. Margaret Bourke-White's high-contrast black-and-white close-ups of, first, the backs only of a crowd of pigs, but then, lyrically, the stilled motion of the automated conveyor belts of hanging carcasses, waiting to be processed, chopped up by heavy workers glowering in the murky dark, until the final image, a full-page close view of mountains of pig dust. From the swarming backs to the crushed remains, no hint of the animality of the pigs or the hu-

Trade Routes Across the Great Lakes

A Portfolio of Photographs of Iron, Steel, Coal and Ships

By Margaret Bourke-White

5.6 "Trade Routes Across the Great Lakes," photo essay by Margaret Bourke-White, in *Fortune*, February 1931, p. 77. (Margaret Bourke-White, *Fortune* magazine, © Time Warner Inc.)

manity of either workers or management. Process is all. And it reaches for a different beauty, namely, the artistic presentation of the photos with black borders on toned frames, and with the photographer's name credited, the only byline in the entire magazine.

The first issue continues with Bourke-White's "Trade Routes across the Great Lakes: A Portfolio of Photographs of Steel, Coal and Ships" (77–81), typical of the portfolios featured in subsequent issues—for example, that entitled "Petroleum" (April 1930). These not only share the fine printing quality of the rest of the publication; they are marked out as different in kind from the photography of the advertisements. Here, clearly, is photography valued as an art in itself. Here the model so passionately promulgated by Alfred Stieglitz but effective within a limited New York cultural circle is projected as part of the task of the new executive. A clarity of gaze—quick, sharp, encompassing at a glance, yet marked with a certain refinement of restraint, moving on to the next, the promise of order, of a sequence of sparkling sights. Here Stieglitz's precision and care are focused on industrial power, on an energy worth treating in this way—indeed, one calling for just this treatment. How sweet a match of form and content this must have seemed. Bourke-White parallels Sheeler's relationship to Ford: every plant is given the Rouge treatment; every industry is read (in photographs and text) as a totalizing system, a Ford Company type of modernity updated toward the new corporation (for example, the March 1930 feature on South Bend).

Indeed, Bourke-White also photographed the Rouge in the late 1920s, as did Walker Evans, for *Fortune*, in 1947.[25] But here the aestheticizing process went beyond one archetypal site: it was applied to the whole of the new style of American industry. And it was more broadly disseminated, both in *Fortune* and through its impact on other magazines and publications. Of course, it also began to appear more and more in advertisements. For these reasons, Bourke-White's imagery of industry arguably set the visual style of industrial America more directly than Sheeler's images specifically.

But what of the internal aesthetics of *Fortune* photography? Compared with Sheeler's careful purity, they are more overtly dramatic in light and angle of view, and much less subtle in terms of textures. But they are more accessible and successful as a result. Both Rivera's *California* mural and Kahlo's *Self-Portrait* (1932) respond to this type of imaging of U.S. industry. Sheeler excludes the workers, except as incidentals; Bourke-White includes them but in separate images in which, at this stage, she handles less well, more naturalistically. Her industrial structures are modernizing updates of A. L. Coburn; they do not reach the abstracted dimension of Sheeler's. But they come close, tend very much toward "modernist purity" in their use of repetition, machine fetishism, evocative exclusion of the organic, regulated light, and "otherworldly" space.

The relatively spare, mechanical objectivity of the majority of the photographs constantly contrasts with the texts running through them; for

all the declared obedience to the hard fact, to mechanization, regularity and order, the *writing* of the texts is always excited, subjective, often passionate. In contrast to the decorum within the ensemble which prevails on the advertising pages, the editorial body of *Fortune* shifts to a different word/image relationship, that of constant contradiction. This, in the early 1930s, is the *opposite* of what Adorno and Horkheimer claim about *Fortune* in 1940. Yet both editorial and advertising are, and claimed to be, *documentary* activities, stressing revelations based on what is being seen, experienced, by the writer and the photographer. And both did so through excess, through incessantly transgressing limits set, first by magazines prior to *Fortune* and then by their own achievements to date. Bourke-White effects the proposal's "undisputed most beautiful," aestheticizing the new corporatism by seeing it through a blend of romantic pictorialism and Neue Sachlichkeit precision (a Moderne, not modernist, trend); MacDonald, MacLeish, Luce, and the other writers effect the "brilliant writing" demanded in Luce's prospectus by producing *literature* about business, drawing on "advanced" writing as well as journalism, to do so.[26]

The striking contrasts between "cool" photographs and "hot" text are not always simply drawn; both constantly seek reconciliations, as demanded by the overt program of the magazine itself. The absorption of modernist, social reformist writers of conscience into the celebration of the new corporation is paralleled to some degree in the photographic imagery. Sekula cites the case of a Bourke-White portrait of a miner which stresses his directness and dignity, accompanying a February 1931 article on the troubled anthracite industry ("Hard Coal," 77). The caption reads: "A young miner. He sees modernity coming to the mines. Besides the traditional art of his trade, he learns a new technique. Brawn he has, and more, machinery to help him." Sekula comments: "The editors of *Fortune* are able to celebrate technological progress and animate the ghost of artisanal work in the same article, the same layout, occasionally—as here—in the same picture and caption. *Fortune* harmonized the rhetoric of modernism and the rhetoric of humanist documentary, combining an estheticized version of engineering realism with an estheticized version of the realism of the social reformer."[27]

This is acute commentary, but requires a little elaboration. Bourke-White's camera often focused on the details of an industrial site, paralleling the sense of experiencing/revealing internal, esoteric, yet hard and factual information which the narrative texts conveyed. Such closeness has precedents, not in Coburn and Stieglitz but in the work of the record photographers working for industrial engineers, the producers of technical manuals and reports. The resultant image is, however, quite unlike the explanatory narrative ideal of such illustrators: its aestheticiz-

A YOUNG MINER AN OLD MINER

5.7 "Hard Coal," photographs by Margaret Bourke-White, in *Fortune*,
February 1931. (Margaret Bourke-White, *Fortune* magazine, © Time Warner Inc.)

ing works by precisely rendering machinery immobile, unproductive,
out of use. It is the close-up of a machine part in the process of being
made, such as the plough-blades pattern illustrating the "South Bend"
story (March 1930), or a sequence of similar-shaped installations, such
as the steam stills illustrating the "Petroleum" story (April 1930).[28]
Again, this is the same procedure as Sheeler's: modernism aestheticizes
by stilling motion, banishing productive labor, excluding the human,
implying an autonomy to the mechanical, then seeking a beauty of repe-
tition, simplicity, regularity of rhythm, clarity of surface. This is the
gaze of management at leisure, marveling at the new beauties which its
organizational inventiveness can create. It is an approach which pro-
motes the instrumental but only to evacuate it utterly: the last kind of
knowledge required to absorb the beauty of these metal shapes is knowl-
edge of their engineering or their purpose. It is necessary only to know
that they were engineered to have some purpose. Thus the accuracy of
Sekula's reference to rhetoric.

The March 1930 South Bend story is an apt example of the early *For-
tune* approach. Conceived by Luce even before the launching, it set out
with a reformist crusading aim to expose "The Unseen Half of South
Bend," the productive depths behind the glittering Studebaker: "the
most typical of the U.S. genius for mass, volume, speed, change, profits

194 Reality in the 1930s

5.8 Margaret Bourke-White, *Plow Blades, Oliver Chilled Plow Co., Indiana,* in *Fortune,* March 1930. (© Margaret Bourke-White Estate, courtesy *Life* magazine)

and *da capo*. Old sanctities remain—but, to them, the several tycoons of the city are, for the most part, indifferent." This makes South Bend, Indiana, "the perfect microcosm, the living example, the photographable average" (52). Such is the "truth" which the writer and Bourke-White transform into a glittering spectacle: the specter of "dark, satanic mills," evoked in Luce's most Dickensian prose, is exposed to brilliant light; the unseen other becomes an ordered domain. Using an army analogy, Luce makes all this explicit: "The South Bend privates are well paid. They labor without complaint and without hope. Were it necessary to recruit the army of South Bend from such as you and I, there simply would be no industrial age. . . . The privates line up, not in mass formation but at intervals of a few feet or a few yards. Mostly they are in long lines, hundreds of yards long each with a machine in front of him before which he makes regular motions" (57). Bourke-White's illustration features tops of car bodies going onto chassis (that is, end assembly) and close-ups of stacked wheels.

The industrial worker appears in these stories, unavoidably. But there is a disproportionate lack of quantitative parallel to the imagery of the plant itself. The text organizes the workers into serried ranks, and the captions to the group or individual pictures are both condescending toward the workmen and reassuring to the executive reader. Thus a black worker: "One of Studebaker's 15,000. He works without complaint." A white foundryman is both named and pictorially given the full portrait treatment: "He thinks not at all, but he has just one thought all the days of forge life, the thought that he is Vulcan and doesn't have to say 'Thank you' to any man" (102). There may well be an element of documentary humanism in the last phrase, but it seems just as artificial as the echoes of Social Realism in the visual style of the photographs. Indeed, it is quite clear from Bourke-White's reminiscences of doing this story that her own sympathy for workmen was, however genuine, quite superficial, swamped by her enthusiasm for breaking new ground in photographic subject matter.[29]

She goes on to tell the story of how she came to be photographing inside the First National Bank of Boston on the night of the Crash but was so oblivious to economic realities that she could register only annoyance at the scurrying about.[30] Like Sheeler, Bourke-White seems unable to develop an approach to photographing human beings, especially workers, that has anything like the power and consistency of her dramatic vistas or the close-up sequences. She shifts between imitation expensive portraits and poorly composed, even blurred-focus group shots. With exceptions, this remains the rule in her *Fortune* work until the mid-1930s. The exceptions are her work in Russia in 1930, 1931, and

1932 (she gave a glowing account of her experiences, especially of the state's treatment of artists), and in South Dakota during the drought of 1934.[31] These—the experience of working on *You Have Seen Their Faces* with Erskine Caldwell, and working for *Life* in 1936—effected a shift away from the superficial. But prior to that there was nothing like the equivalence between "engineering realism" and "social realism," however aestheticized, implied in Sekula's characterization, neither in Bourke-White's photographs nor in *Fortune* imagery in general. Indeed, she celebrated the artist-industry relationship in words little different from Sheeler's worship of Ford: "When the social ideals of artist and patron coincide, at that moment art flourishes. When the grandeur of industry appeals alike to manufacturer and photographer, the industrial artist is creative and free."[32]

Perhaps Bourke-White's historically most significant achievement was an unintended consequence of her Sheeler-like aestheticizing of the illustrations to the corporate documentaries. Her photographs were no longer illustrations to text: they were independent visual interpretations of the material, consumable in their own right, like works of art. They made industry the subject of art, removing it to a second-order domain (no wonder the discomfiture in picturing industrial *workers*). But, formally, given the forces at play within the magazine, this aestheticizing had the effect of fabling, of making metaphoric, the images in the editorial texts, releasing thereby a factual/metonymic space for photography in the advertisements. Adorno and Horkheimer are accurate in their indignation at the editorial pages' betrayal of the "ideal of information" to the advertising pages. We can now add another mechanism by which this was accomplished and say, slightly more precisely, that it was less a question of advertising alone becoming art (alluding here also to Walter Benjamin's characterization of the key to fascism) than the aestheticizing of the entire ensemble and, by implication, of the new corporation itself. The "domain of facts" ("truth" in a word) is surrendered first to the advertising pages (in the rhetorical figure of direct, scientific text and accurate, realist, descriptive imagery), and then expelled altogether. All the modes by which reality might intrude are welcomed, admitted, and then incorporated into the fictive modernity of the magazine.

But this did not occur in the manner of a giant vacuum, sucking in critical realism randomly along with any other social detritus falling before it. There was, indeed, as Sekula notes, a harmonizing of the "rhetoric of modernism" (I prefer to say "modernity," reserving modernism for the discourses of the arts and design) with the "rhetoric of humanist documentary" in the pages of *Fortune*, both in its ideological outlook and its overall layout as a regulatory ensemble. But it was a volatile mix, as

we have seen, and it took some time to achieve. I wish to argue only that it acquired the social power of a coherent regime from the mid-1930s onward, that it shared this power with related publications such as *Life*, and that this signals a central element in the entire visual culture of modernity as it was constituted in the United States in this period. It is a key to the attempted imposition of an imagery of national consensus, an iconography of American life, an iconology of American attitudes. It aimed to figure modernity as "Made in America," to create new ways of seeing the new and of seeing the new as local. Yet these were views from above, from the most powerful positions of both the economy and government. How did the ideological orientations of *Fortune*-type "business culture" stand up to the bitter opposition of those seeking a more equitable democracy? Reform, dissent, and radicalism were well-developed movements, intensifying as the effects of the 1929 Crash were more widely felt. How did the preferred imagery of these movements, that of critical realism and Social Realism, combat the "capitalist realism" of both advertising and the *Fortune* ensemble? These questions lead us to a further, terminal one: how did these two realisms reach the accommodations that made them scarcely distinguishable by the end of the decade?

THE RESISTANT OTHER: DIEGO RIVERA IN DETROIT

CHAPTER

6

Beyond Realism versus Modernism?

In the survey textbooks on American art, the River Rouge plant usually appears as the unstated subject of one of two paintings by Charles Sheeler: *American Landscape* (1930) or *Classic Landscape* (1931). His 1927 photographs of the plant are inevitably anthologized in the photography texts (although core imagery of the other great U.S. regimes of the Modern—the consumable product and New York City—appears much more often, especially the latter). Only one other artist is known to have devoted comparable attention to the Rouge plant and also to have produced a major work based on it—Diego Rivera, in his *Portrait of Detroit* or *Detroit Industry* murals at the Detroit Institute of Arts (1932–33). These works rarely appear in the survey texts on American art, despite containing some of the most accomplished painting done in the United States at the time. Exclusion works here partly by definition: despite their subject, they are by a Mexican artist, and artists working mainly outside the United States are not usually considered contributors to the mainstream of American art. In a relatively recent text, subtitled "A History of Social and Political Art in the U.S.," the Mexicans appear only as precedents

to the 1960s mural movement.[1] As a suite of murals, *Detroit Industry* runs counter to the assumption that significant art occurs in the more individual, personal, and ownable modes of painting, drawing, fine printing, and small sculptures. Its great impact on the mural work of U.S. Social Realists in all media might secure it a black-and-white "source"-type illustration. Generally, this kind of work, even by U.S. artists, rarely surfaces in any but specialist books. A disproportionately minute number appear as tokens in the general texts; Ben Shahn's *The Trial of Sacco and Vanzetti* (1931–32) is ubiquitous.

Assimilated to the category Social Realism, Rivera's murals were submerged in the general dismissal of this kind of work as poor art, compared with the less politically committed Regionalism and the European-directed abstract tendencies contemporary with it. Such an approach marks the key general texts of the 1950s.[2] In the 1960s, following the thrust to establish the French lineage and the autogenesis of the Abstract Expressionists, the Social Realists almost disappeared altogether, despite the probability that most of the major Abstract Expressionists painted their first mature work within its regimes.[3] In the texts of the 1930s and 1940s—even those published by New York's Museum of Modern Art—these processes of exclusion are not so overt, although they are implied by the general program of emphasizing French avant-gardism as the key mainstream of desirable aesthetic development, the model toward which U.S. art and culture must aspire, the local equivalent of which, as we shall see in chapter 11, MOMA was leading a campaign to produce. From this perspective, Social Realism, including Rivera's murals, was gradually excluded. In contrast, as we have noted, Sheeler's *American Landscape* was bought by Mrs. John D. Rockefeller soon after its completion and given to MOMA in 1934. His *Classic Landscape* was just as quickly acquired by Mrs. Edsel Ford. Both paintings were featured prominently thereafter in exhibitions in Detroit and New York, and Sheeler became one of the artists exemplifying the possibility and, eventually, the success of the MOMA program.

So the stage is set for a contrast, even a dramatic confrontation, with implications on all the levels of meaning which we have been considering. In one corner, Modernism accumulates a reductive, cool, abstract styling, a "pure" formality, a concentration on means rather than ends. It evokes the new industrial age, the dreams of the *nouveau riche*, the shaping of a dominant new order, a seamless unity, compelling and total. Clustering in the other corner around the concept of Realism is an equally monolithic regime dedicated to everything other, in opposition: a battling place for the multiplicity of life, for the right of all to satisfying experiences of work and leisure, the democratic openness of the usually unpainted workers, a call to struggle, an avowedly Communist artist.

Sheeler and Rivera suddenly become representatives of two contending artistic, cultural, social, even political orders, whose struggle for supremacy marks fundamentally the development of art since the mid-nineteenth century. Thus Charles Corwin, writing in the *New York Daily Worker* of February 4, 1949, states that "Sheeler approaches the industrial landscape, whether it be farm buildings, textile mills or oil refineries with the same sort of piety Fra Angelico used towards angels. His architecture remains pure and uncontaminated by any trace of humans or human activities, an industrialist's heaven where factories work themselves. In revealing the beauty of factory architecture, Sheeler has become the Raphael of the Fords. Who is it that will be the Giotto of the UAW?"

Such clear contrasts at least advance on 1960s modernism in that they allow back into history the great amount of critical, combatative work done during the past two centuries and reflect some of the obvious conflicts of the crisis-torn 1930s. And, indeed, since the late 1960s a number of studies have sustained both these points.[4] A further advantage is that research into Realism, particularly into documentary photography, has led to a recognition that artists were engaged in a broadening of the range of media and of the variety of audiences with whom they worked. This locates the intentions and achievements of certain artists more securely as well as throwing into relief the efforts of those who did not choose what now appears as a viable option. As well, there has been at least a limited realization of what might be termed the culturally specific nature of visual imagery, that its production, circulation, and specifically, its capacity to generate meanings are very much a function of its use within various cultural and subcultural exchanges. The case of Realism is made concrete in this sense when it is recognized as a description of imagery generated within and around the labor movement or, differently, within and around various socialist governments, or, differently again, within artistic subcultures in relation to both internal debates and "external" pressures.[5]

But the battle of the monoliths is no longer a productive metaphor. Even as loose tendencies, the reduction to merely two obliges both of them to carry too many negative connotations. Already I have indicated the need to discern the productive diversity which makes up modernity in the United States in the first thirty years of this century. Such diversity obtains in other social formations; the same holds for modernisms within artistic practice. And this kind of complexity also characterizes the various realisms within artistic practice. A rampant relativism does not, however, ensue. I argue for certain relations of oppression and opposition and resistance, of force and effect which, at times, appeared to participants to configure in a binary way—and which, at times, did so.

But never monolithically, and always in contradiction: sometimes dialectically, producing resolutions/compromises of another sort, sometimes with tangential or even terminal results.

There are, further, some particular abuses which follow from simplistic readings. The modernist artist is reduced to silence, reaction, or indirection when forced up against certain subjects excluded by the regime within which he or she usually works (for example, the difficulties of the Symbolists and the Impressionists in dealing with any work process at all). The Realist can be restricted by demands that stylistic language must not go beyond that held in common by certain audiences (often hopelessly generalized to mean "the people," that is, almost everybody), that political analysis within artworks remains in concert with that developed by the party or group or tendency with which one is working, that a certain level of "seriousness" be constantly maintained, that each image carry not only correct meanings but an entire ideology, both critical and hopeful, historical and future-directed, specific yet typical, realistic yet idealized as well. These impossible demands have overloaded artists since they began to be explicitly formulated in the late nineteenth century, particularly by émigré radicals such as the *rasnachinski* who became the Bolsheviks, and by dissidents such as William Morris. Small wonder that their institutionalization tended to produce stereotyped art (particularly during the 1940s and 1950s). Both conceptions are static, academic—that is, their solutions are present at the outset.

Instead, I propose a set of readings which subjects this sort of dichotomy to a complexity which renders it real (that is, acknowledged as historically present) but open, which recognizes the power of the urge to simplicity in it (or the devastating simplicity of the urge to centralized power in it), but which also encourages the surfacing of the marginal knowledges which it seeks to contain, enfeeble, incorporate, and even oppress. We have seen Sheeler's picturing at the River Rouge as a somewhat more resonant encounter than a direct matching up of avant-garde modernist art with the most modernizing industry. We have also placed this meeting as one among a variety of ways in which Ford Company was obliged to organize the broader imaging of its own modernity, in which companies like it were forced to seek some control over the imaging of American industry. Indeed, at stake in the later 1920s and throughout the 1930s was management of the imagery of "Modern America" per se. Needless to say, this struggle in the domains of representation was an increasingly important part of the general pattern of struggle for political power, for economic advantage, for social movement, for personal change—even, at times, for survival.

How does Diego Rivera's mural work, for example, enter this field of struggle? In contrast to Sheeler's rupturing of the newly forged links in industrial imagery between "engineering realism" and "social realism," does he not restate the latter, denied by Sheeler—the continuing tradition of humanist naturalism, the organic realism through which the emergent bourgeoisie figured itself during the eighteenth and nineteenth centuries at all those moments when an imagery of difference from the previous rulers was necessary? This imagery is the language of a bourgeoisie in power, but more often it is the language of reform—even, in certain situations, of opposition. Thus it was in Mexico, in the mural movement, after the Revolution of 1910. But was this a bourgeois or a popular revolution? Was that in Russia in 1917? There are internal conflicts here which refuse the nailplating of style, of any ideological materials, onto the backs of classes and even class fractions. And can all the limitations and possibilities which add up to "Rivera" at this moment in Detroit be encompassed by such a broadly sketched stream? Is anyone the monotonous voice of a style or a class? Can one attempt to speak, to paint for two contending classes without duplicity, without showing their contention (without which they are not classes)? Or was it Rivera's political task to restore the nexus between "engineering" and "social" realism and, in so doing, reintroduce an artistic language in which class conflict could be imagined, would have to be confronted? How do these issues relate to the puzzles of his commissioning by the leading capitalists, Ford and Rockefeller, and to the controversies over both murals, leading to the destruction of one of them?

These sorts of questions have circulated around Rivera's Detroit murals at the time and since. I show that, along with others, they also circulate through them. In all, another imagery of modernity is proposed by Rivera at Detroit and in New York. It converges with aspects of those forced forward by such motors of modernity as the Ford Company, but also differs markedly. It, too, is shaped by successes, but mostly by failures. And it is used by the Ford Company in a most extraordinary way.

Rivera was also locked into other battles, particularly in Mexico. The debate which he, Orozco, and Siqueiros conducted in their murals, in both their own country and in the United States during this period, contains some astonishingly different constructions of modernity. These have been explored in Laurance Hurlburt's *The Mexican Muralists in the United States*.[6] Even more important, against this tapestry of contending international and national cultural giants, is the disclosure of the power of certain "smaller" knowledges. Popular, even Popular Front, imagery works through repeating the past.[7] Other readings of modernity are given by the voices of its victims. Usually silent, some appear at this

moment, at Rivera's side, in Detroit in 1932, in New York in 1933. In the next chapter I examine the art of Frida Kahlo in this light. In chapter 8, further ambiguities of U.S. Social Realism are explored, particularly within documentary photography. I then turn to the New Deal administration's unprecedented use of publicity, especially photography and film, and reposition these questions in a way that unbuttons them from art-style categories, and from those stylistic divisions favored in photography history, in order to see them in relation to the regularities of visual imagery within the broader economy of seeing of the period.

Diego Rivera in Detroit: Negotiating an Imagery of Modern Industry

In the great mural cycle once known as *Portrait of Detroit* but now usually entitled *Detroit Industry,* painted in the Garden Court of the Detroit Institute of Arts between July 1932 and March 1933, Diego Rivera went beyond his ostensible subject to attempt a visual statement of astonishing ambition: from within a direct and immediate picturing of the Ford Motor Company plants, Rivera strove to project an unforgettable image of the nature of modern industry—its prehistory, its birth, its present structure, and its future.

What drove Rivera to this complex, contradictory and—some have said—self-defeating task? I argue that he recognized the emergence, in the 1920s, of a globalizing imagery of modernity, that he saw it was taking its strongest form in the United States, that it was essentially tied to the imaging of modern industrial production, and that it was the expression of a dynamic yet alienating economic, social, and political order. He was, of course, scarcely alone is such a perception. His response was, however, exceptional. He set out both to absorb the irresistible inventive energy of this emergent imagery of industrial modernity and to add to it two other contrary kinds of energy. These were, first, an insistence on organic ancientness of industry itself, and, second, a related emphasis on the primacy and the persistence of physical work as still central to industrial production. Without in any sense being reactionary, Rivera was cutting against the mechanist, consumerist grain of modernizing industry in the United States. Nor did he accept the visual imagery which had, by 1929, evolved to most effectively project the new modernity: the clean, white walls, the subtle shadows, the eternal silences, the celebration of objects, the displacement of workers, strife and ambiguity, the controlled power of the picturing of industrial plant by Charles Sheeler and Margaret Bourke-White, for example, the photographers of *Fortune.*

Does the destruction of his Rockefeller Center mural in 1933, and the relative lack of impact on other American artists of his Detroit murals,

mean that Rivera's ambitious dream was doomed to failure? Were the Detroit murals a tissue of compromise—as Max Kozloff, with evident regret, implies in the 1973 article which remains the best interpretative text on these murals?[8] The recent revival of interest in the murals, while due in no small part to the positive promotion of them in recent exhibitions,[9] nonetheless indicates a present relevance of some significance. It seems to me that many have forgotten something that must have been quite obvious at the time: that Rivera was a political negotiator of the highest skill. He had this in common with many artists who have wished to make strong political statements in public places since the late 1960s. We are obliged, in his case, to surrender the simple concept of the individual creator seeking to realize in an unmediated way his unitary intention. Rivera was applying the logic and the tactics of a political survivor and a political agitator to his work in Detroit. The result was a very particular negotiation between intentions and effects. This leads me to propose that, for all the elisions and avoidances in the murals, short-term failure (if that is what it was) may imply at least some measure of long-term success: Rivera may have intuited the correct, *slow* speed of the revolutionary mural. I demonstrate this in two stages: first, in some remarks about Rivera as himself a cultural icon of the period, and, second, in an interpretation of the murals themselves. The novel emphases in my interpretations are suggested by an analysis of the political economy of Detroit in the late 1920s and early 1930s, particularly the battles between labor and capital within Detroit industry.

The Artist as Child-Communist

In May 1931 Rivera was sent a letter by the Arts Commission of the Detroit Institute of Arts, chaired by Edsel Ford. Its members were architect Albert Kahn and two others. The letter read in part:

> At yesterday's meeting the Arts Commission decided in favor of the project to ask you to help us beautify the Museum and give fame to its hall through your great work. . . . The Arts Commission will be very glad to have your suggestions of the motifs which could be selected after you are here. They would be pleased if you could possibly find something out of the history of Detroit or some motif suggesting the development of industry in this town; but at the end they decided to leave it entirely to you, what you think best to do. . . . Everyone in the Arts Commission is very much interested in your work, and knows that an artist must be as far as possible free and independent in his work if something great is to be accomplished.[10]

Rivera came to Detroit in 1932, as he had to San Francisco in 1930 and New York in 1931, with an international reputation as not only the outstanding artist of Mexico, the most accomplished muralist of his day, but also as the best-known "political," specifically Communist, artist in the world. His status as a leading Mexican muralist warranted the respectful tone of the Arts Commission's letter. But Edsel Ford and Nelson Rockefeller, typical of the captains of the new corporatism who so fullsomely welcomed Rivera, were not in the habit of addressing their political elements in this fashion. The very fact that Rivera was invited at all has puzzled many.

In 1927 the artist was sufficiently feared as a revolutionary agitator for J. Edgar Hoover himself to order a "close but discreet surveillance" of him as he passed through the States en route to the celebrations, in Moscow, of the tenth anniversary of the Russian Revolution.[11] Subsequent secret reports on revolutionary activities in Mexico frequently mention Rivera, but paint a generally accurate picture of increasing sectarianism and declining significance.[12] Rivera joined the Mexican Communist party in 1922, shortly after his return from Europe and during the painting of the great 117-panel mural cycle at the Secretaría de Educación Pública in Mexico City. During the following year he was elected to the Party's Central Committee.[13] His work in Mexico always pushed hard at the most radical perspective possible within the intricacies, and the sudden shifts, of the politics of the period. And the situation in Mexico was closely tied to U.S. interests in the area, especially those of the giant oil companies. Rivera made these connections quite explicit in his murals in Mexico, portraying Henry Ford and John D. Rockefeller as drunken hedonists, voraciously living off the bodies and the work of the poor.[14]

Yet by 1930 the attitude of certain key figures in U.S. artistic circles toward Rivera had become very positive. He had been expelled from the Central Committee of the Communist party of Mexico, and from the Party itself, in 1929. He could then be regarded "officially" as a non-Communist, although the basic reason for his expulsion was that he was "too radical," according to his admittedly ultraleftist biographer Bertram Wolfe.[15] There were few other artists capable of such major work, in the United States or elsewhere—none with Rivera's stature and proven record as a muralist, certainly none among artists known for their celebration of capital. Rivera embodies Valentier's vision of the Detroit Institute of Arts as a Renaissance center, while at the same time fitting Edsel Ford's predeliction for modernism as the key to the personal culture of the new corporate executive.[16] Rivera had been lionized in San Francisco and New York; there is even a hint of competition between the new patrons.[17]

Two other factors seem even more important and pertinent to my interpretation. There is abundant evidence that the increasing reluctance of successive Mexican governments after 1910 to continue to grant exceptionally favorable conditions to U.S. oil companies, particularly Standard Oil, caused major deterioration in relations between the two countries, culminating during the regime of the so-called socialist Plutaco Elias Calles in 1924–34. Much credit for maintaining relations is usually given to the activities of Morgan Ltd. banker Dwight W. Morrow, as U.S. ambassador, particularly the ideological effectiveness of his interest in Mexican education and the arts, "climaxed by his inviting Lindbergh and Will Rodgers to visit Mexico and by his commissioning Diego Rivera to paint murals in the Palace of Cortez at Guernavaca." [18] Rivera's 1931 exhibition at the Museum of Modern Art in New York was the first fruit of the Mexican Arts Association Inc., set up the previous December to "promote friendship between the people of Mexico and the United States by encouraging cultural relationships and the interchange of fine and applied arts," with a membership including the Rockefeller and Morrow families. [19] At MOMA, Rivera showed mainly studies of Mexican peasant life, modified his mobile murals on exploitation by Mexican landlords, but displayed his May Day sketches done in Moscow and one clear provocation: *Frozen Assets*—a three-level mural, at bottom a guarded bank vault stuffed with money, in the middle a flophouse filled with corpselike figures, and, at the top, the skyscrapers of New York arranged like tombstones. A low-key controversy ensued. [20] Rivera was becoming a negotiable asset within an international exchange where cultural items assumed great importance as economic ones became too politically hot to handle directly. He had, furthermore, already proven himself a master of the rough-and-tumble of Mexican politics: he was the only muralist to survive the rapid turnover of governments before and including Calles.

The 1931 MOMA exhibition also evinces a further, decisive factor: the Romantic myth of the artist obsessed by essentially individual enthusiasms was given a new twist in the catalogue essay by Francis Flynn Paine. Rivera is pictured as a compulsive child, an adorably, slightly foreign one: "Diego's very spinal column is painting, not politics." [21] In sum, Rivera was chosen to paint the triumphs of U.S. capital, despite his unsavory past, because he was the best artist of high reputation available, possessed undoubtedly traditional skills yet was modern in his outlook, had a track record of work completed, was demonstrably adept at cultural politics, and yet, fundamentally, an innocent in his art and life. How much Rivera himself fostered this mythology remains unclear.

One final question should be considered before we begin a reexami-

nation of the *Detroit Industry* murals. Rivera was invited to paint these murals in May 1931, although negotiations had actually begun with Valentiner in San Francisco the year before. After the 1931 MOMA exhibition, Rivera was approached about the Rockefeller Center mural and, by Albert Kahn, to paint a mural in the General Motors Pavilion at the 1933 Chicago Century of Progress Exposition. In late 1929 the U.S. economy began its rapid collapse into depression. Many jobless workers held the large oil companies, such as Standard Oil, and the large manufacturing companies, such as Ford Motor Company, to some degree responsible if not for causing the Depression then for failing to help alleviate its worst effects. An obvious strategy for such a massively unpopular organization would be to associate itself with popular ideas, forces, places, and people. Was this the underlying reason for choosing Rivera, a "people's artist" par excellence, to paint epic cycles of human progress in Detroit and New York?

There is no doubt that Rivera's time in Detroit, April 1932 to March 1933, coincided with the greatest impact of the Depression: massive unemployment, financial chaos, political struggle, violent class warfare in the streets and factories. Ford Motor Company had, inevitably, a leading role in all aspects of this crisis. Ford responded to the Crash of 1929 with a typically defiant gesture: a wage increase from the famous $5 to $7 a day. But this raise was confined to skilled workers and was followed by wholesale firings, chopping the 1929 work force in half by 1932. During 1933, three-quarters of a million Michigan wage earners were unemployed, and one-third had been unemployed for four years in succession. Production slumped; the company lost an estimated $150 million in 1931–33. Ford's fierce resistance to unionization continued unabated, despite the legal status given the United Autoworkers Union by the Industrial Recovery Act in 1933. As to welfare, the company ran various alleviation schemes and an important hospital, but did not contribute to public relief. For many, its attitude was epitomized in the killings by Ford Servicemen and Dearborn police, which halted the infamous Ford Hunger March of March 7, 1932.[22] At the same time, the crisis of capital finally hit Detroit in the February 1933 Michigan bank collapse, which precipitated a national moritorium. It is understood that a major trigger of the collapse was the speculative excesses of the Guardian Detroit Union Group Inc., of which Edsel Ford and relatives were principal figures.[23]

It did not automatically follow that, in late 1930 and early 1931, Rivera would be chosen as a major popular artist to create a major populist work under the patronage of a major, but extremely unpopular corporate sponsor. By March–April 1932, however, the political situation in Detroit had changed so drastically for the worse that a reading of this

sort is inevitable. It goes quite beyond any simple set of intentions on the part of donor, gallery director, or artist. The situation had become intensely, overtly political. There is little evidence that Rivera himself engaged in these struggles directly, with the exception of some activity within the large Mexican community in Detroit.[24] His political acumen, I argue, went into negotiating the shaping of meaning in his mural. This was done not by a straightforward retreat from some supposed set of obvious obligations, but by seeking a visual language which would speak not only to the immediate crisis but beyond it, through time, through future struggles, to a different, as yet unimaginable future.

Motor City in World History

Commissioned initially to paint only the two side panels of the Garden Court, Rivera's first maneuver was to secure the entire space, twenty-seven panels in all. The role of his preliminary drawings as negotiating works needs further study.[25] The overriding aesthetic conception fills an early Renaissance revival space with a neo-Baroque immediacy, scarcely surprising for a Mexican artist adroit at working with Spanish-style architecture. It is, I believe, important to keep the overall conception constantly in mind—as it is experienced in the Garden Court itself. Most commentators focus on the car industry panels, treating the surrounds as accessories, infill, or unfortunate lapses in taste. This leads to a mis-

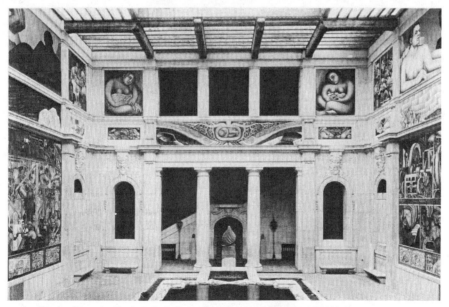

6.1 Diego Rivera, *Detroit Industry*, East Wall, full view, 1932–33. Fresco, Detroit Institute of Arts. (Photograph W. J. Stettler, 1933, Museum Archives, DIA, neg. 3130; © The Detroit Institute of Arts)

reading of the murals as "a monumental glorification of industry," as a failure to indict capitalist society.[26] If, however, we take the cycle as a whole, and the ways in which Rivera is attempting to manage the viewer's processes of seeing as our measure, then we will see the mural program is fundamentally a Marxist one. It is not a comic-book illustration of the Communist Manifesto, but its framework of values is parallel with that text and aspects of subsequent radical history.[27] These emerge in the whole and in details, in clear statement but mostly by accumulation of inferences. I concentrate on these inferences, general expositions of the murals being readily available.

O'Connor has drawn attention to the traditional east-west orientation of the mural court.[28] Its story begins with the imagery of germination—human, organic, and inorganic—on the East Wall, opposite our entrance. While the fertile harvest-goddesses in each corner panel, and the fruits of the earth below them, convey the fecundity of natural growth, this wall already contains hints of the countermovements that will gradually increase in power through the cycle. The long strip panel

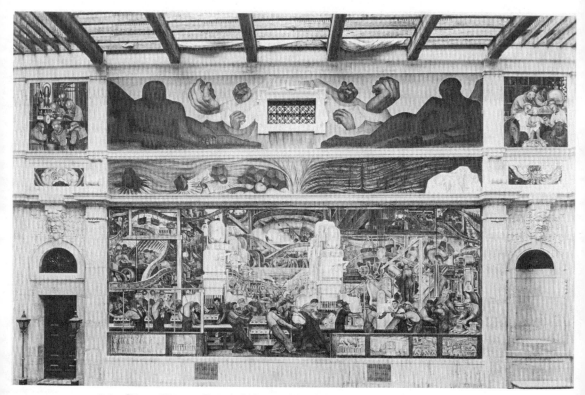

6.2 Diego Rivera, *Detroit Industry*, North Wall, full view, 1932–33. Fresco, Detroit Institute of Arts. (Photograph W. J. Stettler, 1933, Museum Archives, DIA, neg. 2734; © The Detroit Institute of Arts)

210 Reality in the 1930s

centers on the image of the child in the womb, simultaneously evoking a plant seed and a chemical combustion. Yet this child may be still-born.[29] And Rivera added to his drawings the two man-made metallic shapes—one a plough, the other armor plating—anticipating the peace-war duality of the West Wall. Most of the program of the cycle itself is nascent in this panel. The North and South walls continue this narrative of origins by showing the raw materials of the earth being formed by wave movements of earth and sea. These two sorts of beginning come together in the appearance of the four essential industrial minerals—lime, coal, iron, and sand—in the form of four huge, reclining, androgynous nudes allegorizing also the four races of the earth—red, black, white, and yellow.

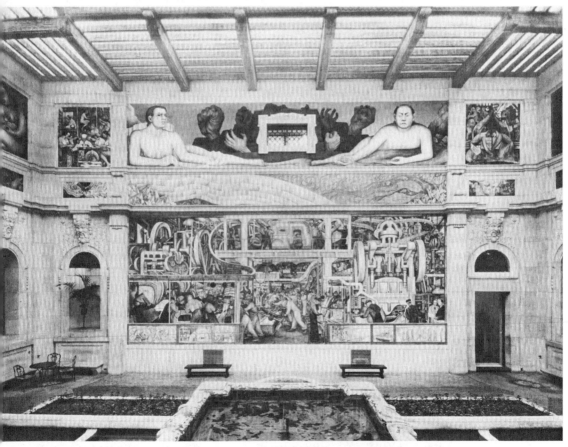

6.3 Diego Rivera, *Detroit Industry*, South Wall, full view, 1932–33. Fresco, Detroit Institute of Arts. (Photograph W. J. Stettler, 1933, Museum Archives, DIA, neg. 3102; © The Detroit Institute of Arts)

Despite obvious visual awkwardness, an astonishing set of implications seems to be in play here. The four races, it is being claimed, emerged from the earth in the same basic way as did the minerals; they are as irreducibly necessary to industry as are the minerals. Is this another example of the grandiose generalizing rhetoric ubiquitous in the frozen classicism of public library academicism in the later 1920s? Or does it defy the distinctions on which racism is based, the reduction of the colored to the subhuman? Racism was, we recall, as much a fact of life in the United States as it was official policy in Germany, notably in Nazi art.[30] More specifically, the East Wall images and these nudes echo Rivera's iconography in the chapel of the Agricultural School in Chapingo (1926–27). In this resumed monastery Rivera matched the processes of natural growth with the stages of revolution.[31] Is there another implication: the equal sharing of the world's riches is a necessity of their harvesting, their transformation? More explicitly, when we connect the upper registers with the main panels in terms of a historical narrative, there emerges a visualization of the sequence of modes of production basic to Marxist analysis: the "primitive," "slave/feudal," Asiatic and capitalist. Rivera's implication here may be that the different experiences and knowledges of all these races have been, and are, indispensable to the development of human industry. And further, Rivera may be implying that the very concept of race is itself inadequate: these are the four elements of humanity—the four corners, the four axes—they are all essential to human productivity; they make up a commonality that transcends their differences.

Pan-American Fantasy

After his two visits to the United States in 1930 and 1931, Rivera arrived at his version of a tendency shared among some Mexican artists and intellectuals—Pan-Americanism. For Rivera, the potential for the unification of the "genius" of the peoples of the two continents was most clearly signaled in the fusion of artistic and industrial achievement:

> The Antique, the classic art of America, is to be found between the Tropic of Cancer and the Tropic of Capricorn, that strip of continent which was to the New World what Greece was to the Old. Your antiques are not to be found in Rome. They are to be found in Mexico. . . . Become aware of the splendid beauty of your futures, admit the charm of your native houses, the lustre of your metals, the clarity of your glass. . . . [In uniting these two, the "antique" Mexican and the new industrial architecture of the United States] Proclaim the Aesthetic independence of the American continent![32]

Detroit Industry is predicated on an epic, historical fusion of "the plumed serpent and the conveyor belt."[33] The grip of this fantasy on Rivera was so strong that, despite his many battles in the United States, he was quick to return for the 1939–40 Golden Gate International Exposition, and to paint a vast mural entitled *Pan-American Unity (Marriage of the Artistic Expression of the North and South of This Continent)* (see fig. 13.6).

The astonishing thing about Rivera's Pan-Americanism was its apolitical assumptions of equality in a situation where the exchange, on every level, was so massively unequal. It casts doubt on my stress on Rivera's political acumen. Given his equally insistent "anti-Americanism"—that is, his attacks on U.S. capital—one can suppose him advancing Pan-Americanism either as consensual diversion to secure space under the cover of which he could get on with more subversive work or as a deferrable dream of desired future. Whichever way it operated ideologically, it was instrumental in the conceptual program of the Detroit murals. Its unreality may well be reflected in the fact that, for all our attempts to discern the underlying unity and continuity of the overall ensemble, gaps and gulfs do persist between the ways the upper and lower registers establish their meanings.

Work Ancient and Modern

At the heart of the matter is the picturing of work. How was this done? Above all, Rivera drags us away from the generality of allegory, placing us right in the middle of the shop floor. The owner, and in this case patron, Edsel Ford, appears modestly, in the bottom right of the South Wall, alongside Valentiner, the commissioner. Individualized workers are shown doing specific, identifiable jobs requiring some skill or physical endurance: at the center of the North Wall, *Making a Motor*, a group of workers struggles with a trolleycart carrying eight engine blocks. Behind them, the processes involved in transforming molten steel into the engine blocks are indicated on the left side, while on the right the making of transmissions is shown. Both are presented in a way at once more general and more specific than the machine slaves figured so emphatically in films from Fritz Lang's *Metropolis* to Charlie Chaplin's *Modern Times*, closer to the descriptions of working in the deafening hell-holes in John Dos Passos' *The Big Money* and in Céline's *Journey to the End of the Night*.[34] Why does Rivera insist that we enter the panels through these straining workers at the front? Perhaps to emphasize that hard physical labor is at the basis of all work, that it persists even in this most modernized environment. Perhaps, too, he did not wish to depart too

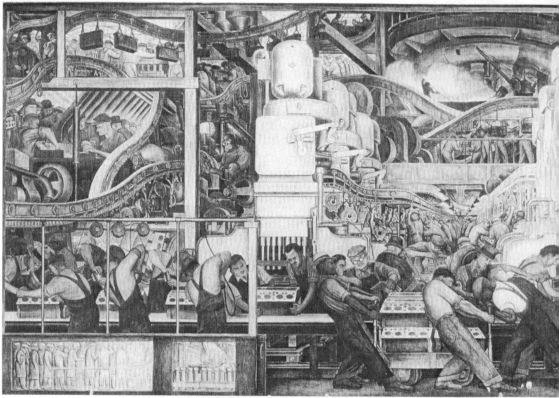

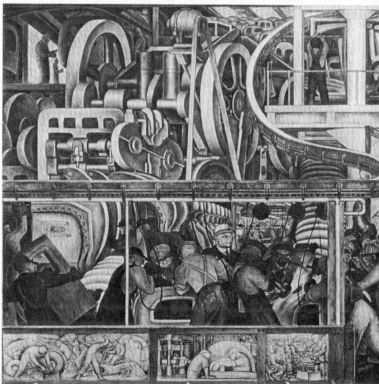

6.4 Diego Rivera, "Making a Motor," central panel of the North Wall, *Detroit Industry*, 1932–33. Fresco, Detroit Institute of Arts. (Photograph W. J. Stettler, 1933, Museum Archives, DIA, neg. 32477; © The Detroit Institute of Arts, Founders Society Purchase, Edsel B. Ford Fund and Gift of Edsel B. Ford)

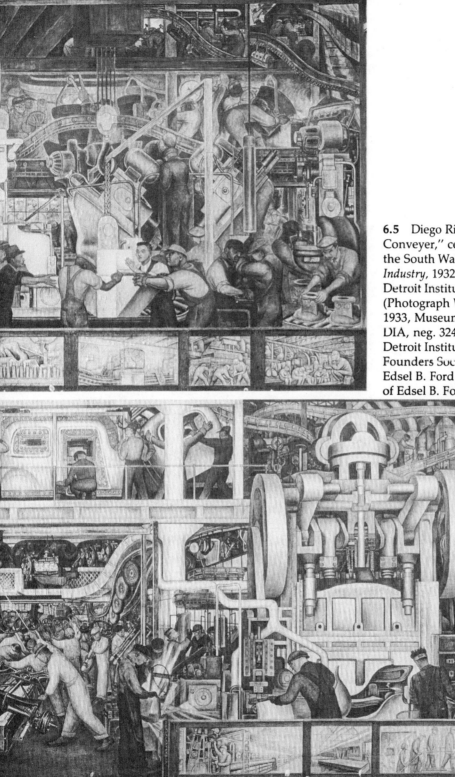

6.5 Diego Rivera, "The Belt Conveyer," central panel of the South Wall, *Detroit Industry*, 1932–33. Fresco, Detroit Institute of Arts. (Photograph W. J. Stettler, 1933, Museum Archives, DIA, neg. 32448; © The Detroit Institute of Arts, Founders Society Purchase, Edsel B. Ford Fund and Gift of Edsel B. Ford)

far from the conventions of Socialist Realism being codified at the time in the Soviet Union. Interestingly, the same position on the South Wall, *The Belt Conveyor*, shows two workers manipulating a chassis on to the assembly line so that its body, being made in the rest of the panel, might be fitted. The treatment here is a little more advanced, implying progress in the passage across the Garden Court, from the earth's fire to the open light.

A central question emerges here: just how modern was Rivera's picturing of industry? The Ford Motor plant at River Rouge, where he did most of his looking, was the culmination of twenty years of the most innovative manufacturing in the world. It was also the largest, the most completely self-contained, and, arguably, the most efficient factory complex anywhere. It was the centerpiece of a modern social order, a way of life for its employees. Its procedures were imitated everywhere. For all the embattled demands of the Depression, River Rouge remained the model, the exemplar, the motor of modern industry. Rivera even includes a party of goggling tourists (at the center of the South Wall). The central principles of the plant's organization were, as we have seen, a commitment to an unprecedented scale of production, the total control by management of every detail of movement and making, the reduction of labor to infinitely small, repetitive tasks, the maintenance of flow from supplier to sales agent, the infinite replication of similar products, and the saturation of all markets. Until the mid-1920s, Ford Company had maintained sufficient market share for it not to have to enter into major advertising battles. The launching of the Model A in December 1927 signaled Ford Company's passage to a new, updated modernity.

Rivera did not follow the advertiser's lead. There are a number of significant ways in which his mural cycle draws back from an enthusiastic modernism. The Rouge River plant was resolutely functionalist: it was this aspect of modern industry which inspired the machine aesthetic of artists as diverse as Charles Sheeler in the United States and Fernand Léger in France. Rivera insisted on retaining the physical facts of hard labor by working men as central, as prior to any abstract metaphor of work. He stressed the world-historical ancientness of industry against the modernist presumption of "everything new." His conception of industry as earth-based, as a developing and a harvesting of resources, is essentially *agricultural*. He dropped the overt depiction of Michigan farming, which was to be the main subject on the introductory East Wall, in favor of a symbolic imagery of germination. He saw industrial workers as peasants—not just because some of them actually had been peasants prior to mass production, and were being actively moved off the land and into factories all over the developed world, but because both types of workers shared the same necessity to sell their labor, were

subject to exploitation, and desperately desired revolution. Furthermore, he visualized the factory not as a clean-lined, self-replicating through-put system but as a set of great machines attracting workers to service it like drone bees: the assembly line reaps labor power, like a combine harvester.

There are three ways in which Rivera's depiction of machines differs from the modernist "machine aesthetic." First, he has an evident interest in showing the spectator how each machine works, what it does, its construction and its functions. Second, he is concerned to show how the machine is worked, what its operator does. In both these ambitions, he has more in common with the engineer-photographer, who had been recording and publicizing the great manufacturing industries for over thirty years, than with the priorities of Sheeler, Bourke-White, or the French Modernists. The recording vision of engineers itself changed during this period, as we saw in chapter 1. Rivera's strongest refusal of up-to-date modernity, U.S.-style, should be seen against this development. Commentators emphasize that he spent much of his first months in Detroit exploring the Rouge plant. He was accompanied by Ford photographer W. J. Stettler, who provided reference photographs clearly used by Rivera, particularly *Spot-Welding Reinforcement Strips on Fenders* and

6.6 W. J. Stettler, *Spot-Welding Reinforcement Strips on Fenders*, Ford Motor Co., River Rouge, Dearborn, Mich., 1932. (Museum Archives, DIA, neg. 2910; © The Detroit Institute of Arts)

Final Assembly of Chassis, "B" Building, in the center and right side front of the South Wall. He may well have also used some of Stettler's shots of conveyor belts for detailing, but the usage stops there. The overall conception of the factory is not one of a rationalized, systematically ordered environment, organized into long, straight corridors around the incessant assembly line, to which workers are robotic servants, in a series of buildings with separated but sequential functions. *Making a Motor* moves us from the steel mill in the center background through various productive processes under the same roof to the engine blocks and transmissions being conveyed at the front. *The Belt Conveyor* panel is about stamping out and assembling the body for its union, with the chassis at the center front. This division between machine and body-making functions recalls that of the first Ford plant, the home of the assembly line, Highland Park. In many ways, Rivera's imagery echoes the photographs taken in 1913 by Spooner and Wells for the industrial engineers Arnold and Faurote, and used by Colvin. A striking instance is *Operations 48–57—Ford Motor-Assembly Line.*[35]

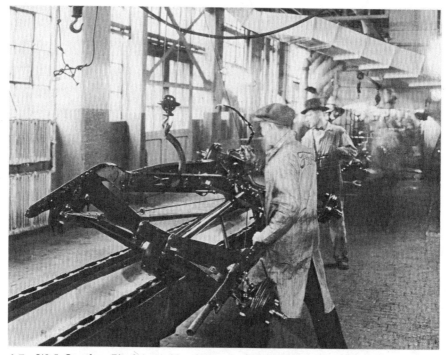

6.7 W. J. Stettler, *Final Assembly of Chassis, "B" Building*, Ford Motor Co., River Rouge, Dearborn, Mich., 1932. (Museum Archives, DIA, neg. 2939; © The Detroit Institute of Arts)

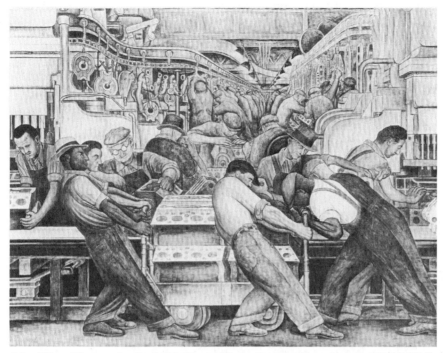

6.8 Diego Rivera, detail of "Making a Motor," central panel of the North Wall, *Detroit Industry*, 1932–33. Fresco, Detroit Institute of Arts. (Photograph W. J. Stettler, 1933, Museum Archives, DIA, neg. 3106; © The Detroit Institute of Arts, Founders Society Purchase, Edsel B. Ford Fund and Gift of Edsel B. Ford)

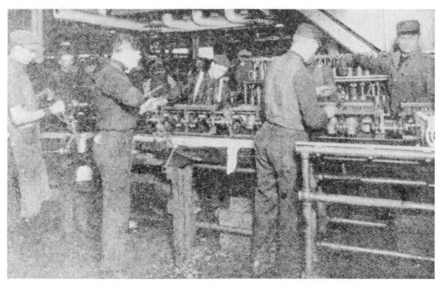

6.9 Spooner and Wells, *Operations 48–57—Ford Motor-Assembly Line*, Highland Park, 1914. (Ford Archives)

Ford operations were frequently photographed in the years following. We noted in chapter 3 the impact of Sheeler's aestheticizing vision on company photographs of the plant. These were used to illustrate Edwin P. Norwood's *Ford Men and Methods*—published in 1931, and likely reading for Rivera—with captions which tied them to the book's narrative of the Ford production processes, sharing its emphasis on machine power and organizational prowess.[36] But the interest in the men and machines at work together was alive in other company imagery. A sequence shot in mid-1924 to record the production of the ten-millionth Model T shows an unusual number of workers in the background anxious to get into the picture, and reveals the ubiquitous overhead chain conveyors as well as the direct handling needed in assembling the engine blocks. Rivera's interest in the junction of engine block and transmission housing at the point at which they begin their journey between the rows of multiple spindles—the focus of *Making a Motor*—may have influenced chief Ford photographer George Ebling in one of his choices for a panel for the Ford Pavilion at the Chicago World's Fair of 1934. Reading back to Rivera's mural, we can see that he has synthesized the operations in the last two photographs, adding in an older emphasis on handling to a system rather more mechanized than it seems in the mural (while the left side remains a slide, on the right side the engine

6.10 George Ebling, Photomural, Ford Pavilion, Chicago World's Fair, 1934. From the collections of Henry Ford Museum and Greenfield Village. (Ford Archives, 0-4176)

blocks—still on little trolleys—are moved along by the chain-driven line). He obscures the turning of the line at this point, making the men at work the key actors down the passageway between the spindles. The size of the spindles has been increased somewhat, but not to the extent claimed by many commentators: the spindles, and the stamping presses on the south wall opposite, were large machines which dominated the floor, as these photographs, and Sheeler's images, demonstrate.[37] In other photomural panels at Chicago, Ebling also responded to the elements of the Sheeler, Bourke-White aesthetic: *Moulding Headlamp Shells* adds to its focus on the worker at work a foreground display of rows of shiny shells. Rivera's insistence on the fundamental equivalent of men and machine power is fundamental to his conception, but it is one which sees these two forces as in dynamic struggle under capitalism, a disequilibrium not a fictive balance.[38]

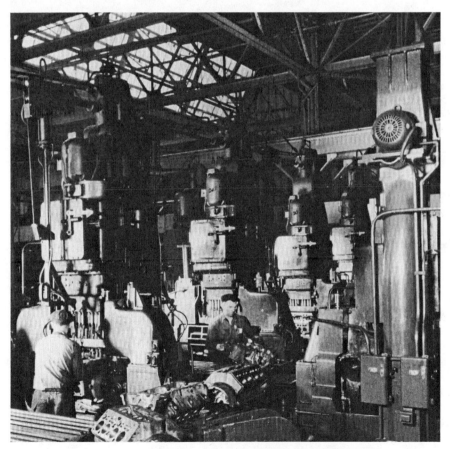

6.11 Junction between multiple spindles, Ford Motor Co., River Rouge plant, Dearborn, 1932–34. From the collections of Henry Ford Museum and Greenfield Village. (Ford Archives, P.189.11049)

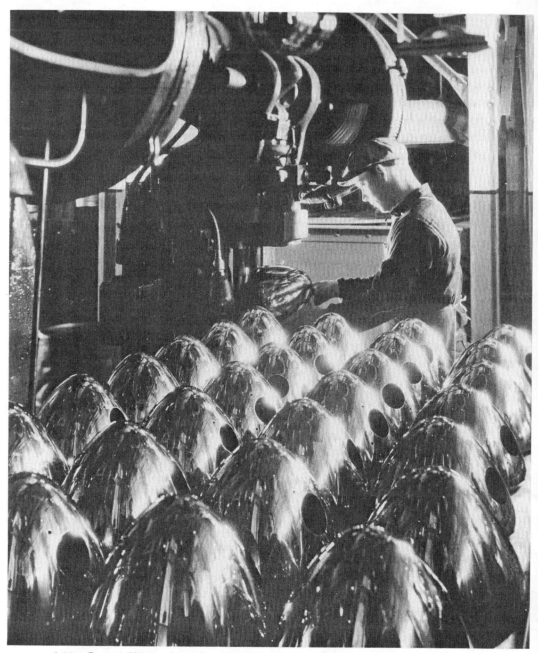

6.12 George Ebling, *Moulding Headlamp Shells*, Ford Motor Co., River Rouge plant, Dearborn, 1932–34. From the collections of Henry Ford Museum and Greenfield Village. (Ford Archives, P.189.11075)

Rivera shares with many modernists a delight in the play of anthropomorphic ambivalences, especially in the larger machines in the automotive panels. Their erotic sensuousness contrasts with the singularly unerotic nudes above them.[39] Yet they have little in common with the sublime indifference of Duchamp's mechanomorphs, nor much with the wham-bang-thank-you-m'am literalness of Picabia's sex machines. They do not suggest robotics or the otherness of things implied by Neue Sachlichkeit lighting. What sustains them is not at all modernist: it is the directness of their Pan-American substitution. The huge stamping presses of the South Wall draw their form from the Aztec goddess of earth and death, Coatlicue—particularly from the large stone statue in Mexico City.[40] Just above "her," on the "high altar," workers weld a car body with detailing like a Mayan Codex. Again, echoes of the Mexican Baroque.

As a mural cycle, *Detroit Industry*, in its fluid excesses, its solid obviousness, its unevenness, its absences, seems to invite the containment of generalization. Orientation to the cardinal points, like the great religious frescoes; movement between dark and light; the eternal battle between the binaries, and between capital and labor, science and religion: students of the paintings have argued each in turn. Rivera has declared his own interest in the history of human industry, in Pan-American fusion, in the Golden Section, and in "the undulating movement which one finds in water currents, electric waves, stratifications of the different layers under the surface of the earth and, in a general way, throughout the continuous development of life."[41] I have drawn attention to the force of already extant representations of industrial work, especially the engineer's narration of these productive processes. But we have also seen that Rivera does not fully follow any of these overall logics. Rather, he absorbs each of them into a volatile flux of visualizations, both generalizing and particularizing in their impact on the viewer. I have stressed that the murals orient the viewer primarily at the junction between the two great "halves" of car making: making the motor, and assembling the whole. The specific sequencing of the Rouge is not followed—the process was, as we have seen, carried out in many separate sheds—so we are not placed in a spot which could be located on a map of the plant. Further, a crucial aspect of car building is absent—the whole set of processes around manufacturing the axles and the chassis. Sketches of the South Wall automotive panel show that Rivera had planned to include the stamping and shaping of the chassis frame in the lower right section: a 1934 photograph shows that the large "Coatlicue" press was the chassis one, not that for stamping fenders. In the fresco

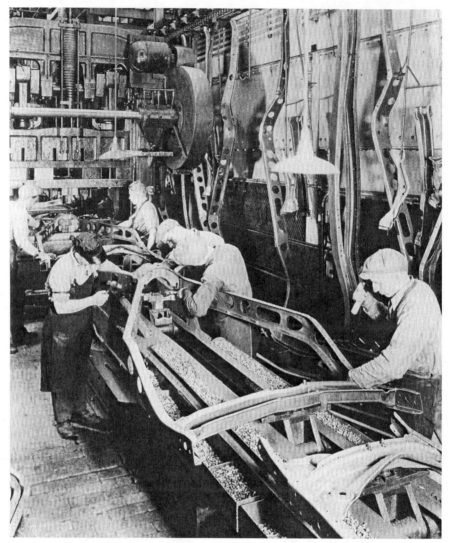

6.13 George Ebling, *Spindles, Stamping and Rivetting Chassis*, Ford Motor Co., River Rouge plant, Dearborn, 1932–34. From the collections of Henry Ford Museum and Greenfield Village. (Ford Archives, P.833.59659)

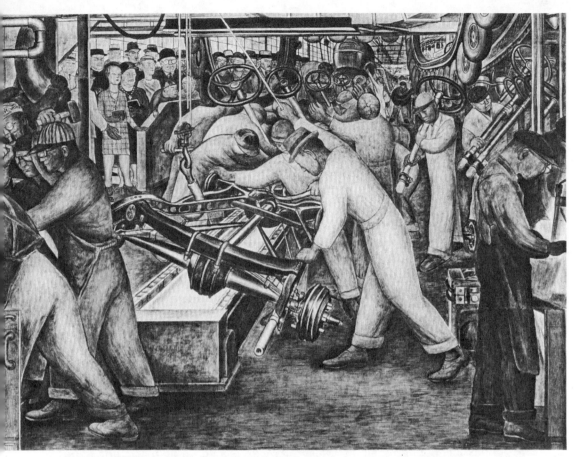

6.14 Diego Rivera, detail of South Wall, *Detroit Industry*, 1932–33. Fresco, Detroit Institute of Arts. (Photograph W. J. Stettler, 1933, Museum Archives, DIA, neg. 3139; © The Detroit Institute of Arts, Founders Society Purchase, Edsel B. Ford Fund and Gift of Edsel B. Ford)

itself, however, Rivera has pictured fender welding, a function subsidiary to the body shaping going on through the rest of the panel. Why?

The chassis appears in the lower middle of the South Wall, complete with axle, being manhandled onto the line (with the help of a crane absent from the sketches). Where did it come from? Is it too much to say: we, the viewers, bring the chassis to this meeting of motor and body, just as we turn from one panel to the other? Does not our act of seeing make us the *bearers* of meaning, the vehicle for the continuity of the work being depicted around us, through us? As we look back and forth, are we not a crucial link in the completion of the chains of meaning of this work of art?[42]

Rivera often said that art's main purpose was to release fundamental human emotions. In a 1940 interview he added, almost as an aside, those of "sex primarily."[43] The erotic quality of the treatment of the large spindles and presses in the automotive panels has been routinely noted by commentators. We have said that they share little with the sensualizing modes of other modernists, from Duchamp to Léger. There is another, larger, sense in which this is true: if we step back and view the North Wall and South Wall automotive panels separately and then in sequence, it becomes conceivable that Rivera was attempting another grand resolution of dualities around a fusing of male and female principles. And, typically, this generality was also specific, that is, it was about sex. Although the various stages in making the motor and engine body are shown in these panels, they are not set out in sequence, nor in spaces linked by engineering logic. They trace elaborate pathways from the upper regions—the blast furnace on one wall, the welded body on the other—around the sides of the panels—through mold making to honing and drilling operations on one wall, through stamping, polishing and painting on the other—to converge at their lower centers where the engine blocks and the chassis, respectively, begin their journey back into the depths of the factory. There are, of course, many subsidiary operations feeding this fundamental pattern. Does not this convergence, on both walls, imply a pelvic shape, if read literally? Further, if the multiple spindles at the center of the North Wall are "erotic," are they not so as images of gonads at the entrance to the vagina? Would not the appearance of the engine blocks at this point imply semen entering a passage of impregnation? *Making a Motor* is an entirely masculine world in its peopling; this junction concentrates physical labor, male bodily power. We have just turned from the germination themes of the East Wall. Could it be that our viewing, our act of seeing, is itself an act of love, one which speeds the engine blocks down through the rippling passage between the erect spindles?

This extraordinary reading does not stop there. If we ask what has happened to the semen/engine block after its disappearance into the warmly glowing distance, we need only turn around to the center of the South Wall to find it reappear as fully fitted-out engine, complete with doglike "ears" and "legs" (a visual joke repeated in the "predella" panel below in which Henry Ford lectures the workers). The engine hovers above the chassis, ready to be gently maneuvered onto the chassis. If one traces the convergent pathways around this panel, they pass through huge machines echoing Mexican goddesses, which are shaping the rounded parts of the car's body, and decorating it. The feminizing metaphors here scarcely need underlining. The whole panel might be

seen as a womb, the engine a fetus. Few women workers appear, as previously noted, but women are prominent among the visitors watching the final stages of assembly, where chassis, motor, body, and the lesser elements of the car come together. The watchers are mainly cartoonlike caricatures of the band of clergy, wowsers, and other reactionaries who sought, in the last days, to whitewash Rivera's mural. If this interpretation is correct, his ridicule of them also includes obliging them to act as midwife, to be figuratively in the swim with the natural action which matches the sex act occurring on the opposite wall. If the rippling effect there indicates the thrusts of impregnation, here the sharp shift through space marks the ultimate assembly line, the passage of birth.

Two subsidiary points add to the resonance of this interpretation. Coatlicue is the Goddess of the Serpent Skirt, and Rivera's model—the famous fifteenth-century stone carving in the National Museum of Anthropology in Mexico City—summarizes the warring dualities of Aztec cosmology. Among these are the equally strong masculine and feminine principles: serpent, dress, breast, and turtle figures switch through the sculpture as do male-female fusions in and between these two panels. Another relevant duality is, of course, birth and death. Sexual organs appear on other walls: on the South Wall as a diagram in the *Surgery* panel and on the West Wall, at either side of the exit, symbolized in the steam power pipes at left and the turbine tubes at right.[44] The symbolic sequencing of these panels is, on the left, steam, old-fashioned power, masculinity, worker resistance and oppression (the last implied in the heads' down workers' lunch scene planed for the space below but shifted to a predella panel on the North Wall), and, on the right, electricity, new power, femininity, manager/engineer/boss, ruler (literally)/instuctor.

My claim is that, within all the partial narratives—religious, historical, philosophic, technical, cross-cultural, racial, artistic—at work in this mural cycle, Rivera also sets in play an extraordinary reading of the current stage of industrialization, and the role of humanity (including womankind) within it, as creators, drones, and victims. Only by metaphorical inference are machines and flesh actually fused; everything depicted is verifiable by observation. Except, that is, the overriding compositional order: my suggestion is that here, on an epic scale, and through the power of the rhythms, technology has become body, that the most modern system of machine production in the world has been presented within an imagery that is as ancient as mankind, and which is arranged around the two seminal acts, conception and giving birth. This absorbs all the dualities previously listed, plus others, such as male-culture, female-nature. It also, Rivera might have hoped, brings together

the themes of all the murals—the figures above, the corner panels, the two end walls. It is breathtaking in its literalness—some might say crudity. It is exceptional in what it demands of the spectator: to be the inseminator, the life giver; then, in turning to the other wall, the deliverer, the life maker of a new order of working, the basis of a perfectible social order. If we take all the murals together, the message becomes: along with the work of the earth itself, of chemical fusion, of science and technical invention, of the new forms of organized work, of the sweat of working men and women, the meaning being created as we read these murals is a contribution to the creation of a new sociality. This is awesome in its optimism.

The final refusal of modernist hegemony occurs in a number of absences. Electrical power to the plant, for example, is confined to thin panels on the West Wall, and the electrification of the car is not shown. Women workers, who assembled the car's electrical systems, and did much else besides, appear in the upper right corner of *Chassis Assembly* and in the *Pharmaceutical* panel, upper left South Wall. Even more remarkable in the context is the virtual absence of the new consumer society. Oriented above all around the usable object, designed to look utterly original, machine-made and of its times, consumerism is, in this mural, denied its fetish. The new Ford V8 exists in the South Wall as a scarcely distinguishable blot through a door in the distance. All this work for nothing? No, all this work for its own sake, because human society has its past, present, and future in productive work, not in exchangeable commodities. It is always this general—thus the world-historical allegorizing; and it is always this specific—thus Rivera has painted not "The Machine Age," not "Industrial America," not even a "Portrait of Detroit." He has painted "Working for Ford." Rivera's outlook was, in sum, essentially historical, that is, about human growth through work and struggle. It lacked the futuristic utopianism more typical of modernists, in both art and business.

The Artist as Sightless Visionary

What artistic vision sustained the Detroit project? Rivera's conception has the grand sweep and the obsession with detail of an epic novel. But this is also the worldview of a historical materialist—epochs in the nitty-gritty, human history in every act. A minor key is a conception of the artist not as creator or orchestrator, but as observer-victim of the historical (to him, natural) forces flowing through him. Rivera's sense of this is signaled by his self-projections: in the upper left corner of the North Wall, his unmistakable features appear on a bowler-hatted figure. Like Raphael in the *School of Athens*, he turns away from the direction of the

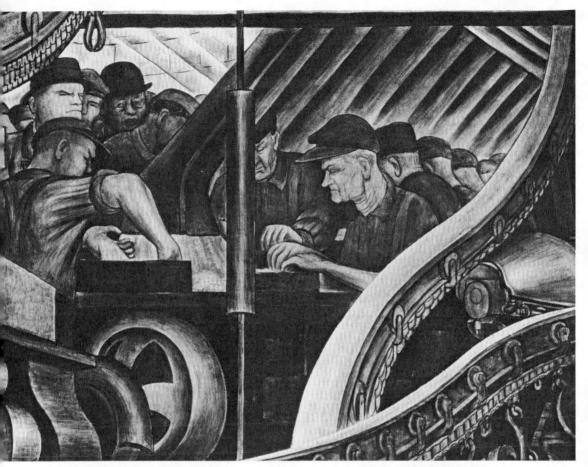

6.15 Diego Rivera, "Mixing Sand," detail of "Making a Motor," central panel of the North Wall, *Detroit Industry*, 1932–33. Fresco, Detroit Institute of Arts. (Photograph W. J. Stettler, 1933, Museum Archives, DIA, neg. 3116; © The Detroit Institute of Arts, Founders Society Purchase, Edsel B. Ford Fund and Gift of Edsel B. Ford)

gaze of others nearby to look out of his painting. Like Michelangelo painting his own face in the cloth of the condemned in *The Last Judgment*, Rivera portrayed himself in a position of—to put it mildly— extreme uncertainty. First, he gave himself mulatto pigmentation; then he positioned the artist as an observer, indeed, a visitor-inspector, entering the factory on the side of management (with the permission, perhaps the eyes, of management). Not, that is, as a worker, as his statements outside the factory claim. Beside him a green-skinned, mean-faced foreman watches, like a hawk, the men mixing and packing sand for molds.

In the play of gazes across the court, this position evokes the hard-driving Sorensen on the lower left of the South Wall: two acute observers of the Ford system echo each other. And opposite, below, Rivera is Edsel Ford, the donor, and Valentiner, the enabler. Their gazes do not meet, because Rivera's eyes have rolled up into his head. Think of the readings unleashed through the veil of the mural by the multiple possible interpretations of this white-eyed aversion! The disguised intruder's fearfulness (will I be caught yet again, will get away with it?); or the prophet's dry-mouthed dread at his gamble with history, with future judgment. Is there guilt at being in the factory in the manager's powerful position (some, perhaps, not much); or maybe the eyes are turned away in horror at what he sees (the exploitation, it's too much)? There is, too, the ecstasy, the awe, the sublime experience of seeing god/nature/history all at once in their essential interdependence. In the midst of this, at the mercy of these forces, is the agonized surrender of the artist submerged by his creation, made blind by its completion: the all-seeing and sightless visionary.

6.16 Diego Rivera, detail of "The Belt Conveyer," showing Edsel Ford and William Valentiner, central panel of the South Wall, *Detroit Industry*, 1932–33. Fresco, Detroit Institute of Arts. (Photograph W. J. Stettler, 1933, Museum Archives, DIA, neg. 3131; © The Detroit Institute of Arts, Founders Society Purchase, Edsel B. Ford Fund and Gift of Edsel B. Ford)

The Slow Speed of the Revolutionary Mural

What of Rivera's treatment of that other great subject of modernity—the future? Is it here that his refusal of artistic modernism and new corporatist modernity takes on an overtly political edge? Elie Faure thought so: "The poetry of the machine which was born in the frescoes of Mexico and San Francisco dominate those of Detroit: flames escaping from drills, dazzling, crackling motors, silent and dancing rhythms of rods and pistons—all these beat the cadence of a new march—the rehearsals of a still silent humanity."[45]

The French poet here applies a Third International reading to these murals: industrial workers of the world, strengthened in their work, form communal bonds under revolutionary leaders and rise up to establish worldwide workers' power.[46] Rivera certainly adhered to this kind of conception in the planning of his Mexican murals and was to return to it in New York in 1933. To Wolfe this message is conveyed in these murals, not in directly agitational terms, but by their positing a man-machine unity beyond class struggle: "He would paint the human spirit that is embodied in the machine, for it is one of the most brilliant achievements of man's intelligence and reason; the force and power which give man dominion over the inhuman forces of nature to which he had so long been in helpless subservience; the *hope* that is in the machine that man, freed by it from servitude to nature, need not long remain in servitude to hunger, exhausting toil, inequality and tyranny."[47] On this reading, Rivera becomes "The Giotto of the UAW," the artist of work after the revolution. It is a reading bedeviled by all the abstractness of wishful humanism, the same urge to other generalities which constantly blunts edges, blurs distinctions in the passageways down which Rivera propels us. But it may also be a prefiguration of a possible communist modernity, a different kind of reworking of past and present into a nonutopian, practical materialist future—an inspiration not only to many artists, but to many in the reborn union movement, especially in the automotive industries.[48]

The final steps in the sequence occur on the West Wall. An allegory of choice is played out: workers and capitalists are the envisaged actors. Around the slogan "Vita Brevis Longa Ars" are arranged the framing panels of a scowling Henry Ford, engineer and manager, an amalgam of Thomas Edison, matched by a smiling red-starred worker.[49] The dove and the hawk above accentuate this, as do such details as the face/skull floating above the ships plying between Central and North America in the agriculture/industrial labor panel. The "predelle" below the automotive panels picture a hinterland of dominated work: ghostly, robotized

workers, pale machines, and haranguing bosses. Certain juxtaposition-ings convey the same message: on the North Wall above *Making a Motor*, next to the allegories of the red and black races, the *Vaccination* panel is matched by one of bomb building, and on the South Wall, above *Chassis Assembly*, next to allegories of the white and Asiatic races, the *Commerical Chemicals* panel is matched by one in which the making of life-giving pharmaceuticals is turned into a capitalist industry, blessed by the Church.[50]

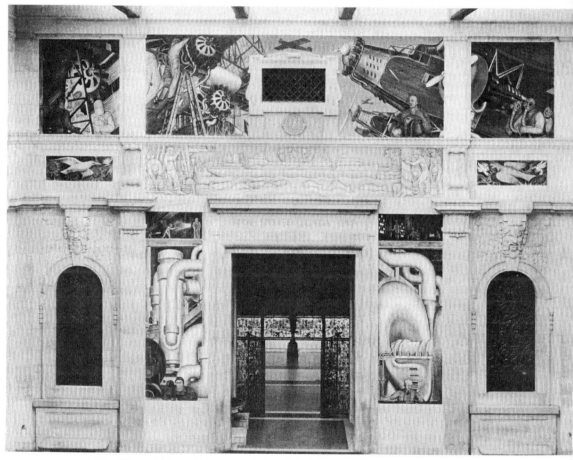

6.17 Diego Rivera, West Wall, *Detroit Industry*, 1932–33. Fresco, Detroit Institute of Arts. (Photograph W. J. Stettler, 1933, Museum Archives, DIA, neg. 3103; © The Detroit Institute of Arts)

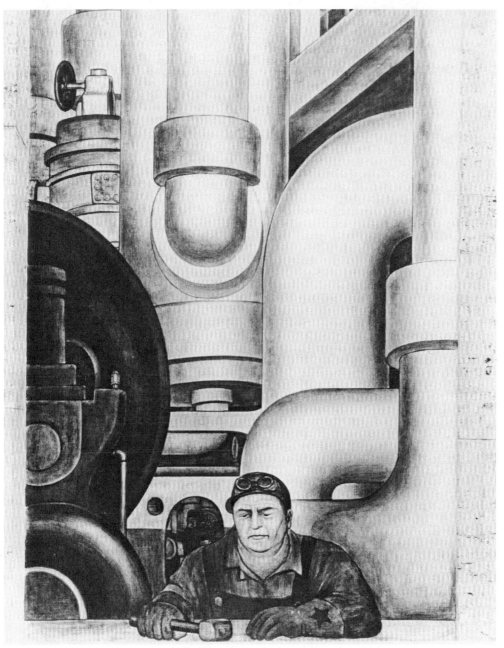

6.18 Diego Rivera, detail of West Wall, *Detroit Industry*, 1932–33. Fresco, Detroit Intitute of Arts. (Photograph W. J. Stettler, 1933, Museum Archives, DIA, neg. 21872-C; © The Detroit Institute of Arts)

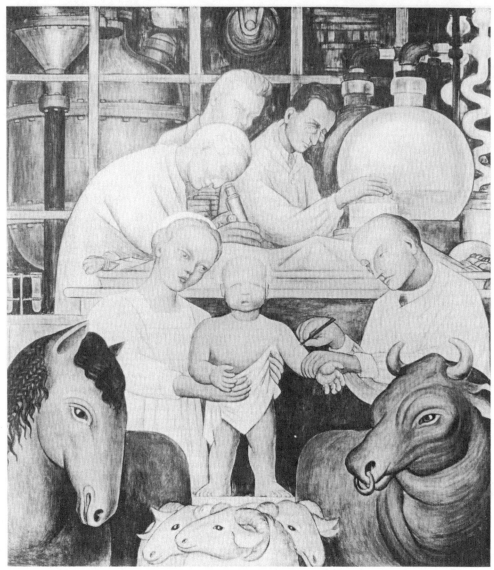

6.19 Diego Rivera, "Vaccination" panel, North Wall, *Detroit Industry*, 1932–33. Fresco, Detroit Institute of Arts. (Photograph W. J. Stettler, 1933, Museum Archives, DIA neg. 3120; © The Detroit Institute of Arts, Founders Society Purchase, Edsel B. Ford Fund and Gift of Edsel B. Ford)

Given the intensity of social unrest and political debate in Detroit in 1932 and 1933, these images are more than allusions, more than minor irritants. They fall short of overt provocation. But this should not be expected; it would have meant the instant end of the project, as it did in New York. These images also connect with the structural pathways I have presented to amount to an ideological time bomb, a revolutionary mural with a slow fuse. Seeing these murals is to be unavoidably faced with a choice: this new world has the potential to grow either for the good of humanity in general and the workers in particular, or destructively, to the profit of a few. As with his drawing for the Rockefeller Center mural, made at this time, the choice is not posited for any class or group; rather it is directed at each individual viewer. Its fullest impact would be on those able to decode allegory, symbolism, complex visual trajectories—in the first instance, the ruling elite of Detroit, the managers. "These are your powers, please use them wisely" is the message of the West Wall. Yet the two major walls go further: they depict, in Kozloff's words, "a format of terrifying and beautiful creativity . . . a kind of gorgeous inferno, unnoticed by all within it. Everything that occurs there is subject, and possibly sacrificed, to an unknown, inexorable will."[51] The will is, as we have seen, an ensemble of certain quite different kinds of will—that of the Earth, of Industry, of Ford Company, of modernity, of mass production, of U.S. Industry, of the Machine, of workers' labor. If Rivera was attempting, on the West Wall, to gently persuade Detroit management into choosing for the good, on the main walls he was trying to terrify them into it.

It is not surprising that the Detroit Institute of Arts is to this day part of the itinerary for new executives in Detroit, nor that it is an essential visit in the orientation programs of new recruits to the United Autoworkers Union. Reuben Alvarez, Ford foundry worker and UAW official, recalled: "When we organized the union at Ford, we used to bring delegations down to see the murals. Those who lacked words brought people down here to sign them on. They were . . . inspirational."[52] Renaissance usage certainly finds an echo here, but the "living bible" becomes a visual testament of the new unionism. Rivera's ultimate negotiation was to place the murals in this position as a living historical reference. It never was, however, a neutral one. Above all, the murals project the power of industrial productivity as a set of specific powers exercised by men working machines. Management may have power over this power for the time being, but not necessarily forever, certainly not for as long as the mural itself will survive. Life is short, and art is long—especially when art is about the important, persisting fundamentals of life, about work and about struggle.

Co-option and Controversy: A Modern Form of Patronage?

The destruction of Rivera's mural at the Rockefeller Center, New York, in February 1934, after ten months of controversy, is famous—and infamous—as the clearest expression in the visual arts of the crisis then engulfing all spheres of U.S. society. In contrast, the controversy over the Detroit murals, flaring briefly in March and April 1933, seems at most a lively footnote to an otherwise relatively (even surprisingly) straightforward project.[53] All parties drew positive, constructive lessons from it. Attendance at the Institute of Arts increased dramatically, and the murals have continued to attract Detroiters and visitors ever since. Rivera said soon after that "establishment" calls for the whitewashing of the murals, and the strength of the "united front" of industrial workers in their defense, reinforced his resolve "to make the greatest contribution I am capable of to the aesthetic nourishment of the working class, in the form of clarifying expression of the things that that class must understand in its struggle for a classless society."[54] This is the basis of his Rockefeller Center program and, perhaps, an important reason why it was projected with such (again surprising) political explicitness. Along with Rivera's need to demonstrate his radicalism to his critics in the New York Communist Party, his victory in Detroit may account for the shifts in emphasis from the sketches which had been submitted to the Rockefeller Center architects from Detroit, prior to the controversy.[55] The liberal establishment, on the other hand, regarded the successful completion of the Detroit project then, and now, as evidence of both the city's maturity and the social value of their new style of enlightened patronage, particularly support for modern, contemporary art. The inspired ideological contract is explicit in the words of Detroit Institute director William Valentiner: "Rivera and Edsel Ford understood each other very well; which seemed to prove that the world would probably be more peaceful if representatives of opposing social orders were constantly in personal touch with each other or were even forced to work together."[56]

That social conflict was hardly absent from Detroit is obvious in the very occurrence of the controversy. The difference lies in the ways the two battles were managed. It can now be shown that what Nelson Rockefeller and his architects achieved with hammers, Edsel Ford managed by the most modern of means—the advertising campaign. Both reasserted the power of their class over cultural definition at a time when that power was profoundly threatened. Both attempted to counter and contain public antipathy by popularizing some of their domains, namely, the "city within a city" of the Rockefeller Center itself. It can be shown that, in the case of the Rivera murals, Ford succeeded where

Rockefeller failed. As well, the relative calm of both artist and public in Detroit compared with their vehemence in New York ceases to be surprising. The Detroit controversy, I argue, was a classic instance of manipulating public opinion, of co-opting radical discontent through organizing its expression in a controlled way.

What were the conditions of the controversy? The murals themselves, for all their transhistorical generalizing, their celebration of the abstract power of modern industrial processing, place the spectator "on the line," in the factory space. They celebrate skilled manual work and contain various political-ideological irritants aimed at provoking the consciences of spectators with some social power. Although not as politically explicit as many murals painted in the United States in the early and mid-1930s (including, of course, his own subsequent Rockefeller Center mural), the Detroit frescoes were stronger than most. Indeed, a loud clamor for their destruction, on the grounds of their evident radical subversiveness, their "communism," would, at this time of crisis, be predictable. Yet such a demand forms only a minor theme in the many statements attacking and defending the murals, extensively reported in the newspapers of the time and well documented ever since.[57] Does this absence confirm interpretations of the murals' pusillanimous ineffectivity, or does it imply a political message so powerful that it had to be skirted around, lest it arouse dangerous passions better diverted to an older, ultimately innocuous agenda? I suggest another explanation, one which acknowledges the complexity of the murals' invitations and the sophistication of most of its viewers, then and since.

Further conditions of controversy remain to be sketched. Another key factor was Rivera's reputation. I have shown it to be double-sided. Revered in Mexico, Rivera became an important item of cultural exchange within the economic war-by-other-means being conducted between Mexico and the United States. We have also seen that his international reputation as a major modernist painter, of the stature of Picasso and Matisse, led to a quite different reading of him by the younger generation of patrons in the United States. In 1930 and 1931 he was lionized by the West Coast wealthy, even painting an *Allegory of California* in the stairwell on the way to the Luncheon Room of the San Francisco Stock Exchange, his radicality confined to reminding hungry brokers of the earth from which their food came and the workers who labored to make it edible! By 1931 in New York, he was presented at the Museum of Modern Art as both a modern Michelangelo and a Romantic naïf. Invitations to do murals at Rockefeller Center and the Chicago Exposition quickly followed. On the enthusiastic advice of professionals such as Barr and Valentiner, the new patrons accepted that the often-avowed political radicalism of artists such as Picasso and Rivera meant little

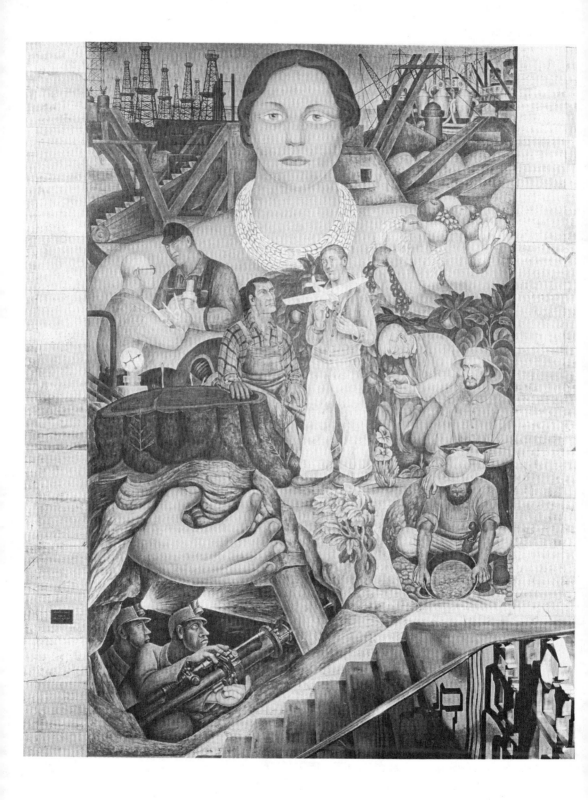

alongside the more fundamental truth they embodied: absolute artistic autonomy, the independence of true genius. In 1931, when seeking support for his idea of bringing Rivera to Detroit, Valentiner wrote to Eliel Saarinen at Cranbrook: "the one difficulty that some people may present is that he is inclined to Communism, but since the Mexican government let him do whatever he wanted with his subject in government buildings, although they were rather radical, I do not see why one should not overlook his political convictions, since he is a great artist."[58] Rivera's passage through America would sorely test the depth to which such liberal convictions were held by the new corporation bosses, even when they were confined to the value-volatile domain of art.

To what extent Rivera was complicit in this process of depoliticization is impossible to estimate. He had learned in Mexico to state his program in the most general terms, becoming explicit as the paint went on, the plaster was drying, and it was too late for changes. This became his procedure in the United States. Rudolf Valentiner did not foresee such a strategy when, entranced by the prospect of a Renaissance revival within his Baroque-style museum, he proposed Rivera to paint the Garden Court. The major donor, DIA patron Edsel Ford, is on record only once about the murals, briefly defending them at the height of the controversy, espousing admirable liberal sentiments in the process: "I admire Rivera's spirit. I really believe he was trying to express his idea of the Spirit of Detroit."[59] Ford's support for Rivera—at least his apparent refusal, as president of the DIA Arts Commission, to buckle under to pressures to whitewash the murals—earned him much credit at the time and has adorned his reputation since.[60] That he was, in fact, involved in a different game will emerge in what follows.

Yet the depoliticization of Rivera was occurring only at the level of a sophisticated cultural elite. In public terms Rivera remained a "people's artist." Was, then, the invitation for him to create a major work in Detroit a political gesture, intended to mollify widespread negative opinion at a time of crisis? The other major precondition of the controversy has already been introduced: the highly charged political and social situation of "Depression Detroit." In July 1930, Congressional Committee hearings on the "Red peril" heard witnesses state that between fifteen

6.20 *(facing page)* Diego Rivera, *Allegory of California*, 1931. Fresco, 43.82 sq. m. Pacific Stock Exchange Luncheon Club, San Francisco. (Photograph Dirk Bakker; © The Detroit Institute of Arts, Founders Society Purchase, Edsel B. Ford Fund and Gift of Edsel B. Ford)

hundred and five thousand Communists were active in Detroit.[61] Rivera arrived there in April 1932, one month after Dearborn police had killed four of the hunger marchers advancing on the Rouge plant, and left in March 1933, one month after the first major "Depression strike"—of six thousand workers at Briggs autobody manufacturers in leased buildings at the Ford Highland Park plant. The Ford Company had a long history of antipathy not only to "Communist agitators" but to any form of unionization whatsoever, successfully breaking up attempts to form national autoworkers unions in 1926 and 1933.[62]

The calls to whitewash Rivera's murals also occurred during another, related crisis. In February 1933, the Michigan banks collapsed, precipitating a national moratorium. Triggering the collapse were the speculative excesses of the Guardian Detroit Union Group Inc., of which Edsel Ford was the principal figure. He is reported to have lost $15 million.[63] More drastically, the city of Detroit itself had been faced with bankruptcy since 1931. The Detroit Institute of Arts, built for $1 million in 1926, with a collection valued at $10 million six years later, was subject to an 80 percent budget cut in 1932, surviving only on Edsel Ford's gifts and the unpaid work of staff.[64] By early 1933, Valentiner recalls, "There was talk at City Hall of closing the Museum, even of selling its art objects."[65] Certain unpublished letters reveal the depth of desperation then felt by the director and chief donor. Valentiner wrote to Ford in November 1932 offering his resignation in favor of someone "who is more able and more interested in popularizing art than I am."[66] Ford and Kahn persuaded him to stay, but he resigned again in April 1933.[67] Early in March of that year, Ford himself wrote to the mayor resigning from his position as chairman of the Arts Commission of the DIA, only agreeing to stay on the grounds that his leaving would precipitate total loss of confidence in the institution. His letter withdrawing his resignation is dated March 20, the day the controversy broke out well and truly.[68]

A city divided, its major industry internally embattled, its economy in ruins, its major cultural institution on the edge of closure—this is the climate in which Rivera brought his murals of Detroit Industry to completion. Small wonder that he added, on the final West Wall, provocative juxtapositions of war and peace, division and harmony, the United States and Latin America. Nor should it surprise us to find Edsel Ford, head of the most hated institution in Detroit, and the DIA, its most vulnerable institution, seeking to capitalize on Rivera's reputation, to forward himself and the institutions as sharing Rivera's populist outlook. If we examine carefully the nature of the controversy, we find that this, indeed, is exactly what happened.

Manufacturing the Masses

As indicated earlier, the successful defeat in Detroit of the call for white-washing was interpreted by Rivera as a triumphant affirmation of his art by those to whom it was primarily directed—"workers and students," "the ordinary people." The defeat was interpreted by the city's intelligentsia as a victory for liberal, civilized values. It seems surprising that, among the very active labor press, only one even mentioned the controversy: the Industrial Workers of the World writer provided a most graphic portrait of the attackers.

> The Reverend Ralph W. Higgins, snooping sky-pilot who headed the Mayor's Fact-Finding Committee in the Brigg's strike, led an organised group of high churchmen into an attack upon the mural. . . .
> "Busy-body" Higgins is supported in his protest by female higher-ups in the Women's City Club. In the last named organization, Mrs. William F. Connally, wife of ex-Judge Connally, treasurer of Briggs Manufacturing Co., along with Frs. Luther and Eugene Paulus, Jesuit teachers, discover in the Rivera murals "a subtle blasphemy that affronts every Catholic."[69]

Why was anger largely confined to such religious groups and focused on the presumed blasphemy of the *Vaccination* panel? What of the other major interests in the city—from older wealth to the other new corporatist manufacturers? Few seemed publicly concerned at the murals' supposed insult to the city; indeed, Edsel Ford spoke out in their defense, in defense of Rivera's spirited expression of the spirit of Detroit.

Staff of the DIA conducted a lively and effective defense of the murals, stressing the integrity of any artist's creative freedom as well as Rivera's specific celebration of the working people of Detroit. A newly formed People's Museum Association organized debates and secured four thousand signatures on a petition for the murals' retention.[70] On the weekend of March 25 and 26, between ten thousand and twenty thousand people flocked into the DIA. The role of the PMA was, clearly, of pivotal importance.

Was the People's Museum Association the "defence committee . . . made up of representatives of Detroit labor and radical organizations," as mentioned by Wolfe and implied in its name?[71] No, the PMA had been incorporated in June 1932 "for the purpose of arousing public interest in the DIA; to advance the knowledge and enjoyment of its collections in every possible manner; to promote and augment its usefulness amongst the people of Detroit and its suburbs." It had attracted nearly

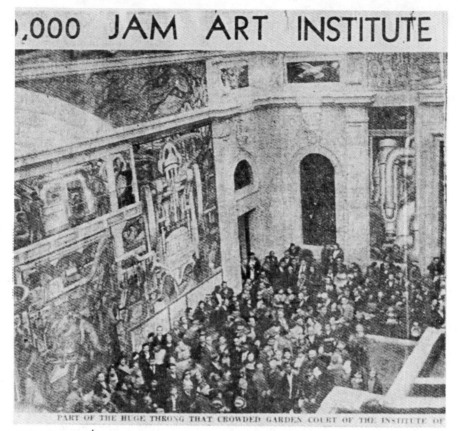

PART OF THE HUGE THRONG THAT CROWDED GARDEN COURT OF THE INSTITUTE OF

6.21 "10,000 Jam Art Institute," *Detroit Free Press,* March 27, 1933. (Museum Archives, DIA)

a thousand members during its three-year existence, at a fee of $1.00 each. Many joined during the controversy, but most joined afterward when public lecture programs on topics from natural history and contemporary exploration were offered. While thousands regularly came to these meetings during and after the controversy, membership did not spread much beyond those who were already members of the Founders' Society and the Detroit Society of Arts and Crafts. Among the PMA's directors can be found a schoolteacher, a journalist, and Mary Chase Stratton of Pewabic Pottery, but the active members were George F. Pierrot, editor of *American Boy–Youth's Companion* magazine; H. G. McCoy, Detroit representative of N. W. Ayer and Son, Ford Company's advertising agency; and, as president, Fred L. Black, personal assistant to Edsel Ford, director of Ford Company advertising and, later, of the extensive Ford Company contribution to the expositions and World's Fairs.[72] Hardly the most obvious representatives of the people of Detroit rising up in defense of their beloved cultural institution.

In his reminiscences Valentiner puzzled: "the opposition in Detroit: I was never able to find out exactly how the attacks started."[73] In his reminiscences, Fred L. Black answers this unequivocally. Instructed by his exasperated and financially harassed boss to make clear to the Council that there were votes in funding the DIA, Black gathered fellow publicists McCoy and Pierrot, came up with the idea of a PMA, in the course of working for which Pierrot seized the opportunity to "get the Museum on the front page" by gathering certain clerics and reporters in front of the *Vaccination* panel and asking them whether they thought it was blasphemous. "We kept that pot boiling for three or four weeks," attracting eighty-six thousand people to the Institute during March. This enabled Burroughs to approach the Council with "huge lists of names" (Black claims five thousand members), eventually convincing them to vote support for the Detroit Institute and relieve Edsel Ford. Black claims that he consulted Ford about every step, who "laughed. He thought it was a great scheme. We'd accomplished the thing he wanted done."[74] In 1979, in information provided to Ford archivists, Pierrot agreed that he "took fullest advantage of this unexpected opportunity to promote the Museum," but denied that he had created the controversy, attributing it to Christy Borth, night editor of the *Detroit Free Press*, saying that the latter faked a condemnatory letter to himself charging that Rivera "promoted communism," painted "oppressed and overworked workers," and "pornographic" naked women, and did "blaspheme the Holy Family."[75]

Whether Pierrot actually triggered the controversy, whether the PMA fueled it by provoking reaction as well as by mounting a noisy defense of it, they certainly became major forces in managing it. Whether Edsel Ford recognized, in April 1931 when the Rivera proposal came forward, an opportunity to improve both the public and cultural stocks of himself and his company is moot. But two years later, in the situation outlined here, there is little doubt that he would have blessed the scheme. (It was, as well, quite consistent with the kind of risk taking on which the Ford Company was founded. It was a trick that would have pleased his father.)

The doors of the DIA stayed open during the crucial weeks while the Council decided its immediate and long-term future, its halls filled with people, many of whom signed petitions of support for the murals, many of whom attended the public lectures. The Institute was, literally peopled—visibly popularized. The threat of closure receded; the Council slowly found ways of resuming the costs. Taking a broad view of the elements which came into conjuncture in the controversy of March— April 1933, certain readings suggest themselves. The desire of the "new industrialists," especially those of the second generation, to develop a new, "modern" culture for their class (to, at least, bring up to date older

cultural passions and practices) is evident in Detroit in many ways, but the DIA was its most prominent repository (in the Fort Knox sense of housing standards). A mural created within the Institute at this moment could be expected to reflect this urge, to represent this new culture, and to eternalize it, "since where else could a building be found nowadays that would last as long as a museum?"[76] Ford Company modernity implied the impermanence if not yet the rapid obsolescence of other structures, but it grasped for the permanence of its own order of continual self-invention. Where could an artist be found to figure forth this new culture, its special beauties, its innovative terrors, its predictive order, its unprecedented energy? In 1930, capital had no visionaries; all of the best artists were engaged with problems of form and decoration, with personal pleasures (such as Matisse), or were in opposition (such as Picasso and Rivera). The question of why a U.S. artist was not chosen is a diversion from this harder issue.[77]

Yet, in the United States in 1930, this new culture, like its bourgeois predecessor, was profoundly threatened, particularly in Detroit. Rivera was commissioned in May 1931; at any point until he started painting in July 1932 the project could have been halted on financial grounds alone. That it was not honors all concerned. But, in this volatile situation, the going on with the mural and the management of the controversy have one thing in common: a bold gamble to popularize the new culture, to secure its survival during this period of threat (how long? temporarily or perhaps "the people" will permanently be in power), to sink it at least partly "in" the people, through the imagery of an artist who figures their aspirations. It became necessary to recruit realism, to co-opt criticism. The gamble with the mural was twofold: it could turn out to be either aesthetically feeble or intolerably politically overt. The Rockefellers lost on both these scores. Edsel Ford won this battle, as we have shown: the mural was, in all its contradictions, a match to the larger social contradictions operative at this time. In contrast, Sheeler's imaging would cut little ice, with its submergence of the contradictions.[78] Fred L. Black, perhaps inadvertently, summed up the controversy, wisely pointing us away from the walls themselves if we are to find the real source of the controversy: "As a matter of fact, the murals were all right. The principal fight was in having a guy like Rivera do them."[79]

This points us at the gamble taken by Edsel Ford and his fellow publicists in their staging of the controversy. (I mention only Ford, Black, and Pierrot here, as no evidence suggests that any of the Institute staff knew of the staging. Nor that Rivera did. If the successful defense of the mural did, as Rivera says, inspire him to a stronger statement in New York, then he too was victim of the manipulation.) As with any gamble

worth taking, the publicists risked the lot. "As a matter of act, we were a little worried sometimes, that somebody would take it into his head to deface them. That was never done, but it could have been. You're always playing with fire when you generate a sort of mob feeling about something. But it worked out alright."[80] A deeper fear is surfacing here: the "new culture," and Ford Company modernity, could survive the defacing, even the whitewashing of a mural in one of its palaces. But it might not survive if the defacings of itself which were occurring more and more frequently in these troubled times became a public whitewash. The mob would be stirred but not always controlled. Its power obliged its rulers to be bold, to seize every possible chance to appear to insert themselves within this power. Learning these skills was necessary to maintaining control within the new modernity, and to its growth.[81]

Rivera after Ford

In the mural for Radio City Music Hall at the Rockefeller Center in New York, to which Rivera rushed from Detroit, choice comes to the fore as basic to the pictorial economy of the mural and its side panels. Rivera transforms the typically Moderne, humanist bad language of his brief— "Man at the Crossroads Looking with Hope and High Vision to the Choosing of a New and Better Future"—into an allegory of political choice between capitalism and communism, addressed not to the managers but to "the people." That the mural was destroyed is scarcely surprising, although it is interesting that the Rockefeller family and their

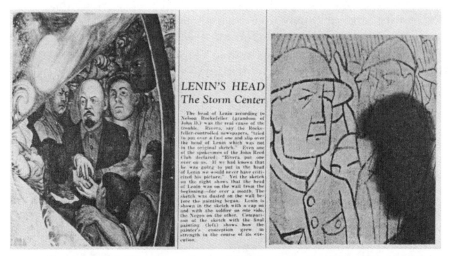

6.22 "Lenin's Head: The Storm Center," *Workers' Age,* June 15, 1933. (Archive of Labor and Urban Affairs, Wayne State University, Detroit)

architects were prepared to accept the basic format—perhaps because the central choosing figure is already chosen by modernity (symbolized by science)—but baulked at the late inclusion of a political emblem, the head of Lenin. Rivera had transgressed the rules of liberalism: a sign from overtly political discourse had entered the generalities of aesthetic discourse (however "realist"), with unimaginable disruptive potential. In contrast, the other murals, by Brangwyn and Sert, were exemplary essays in conventional Moderne allegory, almost instantly self-effacing.

Rivera's portable murals on U.S. history for the New Workers School (1933) show how more and more specific and historical his global historicizing was becoming, primarily, I suggest, because of his growing knowledge of the social crisis of the United States. Commitments become closer to those of the Fourth International—thus the increase in imagery of revolutionary leaders. But neither the Fourth International, the Mexican Revolution (newly "reformist" in 1933–34), nor Rivera himself could quickly come up with a critical relationship to modernity. The last panel on the top left wall of the staircase of the National Palace, Mexico City, done on Rivera's return in 1934, shows the huge head of Marx pointing workers to Mexico of the future: a rather reduced, simply glowing scene of mechanized agriculture dominated by new River Rouge–type factories and radar telescopes, energized by the exploding sun but completely devoid of people. The first sketch of 1929, before the U.S. experience, emphasized agriculture rather than industry and the political leaders, but at least showed people working the land. As an image of the present and the future it is incomparably weaker than his two major U.S. mural cycles: it appeals with the easy banality which instantly declares its conventionality and, at the same time, its other-worldly, "science fiction" distance from the Mexican peasant for whom Rivera claimed constantly to speak. Its simple utopia contradicts the pressing dystopia of Detroit.

FRIDA KAHLO: MARGINALITY AND MODERNITY

CHAPTER

7

The little girl seated at the center of the world possessed a toy airplane that was equal in speed, much greater than that of light, to that of imagination-reason, which discovers stars, and cities before they are reached by telescopes and locomotives. The speed was present in Frida, alone in mechanized space, lying on a cot, from where she saw, weeping, that life-fetus is a flower machine, a slow snail, a figure with a bony frame in its appearance, but in its essential reality above image-reason which travels faster than light.[1]

Frida Kahlo de Rivera is delicately situated at that point of intersection between the political (philosophical) line and the artistic line, beyond which we hope that they may unite in a single revolutionary consciousness while preserving intact the identities of the separate motivating forces that run through them. Since this solution is being sought here on the plane of plastic expression, Frida Kahlo's contribution to the art of our epoch is destined to assume a quite special value as providing the casting vote between the various pictorial tendencies. . . . I would like to add now that there is no art more exclusively feminine, in the sense that, in order to be as seductive as possible, it is only too willing to play at being absolutely pure and absolutely pernicious. The art of Frida Kahlo is a ribbon around a bomb.[2]

These claims must have seemed, to most, exaggerated when they were uttered. Subsequently they have echoed in the emptiness of ignored rhetoric. The distance of marginalization seems infinitely greater than that applied in the 1920s and 1930s to the Social Realists in general and to such peripheral romantics as Rivera in particular. Yet in recent years it has been argued that work such as Kahlo's, interpreted much within the framework set out by Breton, now appears to be "more relevant than the central traditions of modernism, at a time when, in the light of feminism, the history of art is being revalued and remade." This is the central claim of the brilliant exhibition organized by Laura Mulvey and Peter Wollen, titled Frida Kahlo and Tina Modotti, at the Whitechapel Art Gallery, London, in March–May, 1982.[3]

The other major emphasis in the revival of interest in Frida Kahlo centers on the vicissitudes of her relationship with Diego Rivera.[4] Here, however, I want to go beyond the conception of her art as either subservient to or triumphantly independent of him to a more complex sense of ridicule and self-abnegation. I argue that Kahlo's art is also made up of the effects of certain social forces operating within and on Mexico, locating it at many complex conjunctions between traditions and modernizations. Her independencies within these relationships are predominantly—and only apparently paradoxically—figured in herself as victim. The patterns of resistance and connivance in her marginalization help situate the effects of various trajectories of modernity in the visual arts in a way different from the usual foci on either a modernist paradigm or one purportedly standing for realist opposition.

Plumed Serpent and Conveyor Belt

Against the mythology of Kahlo's naïveté, the imprisoning amusement at her ostentatious dressing-up, and her monkeylike semibeauty (the overcompensating hysterical woman figure), Mulvey and Wollen rightly stress her knowingness, her sense of artifice, her consciousness about the implications of choices of artistic style. They point out that the "Mexicanness" of her persona and dress was both rooted in her life and exaggerated (in the Tehuana costumes). They discern a similar "structure of feeling" in her use of popular Mexican forms in her work. This popularizing move was widely shared among nationalist artists, and they set it to work within European tendencies: Rivera within Cubism, Kahlo within Surrealism. It was also archaizing, historicist, most of the popular forms having fallen into disuse. And it was, like Rivera's, a defense against the power of U.S. culture. The writers conclude: "Though Frida Kahlo was not herself a 'history painter' like Rivera, she worked from the point where 'avant-garde modernism,' 'popular historicism' and 'mythic nationalism' met—in her own favourite genre—portraiture."[5]

The specificity of what Kahlo did is indicated by the necessity of self-portraiture: however *knowing*, however much she possessed the powers of bourgeois knowledge, she nonetheless was impelled from the imperatives of the *amateur* visualizer in a basic, not artificially adopted, sense. Kahlo's father was a photographer, her house visually cultured; she scarcely studied art formally but became deeply versed in its history and, having entered the social life of Mexican art as a teenager, never left it. By the later 1930s she was a thorough-going Surrealist, accepted by Breton into the movement, celebrated in exhibitions in New York and Paris. Works such as *What the Water Gave Me* and the *Suicide of Dorothy Hale,* both 1933, and *The Dream* and *The Wounded Table,* both 1940, are among the most complex creations of that tendency, paralleling certain paintings by Dali, some of Breton's objects, as well as work by other Mexican Surrealists such as Antonio Ruiz.

But prior to that period (and, perhaps, in some ways after it), Kahlo's art contains a quality of obsession, a timid single-mindedness, a tentative boldness, which indicated its grounding in routines quite other than those of the professional artist. Certainly she does not follow the orthodox career pattern of juvenalia, then apprenticeship/schooling, followed by wide-ranging experimentation, then the forming of a "mature style" with an eye to contemporary developments, the waves of general style-change. Rather there is only the "amateur" work and Surrealism. And, prior to the late 1930s, this "amateur" work is locked into the constraints of domestic, "women's" work—decorative patterning, done for the entertainment and interest of close friends, as a "hobby," an occupation for a lively mind imprisoned within a broken body, the self-amusement of the less-talented wife of a famous artist. However fabled she may have been, we must acknowledge the small, still voice of the subjugated woman, the cultural drag of the domestic sphere, the constant confining of women's creativity, in her repetition of a limited set of motifs and techniques. In this case, the obverse of sophisticated Surrealist knowingness is a naïveté, a literal lack of artistic culture. Fear of romanticizing it should not preclude us from acknowledging it.

Nor should we forget that this ordinariness is not restricted to the sentimental, the limited, and the obvious; it can also be, in certain circumstances, tough, streetwise, cunning, spoiling for a fight (as in women's embroideries in Chile since 1973). Breton recognized this in his image of seduction—"only too willing to play at being absolutely pure and absolutely pernicious"—but in his sexism he rendered it at the level of salon coquetry, of *haute mode* fashionability (as did Schiaparelli when he adopted Kahlo's Tehuana costumes on her 1937 Paris visit).

The paintings speak of a much more local pain, of the battleground of heterosexual relationships (with some covert allusion to homosexual de-

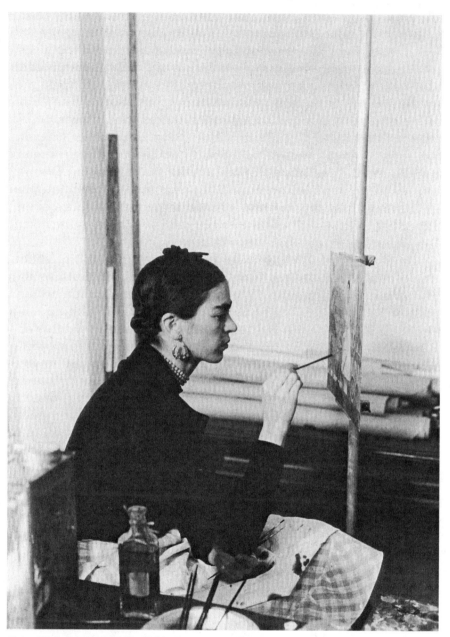

7.1 W. J. Stettler, *Frida Kahlo Painting "Self-Portrait on the Borderline between Mexico and the United States,"* Detroit, November 30, 1932. Photograph. (Museum Archives, DIA, neg. 2846; © The Detroit Institute of Arts)

sire), of the family, of the body and the life-support machines. Her *Self-Portrait on the Borderline between Mexico and the United States* (1932) is her *Portrait of Detroit:* it takes on many of Rivera's concerns but deflates and defiles them by reducing them to simple oppositions, then further undermines them by insisting on the priority of the personal, of "me," doing all of this with the apparent innocence of a naughty child courting the edge of punishment/approbation. It not only subverts the icons of Mexicanness and U.S. modernity so coyly assembled on either side, but it may also parody Rivera's Pan-Americanism. Above all, it turns on a figuring of the ways in which she is produced by these forces as a defiant victim.

Like all of her paintings it organizes a set of popular pictorial conventions—in this case, the confirmation picture, the offering of the believing/pure child/woman to the gaze of Christ/God/abstract male power. Usually, she would be placed beneath the image of her merciful/terrible savior and surrounded by symbols of the virtues which might entitle her to divine intercession. And she is, but the relationships of authority/subjugation are drastically altered. In particular, they are displaced from the level of the individual engaged in massively unequal struggle for the shape of her soul with a singular, perfect divinity to the level of concrete forces creating a mock person, a Mexican-American monument. But, further, it is one from which the individual Frida Kahlo has withdrawn, leaving the appearance of herself as a doll.

On either side of the central figure, symbols of the two countries/cultures are assembled. In obvious ways an ancient, barren, primitive, tropical/exotic culture contrasts with a new, dynamic, growing, modern one. There are also some clear parallels—between the geometry of the temple and that of the skyscrapers, for example. We have heard Rivera, on his visits to New York, claim the skyscrapers as a basis for presuming a continuity between the cultures, with Industrial America extending the culture of the Americas, with due regard for the folkloric richness of Mexico. Kahlo's central figure seems, superficially, to also "pleasantly" project such a unity—an attractive, demure Mexican woman, holding her country's flag, wearing a local necklace but also a U.S. party dress and brocaded armbands, casually standing as if waiting to step forward into some official, ritual celebration of the harmonious alliance of the two nations.

All dressed up but nowhere worth going, she has allowed her Mexican flag to droop, and the formality of her appearance is belied by the dangling cigarette, symbol of the modern woman, U.S. style—an equally silly appendage. Around her, the two grand nations are both

internally rotten and in a shaky alliance. The sun god may well have created Mexican culture but the clash with the female principle (the moon cloud) has reduced that culture to ruins. (Does this predict the crumbling of Rivera's mausoleum, the pyramid he built in the mid-1940s?)[6] Ancient Mexican cultures have died, dried up on the barren deserts, been reduced to rubble and to impotent fertility symbols (the Olmec ceramic, the Aztec striding goddess). Only the Central/South American plant life grows at all, and it does so excessively, luxuriantly, even erotically.

Against this, the imagery of Industrial America is assembled—presciently, more clearly than was common in the United States itself at the time, except for photographers such as Sheeler, Bourke-White and, of course, Edward Weston. Weston had visited Mexico with Tina Modotti six years' earlier and had been hailed by Rivera as "THE AMERICAN ARTIST; that is to say, one whose sensibility contains the extreme modernity of the PLASTICITY OF THE NORTH AND THE LIVING TRADITION OF THE LAND OF THE SOUTH."[7] The components of U.S. modernity are its chief constituent regimes: Ford Company represented by the powerhouse at Highland Park, Detroit; New York City as a forest of skyscrapers; and the industrial air-conditioning ducts of streamlined styling—although Kahlo eschews the imagery of consumerism. These are brought into harmonious relation, creating a new landscape, a different world—even, amusingly in the planted electrical appliances, a new "Nature."

Where are the subversions of Industrial America? The U.S. flag, ascendant compared to the token Mexican one, is nonetheless a phantom figure emerging from the smoke of the Ford power plant: it, rather than cars, is the product of Ford—and it is, literally, "hot air." The New York citadels of entrepreneurial and finance capital are, plainly, also temples which will crumble into ruins, like the Toltec temple, whatever their shared geometries. And in the simple terms of equivalence of level on which an image like this can work, it is the Ford-based patriotism of the flag which will wreak the damage. The U.S. landscape is not even barren desert; it is concrete. There are no idols, remains of past civilizations, but there is a row of steel ducts, lined up like mechanical robots/soldiers (the only "human" product of this environment), their androgynous forms echoing the Mexican fertility figures but, then, only capable of reproducing more machines. Like the impotent bachelors in Duchamp's *Large Glass* (1915–23). This imagery of mass production is, like those of Sheeler and Rivera, dedicated above all to its own replication, but, unlike Rivera's imagery, there is no force of strong masculine labor to alter the direction, to project a different future. Indeed, the color matches across to the Mexican side have the effect of emphasizing the discarded

skull, which is both a very early Indian carving and a contemporary all-souls' *memento mori.*

The final irony is that these fictive ducts are piped into the earth, from which is "growing" a blaring loudspeaker (symbolizing U.S. popular music but also control by the voice of authority—the state, the factory public address system, the police at the riot, the advertiser), an electric light (the benefits of electricity to the home in the form of consumer goods, but here also the lamp of industry and the searchlight), and, lastly, the generator, with leads which light up the Mexican plants, making them artificial creations, but into which is plugged the statue of Kahlo herself, a figurine on a pedestal being cracked by the growth of the Mexican plants, but energized/drained by the U.S. electricity. Presumably, the figurine could "light up" at the flick of the master's switch (at the gaze of Industrial America, of Henry Ford, of Diego Rivera), but it also depends on her energy, on her appearing in a certain way, a dependency which drains her, renders her hollow. She is Carmen, a fake Spanish-American, a fabulous courtesan, a cultural stereotype, a mock woman destined for death at the hands of male jealousy/inadequacy. In fact, Carmen was one of Kahlo's given names, although rarely used. She signed herself here "Carmen Rivera," denying her independent names.

Nearly all of the key struggles within Rivera's *Detroit Industry* are evoked in Kahlo's *Self-Portrait,* but they are handled with an economy

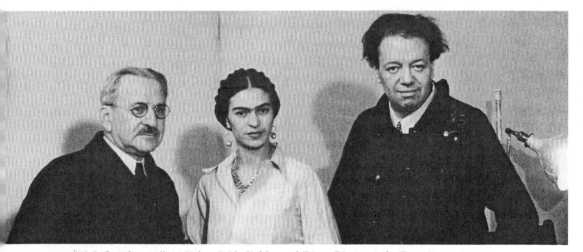

7.2 W. J. Stettler, *Albert Kahn, Frida Kahlo, and Diego Rivera at the Detroit Institute of Arts, December 10, 1932.* Photograph. (Museum Archives, DIA, neg. 2864; © The Detroit Institute of Arts)

which contrasts strikingly with his elaborate allegories, the prodigious machinery of his grand questioning, so much so that the insight of ridicule is indicated. Implanting the loudspeaker, light, and generator especially goes beyond visualizing electricity as a modern natural force (like earth, air, fire, and water in the Chapingo murals of 1926–27): it shows the idea to be silly. By extension, Rivera's epochal conception of modern America as a "natural" outgrowth of the history of the earth, the wave-motion of generation from mineral formation, from childbirth to Ford Company line production, also appears as a simplification. Most explicitly, Kahlo parodies Rivera's *Allegory of California* (see fig. 6.20), image by image. In her painting, Mexico and the United States are statically separated; they meet only underground in a trivial analogy between plant roots and electrical flex. More importantly, they meet in the figure of "Carmen Rivera"—and, in so meeting, they are *held apart* by Kahlo's refusal of such a positioning. She is explicitly rejecting Rivera's Pan-Americanism; it will not do, politically, precisely because it produces someone like her, *like this*.[8]

The same personal/political point is made in *My Dress Hangs There* (1933). Apart from the later still lives and the intermittent portraits of others, this work is a rare absence of Kahlo's staring face and broken body. Amid the pileup of New York buildings, particularly those of Wall Street, above newspaper cutouts of rioting crowds and lengthy breadlines, between columns rising out of burning buildings and overflowing garbage bins, on a line strung from a toilet bowl to a victory cup, hangs Kahlo's Tehuana dress, empty. Her disgust with Gringolandia has grown so great that she removes even herself. But not one of her persona signs: the token of her adopted Mexicanidad shines forth with another kind of beauty in the midst of a city, symbol of a system bent on self-destruction. Capitalist New York had, of course, just destroyed Rivera's Rockefeller Center mural. Compositionally echoing Rivera's San Francisco mural *Allegory of California*, Kahlo's *My Dress Hang There* also evokes *Man at the Crossroads*. *My Dress Hangs There* reverses the meaning of the former, restates the meaning of the latter. It is her most overt picturing of political conflict, and thus becomes a companion piece to *Self-Portrait on the Borderline between Mexico and the United States*. Public politics are grounded in the personal: less than a doll, she remains only as a doll's dress. Less than a set of effects, she is reduced to the echo of an effect. But, in this case, a remarkable reversal is implied: if she has herself withdrawn, the dress acts even more potently as an *idol*, empowered by the energy of conflict and also causing it. Rivera would have delighted in the claim that Mexican insight makes clear to North Americans the real nature of the class struggle. Kahlo gives this intervention a

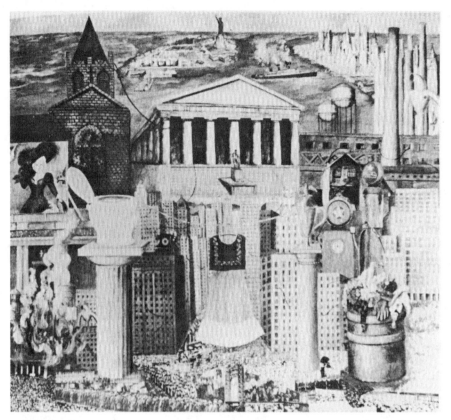

7.3 Frida Kahlo, *My Dress Hangs There* or *New York*, 1933. Oil and collage on masonite, 18 × 19¾ in. (Hoover Gallery, San Francisco)

typical twist: it is the native Mexican *dress* which not only rises above the conflict like lucid slogan, but also gives birth to the tumult, stirs up the energy to fight against oppression. Her "gleeful" mockery is also deeply critical.

By centering Frida Kahlo in this account, I want to distinguish such a focusing from the priority accorded within modernism to self-expression, to the free play of unique aesthetic sensibility, to the sanctity of individualism, in all its relations to the unrelative autonomy of art. All of her paintings are, in one sense or another, self-portraits. But in all of her paintings her facial expression varies only slightly: she early adopts the staring, sightless look of the person shy before the mirror, self-conscious before the camera, forcing herself into the gaze of the other against her will, not unaware of what is going on around her but not overtly responding to it (unwilling to have her response to it recorded). Crucial to the meanings of her work—its withdrawal from high-art individual-

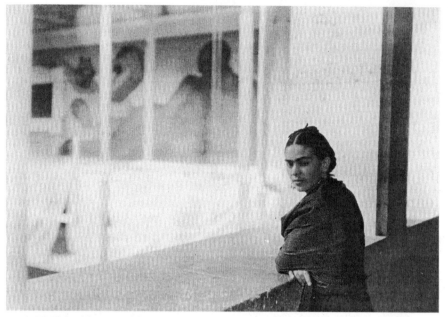

7.4 W. J. Stettler, *Frida Kahlo on the East Balcony, Mural Court, Detroit Institute of Arts, November 30, 1932.* Photograph. (Museum Archives, DIA, neg. 2848; © The Detroit Institute of Arts)

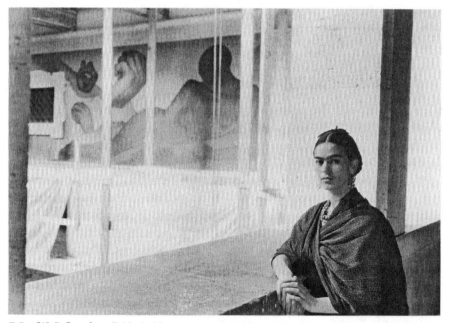

7.5 W. J. Stettler, *Frida Kahlo on the East Balcony, Mural Court, Detroit Institute of Arts, November 30, 1932.* Photograph. (Museum Archives, DIA, neg. 2849; © The Detroit Institute of Arts)

ity—is the disjunctive absence of relation between the ensemble of causes and the marks of effect. Her face cannot be an entry point: it is a closed icon; it is a mask. The paintings are not, therefore, primarily portraits of a "self": they are picturings of the construction of a persona as a set of effects. It is this which she is urging against Rivera's grand schemes of global and continental unity—the "reality" of this kind of grounding, particularly its psychic and physical cost. There is, of course, great variation of expression *within* Kahlo's limited repertoire of faces. My point is that the drastic nature of the delimiting ensures that we read their expressivity as always a costly struggle against the forces of closure.

The Body as the Site of the Specific

The originality of Kahlo's work, the political significance of her perspective, is that it searches through the larger forces active at the time in terms of the domain of the specific. It sorts these forces through an insistence on experiences usually relegated in high art to the peripheries of bad taste or trivia: jealousy, long-term physical pain, private griefs, the small tortures of marriage, the weakness of the invalid, the alienations of the medical subject. Her work affords a rare opportunity to study the effects of power within the domains of the relatively powerless.

Certain paintings were inspired by emotions which are commonly dismissed as trivial, as experiences so singular or minor that they have no generalizable potential. Thus *The Mask (Self-Portrait)* (1945) shows a typical Kahlo bust of herself in front of vegetation, but the leaves have yellowed, gone rotten, and in front of her fine head has been inserted a baby-doll face, with normalized North American features. Even this mask is disfigured by its dyed purple hair, by its inexactly applied eyeshadow, but especially by the merging of the false face and Kahlo's neck, as if this was a desperate last act of plastic surgery aimed at saving her "beauty." Small wonder that the shocking conclusion to the painting is its deliberate defacement, the defiling of the figure by a burning, rubbing away at the eyes until the board underneath has been exposed.

Some other departures from the usual iconic face also take us directly to specific agonies. *A Few Small Snips* (1935) domesticates what, for Posada and the newspapers, would be an ordinary sensation. The woman is lying on a bed, cut savagely all over by her man, who stands blandly above her profusely bleeding body, as if posed for a photograph. A blackbird carries the scroll with the title of the picture across it. This reworking of the German sex murder subject (so popular with the Neue Sachlichkeit artists, the Expressionists, and the Dadaists) within the *re-*

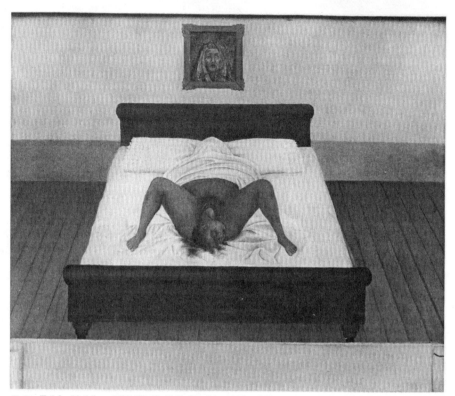

7.6 Frida Kahlo, *Childbirth (My Birth)*, 1932. Oil on metal, 12⅜ × 14 in. (Private collection, USA)

tablo format is also linked through the faces to Kahlo's suffering at Rivera's infidelities. *Childbirth (My Birth)* (1932) similarly faces the viewer square on to the centralized bed: above it hangs a painting of a madonna dolorosa, two knives at her neck. The upper body of the woman is smothered with mummy/corpse-like sheets, as she strains to give birth to a young man/woman, marked with the features of both Rivera and herself, eyes closed. Miscarriage is represented here by the triple death of the "mother"—as the woman who dies in childbirth, who produces a stillborn child (which is also herself), and who fails (dies) as a birth giver.[9] Below, a scroll unfolds across the painting, as empty as the room is spare and comfortless: "The feminine sphere is stripped of reassurance. The haven of male fantasy is replaced by the experience of pain, including the pain associated with her physical inability to live out a feminine role in motherhood."[10]

Again, imagery of this kind of struggle accelerates toward the end of Kahlo's life, as the effects of her adolescent injury become intolerable. She swings from herself as an earth mother in *Roots* (1943) (a deeply

ironic replay of Rivera's monumental *The Fertile Earth* at Chapingo, 1926–27, itself based on Weston's classic studies of erotic beauty—the photographs of Tina Modotti, 1924); to *The Broken Column* (1944) in which she opens up her own body to show her shattered spine as a broken classical column, her body held together by straps and covered all over with the (Dali-Catholic-flagellant) nails of pain; to the allegorical *Marxism Heals the Sick* (no date but late) in which the healing hands of Marx release her from her crutches, her bodice straps; and to the surrealist *The Dream* (1940) in which a creeping thorny vine enwraps her in her sleep, while on top of the four-poster bed a ghostly skeleton is similarly attacked by connected clamps (pinchers for veins during operations and also the firecrackers attached to the festive Judas figure). Yet it is the skeleton whose chest bursts into flowers, not that of the unconscious Kahlo. Paintings such as *Marxism Heals the Sick*, with its flaunting reversal of the Catholic miracle image (desperate for a woman dying in agony), and *Moses* (1945) (in which an array of ancient Mexican civilizations as well as ancient and modern religious leaders cluster above images of male sacrifice and female submission all centered about a childbirth occurring underneath the sun's energy but within an absent figure), return to the level of generalization we saw in the Detroit *Self-Portrait on the Borderline* and similarly reassert the process of deflation we noted (although not as precisely). In particular, *Marxism Heals the Sick* can be compared to Rivera's National Palace utopia of 1934, and *Moses* might perhaps be seen as a parody of the Rockefeller Center mural, replacing the beleaguered astronaut with the sun, birth itself and an implied form, presumably female.

In San Francisco in 1931, Kahlo painted *Frida and Diego Rivera*, a large double portrait on canvas, yet a marriage picture of the utmost conventionality, of palpable sentimentality, even to the dove flying above carrying a message witnessing their love. Mockery here is playful, gentle fun. In 1940, in the *Self-Portrait with Cropped Hair*, she sits on a yellow cane chair (van Gogh?) dressed in Rivera's baggy suit, with her discarded hair scattered over the desert around her like creeping vines and the words and music of a popular song inscribed above:

> *Mira que si te quise, fué por el pelo,*
> *Ahora que estás pelona, ya no te quiero.*

> You see, if I loved you, it was for your hair,
> Now that you are bald, I don't love you anymore.

After their remarriage, Diego called Frida's bluff that she would cut off her hair if he continued his infidelities: he did, and she reduced herself to illustration. This painting is, however, importantly susceptible of a quite opposite reading and is taken up again below.

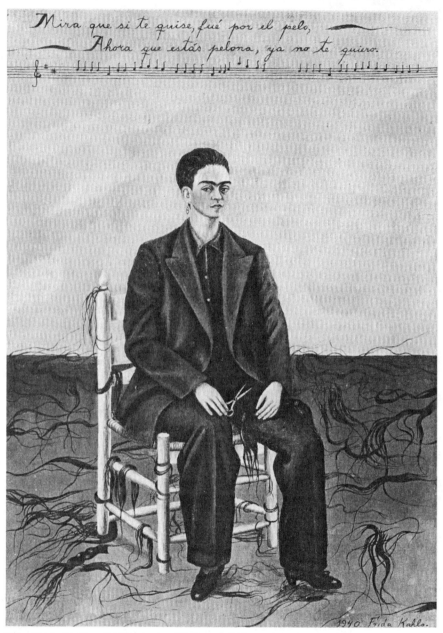

7.7 Frida Kahlo, *Self-Portrait with Cropped Hair*, 1940. Oil on canvas, 15¾ ×
11 in. (Collection, The Museum of Modern Art, New York, gift of Edgar
Kaufmann, Jr., 1943)

Mulvey and Wollen argue that Kahlo not only accepts as her subject matter the feminine "interior" imagined as the world of women in male fantasy, a space for male retreat from the public life which only they have the powers to live, but she goes further in paintings such as this—through Freud's conception of the wound left on the female body by castration—to "reveal the other 'interior' behind it, that of female suffering, vulnerability and self-doubt. Frida Kahlo provides an extremely rare voice for this sphere, which almost by definition, lacks an adequate means of expression or a language."[11] It was perhaps his recognition of this impenetrable otherness which reduced Rivera to babble about "image-reason which travels faster than light" in his 1943 appreciation of her cited above. It was also perhaps this which accounts for the curious failure, the inexactness of Breton's metaphor of "a ribbon around a bomb" in 1938.[12]

One of Modernity's Minor Victims

On September 17, 1925, Frida Kahlo, eighteen years old, was gravely injured when a streetcar ran into her school bus. A metal bar pierced her body. Her spine, pelvis, and foot were smashed. She spent most of the rest of her life fighting against pain, hospitalization, weakness, operations, frustrations of many kinds. She was literally broken, disabled—as was evident to all unless she stayed perfectly still, and was obvious to her even then. On July 4, 1932, while Rivera painted his *Detroit Industry*, a mural cycle triggered by the "seed-child" image on the East Wall, and including a panel wherein doctors and researchers at the Ford Hospital inject vaccine to save the life of young boy in a parody of a Holy Family, Frida Kahlo lay in that same hospital suffering a miscarriage which nearly cost her her life.[13]

Henry Ford Hospital (July 1932) shows Kahlo, tearful, her stomach inflated, lying naked on a metal bed inscribed with date and place, in a space cut in half by a horizon across which unfolds the panorama of Ford Company, Detroit, from Highland Park to River Rouge. Again, the popular form, here the disaster *retablo*, except that there is not the slightest hint of a savior. Around the desperate, bloody figure float six objects connected to her by red ribbons of veins: in the air float her stomach and shattered spine (yet mounted on a pedestal, an inscribed dressmaker's dummy), a fetus with Kahlo/Rivera features, and a snail (Mixtec symbol of maternity); on the ground a machine tool, an iris, and a pelvis with a narrow vagina and the studs holding it together clearly evident. Altogether, an exceptionally moving presentation of the depths of abject self-pity, which we know occurs in moments of great pain/

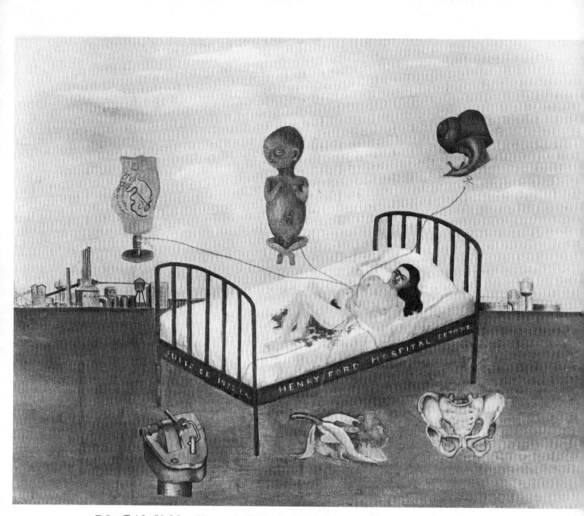

7.8 Frida Kahlo, *Henry Ford Hospital*, 1932. Oil on metal, 12¼ × 15½ in.
(Collection of Dolores Olmedo, Mexico City)

loss but which is rarely represented—particularly that experienced by
women. Kahlo made two other images on this theme at the time. A
sketchy, unfinished oil painting, *Frida and the Cesarean*—the artist in bed
seen from above, a fetus growing inside her, while around images of
doctors operating, Rivera's head, a baby boy, a young woman, some
chemicals and plant forms—may record the period in May and June
1932 when she was told that she would possibly be able to carry a preg-
nancy to term and then have a cesarean delivery. Her hopes were
dashed by the agonizing miscarriage in July. As part of her recovery she
made her only lithograph, *Frida and the Abortion*, in which she again
stands centrally, the image divided between cell division and the devel-

oped fetus at left, while on the right the painter's palette seems to be a substitute, and her weeping vaginal juices at least fertilize plant forms. These last were to appear in *Self-Portrait on the Borderline between Mexico and the United States*, where her address is more general and more critical. The experience of miscarriage, indeed of disablement both dramatic and dully persistent on a daily basis, is as silent in representation as the double "interior" of women's spaces mentioned above. Men have a parallel range of interiorizing experiences, but such a specific treatment rarely appears in their art.[14] An exception is Goya's self-portrait which shows him suffering a heart attack, *Goya and His Doctor Arrieta* (1832); it includes a painted homage of gratitude inscribed across its base. This is matched by Kahlo's *Self-Portrait with the Portrait of Dr. Farill* (1951), in which her palette is her heart. We cannot generalize as to gender from these cases, but perhaps both artists share a traditional Spanish openness to the extraordinary in the normal?

Henry Ford Hospital shapes the words of Rivera's 1943 appreciation: "Frida, alone in mechanized space, lying on a cot, from where she saw, weeping, that life-fetus is a flower machine, a slow snail, a figure with a bony frame in its appearance." He tries to express her achievement in this text but is reduced to descriptions, like this one, which force elements within her paintings together (that is, the paintings give the descriptions force, not vice versa); and to fantastically exaggerated claims, like those of Breton, about her centrality and pivotal importance in Mexican and world art. These claims are not merely projections of male fantasy because the language of both reveals their awareness that something is *at work* on this fantasizing process; both use metaphors/comparisons which evoke "the feminine" to be quickly revised by "the masculine" in order to lead onto something other, unnameable but superlative. Thus the leap by Breton between these two sentences: "We are privileged to be present, as in the most glorious days of German romanticism, at the entry of a young woman endowed with all the gifts of seduction, one accustomed to the society of men of genius. One can expect such a mind to be fashioned according to geometrical principles" (143).[15] The remarks about Kahlo's key positions re the political and the artistic quoted at the beginning of this chapter follow immediately. A more explicit chain from the feminine (soft, dependent, surface, decorative) to the masculine occurs in Rivera's opening words in 1943: "In the panorama of Mexican painting of the last 20 years, the work of Frida Kahlo shines like a diamond in the midst of many inferior jewels; clear and hard, with precisely defined facets" (89).[16] A structure repeated throughout his text: a "feminine" theme is subject to a "masculine" treatment to produce a transcendent truth—or, more accurately, a

position/positions from which certain new truths could be seen/revealed, although it is never quite clear what they are. This structure is, indeed, the one in which I feel caught while writing this chapter and am constantly trying to break. At the last moment, Rivera conjures up windy heroics, and I seek to start the analysis again.

Herrera is right to stress pain as "the most important fact of her life." [17] Pain also constructs Kahlo's art: in the repeated compositional format of lines extending around from a central still figure, like muscular agony aching through the body while the face does its work of masking, showing little, or nothing, or something else. But her imagery of the body has nothing of Dali's phallic dystrophy, or the shrieking, burning, animal anxieties of the German Expressionists, or yet the intense portraits of mood in Munch's studies of sickness. (Mostly these seem to be picturings of the male artist's fears at the consequences for him of the de-

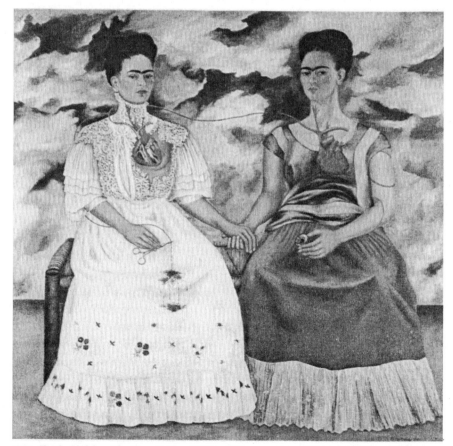

7.9 Frida Kahlo, *The Two Fridas*, 1939. Oil on canvas, 68½ × 68½ in. (Museo de Arte Moderno, Mexico City)

struction of his family.) Kahlo does show us the agonies of childbirth, miscarriage, and failed operations in some works (particularly those of 1932), but mostly she distributes around her self-portraits both anatomical figures—pelvis, rib cage, heart, and arteries—*and* the apparatus of a body dependent on medicine—body straps, wheelchairs, beds which are those of an invalid, which can double as operating tables. Further, within these paintings, the self-portrait face rarely shows pain; instead, it stares resolutely at the spectator—for example, *The Two Fridas* (1939), *The Tree of Hope* (1946), and *Self-Portrait with the Portrait of Dr. Farill* (1951). Here is an important coupling and an important disjunction; what are we to make of them?

The central argument of Foucault's *The Birth of the Clinic* is that what we take to be modern knowledge, in which scientific systems study individuals, emerged in the transformation of medicine in the later eighteenth century from a moral/demographic discourse of disease to a location of pathological reactions in the body, revealed in the form of symptoms to a classifying clinical gaze. The visible and the expressible became newly prominent, "the descriptive formula is also a revealing gesture," thus pathological anatomy—"the discursive space of the corpse: the interior revealed."[18] These remarks seem almost text for Kahlo's conceptions, as Foucault's emphasis on the "birth" of the individual in these circumstances reinforces Kahlo's insistence on the self-portrait as the essential mode for figuring this knowledge. Indeed, in his discussions of the relations between knowledge, eroticism, and death in the nineteenth century, Foucault concludes his brief list of artists (Goya, Géricault, Delacroix, Lamartine, and Baudelaire) concerned with death (not, curiously, with disease/sickness) with some remarks which can serve to characterize the internal economy of Kahlo's paintings with an accuracy, in this case, truly uncanny: "To know life is given only to that derisory, reductive, and already informal knowledge that only wishes it dead. The gaze that envelopes, caresses, details, atomizes the most individual flesh and enumerates its secret bites is that fixed, attentive, rather dilated gaze which, from the height of death, has already condemned life."[19] Like the doctors, clinicians, and the artists listed, Kahlo too exercises a knowing gaze. All the elements in these paintings are on display, accurately delineated, clearly seen. But Kahlo does not *illustrate* the gaze at work, because she is also a patient, a subject of modernizing medicine, a *victim* of it (a figure, incidentally, with no voice in *The Birth of the Clinic*). Despite her constant usage of apparently revelatory devices like cutaways/sections/transparencies, she does not "reveal" in any direct fashion; rather, the surface image opens up to show another image (the broken-column metaphor, the textbook-illustration heart).

Nor does she illustrate the actual sites of hospitalization of her sickness. Rather it is the stripped, bare rooms and desert landscapes which are indicative. They posit the *hospital domain* more emphatically than any naturalism, as "a natural domain, one that is homogeneous in all its parts and in which comparison is possible and open to any form of pathological event, with no principle of selection or exclusion. In such a domain everything must be possible, and possible in the same way."[20] This positivist openness to classification through repetitive patterning of observables operates as a tyranny within Kahlo's scenes, a foreign mode of spatialization. Its general presence parallels the use of medical and mechanical illustration just described. Both "objectivities" are activated within the terms of an utterly different artistic genre, but one which also tends to equalize levels of representation, the popular *retablos*. And, as we have seen, Kahlo changes this conventional iconography of divine salvation from disastrous accident to statements of condemned situations from which there is no hope of rescue, only the determination to persist.[21]

The Law of the Motherless

In the face of such awful knowledge, both Rivera and Kahlo constantly retreat into an imagery of each other as children, infants. Rivera's "little girl seated at the center of the world" is possessed of profound insight *because* of her presocialized innocence amid "realities." So is Kahlo's Rivera as "a huge boy" whose very protruding eyes see more, "a glimpse of the ineffability of oriental wisdom."[22] This passage evokes Kahlo's *The Love Embrace of the Universe, the Earth (Mexico), Diego, Me, and Senor Xolotl* (1949), an extraordinary concoction in which the Buddha-baby Rivera, complete with third eye and lotus, is cradled first by Kahlo (madonna/earth mother), then by a Kahlo-featured Aztec mountain, and finally by the same figure made celestial composed of clouds and of night/day, sun/moon. The precise edge of opposition/struggle of the 1930s and 1940s is here reduced to a slight cracking of the bodies of the mother figures (small earthquakes) across their breasts to the lactating nipples. Has Kahlo succumbed to this syncretic mumbo-jumbo? Is irony absent from such works? It is as if Kahlo were seeking the symbolic form of the good mother in a language even more generalized than Rivera's allegorical androgynes in Detroit.

But has not this search activated all of Kahlo's work? Can we not locate her art firmly in her desires for a whole body, for feminine beauty, for sexual ease, for a stable marriage, for Diego's children, et cetera— sources of inspiration and explanation perfectly adequate for most commentators (especially Wolfe and Herrera)? No, each of these inscriptions

oppresses, indeed castrates her, as well as drains off the political force of her work. I only insist on the particularity of Kahlo's experience as a political domain, and on Kahlo's visualizations, because they offer access to this domain as a realm of competing representations. But these representations are structured in the ways already discussed, and by one further level, the psychoanalytic, through which we need to pass in order to return to the social.

Is not the urge to conventionality in Kahlo's work a tracing of the pathway of the castrated woman so central to Lacan's account of how the (male) unconscious is formed?[23] This theory of the positioning of women in terms of prelingual, powerless *lack* is usefully summarized by Laura Mulvey:

> Woman's desire is subjected to her image as bearer of the bleeding wound, she can exist only in relation to castration and cannot transcend it. She turns her child into the signifier of her own desire to possess a penis (the condition, she imagines, of entry into the symbolic). Either she must gracefully give way to the world, the name of the Father and the Law, or else struggle to keep her child down with her in the half-light of the imaginary. Woman then stands in patriarchal culture as signifier for the male other, bound by a symbolic order in which man can live out his phantasies and obsessions through linguistic command by imposing them on the silent image of woman still tied to her place as bearer of meaning, not maker of meaning.[24]

But again, and despite their common sources/interests/even perhaps knowledge of each other's works (Lacan being also an associate of the Surrealists in Paris in the 1920s–30s), Kahlo is in no sense *illustrating* Lacan's theories. Nonetheless, can her imagery be taken as illustrative of the effects of the drives to which he points, as an art formed by the unconscious with little mediation (the promise of *no* mediation)—something we would expect from a perfect Surrealism *and* from a perfect "naïve" art?

Kahlo does, in fact, paint each of the stages in the formation of the "I" according to Lacan. But here we need to recognize two things. The *exceptionality* of her doing so—only recently, and then via theory, have similar concerns become the subject of certain artists. Usually, the imagery of these stages or of effects of these psychic formations is represented in *displaced* forms—as we might expect, this being the function of most representation. Kahlo herself perhaps succumbs to this in her later work—for example, *Love Embrace* (1949) and *Moses* (1946)—to take images of birth and suckling. But in some of the paintings there occurs

a second, important difference: a kind of representation which is *critical at the level of the psychic*. It does not import material from other levels in order to be so; rather, it stems from a recognition of the power of positioning to which she is being subject, a recognition which is at the same time a *rejection* of such positioning. This is why Rivera and Breton wrote her into the chain feminine-masculine-other: they could conceive criticism only as the correction of the feminine by the masculine, yet, seeing that the result was not dominance of the masculine but was nonetheless powerful, they were left with the rhetoric of excessive celebration.

Their instincts were, structurally, alert but both upside-down and, in the end, feeble. Instead, I suggest that certain paintings mark refusals of the phallocentric positioning of the girl, dislodging its closures (the impotence of the lack, the silence, the bearer, the mere sign) by the deployment of power "normally" reserved for the boy (including both fetishism and voyeurism, "impossible" to women), with the result that the forces formative of sexual difference are not only displayed, they are resisted. This did *not* occur because the childless Kahlo failed to enter the cycle of motherhood and was therefore less than a woman (pre-, on the edge, never experiencing this system) and was bitter about it, thus her paintings. Rather, certain paintings are the complex and mediated products of psychic work with and against the grain, the kind of work which makes historical revision possible—in this case, feminism. A feminism which does not appeal to some preexistent womanly "other," a natural state of being automatically achieved by women liberated from the powers of patriarchy. It is a feminism which works with what is, with what is *given*. Kahlo's insistent subject is *sexual difference* itself, the labyrinths of its formation. She constantly seeks to trap and to turn its processes into emblems fixed by tendrils, still but unstable, images of woman as a sign ready to be spoken differently in another moment yet also able to speak herself differently, to disrupt the signifying process.

If we compare *Moses* (1946), the *Love Embrace* (1949), and other images of motherhood such as Tina Modotti's photograph *Child Suckling at the Breast* to Kahlo's *My Nurse and I* (1937), we can see a radical revision of Lacan's first phase at work. The preoedipal paradise of dependence, of the merging with the mother, prior to the recognition of sexual difference, is both evoked and disrupted here. A lactating sky feeds the earth's plants and insects, an earth mother gently cradles and feeds the girl-child. But the sky is lowering, stormy; the plants dry, nearly dead, the milk useless to them; the inserts are the devoring caterpillar/death moth and the male-eating praying mantis; the paint quality is dull, dry, and harsh. Kahlo's sideways staring face is imposed on her body as a child—an acceptance/refusal of herself as a child. Her mother is literally absent, her place taken by an Indian nurse (probably autobiographical),

who is enveloping, maternal, but also obliterated by a Teotihuacán basalt mask. Symbolically, Mexico's contradictions, but these displacements/restitutions are also personally constitutive of the presence/absence of her mother (remember *Childbirth*, 1932—the mother again visually displaced—wrapped up and enframed). And the nurse/mother is unstable in the frame, rocking, the lower parts of her body a stony maw, as open and insubstantial as her face is closed. But perhaps the most interesting aspect of the painting is the connotative chain around whiteness: the milk from the sky and one breast becomes the water from a flower's roots at the other breast. The white cutout quality of these

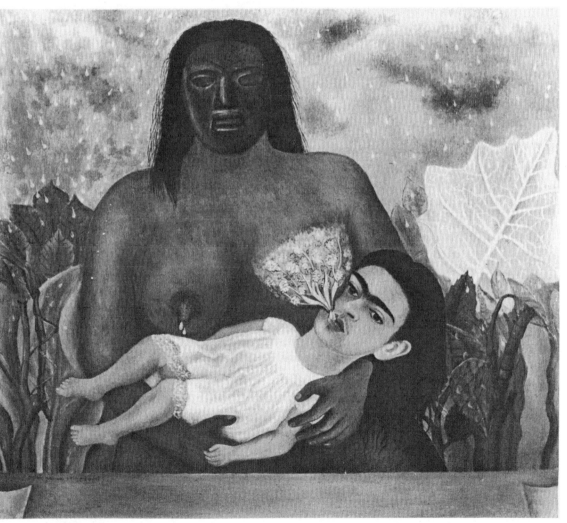

7.10 Frida Kahlo, *My Nurse and I*, 1937. Oil on metal, 11¾ × 13¾ in. (Collection of Dolores Olmedo, Mexico City)

Frida Kahlo 269

flowers (which are also a cutaway to a monochrome rendering of the breast's milk ducts) connects with the lacework at the hem of the child's dress which floats across the center of the body. In turn, the dress connects with the veiny transparency of the large, colorless leaf, rocking among the plants, the visual counterpoint to the swaying motion of the nurse (making them like two cutouts projecting above the simulated forest in a shooting gallery). The lifelessness of the leaf, the stone mask of the nurse: the leaf floats away, the child is just as insubstantial. The life-giving fluid does not deny death; the passage of whiteness is not *from* life to death, but both are present throughout.

These knowledges, properly (for Lacan) the property of the second and third phases, are here pictured at work in the first: the death of the mother, Kahlo's symbolic castration by her absenting, and then by the death-masking of the Indian nurse (less/more than a woman), and acts of recognition of sexual/class/racial difference—that is, in Lacan's terms, the penis has been sighted, as has been the mother's lack, and Kahlo's own. From this point—for Lacan—the boy goes on to jealousy, then a sense of his own power as part of the Law of the Father, and then, ultimately, to the third phase, the fearful, hated recognition that his father, and perhaps he, does not control the symbolic order in which they seemed so powerful. The girl can now only become a woman, sub-jugated to this male order, an object of its desires (its fetishing look or its voyeuristic punishments), accepting her assigned roles or fitfully struggling to hold her child/husband "down with her in the half-light of the imaginary."[25]

Kahlo would seem to exemplify these last two options in, respectively, the marriage picture *Frida and Diego* (1931) and the *Love Embrace* (1949) (globalizing the imaginary in the latter painting). But such collapses back into patriarchal dominance are not guiding the pictorial logic of *My Nurse and I*. This comes, finally, back to the self-portrait head on the child body—not just an excessive regression, a desperate scramble back to the security of the first phase, on the run from castration anxiety (both males and females experience this), but also an unnatural conjunc-tion, monstrous because whereas the child's body knows nothing of the forces, contradictions, and desires which organize her (some of which shape what surrounds her in the painting), the woman does know, and she *looks* it. The sideways glance indicates a withdrawal from confident, confronting knowledge. Yet it is *still* a declaration of knowledge, and it locates the site occupied by this image: it does not merely *reflect* a par-ticular set of unconscious drives, it knowingly displays their organiza-tional form. It does not go "beyond them" but it does articulate them as problematic. Thus, perhaps, her insistence, in her self-portrait faces, on

emphasizing the signs of her "maleness" (the hair above her lip, between her eyebrows): signs of her presence within the symbolic order. (The painting itself is yet to be such a sign, until she is recognized as a practicing artist.) If Lacan's theory disallows this kind of feminist critical possibility, then it is inadequate.

Returning the Gaze/Masquerade

I do not wish to comment on Kahlo as a figure within recent feminist art history and women's art, but it is clear that this kind of work has taken discussion of the image of woman quite beyond the active-passive moralism of Berger's "men *act*, women *appear*."[26] Especially suggestive has been the work on the imagining of women in film, particularly the use of Freud's, Lacan's, and Metz's theories of visual pleasure. Again, I argue here that Kahlo's work is an exemplary site of many of the psychic/ social forces recently theorized *and* that its relation to these forces was an accepting/contesting one, a quiet, still raging across the site. Specifically, the self-portraits go to the point where a woman loses sight of herself through overidentification—and beyond that point, to a reconstitution of the image of woman as an excess, the masquerade of *The Two Fridas* (1939) and *Self-Portrait as a Tehuana* (1943). This process constitutes a value in the face of a specifically modern rupturing of relationships on a variety of levels (personally, even internationally): not a return/recovery of "earlier" values but an assertion of the struggle around (self-)definition as both new and necessary. This will be our route back to the Detroit *Self-Portrait on the Borderline* and the other defiant victim images of 1932.

Visual pleasure is crucial to Freud's basic theory of the tensioned relations between instinctual drives and the self-preserving ego. Narcissism entails identification with the image seen, scopophilia a more distanced pleasure in using another person as an object of sexual stimulation through sight. Under patriarchy, women have become the object of the male gaze to such an extent that the figure of woman can be said to connote *being-looked-at* as such. If looking itself is eroticized, woman is nearly all that is seen, the main object of the spectacle. The male spectator usually has two modes of access to the imaged woman, either directly or via an imaged male figure "paired" with the woman with whom he identifies (thus the woman's passage from independence to the couple so typical of narrative cinema, and the present or implied male in narrative painting and portraiture). Yet the image of woman is always unstable because it also signifies the moment of sexual difference, the oedipal unfolding of castration anxiety. Escape from this traumatic fear takes two forms: voyeuristic demystification of the woman

(with associated punishment and forgiving of the guilty object), or fetishistic substitution by either directly replacing her with another or by an exaggerated aestheticizing of her into a different beauty. Voyeurism tends to entail narrative, fetishism the fixed image (although one can, obviously, be the destiny of the other).[27]

In most of the paintings Kahlo is both the subject and the object, the bearer of the look but also its author. This is not, I submit, to conflate Kahlo the artist with "Kahlo" the depicted image. It is, rather, to say that the paintings are about the relationship between Kahlo and "Kahlo," between women (at least *a* woman) and woman as "sign." I may well be subjecting these images to the containing constraints of both voyeurism and fetishism (how can I not do so?), not only in the persistent analysis on yet further levels of signification (and we are not done yet) but also, perhaps, in the general scheme of this book: "she" is used to disturb the entire ensemble, which is also asked (perhaps constructed) to confirm her.

Kahlo shows herself crippled/"freed" by various culturally assigned roles (wife, mother) but more emphatically as organized by the *imagery* of such roles, and of others such as prettiness. Mexican woman, bourgeois lady, believer in men, Church and the State.[28] Mostly, that is, the image of woman is activated by relationships beyond the look as such. Yet some of the self-portraits (of 1938 and *With Monkeys,* 1938) are clearly conceived as erotic fields, and *every* self-portrait head is fashioned in relation to woman as being-looked-at. The eroticization of vision as such is her subject: it is one of the crucial means by which sexual difference is constituted. Not just the sight recognition of the absent penis but the unceasing availability of women to the look, which, in their being seen, forms and always re-forms them as women. Kahlo's imagery constantly wrestles with this gaze (like a butterfly on a pin?); in this sense, the viewers of her paintings are always assumed to be male (Rivera, all men, the law of the Father, the State), the self-portraits are always a dressing-up.

But what does the male spectator see? Never is the woman contained by the male gaze to the extent nor in the ways typical of most visual imagery under patriarchy. Certainly the image "Kahlo" is squeezed up to the surface, inhabits a flat space, and sits still within it—in contrast to the active movement within three-dimensional space typical of male representation in painting and film. This is a crucial difference to Mulvey, and even more so to Luce Irigaray, for whom women are so confined to closeness, bodily proximity, that touch and not sight is the domain of comfort.[29] Her concept of the "nothing seen," the something "not masterable by the look," has potential for this account of Kahlo—but in negative, by the reversal of her emphatic concentration on the look alone. The internal direction of the gaze within paintings/the screen is

also important, particularly the mode of eye address *out* of the picture. If "Kahlo's" body is always the object of the gaze, her face always *returns* the gaze. Her body, her dress, her positioning, her environment are all signifiers of the subjugations of the male gaze; they are replete with signals of voyeurism and fetishism. But her face always refuses both to the male gaze by presenting him with an image of a woman which has *already been* subject to this psychic processing. In a sense, the male gaze always arrives at a Kahlo painting *too late*.

Too late, that is, for the male spectator to do his voyeuristic/fetishistic work on the image of Kahlo. It has already been done. In *The Two Fridas* (1939) she reverses the conventions of the aristocratic husband-and-wife portrait (conventions are also widely dispersed among popular art and often subverted by her in both forms), substituting an antithetical but sisterly image of herself for the banished husband. In *Self-Portrait as a Tehuana* (1943) the native dress nearly envelops her face, just as the plant and lace tendrils threaten to take over the entire space. The tatoo/forehead "thought" image of Rivera drives home the blame—and this is the further effect of her refusal of the male gaze: it turns the processes of voyeurism and fetishism back to the spectator through guilt. In other self-portraits, this "third eye" image turns into a skull and crossbones. In this way Kahlo builds into the act of looking at these paintings that distancing which is denied women in Freud and Lacan. She takes on to herself the power of overcoming castration. She becomes the author of her own gaze (the staring defiant face signals this, the absence of demure looks away, sideways glances, etc., but it is the process of looking as a whole which does it). And this occurs without, apparently, appeal to a female spectator, a women's culture. Nor can I, at least, recognize a distinct "power of the woman/the Mother" as evoking fears in the male child/spectator in active use in these exchanges.[30]

Perhaps there is an appeal to a female spectatorship, a reaching out past the male gaze to other women. The particular quality of the way Kahlo paints her face comes, technically, from the fact that she is painting her mirror image (rather than from memory, sketches, or photographs). The role of mirrors in checking on "how I look" is familiar and perhaps trivial. But if we regard the paintings themselves as mirrors (beyond their framing, size, being on tin), certain deeper questions appear. Lacan's metaphor of the mirror phase in the formation of the ego again parallels Kahlo's concerns and is resisted by them. There is a poignancy in the parallel occasioned by Kahlo's physical disability: the child joyously responds to the mirror image which shows him to be physically more complete, perfect than he experiences his body to be. Kahlo refuses this misrecognition in all of her self-portraits—overtly in

Broken Column, less obviously in *Self-Portrait as a Tehuana*—again, by a reversal. What is seen in the mirror/painting is not the image of the ideal ego but the image of the imperfect self. It takes as central "the long love affair/despair between image and self-image," but it sets scopophilia working backward, ironically: the male spectator cannot fetishize or identify with the image "Kahlo," except masochistically, by identifying with his own victimization (substituting himself for Kahlo as victim, the woman as the butt of the joke, by becoming Kahlo-who-returns-the-gaze-to-him, by becoming the object of his own gaze, I suspect of his own power).

Two paintings are most explicitly nearly mirrors. In *Self-Portrait as a Tehuana* the curling frames, the coloration, the brittle tonality evoke the mirror, as does the obvious concentration on the figure with little space around of any depth, the obvious posing for inspection. "How do I look?" here takes on suffocating dimensions. Some have been mentioned, but here it can be added that the play of victimization/struggle is again overt. The first impact is stunning: this is dressing up on a grand scale, a feminization so excessive that it passes over into a flaunting masquerade. If *Self-Portrait with Cropped Hair* approaches transvestism with its adoption of man's/Rivera's clothes and a male hairstyle/head—and, by inversion, reasserts a dependent femininity (transvestism by women is sexy)—the masquerade of this, *The Two Fridas* and other paintings, as well as her use of Mexican dress, "involves a realignment of femininity, the recovery, or more accurately, the simulation, of the missing gap or distance. To masquerade is to manufacture a lack in the form of a certain distance between oneself and one's image."[31]

If this is true then we are exposed to yet another source of the emotional power of the movements forming the image "Kahlo": the masquerade, and only the masquerade, evokes the "emptiness below," the fear of "nothing underneath" the mask, the absence of personal identity, and the larger lack of the female as such. Kahlo never shirks from this, or Kahlo's work is only, always a shrinking from this, a horrified covering of it with image over image. *Self-Portrait as a Tehuana* dresses a German-Spanish woman in stylized native costume, excessively; stamps her male god/husband on her forehead, obliterating the mind of the bride; denies her broken body also by obliterating it, floating her head—literally, a dress for the (severed) head; cracks the mirror surface by the tendril lines, connoting ugliness, the failure of beauty, the passing of the flesh, the folly of vanity. And shockingly, the last *The Mask (Self-Portrait)* (1945), with its doll face and dyed hair, obliterates the image as such by its pencil scratching of the paint away to reveal the graphite (the mirror backing) beneath (not overlooking that it is oil on masonite: the effect is as described.)

The black hole of female absence is a consequence of woman's economic, cultural, and psychic dependence. The scratched out eyes of *The Mask* go to the point argued by Elizabeth Cowie in her reassessment of the implications of Lévi-Strauss's work for feminism. She concludes: "It is therefore possible to see 'woman' not as given, biologically or psychologically, but as a category produced in signifying practices—whether through exogamy and kinship structures or through signification at the level of the unconscious."[32] Interestingly, the only images in which the movement of recognition/resistance (which I have been insisting is the political point of Kahlo's work) collapses are the *Portrait of Diego and Frida* (1931) marriage painting and *My Grandparents, My Parents, and I (Family Tree)* (1936), in which Kahlo represents herself as a little girl, with a little girl's head, standing naked in her family house holding the red ribbon which traces her family line present in portraits above her. No critical dimensions exist: she is totally fixed by exogamy; she is a sign for this system and thus, in Cowie's implied sense, "empty" in terms of any other concept of woman. The only "escape" from this image is one which reaffirms it, and is masculine: as a child, she cannot yet add to the family by giving birth; as the adult artist, she cannot.

Child Communist Resists Cultural Imperialism

No greater contrast to the *Family Tree* can be imagined than the earlier image in which Kahlo mediates between two cultures, two lines of civilization—the Detroit *Self-Portrait on the Borderline between Mexico and the United States* (1932). It points us to a concluding question: how does the politics of the particular, the personal, "go public" as it were, in the case of Frida Kahlo? Not just through the normal processes of promotion and explication of an independent artist's work, because, as we have seen, her work begins from "further back" in the communicative exchange, from privacies for which little public language existed (and still does not—except the elaborate languages of displacement and repression, for example, medical, legal, educational). Nor just through the processes by which Kahlo was a figure within the cultural currency of Mexico and of Mexico in its economic/ideological relations to the United States. Tied to the golden heavyweight Rivera in this diplomatic game, whatever Kahlo did is already positioned by its exigencies. But were the rebarbative contents of her work, persona, and life so readily absorbable as exotic eccentricities?

The terms through which Kahlo's art becomes public/visible at broader levels contrast strikingly with those operative for Rivera. Rivera's initiating conceptions were global, sweeping historical flowings of essential forces, which drew types of men, classes, whole people along with them

in patterns paralleling those of the earth itself, yet creating also heroic individuals who could in turn affect the course of history through their decisions and actions. His mural cycles in Mexico and in the United States were elaborate visual organizations of this kind of view, and their unifying principle in the early 1930s was the hope that the elemental energy and ancient culture of Mexico would unite with the new industrial energy of modern U.S. culture to produce a better world for everybody, particularly the workers and peasants of both countries. He had no doubts that his art contributed to this process. However politically naïve and conceptually simplistic these beliefs may now appear, they were progressive at the time (although other artists, such as Orozco and Siqueiros, held stronger positions).

This language of command, of the human actor choosing to influence history, the fates of *his* people, is quite foreign to Kahlo. Her imagery is formed in the conflicts between the static and the flowing, emblems vis-à-vis tendrils, of the fixed and the disintegrating occupying the same, essentially empty, vacant, hollow space. Contra Rivera, the "strong masculine labor" of working-class political struggle has no value for her, although she was a member of the Communist party in Mexico for many years. (*Marxism Heals the Sick* is only partly ironical, she died painting a series of portraits of Stalin.) The Detroit *Self-Portrait* (1932) rejects U.S. modernity and Rivera's Pan-Americanism, as we have seen, because of the kind of woman they produce her as, the vacuous items of cultural exchange they force women to become.

Her relationship within Mexico was more complex and more interesting. She single-mindedly worked only within forms (formats, techniques, styles) which were overtly Mexican, but were not those of her own class, history, or training. These forms were popular, often amateur. *Retablos*, however, were usually painted by itinerant craftsmen and women who made a scratchy living doing visual work as it came, and were associated with religious beliefs which she did not share (although much of *retablos'* power comes from these absent associations). Yet she made little effort to disseminate her work on any scale despite its popularizing visual language. (Rivera made rather more of an effort, but we should remember that murals were situated at the sources of social power—however democratically organized—and spoke to the leaders of the people, and the people through reproduction and reputation. They also spoke visibly of Mexico to tourists, their imagery being eminently exportable in reproduction.) Furthermore, her Mexicanidad was archaizing: she used and celebrated folk forms no longer in active use, especially *retablos*, which had apparently begun to reflect the imagery of mechanical reproduction. Kahlo's Blue House at Coyoacán was, from

the beginning, a museum to this ambition: it contrasts markedly with the International Style modernism of the pair of house-studios, designed by Juan O'Gormon, which Rivera had built for them both in another suburb of Mexico City, San Angel, in 1932.

Outside Mexico, Kahlo's work has yet to be located within the visual culture of her country. Some of its exceptional qualities are shared with other artists, past and contemporary, and some other artists relate just as strongly to folk imagery. Indeed, her lietmotif—the confrontational stare of the victim fixed by the gaze—occurs throughout modern Mexican art, in a variety of media at all class levels.[33] The myriad meetings of Spanish and Indian cultures have created a virtual tradition of difference: the haunting of the everyday by the grotesque forms of the other is the subject of incessant visualization.

Yet little of this seems any more politically progressive than the presentation of Mexican culture in the aestheticized anthology exhibition *Twenty Centuries of Mexican Art*, presented in 1940 by the Museum of Modern Art, New York, in collaboration with the Mexican government; the exhibit ranged from a jade Olmec head to *The Two Fridas*. But Kahlo's actual positioning as a broken lady, a woman, a woman artist, and a Mexican on the losing end of a massively unequal cultural exchange combined to generate the critical knowledges we have discerned. The Detroit *Self-Portrait on the Borderline* (1932) is, again, indicative: the apparent "equality" of the two cultures is a false one; their static struggle is to the detriment of Mexico. Indeed, the painting's juxtapositioning of U.S. and Mexican cultures echoes countless images of the intersection of Spanish and Indian cultures. Similarly, the *Two Fridas* could be interpreted as alluding to various representations of the most famous instance of this relationship, Cortez and Malinche, both strikingly portrayed as nude by Orozco in this National Preparatory School Mural of 1926.[34] These images also bear the marks of the *internal* effects of imperialism, the isolation of dependant peoples from their own culture, especially the isolation which comes from having to search the national past for signs of an organic unity which will serve the present by being strong enough to equal the power of coherency in the invading culture. A parallel is Octavio Paz's questioning of the necessity to combine the Indian and the Spanish elements, and the abstracted unreality of doing so at a time when Mexico's *internal* historical evolution was not demanding such a unity in just this way.[35]

The artificial fragility of the Mexicanidad movement among artists and intellectuals is evident in all of Kahlo's dressing up, conservation, and in her self-image as different kinds of Mexican woman (women from different regions, classes, racial groups than her own). In *Self-Portrait on*

the Borderline (1932) her image becomes overtly socialized: U.S. modernity will transform Mexicanness into objects of tourism (after oil exploitation, the second largest Mexican-U.S. industry at the time), subject the elements of nationality to that same neutralizing gaze with which it isolates and aestheticizes exotic cultures all around the world, sweeping aside local relationships to cultural signs, however fraught they may already be.

Keeping the Indians "Indian" was (and remains) also useful to the non-Indian Mexican government: troublesome peoples remain "backward," and look great for visitors as well. Kahlo is facing the fearful realization that, despite the history of her country, despite the relatively recent Revolution of 1910, there may well be no deep or essential Mexicanness, only the isolated, random, leftover signs of it. Not just that she, or Rivera, or whoever, has yet to find the imagery of the new Mexico but that there is none to be found, there is nothing there, there is only the searching and the surviving. Which returns us, finally, to the theme of the previous part of this analysis: it is not just a coincidence of structure that the same form of fear of the nothingness of the nature of woman is also at the basis of her Mexicanness. The empty "woman as sign" is full only as an item within exchanges conducted by men, by others, by societies—particularly modernizing societies, with their tendency to break down local, regional, neighborhood, and even family support systems in favor of "rationalizing" primarily commodity relationships of exchange.

Kahlo's incessant self-portraits are not merely a desperate effort to fill in this yawning, destroying emptiness, a voluptuous noise obstructing the deafening silence. Male artists do this: thus the romantic self-portrait, the artist and the model theme. Rather, Kahlo's self-portraits are (as suggested earlier) images of woman constituted as a set of effects. And this is the basis of their resistance: they are an assertion of self and nation—always, importantly, together—against perennial fears of nothingness but specifically against the increasing (and increasingly "modern") forces working actively to deny women and Mexico. They do not posit any essential femininity or Mexicanness but recognize the necessity of constantly constructing both with the materials to hand. But *different* constructions, from the as-yet-unspecific possibility of a life and a world "not masterable" by either the male look or the imperialist gaze. Kahlo's work is work on and in the constitution of sexual and national difference; its critical point—her "delicate," "perfect" *situation*, in Breton's words—is not a statement or a creed or a policy but an ongoing, persistent commitment to masquerade as a political project.

The concept of women's sexual difference, and of difference between

women, is based here on the recognition that all women have in common *the multiplicity of the feminine:* "a common feminist politics consists in a multiplicity of different positions, struggles and theoretical projects."[36] This suggests a politics of constant resistances, large and small, particularly concerning how we live in the processes of representation. It helps us say of Kahlo, for example, that what we value is not something long term, coherent, essentialist, and displaced like "Her art was her form of resistance," but rather her art's demonstration that we are shaped as subjects always and everywhere, and—equally important—that we can resist the oppressiveness of this shaping, if not always and everywhere, at least often and on some important sites. For example, those points at which sexual class and national difference are secured/*in*secured. And further, that resistance is not confined to proven, legislatable (and thus usually limiting) forms, but can be diverse, inventive, and surprising. Or, as Lucy Lippard put it: "From the broken but gaily decorated body of a victim beams the direct, expressively expressionless gaze of a survivor. I keep returning to the duality and synthesis that mark so much major women's art. Between the poles of populism and avant-garde, Indian and European, cultural revival and modernism, Kahlo sowed the seeds of a new vocabulary for the expression of female experience."[37]

These "poles" are not always dichotomous, nor are they entirely ungendered. Kahlo's obsessions indicate that all of these forces work constantly over and through each other during this period. Her work shares with some others the inspirations of logics which are not necessarily binary, but rather puts oppositions into struggle, sets them in play, generating quite other definitions of difference. The masculine and the feminine, at their most grandiloquent in Rivera's epic cycles, are subject to slippage between genders. Although a rare voice at the time, Kahlo's sexualities subvert this great divide more subtly, just in their masquerading. Past and future appear no longer as historical reconstructions or utopian/dystopian figurations, but as consequences of the complex play of other forces, mainly those seeking to reduce societies to ideologies, individuals to ciphers. Self-education becomes an incessant battle to construct identity out of dispersed, ill-fitting, overcoded fragments. Yet the victims of modernity can, her art shows, make themselves, in however apparently minor a key. The not-so-meek might not inherit the earth, but they will survive.

While Kahlo pursued these concerns privately, Orozco did so in the public arena of the mural. In contrast, Rivera's world historical scope and Siqueiros's programmatic sectarianism (although his imagery ranges wildly between inflated allegory and hysteria) were masculinist in most of their orientations. As Mexicans, all perceived modernity through

their experience of the United States more significantly than they perceived their artistic inheritances from the European avant-garde. The United States was present in its impact on Mexican life and society for all these artists from birth. They all went to the United States during the 1930s, figuring its modernizing energies in different ways. We have explored Rivera's and Kahlo's very different readings. In Los Angeles in 1932 and New York in 1936, Siqueiros painted against imperialism and for revolution while experimenting with industrial paints and the abstract imagery they permitted. These two elements come together successfully in the Mexican Electricians Union Mural of 1939–40, which shows the modern world as driven by an infernal money machine, its sociality riven with fascism. The other forces of modernity, here represented by armed revolutionaries and electricity towers, rise up triumphantly.[38] Orozco painted *Prometheus* at Pomona College in 1930, and allegories of Science, Labor, and Art at the New School for Social Research in New York during the following year, but his major U.S. work was the cycle at Dartmouth College painted in 1932–34. His preparatory panel was *Man Released from the Mechanistic,* and the North Wall at Dartmouth pairs the brutal cross of the conquering Cortez with an utterly lifeless accumulation of steel shapes representing the *Modern Machine Age.* The message is clear: all modern institutions, including education, are irredeemably corrupt; only heroic reincarnations of ancient heroes such as Quetzalcoatl can save humanity.[39] Orozco rages against the entire regime of modernity, seeing nothing positive in it: his art is a

7.11 José Clemente Orozco, *Dive Bomber and Tank,* 1940. Fresco, 9 × 18 ft. on six panels. (Collection, The Museum of Modern Art, New York, Commissioned through the Abby Aldrich Rockefeller Fund)

prophecy of doom. His specific imagery of modernization ranges from animal-machine hybrids to treatments of the icons of the new technology, such as the Queensborough Bridge, as if they were primeval formations.[40]

Four different perspectives in the present, four distinctive ways of imaging modernity. The diversity of the Mexican response hardly stops there: other painters, and photographers such as Manuel Alvaro Bravo, add to this complexity. Nor did the Mexican artists carry the torch of critical art alone, although they did so most spectacularly. In the next chapter we turn to the work of artists in the United States, particularly photographers, and examine their work during the 1930s.

If "business culture," *Fortune*-style, represents the effort to shape an imagery of modernity from the commanding heights of the economy, then Frida Kahlo's efforts to establish some footholds for identity, however fleeting, registers certain of the effects of *Fortune*'s rapacious regime as well as exemplifying one kind of struggle against it. Diego Rivera's Pan-Americanism tried to tackle U.S. modernity's innovative energies head-on, to absorb their prodigality into a historical vision that was both materialist and mythic. His cinemascopic battles of the giants and the peoples cannot be said to have succeeded in establishing a prevailing style in the early 1930s, although it was widely influential, and aspects of its imagery leave a legacy of accurate witness and radical relevance that can still inspire, and may do so again. These two artists, however sharply their work brought out the contradictions of the times, nevertheless embodied exceptional forms of resistance: they came from beyond the margins of mainstream U.S. culture and carried with them many of the values of otherness. What of the imagery of refusal, dissent, and reform that had been evolving inside the United States since before 1900? What were its roles during the crisis of the early 1930s? How did it develop during the Depression

decade? How did it become part of the imagery of democratic dissent then consensus, of modernity for everyman?

Work and the City: The Ambiguities of Social Realism

In the modern imagery of the city there seems to be a tendency to match the soaring skyscraper and the scurrying crowd below, a pairing which reduces individuals/people either to awed viewers or to atomized, anonymous those-who-are-viewed. In neither case are people autonomous participants. In the 1930s, however, the mix seems more volatile than the equally hegemonic industrial plant imagery. Struggles in the city preoccupied Social Realists in all media, as they did the Social Surrealists such as Louis Guglielmi and Paul Cadmus.[1] Again with striking exceptions, such as Evergood's *American Tragedy* (1937) (see fig. 3.12), or the early 1930s work of Thomas Hart Benton, and in scarcely known instances, such as Maynard Dixon's *Industry and the Worker* (1936), the industrial worker in or near the factory is rare even among these painters, so utterly did the imagery of this modernity seem dominated by management projections and so persistent was faith in the beneficence of value-free technology as such in the labor movement.[2] The industrial worker is prominent in Works Progress Administration murals on this theme as well as in certain lithographs and even paintings produced under the scheme.[3] Some are obviously influenced by Rivera's, Siqueiros's, and Orozco's approaches to the subject—for example, Hahndorf's industrial scene in the Coit Tower, San Francisco; Ben Shahn's in Louisville High School, New Jersey; Edward Millman's study of riveting for the Moline, Illinois, Post Office (c. 1938); and Letterio Calapai's *Historical Development of Signal Communication* (1939), which shares much with the *Portrait of the Bourgeoisie* section of Siqueiros's Mexican Electricians Union mural of the same year. Most seem to have developed from the Mexican example both quite specific treatments—such as Charles White's stirring statement of black oppression and independence, *Art in the Service of Struggle* mural for a Chicago library (1939–40), and Evergood's *Story of Richmond Hill* (1938) in the Queensborough Public Library—as well as generalizing ones, such as Anton Refregier's and Phillip Guston's murals for the WPA Building at the 1939 New York World's Fair.

In nearly every case, industrial plant imagery is shaped by the thrusting energy and cool lines set out by Bourke-White et al., appearing as a backdrop to the foregrounded workers, a new "nature" which the workers have to process as they did the land in the past.[4] In only some cases do the workers participate in the planning of production, although it is implied often, and images of worker control were rare indeed, and

were among the first works whitewashed in the 1950s. But the model treatment of industry was typically the reformist picture of committed workers organized by concerned professionals leading to a society of healthy people—as in Marion Greenwood's Red Hook Housing Project, Brooklyn, *Blueprint for Living* murals (1940). And taken together, the impression (because many were destroyed or are unknown) is that the imagery of industry came trailing behind pictures of American history, of absolute principles, and of life in the city or country. This emphasis accords with the general ideological aim of the Federal Art Project: to be one of the government agencies effective in promoting a nonantagonistic sense of classless consensus about shared national goals.[5]

What of the work of American artists active in the dissident political organizations? How has it fared in the professional memories of art historians? The retrospective eclipse of Social Realism is now almost entirely reversed: it is rare to find an artist active in the 1930s whose work was not in some way touched by a felt necessity to respond to the demands of the time, however much these impulses were constrained by the power of state populism when working on the project. This is true even of those artists involved in abstract painting and of the early work of most of the later, celebrated Abstract Expressionists. Knowledge of the large number of artists who devoted themselves to themes of social injustice increases constantly, and close studies are being made of the relations to working-class struggles of artists such as Phillip Evergood, William Gropper, Art Young, Ben Shahn, and Hugo Gellert. It has been claimed that the labor movement made little use of even this work, but, while this might be true for certain retrospectively celebrated easel paintings, it seems unduly negative given the wide circulation of the graphic work of these artists in magazines such as the *New Masses* and newspapers such as the *Daily Worker*.[6]

Research on the role of visual and other imagery in such traditional labor movement media as pamphlets, leaflets, banners, newspapers, journals, books, and badges is relatively recent. It was scarcely surprising in the conservative political climate of the 1980s that the first major public presentation of U.S. labor movement culture occurred in Berlin, in the exhibition Das Andere Amerika (Neue Gesellschaft für Bildende Kunst, April 1983). While the exhibition documented a variety of representations of the "other America," it reportedly emphasized the work of artists without specifying the concrete politics of their "interventions." The catalogue is, however, more informative on this score, and it includes some examples of work which, like Kahlo's, searches through social conflict in quite personal ways—that of Alice Neel, for example.[7] The organizers interpreted the labor movement as a constellation of

mostly scattered minority struggles, implying that organized labor was already irredeemably compromised by capital. This contradicts the huge growth in union membership from the mid-1920s to the mid-1930s, from 5 percent to 24 percent of the U.S. work force. As well as the intensity of many union-centered struggles, such as those we have noted at the Rouge. Resistance on all of these levels needs careful and considerate evaluation.

It was, however, work in the medium of photography that most actively contributed to the construction of an imagery of modernity in the 1930s. The differing demands of state consensus and democratic dissensus were negotiated, crucially, in the mass media. It is to the many lives of photography that we now (re)turn.

From Documentation to Documentary

During the 1930s, photography became the dominant visual media in the United States, not just within the imagery of reform but within the visual culture as a whole. Its manifest usefulness within an astonishing variety of social discourses—from police files to movie stills—continued to spread. It became more and more harnessed to the job of circulating images of products and ambience, to promoting the spectacle of consumption. As we saw in the study of photography within the *Fortune* ensemble, this tended to erode the "truth-value" traditionally associated with the medium, to suspend its veracity as documentation, as witness of actuality, in favor of advertising's imagery of desire.

Yet documentation had been a vital tool in the hands of the social reformers and continued to be so throughout the period. One difference after 1932 was that the private and academic "technicians of reform," such as Lewis Hine and Rexford Tugwell, were now in government, with the chance to implement their ideas as state policy.[8] The translation from oppositional proposal to official implementation was not, however, a simple switching of great concepts into hard reality. Some of the ideas turned out to be not so good, some warranted the hostile reaction they encountered, while others—as we shall see—met with the sharp criticism or silent noncooperation of the Farm Security Administration (FSA) photographers themselves.

Documentary photographers had the task of recording the lives of "the people," serving thereby the agencies of social control. But they did so, often, in exchange for some effort by those agencies to reform the "inhuman" and "unjust" conditions under which at least some of their subjects lived and worked. This ideology of social reform might seem to cut directly against the interests of the new corporate/consumerist modernity. Was this the case? To what extent did the reformers

take on the ideology of modernity, and some of its subtle signifying practices? How far were the critical devices of realism incorporated into the imagery of the new corporate state? What signs of resistance still animate these images when we read them against the grain of their incorporation?

Recent studies have moved beyond the insoluble red herring of the truth-versus-fiction value of the photographs and films, beyond the opposite concern exclusively with aestheticizing readings of them, to an emphasis on "documentary expression," that is, on the photographs as accurate records of human experience aimed at effecting an emotional response in certain viewers. This contradicts an implied model of disinterested recording of typical facts with no effective intentions at all, against which all photographs can be measured and found wanting. No such expectations were held by anybody involved at the time, despite Walker Evans's declaration that "this is pure record, not propaganda."[9] As well, recent interpretation is quite clear about the use-value of documentary. Thus Stott's "definition" of documentary as a mode which "treats the actual, unimagined experience of individuals belonging to a group, generally of low economic and social standing in the society (lower than the audience for whom the report is made) and treats this experience in such a way as to try to render it vivid, 'human', and—most often—poignant to the audience."[10]

This definition applies broadly to the social relations of documentary since Barnardo and Riis in the 1880s and 1890s, to Hine after 1900, and to the FSA-related photographers and filmmakers of the 1930s.[11] There are however, many distinctions as to political intentions and effect to be drawn here—something which is occurring in recent studies.[12] The concept "documentary" is misleading in that it drains off the radical political thrust of, for example, the Workers Film and Photo League, especially its early 1930s efforts to use "the camera as a weapon" of class struggle through the organization of groups of worker-photographers.[13] The concept implies that, whether radical, gradualist, or reformist in their political beliefs and practices, all involved in documentary took what they conceived as the life experience of the poor and the working class as the touchstone of authenticity, of humanity. Most writers now stress how careful the documentarists, responding to their commissions, were to set up shots which sharply conveyed the "look of poverty" as well as the possibility of recovery from it, either through political struggle or by consenting to/joining in New Deal programs.

Yet even this open kind of interpretation still presupposes a prepolitical innocence, the allocation of which keeps shifting from photographer to subject to commissioning agency. The hyperconscious ironies encir-

cling James Agee's text in *Let Us Now Praise Famous Men* seem only implicit in Walker Evans's photographs in that book and in his FSA work of three years' earlier.[14] On the other hand, Evans's images can also be read as exercises in critical restraint. Along with more complex accounts of the pictorial intelligences at work in constructing the photographs, we need a similar account of the forces constructing the conditions of their making, for example, the "authorship" of the FSA photographs by its administrators as part of a national system of surveillance. Or, on the other hand, the importance of Nykino and Frontier Films for theoretical debate and party strategy in developing resistances to this kind of state power.[15] The account of 1930s documentary photography should extend to encompass the circulation and receptions of these images, tracing their role within the construction of popular perceptions of the United States during this crisis period.

When, in the early 1920s, Roy Stryker searched for photographs to illustrate Rexford Tugwell's university/school textbook *American Economic Life*—a survey of the strengths and weaknesses of the U.S. economy, later to become a key New Deal textbook—Lewis Hine's studies were among the few available.[16] After World War I this scathing critic of the injustices, the casual brutalities of U.S. industry seemed to become a champion of industry's new style of growth. Hine's *Men at Work* of 1932 is subtitled *Photographic Studies of Modern Men and Machines*. Its preface, "The Spirit of Industry," states:

> This is a book of Men at Work; men of courage, skill, daring and imagination. Cities do not build themselves, machines cannot make machines, unless back of them all are the brains and toil of men. We call this the Machine Age. But the more machines we use the more we need real men to make and direct them.
>
> I have toiled in many industries and associated with thousands of workers. I have brought some of them here to meet you. Some of them are heroes; all of them persons it is a privilege to know. I will take you into the heart of modern industry where machines and skyscrapers are being made, where the character of the men is being put into the motors, the airplanes, the dynamos upon which the life and happiness of millions of us depend.[17]

This statement exemplifies Stott's emphasis on audience address: certainly the "you" is not the workers, in the first instance. Documentary here means cross-class introductions (perhaps even to the children of the comfortable): workers look like this when they work.[18] But Hine's perspective has not become entirely managerial. He clearly wants to

8.1 Lewis Hine, photographs for R. G. Tugwell, T. Monroe, and R. E. Stryker, *American Economic Life* (New York: Harcourt and Brace, 1924)

reassert the importance of the skilled tradesman to modern industry, to emphasize the value of artisan pride at a time when work was submerged in Depression desperation. Although limited by its primary focus on the construction of the Empire State Building, *Men at Work* also includes a selection of images from thousands taken over the previous ten years. Essentially, it is organized according to choices shaped by the larger contradictions of its moment.

8.2 Lewis Hine, frontispiece, *Men at Work* (New York: Dover, 1932; photograph International Museum of Photography at George Eastman House)

Hine's exceptionality lies in the focus on workers rather than the implied independent otherness, the separate beauties, of machines, buildings, industrial plants, and cities which more and more figure Sheeler's and Bourke-White's photography and which, as we have seen, emerge as the imagery of industry in the early 1930s and come to dominate representations of this subject by the mid-1930s. Hine pictures the manual strength and the skilled competence of workers in a variety of industries, their cheery dedication, their willingness to risk all to get the job done. The captions underline this heroizing; they draw it off directly from the "character" of the workers. Nearly all the shots are taken close in to the job being done, the captions explaining its nature, its place in the narrative and significance for society. Of the twenty-six shots of the Empire State Building, only construction workers are shown; the city is seen solely from their work sites (actually glimpsed in between them), and the building itself is not seen. Indeed, he selected out shots of the building, its frame, and its cladding. He also omitted images of more traditional practices, such as ironworking on the site, and those of older workers, with captions such as "Old timer—keeping up with the boys. Many structural workers are above middle age."[19] The *building* of the structure is the world of these photographs—New York exists by implication, as a consequence: "Cities do not build themselves."

On the other hand, Hine reaches for the dominant themes of 1920s modernity in the very choice of the Empire State Building, the weight it receives in the book. More importantly, he attempts, pictorially, to virtually "fuse" men and machines, to accept the dynamism, the necessity of the Machine Age. He goes some way toward accepting the corporatization of imagery, making—in Tratchtenberg's terms—an "interpretative" rather than a "social photography," becoming a moral rather than a social realist.[20] But Hine pictures this modern unity in ways which the new order was rendering anachronistic. He wants to show how "the character of the men is being put into the motors." Thus the pictorial rhythms of the skyscraper series are created by a choreography of workmen moving gracefully through their tasks rather than by the structural logic of the steel skeleton growing. The workmen building turbines and transformers may be dwarfed by these machines but they are shown measuring, shaping, applying other tools to them. Mostly, they quite match their machines, which seem at the command of their strength or knowledge—indeed, seem to echo their movements as they subject themselves to its motions. In all this, Hine is paralleled by Rivera, tackling the same problems in Detroit, although carrying different cultural and political baggage. And, like Rivera, he rejects as much of modernist aestheticizing as he absorbs: "I have a conviction that the design regis-

tered in the human face through years of life and work, is more vital for purposes of permanent record, (tho' it is more subtle perhaps) than the geometric pattern of lights and shadows that passes in the taking, and serves (so often) as mere photographic jazz."[21] There is, hidden here, another conception of labor, one in which photography is itself a form of working, paralleling that of the men.[22] Even when, like their labor, it serves the corporations—in this case Hine acted initially under a commission from the builders.

Despite this, Hine's range, scope, and sensitivity to contradictions went against the grain of the hegemonic imagery of modernity being dispersed through the business magazines and the advertising agencies. Rivera's approach is again paralleled here, although Hine's art did not suffer the same fate as the Mexican's Rockefeller Center mural. Industrial work in the cities, and the rapidly changing conditions under which it was being carried out, attracted some other artists. These include John Gutman, a German photographer in San Francisco in the 1930s, and a number of other recorders of city life whose work has been subsequently eclipsed.[23] Gutman's photographs are exceptional in their insistence on the unique potential of individuals, their survival capacities in a setting of impending doom. He does not reduce people to crowds, thronging through the soaring citadels of commerce. In Berenice Abbott's WPA-commissioned photographic survey of New York, victims of the Depression cluster at the base of a skyscraper city, but they do not persist in her photographic project, whereas the buildings do, constituting a strangely empty city, autonomous, changing itself. In his lithographs of New York and other cities, and of industrial plants, especially in New Jersey, Louis Lozowick develops a strong political commitment to figuring the city from the perspective of the street and those on it, and from the perspective of those who build its monuments.[24] Few artists treat office workers during this period in a celebratory way. Some, like Raphael Soyer and Reginald Marsh, are curious about the smart, modern beauty of the secretary, for example, but within a developing critique of the society being reconstructed around them. Even Edward Hopper's paintings, treated in the 1960s as light studies, can now be seen as portraits of mood, of the isolation of individuals in cities, of the awkwardnesses of their individuality. While there is some fine and subtle art among these and other treatments of work in the city, it has to be said that the majority of attempts to tackle this pressing subject are characterized by either plain ordinariness or an ideologically defensive ambiguity.

New Deal Displacement

The city-crowd, plant-worker, and product-consumer iconography of the visual imagery of modernity underwent, as we have seen, many changes during the 1930s. Equally remarkable was mobility between these couplets. The image of the industrial worker, for example, was not only put "out of focus" by the intensely stylish concentration in *Fortune*-type photographs on industrial plants and machine parts, but it was also *displaced* by the increasing attention paid to another kind and place of work—agricultural labor. In the popular memory, the industrial worker appeared at the ghostly peripheries of recollection. Center stage was occupied by the conscience-piercing visages and empty landscapes of the farm worker, embattled into destitution.[25] Republication of these photographs sharply increased during the 1970s, mostly within the frameworks posited by the October 1962 exhibition at the Museum of Modern Art in New York—The Bitter Years, 1935–41—compiled by Edward Steichen, with input by Stryker into at least some of the publicity.[26] As a distinctive body of work, the Farm Security Administration photographs came to the attention of the professionally interested at the First International Photographic Exhibition, held in New York in 1938. This interest was reinforced by the first wave of articles in 1941, at about the time the unit was absorbed into the Office of War Information, and by a second set, just after the war.[27] Gradually the FSA photographs have come to represent the "common experience" of their period, to the exclusion of other imagery, and, within them, those which show the sufferings and struggles of dispossessed farmers have received the most attention, coming to represent the "Depression experience."

Questions immediately arise. The FSA program began in July 1935 and began to distribute photographs for government, business, and private publicity purposes in the following year. They were not, then, contemporary records of the "depths" of the Depression. Yet unemployment, declining during the recovery of the mid-1930s, reached over ten million in 1939, and certain areas of the country, particularly the South and Southwest, continued in a disastrous condition throughout the period, especially the agricultural areas of the Southwest. It was the job of the Farm Security Administration to rectify this situation: the photographs were conceived of as an important way to dramatize the plight of these people and to thereby justify government intervention on their behalf. Nonetheless, attention has focused on the images of loss and desperation rather than those of recovery and reconstruction. If there is some ambiguity as to the reading of these photographs, we need to ask

how they were interpreted at different times. If they served the processes of displacing the imagery of industrial labor, when did this occur and why? We have noticed already profound shifts and swings across U.S. society in and between the early, mid, and late 1930s: how did these changes organize the conception and the reception of these photographs? In particular, FSA photographs seem not to foreground two other, crucial aspects of industrialization, aspects close to their own domain: the mechanization of farming, and the fact that most of the displaced farmworkers whose displacement they do so dramatically document ended up as workers in city-based industry. Does this not suggest that the major task of the Agricultural Adjustment Administration (of which the FSA was part), when seen at its broadest, was less to secure agriculture on its traditional bases in independent small farming, more to facilitate the shift of the U.S. economy from its dependence on primary production to those industries essential to mass consumption? Asking these questions demands, in turn, a fresh reading of the FSA images, and the many others like them made during the period. John Tagg puts the issue this way:

> What we must be aware of in our analysis of FSA photography is the constitution, at a moment of profound social crisis, of "poverty and deprivation"—of what Herbert Hoover called "Depression"—as both the target and the instrument of a new kind of discourse which became, though fleetingly, as production and mobilization for war brought immense changes in the historical forces, a formidable tool of control and power. We must ask how it was in the power of this "Depression" to produce the "true" discourse of the FSA photographs. What was the political history of this "truth"? How was it produced and circulated? . . . What is the function, the *office*, of "realistic" representations of misery in the bourgeois state?[28]

I approach these questions by first sketching something of the organization of the FSA program, including some analysis of the photographs produced by it, and then trace their distribution during the 1930s. This enables an answer to Tagg's questions, but only when the imagery of subjection, figured mainly through pictures of rural poverty, is seen in relation to the imagery on which we have focused—that of growth and power, figures of industry and the city.

Roy E. Stryker was a student then assistant, during the 1920s, to Rexford Tugwell, professor of economics at Columbia University and subsequently the assistant director of the Department of Agriculture in the Roosevelt administration. Stryker was initially appointed to the Depart-

ment of Agriculture in May 1934, as an "information specialist," with the following duties: "to plan, execute and advise with regard to information and material in the form of charts, graphs and other pictorial and visual media, relating to the programs and activities of the Agricultural Adjustment Administration."[29] By July of the following year he had become chief of the Historical Section of the Farm Security Administration and had established the priority of photography over all other media, and the centrality of documentary. Thus the task became

> making a documentary record of the problems, objectives and achievements of the FSA. I have been given the responsibility of conceiving and developing this record in a unified form of expression through the employment of photographic media, employing the literary and graphic arts in so far as they are complementary and necessary to the photographic form of communication. This record serves not only a historical and sociological function, but also provides, for public information, an accurate and objective testimony of the FSA program, the conditions which make the program necessary, the contemporary accomplishment of the program, and the ends which the program hopes to serve.[30]

Stryker recalled Tugwell's key instruction: "Roy, you've got a real chance now to tell all the people of America that people in distressed areas are just the same as everybody else except they need a better chance." Stryker went for the basis of this sameness, a structure which "insisted on seeing the American scene whole rather than in part or from one point of view," a structure which was insistently both totalizing and atomizing, in which the whole consisted only of accumulated parts, and the parts all bore the signs of the whole.[31] It is one of the most striking instances of the classic mid-1930s meeting of extreme individualism and modern social planning. Small wonder that his instructions to photographers read like the contents pages of economic geography text books.

Indeed, his approach is, in all essentials, and many details, rehearsed in the project for the publication of *Pictorial History of American Agriculture*, on which he collaborated with Professor Carmen of Princeton in later 1935 (suggesting, at one point, that Henry Ford might be interested in financing it).[32] Nor were the FSA photographers the first to celebrate the stoic virtues of rural life: New York society portraitist Dorothy Ulmann also eulogized the folk in *Roll, Jordan, Roll* (1933) and *Handicrafts of the Southern Highlands* (1937).[33] The FSA photographs can be seen as part of this regionalist reach, one which was to become more and more prominent in painting, including murals, where it has long been con-

ventional to discern a regionalist tendency.[34] Indeed, a perceived threat to this rural pastoralism, figuring these "pseudo-peasants" as victims of unknowable other forces, informs the entire program: these "historical relics" became the subject of salvation through, first, recording, and then "sociology," that is, welfare. A parallel Federal Art program in the visual arts which moved through the same social logic was the Index of American Design, a project to make watercolor pictures of examples of every artifact used in the country, especially those in danger of extinction.[35] Writers were set to work on an ambitious series of guides to each state in the union and the major cities, and most did so in a manner which valorized the minutae of everyday experience to an astonishing degree.[36]

Henry Ford's modern archaizing at Greenfield Village ceases to be exceptional. The inventory becomes the key figuring device of the moment, a patient listing of everything seen, a mounting excitement as more and more is recorded as if the ultimate desire of the documentary cartographer hovered always on the verge of realization: the map so fine that it fits exactly the world it seeks to measure, not like the artifice of the model which stretches across reality, retaining its stylish similarity while the world beneath it crumbles in ruin (a European metaphor), but more like a never-ending dollying by a mobile camera, a film becoming indistinguishable from life because only that which appears before it, carefully posed as a chance meeting with the matter-of-fact, counts as "life" in its pristine form. The map/model is modernized by a simulation of the journey through itself. The documentary process, then, becomes a journey of progressive discovery and disclosure of the signs of blooming health on the surface of the social body, excavated by these meetings, when one class comes to see the other and calls on "humanity" to account for the felt fact of recognition across difference.

In the FSA photographs, two angles of glance were often picked out and framed by the project's presentation: the frightened look out and away, signifying despair in need of sympathetic comfort; and the direct look at the viewer, signifying independence, valor, the right to recovery. How was capital served by this insistent focus on the docile desperation of its victims? Is it too easy to answer that this is a pathological gaze, a picking over of the symptoms of disease, a searching so thorough that it must disclose signs of health? Thus the implied assumption of Tugwell's instruction: these "distressed" peasants are temporarily beyond the pale of "all the people of America," and thus have a democratic right to restoration (to health, sanity, normality). Sympathetic professionals (with liberal values transcending the widespread dismissal of these people as "white trash" and "niggers") have a duty to act so as to aid this process.

Once again the future of the present as an aberrant past intrudes into progress toward the future. Photography, by its nature, has a double role here: it is a witness of "truth," of actual occurrence before the "objective" lens, and thus is shocking evidence of anomalous lives requiring corrective aid, but it also evidences the completion of the pictured moment, its entry into history, its past-ness—or, at least, the inevitability of its dating—and thus hints at the alteration of conscience by time. The photograph insists on the existence of its subject (these suffering people), but it also predicts their disappearance, death, their insertion into the succession of images which more and more come to stand for history. This kind of reflection is developed by Susan Sontag who says of Riis, and of Davidson's *East 100th Street* (1970): "The justification is still the same: that picture-taking serves a high purpose: uncovering a hidden truth, conserving a vanishing past. (The hidden truth is, moreover, often identified with the vanishing past . . .). What renders a photograph surreal is its irrefutable pathos as a message from time past, and the concreteness of its intimations about social class."[37]

However commonplace such readings are now, however accurately they characterize the "appropriative," "imperious," "predatory" impulses of those with cameras, they tend to be unhistorical. The connections, in photographic revelation, across classes and between times are meaningful, but they have to be specified and, in turn, related to the stage and shape of development reached by the broader visual culture. Undeniably, the photography under discussion was working to both introduce the plight of the seasonal worker into current discourses of social concern and to de-historicize the present, project it into a vanishing past (the rural dispossessed, the city poor) or an idealized future (industrial plant, the soaring city ceaselessly replacing itself). But it did so in historically specific ways, as we are beginning to see.

Picturing Poverty, 1935–36

Interpretation of the FSA photographs is often bounded by the monographic archetypes of an impassioned, committed, realist Dorothea Lange, on the one hand, and a coolly reductive, modernist Walker Evans, on the other. Between them, the FSA normalcy is seen as typified by the hard work over the years of the others—half a dozen at any one time, twenty in all between 1935 and 1943. Certainly there were interesting differences in approach, although even expert analysis sometimes struggles with underdocumented authorship.[38] In this analysis, however, individual interpretation comes up as shaped by the developing program: its variations are of most interest; the archetypes do not hold.

Of the 270,000 pictures taken at a cost of nearly one million dollars in the eight years of the FSA, Stryker "killed" approximately 100,000 negatives during the initial selection, categorizing, and filing to which all the images were subject.[39] Of the prints made by FSA photographers under Stryker's direction or collected by him from other sources, 77,000 (a small percentage) are in the active file of the Library of Congress, and it is on a random sampling of these, plus reference to published prints, that the following observations are based.[40] No general survey or characterization is attempted; relevant here is only the question of how the FSA stands to the developing imagery of modernity. What was it about the program, its organization, and its images which made them so attractive as the raw material for displacement of attention from the plight of industrial labor, even the stressed cities? Conversely, how were non-agricultural themes figured in FSA imagery?

In December 1936 Russell Lee, employed to replace Carl Mydans who had left to join the new Luce photomagazine *Life*, went on one of the field trips which quickly became the standard FSA mode of production. The job was the same as the others at this stage: picture the rural poverty

8.3 Russell Lee, *Hands of Mrs. Andrew Outermeyer, wife of a homesteader*, 1936. Library of Congress, Prints and Photographs Division. (LC 262-10582)

which the Resettlement Administration program was designed to alleviate. As he moved from house to house in Woodbury County, Iowa, shock became indignation. Obviously setting out to do a step-by-step survey of properties, he disrupts the rhythm of shots with searing close-ups of animal skeletons, dugouts, the wrinkled "hands of Mrs. Andrew Outermeyer, wife of a homesteader." This last image is famous because it makes a generalizing point about the relentless wearing of unrewarded hard work upon the human body, especially when reproduced without, or with only sketchy, contextualization. And doubtless Lee reached for the emotive empathy of the close-up, so recently established in visual discourses by German photographers such as Lerski, and by Eisensteinian montage and the Hollywood glamor shot. Indeed, he is opposing European realism to the American Dream, localizing it here as an absence of glamor, of even "normal skin": these are the hands of "the people." The skeletons contrast with landscapes of tilled fields, the dugouts with houses, themselves ramshackle enough. And the hands contrast with a full portrait view of their owner, seen against the side of the makeshift house, in a husband-and-wife portrait. While his body is bent and bowed, his expression angry, she struggles to stand up—indeed, to pose herself, to smile for the camera. Her withered hands rest on her dress, less stirring in themselves because we can see her age, but one

8.4 Russell Lee, *Mr. and Mrs. Outermeyer, Homesteaders. Have lost their farm to a loan company,* 1936. Library of Congress, Prints and Photographs Division. (LC 11121-M3)

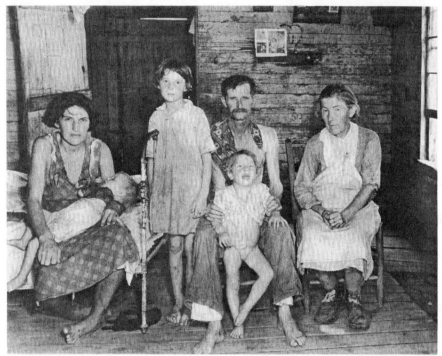

8.5 Walker Evans, *Bud Fields and His Family, Hale County, Alabama*, 1936.
Library of Congress, Prints and Photographs Division. (LC 342-8147A)

8.6 Walker Evans, *Kitchen Wall in Bud Fields' Home, Hale County, Alabama*,
1936. Library of Congress, Prints and Photographs Division. (LC 342-8147A)

part of an ensemble of cues of desperation. Lee's caption makes it clear that these farmers have been forced to become homesteaders not only because of their age, crop pests, and erosion, but simply because they "have lost their farm to a loan company." This photograph and others like it in the sequence are not famous, yet they arguably match at least some that Walker Evans took in Hale County, Alabama, a few months earlier, becoming the images in the book *Let Us Now Praise Famous Men*.[41]

Injustice does not "naturally" picture itself: the FSA photographers tried many ways to match their images to their perceptions. At Woodbury County, Lee tried techniques which he hoped would have impact as single shots, as shots in sequence, as generalizing images, as pictures of the specific, as typicalities, as exceptions. A modernist use of close-up is followed immediately by a Hine-type human interest shot. FSA photographs tend to move rapidly between images in which the impact depends on devices to make the subject strange (usually flattening, cropping, odd angles, unexpected lighting—all the devices of avant-garde modernism) to images constructed around the conventions for serving up straightforward "unmediated" actuality (the devices of realism). No clear struggle between the two poles is implied; on the contrary, elements from both traditions mix freely in many images. Often, difference of approach seems to relate to presumed appropriateness to subject matter (for example, the usefulness of modernist precision in organizing eroded landscapes—Evans near Jackson, Mississippi, March 1936, or Lange at Childress County, Texas, June 1938, or at Rolls, Texas, May 1939), but equally often techniques seem used, apparently, against the grain of the subject yet serve to deeply enrich the reading (classically, in Evans's interiors of the sharecroppers' homes in Alabama).

In contemporary art circles during the early decades of the century, the debate seems to have opposed photographic "purism" to "pictorialism," some elements of which echo in these images, but not many. The documentary mode, especially as practiced by Evans, Weston, Strand, and others during this period, soon entered as a major force in modern photography. Its continuities and differences are less with pictorialism and purism than with modes already discussed: *Life*-style "naturalism," on the one hand, and a new tendency to aestheticism, on the other. Both are active elements within the imagery of modernity as pursued by advertisers and publicists of industrial growth and consumption. The stylistic point here (for the little it is worth) is that documentary photography is not opposed to modernism, nor is it only realist: it draws in both tendencies; their contrary connotations activate the imagery, not problematically but productively. The surprising oppositions which so dynamically integrated images and text in *Fortune* occur again here, al-

though in different forms. Nor should this surprise us, as the *Fortune* story—with its emphasis on prior research and global analysis, mixed with personal experience of the writer and photographer on the spot, all focused on both the human experience and the overall implications of the situation—was clearly a major model for the entire FSA project. *Let Us Now Praise Famous Men* began as a *Fortune* story, with Evans's involvement seen as part of the FSA project. What is the "politics of truth" in action here? Can we say, with Stange, that Stryker was at the FSA "already working in corporate public relations?"[42] For a government, we would have to add, actively pursuing joint policy objectives with the new corporations.

Lee's Iowa journey also realized some striking single images of destitution. *Christmas Dinner at Earl Daley's House, Smithland (Vicinity)* does not hesitate to focus on the flies crawling over the children's food as its main subject. On the same trip, in Sioux City, Iowa, Lee's camera moves slowly through the dormitory, kitchen, offices, and outside spaces of a Homeless Men's Bureau, piling up moments of quiet pathos. The men become victims of a calamity akin to a natural disaster (compare Evans's and Edwin Locke's Arkansas-Tennessee flood pictures of 1937). At this time, Lee could name a human cause—exploitative landowners and finance companies. The dustbowl of the Southwest, however, was beyond human control by the mid-1930s, although it was part of the FSA's argument that "rational planning" could have prevented the human disaster that followed. Dorothea Lange had photographed migrant laborers for a University of California research project in 1933–34, and continued with this theme throughout most of her FSA work.[43] The paradigmatic, now almost emblematic, *Migrant Mother* of 1936 is "truly a classic of human compassion"—more accurately, a classic pictorial demand for compassion on the ground of shared humanity.[44] When seen in sequence of shooting, it too becomes part of a search for impactful imagery in an interesting, if probably tacit, collaboration between photographer and subject to achieve "the look of the worthy poor." Thus the "straightening up" which occurs between this frame and 9093-C (the foreground thumb removed, the children face forward, the woman looks more stoic), when the photographer comes to call. The "concreteness" of photography's "intimations of social class" is there to be manipulated by all concerned. Lange recalls:

> I saw and approached the hungry and desperate mother, as if drawn by a magnet. I do not remember how I explained my presence or my camera to her, but I do remember she asked me no question. I made five exposures, working closer and

closer from the same direction. I did not ask her name or her history. She told me her age, that she was 32. She said that they had been living on frozen vegetables from the surrounding fields, and the birds that the children killed. She had just sold the tires from her car to buy food. There she sat in that lean-to with her children around her, and seemed to know that my pictures might help her, so she helped me. There was a sort of equality about it. . . . The pea crop at Nipomo had frozen and there was no work for anybody. But I did not approach the tents or the shelter of other stranded pea-pickers. It was not necessary; I knew I had recorded the essence of my assignment.[45]

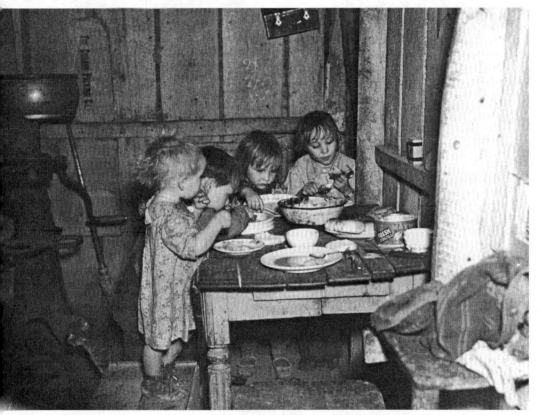

8.7 Russell Lee, *Christmas Dinner at Earl Daley's House, Smithfield (Vicinity)*, 1936. Library of Congress, Prints and Photographs Division. (LC US F34-10124)

The slippery mobility of connotation in such a case is clear in George P. Elliott's metaphorical reading of the photograph:

> [*Migrant Mother*] centers on a manifestly decent woman whose face is ravaged by immediate worry; her right hand plucks at her cheek, pulling down the right corner of her mouth, which looks as though it wants to be humorous. She is poor, and we assume that poverty and the uncertainty of her future cause her worry. But the viewer is less concerned with her

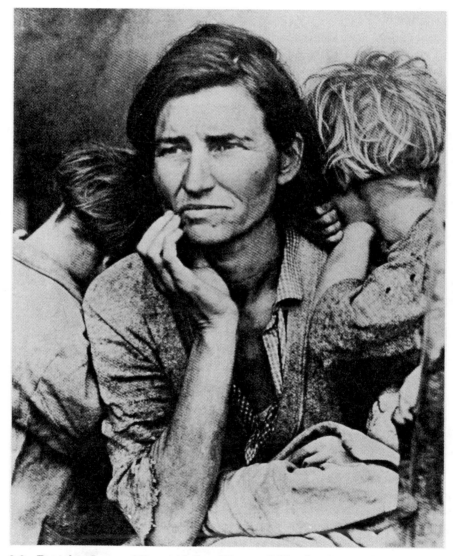

8.8 Dorothea Lange, *Migrant Mother, Nipomo, California*, 1936. Library of Congress, Prints and Photographs Division. (LC 9058)

poverty as such and far, far less with feeling guilty about the social conditions that imposed poverty upon her, than he is with understanding the profounder, the humanly universal results of that poverty. For the picture is a sort of anti-Madonna and Child.[46]

The evasions endemic to the entire project of documentary humanism are explicit here. Is this the function of "realistic" representation of misery in the bourgeois state: to shift sympathy, anger, and fear away from the cities and industry, and then evade it through passive, abstract speculation? Or can we also—but not, in the circumstances, equally—say that Florence Thompson, subject of this photograph, enters into the role of photographic subject perhaps conscious, as Lange hoped, that "pictures may help her"? The point here is that such tacit consent, as well as being a sign of powerlessness, is also a sign of her adaptability to new regimes of power, her ability to use anything toward survival, her refusal to be a victim even while so evidently pictured as one.[47]

Within two years, by early 1938, the FSA emphasis moved more toward stressing the successes of the program, and the critical edge of the 1936 images—multifarious as it was—was blunted. At Pie Town, New

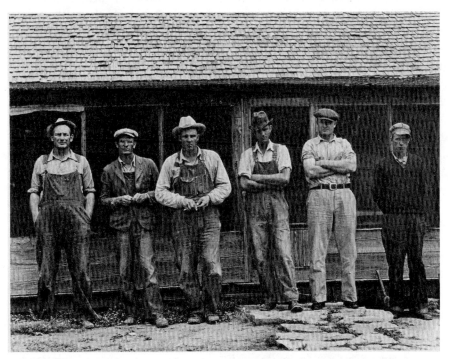

8.9 Dorothea Lange, *Former Texas Tenant Farmers Displaced by Power Farming*, 1937. Library of Congress, Prints and Photographs Division. (LC F34-17265-6)

Mexico, in 1940–41, Lee recalled that "My objective required that I show what the people of Pie Town—the old, the young, the diligent, the frivolous, and the careworn—were like; wherein they were just folks and wherein each was a unique individual." The town emerged when two hundred migrant Texas and Oklahoma farmers decided to form a community. Lee's series traces recognizable evidences of community, mapping relations between families visiting each other, families going to church, attending a meeting. A typical caption: "Farm women and children laughing at some antics of the men folks on an all day visiting."[48] Lange had matched the appeal of *Migrant Mother* with a male equivalent in such lineups of healthy, willing workers puzzled by their being discarded as *Former Texas Tenant Farmers Displaced by Power Farming*, May 1937. In *An American Exodus: A Record of Human Erosion*, the photoessay compiled with Paul Taylor, this same photograph was captioned: "All displaced tenant farmers. The oldest 33. All native Americans, none able to vote because of the Texas poll. All on WPA. They support an average of 4 persons each on $22.80 a month. 'Where we gonna go? How we gonna get there? What we gonna do? Who we gonna fight? If we fight what we gotta whip?'"[49] These sentiments were no longer admissible in the FSA program itself.

Indeed, they were never prominent. The Roosevelt administration never wavered in its absolute support for private ownership, its rights and privileges. It did, however, aim to trade off restrictions on profiteering and excessive monopolization against welfare programs and codes of "fair competition" for U.S. industries. In setting up the latter, the aim was "to bring about a greater mass purchasing power by increasing payrolls and farm incomes without a corresponding rise in retail prices to restore our rich domestic market by raising its vast consuming capacity."[50] Roosevelt's focus on the citizen as consumer was motivated by a class fear which he did not disguise. "The millions who are in want will not stand silently by forever while the things that satisfy their needs are within easy reach," he said in an election speech in 1932.[51]

By 1935 the U.S. economy had revived: a $640 billion profit for all manufacturing and trading corporations in 1933 rose 64 percent to $1,051 billion in 1934, while banking profits rose 14 percent to $240 billion. General Motors' profit rose 20 percent in the first half of 1935 compared with the previous year. But these benefits did not spread through the society or across the country. If the New Deal administration managed to raise dividends and interest by over 50 percent since 1929, it also reduced wages by almost the equivalent amount. The cost of living was increased by fewer workers producing more. Oligopolization continued; smaller business was decimated. The consumer was certainly created,

made a citizen of the USA during this period, but was not protected despite the rhetoric.[52] In agriculture, none of the agencies could tackle the political causes of exploitation, suffering, and inadequate technique: administration policy precluded pointing to the degradation of absentee landlordism, local oppression, and the refusal of owners to mechanize in an equitable fashion. Landowners and their political representatives were voluble in their attacks on the FSA, causing it to proceed cautiously. The independent farmer was heralded as the ideal, and thus communes were not seriously supported.[53] But the forces wearing down the independent farmer were also not attacked. Instead, an objective was "to stem the dangerous tide of migratory workers" by helping them become independent farmers. This "piecemeal social engineering" approach was evident throughout the FSA, as a 1941 manual for officials made clear.[54] Small wonder that reformist activists such as Lange were driven to publish critical exposés such as *An American Exodus* outside the program.

Scenes of FSA officials dispensing welfare increased year by year. And both the distressed, unemployed migrant and the co-op leader seemed to succumb to the hard-slogging farmer and family, especially when heroized by the low angle (a Joe Delano speciality). Disintegrating, cobbled-together shacks were replaced by shining white clapboard houses in rows with neatly machined land between. Having propagandized the fact of rural poverty, it was then necessary to show the FSA's successful "solu-

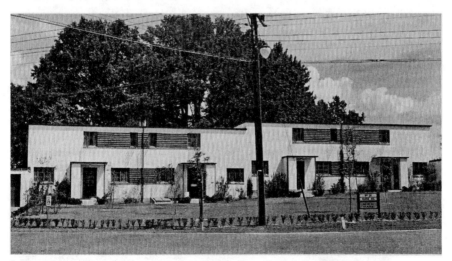

8.10 Marion Post Wolcott, *The Medical Center, Greenbelt, Maryland*, 1939. Library of Congress, Prints and Photographs Division. (LC F34-52033-D)

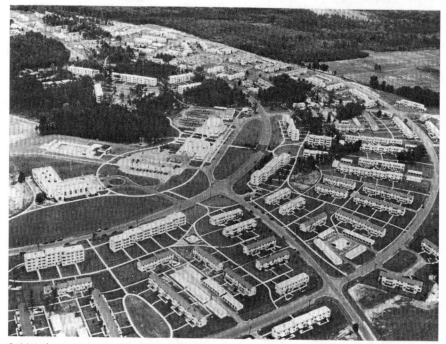

8.11 Anonymous, *Greenbelt, Md. Sept. 1938. A model community planned by the Suburban Division of the U.S. Resettlement Administration. Airview of project.* Library of Congress, Prints and Photographs Division. (LC US F344-7483-2B)

tions" to this "problem": less the new farming communities than the near-city, "greenbelt" towns, for example, *The Medical Center, Greenbelt, Maryland* (August 1939), by Marion Post Wolcott, or Rothstein at "Sunnybrook Farm," Grundy County, Iowa (September–November 1939).

Stryker's policy formation during these years combined a commitment to the objective force of the analytic frameworks of sociological descriptiveness (to enacting, photographically, an inventory of the nation, a pictorial fit with the map, a visualization of everything visualizable) with a sense of the demands of bureaucracy and the vicissitudes of public politics—an absolutely typical New Deal combination. This meant that he could share with the photographers a belief in the neutrality, even the serving, life-affirming character of taking photographs, while at the same time unhesitatingly destroying most images of dissent, disapproval, collective anger, and radical organization. Further, the unit not only supplied photographic service to a range of other government departments but Stryker passed on information about "unrest and injustices" which the photographers reported to the "appropriate authorities." Doubtless a genuine concern to assist the alleviation of "injustices," effective in many cases, this also served the surveillance and policing functions of the state.[55]

Some picturing of bosses, collectivity, and union activity occurs in the FSA files. Lange's *Plantation Overseer and His Field Hands*, Mississippi Delta (1936), is a well-known study in the gross, petty arrogance of local power, as is the portrait the *Landowner*, Moundville, Alabama (1936), with which Evans opens *Let Us Now Praise Famous Men*. The viewer's sympathies are directed toward "Stanley Clark, old time socialist leader" as he addresses a *Workers Alliance Meeting*, Muskogee. Microdifferences of power and position are marked in Lee's *Committee from a Local Chapter of the United Canning, Agricultural, Packing and Allied Workers of America, meeting with an FSA supervisor to request work grants, food and loans for sharecroppers and tenant farmers in the county*, Supulpa, Oklahoma (February 1940). On one level a straightforward publicity shot, on others some deep-rooted class and racial tensions are figured in the visible withholding stiffness of the committee members, particularly its black leaders, the awkward chairperson-pose of the official. In another image of an official Lee picks up the clerk's camera-clowning grin as he opens up his office to the queue of glumly waiting Mexicans; the effect is that the clerk's gesture underlines the condescension of dispensing relief (San Antonio, Texas, March 1939). The independence, resourcefulness, and "grit" of the mythical yeoman farmer is invested in some images of

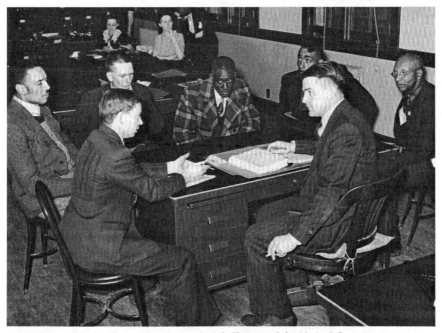

8.12 Russell Lee, *Committee from a Local Chapter of the United Canning, Agricultural, Packing and Allied Workers of America meeting with an FSA superviser . . . Supulpa, Oklahoma*, 1940. Library of Congress, Prints and Photographs Division. (LC F34-35160-D)

employed (as opposed to dispossessed) farmers, particularly early in the program when these men had adopted new roles as representatives of cooperatives. Many of Marion Post Wolcott's apparently celebratory images are implicitly critical, especially those of the lifestyles of the rich, of black workers, and of the racial divisions in cities and towns.[56] Discrimination being such a structural factor in U.S. society at the time, signs of it nevertheless still appear as visual shocks within the broader thrust toward a shared humanity being promoted by the project as a whole. These surface constantly, for example, in Esther Bubley's cross-country bustrip from Washington, D.C., to Memphis and back, in September 1943.[57]

But images of apartheid seem to be exceptions, attributable less to official policy, more to the concerns of certain of the photographers and the unavoidability of realities when an encyclopedist survey is undertaken. If local bosses sometimes appear, their financial controllers do not. Nor do the local agents appear in their economic relations, but rather quite separately, as part of "the town." Union activity is recorded but not much of it, proportionately. All of these restrictions also marked documentary film of the period, frequently amounting to censorship.[58] More generally, and more potently, the Historical Section was securing control through surveillance by producing, as documented "reality," a certain broad reading of U.S. agriculture which, while it did not simply and directly illustrate administration policy (and may have influenced it to a degree), certainly pulled back continually at the boundaries the policy set as permissible. Thus the ambiguities and near-absences we have noted.

The Home Base of Normalcy, 1937–42

Another combination of contraries perhaps gets closer to the heart of the FSA program as a relentlessly ambitious fact-finding machine which was, at the same time, carefully self-censoring. The totalizing gaze just described goes, in structure, quite beyond agriculture, following a rhetorical logic of tracing the social networks in which agricultural production was enmeshed, but becoming, in fact, an effort to picture the entire country, the nation. Yet it is not only a "scientific" accumulation of observations about everything in America. It is also an elaborate edifice erected on a very narrowly circumscribed sense of "essence." By a powerful paradox, something quite opposite to the nation as a whole seen as a modernizing machine is taken to prompt the exclamation This is America!—the small town, it alone, it by extension.

What is the relevance of the small town to this study of modernity?

When the sociologist Robert Lynd proposed the subject to Stryker in the spring of 1936, Stryker apparently saw an opportunity to record a way of life rapidly succumbing to the modernizing pressures of city growth and the development of new towns, from middle towns to Levittowns.[59] Does the small town, then, stand for a present-becoming-past, an unmodern otherness, a regional nostalgia, a simple difference, regrettably but inevitably fading?

In this view, the Midwest and the South, as a whole, and the small town in particular, became an obvious domain of the *not-modern*: resistant, backward, uncontrollable by planning, subject to local powers and prejudices. In contrast, the bustling cities of the East and the industrial plants of the Northwest became sites of burgeoning modernity. If, in the mid- and later 1930s, the dispossessed rural worker displaced the unemployed industrial worker as the key human symbol of depression, did a parallel movement occur here, with the imagery of the factory and the towering city modified by the quiet look down Main Street? Something more seems at stake here, something more significant. Our explanation must account for the intensity with which the small town was invested with positive value during the mid- and later 1930s, in the FSA photographs and elsewhere within the visual culture, and for its ubiquity as a symbol of "why we fight" during the war years. It was absolutely *not* a fading cultural form: it became a key site for the generation of "natural" truth—indeed, as we shall see, for modernization. It was thus quite crucial to the visualization of modern America. How did this occur in the case of the FSA photographs? How does it relate to the other tendencies we are tracing? Is it simply in position, or is it, like the others, imbricated in an exchange of values? To what degree does it mobilize social fact/social fiction?

No equivalent to the Historical Section was created by any other New Deal agency, although many had information and publicity departments. In 1940 the National Defense Advisory Commission started a small photographic unit, which was absorbed by the Office of Emergency Management in 1941 and the Office of War Information in 1942. Later that year it came under Stryker's control when his unit and the OWI were fused. Despite this bureaucratic activity the FSA Historical Section stood out from other efforts to communicate government policy to the public. In the later 1930s, and during the war years, it serviced a range of other departments, for example, the U.S. Treasury (Savings Bond Division), Public Health, Agricultural Adjustment, the Rockefeller Committee on Cultural Relations with Latin American Countries, the State Department, and the Rural Electrification Administration.[60] Signifi-

cantly absent from this list is the Industrial Recovery Administration, intended to be the key agency of the New Deal for manufacturing industry and the cities, that is, for countering the impact of the Depression on the most obvious forms of modernization. It was, however, legally blocked in May 1935, after operating for only a few months. Although the challenge was mounted by a small farmer, its success testifies to the power of vested interests, such as those we have been examining: the hostility toward the New Deal in general, and the Historical Section in particular, among rural property owners and large suppliers, as well as within the ranks of commercial publicists. This is attested to by the anti–New Deal outcry which exploded into a storm around Rothstein's moving a cow skull in his 1936 drought pictures.[61] Some indication of the likely reaction of, say, Ford Company and *Fortune* to the hypothetical establishment of a propaganda agency under the IRA can be inferred from the struggles of filmmakers trying to treat industrial subjects.[62]

FSA photographers occasionally pictured aspects of manufacturing industry, particularly the towns around great plants. Walker Evans's study of Bethlehem, Pennsylvania, during November 1935 set the pattern: the plant appears as a towering terminus above the rows of worker housing. He went on to treat similarly Birmingham, Alabama, in 1936. His influence is evident in the later studies, for example, in Jack Delano's *Pittsburgh, Pennsylvania* (1941).[63] These restrained meditations on difficulty, conveyed largely through the absence of people, are the rare instances of a range of subject matter apparently ruled out of the Historical Section's purview. As noted above, even greater ambiguity attends the picturing of the industrialization of agriculture.

Against this background of omission, the figures of the dispossessed farmer and the country town become mythical archetypes of evil and good, of disbalance and restitution, of despair and health, of depression and recovery—indeed, of Depression and Recovery. But not quite so simply. Just as the homeless sharecropper was matched by the rooted figure of the independent yeoman farmer, the small town suffered its vicissitudes, yet rebuilt itself through a collective will founded on "the same" independence. In its external relations, the government agency took the place, temporarily, of "outside forces" such as natural disasters and exploitative property owners. The "shooting scripts" written by Stryker for his photographers in the field are never more energized and elaborated than when they deal with the small town: what excites them as texts is precisely the double movement between the unquestioned imperialism of the totalizing external gaze and the absolute reverence for the autonomous truth of the local, the particular.

Stryker's notes on his conversation with Lynd lodged the small town

within the structure of typicality presumed by the sociological survey as well as adopting its methodology of revelation through interrogation of the subject:

> What do people do at home in the evenings? Do the activities of a small town differ from those in the large city? Do they vary according to income groups? How do various social levels dress when they go to church? Where do people meet? Do beer halls and pool halls take the place of country clubs for the poor? Do women of lower income levels have as many opportunities for social mixing as their wealthier counterparts? Are there differences in the way people of the same social level look and dress in small towns as opposed to large cities? Is it more necessary for middle income people to keep up a neat and polished appearance in large cities than in small towns?[64]

Many of the polarities we have been discussing mark these questions: city/country, East Coast–Northwest/Midwest-South, class difference. But just as striking is the urge to unity, to disclose human sameness beneath difference: in dress at church, in the beer hall substituting for the country club, in subscription to "appearances." There is a sense in which Stryker knows the answers to these questions, knows that the values he seeks lie at the points of intersection between the forces of class, place, gender which he is colloquially naming. He is, further, convinced of the social good which would result from displaying these values. Show the truth and social change would automatically follow: democracies just are constituted to respond in this way. Thus the Historical Section's reformist political passion.

The real problem for Stryker was to position the photographers in ways that helped them picture these values as lived. There is a major difference between the instructions of 1935–36 and the shooting scripts of 1937 through 1941–42. The following is a memo from the first period:

> Types of photographs desired for Resettlement files.
> 1. Relocation
> (a) Unsatisfactory farm areas . . .
> (b) Destitute or low income farm families
> (c) After relocation
> 2. All the previous headings which have undergone change
> Rehabilitation of individual families.[65]

Certainly the photographers employed at that time—particularly Lange, Shahn, and Evans—had already demonstrated their commitment to the social role of photography as well as their competence at

producing stunning images of destitution and exploitation, and Stryker wrote long letters and held detailed discussions with each. But the language of the memo stands in stark contrast to poetry of the list in the small-town scripts, such as this:

(On Potato Digging)
The digger
 in operation
 close-ups of machine
 machine and a tractor (or team)
The potatoes in rows
The fresh earth . . .
The People:
 the farmer
 the pickers
 at work
 after work
In the towns:
 recreation
 beer halls
 pool halls
 buying groceries
You might have the luck to find some little farmer digging
 potatoes in the old-fashioned method—one horse plow.[66]

Or, in a script developed with Arthur Rothstein, May 24, 1939, for the Western Ranges: "Herder and dog on ridge (Silhouette). This is somewhat of a symbol picture. I. Cow Town. The pictures of the town should follow in a general way the earlier shooting script on small towns. Note especially the people, the street scenes which will emphasize the fact that it is a cattle town. Men on saddle horses. The dress of the cow puncher. Try to get a good picture of a group of men wearing boots, emphasize the feet in the picture."[67]

In February of the following year, Stryker made another of his periodic "List of Topics" necessary to fill out the overview of small-town USA which the Historical Section had been constructing.[68] Its main subject was movement, especially the joys of visiting, for example, the People go to Washington. It throws into relief the structure of the other scripts. They are journeys of discovery, itineraries for voyagers traveling among the socially fixed, capturing relationships by immobilizing them in one photograph after another, images pinned to each item on a predetermined list of contents. Stryker to Marion Post Wolcott, May 5, 1941, before her excursion to the Plains Country: "Search for ideas to give the sense of loneliness experienced by women folk who helped settle the country."[69] To John Vachon, some "Random notes on Iowa," 1940:

1. *Rich level farmland*
 (a) the heart of the Corn Belt
 (b) prosperous independent farmers but with plenty of debt tenancy, land on all sides.
 (c) dominantly rural, no *large* cities.
 (d) outstanding for the spirit of social equality which pervades all walks of life . . .
 Watch for chance to get pictures in early or late light showing land *texture*.[70]

To Rothstein in 1939 regarding the Iowa State Fair: "(I am under no illusion about the state fairs. They have become very smart and have a decided urban tinge). The Iowa State Fair is probably one of the outstanding agricultural fairs in the U.S. Keep your camera pointed at the rural side of it. Sprinkle in plenty of amusing and interesting things around the concessions, the races, etc."[71]

The values being sought are clearly stated in these scripts: closeness to natural forces, to the movements of the earth; the assimilation of mechanization to the traditional order; the integration of the small town into rural work; the powerful witness of the "old-fashioned," but the acceptance of the new; recognition of the small town's/the rural community's location within the national economy, but insistence on its internal values as somehow more "truely American," these values based in the struggle of individuals ("loneliness") and the consent to community (both cowboy gear and "the spirit of social equality"). They are approached by the visiting recorder, who comes armed with a sociological overview, an "objective" instrument, and a determination to discover a decency of living which, although threatened (by bosses, modernization, natural disaster, and urbanism), nonetheless contains the strength to preserve itself, particularly if its purity can be shown to those elsewhere with power over it. "Keep your camera pointed at the rural side of it" becomes a moral injunction, with as much force in a shooting script list as "Watch for a chance to get pictures in early or late light showing land *texture*."

To what extent did the photographs accord with these instructions? During 1935 and 1936, when much of the strongest critical imagery was made, the situation was fluid, with Stryker and the photographers constantly learning from each other. The 1937 stress on the small town was the key agency through which these relationships were codified, even forged into bureaucracy (albeit an unusually open one). Photographers who accepted the program, such as Rothstein and Lee, stayed and developed.

Those who did not, such as Evans, Shahn and Lange, lost their jobs for periods or altogether. Entailed here, too, is a shift not just from the

Southwest areas of distress to the small town in the Midwest, but also from potent social criticism to various kinds of reformist affirmation. The "Roosevelt Recession" of later 1937, early 1938, was the consequence of a precipitous attempt to cut government spending. It also had the effect of signaling to reformers within the administration that the limits had been reached. In mid-1938, Stryker got the idea that rural poverty was being "oversold" and that the Section should swing to "positive" pictures of rural life.[72] The proportion of these coming in duly began to increase, particularly Post's pictures of northeastern farms and Delano's of strong, happy workers. Thus, while some photographers stretched the politics of the program to their limits regularly (Lange), others did so rarely (Rothstein), and still others scarcely at all (Mydans, Lee, Post, Delano, Collier). Most of them took the scripts as suggestive frameworks on which they could embroider their experience of the place itself (this being the frequent, and typically 1930s, justification of additions, elaborations). Some literally illustrated lines in the scripts, for example, John Vachon's *Mothers of Women's Club Making a Quilt, Granger Homesteads, A U.S. Resettlement Administration Project, Iowa* (May 1940), exactly shows Stryker's point about "social equality" in the script cited above.[73]

The small town/rural community also figures prominently in another aspect of the process of "making positive": the subjection of the critical imagery to nostalgic reverie. A striking case occurs with Evans's *Railroad Station, Edwards, Mississippi*, of February 1936. If we read it in its sequence, within the journey being undertaken by Evans, it is inflected deeply by the careful studies of eroded soil just beyond the town. It becomes a single point of externality, passage, escape within an otherwise bleakly landlocked domain. It joins a sequence of images which state their meanings first, with a slow attention to surface texture but, ultimately, with the closed finality of hopeless irreversibility. Initially soft, attractive, these are sharp, hard images. Contrast Stryker's own reading of the single *Railroad Station*: "The empty station platform, the station thermometer, the idle baggage carts, the quiet stores, the people talking together, and beyond them, the weather-beaten houses where they lived, all this reminded me of the town where I had grown up. I would look at pictures like that and long for a time when the world was safer and more peaceful. I'd think back to the days before radio and television when all there was to do was to go down to the tracks and watch the flyer go through."[74] As Tagg notes, this opens the image to a process of wishful dreaming, profoundly ideological in that it constructs an imaged world of childhood simplicity, a fugitive social primitiveness, excluding the contexts of its creation and eclipsing other experiences

of the same social domain—the farmer's, the black's, the railway work-
er's, for example, but not, significantly, the coast-to-coast or city-to-city
traveler.[75]

Is this too harsh an account? Did not Stryker, twenty years later, say
of Lange's *Migrant Mother* (1936), the classic FSA image of social concern:
"This is one of the few pictures that will live. I still get excited by it,
disturbed by it"?[76] Did not FSA photographers continue throughout the
1930s to expose instances of injustice, for example, Lange in Imperial
Valley, California, against local attacks on a Resettlement Administration
camp (1937), Rothstein in Herrin, Illinois, against the eviction of share-
croppers (1939)?[77] Quite, but the point remains that what is taken to be
so moving, so unjust, so un-American about these situations is that
people have been prevented, by natural disaster, human greed, or po-
litical incompetence either from staying in or aspiring to their "natural"
place, which is, precisely, the small town/rural community. It is just
those people who have triumphed over adversity—past or recent—and
achieved such a sociality who are celebrated by the Section: thus the
instructions to Vachon re Iowa, Lee's imaging of Pie Town cited earlier,
and Stryker's reading of *Edwards, Mississippi.*

Nor was this dreaming a passive, merely contemplative activity. It was
just this self-reliant yet mutually dependent commonality that the New
Deal planners hoped to engender in the new towns in which dispos-
sessed farmers and the urban poor were resettled. Stryker's visit to
Greenbelt, Maryland, near the beginning of the project, was recorded
by Carl Mydans, as was Rexford Tugwell's (by another photographer) in
the following year. The images tell us little about the intentions of these
social technicians—both men are posing as interested visitors. Yet what
happened in these places was crucial to the realization of their dreams
of futurity.[78] Nostalgia, here, takes on a double edge: not only does it
dream of a trouble-free past, but it searches for the values basic to a re-
created future. The new small towns are really the old ones, only relo-
cated and modernized. Russell Lee's image of a farming couple listening
to the radio, *Hidalgo Country, Texas* (1939), when contrasted with other
picturings of couples in interiors, certainly discloses its class and re-
gional specificity, its place on the intersection of Stryker's socioeconomic
map.[79] Taken in itself, it is relevant to this inquiry in a number of ways.
The radio to which the couple is listening is a modern device, one which
has only recently changed their living habits and knowledge of other
worlds, yet it has been assimilated through the archaizing style of its
cabinet (nonetheless advertised as "the latest, newest thing") and by its
replacement of an older social centerpoint, the fireplace (a factor not
irrelevant in its design). Further, it has changed this couple's relation-

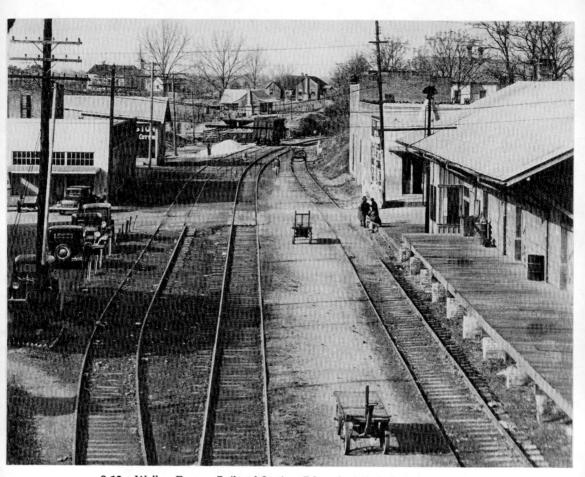

8.13 Walker Evans, *Railroad Station, Edwards, Mississippi*, 1936. Library of Congress, Prints and Photographs Division. (LC 347-1295A)

8.15 (*bottom right*) Arthur Rothstein, *State Highway Official Evicting Sharecroppers from the Roadside to an Area between the Levee and the Mississippi River, New Madrid County, Missouri*, January 1939. Library of Congress, Prints and Photographs Division. (LC US F33-2975-M3)

8.14 Walker Evans, *Soil Erosion, Vicinity Tupelo, Mississippi,* 1936. Library of Congress, Prints and Photographs Division. (LC US F342-3051A)

ship to necessity and scarcity: the bareness of the rest of the room, the couple's threadbare clothes signify a sacrifice of much toward the acquisition of this modern marvel; it is an investment in dignity, the future, in social mobility—all defined externally. And the reverse is true: their ease with the radio naturalizes/legitimizes modernity; this is, of course, the structure of countless advertisements during the period (especially in *Saturday Evening Post*—see the remarks on Norman Rockwell above). Perhaps the most subtle intrusion of modernity is evidenced by the fact of this photography itself: the couple consent to pose as the objects of sociological record; they compose themselves as doing something they would "normally" do of an evening.[80]

Taken in sequence, however, this image's disclosure of the couple's ripeness for modernity (albeit, a heavily modified one) is underscored by its being matched with an image of a modern kitchen in a house in the same district—one, indeed, so new, so bare, so fantastically rationalized that it becomes a nearly alien space. Lee's flash lighting and his symmetrical composition read, interestingly, against the grain in both

8.16 Carl Mydans, *Greenbelt, Md. Nov. 1935. John Carter, Roy Stryker, and Major Lewis, of the U.S. Resettlement Administration, at the Project.* Library of Congress, Prints and Photographs Division. (LC US F33-269 M-1)

8.17 Anonymous, *Greenbelt, Md. July 1936. U.S. Resettlement Administrator, R. G. Tugwell*. Library of Congress, Prints and Photographs Division. (LC US F34-15006-C)

8.18 Russell Lee, *Couple, Hidalgo County, Texas*, 1939. Library of Congress, Prints and Photographs Division. (LC F34-32010)

cases. Presumably this is the kitchen of a model house, either a commercial sales venture or a model home demonstration by a government agency, something the Resettlement Administration frequently did. It inserts a highly developed instance of modernity into an environment which probably contains equivalent ambiences only in some of its stores and in its industrial machinery. Further speculation would degenerate into a reverie equivalent to that cited above: my point in illustrating this photograph along with the other is to urge against a simple old-replaced-by-new reading, a more complex sense of the resilience of an unromanticized small-town environment in the face of the undoubtedly excessive shocks of modernity. Indeed, the analysis tends to argue that the ideological pull of the small town/rural community as a site of "true" values was so strong during these years that it modified the values of order, rationalization, clarity, and constant change being projected through the industrial and consumer imagery of modernity. Part of the strength of the small town is its sociality, but much of it was its fugitive attractiveness as a symbol of a lifestyle no longer possible.

Antipathy toward modernity's excesses, its sensationalized violence, its oversignification marks Stryker's boast about the moral restraint of the FSA project, the subjects it did not cover: "in our entire collection we have only one picture of Franklin Roosevelt, the most newsworthy man of the era. . . . You'll find no record of big people or big events in the collection. There are pictures that say Depression, but there are no pictures of sit-down strikes, no applesalesmen on street corners, not a single shot of Wall Street, and absolutely no celebrities."[81] Levine correctly reads this as evidence that the FSA project refused to endorse the homogenizing forces of modern mass culture, affirming instead the values of regional and folk culture.[82] This overlooks, however, Stryker's selective memory, the fact that he added many news photographs of strikes to the files, that his photographers recorded many of them, as well as many other signs of the times, especially advertisements. The photographers, that is, discriminated among these manifestations of modernity, supporting some, rejecting others, in ways more politically subtle than Stryker's list implies.

The small town transformed into the new town appears in many Resettlement photographs, such as Wolcott's *Medical Center, Greenbelt, Maryland* (1939) and John Collier's *The Clinic, Farm Security Administration Agricultural Workers' Camp, Bridgetown, New Jersey* (1942). These sell government services in ways scarcely distinguishable from photoadvertisement in the business magazines and from images of housing in modernist journals such as *Architectural Forum*. Collier's image is also propaganda imagery—not just of an agency doing its job but of a gov-

8.19 Russell Lee, *Kitchen, Hidalgo County, Texas,* 1939. Library of Congress, Prints and Photographs Division. (LC F34-32145)

8.20 John Collier, *The Clinic, FSA Agricultural Workers' Camp, Bridgetown, New Jersey,* 1942. Library of Congress, Prints and Photographs Division. (LC F34-83435)

ernment at war looking after the health of the social body (even unto the most apparently insignificant, a little black boy).

In the move toward war, particularly in response to the necessity to propagandize the "American Way of Life" overseas, the Historical Section boomed. Absorbed into the Office of War Information in 1942, it was soon sending twenty-five hundred prints of U.S. life overseas each day: "at a photo exhibit at a secret Chinese base behind Japanese lines, the twenty thousand peasants who would see the pictures would not feel that Americans were such a strange people, after all."[83] Despite the success of commercial farmers' lobbyists in politically positioning the FSA as inessential and wasteful, despite the closure of the photographic unit on Stryker's resignation in October 1943, it is arguable that the Section's work laid an important part of the basis of the mammoth visual propaganda effort of the U.S. government during the war. And central to its doing so was its commitment to the disclosure of small-town values, its insistence on their significance to the conception of the United States itself as a nation worth recovering for—and, then, worth fighting for. Stryker's urgent memo to all photographers, dated February 19, 1942, made the wartime shooting script unequivocal:

People we *must have at once.* Pictures of men, women and children who appear as if they really believed in the U.S. Get people with a little spirit. Too many in our file now paint the U.S. as an old person's home and that just about everyone is too old to work and too malnourished to care much what happens. (Don't misunderstand the above, the FSA is still interested in the lower income groups and we want to continue to photograph this group).

We particularly need young men and women who work in our factories, the young men who build our bridges, roads, dams and large factories. Housewives in their kitchen or in the yard picking flowers. More contented-looking old couples.[84]

Conjured here, at last, are the beneficiaries of modernity rather than its victims. The work of displacement and substitution has been completed by a gradual reversal, transforming the rural, unemployed, small town into what is no longer an opposite but just another facet of American multiplicity. In words scarcely distinguishable from the 1936 prospectus for *Life* magazine, industrial work reappears as primary, is reborn in the youthful builders of the corporate state as a modern haven for the family, the individual, and the past. Above all, the look of contentment. Small wonder that Stryker was approached at Nelson Rockefeller's behest to establish a photographic section for Standard Oil's image improvement, and that he did so in 1943, taking staff such as Russell Lee with him.[85] The FSA Historical Section can be regarded, both literally and in Tagg's discursive terms, as an *office* for the creation, distribution, and transmutation of an imagery of depression into an imagery of recovery. In the next section we see that it was also part of a broader stream which reconstructed "the people," the object of documentary photography's humanism, central to a very loaded imagery of *Life.*

Persuading the People

Hurley devotes a chapter of *Portrait of a Decade* to "Putting the Pictures to Work," with no doubts that "Stryker and his team were effective, both as propagandists and as pioneers of new aesthetic styles in photography."[86] He traces a variety of usages. Internally, the program used the pictures of poverty to justify itself to Congress and those close to the legislators: thus the fifty photographs of the *First Annual Report of the Resettlement Administration* (November 1936). Similarly, Historical Section photographs illustrated the publications of the FSA itself, both the pocket-sized handouts to clients—booklets such as *America's Land*

(1936)—and manuals for officials, such as the *Small Town Manual for Community Action* (1936 for the Department of Commerce) and *Farm Security Administration* (1941). This last includes the Historical Section within a diagram of the divisions of the Washington office but does not distinguish its work within the Department of Information. It adds to the end of its booklist a short section of visual aids designed to assist FSA officials in their telling of "the Farm Security Administration story, and in presenting information to borrowers on general and technical farm problems. This material includes posters, slides, film strips, motion picture films, and photographic displays" (237). The films *The River* and *The Plow That Broke the Plain* are singled out as having "great audience appeal and educational value."

One might assume that FSA officials made extensive use of the visual aids and that their expressed needs, solicited by manuals such as this, to some extent shaped the program. However, no study of this sort of usage seems to have been undertaken: Hurley does not do so, and reviews of the entire FSA, such as that by Baldwin, while illustrating the most dramatic of the 1936 "plight" photographs, fail to mention the Historical Section at all. Similarly, the 1941 manual for officials has a set of images on the work of the FSA arranged in double-page "before and after" spreads. Overloaded jalopies and a "Migrant Mother"–type woman and child in front of a tent with the caption "America's farm migrants—uprooted—hopeless" contrast with neatly rowed tents and caravans titled "Farm Security family putting down new roots." After contrasting erosion with regular plowing, the story continues, "Thousands of FSA supervisors bring their expert technical knowledge to the doorsteps and the fields of the lower third of America's farm people, showing them the handy way to do things, and suggesting methods which help farmers meet their problems." The "doorstep" and "handy" are illustrated by women talking on the porch and sewing mattresses, the "fields" and "methods" by men posed in front of a combine harvester and a woman addressing a gathering: "FSA families learn to cook together—to use in common machines they could not own individually, and to thrash out their problems in group meetings—a modern revival of an old American custom." Although the photographs are uncaptioned, this is itself a typical Historical Section display of the later phase: the approach is simple, direct, but low key. Modernization has a subsidiary role within this program of gradual, government-assisted self-help, to enable these people to reach a small-scale community independence.

What of the *external* life of the FSA photographs, beyond their uses within the agency itself and within the internal politics of the Roosevelt

administration? On this hinges whatever assessment we might make of their impact within the broader visual culture. Hurley shows that Stryker was both assiduous and careful in this regard, and that he organized distribution of the imagery in two broad ways: through the mass media so as to draw attention to the plight of the migratory workers and the administration's efforts to deal with it, and through the institutions of commercial, professional, and art photography so as to secure the reputation of his team as "fine photographers."[87] The greatest impact of the "plight" photographs seemed to occur from 1938, with the "positive" images influential from 1941 onward when the United States entered the war. Obviously, the FSA photographs did not in themselves effect the metaphorical displacements claimed in this chapter; they are part of a broader stream of visualizing "the people," in which wholeness seems always implied by concentration on individualized parts. If the 1936 FSA photographs highlighted a sickness in the social body, was not their main task in the later 1930s and 1940s to image the health of the totality?

How much the visual arts became, in this period, a servicing agency of mass culture, while many key concerns of "the people" invaded artistic visualization, has been a major theme of this study: Sheeler and Rivera at the Rouge, Bourke-White at *Fortune*, represent stages on a variable, shifting, problematic, but indissoluble exchange which culminates in the industrial designers and architects discussed in part 3, but which certainly shapes the FSA photographers as well. Not only was recognition as competent professionals necessary to mass media distribution—given professional jealousies, suspicion of governmental misinformation, and political opposition to the "message"—but acknowledgement as "fine art" photographers was essential to securing space in business magazines such as *Fortune* and even some of the photomagazines such as *Life*.

Indeed, consciously or not, the "FSA style" consists precisely in aestheticizing the instrumental directness of orthodox Social Realism. Hine, it must be remembered, was an exceptionally fine photographer within this tendency, was not typical of it, and, as we have seen, reshaped his work in the later 1920s and 1930s. Our analysis has shown the use of "modernist" compositional and lighting devices within both individual shots and sequences. This created a distinctive "look" to FSA imagery, sharing in as well as changing the visual forces at play in the magazines and newspapers, and thus securing the conditions under which FSA photographs appeared as both continuous with and, interestingly, different from those already in use. As time went on, the photomagazines went from strength to strength; soon their priorities began to impact on the FSA program. As early as 1936, *Life* and *Mid-Week Pic-*

torial had secured exclusive use of certain sets of images selected by Stryker.[88] In the most critical analysis of the FSA project to date, Stange argues that the FSA style was above all the expression of a self-serving managerial instrumentalism, its liberal reformism a disguise. This appears just in its aesthetic orientation: somewhere between the refined "resolution of art" and the socially specific "particularity of documentary."[89]

Stryker's distributional strategy also established the emblematic status of FSA imagery in popular memory. While the mass media was, and remains, committed to the paradoxical cycle of self-regeneration through self-obliteration (with the daily newspaper its centerpiece), art and academic institutions, for their own purposes, treat FSA images as worthy of preservation and of constant repetition and republishing (a process continued in this text), thus keeping them available to the broader culture as a reference point. But this is not an objective process: by removing most of the contexts of creation and circulation of these images, the institutions set them up as historical icons in general ways, and produce readings of them which tend toward the metaphorical concern, the universalist passivity typified by the remarks on Lange's *Migrant Mother* cited above. Not that this goes against the grain of the program: we have seen that the 1936–37 radical anger of, particularly, Lange, Shahn, and Lee was gradually shifted to the late 1930s reformist zeal, at which Rothstein, Delano, and Post proved more adept, then to a subsequent embattled celebration of the normal. And, if our general argument is correct, from 1937 when the photographs began to reach broader audiences in the pages of *Look*, the task of this body of images was to concentrate attention on the rural victims of modernity (desperate but recoverable) and the basic values of the small town, diverting focus from the modernizing forces at work in the countryside (mechanization and monopoly) as well as from the industrial victims of modernity (desperate and angry) and the uncontrollable complexities of the city.

OFFICIAL IMAGES, MODERN TIMES

CHAPTER
9

New Deal Double Shuffle

The photograph *Negro Women Weighing Wire Coils and Recording Weights, to Establish Wage Rates* was commissioned by the Women's Bureau in 1919 to show adequate, even advanced, working conditions. It is evidence of how far Scientific Management principles had penetrated official understanding of the most desirable work practices—those that were, at once, equitable and efficient. Progress toward rational labor was setting a standard for the measurement of justifiable reform. This was to echo through the thinking of New Deal administrators such as Rexford Tugwell.[1] In 1979 the editors of *The American Image: Photographs from the National Archives, 1860– 1960* reproduced this photograph alongside one by Lewis Hine, from the records of the Children's Bureau: *Addie Laird, 12 Years Old, Spinner in a Cotton Mill*. The caption states, "Girls in mill say she is 10 years old . . . North Pownal, Vt., Feb. 9, 1910."[2]

A moment's reflection on the kinds of work pictured, however rich in obvious contrasts, shows that the comparison does not set like against like. The mill girl dances dangerous attendance on a machine—in fact, on rows of mechanized spinning jennies. The black women

work within a sorting section, handling already machined coils. The photograph records their inscription into a system which will reward them, piecemeal, according to their performance of a small, repetitive task, with a closely determined sequence covering both the manufacture and the distribution of the product. A Taylorized factory, dedicated to Ford-type mass production, was, as Highland Park and the River Rouge evince, no better place to work than a nineteenth-century mill. For many, indeed, it was worse, despite the decreasing exploitation of child labor and other, much-publicized but mostly fraudulent, welfare improvement. This is attested to by many of the photographs commissioned for the Women-in-Industry Service, predecessor to the Women's Bureau during 1918–20; the photographs are now in the U.S. National Archives, Washington, D.C.[3]

There is, however, a significant difference in the perspective of the photographing agency. Hine's conscience-tearing exposés were initially inspired by his own horror at manifest injustice and were financed by private philanthropy. When these approaches became part of the reforming armory of governments accountable not just to business but to the people, such negative picturing of the problem soon demanded to be matched by positive renderings of progress toward at least some solutions. We have seen this movement occur within the short life of the FSA Historical Section; recent research shows it to be part of a larger tendency of official self-promotion, especially on the part of the New Deal agencies. During the later 1930s, governmental use of publicity reached new levels of subtlety and sophistication. It also merged so closely with the approaches of the new photomagazines that an extraordinary continuity of image and outlook seems to occur. The economic and political "new deal" being forged by the new corporations and the welfare state took on its most effective symbolic form in the visual imagery of everyday life in these vivid, tangible proofs that democracy was natural, that it was alive in America, and that it was well tended by responsible government.

The over five million photographs in the U.S. National Archives (founded in 1934, itself a New Deal agency) are an accumulation of records commissioned by various arms of government since 1860.[4] Their organization largely reflects the 1930s drive to documentation—its democratizing ethos allied with the often brutal exercise of power—and is itself the first obstacle to interpretation.[5] Their division into 409 record groups tied to each government department encourages the impression that, from the battlefield shots and the survey landscapes of the 1860s and 1870s to the present, governmental publicity has been largely a piecemeal matter—albeit carried out on a huge scale—wherein each

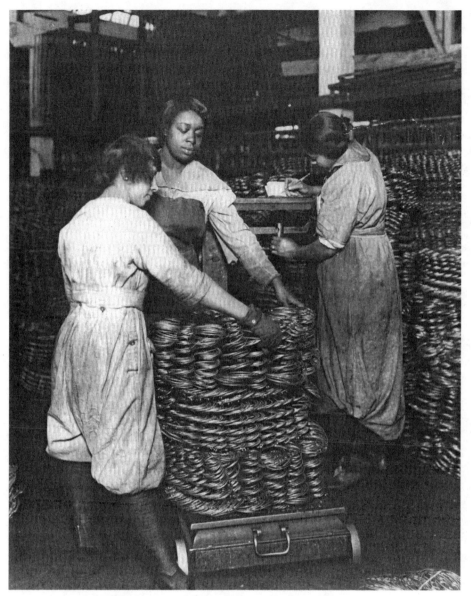

9.1 F. P. Burke, *Negro Women Weighing Wire Coils and Recoding Weights to Establish Wage Rates*, April 16, 1919, Records of the Women's Bureau. (National Archives, Washington, D.C., photo no. 86-G-5L-1)

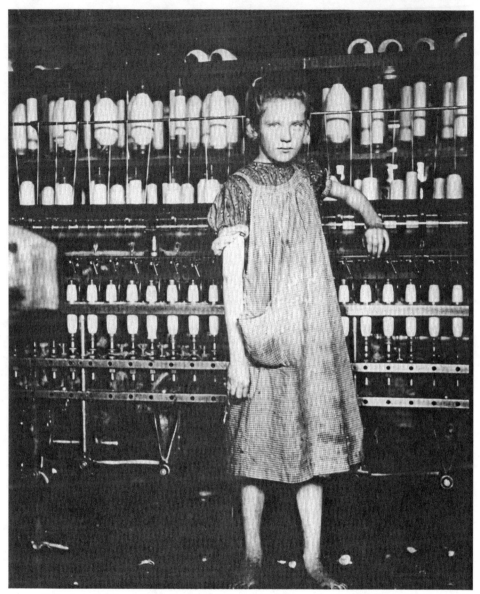

9.2 Lewis Hine, *Abbie Laird, 12 Years Old. Spinner in a Cotton Mill. "Girls in mill say she is ten years old," North Pownall, Vt. Feb. 9, 1910.* Records of the Children's Bureau. (National Archives, Washington, D.C., photo no. 102-LH-1056)

agency commissioned photographers to record its own initiatives and achievements, to publicize its services, and, sometimes, to indicate its longer-term goals. While such programmed institutionality would seem to have been the rule, other factors occur as (dependent) variables. Throughout the archive are countless examples of images which, for a variety of reasons having to do with both the photographer and the contextual forces at play, exceed conformity to a bureaucratic brief.[6] A contrary development is for the disparity as to agency to be checked, and for the whole publicity effort to be melded into a unity tied to the overall ideological thrust of the government of the day. Both tendencies were active from 1933—sometimes in contention, at other times in concert.

Writing in 1938, sociologist James L. McCamy noted that since the onset of the Depression, publicity for new governmental programs had reached "frantic" levels. This occurred against the grain of both business interests and the ideology of laissez-faire individualism, in spite of legislation specifically prohibiting it. Loud cries of "propaganda" attended every initiative and continued throughout the decade.[7] McCamy tabulated what amounted in most media to a threefold expansion in publicity by the "recovery" and the "new-permanent" agencies over the "predepression" agencies. More government meant more publicity, but it also meant more publicity to justify the mere fact of increase. Intervention had to be refigured as something other than interference: acceptance of new kinds and scales of relief, at unprecedented cost to taxpayers, had to be sought. Private enterprise was portrayed as failing to distribute its profits adequately, and welfare clients often had to be persuaded of the usefullness, as well as the acceptability, of the assistance being offered them. Photographs (mainly directed at newspapers) and film played a leading part in this effort.[8] In such a volatile ideological climate, Daniel and Stein's supposition seems astute: "Perhaps herein lies the motive for the characteristic 'documentary' style of New Deal publicity—a style that looked candid, intimate yet non-intrusive, even as it promoted the value of forceful, bureaucratic governmental intervention to shore up a stagnant economy."[9] This prompts two questions: How, why, and to what extent did this shift in approach occur? What was the role of the FSA in this shift, subsequently celebrated to the virtual exclusion of all else (including the idea of a New Deal "style")?

These questions cannot be answered satisfactorily on the basis of present research. Certain lines of inquiry are, however, suggested by studies such as that of Daniel et al. If we return to the Women's Bureau photographs and—allowing for the relatively small sample it has been possible to survey—contrast them with the treatment of work in the

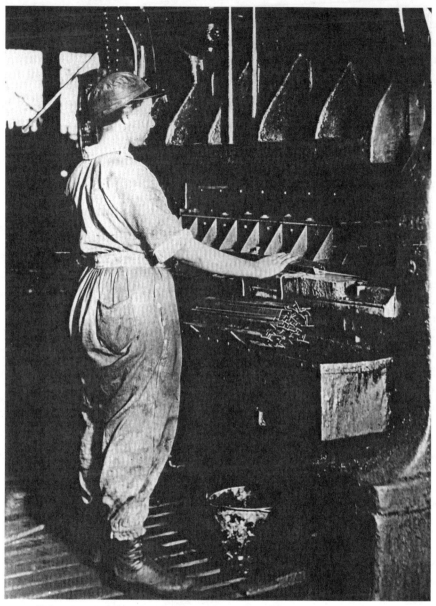

9.3 *Girl at Punch Press, Detroit, Michigan, 1/20/1919*, Records of the Women's Bureau. (National Archives, Washington, D.C., photo no. 86-G-7A-14)

9.4 *French Battery Co. 4/8/27.* Records of the Women's Bureau. (National Archives, Washington, D.C., photo no. 86-G-2Γ-3)

photographs commissioned by both "predepression" and New Deal agencies, some striking differences emerge. The Women-in-Industry Service was a modest official initiative, directed at helping working women move from arbitrary and dangerous conditions to safer, more regulated working environments. It assumed that rational labor was an advance, and was directed—like most reform photography around the turn of the century—at the goodwill and "good sense" of the employer. Its before-and-after contrast shots aimed to change the way bosses saw their own factories, to draw attention to bad lighting, unprotected belting, and to suggest desirable improvements. This took on a more national purpose during World War I. *Girl at Punch Press, Detroit, Michigan, 1/20/1919* is captioned: "Woman operating machine three times too heavy for woman to operate—bending angle iron. She must lift heavy pieces of iron. She must stand continuously." In some cases, the visual evidence belies the caption: a ramshackle gravity-conveyor system at French Battery Company, taken as late as 1927, is labeled: "Room full of women assembling. Good seating."[10]

There was, as we saw, a major before-and-after contrast implied in the FSA shift from the plight pictures to the home base of normalcy after 1937–38, and there is no doubt that it was based in a humanitarian im-

pulse as strong as that which inspired the Women's Bureau and other reform initiatives. An element of social critique may also be shared. But, by the mid-1930s, at least two key factors were different: the Ford-Taylor type of totalizing mass production had failed as a universally desirable model of industry, precipitating the search for a more flexible ethos, and "public policy" (that is, government) had emerged as essential to the organization of the economy—including industry—and the society at large. New Deal photographs of work, therefore, were no longer directed mostly at the factory owners or the farm bosses; they were aimed at "the people," at mobilizing/creating "public opinion" as a political tool.

Does the figural displacement of the industrial worker by the farmhand, so marked within the visual culture of the period, appear among these changing tendencies in official imagery? Manufacturing industry emphatically resisted government attention, except, of course, when conscripted into the war effort from 1940. Industry, as we have seen, was its own, enormously effective, publicist. Government-sponsored photography of heavy industry seems to have been confined to its own manufacturing and building projects, such as the Tennessee Valley Authority, and to the activities of agencies whose responsibilities extended to infrastructure relevant to industry, or relief services tied to it—like the unemployed or injured.

Lewis Hine's work for the government during this time testifies to the displacement, and to its nature as an ideological fissure. Although some of his difficulties can be attributed to illness, it is arguable that he became a victim of the New Deal double shuffle, that he failed to update his imagery of modernity in the new style demanded by the new bosses.[11] Hine was commissioned by the TVA to record less its massive monuments, more the way of life being obliterated by the dam—the evacuees, their "folk" crafts and culture.[12] Between December 1936 and February 1937, under the auspices of the National Research Project on Reemployment and Recent Changes in Industrial Techniques set up by the Works Progress Administration, Hine journeyed through the heavy industrial heartland of the Northeast, making more than six hundred photographs. Most of them record survivals of the old ways, in contrast to dedicated machinery and mass production assembly techniques. Nineteenth-century vistas predominate among the establishing shots. Some portraits of skilled working men and women match the power of his earlier work, as do some of the interiors of workers' dwellings. Some display an exquisite sense of the mutual play of skill between worker and machine: the "essence" of creative labor almost impossible for still photography to capture. These locate themselves midway between the

exposé character of the child labor pictures of the 1910s and the worker positioned (somewhat proudly and rhetorically) within the machine of *Men at Work*. But the campaign seems to lose energy as it proceeds.[13] How different are the images in the collection of prints Hine loaned to the National Research Project, presumably for its record and publicity purposes. The five boxes of his own and others' images, taken between 1905 and 1935, include images omitted from *Men at Work*, mostly showing more traditional processes on site, for example, ironworking. They are categorized by him as a panorama of American life defined primarily by the nature and conditions of work. They reveal Hine as a one-man FSA, with an outlook on what was essentially American as profound as that of Roy Stryker, but not as in tune with the times. Chronicler of the harrowing exploitations of the transition from the old to the new capitalism, his vision could not shed the negative connotations of an era that was meant to have ended. The sharp edges of realism—either hard machines or noble workers—set in the blurred depths of irrational space, was an aesthetic easily dismissed as awkwardly anachronistic by the new eyes.

Industry, and its social relations, was very much the province of the Social Security Administration. Created in 1936 to assist the needy, the aged, dependent children, and the unemployed, this agency launched a major publicity effort, not least around its selling of insurance (thirty-seven million clients had to be induced to pay premiums for seven years before being entitled to receive benefits).[14] Photographs were commissioned to show its enterprise in distributing various benefits, but then other photos were gathered under such different headings as "Workers," which was divided into "Workers Going to Work," "Workers' Hands," "Workers, Non-Covered" (presumably by insurance against unemployment), "Old Workers, Closeups," "Young Workers, Closeups," and "Workers at Work." This last category was further subdivided according to the trade or industry, as was Hine's loan collection.[15] Just when between 1936 and 1948 (the life of the agency) these archival divisions were made cannot be established, although the accumulation of images necessary for some degree of sufficiency in these categories occurred, on internal evidence, around 1940. Many photographs were made by Dunbar-Stewart, including those in that iconic FSA category "Workers' Hands." They differ from Russell Lee's *Mrs. Outermayer* in that they are all engaged in a specific job. The same company took most of the heavy machinery images. These clearly descriptive portraits of individual workers at single machines are contrasted in the files to more dramatic sequences by Rothstein and more generalized narratives by Delano.

The Social Security Administration had, by about 1940, built up an archive which profiled American working conditions and, under "Miscellaneous," a wide variety of aspects of American life. These were the sites on which it offered its services. The point is that the archive was defined according to the codification of American society being installed by the Roosevelt administration, and through a structuring of imagery that had evolved during the preceding four years out of the combined efforts of independent photographers such as Hine,[16] commercial studios such as Dunbar-Stewart, and teams on the payroll, such as those in the Historical Section of the FSA. One senses here the ideal New Deal reference set: a combination of records of the constructive work of a specific agency set within the framework of an ideal of American life—open, democratic, honest, hardworking, productive; urbanized and industrialized, and thus containing problems and pockets of misfortune; with its civic heartland in the countryside, on the farm and in the village, its reality increasingly in the suburbs.

The archaizing and modernizing drives, so often in contradiction and contention, achieve an imaginary resolution here. During the decade, agricultural production was totally transformed: it was mechanized by the large landholders, and its output regulated by government. The Department of Agriculture, in concert with the landowners, achieved this transformation, in part, though an imagery that amounted to "bucolic" propaganda, one which comforted all concerned with the illusion that nothing really fundamental was changing.[17] The recuperative effects of rural work, and consequent benefits to the health of the social body, played a significant role in the first of the New Deal agencies, the Civil Conservation Corps from 1933 to 1940, when it became involved in defense-related work. So popular was this initiative that publicity did not need to be generated until its role came under question in 1940 and morale—especially of its black enrollees—needed a boost.[18] The National Youth Administration was established in 1935 to meet the relief needs of many young people (estimates reach seven million), especially those not covered by the CCC—young women and city-based youth. Its use of photography was closely related to local and regional, rather than head office, publicity and was directed mainly at newspapers rather than national circulation photojournals. Some of these photographs signal the emergence of a youth culture at variance to the official ideologies, both conservative and reformist.[19] In all these respects, the NYA photographs differ from those of the second phase of the FSA.

We have not yet tackled the second question asked above: What was the role of the FSA Historical Section in the emergence of a New Deal "style"? The description of the influence of the Department of Agricul-

ture should restore a sense of proportion. That department took the leading role in regulating the entire industry; it supported the monopolization and mechanization of production; it set the agenda that shifted redundant rural workers off the land and into the cities, factories and, in some cases, the greenbelt towns. The Farm Security and Agricultural Resettlement administrations were in effect, and then de jure, subsidiary branches of this department. They dealt with the problems, the "other side" of the bucolic landscape. The USDA's hundreds of thousands of photographs were more prominent in newspapers than those of the FSA at the time. On the other hand, Stryker's section led the way in creating images of both rural poverty and the human resources available to other parts of society. It raised the standard of official photography to a level that matched—in form, content, and outlook—the best photojournalism of the day.[20] Although it was not the originator or the only source of significant New Deal photography, it became prominent by 1938 and predominant by 1940–41. The hundreds of FSA images in the files of other agencies, such as the Social Security Administration, attest to this impact. The FSA photographs were perceived as fitting the government's ethos, able to supply images that expressed this official generality through telling particulars. Stryker's vigorous distribution of his section's output, in concert with the vast circulation photomagazines, was teaching millions to see themselves, and America, in new ways. Small wonder other departments sought to imitate the FSA's success, to use its images, or to request FSA photographers to cover material relevant to their briefs.

By 1940, with war imminent, heavy industrial production reappeared dramatically among these requests. The New Deal displacement of the industrial worker ended abruptly. The dispossessed rural hand, the redundant sharecropper, lost identity as an object of pity, deserving of welfare; indeed, America's peasantry faded into invisibility as revived manufacturing industries swallowed them into the now-thriving factories. The FSA, and its Historical Section, had accomplished the conjuring trick that—despite the critical energy present at the inception, and sustained by some throughout—became the task set for it by the New Deal double shuffle.

By 1942, when the publicity efforts of many of the agencies, including the FSA, were absorbed into the Office of War Information, it was the FSA vision of middletown normalcy and its integrative aesthetic which best expressed the basic drives of America's internal alliance. This expression incorporated a continuity with the imperatives of the mass-circulation photomagazines. Together, these ubiquitous picturing machines set the tone for the imagery of America at War.

Modern Life Begins

Newspapers and illustrated weekly magazines began using photographs extensively around 1900. The photomagazine as such, however, seems to have peaked first in Germany in the late 1920s and early 1930s in publications such as *Berliner Illustrirte* [sic] and the Communist party's *Arbeiter Illustrierte Zeitung*, both of which achieved over one and a half million circulation at the time. Few artist-designers anywhere matched the radicality of John Heartfield's photomontages for the latter, but overlapping, cropping, outlining, and otherwise shaping of photographs within the layout was common to both newspapers and magazines. Typical of the moment was the growth of "photojournalism" or "photo reporting," in which individual photographers frequently, on their own initiative or under editorial direction, would record an event or visit a region or place previously unphotographed and then present a "photo essay" on the subject for publication, with captions written by journalists. Outstanding photographers of this type included Walter Bosshard, Martin Munkacsi, Erich Salomon, Wolfgang Weber, Felix H. Man, Georg Gidal, and Alfred Eisenstaedt, working with editors such as Stefan Lorant. In the mid-1930s most of these men left Germany to play crucial roles in the growth of the photomagazine in England, France, and the United States.[21]

Luce's initial conception of *Life* paralleled the modernization of news information which had inspired *Time*: he planned to organize a selection of outstanding photographs from the stocks of the photo agencies and then shape them mainly around the twin structure of the "big Newspicture Story of the Week" and a "Big Special Feature."[22] Pirating a photomagazine proved impossible, so the staff of Eisenstaedt (from Berlin), Bourke-White (from *Fortune*), Tom McAvoy (from *Time*), and novice Peter Stackpole was expanded to include others such as Carl Mydans (from the FSA) as well as freelancers such as Robert Capa (based in France). In marketing terms, *Life* aimed at the mass-circulation illustrated magazines such as *Saturday Evening Post*, seeking to steal their advertisers by taking an even greater punt on the attractiveness of the "photo story," on the buying power of information packaged primarily visually. Time Inc. sunk millions of dollars into the project, but advertisers found it difficult to adjust to a layout which did not clearly mark off editorial, pictorial, and advertising sections, and to a scale of rates higher than other illustrated magazines with greater total sales. Time Inc.'s sales people pointed out the value of the more "open" layout in giving advertisers more "positions" opposite the editorial matter (which indicates that Adorno and Horkheimer's point about the integration and

transposing of editorial and advertising was scarcely an accidental effect). And they commissioned a market research survey, headed by prominent academics, which demonstrated that the magazine's "pass-around" readership was so high that its actual circulation by late 1937 eclipsed that of any other picture magazine in the United States.[23] The techniques of modernization, both in the organization and in the design of the magazine, are exactly those we have noticed earlier: only their precision and scale are increasing, as well as their capacity to absorb complexities.

It is not only *Life's* form but its content which makes it so revelant as the key instance of later 1930s imagery of modernity. For while "modern life," "Industrial America," and "Modern America" were featured within it as themes among others, more importantly its very fabric represented, almost transparently, the shape of modernity in the United States at this time. It shared this quality with much else in U.S. culture contemporary with it, but in an exceptionally overt fashion. It recorded and celebrated the institution of the imperatives of corporate capitalism within the details of everyday life, the normalization of the contradictions of the moment. It brought together, weekly, the fertile fictions of a nationalistic industry, a benevolent government, and an honestly striving, basically tolerant, essentially democratic people devoted to the values of community, family life, and personal independence—all assembled as if for snapshots in a large (but not larger than life) photo album. It was a public archive of Americana as it was lived. The encyclopedic thrust of the social reform photographer was there, but, like the FSA program, it was tied to a view of the United States both general and particular. Mydans recalled: "We had an insatiable desire to search out every facet of American life, photograph it and hold it up proudly, like a mirror, to a pleased and astonished viewership. In a sense our product was inbred: America had an impact on us and each week we made an impact on America."[24] Again, the wish to be subsumed in one's subject at the moment of seeing, to disappear as an image maker, to achieve an invisibility which leaves only the sight of the subject for the viewer. In this case, the viewer and the subject are the same: "America"—an American seeing him- or herself. The subject—as opposed to the historical and the bizarre so important in the German precedent—was unequivocally *here:* again, in Luce's words, "While journalism accents the abnormal, the hopeful fact is that the photograph can make normal, decent, useful and pleasant behavior far more interesting than word journalism usually does."[25]

Dedication to the representation of the interests of the "normal, decent, useful and pleasant" took some years to establish as itself normal,

decent, useful and pleasant. But the ambition was there from before the first issue, in Luce's 1936 prospectus for *Life:*

> To see life: to see the world: to eye-witness great events; to watch the faces of the poor and the gestures of the proud; to see strange things—machines, armies, multitudes, shadows in the jungle and on the moon; to see man's work—his paintings, towers and discoveries; to see things thousands of miles away, things hidden behind walls and within rooms, things dangerous to come to; the women that men love and many children; to see and take pleasure in seeing; to see and be amazed; to see and be instructed.[26]

How, according to Luce, are we to "see life"? First, by seeing "the world," understood in the next phrase as a fictive "presence" at events apparently shaping contemporary history (soon to be staged as if they were). This is immediately followed by an ideologically shrouded class contrast: the "faces of the poor" evokes directly the vacant stare of the powerless, the play of glances so structural to the FSA photographs, the convention which they amplified so by embedding it in the close-up, whereas the "gestures of the powerful" conjures historical actors, people conscious that their recorded presence makes history, that their appearance will be minutely studied. Evoked also is a play within the phrase: the power of the rulers, the rich, the famous is such that even their gestures (the signals of their power), however artificial they might seem, have impact. And between the two phrases scurries the entire political terrain we have been examining in this section, albeit evacuated of class reference: the "powerful" and the "poor" have been/always will be with us; inequality is eternal and natural, yet part of the power of the rulers is their tie to this relationship, and their capacity to graciously "elevate" the poor by a gesture. The democracy of the list is not the equality of those listed, but the fact that some ("the poor") were listed at all. Both rich and poor are objects of the camera's gaze (the gaze of totality, record, "humanity," "the machine"), but whereas the powerful are free to take the photograph of the poor as evidence of a situation to be watched, perhaps alleviated, the poor can only submit themselves as objects of its gaze, if they do not want to retreat into invisibility altogether.

"Machines" is the first figure on Luce's list of "strange things," just as "the women that men love and many children" is the last. Between these two lies the space traversed by modernity itself since the early nineteenth century: the new machinery finally arrives at the family; having reorganized work, business, and consumption, it is now the foundation of ordinary lives, the valued "small things," the "tender mercies." All the infinite variety of human experience can be contained

by these constants. But it is a constant battle. Luce's language in this prospectus is shaped by modernity in further ways: its *list* form scarcely holds the tremendous differences of type and genus named within it: "shadows in the jungle and on the moon" can be linked most obviously by the artifice of photography itself. Things "dangerous to come to" (so they can be approached through a blurred picturing of them—eventually there will be nothing unpicturable) need the evocation of women-men-love-children to counteract their otherness.

Most indicative of the text's modernity, however, is its framing at its beginning and end by phrases starting "to see." "To see life" becomes instantly "to see the world," a totality immediately invoked as the overall reference. And after the declassed contrast and the new volatility of the relationships between elements on the list, the text ends with three relationships to visualization that are far from arbitrary: they are essentially modern in their stress on the visual and in the way power is distributed within modes of seeing. This goes quite beyond the emphasis on the reader sitting and looking, which is the obvious target of a picture magazine. "To see and take pleasure in seeing" locates the viewer as primary, active, delighting in seeing for its own sake, following the probing eye of another as it discovers, enjoying the revealed, exerting control through sight, creating new sights, becoming the photographer. "To see and be amazed" and "to see and be instructed" evoke the nineteenth-century figures of Nature Teaches, and God's Hand in Nature, both observable in the visible: knowledgeable seeing is seeing evidence of the world being organized in these ways.

The viewer here is passive, receptive, moved, learns, accepts. This sequence is called for in Luce's text by a new overriding order—the *spectacle* itself. Not special occasion spectacles, such as a gathering of "multitudes" or "armies," but life consisting above all of an incessantly circulating set of constantly replenished sights, an unending variety of images of human "experience," often surprising ("unseen") but always essentially similar. Something of the dream of utter lucidity which inspired early modernism is recalled here—Melnikov's architecture, Rodchenko's photography, Dziga Vertov's "I Am a Camera."[27]

But these artists' demands that everything in the world be subject to the glare of the objective machine, that artistic personality be subsumed in the "camera eye," were attempts to restore the power of seeing and of visibility to the powerless. The pleasure held out by Luce, however, is quite the opposite: the pleasures of *submission to the spectacle*, to the fragmentary narratives organized by *Life's* humanism, to the shock of the new restored to inactive balance by the reinsertion of the updated conventional. At the core of all the excitement, openness, liberating

promise of the new *Life* lies this ideological closure: by being made the primary object of their own fascinated gaze, "the people" are constructed as still signs in a spectacle apparently beyond management, beyond fundamental change because it is always changing, willy-nilly, anyway. At every moment, the imagery of democracy is evoked and betrayed: a rhetoric of freedom disguises a hierarchical "empire of signs."[28]

All involved with the early issues of *Life* magazine attest to the unplanned, seat-of-the-pants, exhilarating adventure which creating it must have been.[29] This can only reinforce our lack of astonishment at the predictability of the product. The front cover of the first issue was a full-page, closely cropped view of part of the Fort Peck Dam, dramatically angled so that the massive concrete structures seemed to sweep across in formation, gliding juggernauts recalling huge ships but also so obviously solid, stilled, permanent, like Egyptian temples. Below, two tiny workmen, heads bowed over some trivial task, appear only as ciphers to register awesome scale. Bourke-White here sets in play many of the modernizing devices we have observed above: composition by repetition and regular variation, broad differences marked by highly contrasting planes, lesser differences by a surface modulated by light shadowing. The implied independent "life" of the machine, or the mechanically made; the absolute dominance over the manual worker by the new technological form; pure product of engineering thought realized in the simplest, most dense of materials according to a mass production system of construction which also has a logic of its own. These are the instant monuments of the modern age—architectural machines so resolutely sure in their declaration of their own eternity, irresistibly powerful, strangely beautiful. This vision returns to Sheeler's aestheticizing, as did *Life* itself when it reran the 1927 Rouge photographs (August 8, 1938).

As the first *Life* cover, however, its connotations move us away from a purely machine-aesthetic reading—which is exactly that of Sheeler at Ford Company in 1927—to the later phase of mid-1930s modernity. The shift is marked in the editorial itself: "What the Editors expected—for use in some later issue—were construction pictures as only Bourke-White can take them. What the Editors got was a human document of American frontier life which, to them at least, was a revelation" (*Life*, November 23, 1936, 3).

The high modernist style of the front cover was followed by a photo-essay feature on the towns around this Montana construction site, composed as if for an FSA shooting script. The Fort Peck Dam, the largest earth-filled dam in the world at the time, was a classic New Deal project. Costing $100 million, it aimed at fulfilling an economic need—

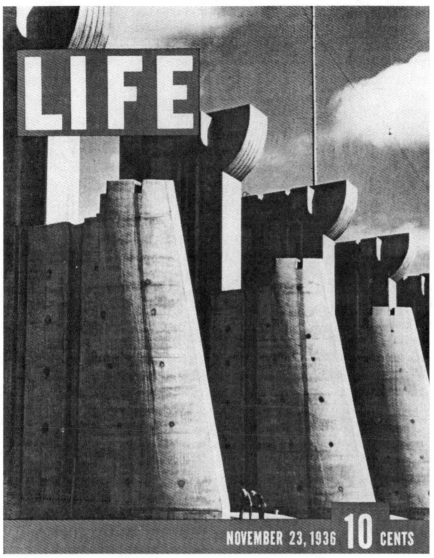

9.5 Margaret Bourke-White, *Dam, Fort Peck, Montana*, 1936. Cover of first issue of *Life*, November 23, 1936. (Margaret Bourke-White, *Life* magazine, © Time Warner Inc.)

promoting commerce on the Missouri River—and providing relief work for ten thousand Montana unemployed. The entire project, including dams in the Columbia basin in Washington state, was supervised by the army. Bourke-White and *Life* had again "scooped" the New Deal publicists, just as she and Caldwell did the FSA "plight" pictures in *You Have Seen Their Faces*. New capital, the latest industrial technology, large-scale social planning, "the people" at work, reaping benefits—all the elements of Corporate State modernity are present. Present but not in harmony. This is 1936, the year of continuing recovery for the large corporations but continuing misery for the unemployed, especially beyond the North and the East Coast.

Bourke-White's photo story of the town of New Deal gets as close to the subjects as does Lange's work in California and Lee's in Woodbury County, Iowa. She submitted to *Life* the kind of work she knew was being done in parallel fashion for the FSA but which had only just begun to be published in limited-circulation journals such as the Kelloggs's *Survey Graphic*, in internal FSA publications, and, of course, in the photo books just appearing or in preparation. But the story itself differs from the FSA picturing of poverty and celebration of the small town by an extraordinary stress on the desperate anarchy of the way of life in these towns. Of the sixteen images in the story, half dramatize the bars and brothels of the shanty towns which were built in defiance of the army's regulating the official workers' camps. Only one photograph shows men at work on a tunnel (posing as if at work on its internal webbing—it is a prefabricated unit—their only possible work could be removing its stay bars). The text embroiders a "Franklin Roosevelt has a Wild West" metaphor, ridiculing the economic value of the project, questioning whether the workers actually work: "Life in Montana's No. 2 relief project is one long jamboree slightly jogged by pay day." Opening with the cover discussed above, the story ends in a stunning double-page spread, *Montana Saturday Nights:* two repeat shots along a crowded bar cut diagonally across the pages, halting at the face of a young girl, glazed eyes staring out, still in all this animated noise. Below is a "Migrant Mother" shot: the mother stands staring, exhausted, her two children clinging to her bruised hands. The text ties them together in the lively, ironic, know-all urgency of *Time-Fortune* language:

> The pioneer mother can trek in broken-down Fords as well as in covered waggons. And she can crack her hands in the alkali water of 1936 as quickly as in the alkali water of 1899. When the Fort Peck project opened in 1933 the roads of Montana began to rattle with second-hand cars full of children, chairs, mattresses and tired women. Most of them kept right on rattling towards some other hopeless hope. Some of

them parked in the shanty towns around Fort Peck. There, their women passengers got jobs like Mrs Nelson (*right*) who washes New Deal without running water, or tried their feet at taxi-dancing like the girls on the preceding pages, or made money like Ruby Smith on page 15, or gave birth to children in zero weather in a crowded 8 by 16-foot shack like many an unnamed woman of New Deal and Wheeler. The girl at the bar (above) who works as a waitress ("hasher") takes her child to work with her because she can't leave her at home. She sits on the bar while her mother kids with the customers. The group on the right, it will be noticed, resembles a statue recently erected to the Pioneer Mother of the old frontier. No statues are expected at New Deal.

Thus the desperate anarchy of the angry unemployed is contained: by government projects which remove them far from the centers of power to make-work projects where they struggle to survive. The social-sexual otherness of this proletarian "underclass" appears in the flashbulb's glare in all its shocking, sad strangeness, enframed by the power of the modern dam and the powerless resignation of the victims. It is the same displacement as that structuring the FSA, only more concentrated in this more urgent public forum.

Many other themes of late 1930s modernity are announced in the first issue of *Life*. Color photography activates mostly the advertisements; it will slowly migrate into the editorial pages. Most advertisements are for cars, with Chrysler Corporation again one stylistic step ahead of Ford Company. Ford's advertisement isolates an image of the car, with text beginning "New and modern in appearance, the Ford V8 for 1937 is powered by a modern V-type 8 cylinder engine," whereas Chrysler adds to the image of the car a sequence of pictures of it in use, all presented on the inside front cover as a news story: "First pictures and details of the New Plymouth." Most of the advertisements are organized around consumption and obsolescence, although few (and fewer as it goes on) are as explicit as Zenith Radio's "The 'Old' is Out; the 'New' is Here!" Color also features in the section devoted to art, a portfolio of John Steuart Curry's pictures of life in Kansas. The editors trumpet: "On looking at what happened to this issue the Editors are particularly pleased that Art is represented not by some artfully promoted Frenchman but by an American." And, in keeping with the tensions noted in the Fort Peck photo essay, Curry appears here not as a simple regionalist, but as an imager of rural order darkened by natural forces and the strangeness of local custom. The final indicator of the transitional character of this issue occurs at the back of the magazine: next to the photo credits (which includes a glamor shot of Margaret Bourke-White herself)

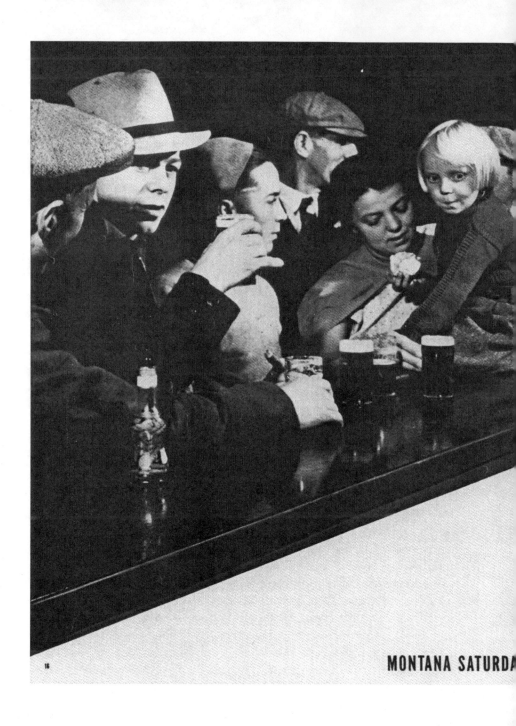

MONTANA SATURDA

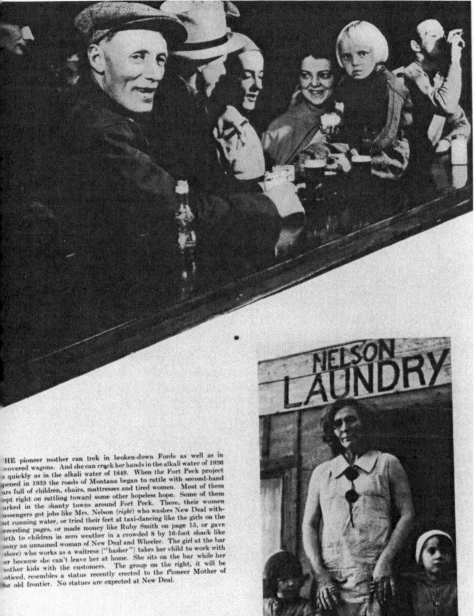

THE pioneer mother can trek in broken-down Fords as well as in covered wagons. And she can crack her hands in the alkali water of 1936 as quickly as in the alkali water of 1849. When the Fort Peck project opened in 1933 the roads of Montana began to rattle with second-hand cars full of children, chairs, mattresses and tired women. Most of them kept right on rattling toward some other hopeless hope. Some of them parked in the shanty towns around Fort Peck. There, their women passengers got jobs like Mrs. Nelson (*right*) who washes New Deal without running water, or tried their feet at taxi-dancing like the girls on the preceding pages, or made money like Ruby Smith on page 15, or gave birth to children in zero weather in a crowded 8 by 16-foot shack like many an unnamed woman of New Deal and Wheeler. The girl at the bar (*above*) who works as a waitress ("hasher") takes her child to work with her because she can't leave her at home. She sits on the bar while her mother kids with the customers. The group on the right, it will be noticed, resembles a statue recently erected to the Pioneer Mother of the old frontier. No statues are expected at New Deal.

HTS: FINIS

9.6 Margaret Bourke-White, *Montana Saturday Nights*, 1936. *Life*, November 23, 1936. (Margaret Bourke-White, *Life* magazine, © Time Warner Inc.)

is an advertisement in which the *Des Moines Register and Tribune* clamorously celebrates its skills in photojournalism. Under the screaming headlines "GANGSTERS MOLL CAPTURED IN IOWA," a panorama of figures struggling against a car is captioned: "Notice the animal snarl on the face of the captured girl. Her lover sits wounded at right." Inspection of the image shows quite clearly that Bonnie Barrow is not struggling to escape but objecting to being photographed.

Life went on. The tensions between different modernities, between the contending elements of modernity, were gradually brought into line, compromised, and controlled through the insistence on "normal, decent useful and pleasant behavior," even when the facts demanded the recording of quite opposite realities. The FSA 1936 pictures of poverty persisted as a conscience-rending abnormality until they were absorbed into the positive national family promoted by *Life, Look,* and other imitators as well as by the Office of War Information, just as Lorentz's fictive documentaries in support of the New Deal led directly to Frank Capra's *Why We Fight* series of films.[30] Photography's role in the process, especially the absorption of the radical, critical edge of Social Realism into the service of consensual documentary humanism, was intensely valued in both the popular photomagazines and the art institutions. At Standard Oil of New Jersey, Roy Stryker willingly subsumed documentary under "Public Relations Photography."[31] Edward Steichen in 1938 announced his retirement from commercial photography to undertake a program which would have gladdened the heart of both Stryker and Henry R. Luce: "a vast photographic mural of America, beginning with astronomical photographs of the heavens, indented lower down mountain ranges, cities, factories, then breaking up into smaller scenes of streets, homes, offices, hospitals, with a winding decoration consisting of tasseled growing corn."[32] Steichen went on to become curator of photography at the Museum of Modern Art, head of aerial photography for the U.S. air force, and organizer of major photographic exhibitions in which American modernity, *Life*-style, was projected, both nationally and globally, as the way of life natural to the "Family of Man."[33] The persistence of this construction as a reference for "truth" is remarkable: when, in 1983, *Newsweek* sought a fiftieth anniversary theme, the decision was to devote the entire issue to the histories of five families from the "industrial heartland city" of Springfield, Ohio. The cover was entitled *The American Dream*, and its legend read: "For fifty years *Newsweek* has covered the people who make news. Our anniversary issue celebrates the men and women who live the news, the unsung people who make our country. This extraordinary saga of five heartland families is richer and more compelling than fiction. It is the true story of America."

DESIGN OR REVOLUTION? STYLING MODERNITY IN THE 1930s

PART
3

DESIGNING DESIGN: MODERNITY FOR SALE

What about the plethora of obviously modern imagery? What of, for example, the "streamlining" of everything from airplanes to pencil sharpeners by the industrial designers, new heroes of the Design Decade? Does not the subtle minimalism of the European Modern Masters become an "International Style," effecting profound changes in American architecture, transforming the great cities and the small towns alike? Did not the American home become a cleanly ordered domestic environment, filled with efficient appliances, sharply up to date in form and function? Were not the people entranced by the imminent prospect of a world of organized plenty, of pleasant work and increased leisure in well-planned cities of the future? Do not certain key tendencies in the arts and crafts of the 1920s—purism, the Bauhaus, Swedish design, for example—converge by the end of that decade into a genuinely new "modern style" characterized by a purity of form, an exact sense of function based on the machine, a preference for mass-manufactured materials, a careful deployment of a purposively limited vocabulary, and an uncompromising rejection of the gross clatter of connotation so offensive in all previous imagery?

Can it be denied that the visual culture of the

United States, as elsewhere in the "advanced" world, was transfigured by a consciously modern simplicity of style, rooted in the experiments of the geometric abstractionists of the 1920s but spreading to all aspects of everyday life in the subsequent decade? Why not, then, celebrate the now-familiar canon of modern classics such as the Chrysler Airflow and the Douglas DC-3 airliner (both 1934), Loewy's Coldspot refrigerator (1935), Dreyfuss's Twentieth Century Limited train (1938), Bel Geddes' Aerial Restaurant proposal (1934), Fuller's Dymaxion car (1934), Teague's Kodak Baby Brownie (1935), Jensen's Monel metal sink (1931), to say nothing of such architectural favorites as the Chrysler and Empire State buildings, Wright's Edgar J. Kaufmann house (1936), paralleling the French and German icons, such as the Pavilion L'Esprit Nouveau and the Bauhaus, as well as Asplund's pavilions at the Stockholm Exhibition (1930)? Are not these, like the River Rouge plant itself, the distinctive icons of the age, the images which capture its spirit most crisply?

All of these questions represent interpretations of aspects of the 1920s and 1930s which remain influential in popular memory, in nostalgic re-creations and scholarly histories. Art and design histories, especially, emphasize the emergence and priority of their own actors and institutions in defining the period as "modern." But in terms of the account of modernity developed here, all of these interpretations are partial, at best, or self-serving and wrong.

To complete the argument it remains to show how the "obviously modern" took visual form in the 1920s and 1930s and how it was subject to the powers of the imagery of modernity as a broad regime of visual "truth," becoming a theme (or set of themes) within it. To do so I want to return to questions of architectural design and functionalism, but to place them in relation to other specially relevant discourses (especially those of photography, industrial design, and expositions) and crucial agencies of modernity (especially the Museum of Modern Art and the New York World's Fair). I am not claiming that these are the only discourses and agencies relevant to the construction of the "obviously modern," but they do seem to have been among the most influential. The viewpoint from the larger regime enables an account of modernism and its configurations somewhat different from the exaggerated, mystifying valorations which have held sway for so long. It may also help resist the unseemly stampede to reduce modernism to a single, mainstream, reactionary, and inevitably institutionalized form, which tends at the same time to bury modernism's critical aspects. The unfortunate effect has been to render modernism readily rejectable by an easy, superficial type of postmodernism, one of style rather than subversive substance.

Stepform Deco and Good Taste

Nearly half of the exemplary products listed in Stephen Bayley's *In Good Shape*, a survey of "Style in Industrial Products, 1900 to 1960," were designed in the 1920s and 1930s.[1] Pevsner's account has become an orthodoxy: the ideals of William Morris and the sensible architecture of the English Domestic Revival movement influenced German architects and designers, particularly those organized in the Deutscher Werkbund, whose successful inauguration of machine-based design had an immediate impact back in England and, soon, in the United States. The Sachlichkeit of Muthesius, Behrens, and Gropius, evolving during 1909–14 and synthesized at the Bauhaus, was the genuine and legitimate style of our century.[2]

Subsequently added to this story of genesis is the further claim that, if it was the institutionalizing activities of the Design and Industries Association (established in London in 1915), including both working designers and publicists such as Pevsner, Gloag, Read and Bertram, which seemed to shape English developments, in the United States it was the freelance, commercial design offices of certain individual designers which become generative then typical. There is a tendency now to celebrate Bel Geddes, Loewy, Dreyfuss, Teague, Van Doren, and one or two others as, if not the "pioneers" of modern design in general, certainly the founders of modern industrial design, a new profession, unwedded to architecture: "It was these men, working as industrial designers of objects as diverse as duplicators and dump-trucks, who created the imagery of the twentieth century in a country whose avidity for image instead of substance has been so eloquently described by Daniel Boorstin and Vance Packard. Soon the manufacturing giants themselves were forced either to hire these men or create their own design teams to do the job for them."[3] Bayley's implication is forwarded explicitly by Gebhard in 1970: "The Bauhaus talked about the integration of design into industry—the Americans accomplished it."[4]

Despite its internal tensions, this historical tale, peopled by these master architects and designers and illustrated with a canonical set of buildings and products, remains in place, echoing even in such contextually alert revisions as those of Heskett and Meikle, and institutional histories such as that by Pulos.[5] However European modernism is positioned, there seems to be agreement that in the United States there was a stylistic shift between the French-dependent Art Deco, "modernistic" 1920s—when the car and the ship were the icons of the new, and a preference for a decorative, mainly vertical layering of angular forms prevailed—to the self-sufficient American design of the 1930s, with its

worship of the airplane and the express train, a recognition of the "machine" as fundamental, and a recasting of everything possible in curved "streamlined" forms.[6] These formulations tend to assume what they have to prove; they are a kind of style history which works by accumulating formal likenesses and hoping that a label will stick, that the resemblances will look like family ones. They have only the most carefully qualified accuracy: at best, they may hold for certain tendencies in industrial design; instead, they slide into standing for something essential about all new visual imagery from the period. I take them to have some purchase only on the visualization of the modern within industrial design. We will see that industrial design was not all, or even mostly, concerned with modernist imagery, and that other powerful agencies had different views of how to visualize the present: the Museum of Modern Art, for example, spearheaded a strong attack on both deco and streamlining in the name of a "functionalist" purity of form, a more "genuine" modernism.

Design, in the United States as elsewhere, still awaits a historical account alert to the full range of the complexities and contradictions which shaped it. Meikle's *Twentieth Century Limited* is the best to date. Also essential is a far greater exercise of discriminative description in assessing the nature and quality of the much-fabled design "solutions" constituting the canon.[7] My remarks here remain, therefore, tentative and confined to industrial design's relationship to the broader visualizations of modernity we have been tracing. Can we simply assume that, because such a task was its often-declared raison d'être, modern industrial design was in fact central to the broader social project of imaging modernity? Such a simple equation of rhetoric and effect is thrown into question by the argument for the powers of the quite different phases of the imagery of modernity which I am urging.

The American System of Manufactures frequently gave rise to functional machines such as the Corliss steam engine, centerpiece of the 1876 Centennial Exposition in Philadelphia, and such typeforms of mass manufacture as the Waltham "dollar" pocket watch and the Singer sewing machine. But these were generally regarded as "basic," their aesthetics invisible in a period when art in industry mostly meant the application of "aristocratic" ornamentation to machines and products. As American industry shifted more and more to the profitability of mass manufacture, assembly, distribution, and marketing, which culminated in the Ford Company modernity discussed earlier, either "design" remained an effect of engineering requirements, of the limitations of materials and the organization of the manufacturing process, or it meant a pregiven "pattern," usually purchased in France or England, to which

the local productive processes were applied. Buying "designs" was cheaper than investing in the design process, cheaper than importing already trained designers. Beaux Arts revivalism dominated, as it did in architecture, with some incursion of Arts and Crafts and Art Nouveau. All of these tendencies spread from the homes of the rich, through their offices to official buildings, and were then distributed by the retail stores and magazines down the class hierarchy. The mixtures, transpositions, and stubbornly maintained distinctions which we noted amid the advertising in the pages of *Fortune* were characteristic of design in all areas: the shifting ensemble was the chief regulator. The forms in which it coalesced in the late nineteenth century remained dominant until the 1950s; indeed, in certain domains (for example, the front rooms of most middle-class houses) it still sets the tone of normality. Any claims for the impact of modern design must always be measured against the power of this distributive mechanism.

It has been argued that the excessive overproduction of successful and widely applied Ford Company–type mass manufacturing, allied with the need to assuage the social unrest caused by the very changes this system was effecting in working life, was the key impetus for the great expansion of advertising in the 1920s, from $15 million in national periodicals in 1915, to $150 million in 1929. The same causes lay behind the transformation of industrial design. In the 1920s, industrial design was a subsidiary sector of advertising; by the early 1930s it was being heralded, along with advertising, as the major means to stimulate consumers to buy in the interests of national economic recovery. Industrial design's amusing glamor and its peculiar, elusive aesthetic are both founded on just this need of corporate capitalism. It is a specialization within a continually dividing labor process; indeed it can occur at the interstices of various already given specializations (for example, initial product design as well as later packaging). Advertising insisted more and more on substituting its own representations for the referents it was selling; industrial design increasingly sought to invest the referent with the signs of representation, to physically transform it into its representation, turning the product into its advertised exaggeration. To do so, it invaded the productive process, demanding that it recast its priorities: thus the Model A shift at Ford Company in 1927, and the General Motors and Chrysler precedent of the preceding years.

Industrial design, in this context, becomes a discourse for the insertion of the priorities, values, and imagery of advertising deep into the productive process. The 1920s faith in the persuasive powers of expansionary advertising to locate and extend the markets for luxury, then consumer, goods was checked by the depth of disaster in the Depression.

More and more from the early 1930s the product had to "sell itself." Designers avidly promoted themselves as the "saviors" of industry, taking over from the advertising agencies the role of stimulating consumer spending. In this sort of relationship between advertising and industrial design, there is the demand for integration flowing from their shared economic purpose, and an obvious pull toward stylistic continuity, even uniformity. But there is also the potential for difference (within the overall ensemble serving the same ends, of course). The shifts between various moments which mark other visual cultural practices might also be expected to operate here: for example, it would be unsurprising if, say, in later 1930s magazines, overtly modern products were featured in emphatically realistic advertisements, whereas we might expect greater integration in the later 1920s and early 1930s.

Advertising's parentage of U.S.-type industrial design is traceable not only to their common economic purposes but to the histories of the individuals who shaped the design profession. Most were art or architecture graduates, and most spent the 1920s as advertising artist-illustrators. Joseph Sinel, John Vassos, Raymond Loewy, and Walter Dorwin Teague are the outstanding examples, but others served similar apprenticeships—Arens, Deskey, Guild, and even Bel Geddes.[8] Teague had been contributing decorative typographic borders to expensive advertisements since 1911, for example, to the 1915 campaign for the Pierce-Arrow car managed by the Calkins and Holden agency, one of the first to try selling a car by its look. As Meikle observes, "the important point was that a leading advertising agency wanted the automobile sold like clothing— on the basis of style. Its design should exude the 'atmosphere' of its advertising. In short, the automobile should become an advertisement for itself."[9] This kind of integration occurred only in the imagery of luxury at this early stage: indeed, it was rare even in this market in the United States until the mid-1920s. It was precisely the ambience of integration, the ease of total style casually worn, a coherence pervaded with the sense of the expense on which it is based, but by the subtle implication only—in short, "good taste"—that Ford Company sought to impart to the Model A and the campaign around it.

Ford Company was retreating upmarket in the face of the 1927 recession, but was forced to "democratize" luxury taste to do so. The scrapping of the Model T, and the massive retooling operation necessary for the changeover, was quickly dubbed "the most expensive art lesson in history" and widely recognized as the most dramatic evidence of the necessity for all business based on mass production to give priority to "beauty" in the competition for sales.[10] That this "beauty" came from art was constantly averred in the advertisements' citing of paintings,

their liberal sprinklings of antiques, as well as their deployment of painterly and fine printing styles of rendering, and in their very form— the white spaces, the internal framing, the Teague borders. Calkins trumpeted in 1927: "The forces making our fast-paced, bright-colored sharply-defined civilization are producing our modern art. It is appropriate that modern art should enter business through the door of advertising."[11] The depth of art's influence was shown in the discussion of *Fortune* advertising. But so, too, was the variety within the ensemble itself: how was it that industrial design seemed so exclusively devoted to the modern?

The simple answer is that, quantitatively speaking, it was not. Alone among writers on the subject, Pulos devotes some attention to what emerges from our analysis of Ford's archaism, of the subscription of Sheeler and the Social Realists to "American Scene" painting in the early 1930s, of *Fortune* advertising to a variety of inherited styles, and of documentary photography to the central value system of the small town: that the "other side" of all of the phases of modernity was a searching for an older America, anachronistic but persistent, fragile but deeply rooted. Industrial design, as we saw, had been primarily devoted to use modern technology to replicate products and ornaments from the past, especially Europe's. In the 1920s and 1930s this continued apace, but to it was added a search for a uniquely American style. Confining modernity to the (re)productive processes, leading designers concocted two new revival styles: "The Spanish Colonial style was a curious blend of Spanish Baroque fashions with Indian forms, and the Northeastern Colonial, an agglomeration of Jacobean, William and Mary, Queen Anne, Georgian, and Rococco influences with traces of German folk art and French and Italian Renaissance, tossed into a cultural salad to nourish the American's transplant spirit. Its best products were two styles of furnishings that have come to be considered natural to American domestic interiors."[12] The most spectacular installations of this type were, of course, the elaborate picture-palaces, the movie houses, but "period style" swept through the upper floors of executives suites, professional offices, retail stores, and the front rooms of most homes that could afford it or something like it. The modern was, with striking exceptions, confined to the factory, the trading areas, the secretary's and storage rooms, and the kitchen and bathroom of the home.[13] The new corporatism managed the modern for its workers and exported it to its consumers. In the subcultures of the rich, the Colonial revivals were preferred, the modern entering only as either briefly fashionable Art Deco or a refined modernism (see fig. 5.3). Henry Ford re-created Greenfield Village while Edsel subsidized the Detroit Institute of Arts, Abigail

Rockefeller revived Williamsburg while Nelson took on the Museum of Modern Art.[14] Consumers of both the "traditional" and the "modern" in all their varieties were being cultivated with equal assiduity by the new corporatism, depending on their market (class, geographic) location.

Acknowledging, then, that stylistic diversity reigns overall, and that market expansion can be as readily achieved by replicating the old as creating the new, what can be properly said about ways in which modernity was visualized in industrial design? Immediately obvious is that, for all the conventional cant about the boom of the 1920s and the optimism of the jazz age, and despite the prodigious innovations of the modernist avant-garde in Europe since c. 1905, a distinctive imagery of modernity was exceptional in industrial design until the later 1920s. The exceptions include factory design such as that of Albert Kahn, and certain "basic" mass-manufactured products such as the watch and sewing machine already mentioned, and others, such as Eastman's Box Brownie of 1900. (These were sometimes heavily decorated, or were the "cheap" end of a heavily decorated range—as in the case of Singer and Kodak.) In Europe exceptions included Josef Hoffman's tray of perforated sheet metal painted white of 1905, Behrens's range of electrical goods for AEG, Barnack's Leica Camera (prototype 1913, marketed 1925), and the Swedish Electrolux Model 5 Vacuum Cleaner of 1918 (produced in the United States from 1931). The startling geometries of de Stijl, the Bauhaus artists, and the Russian Constructivists were usually hand-tooled craftworks, rarely achieving mass production until the later 1920s and 1930s.

Until then, the modern, in visual terms, meant, for most people, that limited range of fashion and furnishings so deftly promoted in the Exposition Internationale des Arts Décoratifs et Industriels Modernes, held in Paris in 1925. There Le Corbusier's purism was as exceptional as Melnikov's and Rodchenko's revolutionary modernity: the prevailing tendency in all fields was a simplified, stripped, geometric, planar Arts and Crafts decorativeness, still replete with classical and organic imagery but tending to express it more through evocation and allusion rather than imitation. Machine production was both an inspiration and a possibility for much that was on display, although there was also a persistent tendency toward recovering richness and expense through the overlaying, building up, even stacking of varieties of heavily worked materials.[15] One measure of the rarity of even this "modernism" in the United States was the industry's advice to Secretary of Commerce Herbert Hoover in 1923 that the United States should not participate in the Paris show on the grounds that "while we produced a vast volume of goods of much artistic value [we could not] contribute sufficiently

varied design of unique character or of special expression in American artistry to warrant such a participation."[16] In 1925, as in the shock of the Armory Show of 1913, *modernism* meant the bold, bright geometries of the latest French style, and it was largely the province of high fashion and art. *Modernistic* was a term used by designers and artists to isolate and reject "vulgar" versions of their modernism. It was also applied to everything that looked modern from positions culturally outside these expensive domains. In both cases, the suffix indicates a reading as extreme, radical, exaggerated.[17] These usages seem as marked in the United States as in other cultural provinces, such as Australia. It did not necessarily mean that the local product was inferior, as indeed some of it was, in its rush to imitate. Rather, it meant that the overall play of forces produced different priorities, often entailing a principled rejection of modernism, or the creation of locally relevant transformations.[18]

The apology given to Hoover indicates the fears of at least the industry's leaders that they could not match the French designers either in making a stripped Arts and Crafts "modernism" (with its threat of becoming a new "universal" style) or by boldly countering with a national style. In the mid- and later 1920s, the power to define modernity in visual terms was clearly ceded to this branch of French taste. Thus Raymond Loewy, expatriate Frenchman, in the text of a tasteful 1928 Bonwit Teller advertisement in that company's occasional magazine *Park Avenue Fashions*, writes:

> Modernism? modernism, in its every phase, is in a state of evolution . . . which accounts for the fact that many atrocities as well as singular beauties, are committed in its name. True modernism is good taste! Bonwit Teller are modernists in that they interpret in dress that which the age expresses in art . . . the intrinsic ideas of beauty rather than its superficialities, since so many strange caprices mask under the term of modernism, it is with scrupulous care that they select the new . . . with stricter zeal than ever that they enforce the laws of their traditional good taste. Modernism in dress and accessories, as this shop presents it, is simplicity . . . which is beauty's first and last demand![19]

How reassuringly is "modernism" submitted to the eternal verities of beauty, good taste, even its opposite, "tradition"—all managed by "this shop"! But what is the "bizarre," "superficial" set of "atrocities," these "strange caprices," masquerading as true modernism? For Loewy's high clientele, the social and aesthetic radicalism of the purist avant-garde had to be firmly rejected, along with the specter of mass machine production being an actual, rather than an inspirational, element in the cre-

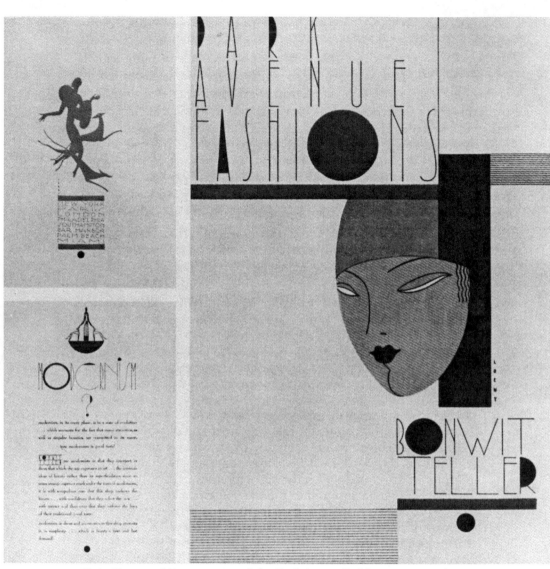

10.1 Raymond Loewy, artwork for *Park Avenue Fashions*, occasional magazine, Bonwit Teller, New York, 1928. (Raymond Loewy International Inc., New York)

ation of these luxury goods. The machine is, of course, not mentioned (hinted at, perhaps, in the reference to "our age"). Yet the evocation of extremity works in another, less specific way: by constantly implying the existence of yet more modernist imagery than these startling frocks, cars, interiors (whether such ridiculous exaggerations exist or not beyond a mock-horrified imaging), these frocks etc. are installed as both up to date and decorous. For Loewy, as for his designer colleagues, "modernistic" excesses become crude lapses in taste: "true modernism is good taste."[20]

What Is Modern Design?

At the very end of the 1920s, however, a change occurred—or seemed to. There was a marked increase in the employment of industrial designers by the new corporate manufacturers and even retailers, and an explosion in the number of design patents taken for the "styling" of a machine or product. Was this merely a continuation of the importing of European, especially French, models, only now updated to a "modernist" style, or was a distinctive modernism created by industrial designers in the United States? Most recent writers take it that both occurred: Art Deco was imported but had a relatively short life (as, it is implied, benefits a fashion, and a foreign one at that), whereas U.S. industrial design came up with a persuasive imagery of modernity, a look of novelty, speed and change, particularly in consumables, packaging, domestic appliances, transportation, and exposition display. This was, it is now believed, unparalleled elsewhere and is, for this reason, as obviously "American" in appearance as the utilitarian manufactures of early and mid-nineteenth century. The only major remaining difficulty of interpretation, it seems, lies in discerning the relationships of this imagery to the avant-garde modernism in Europe, especially Germany, Holland and Russia, that preceded it, one which seems so much more resolute and yet subtle in its commitment to a strict machine aesthetic. While some regret the lack of finesse, others plainly see the unabashed commercialism of the local approach as at least an ingredient of the "Americanness," and the popularity, of the designs. The implication here is that the criteria for good industrial design were changed by the undeniable success of these products.

Hardly a spontaneous outpouring of a coincidental gathering of skillful and self-promoting designers, the growth of the late 1920s and early to mid-1930s was based on two economic factors beyond those already advanced in relation to advertising: standardization and obsolescence. Harley J. Earl's successful reshaping of the 1927 La Salle led Alfred P.

10.2 Margaret Bourke-White, *Detail of a La Salle*, c. 1933. (© Margaret Bourke-White Estate, courtesy Life Picture Sales)

Sloan to appoint him head of an Art and Color Section at General Motors, Detroit, with a staff of ten designers and forty other employees. By 1938 this department had become the Styling Section, with over three hundred personnel, and Earl a vice president. His postwar chromium and tailfin fantasies are his best-remembered work, but his significance for this discussion is his agency of the policy of deliberate, yearly reinvigoration of the market through, primarily, changes in the look of the car, its body, its external packaging. Engineering changes were also made, but less often, and less and less significantly.[21] Rathenau's employment of Behrens to coordinate the entire AEG range, from factories to electric fans, and Benscheidt's of Gropius for the Fagus factory were exceptionally early initiatives by young industrialists with a sense of the independent value of fine design as well as its commercial advantages. Standardization was entering, but obsolescence was unplanned.

By the later 1920s in the United States, however, a number of such industrialists (the new corporatists) led their generation swiftly in the same direction. Standardization had proceeded apace under the aegis of Hoover's Department of Commerce, almost matching Germany's rapid advances: by 1925, four hundred trade groups were developing schedules of simplified shapes and sizes for thousands of articles.[22] Governments tended to organize standards for technical measures and specifications of connections to ensure interchangeability. Component standards were mainly set within industries and were subject to the competing needs of monopolies and small producers. Mass production depended on standardization in both senses, but its success had created a vast oversupply, requiring a contradictory movement of the kind we have seen built into Ford Company types of modernity since their inception—in this case, the opposite of the repetition of reductive sameness which is standardization, that is, a constant changing, a structural obsolescence. Yet the massive investment in productive plant could not be overturned on a yearly basis, therefore change was confined largely to the most flexible element in the process—the assembling of the parts beyond function—the wrapping, the surfaces, the appearances of the product. The Ford Company shifts to the Model A, to the 1933 V8, and then to the coherent curves of the 1936 Lincoln Zephyr are a classic sequence.[23] As long as engineering remained relatively static, while packaging was volatile, industrial design was primarily a matter of promoting obsolescence through the kind of styling which would call attention to appearance itself as a key factor in the use of a product. Surely it is this which marks off U.S. industrial design of the early 1930s—the degree and kind of commitment to the priority of the visual, and within it, the visualization of dynamic change. Is not this the source of U.S.

industrial design's modernity, the explanation for its necessity—a constant changing of traditional patterns being an intolerably obvious contradiction? Obsolescence was redefined as the incessant replacement of the look of the new by an even newer look and became as central to the economics of the new-corporation as mass production itself.

Strictly speaking, however, obsolescence requires only that the change be constant and regular, even when concentrated in aesthetic appearance. If yearly changes to different "traditional" styles in the presentation of a product would logically lead to confused customers (yet they were happy to accept a range of traditional styles in the one product being simultaneously available), then would not variations on the themes set in motion by the stripped neoclassicism of Art Deco suffice? Art Deco performed just this service in the packaging of certain goods, for example, personal effects and accessories, and especially window displays. Bel Geddes was justly proud of the impact of his dramatically set luxuries in Franklin Simon's storefront in 1929: "Then presto! Within two months the whole street changed. For three years Fifth Avenue windows became more and more exciting to look at—and the passerby looked."[24] The Parisian style was spread through a traveling exhibition of selected exhibits, beginning in early 1926 at the Metropolitan Museum in New York. This same institution had been staging annual "art in industry" exhibitions since 1917, and in 1927 put on an influential show of Scandinavian design. Art Deco was distributed further in the fifteen rooms of the International Exposition of Art in Industry staged in 1928 by Macy's own department of design, and reached its artistic apogee in the Metropolitan's 1929 show Contemporary American Design. It came to dominate high fashion and decoration, and was distributed from this class culture through imitation and advertisement—not only via the magazines but through the press reporting of the doings of glamorous "society life," and especially through its simplified exaggerations in the movies, as "Hollywood deluxe." As early as 1920, Cecil B. DeMille's *Forbidden Fruit* inaugurated the often-repeated fantasy of class transcendence through "jewels from Tiffany, gowns from Poiret, and perfumes from Coty."[25] By the end of the 1920s, a Deco Moderne of this kind was the actual and symbolic imagery of wealth in its most up-to-date manifestation. Such ostentatious display scarcely survived the Depression; in the bitter years after 1931, the big stores withdrew from it.

Turning from fashion, decoration, and furnishings (where Art Deco and its derivations were strongest), let us continue to ask questions about the bases of a distinctive imagery of modernity in connection with the design of broadly marketed vehicles and other machinery, office equipment, and household appliances. French design was very much

based on a complex structure of craftworkers servicing an essentially luxury-led industry. U.S. industrial modernity was based on mass production for mass markets, as we have seen. Is this the key difference which led to a design modernity, distinctively American—not Deco Moderne but authentically different? Such products began to be designed in 1929, but achieved mass production (if they did) only some years later. If they were prefigured in 1920s dreams, they were the actual products of a slightly but importantly later moment. Moreover, many of them were made from new materials—plastics, composition, veneers, alumina—most of which was mass producible in relatively simplified forms. Bel Geddes' counter scale so impressed its manufacturer that he was commissioned to design the entire Toledo factory.[26] Also in 1929, Raymond Loewy's transformation of the Gestetner office duplicator from a spindly, sewing-machine openwork type of an encased form is a classic "before and after" of the new industrial design. Examples such as these are worth some scrutiny to discern the nature of the change.

In his astonishingly self-congratulatory book *Industrial Design*, Loewy reproduces a snapshot of himself and Sigmund Gestetner "looking at the clay model of his new machine for the first time."[27] Why does Gestetner look so puzzled/pleased and Loewy so intense/artistic/creative/nervous/shifty? Because Loewy knows that he has made no significant functional alterations (merely straightened up the protruding legs of the stand), because he has repackaged the parts in a simplified envelope, reshaping a working machine (rather than a fashionable product) according to the aesthetic of late 1920s Art Deco Moderne? Will he get away with this exercise in pure formalism? Will industrial design be born from this deceptive smothering of an old machine with modeling clay? Sigmund smiled: "Loewy's changed shape successfully rejuvenated the company's image and the Model 66 remained in continuous production until after the Second World War."[28] Gestetner recognized that Loewy had created a shape which could be repeated constantly not only in encasing the old reliable machine, but in company advertisements. Marketing a range of products through the look of one was now the important thing, and the look had to be the "true modernism" of "good taste." Teague's 1936 standardization of Texaco's service stations and product packaging around a red star and three parallel lines on white ground reversed this to go one step farther: a range of products and services was marketed through one look.

We need to be still more specific about the process of "reshaping according to the aesthetic of late 1920s Deco Moderne." While the general public—indeed, most observers—could see little significant difference between the angular geometries of contemporary design, assimilating

them all to a general sense of "the modern," professional designers and manufacturers, particularly in France, could well see that the tendency of which Le Corbusier was the most vociferous exponent was different. It was more thoroughly committed than they to machinery as the basis of design, to abstract form, to the use of standardized elements and new materials. Although the explicit distinction between Art Deco and modernism was not made until the later 1930s, these differences were quickly spotted. In this highly fashion-conscious and fickle industry, the threat of a quite foreign kind of design thinking and a mass-reproduction-based industrial structure was real. Displayed in the Expositions from Paris in 1925, it became the leading style of these international fairs. Its impact on high cultural design was, however, soon modified by the structural demand for at least the look of singular luxury, so, after certain classic early installations, it mostly appears as an element within more eclectic compositions—in, for example, the 1930s work of British interior designers such as Oswald P. Milne, Oliver Hill, Betty Joel, and Duncan Millar.[29] In France, Emile-Jacques Ruhlmann had led the tendency toward simplification, but it was Robert Mallart-Stevens who most influentially, and instantly, combined key elements of the two tendencies in exposition and luxury design. One senses that, around 1930, his work would have been regarded as the edge of modernist "good taste."[30]

Loewy's Model 66 rises off its grained plywood cabinet in forms stepped like those of Paul T. Frankl's famous 1930 skyscraper bookcase. The graining, two-toning, and the contrasts of chromium silver handles with the darker body are all Art Deco devices. The "restraint" of the rising forms, their planar surfaces, and the rounding-off of the cabinet and main form derive from a more purist modernism. Like Mallart-Steven, Loewy was "correcting" the excesses of Art Deco by cautiously applying some of the imagery derived by the European modernists from observations of machine forms and processes. There is no little irony in such a circuitous route to the designing of a machine so that it will look like a machine. French taste would only accept machine imagery after it had been processed, rendered symbolic, by its avant garde. In the United States, however, we saw the beginning of this taste-making process being set into reverse: returning to its sources where now, doubly blessed as being both actually and symbolically functional, it seemed able to fit form to function. Loewy was doing exactly what we have seen Sheeler and Bourke-White do so successfully: he was aestheticizing American industry by applying modernist imagery to it. And, like theirs, Loewy's representations of modernity were widely distributed through mass production and mass advertising. Yet unlike French pre-

cedents, the imagery of industrial modernity in the United States was popularized. Its impact was, therefore, more total: instead of temporarily displacing Art Deco and preceding styles in certain imaging domains, such as expensive fashion, the imagery of the new in the United States cleared away a much greater range of precedent by rendering it quickly and obviously visually redundant. Entire commercial fields would be exposed to the new corporatist who had a product with the new look; thus the process of obsolescence started feeding on itself. An influential 1934 article in *Fortune* celebrated the sales increases in the hundreds of percent which occurred after redesign.[31]

It is scarcely surprising that one of the key designs of this moment—the Gestetner—should be a piece of office equipment. Others include Dreyfuss's desk phone for Bell Telephone in 1937 (preceded by the scarcely distinguishable Siemens telephone of 1931 by Jean Heiberg), Teague's Wiz Autographic scales register of 1934, and his mimeograph for A. B. Dick in 1938, as well as an integrated range of office filing and other furniture for the Remington Corporation. What nearly all of these designs do is reshape an office machine so that it looks like a smaller version of a machine used in factory manufacturing. Factory machinery itself only rarely received the attention of the new breed of industrial designers, and from Teague more than most.[32] Much of this kind of redesigning seems to be repackaging of the heavy machinery so that it looks visually more coherent—the main functional advance being that the machine itself became a more saleable product. The modernization of office and sales machinery created a variant of the consumer/product couplet: the Gestetner/secretary, the adding machine/salesgirl. As office work became more and more systematized, the relations of power turned over: the office girl served the machine, which gradually consumed her skills and eventually her job.[33]

The industrial designers' own offices were themselves subject to modernization. Indistinguishable from those of advertising artists in early and mid-1920s, they began to change significantly around 1930. The often-reproduced photograph of Raymond Loewy in the model industrial designer's office which he and Lee Simonson created for the 1934 exhibition Contemporary American Industrial Art at the Metropolitan Museum in New York, with its stylish mix of Deco and streamlining, is more a display of products than a *tromphe l'oeil* working environment.[34] And the single posed figure of the dapper Loewy is also misleading. While some, such as Dreyfuss, tried to keep a close hand on the work and the staff small, most designers reacted to success by expansion and rationalization, very much along the lines of Ford Company and Kahn Associates, although obviously on a smaller scale. Most followed the

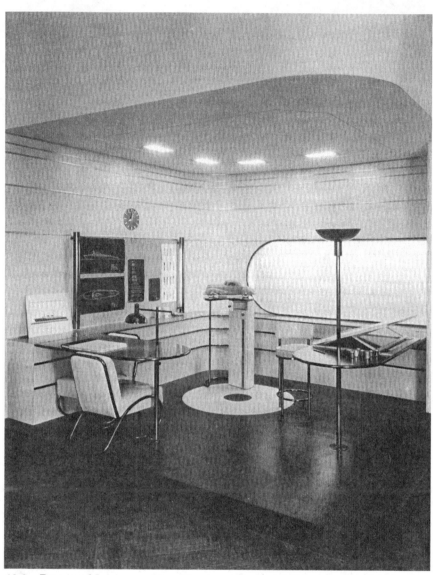

10.3 Raymond Loewy and Lee Simonson, industrial designer's office, for Contemporary American Industrial Design exhibit, Metropolitan Museum of Art, 1934. (The Metropolitan Museum of Art, neg. MM 6769 B)

teamwork model, with the office becoming more and more the creator of the designs, the chief executive becoming the promoter of the office itself (a residue of the older Henry Ford model).[35] Some achieved an astonishing scale of operation: by 1941, products for whose design Loewy's Fifth Avenue, sixty-employee office was responsible grossed $750 million, rising in 1946 to $900 million.[36] Like movie stars, the industrial designers themselves came to stand as public surrogates of the new rich. For example, when journalist Robert E. Girvin sought a contrast to an FSA photograph of four women in the concrete horrors of an Ohio Asylum, he chose a picture of the supersmug Loewy relaxing next to the pool of his "fine new Palm Springs, Calif., home."[37]

So far in this chapter, "machine imagery" has been a fictive rerouting of the symbolic functionalism of the European modernists. Does this also apply to the other distinctive domains of U.S. industrial design: consumables, transport, and expositions? Does a solution such as Bel Geddes' range of stoves for the Standard Gas Equipment Company of New Jersey in 1932 qualitatively move past Loewy's resculptured Gestetner to a different modernity of design? Bel Geddes reduced the company's one hundred models to twelve standardized components that could be recombined to produce sixteen models. The stoves had another major manufacturing advantage over predecessors: the frequent cracking of enamel walls in assembly and transport was avoided by clipping the panels to an internal steel frame ("applying the principle of skyscraper construction," in the designer's words). Eliminating projections, sharp corners, and recesses meant a "cleanlining" of the whole shape ("Immaculateness was a major consideration in the design").[38] Teague commented on this type of design in 1940: "A gas range should look well, but it should also be easy to clean, it should bend the cook's back as little as possible, and require a minimum of attention; and it should fit into the bright, immaculate scheme of the modern kitchen. These secondary requirements have revolutionized range design in recent years, and not the demands of cooking alone, which after all was done quite successfully on the old-fashioned cook-stove."[39] Spelled out here is industrial design's contribution to the imagery of modernity: the reduction of options; the exchangeability of standardized elements; shapes occurring as effects of manufacturing procedures; a simplified, singular unified gestalt; and an "ease of operation and the appearance of ease of operation."[40]

Yet there is also an implication that, as opposed to Loewy's clay-sculpted Gestetner, the SGE stoves took shape "naturally" from the conditions set in the brief. Bel Geddes said that his office always proceeded in this evolutionary way: objectives set; schedules planned; research into current production, usage, and consumer response; only then a draw-

ing, modified by clients, tests, practice.[41] In the earlier quotation Teague declares himself a vehement functionalist:

> For the spirit of craftsmanship is independent of its tools. . . . As modern industry has advanced in mastery, designing for purely functional ends alone, it has created examples of perfected order. . . . In the superlative rightness of certain modern aeroplanes, power plants and machine tools, parkways and bridges, nothing has been admitted which did not contribute to performance, and forms have been determined solely by efficiency, materials and processes; while an accurate integration of all the parts in precise relationships has

10.4 Norman Bel Geddes, SGE Oriole Stove, 1932. (Norman Bel Geddes Collection, Theatre Arts Collection, Harry Ransom Humanities Research Center, The University of Texas at Austin, by permission of Edith Lutyens Bel Geddes, executrix)

been achieved by the pressure of necessity. As a result these things approach a classical, abstract beauty of form which advances towards perfection.[42]

Both men see the product as issuing from the demands of function—those listed, plus others such as "Compactness, lightness of weight, durability, automatic operation, low operating costs as well as low production costs." For Teague, these "universal functional requirements" lead to the "ultimate rightness" of form which is the "aim of design"; they create the single "perfect form" which is the right solution to a given design problem.[43] Design does not "style," it does not fit prescribed forms; it is a process whose relentless functionality, like that of engineering, simply results in the ideal form—classical, abstract, perfect.

But why were the SGE stoves so immaculately squared off, like outcasts from Mondrian's studio, combinable in ways echoing Van Doesburg's mobile rectangles around a grid? Was this the only, the best solution—the "perfect form"? Loewy's famous 1935 Coldspot refrigerator for Sears took their sales from 15,000 to 275,000 units in five years. It contained some engineering innovations, especially the use of aluminium for the internal shelves (a fertile transference from the radiator grille of the Hupmobile), but was again a product of clay modeling, and was sold on its look: "Lovely Modern Design," read the advertisements; "Study Its Beauty." To this was added price reduction gained through quantity manufacture, and modernist simplification became a way of cheaply improving the quality of appearance (the association with expensive Art Deco) in a mass-produced item. None of this automatically explains why Loewy shaped the refrigerator into the cleanly vertical box, with dazzlingly white clipped panels and rounded corners. In the 1936 model the door wrapped around these corners and chromium stripping almost disappeared. This "ideal form," this single, unified enveloping shape, certainly became archetypal in U.S. industrial design modernity. Does it matter whether it evolved as a consequence of functionalist industrial design correctly applied, or whether it was a wrapping-around of functions by a modern-looking shape, itself the product of the competing aesthetic tendencies in international art, architecture, and design which we have been tracing?

This question exercised contemporary designers; on it, the moral authenticity of their profession rested, its independence, its originality, its right to claim a key role in elevating public taste, its difference from art and architecture on the one hand, and from cosmetic packaging/advertising on the other. Thus Teague's willingness to abstract functionalism into a pure formalism in his remarks cited above, thus the silence on the part of all the designers regarding their debts to avant-garde modernism. But most knew well enough that the abstract shapes they had

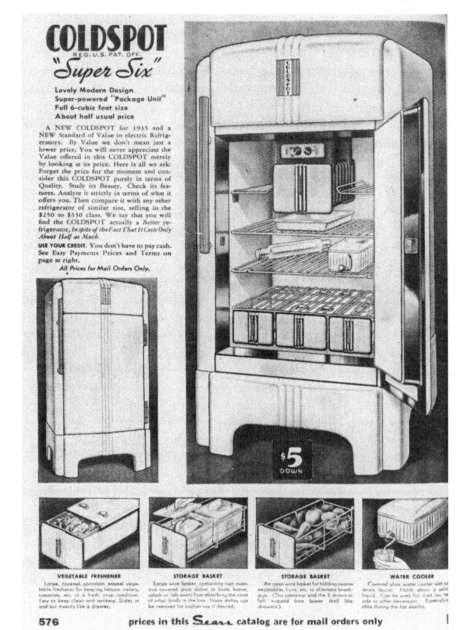

prices in this *Sears* catalog are for mail orders only

10.5 Sears Roebuck Co., advertisement for Coldspot "Super Six" refrigerator, designer Raymond Loewy, 1935. (Courtesy of Sears, Roebuck and Co.)

evolved were transpositions from situations in which they were explicitly functional: the aerodynamic streamlining of the much-heralded Douglas DC-3 1934 was only metaphorically used on objects such as electric fans and refrigerators which had no need to travel at speed through space. Van Doren writes amusingly of the "Borrowed Streamline": "The manufacturer who wants his laundry tubs, his typewriters, his furnaces streamlined is in reality asking you to modernize them."[44]

By 1940 the "fast-paced, bright-colored, sharply-defined" quality of modernity could be evoked by the rounding of corners and cladding in new materials. (Van Doren in fact goes on to painstakingly demonstrate how these rather obvious effects can be achieved.) This is modernism by stylization, imposing a look of mechanical functionalism on consumables with no relation to the kinds of purpose imaged. The U.S. designers were doing exactly what Le Corbusier and the Bauhaus did a few years earlier—transposing the imagery of industrial functionality into domestic domains as the primary means of proclaiming the new order of integrated production and consumption. In the corporate economy of the United States, a parallel process inserted one product in the home or office as the first representative of a range of similar products: "the bright, immaculate scheme" of the future living environment promised in a million advertisements, and even by New Deal governments as we saw in the case of Greenbelt, Maryland, in 1936. It is also the vision of electrification at the end of Joris Iven's film *Power and the Land*.

Manufacturers and advertisers seemed rarely troubled by the distinction between evolved and imposed modernity of design. The uniformity of solution arrived at by the designers indicates that they, too, bowed to the priority of the commercial. Some usages seem so extreme as to be fanciful, even ironic, namely, Loewy's much condemned streamlined pencil sharpener of 1934.[45] Indeed, there seems to have been a constant crossing of this kind of purist definition: styling is inspired by functionality, "pure form" arrived at by bold styling. Particularly in the upbeat, high-promotion, confidence-building hall of mirrors that was the corporate center of recovery economy, such a play across and within signification was both inevitable and, for a time, fertile.

Some questions remain. We have shown that modernist imagery does not have to be machine-based necessarily (that, indeed, the step from all the functions fully assembled to a product shape remains a heavily conditioned aesthetic leap), rather that it need only allude to one of the dynamics of modernity, one of the couplets within the imagery (usually industrial production), and this can be done by such slight devices as excluding the protuberances, using white sheet surfaces and high colors, and rounding the edges. Why then was there such enthusiasm in

the mid-1930s for one of these gestalts—"streamlining"? How did it come to stand for "modernize" by itself? The spread of its popularity can be traced within industrial design until it became a fad following the unveiling of the first fully streamlined train, the diesel-powered Zephyr, and the Union Pacific's M-10,000, at the otherwise Deco Moderne Chicago World's Fair in 1934.

The Common Absolute

The story of streamlining in the United States has been frequently told: how the pseudoscience of increased speed and decreased fuel consumption filled advertising for cars, trains, air travel; spread rapidly through product design to fashion, to office organization; until it entered the language as an expression for all relations which were revised to become "fast," "bright," and "sharply defined"—in a word, modern.[46] Streamlining became industrial design's greatest contribution to the imagery of modernity in the 1930s, in both its insistence on the pertinence of a limited repertoire of mostly ovoid shapes and as a process of shaping, of "cleanlining" things and relationships of use between them. Accepting the dominance and diversity of streamlining, the key questions for this account concern its significance within various industries, its public popularity—what was it about streamlining that made it so available at this juncture?

Some obvious causes can be readily acknowledged. Having arrived, by the later 1920s, at a position where styling was all, the site of obsolescence, motor body designers were open to any concept which would increase their scope for invention beyond color and fitting changes, especially if it could be allied with an engineering rationale, however superficially. And, given the economic and social significance of the automobile industry, any such major shift in imagery was bound to reverberate widely. Curiously only the short-lived Chrysler Airflow for 1934 went significantly toward total aerodynamic shaping: much more successful were designs which were only partially streamlined. Again, a modern extreme (and streamlined ones were fantastic) set the stage for acceptable compromise.[47] The rising popularity of air travel, symbolized above all by the Douglas DC-3 (designed in 1934, in service to American Airlines between Chicago and New York in 1936), was profoundly influential. And the new trains, especially the luxury streamliners such as Dreyfuss's Twentieth Century Limited for New York Central and Loewy and Paul Cret's Broadway Limited for the Pennsylvania Railroad, introduced together in 1938, also not only had a huge impact on other similar vehicles but became, like certain cars and airplanes, references for the

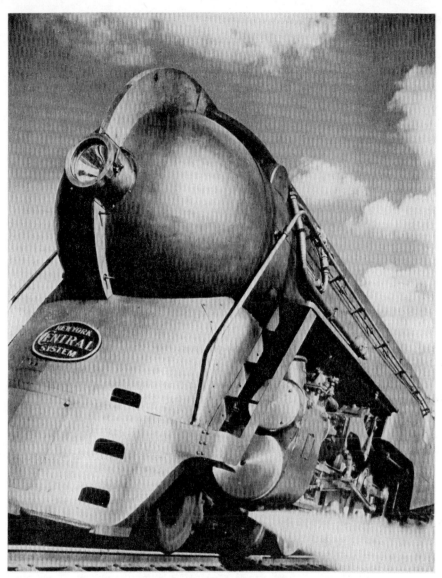

10.6 Henry Dreyfuss, Twentieth Century Limited (head-on view of locomotive) for New York Central, 1938. Photograph by Robert Yarnall; copy photo by Scott Hyde. (Henry Dreyfuss Archive, gift of Henry Dreyfuss, courtesy of Cooper-Hewitt, National Museum of Design, Smithsonian Institution/Art Resource, N.Y.)

symbolizing of modernity in all fields. Yet, although these industries wielded enormous power, and although the cutthroat intensity of their competition with each other must have exerted a magnetic attraction, their example alone is insufficient explanation of the spread of streamlining.

One further cause, central to industrial designing itself as a process, is implicit in the gap noted earlier between recognizing functions and assembling them within one form rather than another. The dilemma of pure functionalism occasioned much rhetorical blustering on the part of designers but little practical hesitation. In *Art and the Machine*, Sheldon Cheney and Martha Cheney made plain an element in design repressed in the theory of International Style modernism. In addition to honesty to materials and simplicity of form, the designer, they noted, should adhere to the principle of "functional expressiveness."[48] Just as important as being functional, a product had to look functional, appear to be a creation of the new age. It was at this point that U.S. industrial designers took a step that their purist predecessors (and their Museum of Modern Art contemporaries) were not prepared to take. They gradually "learned not to express personal perceptions of the machine age but to embody in their designs images of technological and material progress reflected back from the public."[49]

The function of attracting consumers was added to the other determinants of a product's form, becoming more and more prominent as the decade progressed. This principle most obviously distinguishes industrial from architectural and interior design, especially the scale of operation, the mass market in which it is situated. Depression-wracked manufacturers, embattled governments, expansionist advertisers, and committed technologists all recognized that these industrial designers "seemed to be able to anticipate the special intersection of onrushing technology and volatile public preference."[50] All employed the industrial designer to insert their products, messages, and values into this intersection. The designers shaped the input according to the play of forces at the junctions of demand and taste: this was the crucible through which they modified modernist imagery, drawing on the images and emphases originated elsewhere in the visual culture, testing them to see what would be acceptable to the targeted audiences and markets. Here the generative power of the motor manufacturers, of the new corporatists in many fields, of the advertisers and packagers, became relevant. And soon the industrial designers cold draw on a stock of their own creations, quoting or alluding to them along with the others as an imagery of the new.

Was the success of streamlining entirely attributable to the plausibility

of its futurism? Streamlining claimed to be the ultimate form of each object, and to sort the relationships between them: it was to be the basis of not only everything in the future society but of its organization as well. Perfectly formed objects humming along at the same speed in perfectly regulated environments: this vision was pictured in "dream homes," theater foyers, the new skyscrapers, and countless advertisements. Its futuristic form appeared in the expositions and in science fiction literature and comics; these were the domains in which it exaggerated and parodied itself, to the knowing delight of most of its spectators.[51] Albert Kahn adopted it for the administrative areas of the industrial plants which his firm continued to proliferate across the continent. He also instantly grasped the curious literalism of the abstract language of these "futuristic" forms—thus the "gear-box" basis for the rotunda of his Ford Exposition building at the Chicago World's Fair.[52] In all of its applications, one part of streamlining's visual message was the promise of smooth sailing through the elimination of friction; its aim was to sweep through resistance of all kinds. It strove to be the visual surface of the irresistible tide of modernity itself—the modern in its purest form, unencumbered by conflict or any of the accoutrements of compromise.

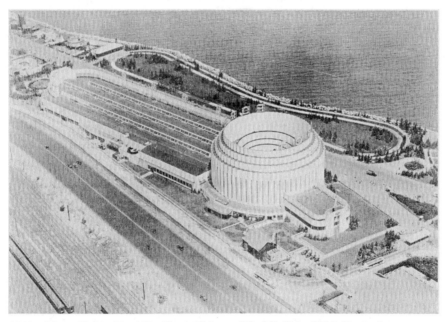

10.7 Albert Kahn, Ford Pavilion, Chicago World's Fair, 1934. From the collections of Henry Ford Museum and Greenfield Village. (Ford Archives, P.O.4169)

But industrial design streamlining was not simply futurist. Meikle astutely locates a key reason for its power in a double movement typical of all the modernizing forces we have examined: "the streamlined style expressed not only a phallic technological thrust into a limitless future. Its dominant image, the rounded, womb-like teardrop egg, expressed also a desire for a passive, static society, in which social and economic frictions engendered by technological acceleration would be eliminated."[53] What is so typical here is the sequence open-close-open or, more graphically, shatter-resolve-destabilize. It operates in the very design process of streamlining across two dichotomies, nature/civilization and gender. The "style" of the Machine Age, expressive of an ever more technological society, always shaped its machine products in softly curving, textured organic forms. The disturbing implications of a new, machined Nature were pacified by the suggestion of familiar shapes and surfaces; its changes would be benign, conflict-free, inturning, neatly self-contained. But nature itself was uncivilized, unpredictable: perhaps the Machine Age would, too, become unstable. Similarly, the male-female imagery of the extruded "tear drop" and the womblike "egg" went, in streamlining, beyond simple penetration and passivity, beyond even a kind of technological rape. They occured not only side by side (the Trylon and Perisphere at the World's Fair, the Twentieth Century Limited enters Long Island Railroad station—see below) but importantly in the same shape. Sought here was an imagery of androgyny, promising to resolve the gender conflicts created by the restructuring of the family occurring at the time, the increase in the division of labor within it, the isolation of the mother as housewife, the father as absent robotized worker, the children as youthful consumers. In the "dream kitchen," the housewife stood surrounded by practical, nearly autonomous, supernatural, suprasexual objects, in a state of excitement, trembling with anticipation, watching for these metallic amoeba to divide and multiply—waiting for her transcendent absorption into their world?

The imagery of streamlining in the 1930s abstracted the patriarchal power marshaled against the consumer in the previous decade. We need only recall the J. Walter Thompson advertisement in *Fortune,* June 1930 (fig. 5.2), in which the peacefully ironing housewife is advanced upon by a Bourke-White image of power station turbines and banker Sissons's Social Darwinism. Streamlined products attempt to declare, then resolve, the unusually explicit imposition of power displayed in this advertisement in their very shaping, in the sort of handling (using) they required. In this sense, streamlining became the most concentrated embodiment of the commodity fetishism increasingly ascendant in many social relations. Most modern design reduced use value in favor of the

exchange/symbolic value of objects, separating them by encasing the working parts of machinery, closing out the necessity for knowledge of their workings, deskilling the user, confining him or her to simplified, easier relationships to things. The Model T chassis, the crystal set, the open-range cooker became anachronistic echoes of a self-reliant era. But this, too, has its romanticism: when distributed equitably, modern technology relieved millions of people from peasant conditions, including many in the United States. Just such a struggle beyond subsistence occurred in the period under study: the battles of the Rural Electrification Administration against the private companies and landlordism were not won until after World War II.[54]

Perhaps something of this informs the claim of the Cheneys, Lewis Mumford, and, following them, Meikle, that industrial design in general, and streamlining in particular, "increased one's freedom through greater control of minute segments of the environment."[55] Certainly these goods were sold as labor-saving devices (replacing the disappearing servants of the rich, the drudgery of the poor) and as subject to our fingertip control—"just touch a few buttons." But such liberating effects are fundamentally countered by the conditions of having this control delivered to the modern workplace and home: the surrendering of workers' skills and job control, the positioning of the woman as housewife/consumer dependent on the external supply of an inherently obsolescent range of commodities. Women resisted this pressure in a variety of ways—thus Frida Kahlo, explicitly, in *Self-Portrait on the Borderline between Mexico and the United States* and in *My Dress Hangs There* (fig. 7.3).

As we have seen, resistance to brutal inequities which underlay modernity's visible progress appeared in a variety of visual forms—from Rivera's mythic epics, through the protests of the Social Realists, to the critical connotations in certain FSA photography. Kahlo's marginal refusals are unique in themselves, but she was not alone in expressing dissent in terms shared by few others. Rockwell Kent's neoclassical critique deserves detailed study. And John Vassos, designer of advertisements very much in the Loewy mold, launched a comprehensive attack on the consumer society during the 1930s, within the paradoxical framework of expensive limited edition books, superbly designed in advanced Moderne modes. *Contempo: This American Tempo* (1929) celebrates America as the phoenixlike hope for Western civilization after the "burned-out world" of Europe, sees the skyscraper as "the most perfect example of abstract beauty the world has had for generations," yet pictures such modernizing forces as advertising as "an edifice reaching to the skies, and built on—BUNK." In *Ultimo: An Imaginative Narration of Life under the Earth* (1930), a rationalized utopia is envisaged, an under-

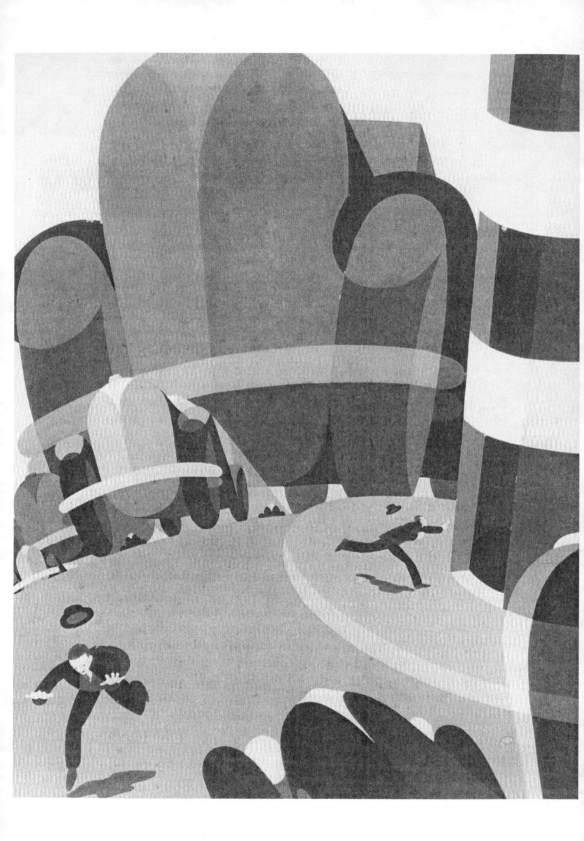

ground population center seems perfectly harmonious. In the following year Vassos produced the extraordinary *Phobia*, a visualization of each of the fears of mankind, sourcing them constantly to the pressures of the modern world. Thus *dromophobia*, fear of crossing the street, is illustrated by monstrous automobiles looming over terrified pedestrians, reversing the streamlined speed imagery of car advertising. By 1935, with acknowledgments to the impact of the Mexican muralists, he created his most thorough-going critique, *Humanities*. The contradictions of class exploitation are sharply shown as present in every aspect of society: the machine exists to process workers into the wealth to sustain the leisure of the rich. Despite the deluxe, streamlined sophistication of Vassos' imagery, it works to expose, rather than disguise, its economic base.[56]

Among the more striking embodiments of the self-enclosing double movement of streamlining was the "gigantic decorated phallus" of the modernized locomotive, hurtling toward the future at unimaginable speeds, a spectacle of envy and awe, carrying within it an absolutely still string of luxury compartments, every detail carefully designed for efficiency, clarity of purpose and fit, an integrated ensemble of echoing curves, an utterly ordered space, contained, separated from the changing pictures outside, a site of only the expected. This Tiresian couplet of engine and compartment exerted a powerful attraction which persists in recent discussions of streamlining, like a visitor from outer space, a transitory future moment accessible now through the price of a ticket. How wishful, how fragile it is!

Like sailing ships at the advent of steam, these fantastic carriages reached their design apogee at the moment of their greatest vulnerability. They were losing passengers in droves to the car, bus lines, and the airplane. Like the Model A shift, these modernizations represented an effort to reach out upmarket in times of crisis. It is typical of the internal contradictions of U.S. industrial design that its apparently most potent imagery of modernity should be that applied to a traditional form. Indeed, here seems to lie the final, perhaps strongest reason for the appeal of streamlining: rather than a simpleminded, delusory dismissal of the past in favor of an uncritical celebration of a totally transformed future, industrial design put this promise to work by applying it to a repackaging of the past. Most of the mechanical and electrical machines, appliances, and devices that make up modern technology were

10.8 (*opposite page*) John Vassos, "Dromophobia, the Fear of Crossing the Street," from *Phobia* (New York: Covici, Friede, 1931)

invented and in circulation between 1875 and 1925. With the possible exception of radio, few of the new products of the postwar period received the attention of the new industrial designers. Their role was the conservative one of modernizing appearance but without deeply changing function, and thus maintaining all of the relations of power already in operation. The "new world order" projected by the dazzling array of an ensemble of these streamlined products was one in which everything would look different, but everything would stay the same. Geddes' floating, revolving restaurants and blimplike flying wings were recognized by all as impracticable fantasies whose extremity, and exceptionality, confirmed the constant message of streamlined modern design: the frictions of the Depression present will be displaced by a dynamic but controlled future, most of which is already with us now, ready to be instituted by a strong corporatism with the aid of a benign state.

Thus was the modernism of industrial design modernity incorporated into the *Life*-style regime of modern imagery: its exaggerations were charming, inspiring projections; its concrete services were changing certain details of our lives generally for the better. Above all, it was available for absorption into the variety of everyday normality, modern American style. *Life* magazine itself did this integrative work repeatedly: much fun was had with the futurama fantasyland of the 1939 New York World's Fair, and industrial design was located exactly in features such as "Furniture for Modern Living" (July 31, 1939, 42ff.), that is, in the kitchen and the bathroom, but in the rest of the house only as a way of organizing efficiently the supply of old-fashioned goods.

"PURE" MODERNISM INC

The MOMA Machine

Two fertile agencies in the generation of the visual imagery of modernity remain to be examined. Their influence was great at the time, and was seminal, for it persists. They were utterly different in ideology, audiences, aspirations, and interests, yet both were closely tied to industrial design, strongly shaping its processes of imaging, but in quite contrary ways. I refer to the exhibiting, marketing, and interpreting of contemporary art, which finds definitional form in the Museum of Modern Art, New York, founded in 1929, and to the trade fair expositions, especially the spectacular New York World's Fair of 1939. A discussion of their roles completes the setting for the argument of this book.

The Museum of Modern Art (MOMA) has been frequently celebrated and critically characterized, but no social history of the institution has been undertaken.[1] The New York World's Fair has been thoroughly discussed in a fine Queens Museum catalogue and in more general texts.[2] The question for this account arises from the fact that neither seems an obvious candidate for the promotion of the expansive, all-inclusive *Life*-style imagery of modernity which I argue was the most productive regime operative from the mid-1930s. On the contrary, MOMA is renowned for its commitment to a certain formal

purity as the true modernism, while the World's Fair, on the other hand, is usually recalled as a domain of the modern in its most futuristic, symbolic, and obvious form, as fantastic and unrealistic as any sideshow. It will not do, however, to regard them as simple exceptions to the overall tendency. Nor, on the other hand, are they as central to the imaging of modernity as is sometimes asserted—in, for example, such celebrations of Alfred H. Barr, Jr., director of MOMA for decades, as "More than any other person in the twentieth century, he influenced the way we look at the art of our time."[3] They were, nonetheless, representative of crucial formative discourses: their shaping roles can be best highlighted by seeing them at aesthetic and social extremes, as embodying exaggerated modernism of polar opposite sorts, yet locked together because of their ties to the diverse generality of *Life*-style modernity whose more central agencies we have already examined.

On September 19, 1929, the New York City Board of Regents granted MOMA a charter "for the purpose of encouraging and developing the study of modern arts and the application of such arts to manufacture and practical life, and furnishing popular instruction."[4] In fulfilling the first of these purposes, MOMA achieved a profoundly influential, and—in the 1960s—a dominating position. This emphasis was in its very beginnings: in founding the museum, Lillie P. Bliss, Mrs. John D. (Abby Aldrich) Rockefeller, and Mrs. Cornelius J. Sullivan had not the slightest doubt that the primary necessity was the acquisition and display of French painting from the Postimpressionists to "the most important living masters."[5] Alfred Barr had by then developed an overview of the style history of Modern art around which the museum was organized, influencing countless subsequent other galleries, exhibitions, and texts. It was codified in a series of five lectures given at the Farnsworth Museum of Wellesley College, where he taught, in April and May 1929. Under the title "Modern Painting: The Ideal of a 'Pure' Art," Barr gave a formalist reading of earlier art, located the Postimpressionists as antecedents to the all-important Cubists, then pointed to the influence of abstract painting on all the other arts from architecture to "commercial art." Late Cubism, Dada, Neue Sachlichkeit, and Surrealism were post-Cubist "disintegration." Modern American painting was surveyed. Since Cubism, the Bauhaus and the Lyef group in Moscow are the most suggestive, but they seem to be valued most for their "constructivism." Such a relatively unpolitical reading of an intensely political art, which we saw earlier applied to modern Mexican art, is also evident in Barr's recollections of his visit to Moscow. The Wellesley lectures end by counterposing Rodchenko and Stepanova's call for the "death of painting" with the assertion of "the triumph of artist."[6]

Barr's reduced, decontextualized, and exclusionary view of Modern art's history was immediately institutionalized in the exhibitions program and the slowly growing permanent collection. Oddly, he used a streamlining metaphor when, in his 1933 Report to the Trustees, he characterized the ideal collection as a torpedo, its nose "the ever-advancing present, its tail the ever-receding past."[7] Indeed, his was a streamlined art history, instantly graspable in its simplicity, mobile but reassuring in its regularity, in the classical order of its stylistic successions. It was also a history erected on the artist's passion for form and the discriminating spectator's tasteful response to this quality of feeling. It confined the psychological to the personal and the social to the individual. Barr's much-debated reading of Picasso's *Demoiselles d'Avignon* exemplifies the former, as does the decontextualizing of the artist's *Guernica*.[8] In all these ways, it directly served its primary ideological purpose of providing an aesthetic framework, an art historical narrative, essential to the cultural ambitions of the East Coast nouveau riche. It became a model for the kind of art they wished to promote in the United States and of all the relationships in which that art could be embedded.

When Nelson D. Rockefeller took over from A. Conger Goodyear as president of MOMA in 1939, he chose to pose for the commemorative photograph in front of *Classic Landscape*, on loan from Mrs. Edsel Ford for a retrospective exhibition of Sheeler's work.[9] This symbolized an expansion and deepening of the museum's first commitments. The French avant-garde would not merely be exhibited prior to feeding the Metropolitan, but it would be purchased for a permanent collection. And a "daring and exclusive" collection of American art would be formed; certain local artists would be selected to join the modernist masters. Sheeler's aestheticizing of the industrial base of these patrons' wealth served as a mirror on gallery walls: he took his art to their productive sites; now these sites, sanitized, entered the spaces of art. The new corporatists could, in painting such as this, look at art and see their own worlds.

Yet every case study we have done should lead us to doubt the adequacy of such a direct, simple relationship of patron to artist, of power to image. Not to dismiss it, but to recognize it as lodged within more potent because more complex forces. The Rockefellers' modernity, like Edsel Ford's, was leavened by the appearance of liberalism and an attachment to modernism, in contrast to the entrepreneurial "feudalism" and the cultural conservatism of their elders. Thus the demand for rational order in the organizations serving them, in the distributors of their products, in the architecture of their systems of production, namely, the shining steel and glass facade of the 1939 MOMA building on West 57th

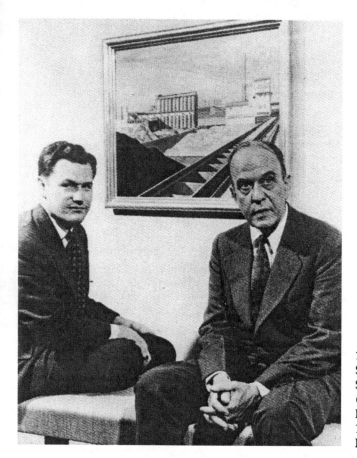

11.1 Nelson Rockefeller and Stephen C. Clark before Charles Sheeler's *Classic Landscape* (1931), *Charles Sheeler* exhibition, the Museum of Modern Art, New York, 1939. (Photograph courtesy, The Museum of Modern Art, New York)

Street. But, as Duncan and Wallach brilliantly show, the opaque wall separates out its public exterior and plummets the visitor directly into an apparently chaotic private domain inside. They go onto demonstrate that, within the viewer's ritual passage through the imposed, exclusive style history of Modern art already described, laid out in the succession of enclosed rooms, a more complex set of values is generated, centering above all on conceding respect for the extremity of the artists' need to express only their uniquely individual insights. Viewers are asked to affirm general individualism by surrendering their own. The authority of the museum lies in the success of its demand for awe without understanding of a modernist enterprise committed to constantly further and further abstracting the key signifier of individualism, speech—in the case of art, visual language. Surrealism began to enter the collection in 1934 with Modern Works of Art: Fifth Anniversary Exhibition. It was

11.2 (*opposite page*) Herbert Gehr, *Museum of Modern Art, New York,* from *Life,* 1939. (Herbert Gehr, *Life* magazine © Time Warner Inc.)

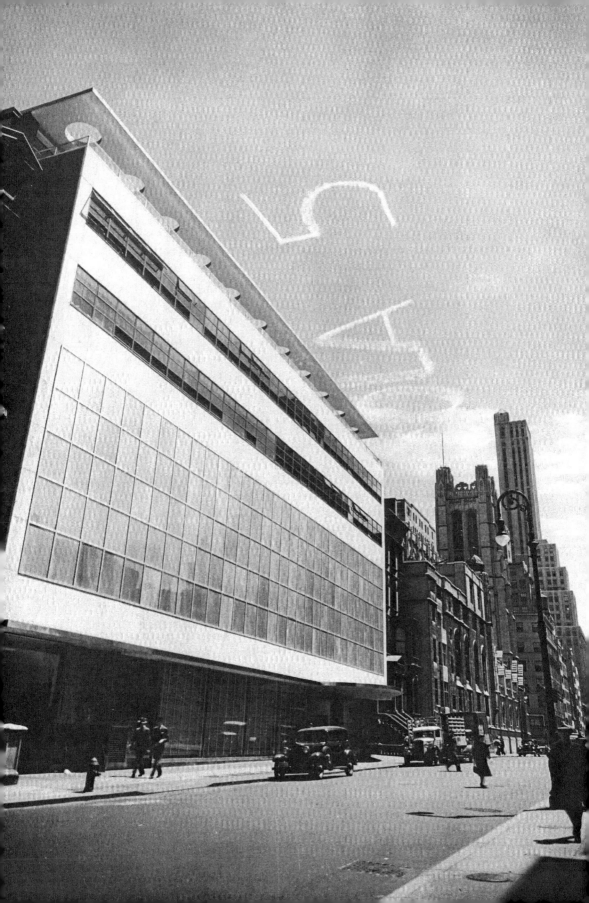

consolidated as central when the exhibition Fantastic Art, Dada and Surrealism joined Cubism and Abstract Art as, together, the definitive exhibitions of the decade. MOMA's interior entailed not only the transcendences of pure geometries but the eccentric irrationalities and the Freudian identifications of the spiritual. Everyday life, realities of relationships, communality—all these become "mundane," "vulgar," and irrelevant beside the enviable otherness of art.[10]

To design, and public education—the other duties of the museum charter—no such freedom was given or evoked. MOMA developed what amounted to an aesthetic policing through a two-sided strategy: despite all the celebration of the Bauhaus vision of uniting arts and crafts, architectural design remained dominant, while at the same time the "pure functionalism" held to be at the core of design was acknowledged only in those industrial products created by "anonymous" specialist engineers. This pincer movement aimed at effectively discrediting U.S. industrial design as an independent discipline. The "standards" of design that MOMA was determined to maintain—those embodied in the design work of the European Modern Master architects—were, by definition, absent from the American scene except as importation and imitation. MOMA staff seem to have seen their role as promoting Bauhaus-type and vernacular "design" as a condition for the elevation of public taste and the emergence of genuine local designers.

Barr was, initially, quite open to the stylish energy of Deco Moderne. In a questionnaire sent to Wellesley College students in 1927, he listed a number of individuals and institutions, asking for an account of their significance for "modern artistic expression." His own answer to Saks Fifth Avenue read, "Through its advertisements and show windows this department store has done more to popularize the Modern Mannerism in pictorial and decorative arts than any two proselytizing critics."[11] His 1927–28 European visit, especially to the Bauhaus, firmed up his views. In an essay "The Modern Chair," written in 1930 for *Fashions of the Hour*, a publication of the Marshall Field store in Chicago, Barr makes an important distinction between the "decorative" and the "constructional" in modern design. The first turned the "serious pictorial experiments" of Picasso and Braque into "Cubistic mannerisms," often adequate to hangings, wallpapers, and magazine covers but "unfortunate" when applied to utilitarian objects such as furniture, for example, the "absurdly impractical" skyscraper bookshelf. In contrast, the architecture and design of Gropius, Le Corbusier, and Breuer (especially the tubular steel chair) are constructional. Ornament is eliminated; each article is regarded as a machine for its special purpose, although incorporating "the finest possible proportions and the handsomest textures." This is the

coming thing in all design fields—witness the success of the new electric refrigerators. Barr fears that women perhaps will prefer the decorative, "their eyes are trained in the judgment of pattern and color," and concludes: "But the aesthetic judgment of the American man is most highly developed in the matter of deciding whether the 1930 Buick is better looking than the 1930 Chrysler. Let his wife buy the curtains; let him buy the chairs!"[12]

There is no suggestion that the "look" of the car has been subject to a careful and complex design process. Acknowledging in the same essay that "the makers of the new electric refrigerators have ignored both period styles and modernistic decoration, and have produced one of the finest examples of modern furniture—a machine for keeping food cold, but also to the eye a beautiful and perfect object," Barr can find no reason for this surprising exception. Certainly his remarks predate the integrative forms of Loewy's Coldspot of 1935 and Dreyfuss's icebox for General Electric of 1934, but the latter company had introduced a relatively clean-lined and functionally explicit "monitor-top" type in 1926.[13] The message of his essay is that, while awaiting the emergence of a genuine modern design in America, we should "develop a modern taste" by paying attention to the work of the European constructionists and to "our warehouses, grain elevators, refrigerators, motorboats and airplanes"—these being, of course, not authored in any significant way.

Such a policy shaped MOMA's approach to design in the early years and subsequently. The museum's architecture department was established in 1932, and the first exhibition of furniture and decorative arts was held the following year. Entitled Objects: 1900 and Today, it "explored the relationship of functionalist design to one of the earliest modern design movements—Art Nouveau."[14] At this point Barr was urging the trustees that "our work in American architecture, industrial and commercial art should be emphasized," although largely for the expedient reasons that the Whitney had the major charter for American art and MOMA should be concentrating its relatively slim financial resources on French and European art.[15] He wrote to Bel Geddes in 1934 that streamlining itself was an absurdity, that Loewy's pencil sharpener exhibited such a "blind concern with fashion" that it was "difficult to take the ordinary industrial designers seriously," and therefore he and his associates "played up the anonymously designed industrial object rather more than the object which shows evidence of styling."[16] This approach was brilliantly embodied in Philip Johnson's 1934 exhibition Machine Art. It took to an extreme the modernist aestheticizing of the Detroit Society of Arts and Crafts exhibition Art in the Automobile Industry held at the beginning of the previous year (see ch. 3). Divided into

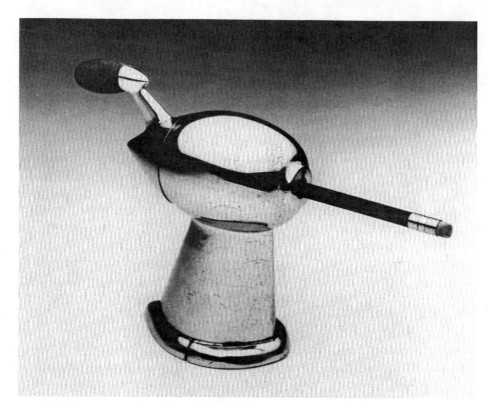

11.3 Raymond Loewy, pencil sharpener, 1933. Prototype, wood and metal. (Brooklyn Museum 87.111.78; collection of Jack Solomon, Circle Fine Arts, Chicago; photograph Schecter Lee)

industrial units, household and office equipment, kitchenware, house furnishings and accessories, scientific instruments, laboratory glass and porcelain, it included no working machines but rather machine-made products. All the domestic and office material was as simple and spare as the laboratory equipment—or at least, clearly aspired to that state. Only the objects themselves were shown and given titles, manufacturer's name, and price but no hint of details of use or context of use. Of the 402 items, for only 56 was a designer listed, and only the most "functional" of their designs were chosen (for example, Teague's Steuben glassware).

The brilliance of the exhibition lay in the boldness of its conceit, the reversals it initiated. The viewer was asked to accept that modern machine technology, bent only on the pursuit of function, had mechanically, almost incidentally, created a range of things used in all aspects of modern life that were unprecedented in their beauty when taken as individual objects and that, when taken together, suggested a new

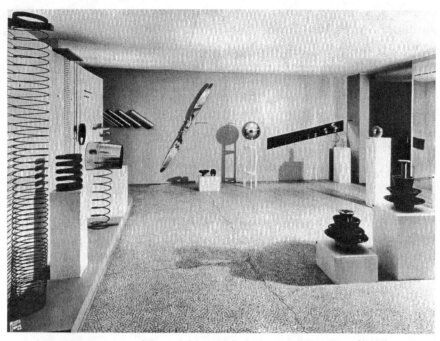

11.4 Installation view of the exhibition Machine Art, Museum of Modern Art, New York, 1934. (Photograph courtesy, The Museum of Modern Art, New York)

aesthetic order already firmly installed throughout our lives. Any suggestion of applying art *to* industrial machinery or useful objects was relegated to the premodern "anomaly" of conflating craft and machine production. In contrast, Johnson claimed that "Conscious design and the development in machine building have fused and the twentieth century restores the art of making machines and useful objects to its place, as a technic of making rapidly, simply and well the useful objects of current life."[17]

Again, certain U.S. industries (for example, those making precision instruments) and the Bauhaus alone approached this ideal; the "modernistic" French machine-age aesthetic and American "styling" and streamlining were false directions. It was essential for designers and public to recognize the art *in* machine production. Only then—by some unspecifiable process which only Le Corbusier and the Bauhaus architects had accomplished—could such an "art" be designed *into* those products, buildings, and environments still encumbered by anachronism. Good modern design imitated "natural" machine production: it was invisible; even its imitating should not be noticeable. What specters of total rationality were unleashed here? Small wonder that, for as long as this remained, Johnson was willing to defend the place of at least the Miesian tendency in modern German architecture within Nazi totalitarianism.[18]

Barr's preface to the Machine Art catalogue set out the steps for acquiring a taste for the art in machine products. Beginning from the transcendent formalism of the statement, "the modern machine-made object approaches far more closely and more frequently those pure shapes the contemplation of which Plato calls the first of the 'pure pleasures,'" he alerted viewers to the autonomous beauties of embodied geometric shapes, to the precedence of static over kinetic rhythms (noting in passing that "Even the streamlined object is more frequently admired when at rest than in motion"—a preference Sheeler would develop further than most, in his 1939 Power series), to the beauty of unornamented, "bright steel" surfaces, and to a balance between crude obviousness and excessive complexity. Knowledge of mechanical and utilitarian function can "embrace" appreciation but is less important than appearance. Practice in this sequence of recognitions develops "a modern taste." This not only excludes all association and connotation, all sense and knowledge of use value, history, and context, but reduces the appreciation of design to *half* the already rather thin structure of response to Modern art. There is no scope for the irrational here, and the only individualism encouraged is the necessary subjectivity of experiencing the unspeakable, incommunicable beauties of a ball bearing by oneself.

Designers are divided into the "technical" and the "artistic." Among the latter, industrial designers get their usual mocking in "even the most impractical and fantastic 'styles' of 'modernistic' plumbing fixtures (not included in the exhibition)." But neither sort of designer is really necessary except in those cases when "function does not *dictate*, it merely indicates in a general way." Far from there being much scope here, however, "The role of the artist in machine art is to choose, from a variety of possible forms each of which may be functionally adequate, that one form which is aesthetically most satisfactory. He does not embellish or elaborate, but refines, simplifies and perfects." What these last phrases mean is quite clear in the context of the exhibition: the artist-designer seeks, in the design process, the anonymity, the invisibility of the technical designer. (The buried part of the conceit is the unstated hope that this functionally conscious designer's previous artistic competences, especially an assimilated knowledge of classical order as well as modern alertness to the new, will come through, as they do in the case of the European masters, so that a kind of modern design will evolve, *superior* to that of both the technical and the Deco/streamliner industrial designer.)

For Herbert Read, under the influence of both Gropius and Barr, the creation of such an aesthetic became the crucial modernizing role of the "abstract artist" in all aspects of the constructive planning of our modes

of living.[19] Little latitude was allowed in this matter: in 1938 the Useful Objects under $5 exhibit was matched by a major Bauhaus retrospective, and in the epochal Art in Our Time of 1939, celebrating the museum's tenth anniversary and its new building, the design section consisted only of Fuller's prefabricated bathroom and chairs by Corbusier, Breuer, Mies, and Aalto. Despite the importance of design to the "pure formalism" at the heart of the MOMA project, making this explicit in an industrial design department of the museum was a torturous process, even given the loyalty to the ideal of curators such as Eliot Noyes and Edgar Kaufmann, Jr.[20] Whatever its internal problems, MOMA followed the Metropolitan and other museums in insisting that it, rather than the nascent "profession" of industrial design, shape the modern visual culture of the United States, determining its look and setting its standards. The basis on which it claimed this right was its custodianship of the transcendent values of Modern art. What gave it the power to do so was its positioning as the key high cultural instrument of East Coast new corporatism. In style, in its stunningly innovatory inscription of quickly conservative values, MOMA's reach for cultural leadership shares much with other new corporate avant-gardists, such as Time Inc.

Styling International Architecture

In 1932 Philip Johnson and Henry Russell Hitchcock inaugurated MOMA's architectural department with the exhibition Modern Architecture: International Exhibition in which they claimed that a new style— the only genuinely worldwide one since the Gothic precedent with the same title—had come into existence: the International Style. Unified and inclusive, it had in the 1920s "produced sufficient monuments of distinction to display its validity and its vitality." Strongly supported in a preface to the catalogue by Barr, this exhibition crystallized much within architectural discourse, was reinforced by the propagandist efforts of the architects and other writers such as Gideon, Pevsner and Zevi, and has remained profoundly influential ever since. Only recently has its account of the International Style been dislodged as the normative narrative of modern architecture as a whole. Venturi's stress on complexity and contradiction was the first successful query. Frampton has located some of the movement's more critical contexts, and Curtis exposed the depths of its classicism.[21] Others, such as Manfredo Tafuri, have proposed quite different avant-garde models, and, above all, a variety of architects and writers, including Philip Johnson, have shifted their allegiances to the supposedly completely different semiotic mobility of the "Postmodern."[22] Gebhard's proposal, which is supported by my argu-

11.5 Installation view of Modern Architecture: International Exhibition, Museum of Modern Art, New York, 1932. (Photograph courtesy, The Museum of Modern Art, New York)

ment, is that neither the International Style nor any other European-based transplant was widely *built* in the United States, whereas a broader "Moderne" was—and, indeed, it absorbed International Style elements such as horizontality and white-stuccoed surfaces into it.[23] The lack of response to this analysis since it was made in 1970 attests to the power of the International Style construct, the potency of the ideal in professional architectural discourse, to its systematic exclusion of its own material base and majority practice as always "mere" *building*.

Building, in two different senses, marked out the limits of the International Style as Hitchcock and Johnson conceived it. The "underlying principles" they discovered have been often quoted: "There is, first, a new conception of architecture as volume rather than as mass. Secondly, regularity rather than axial symmetry serves as the chief means of ordering design. These two principles, with a third proscribing arbitrary applied decoration, mark the productions of the International Style."[24] The boundaries of the style were set, on one side, by the inclusion of the "doctrinaire functionalists"—the city planners of Frankfurt and Stuttgart, who are seen as "primarily builders, and architects only unconsciously"—as well as architects such as Hannes Meyer, recently ousted from the directorship of the Bauhaus for his Marxism and replaced by Mies van der Rohe.[25] To these people the very idea of a modern style was a contradiction in terms (as it was, essentially, in Gropius's

theory) precisely because total commitment to function made overtly stylistic elements an artificial addition and because the variety of functions to be shaped was so immense that no consistency of solution could possibly result. The force of such beliefs in Europe, and rhetorical acceptance of much of them by the Modern Masters, obliged Hitchcock and Johnson to devote considerable attention to justifying their very seeking of a style. Nonetheless, the pure functionalists' assumption about variety of functions precluding style collapsed before the combined influences of finite materials and technologies, the impact of "masterful" examples, and the synthesizing powers of style historians. Hitchcock and Johnson pointed to this inevitable exercise of some shared aesthetic preferences by even the most "doctrinaire," thus eliding them into the stylistic camp. In doing so they reduced the complexity and capacity for self-criticism of this work and, at the same time, detached it from the systematic socialism in which it was based, downplaying also the links of Gropius and Bauhaus to political radicalism (as contentious and varied as those were). The political contexts were, of course, undeniable: this was a process of backgrounding them, thus shifting the whole ensemble to the liberal center. Barr's preface to Hitchcock and Johnson's volume is quite explicit about this. The authors, he said, "have made little attempt to present here the technical or sociological aspects of the style except in so far as they are related to problems of design. They admit, of course, the extreme importance of these factors, which are stressed in the criticism of modern architecture to the practical exclusion of problems of design." [26]

Central to the International Style construct was a reductive, simplistic reading of the "monuments of distinction" created by Le Corbusier, Mies van der Rohe, Gropius, and a few others. The socialist commitments of Gropius, Oud, May, Muller, Mayer, Stam, and the Russian architects were either ignored or ridiculed: "Too often in the European *Siedlungen* the functionalists build for some proletarian superman of the future." [27] Yet, in an otherwise silly performance, Tom Wolfe was right to sense the hypocritical bleaching with "authenticity" of the whole project of modern architecture based on the quantitively few efforts made by these architects with working-class housing in postwar Europe. [28] Nor was there more than token—although frequent—acknowledgment of the communality of the design process so central to the Bauhaus. [29] Mostly, the "shortfall" in pure functionalism was exploited to open up space for the individual architect's exercise of "aesthetic discipline." Working hand in hand with the practical interest in a high degree of functionalism, it generated the major works and projects. Barr's gloss on the three underlying principles—all formal ones—brings this out, es-

pecially his transformation of the third negative into a positive: "emphasis upon volume—space enclosed by thin planes or surfaces as opposed to the suggestion of mass and solidity; regularity as opposed to symmetry or other kinds of obvious balance; and, lastly, dependence on the intrinsic elegance of materials, technical perfection, and fine proportions, as opposed to applied ornament."[30]

Restraint in the exercise of these principles—as in the expensive individualism of Mies's interiors—set the other boundary of the style. "American functionalists" are so in name only; being mere "builders," they crudely treat "design as a commodity like ornament": "American modernism in design is as superficial as the revivalism which preceded it. Most American architects would regret the loss of applied ornament and imitative design. Such things serve to obscure the essential emptiness of skyscraper composition."[31] Howe and Lescaze's Philadelphia Savings Fund Society building of 1928–32 is among the very few American buildings included, but it is criticized for failing to relate its corner-curved (streamlined) base to its tower. The only other skyscraper, Raymond Hood's McGraw-Hill Building, New York (1931), is allowed in because of its "lightness, simplicity and lack of applied verticalism," but its "heavily ornamental" (again streamlined) crown is castigated.[32] Enthusiasm for the modernity embodied in U.S. factory and skyscraper construction—as much as the accepted influence of Frank Lloyd Wright—had deeply inspired the visiting European modernists such as Mendelsohn and Neutra, and was enthusiastically communicated in Europe through their books.[33] But the actual authors of these structures, with their conniving chatter about "one function of a building is to please the client," became "modernistic impresarios," locked into a position which deeply offended Barr's sense of art's autonomy, his own class location, as well as the museum's social power: "We are asked to take seriously the architectural taste of real estate speculators, renting agents, and mortgage brokers!"[34] Such "half-moderns" were not really architects: they were as crass and excessive as the pure functionalists were "puritanical." Instead, the International Style architect, the true modernist, applied "aesthetic principles of order, the formal simplification of complexity," using "the beauty of natural surroundings and the beauty of rich smooth surfaces," when available, to enhance the "quality" of the work. Architects could thus join artists as practitioners in a domain of transcendent aesthetic judgment. Industrial designers, on the other hand, should disappear into the invisible technicalities of pure functionalism. How obviously this double standard subverts the often-proclaimed Bauhaus idea! Less obviously, it subverts MOMA's charter. Between them, the purest forms, the most refined imagery of the mod-

ern age, are being created. Only they can create the imagery appropriate to a modern America. "Modernistic" streamline-type designers and "Modern" architects were producers of contemptible *kitsch*.[35]

How, then, does the MOMA project relate to the broad regime of *Life-style* modernity? Mostly by difference—through the very exclusiveness of its commitments to the autonomy of art, to the priority of the "aesthetic discipline," to a formalist purity. Its invitation was one of transcending the ordinary through these exclusive passages—not by escape to the past, but by participation in the avant-garde edge of the present, in the delightful promises of future power. In doing so it served directly the subculture of the rich, "deepening" modernistic fashionability, and also served the whole ensemble as an extremity, a benchmarker. Yet even in these esoteric domains, the same double-crossing structures we have noted in all the other agencies of modernity obtain: the ever-changing testament of the constancy of control, the illusion of speed around static regularities, themselves incessantly disturbed, the promise of liberation in the act of installing more subtle repressions, the promotion of the values of the new corporation as a democratic openness, the celebration of intimations of eternality in the midst of the mobility of modernity.

None of this is a conspiracy to deceive: the creativity of all these agencies—from Ford Company to MOMA—and of new corporate individuals—from Henry Ford to Alfred Barr—was prodigious. The period was exciting, open for change; the opportunities must have seemed ready for taking. The regime of Corporate State modernity we are now seeing in a process of implosion was a convergence of avant-garde leadership in a number of contingent discourses. When Henry Luce in 1935 revised the prospectus for *Architectural Forum* (now owned by Time Inc.), the major distributor of International Style values among magazines, he wrote:

> To influence architecture is to influence Life. The most widely accepted concept about architecture is that it is above all the *social art*. "Design for living" is a phrase which cannot be escaped. And perhaps never before in the history of the world has it been so imperative and so possible to do something, by conscious thought and effort, about "designs for living." The reason why it is imperative to do something is that, by general agreement, the old order, that is to say the only existing order of life and thought, is passing or has already passed— and unless chaos is to intervene, a new order must be more or less consciously created—and, in terms of decades, soon. ("Either you will have architecture or you will have revolution" is the famed phrase of Le Corbusier.)[36]

In 1935 Luce could not see (or chose not to emphasize) the lineaments of the mid-1930s consensus forming. His call here is for modern architecture to commit itself to an unspecified, but certainly counterrevolutionary, social program, directed against the murky chaos of unplanned, irrational Depression America. By 1939 it had become clear that MOMA was to serve the corporate state on its own terms, and that it would be valued for doing so by even the titular head of institutionalized welfarism, Franklin D. Roosevelt.

In a radio speech of May 10, 1939, concerning the opening of the new building, President Roosevelt said:

> The arts cannot thrive except where men are free to be themselves and to be in charge of the discipline of their own energies and ardors. The conditions for democracy and for art are one and the same. What we call liberty in politics results in freedom in the arts. . . . A world translated into a stereotype, a society converted into a regiment, a life translated into a routine, make it difficult for either art or artists to survive. . . . In encouraging the creation and enjoyment of beautiful things we are furthering democracy itself. That is why this museum is a citadel of civilisation.[37]

Yet MOMA did serve the convergences of *Life*-style modernity and the State quite directly at times. Between 1940 and 1946, the museum executed thirty-eight contracts worth $1.5 million for various government agencies, including the Office of War Information, the Library of Congress, and the Office of the Coordinator of Inter-American Affairs (Nelson Rockefeller). It staged forty-eight exhibitions related to the war effort—nineteen abroad, twenty-nine in the museum itself. Among these was Road to Victory, mounted by Edward Steichen, using FSA images for more than a third of its display.[38]

Similarly, MOMA's insistence on French painting and European Modern Master architecture was aimed at creating a vacuum, drawing in comparable American art. This process of elevation through example was leavened by selective appropriations of American art. While the museum mostly drew in appropriate celebrations of the new corporation, like Sheeler's, it could scarcely avoid some relationship to the major currents in American art. Dominant Social Realism appeared only exceptionally. The "American Scene" was acknowledged as the typical site. In fact, in our argument, it is the site of convergence, part of the *Life*-style implosion occurring throughout its critical edge in parallel ways to those in photography. By 1933 MOMA had given Edward Hopper a retrospective and had inaugurated one-man photography shows with Walker Evans's nineteenth-century houses. More and more, how-

ever, the museum appeared to support those artists experimenting with formal abstraction—beyond Stuart Davis's lively and subtle "jazz" modernity to the nonfigurative geometries of the American Abstract artists. These observations need more careful testing, but the point here is that, despite its position of distanced engagement, MOMA was subject in general terms to the same shaping forces operating on all the agencies of the imagery of modernity at the time.

Tafuri and Dal Co are harshly accurate in their assessment of the quality of the contribution to architectural thought made by the concept of the International Style: "When compared with the evolution of the skyscraper in the 1920s, with the work of Hood, and with the experiments of Albert Kahn, the attempt made by the Museum of Modern Art reveals all too plainly its own superficiality."[39] Zevi gets closer to the Modern movement's complexity when he replaces the "three principles" with his seven "anti-rules," but then seeks transhistorical locations for them.[40] Yet the International Style, like Barr's Modern art history, was not only a connoisseur's checklist; it was a powerfully influential attempt to both emphasize and define the imagery of "true" modernity according to a passionately formalist aesthetic. Its success was due less to its supplying of "stable values" to "the America of the Great Crisis"[41] than, in the early 1940s, its enthusiastic compromises for the war effort. At both moments, the MOMA project was, in different ways, simplistic, yes, but also subtle.

Architecture and the Photomodern

The Modern Architecture: International Exhibition consisted mainly of panels showing plans and photographs of an array of buildings. As an exhibition, particularly one celebrating European architecture, it could be little else. The use of photographs more than renderings, wash drawings, and perspectives, while not of course new in architectural exhibitions, was carried through with a tenacity which became typical of the publication of Modern movement architecture. More than the book *The International Style: Architecture since 1922*, the exhibition panels contrasted European success with American crudity; on this level of presentation, the locals decidedly lost. Somewhere here lies an approach to the question of why photographs of buildings, particularly modern movement ones, occupy so prominent a place in the imagery of modernity alongside those of factories and fairs, cities and crowds. More specifically, just what was it about modernist architectural photography which enabled it to project its visions so prominently onto the visual surfaces wrought by the likes of Kahn, Sheeler, and Bourke-White, by advertis-

ing artists with airbrushes, in the gleaming dream-kitchens of the industrial designers?

Architectural practice had come to include photography among its internal instrumentalities—for recording sites and the progress of construction, for project presentations. While historical architecture was shifting its aura due to the countless reproductions which had, since 1900, been widely circulating as evidence, mostly of place, architects were relying more and more on photographs of buildings for information and inspiration in their designing. Photography was showing other, related perceptions, too: the newsreel made happenings into events, documentarists revealed the "hidden depths" of the cities and countryside, microphotography transfigured the aesthetic order of the natural world. All these developments drew architects, as other designers, toward photographic "truth"—especially given that in the 1930s photography was frequently heralded as the liveliest of the modern arts.[42]

"Modern buildings call for modern artistic photographs to do them justice": Blakeston's call in 1932 in the *Architectural Review* (parallel publication in England to the *Architectural Forum*) was a recognition of an essential, necessary connection.[43] The directness of instrumental realism was as inadequate to the acclaimed new aesthetic of modernist architecture as the blurred mists and shifting focii of pictorialism. Like the industrial designers and other advertisers, Modern Movement propagandists used photography extensively and vigorously. In *Vers une architecture*, Le Corbusier had already established the canonical sequence—or better, the continuous loop of the elements. These were the vernacular industrial structure, the newly engineered machine marvel, the modernist building and town plan, and the confusion of past architecture—except for the clarity and grandeur of St. Peter's, Rome, and the Parthenon. Le Corbusier necessarily depended on side-by-side contrasts of similarly styled photographs to make his points.[44] The chapter on the Parthenon alone, "Architecture: Pure Creation of the Mind," prefigures the evolving aesthetic in the ways its visual logic works against the grain of the subject. These ancient structures are seen as a romantic, dark otherness, with patches of light opening up emotive fissures within an overall call to rational order. Blakeston's appeal was already being answered, not by an appropriation of instrumental or Social Realism, but by an application of a tendency within art photography, one which has occupied us throughout this enquiry—that devoted to the aestheticizing of industry.

In U.S. "art" photography we have seen how the industrial machine (in both senses) became a subject for Sheeler not only because of the direct commission from N. W. Ayer, but also because of the context of

his avant-gardist explorations of Manhattan with a prior poet of reticent focus on the machine, Paul Strand. Along with the early work of Weston and Evans, this approach parallels that developing in Europe. For Rodchenko and El Lissitzky in Russia, the "new photography" meant the surprising of politically potent realities, an activist scanning of the world, deliberately *making it strange,* so as to be ready for collective renewal. For the leading German photographers, however, the autonomy which they claimed for their art was grounded in the belief that it was the only art form able to "do justice in pictorial terms to the rigid lines of modern technology, the spacious interwoven girderwork of cranes and bridges, and the dynamics of one thousand horse-power machines."[45] How short a step it was, for these photographers, from their self-referentiality to subservience to burgeoning monopoly corporatism, is epitomized in Renger-Patzsch's agreement to change the original title for a collection of his intensely-lit, cropped close-ups from *Die Dinge* (Things) to *Die Welt ist schön* (The world is beautiful) (1928).

The universalizing of this uncritical formalism occasioned Walter Benjamin's caustic comment on "the posture of a photography that can endow any soup can with cosmic significance but cannot grasp a single one of the human connections in which it exists."[46] This posture made photography ideal for advertising, as did its techniques of singling out surprising viewpoints, exclusion of context, equal intensity of attention irrespective of subject, and its philosophy of incessant renewal. Even its formal preferences for graduation of textures contributed to its renovation of advertising photography. So successful were Renger-Patzsh, Finsler, Burchartz, Biermann, and others that Brecht was driven to posit the necessary *artifice* of a radical realism: "less than ever does the mere reflection of reality reveal anything about reality. A photograph of the Krupp works or the AEG tells us next to nothing about these institutions. Actual reality has slipped into the functional. The verification of human relations—the factory, say—means that they are no longer explicit. So something must in fact be *built up,* something artificial, posed."[47] Doubtless he had in mind not only his own theater, but Heartfield's photomontage. Yet the dominant tendency continued to aestheticize not just the production processes and the products of monopoly capital, but its victims as well. Of Renger-Patzsh again, Benjamin observed that his type of photography was becoming "more and more modern, and the result is that it is now incapable of photographing a tenement or a rubbish-heap without transfiguring it. . . . It has succeeded in turning abject poverty itself, by handling it in a modish, technically perfect way, into an object of enjoyment."[48] The U.S. parallels have been obvious throughout our discussions.

"World is beautiful" aestheticism increasingly served modernist architecture, especially during the 1930s. It seemed the ideal subject for all the devices of the "new vision": "clear, sharp and precise reproduction, shots from unusual angles, close-up or from a great distance, narrowly limited detail instead of an ensemble, isolation of particular features, emphasis on material surface and abstract structure."[49] The vagaries of weathering and the unpredictability of individual usage were exorcized by concerted efforts to photograph the buildings in their glistening white, brand new condition, before they were inhabited or in use. People disappeared as quickly as did surroundings. The structure itself stood against an even, gray sky. The essential dialogue was between two modernists: the architect, creator of these unprecedentedly open and complex spaces, these paradoxically subtle plays with standardized shapes and unvarying materials, and the photographer, revealer of the "objective" regularities and the unexpected occurrences in the photographed world, working all the devices of the "new vision" with and against these already strange creations. The machine for seeing meets the machine for living: it is as if they were the only two elements in existence. The photograph of a modernist building becomes the only evidence of this otherworldly contact. Each one records an archaeological fragment but in reverse: for these are glimpses of cities on other planets, fragments of our future, empty spaces existing to be peopled—by us?

Further research might be able to decipher some historical patterns in this relationship of necessity. Is there a gradual diminution of the "vernacular" industrial inspirations into blurred grays, blotchy shadows, and rough outlines as the sharp, bright, highly white modernist structure shines forth? Within the general effect of fragmented seeing, of estranging the viewer, is there a class division in which individual houses for the rich are expressed in more complex and subtle visual terms than the steady coercive regularities of the mass-housing projects (few as these were in the United States)? But whatever signs of privilege these images conveyed in the mid to late 1930s, they were also read against intention in quite the opposite way. Modernism's own appropriation then denial of the vernacular was spectacularly reversed when the abstract forms of the architectural photomodern were adapted to provide the visual cloaking for the single most prodigious gathering and manufacturing of modern imagery in the entire period under study—the New York World's Fair of 1939–40.

FUNFAIR FUTURAMA: A CONSUMING SPECTACLE

<div style="text-align: right">

CHAPTER
12

</div>

Unveiling, in March 1937, Harrison and Fouil-houx's design for the Theme Center of the up-coming New York World's Fair, president of the Fair Corporation Grover Whalen described the Trylon and Perisphere in terms typical of later 1930s modernity: "We promised the world something new in Fair Architecture and here it is— something radically different and fundamentally as old as man's experience. . . . These buildings are themselves a glimpse into the future, a sort of foretaste of that better world of tomorrow, of which we hope in some part to be the harbingers. We feel that simplicity must be the keynote of a perfectly ordered mechanical civilization."[1] The only excess in Whalen's language was in the very last phrase, yet it was assuaged with the overriding notion of popular modernity—"simplicity"—and by the constant, seesawing erection and erasure between "the old" and "the new" which secured this simplicity. The Trylon was a 610-foot triangular tower, the Perisphere a globe 180 feet in diameter. A 65-foot-high bridge linked the two, and a 950-foot long, 18-foot wide Helicline encircled them. Steel structures on a reinforced concrete base, covered with white gypsum board, with parts sheathed in stainless steel—the effect aimed for was one of "shimmering surfaces and seeming weight-

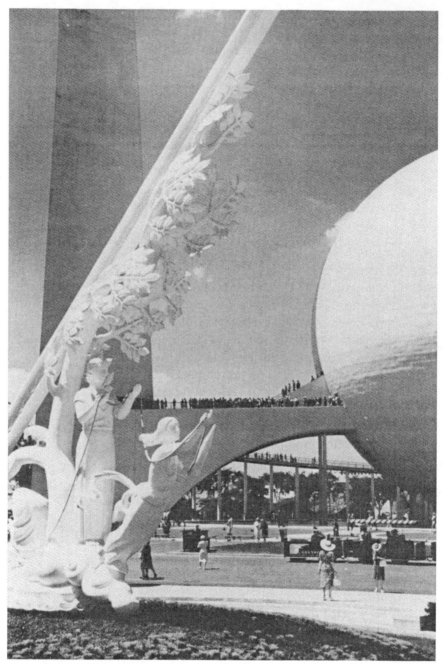

12.1 Richard Wurts, *Theme Center and Paul Manship's sculpture "Time and the Fates of Man," New York World's Fair, 1939–40.* (Dover Publications, New York)

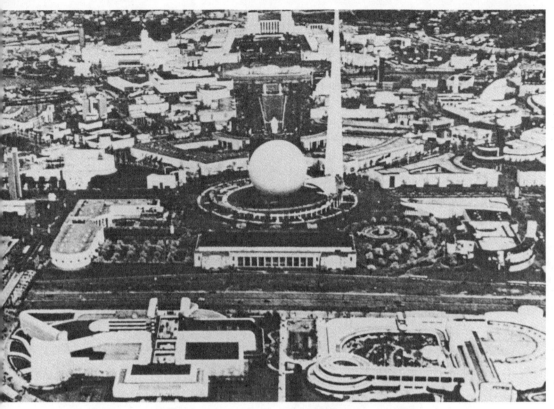

12.2 Aerial view of New York World's Fair, 1939–40. (Reprinted from *Architectural Record*, August 1940, copyright 1940 by McGraw-Hill Inc. All rights reserved. Reproduced with the permission of the publisher)

lessness," especially with the jets of water appearing to support the sphere.[2] By far the largest, most focally placed and unembellished structure at the fair, the Theme Center functioned as a reference point at Flushing and as a readily reproducible logo of the fair itself. Its ubiquity in 1939 ensured something of its persistence: what remains in popular memory is primarily a landscape of glistening white buildings, like a city of pure forms shining in the distant haze, a far-off mirage of a place where everything seems clear, perhaps "perfectly ordered." If the "pure formalism" at the heart of the MOMA program was the aesthetic core of new corporate high cultural modernism, here, surely, was the ultimate expression of new corporate modernity for mass consumption—the Modern made simple, marvelous, and total. It supplied a wealth of modern imagery from an extreme position, as did MOMA. But it was opposite in that its exceptionality was that of permissible, even desired, exaggeration, the half-serious fun of the fair.

First plans for the fair in 1935 aimed at "alleviating some of the economic distress in the metropolitan area" as well as increasing money circulation through tourism and, like the Chicago Fair just completed, reaping a "modest profit."[3] The liberal intelligentsia of the city quickly rallied support for something "more than" the usual celebration of new machinery plus sideshows. In Lewis Mumford's words, the fair should tell "the story of this planned environment, this planned industry, this planned civilization," and a "Fair of the Future" Committee shaped the adopted themes: showing the social "Interdependence of Man" and contributing toward "Building the World of Tomorrow." The main principles of American reformism, currently organizing the New Deal, sought the opportunity to do further good work by showing themselves to Americans and the world. Thus the carefully constructed educational itineraries of the "focal exhibits" of each fair sector, themselves divided according to the major functional areas of modern living: Production and Distribution; Transportation; Communications and Business Systems; Food; Medicine and Public Health; Science and Education; and Community Interests. These were to be introduced and integrated in the Perisphere display.[4] Haunted by the Depression disaster at home and the rise of war and fascism in Europe, publicity statements defined the theme of the fair thus: "To contribute to a Happier Way of American Living by demonstrating how it can be achieved through an understanding of the growing Interdependence of Men of every class and function and by showing the things, ideas and forces at work in the world which are the Tools of Today and with which the better World of Tomorrow is to be built."[5] The fractured language of a declassed and sterile management humanism recalls that of the Rockefeller Center commission given Rivera a few years earlier, in 1932.

Mr. New Deal Goes to the Circus—or rather, was taken. There was no doubt in the minds of the fair organizers, including the Theme Committee and the Board of Design which oversaw the planning of the whole and of each exhibit, that corporate state America embodied already all of the main elements of the desired World of Tomorrow. That is to say, it *almost* did, and could quite readily if enough Americans believed it. Recovery through rejuvenation, with the City of Plenty as the goal, prefigured here at Flushing Meadow, just around the corner. The focal exhibits, official centers of each sector, were surrounded—and usually overwhelmed—by the displays by major corporations. And the Amusement Zone (renamed, in 1940, The Great White Way) pulled vast crowds to shows such as Billy Rose's Aquacade, Bel Geddes' Crystal Gazing Palace, and Salvador Dali's Dream of Venus pavilion.[6] That the self-help, public assistance, and community responsibility messages of

New Deal liberalism penetrated far is open to doubt. But the American-ness of the environment was not: unlike previous fairs, no pride of place was given to foreign exhibits, their pavilions clustering in the far-flung precincts of the Federal Building. Only the Russian Pavilion, with a piece of kitsch verticalism matching that of the Trylon, stood out. De-signed by Iofan, winner of the 1931 Palace of the Soviets Competition, it continued the 1937 Paris Exhibition standoff against Speer's Nazi monument, but in New York it was faced with a competition both absent and all-pervasive.

New York 1939–40 was, like no fair before or since, the province of the new breed of industrial designers. Teague played a major role in planning the fair from the beginning, dominating its Theme and Design boards, drawing in other industrial designers to create the focal exhibits and the publicity. Teague, Bel Geddes, Dreyfuss, Deskey, Arens, and others also took commissions from the major private exhibitors. Teague's taste profoundly influenced the choice of architects for the major official buildings and the private exhibits. And there are clear instances of ar-chitects who normally worked within either the Beaux Arts or Art Deco tendencies accepting an industrial design aesthetic for the occasion. The Theme Center, by architects of the Rockefeller Center and the Philadel-phia Savings Fund Building, is the obvious example. Others include the Gas, Petroleum, and RCA buildings by Skidmore, Owings, and Merrill (the last with Paul Cret).[7]

It was the ideology, the practice, and the developed imagery of in-dustrial design which here drew together all of the elements of U.S. mo-dernity into a striking, generalized, and ambiguous visualization of (in O'Connor's apt phrase) a "usable future."[8] Absorbing the eighteenth-century site plan as well as the sociology textbook sectors imposed on it, the designers of built form at the fair succeeded in creating an imagery which momentarily transcended its sources and entered the domains of pure metaphor. Rem Koolhaas has shown how the dialogue between Manhattan and its laboratory, Coney Island, climaxed at the fair, and has revealed the metaphor of fabulous, always unattained utilitarianism embodied in the history of the skyscraper.[9] The fair buildings became a kind of anti-Manhattan of low, windowless buildings, "exiled interiors." A World's Fair poster made explicit the echoes of Coney Island's Globe Tower and Needle in the Perisphere and Trylon.[10]

But these two structures are, essentially, foyer/auditorium and an ele-vator shaft. One possible body analogy could see them as the stomach and vertebrae of a skyscraper (the Helicline becoming thereby an ali-mentary canal), an inner circulatory system detached from the floor which it services. Another analogy sees the Theme Center as the geni-

12.3 World's Fair as seen from Midtown Manhattan, *New York Post* photo, 1939. (Queens Museum)

talia on the site plan taken as a whole body. Or, in an awkward literalism not untypical of this moment, the twinned male and female forms could unwittingly symbolize the striving for androgyny which was shaping streamlining itself. From a mechanical perspective, the Theme Center serviced only itself—its structural purity follows from this self-reference. Unlike the Eiffel Tower's proud display of its internal engineering, this symbol enclosed its utility. Here we can discern the impact of both International Style and industrial design. Harrison and Fouilhoux searched for the "pure forms" which constituted the art in the machine on Barr's reading, *and* for the architectural life of these forms as the stripped geometries basic to the design vocabulary of the European modernists. The spheroid and three-sided, extruded pyramid must have seemed the

"inner shapes" of their functions, like two elements in a mathematical world consisting only of Platonic forms. In this sense they become an abstraction not only of the modern skyscraper city but also of modern industry, of the machines and of the factories. The "factory aesthetic" assimilated by both modernist architects and photographers is signaled in these gleaming white surfaces: they abstract industrial structures such as gas containers and coking ovens through their visualization, in turn, by photographers such as Sheeler and Bourke-White. By the late 1930's, as we have seen, this way of seeing had become the architectural photomodern, a domain of dynamic surfaces and startling spaces of un-expected shifts in our seeing, a domain of the always new. The Theme Center was frequently photographed in this way (by Richard Wurts, for example), and the circulating paths suggest that it was intended to be experienced this way.[11]

As preface to his 1940 book *Design This Day*, which itself reflects his triumphs at the fair, Teague quoted the same words of Plato cited by Barr and Johnson at the beginning of the *Machine Art* introduction of 1934: "By beauty of shapes I do not mean, as most people would sup-pose, the beauty of living figures or of pictures, but, to make my point clear, I mean straight lines and circles, and shapes, plane or solid, made from them by lathe, ruler and square. These are not, like other things, beautiful relatively, but always and absolutely" (*Philebus* 51c). The Theme Center was industrial design's paradigm object, the "pure form" rep-resenting the single successful design solution. It was a functioning machine, with the job of taking masses of people through itself, continu-ously and efficiently. Typically for industrial design of this period it was an *enclosed* machine, the function of which was disguised, its usage un-stated, its consumers subject to direction as to how to use it. It invited both organic and mechanical analogy, one working ceaselessly over the other, organizing Nature's randomness but mitigating the cold ratio-nality of the Machine Age. Most of these qualities were true of other exhibits at the fair, both in their external shaping and the explanatory logic of the internal exhibits. In contrast to earlier fairs, machines were not the centerpieces: the *processes of production* became focal. Whereas Ford Company had, in the Panama Pacific International Exhibition in San Francisco in 1915, attracted great crowds by showing an unadorned section of the assembly line in operation, now its major pavilion (de-signed jointly by Kahn and Teague) was built around a huge 160-feet-in-diameter turntable, topped by the new V8, carrying eighty-seven mechanical puppets representing work on each stage. Firestone went one step further: its mock-up assembly line was actually sheathed in curved panels to show it to be "streamlined."[12]

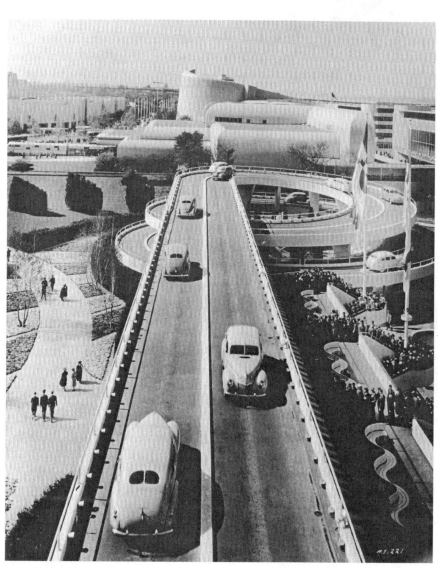

12.4 Albert Kahn, exterior view of Ford Pavilion, showing circular car ramp, New York World's Fair, 1939–40. From the collections of Henry Ford Museum and Greenfield Village. (Ford Archives, P.O.4257)

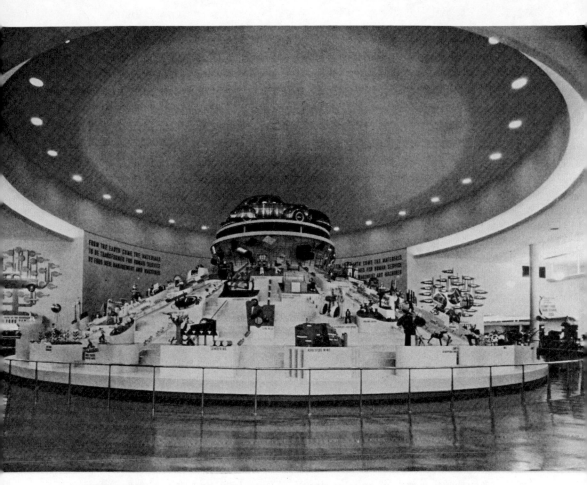

12.5 Ford cycle of production, Ford Pavilion, New York World's Fair, 1939–40. From the collections of Henry Ford Museum and Greenfield Village. (Ford Archives, P.O.4845)

As Meikle accurately observes, the Theme Center was typical of industrial design modernity in one further sense, its contradictory shapes: "The Trylon representing limitless flight into the future, the Perisphere controlled stasis."[13] Within the Perisphere, the public circled around balconies high above Democracity, "not a dream city but a practical suggestion of how we should be living today, a city of light and air and green spaces."[14] Like Bel Geddes' Futurama—a fifteen-minute simulated airplane ride of the America of 1960, followed by a re-creation of an actual city intersection in the General Motors Building—this world of tomorrow was constructable out of present-day technologies, under the enlightened planning of welfare government working hand in hand with the new corporations. "The future is (almost) new, and it is in good

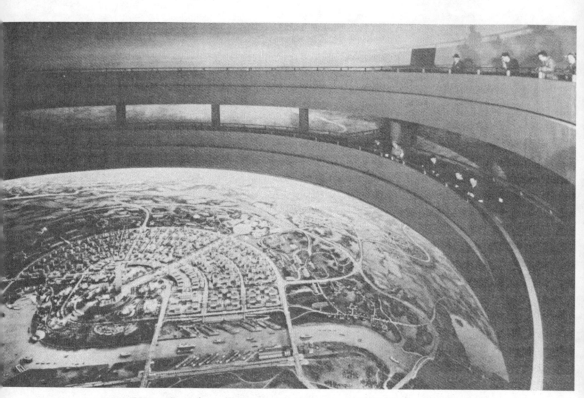

12.6 Henry Dreyfuss, Democracity, interior of Perisphere, Theme Center, New York World's Fair, 1939–40. (Photograph by Richard Wurts; Dover Publications, New York)

hands" was the obvious message. When, however, it came to visualizing the future city, both Dreyfuss and Bel Geddes—on their own frequent insistence (and, as we have shown, in reality) creators of a distinctive industrial design imagery of modernity—chose to install Le Corbusier's otherwise unrealized *Ville radieuse*.[15] Was this a failure of imagination, a harbinger of the success of the International Style in U.S. architecture after the war, or a further, typical industrial designer's transformation of any and all of the different streams of modern imagery into another act of publicity, another installing/destabilizing moment in the restless, incessant, voracious re-creation of the consumer society of the spectacle?

12.7 (*Opposite*) Norman Bel Geddes, City of 1960, Futurama exhibit, General Motors Pavilion, New York World's Fair, 1939–40. (Norman Bel Geddes Collection, Theatre Arts Collection, Harry Ransom Humanities Research Center, The University of Texas at Austin, by permission of Edith Lutyens Bel Geddes, executrix)

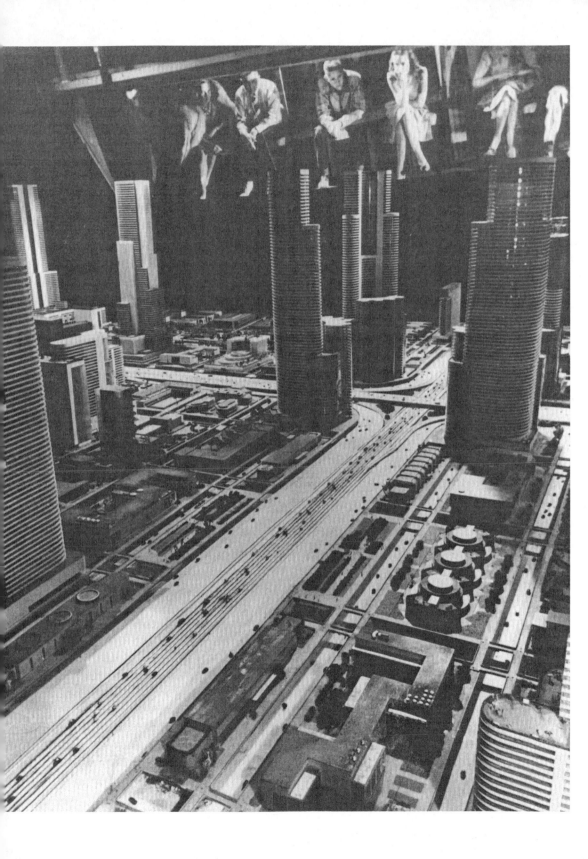

In all these ways, the World's Fair manifests its exceptionality by exaggeration within the spectrum of later 1930s *Life*-style modernity. But, in other ways, it was typical of the regime—indeed, was an epitome of key aspects of it. Despite contemporary claims that streamlining had become, at the fair, the "national style," despite the memory of a coherent domain of pure white forms, plurality reigned in the architecture of the fair. Partly, this was an effect of its contradictory purposes—the rigidity of the ground plan and the sectors collapsed under the visual onslaught of the commercial competition for attention. Santomasso usefully distinguishes three tendencies: a Beaux Arts Moderne (simplified classicism, especially in the fair-built structures and the Federal Building), an *architecture parlante* (architectural form taking on the shape of its content, for example, the twin ocean liner prows of the Marine Transportation Building, the RCA Building's radio tube plan), and streamlined form (classically, the Ford and General Motors buildings).[16] Yet he notes some of the many convergences across these distinctions, and even speculates whether the fair buildings achieved what he calls—in view of their dedicated commerciality—a "Corporation Style." This approaches my broad argument about the creation of diverse imagery of modernity as precisely the imagery of the corporate state.

But architectural/design style alone can never capture the experiential base of constructed modernity. This fair drew on the 1930s rhetorical theme of "the people," adding into it the planner's sanitized version, the "average American." Susman points out how the fair cast the people as actors on the set which it had created, acting their desired roles as consumers/customers, decorating otherwise incomplete buildings, animating the empty city.[17] Harrison shows how color-coding by day attempted, and newly available fluorescent light at night succeeded, in transforming the pure and not-so-pure geometries into a highly colored fantasyland.[18] Nor was the archaism, the inevitable obverse of futurist modernity, absent: the Court of the Nations and of the States was a veritable Greenfield Village of processed re-creations, reducing to interior decoration the work of even International Style masters such as Gropius, Breuer, and Bayer (in the Pennsylvania Pavilion, a mock-up Independence Hall).[19] Strive as mightily as they could with constructivist exposition design, their efforts were subject to the virile debasements, so typical of the fair, reflected in another of Whalen's "explanations" of the Theme Center: the Perisphere and the trylon joined the "Greek idea of beauty of form and harmony with the Gothic conceptions of reaching ever upwards for a better world."[20] And while Firestone streamlined its assembly line by adding teardrop-shaped partitions to its mock-up work space, this was only the culmination of a three-part "experience": view-

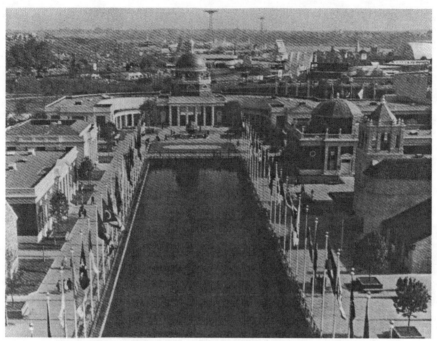

12.8 Court of the Nations, New York World's Fair, 1939–40. (Dover Publications, New York)

ers arrived at it after passing through a re-creation of the jungle in which the rubber was tapped, and a working American farm which used many machines and rubber products in a "natural" way. At the end of the 1930s, there is no irony at all in this junction of incongruities.

Art at the fair displayed the same diversity of modernities. Prominent were the frozen neoclassic silhouettes of Paul Manship's sculptural groups and the ponderous heaviness of other monuments scattered around the grounds. Commercial commissions sometimes achieved unmatched heights of literal gimmickry: Henry Billings's mobile mural for Ford Company was a seventy-foot-by-forty-foot altar piece to the combustion engine. A V8 motor, surrounded by Cubist fragments of the science, technology, and mass production central to the modern world, was actually activated in all its parts by inbuilt gears as it told its story. At the top, Sheeler in apotheosis, his *Criss-Crossed Conveyors* supplying the image of the River Rouge plant. Like Kahn's absorption of the Turin Fiat factory in the test track spiraling out of the pavilion with multicolored Fords continually running on it (driven by visitors), Billings has assimilated the transpositional boldness at the heart of Ford Company modernity.[21]

Art as art was only included in the fair late in the planning, following

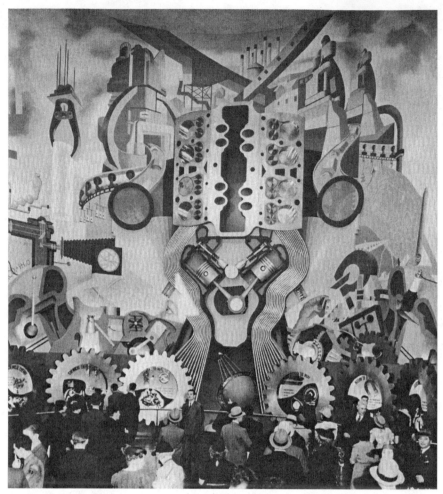

12.9 Henry Billings, mobile mural, Ford Pavilion, New York World's Fair, 1939–40. From the collections of Henry Ford Museum and Greenfield Vilage. (Ford Archives, P.O.5725)

protest at its exclusion—a Masterpieces of Art Building contained Old Masters selected by Dr. William R. Valentiner, and a Contemporary Art Building showed the exhibit American Art Today in 1939 and a survey of over eight hundred works from the WPA Federal Art Project in 1940. Holger Cahill directed both exhibitions' careful and representative surveys, and Stuart Davis's report attests to the efforts made to keep selection procedures democratic.[22] Davis's notes on the struggles he experienced with his RCA mural attest to the stresses felt by a politically active modernist convinced of the autonomy, the necessary indirection of Modern art. These contrast greatly, as O'Connor shows, with the excited dedi-

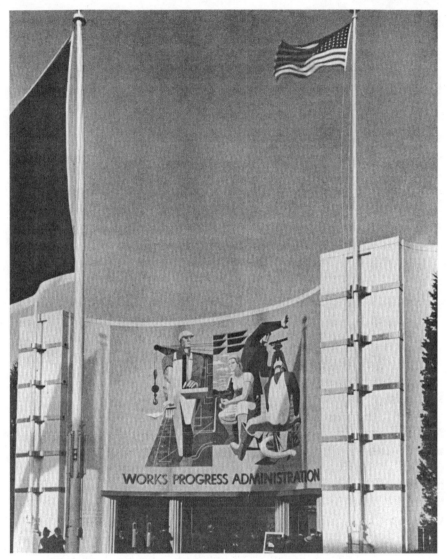

12.10 Phillip Guston, *Maintaining America's Skills*. Mural, Works Progress Administration Building, New York World's Fair, 1939–40. (Dover Publications, New York)

cation to expressing reformist ideals inspiring the WPA muralists at the fair, such as Phillip Guston and Anton Refrigier.[23] Taken together, the art at the fair reflected both the diversity of current tendencies and their convergence around a "WPA Modern," especially if we include the murals and the decorations in the focal exhibits.[24] This mildly modernist, "semifigurative" narrative abstraction was not as striking as the pure forms of either the modernists or the industrial designers, but it was eminently serviceable as recognizably up-to-date but not at all radical, neither aesthetically nor politically. A flexible American Scene modernity, able to lean toward any of the tendencies in current or recent art, as the occasion demands. Thus the aesthetics of the mural movement became World War II graphic design and advertising, the aesthetics of necessary austerity, of social convergence, of the Modern reduced to its most accessible denominator—the "simple."

In an important sense the fair recognized the overreach of its planar futurism. For the second season in 1940, the management was replaced and the fair reorganized around a content relatively absent in 1939: it became a "super country fair." The social planner's rhetoric about the "Interdependence of Man" went the same way as the slogan "Building the World of Tomorrow," to be replaced by "For Peace and Freedom." American folkways filled the space created by the departed Soviet Pavilion. Bel Geddes added six hundred churches, several hundred petrol stations, and a university to his Futurama, and the Town of Tomorrow, already token compared to the utopian projections, declined still further into irrelevance. Above all, many of the focal exhibits were taken over by the private corporations: the Consumers Building became the World of Fashion, and Coca-Cola assumed responsibility for the entire food hall.[25] These moves replay tendencies which, as we have seen, shaped the period. To draw analogously on one of its creatures, we might see Clark Kent's progress from Smallville to Metropolis as the simple dream of 1920s–30s modernity, and Superman's perpetual, always nearly failing struggle to assert the values of one within the other as somewhat closer to its actualities.[26]

We would misunderstand the modernity collected at this World's Fair if we took Democracity to be its ideal, core, ambition. As Berman has observed, Le Corbusier's cities solved the architecture-or-revolution dilemma by keeping people off the streets, denuding the domain of collective resistance, surrendering it to the car, and locating everybody in their sectors.[27] The people might marvel in their millions at this metaphor of their own destruction, then go on with their lives, as ultimately uncontrollable by these totalitarian plans as they were by the fair organizers. Both sides of this experience are captured by E. L. Doctorow in his novel *World's Fair:* the boy from the Bronx is wide-eyed at the theme exhibits

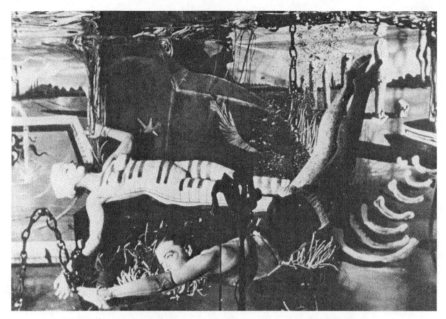

12.11 Salvador Dali, *Dream of Venus Pavilion*, New York World's Fair, 1939–40, in *Life*, March 17, 1939. (Eric Schaal, *Life* magazine © Time Warner Inc.)

but learns most in the amusement section, while the enjoyment of his parents is leavened by sharp skepticism about the messages they are being sold by both government and private pavilions.[28] Robert Moses's quintessentially modernist gesture of organizing the sweeping away of the Valley of Ashes and Garbage that was Flushing Meadow before the fair, this powerful creation of a tabula rasa, was defeated by the fair itself, by the contradictions it assembled, by the people who surged through it, simplifying it, complicating it.[29] The rationalized world dreamed in modernist architecture and town planning, one into which the carefully wrought solutions of the masters would fit like segments in an ever-spreading jigsaw, was grist to the mill of the fictive World of Tomorrow. The overriding logic of design at the fair, as in all of *Life*-style modernity taken as a social order, is *dispersive*. As every element of the spectacle arrives at its place, the ensemble shifts, the embodiment of the present is unstable, in motion again. It seeks the eternality of an "equilibrated universe," an infinitely expanding corporate capitalism, whose every relationship can only be shaped by the self-reviving fantasies of publicity. But the very double-crossing, dynamic conditions essential to its success also bred rejection, reversal, resistance and, ultimately, failure. Which is what happened during the next thirty years and is only now disintegrating beyond, perhaps, even modernity's powers of dispersal.[30]

THE MODERN EFFECT

MODERNITY BECOMES NORMAL

<div style="text-align:right">

CHAPTER
13

</div>

"Simple lines are modern. They are restful to the eye and dignify and tend to cover up the complexities of the Machine Age. If they do not completely do this, they at least divert our attention and make us feel master of the machine."[1] In the twenty years since the emergence of the Highland Park domain of invention, is this what U.S. modernity had come to: the self-denying superficiality of surface styling? Paul Frankl was, in 1928, reassuring retailers and consumers that the Art Deco "modernism" was not as exotic, expensive, and foreign as it looked, that it could be absorbed by a "natural" process of simplification. As he wrote, in the late 1920s, the relatively arbitrary usage of imagery typical of Ford Company–type modernity was being replaced by a much more regulated relationship: drawing in particularly the avant-garde modernists (photographers, painters, architects especially), modernity circa 1930 was taking form in domains of representation devoted above all to aestheticizing American industry—first its productive plants and then, in industrial design, its products. It was a fertile moment, containing the promise of purity, subtlety and breadth, for both artists and industry.[2] *Fortune* and the Museum of Modern Art—vanguard agencies for the distribution of a new integrative imagery of

modernity—were born of this moment, as was the Americanization of industrial design. Something similar seems to have occurred with the other couplets of 1920s modernity: the city/crowd, the consumer/product. Yet, in less than ten years, Frankl's reassurances were being applied to even this revised modernity: thus Van Doren's realism about the "borrowed streamline" ("The manufacturer who wants his laundry tubs, his typewriters or his furnaces streamlined is in reality asking you to modernize them") and Whalen's "simplicity must be the keynote" of a perfectly ordered, planned, corporate society, symbolized in the World's Fair, and almost achieved in contemporary America.[3]

Simplifying the modern, reducing it by naturalization into the ordinary, proved impossible during the 1920s and 1930s. The very energies, the prodigious transformatory powers which led to alarmed calls for containment, seemed also to burst through, override them. Yet Ford Company modernity, as part of the larger tendency of modernization by mass production and mass marketing in the 1920s especially, was subject to its own failures and successes. As we have seen, worker and family resistance, on the one hand, and rising expectations on the other forced Ford Company and other mass manufacturers to modernize their product and their image in the late 1920s. "Modernize," at that moment, meant to aestheticize, to elevate the product (and, in fantasy, its user) to the high cultural domains of high "society." The products of the new corporatism began to echo something of the subculture of its captains. The recession of 1927, which may have triggered this move, took on awesome dimensions in the collapse of the finance sector in 1929, and in the rapid spread of depression for five or six years thereafter (for ten years in the rural sectors). This quickly destroyed the illusions of aspiration, the singular matchings of circa 1930 modernity, necessitating an alliance of the new corporations with the planners' state, and an imagery of social democratic consensus. Neither Deco nor streamlining—much less modernist purism—could serve as the basis for a universal style. Rather, they remained reference points for ideal modernity which U.S. society celebrated but, at the same time, conspired not to achieve.

The *Life*-style modernity which emerges in the mid-1930s was simplifying in its populist thrusts but also complicating in that its basic metaphor of "teeming humanity" (individualism within a consensual society) required the constant manufacture of diversity. It attempted to absorb the discontent of workers degraded by modern manufacturing, and of families being reshaped by the demands of commodity consumption, by including them in a newly evolving "American way of life." Crossed over here were certain fundamental dichotomies—between past and fu-

ture, heavy industry and agriculture, between the city and the country, the East Coast/Northeast region and the Midwest/South. All of these were fed through the three couplets, and now, sometimes, these were confused, but they were never conflated. Rather, substitutions occurred, such as that of the rural dispossessed for the urban unemployed.

Constructing a new "American way of life" so as to absorb its victims also meant incorporating that art which had evolved to work in their interest—the realisms of social reform. Rivera's proposal, that modern industry was the most recent stage in the organic evolution of man's efforts to transform nature and still give a central place to human work, was accepted into the melting pot, however incompatible it may have been with the celebration of the autonomy of modern industrial processing figured by Sheeler et al. Kahlo's feminist rejection of both, however, was so profoundly oppositional that it had to remain marginal— eccentric if noticed, preferably invisible. But the approach to imaging most suited to *Life*-style modernity seems to have been the humanist inventories of the documentarists, especially that of the writers and photographers. Thus the dialogue between the FSA and the photo essay, united in their search for Smallville. The critical edge of their Social Realism was acknowledged, but then blunted, by the promise of Recovery. Similarly, the Mexican inspiration of the WPA murals was gradually absorbed into a positive picturing of the American scene.

Quantitatively speaking, imagery of contemporary life or of the future was probably less apparent than were replications of images previously made or new images of life in the past. Modernity also meant the increasingly efficient reproduction of the past—repetitions of its aristocratic or folk artifacts, eclectic contemporary variants of them, even whole environments from the age before the modern corporations and technologies, were re-created on canvas or in actuality. While this sort of archaism seemed, in the 1920s, a rather uncontentious, even bland reversal of the figuratively unstable Machine Age modernistic, in the 1930s it was an ideologically much more embattled ground. Its values were sought by the new corporatists, the New Deal welfarists, and by the radical critics of both. Their restatement in contemporary life was a central metaphor of *Life*-style modernity. The disputes were about how best this sort of life could be secured, for which sectors of the population, and at whose expense. Modernity seemed, often, to be tied to the changing conditions necessary for the recovery and redistribution of these values. For the main thrust through 1920s new corporate modernity and even 1930s corporate state modernity, however, this archaism was illusory; a quite different social order was under construction, one

inimical to small-town values, entailing a different quality of conformity, yet so lacking in content that it could find figurature expression only in imagery of the past, the fashionable, or the future.

From the perspective of the "overtly modern," *Life*-style modernity must have seemed a pathetic compromise. But the pure formalism of the Museum of Modern Art, and the populist futurism of the New York World's Fair, however detached and managerial their attitudes, seemed to work productively as extremes within an ensemble devoted to an imagery of diversity, of integrative variety, a modern demotic. And we noted how structurally conservative they were. The other edge of the ensemble was, I submit, not the agencies of archaism (because they work so very much within it, are themselves modernized), but the victims, the dispossessed, those multitudes whose lives were changed by corporate state modernity not for the better. Few of them were in a position to create an imagery of themselves. Walker Evans's interiors attest that many ingeniously used the imagery directed at them to decorate their lives, to ponder in their dreams the lives of others. When they did become the focus of the new corporations' need to expand their markets (mid-1930s rather than 1920s) and of the state's need to secure its survival and its social control, then the visual image of them was fought over. The 1936 "plight" pictures, Lange's and Taylor's continuing work, Evans's and Agee's book, Ivens's films, Shahn's prints and photographs, Steinbeck's writing—all these began as an imagery of protest against exclusion, demanding entry or return to a society modernizing in directions which would leave the subjects of this imagery for dead. Indeed, the project of *Life*-style modernity was to incorporate what it saw as unhealthy aberrations to the fictive wholeness at the center of the social body.

The transition across the ensemble, from Sheeler's purist modernism actively aestheticizing new corporatism to the *Life*-style incorporation of it into the "mainstream" of American life is complete when we read Roy Stryker, director of photography for the Standard Oil Company of New Jersey, saying in 1948:

> Industry is human beings. It isn't a bloodless thing. It isn't groupings of wheels and gears in rhythmic compositions. Industry is far more than masses of masonry and grey-blue steel against a black sky.
>
> Industry is human beings laboring for mankind. . . . Men who work, women who care for them, children who grow strong by their labor so they can work in their turn—these people and the communities they form ring the challenge for modern industrial photography.[4]

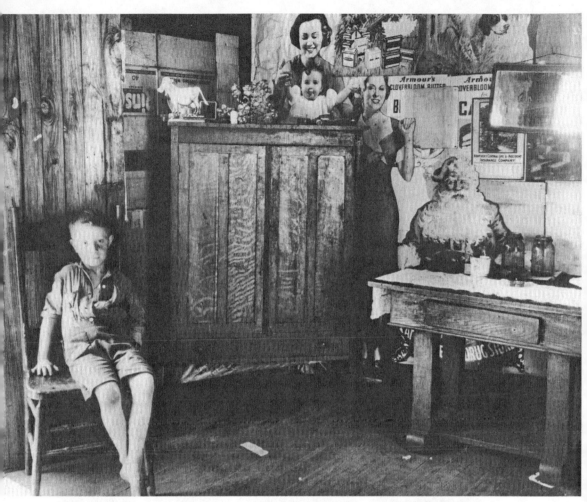

13.1 Walker Evans, *A Miner's Home, Vicinity Morgantown, West Virginia*, 1935. Library of Congress, Prints and Photographs Division. (LC F342-894A)

The fragility of his optimism is inadvertently given away in the last sentence, with its echoes of the reformist mid-1930s: "these people" did challenge not just modern industrial photography but modern industry itself. Although she was speaking in the doorway of a clean modern building in a Resettlement Administration newtown, and although her words were readily submerged in the populism of *Life*-style modernity, Ma Joad's remarks at the end of John Ford's 1939 film of Steinbeck's *The Grapes of Wrath* form an important counter to Stryker's platitudes: "We're the people that live. Can't nobody wipe us out. Can't nobody kick us. We'll go on forever. We're the people."

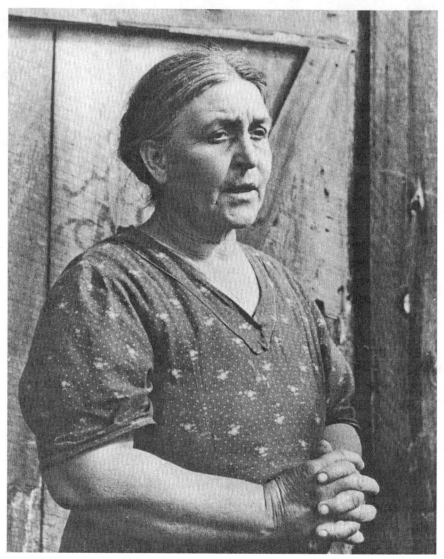

13.2 Horace Bristol, *Woman at California Migratory Labor Camp*, 1938. *Life*, June 5, 1939, taken on assignment with John Steinbeck; woman pictured inspired Ma Joad. (Horace Bristol, *Life* magazine © Time Warner Inc.)

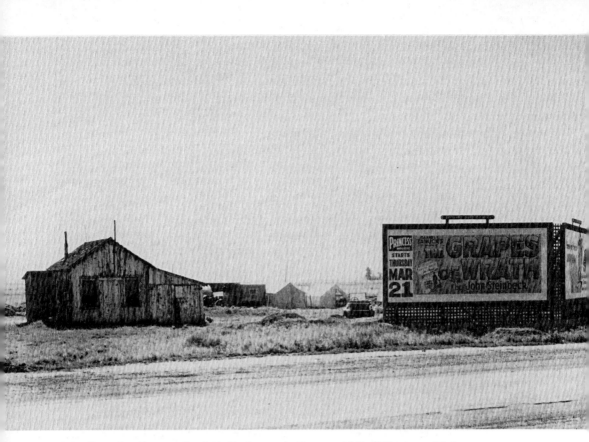

13.3 Dorothea Lange, *Roadside Settlement in Commercial Pea District on Highway #33, San Joaquin Valley, Calif., April 9, 1940*. Records of the Bureau of Agricultural Economics. (National Archives, Washington, D.C., photo no. 83-G-41563)

Modernism Meets the War Machine

The single most obvious failure of the New York World's Fair was the desultory sector of middlebrow, middle-income houses labeled Town of Tomorrow. The most popular industrial designer of the 1940s was neither an enthusiastic streamliner nor a MOMA purist, but Russel Wright, who mass produced simple, cheap, yet clearly craft-based domestic ware. Streamlining failed to dominate the one sector in which it reached such prodigious expression—the railroad—less for any reason connected with its stylistic adequacy but more because General Motors found it convenient to exert its monopoly of rail transport manufacture with a diesel engine unsuited to that type of modernizing. Such instances proliferate during the 1940s, spelling the end of the utopian project of American modernity, its retreat into pockets of lessening influence.

There has been some puzzling about why the imagery of the overtly modern seems to decline after World War II. A complex of reasons are suggested: machine technology was seen to produce problems as well as benefits, social planning took on repulsive forms in Nazi Germany and Stalinist Russia, and human perfectability seemed a fragile fantasy after the war experience—and especially after the bomb which ended it.[5] From these perspectives, the between-wars faith in modernity seemed naïvely optimistic. But we have seen that it never was such a simple affair. And it seems an obvious inference that, far from collapsing after the war, *Life*-style modernity became the dominant shape of visual culture in the United States during the war. Nor should it surprise us that this further evolutionary adjustment in the regime of modernizing imagery was engineered by many of the same artists and agencies we have been tracing.

In October 1939 Charles Sheeler was given a retrospective of paintings, drawings, lithography, and photographs at the Museum of Modern Art in New York. Also in that year he traveled in Colorado and Alabama taking photographs preparatory to a *Fortune* magazine commission for six paintings on the theme of power. One of very few retrospectives of a single artist, a living artist, and particularly a U.S. artist, staged by MOMA, the show stamped Sheeler as a significant contributor to its program of creating a modernist culture in the United States. The *Fortune* commission drew him directly into the most vigorous organ of U.S. business triumphant on a much broader scale than the 1927 Ford Company connection. And the subject, the processes of power generation by such public authorities as the Tennessee Valley Authority, inserted him in the New Deal publicity program, an enterprise which employed the talents and political/ideological perspectives of a number of realist and some modernist artists, especially photographers and filmmakers. Thus the demands of three major sites of the modern converged in this one commission. The imagery of modernity had evolved well beyond contingency: the frequency of such congruences declared its institutionalization, its arrival as a dominant order. But each instance had its particularities, its own relations to modernity's regulators and dispersive drives. I briefly review some key examples of modernity at war, beginning with Sheeler's *Fortune* commission.

Sheeler took a number of photographs of power generation and dissemination in the southwestern United States, primarily in preparation for the *Fortune* paintings.[6] *View of Boulder Dam* does not locate the dam geologically; nothing of the stunning environment is present. There is no indication of water, that its concentrated movement is the source of the power. Sheeler does not use the exaggerated view-from-above of

13.4 Charles Sheeler, *Suspended Power*, 1939. Oil on canvas; 33 × 26 in. (Dallas Museum of Art, gift of Edmund J. Kahn)

Moholy-Nagy nor the engineer's wonderment of El Lissitzky's photographs of the Dneiper Dam. Instead, the great wall of the dam wraps itself across most of the space, etched against the clear sky above and the shadows falling across and below it. The pressure of areas of light contrast are the major holding devices of the image. Below the dam is a

powerhouse, its projecting forward broken by the shadow which falls across it. The sense of power is subtle, the slow awareness we have of pressure on the wall before us, the sense that this power will be distributed through its diagonals, and then this made explicit by the raking in from midleft of the steel frame structures holding up suspended electricity conductors. *Installation* again shows no movement, refuses to make visible the mechanism of power: we look down into the pit of a generator into which a "runner" (turbine propeller) has just been carefully lowered. The related painting, *Suspended Power*, looks up at the huge runner descending into the pit, majestically, a weighty study in potential energy, while the accompanying text admits the necessity of calling on public funding for projects of this unprecedented size. The only work being done by people is the guiding of haul ropes—as at the Rouge, men are minor adjuncts to the drama of scale. All of these images depend heavily on meticulous focus across the widths and curves made possible by the wide-angle lens. The paintings also draw on this "new" visual possibility.

"Power: A Portfolio by Charles Sheeler" was the centerpiece of the December 1940 issue of *Fortune* magazine.[7] It followed a feature on Chrysler Corporation's recent successes, and a detailed projection of what an ideal air-sea military base might be like if organized along the lines of the most efficient and powerful new corporations. The portfolio begins with a small watercolor of an old mill, then moves to the TVA "runner" just discussed, followed by a view of Boulder Dam which stresses the transmission tower more, setting its tracery against roughly equal sections of sky, dam and earth, evoking from the writer rapt admiration for its "intensity of feeling . . . as truly a religious work of art as any altar piece, or stained glass window, or vaulted choir." This echoes the usual description of Sheeler's *Ladle Hooks, Open Hearth Building—Ford Plant* (1927), and his evocation of American business as the "religion" of the twentieth century, complete with monuments such as these.[8] The next image, of locomotive wheels, I discuss in a moment. The fourth, *Steam Turbine*, a view within the Hudson Avenue station of Brooklyn Edison Company, sets an older, angular exposed pumping mechanism against a delicately hued, streamlined steel alloy loop— again, massive, and containing an astonishing quantity of energy. The relationship between older and newer modernities seems, here, the rather simple one of replacement.[9] Finally, Sheeler painted an angled view of an airplane wing, emphasizing the propeller blades and engines. In the words of the *Fortune* writer introducing the portfolio: "Sheeler has expressed the new portent in the poised and infinitely precise propeller, aimed at the sky."

Once we see past the overwhelming initial impact of the double-page spread of the painting of locomotive wheels, *Rolling Power*, a puzzle occurs. Why did Sheeler here ignore the currently most fashionable, overtly modern aspect of his subject, the streamlining of the engine body (designed, in this case, by Henry Dreyfuss), and instead picture a detail of its workings, stressing the work of steam in turning the wheels rather than the glamorous speed of this key symbol of modernity? The simple equation of image and ideology, of style and submission, is certainly evoked by much of modernity's insistence on formal clarity. But it is only fulfilled at the cost of instant impotence. Sheeler's functionalism was not just direct, it was fundamentalist: his recurrent reference for it was Shaker design.[10] Something of this persists in his choice of the coal-powered train; his approach was prefigured in Curt Ewald's "Thoughts on the Shape of the Trains" of 1927:

> There is no doubt that in the whole field of mechanical design, the steam locomotive is the machine which enjoys the conditions most conducive to a satisfying aesthetic effect. . . . The locomotive is a self-contained unit, comprising the creation of power (the steam boiler), the transmission of power (the engine) and the release of power (the working parts). One's eyes can literally trace the flow of power from combustion through the generation of steam, the driving mecha-

13.5 Charles Sheeler, *Rolling Power*, 1939. Oil on canvas; 15 × 30 in. (Smith College Museum of Art, Northampton, Mass., purchased 1943)

nism, the driving wheels and the frame to the draw bar which pulls the carriages attached to it. Furthermore it can follow the vertical flow of power which derives from the transference of the heavy weight of the boiler onto the boiler supports, the frame, the axles and the wheels and finally the rails. Thus the primary features of the machine as a whole and those of its component parts are clearly visible: hence their overall organization is an embodiment of the highest aesthetic values. Herein lies the considerable advantage of the steam locomotive as against other types of machine whose function cannot be immediately deduced from their external form. For instance, the stationary steam engine is separated from the source of its power and in large measure also from its working parts; and as for the electric locomotive or the machine tool, the eye is equally unable to spot the power source.[11]

Sheeler maintains a similar insistence on ostensive function, and remains with the values of an earlier modernity in his refusal to paint the darting arrow of the stylized wrappings of the engine body, so attractive to the new industrial designers. But he shifts to modernism in the way he crops the visual field to a direct gaze at/of the wheels, effectively courting the contradiction of the (nearly) stationary engine.

Source of these tensions, as well as an acute sense of their productivity, appears in the caption stretching across the pages underneath the image:

Here is an anatomical study revealing the striving mechanism of a Hudson-type locomotive, designed to haul heavy New York Central passenger trains up to possible speeds beyond 100 miles per hour. In this canvas the sometimes subtle difference between painting and photography may be best examined. Sheeler, himself a photographer of high distinction and perhaps the first to exhibit both his paintings and his photographs on an equal artistic footing, puts the difference in these words. "Photography is nature seen from the eyes outward, painting from the eyes inward." And a critic of his work has written, "We know upon consideration that nature was never quite like that, so luminuous, so formally beautiful, so rich in design, yet nothing seems to have been altered." The even illumination of this painting ("Light," says Sheeler, "is the great designer"), the precise lines of the machinery, evoke as no photograph could the physical sensation of tractive effort, the pull of the drawbars of 45,000 locomotives as they provide the continent with an exchange of goods once possible only to those who lived by the shores of the sea.

The promise of Rouge 1927 fulfilled: the new corporatism has created a new world of different relationships between things; industrial power is the basis of an order articulated with a clarity without precedent. The ease, even grace, with which the writer shifts from the technical to the artistic and on to the economic, each joined by the precision of his specialist language, exemplifies the new corporatist discourse of the modern whose vicissitudes during the 1930s we have examined. The point to make here is that Sheeler is taken now, as he was in 1927, as exemplifying the novel way of seeing appropriate to the new order. What is the nature of this seeing?

The photograph *Wheels* and the painting *Rolling Power* which grew from the series of which it formed part are exceptional works, even among this powerful group.[12] Close focus, concentrated framing of the wheels and forward piston on one side of a new locomotive, arranged flat, exactly parallel to the surface of the image, lit from the side by a cool, clear light, painted with delicacy of color and a loving fidelity to detail. The overall effect is one which so totally excludes human agency—to the extent that the small elements seem to be machines for producing the larger parts—that we sense we have voyeuristically, suddenly, perceived what might be seen by one machine gazing in rapt admiration at the special, different, machine beauty of another.

In pictures such as these, the concept of a "machine aesthetic" achieves sense. No longer representations of machines, given as either anthropomorphic colossi or as possessing a steaming, thumping organic energy—such was the norm established by photographers like Arthur Lange Coburn. The very stillness of these pictures, their refusal to depict any visible energy, any obvious power, is what gives them their power as images, as form straining against form, organizing itself across a surface for reasons of its own, constantly returning to itself. Thus the structuring of these images, their proximity to being *only* structure (rather than pictures of something moving, some narrative sequence), makes them perfect analogies of the "invisible" powers of modernity. Not just the celebrated invisibility of "clean" energy such as electricity, but the anonymous, yet unmistakably visible, guiding hands of the powerful people within these industries and bureaucracies, the new generation of leaders, who, in the 1920s, began to replace the individualist entrepreneurs epitomized by Henry Ford. Indeed, as isolated images, Sheeler's go beyond even this, to a point where the human agency of owners, managers, and engineers is absented, even their domain of perception.

But not only this: also at work is a *double repression* of, on the one hand, "realities" of relationships, particularly social relations (labor power, factory society, local politics, the Depression, unionization),

and, we can now see, another, contrary but nonetheless real fear of the independent pathology of the machine, of the otherness of the new modern order being celebrated apparently so unequivocally. Back in 1923, Sheeler had described an exhibition of Alfred Stieglitz's photographs in terms which resonate through our analysis.

> In turning to the recent portraits which comprise the bulk of the exhibition, one's previous opinion is once more confirmed that the eye of Stieglitz's camera could have been of inestimable value at the time of the Inquisition. Sometimes these exhibits A, B, (*et al.*) hover so near the realm of pathology, that so slight a disturbance as the vibration of a passing truck might send them over the borderline. Now our attention is arrested by a head which fills the rectangle to overflowing and presents to us a section of a countenance at such close range that it is as unfamiliar as an astronomical photograph depicting the typography of a distant planet. Again we may be abruptly halted by the portrayal of the tortured sandaled feet of one who, in order to escape the grilling, may be confessing to a crime she has never committed.[13]

Rarely is the panoptic quality of modernity's gaze so bluntly stated. Rare, too, is such transparent testimony to photography's century-long complicity in institutional surveillance, particularly the cross-class, transgressive *jouissance* which the emerging modernist aesthetic drew from its "dangerous" proximity to such techniques and effect. This kind of connection enabled modernist representation to *reveal the real*, to step up its emotional impact, precisely by subjecting its surfaces to extreme formal and technical constraints—indeed, to tortures. Thus Sheeler's clumsily excessive Inquisition analogy. Then, further, in cases such as *Rolling Power*, modernism *reveals the modern* as a different order of reality.

Sheeler's *American Landscape* and *Classic Landscape* (see figs. 3.8 and 3.9), along with his Rouge photographs, had approached this realization (the factory that runs itself, without even managers). But they withdrew from it, paving our return to "normality" with connotations of the agricultural landscape, of national pride in this burgeoning American industry and, crucially, of Ford Company's type of mass production as a paradigm of benign power. The two *Landscape* paintings stand in relation to the Depression at the same necessary, abstracted, and internalized distance as do the *Power* pictures to the industry-wide boom of the late 1930s. They exaggeratedly, boastfully, display the success of the *Fortune* program of confident, unlimited growth in U.S. industry as a whole precisely by celebrating the independent life of its means of production. (A later, postwar consumerist age would seek the abstract celebration of

its products, isolated from their productive processes, in Pop art of the 1960s.) And they do so through a visual style which, with all its overt, cleanly shining novelty, was also an imagery of an older order—equally constrained, focused, even fundamentalist. Sheeler's art offers the still, silent point of the conjunction of the preindustrial pastoral with the future industrial utopia. Thus the *Fortune* writer, introducing "Power: A Portfolio by Charles Sheeler," tells us that

> The quality that has made Charles Sheeler one of the greatest living American artists can probably be best appreciated through these six canvases, commissioned by *Fortune* and painted in the course of the last two years. For the heavenly serenity of Sheeler's style brings out the significance of the instruments of power he portrays, from the overshot water-wheel above, still turning millstones at Hamilton, Alabama, to the radical motor in the wing of the Yankee Clipper. He shows them for what they are: not strange, inhuman masses of material, but exquisite manifestations of human reason. As the artists of the Renaissance reflected life by picturing the human body, so the modern American artist reflects life through forms such as these; forms that are more deeply human than the muscles of the torso because they trace the firm pattern of the human mind as it seeks to use co-operatively the limitless power of nature.

On this kind of reading, the compelling power of these reticent presentations of the chaneling of enormous natural energy is their cool conferral of the imagined strengths of a proud past and the boundless promises of an unknown future onto the present productive order. This is the primary communicative context of these images: the color feature, within *Fortune's* inflexion of the discourse of modernity. It desperately seeks an aesthetic of significant omission, of the portentiousness of what is not being said: the powerful forces that are not being trumpeted, along with the vastly destructive doubts that hedge all around. The engineer's perspective which animates the journal's text—the rhetoric about human rationality being embodied in the machine, about the designer manipulating nature's "limitless power"—is belied by the imagery, which releases, at least in some cases, a glimpse of another, uncontrollable, mechanical order, and in others, the solid understatement of a pastoral naturalism. Neither of these ranges of imagery exactly fit the new corporatism: as we have so frequently seen, it pictures itself through appropriation and approximation.

In this December 1940 issue of *Fortune* magazine, the new corporations are offering their second, grand-scale "new deal" to government.

The above-mentioned feature on the ideal air-sea military base, right next to the Sheeler *Power* supplement, makes a direct bid to do the job for government in the event of war. The new corporations could run the war along the most efficient and effective lines: look at our diagrams, see our images, accept our proposals. See in Sheeler's paintings how enormously strong and varied a productive system New Deal/New Corporation America already is: a natural powerhouse, an arsenal for democracy. Enter the imagery of the war machine—with typical Time Inc. prescience: the Japanese air force bombed Pearl Harbor one year later, on December 7, 1941.

The Parameters Close In

For all that Sheeler's work sought to naturalize, and nationalize, his imagery remained, as we have seen, too charged with the refinements of abstraction, too much a part of the visual language of the bosses, to ever become an adequate basis of a popular aesthetic of modernity. It did, however, form part of its reference points: less detached than MOMA purism, but not subject to the kitsch literalism of World Fair industrial design. What of the other great tendency of the 1930s—the imaging of reality, the *Life*-style picturing of the lives of the people. What was its role within the war machine?

In October 1933, Lewis Hine went to the Tennessee Valley dam sites to begin what he hoped would be a major survey of TVA projects. Twelve years earlier, Henry Ford had sought to build a new Detroit there, at Muscle Shoals. Hine concentrated on the evacuees, the folk culture about to be eclipsed, and the labor of the construction workers. The TVA preferred records of charts, plans, and installations—perhaps Sheeler's eye would have been more suitable?—and failed to extend Hine's commission.[14] In 1936–37 Hine visited the Baldwin Locomotive Works at Gladstone, Pennsylvania, as part of his work for the National Research Project of the WPA. *Factory Interior* shows a crowded workshop, men doing a variety of jobs related to glassblowing, in convenient proximity to the kiln and each other: it is the essence of a craftman's gathering.[15] In 1937 Charles Sheeler visited the Baldwin plant, making a small series, concentrating on the fall of light through the factory space, its picking out of a rich variety of metal surfaces.[16] Utterly devoid of any human presence, let alone any work process (again, it is the factory as a machine that seems the creator of these machine parts), the contrast with Hine's aesthetic, and ideology, could scarcely be more marked.

Nor could a comparison between Sheeler's *Power* series and another globalizing vision of 1939: Diego Rivera's fresco, *Pan-American Unity* (1940), painted for the Palace of Fine and Decorative Arts at the Golden

Gate International Exposition, San Francisco. In five large panels, the craft skills of ancient Mexicans are juxtaposed alongside the machine skills of modern U.S. architects, workers, and artisans. Among the inventors, Henry Ford and Thomas Edison tinker happily together: an image as bucolic as any put out by Ford Company publicists. The only critical note is a panel warning of the evils of fascism in Europe: alongside Hitler and Mussolini, a devilish Stalin appears. San Francisco looks like Democracity: war is elsewhere in this rather bathetic idyll.[17] As in the imagery of the modernized future in the last panel of his nation's history at the National Palace, Mexico City, Rivera has here lost contact

13.6 Diego Rivera, "The Plastification of the Creative Power of the Northern Mechanism by Union with the Plastic Tradition of the South," panel C in the mural cycle *Pan-American Unity (Marriage of the Artistic Expression of the North and South of This Continent)*, 1940. Fresco; 6.74 × 22.5 m. City College of San Francisco. (Photograph Dirk Bakker; © The Detroit Institute of Arts, Founders Society Purchase. Edsel B. Ford Fund and Gift of Edsel B. Ford)

with the flow of forces most sharply shaping contemporary life—and it shows. Not so Siqueiros, in his savage depiction of fascism, capitalism, and the revolutionary struggle against both in his Mexican Electricians' Union mural, and in his efforts to force new industrial materials into abstract shapes adequate to the global battling of all these forces. Not so Frida Kahlo, whose only painting of her body, naked, *Self-Portrait: The Circle* (1950), shows it headless, the victim of explosive, flaming, cracking, erasing forces of disintegration.[18]

The most informative contrast with Sheeler's work for *Fortune* has already been introduced: government publicity, especially the imagery of the new welfare state created between 1936 and 1940. It is this which was collected, from the beginning of 1942 under the Office of War Information, into a "living archive" of national life. It was the apogee of *Life*-style modernity, especially when the broad picturing of everyday life, with its finely calibrated admixture of the typical and the specific, was

concentrated around organizing the nation into a cohesive, positive, and productive war machine. There was an increase in the circulation of imagery around industry, a revaluation of work as the forger of true masculinity and of a new necessary feminity, as the source of physical health, and as the foundation of dutiful sociality. We have heard Stryker on how to construct this imagery, and have seen it done, for both the government and the corporations (no longer so new) seeking a renewed alliance during this global emergency.[19] A striking instance, epitomizing documentary in the service of the war effort, was the massive photomural created by photographers of the Farm Security Administration to promote the sale of defense bonds in late December 1941.[20] Installed in the concourse of Grand Central Station, New York, it was approximately 85 feet high and 120 feet long, filling the entire upper east wall.

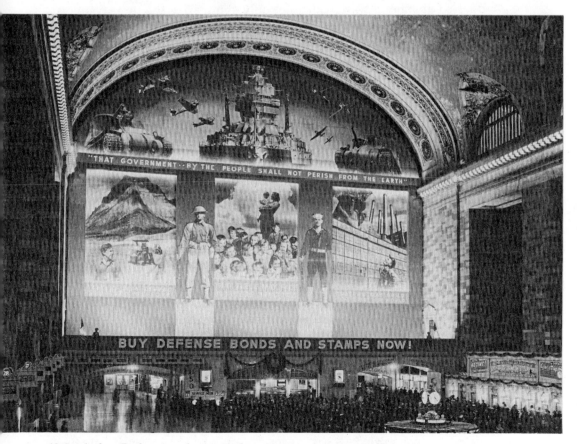

13.8 Arthur Rothstein, photomural to promote the sale of defense bonds, Grand Central Station concourse, New York City, 1941. Library of Congress, Prints and Photographs Division. (LC US F34-24493 D)

The mural has been dismissed as the crudest example of Stryker's compromise policy of showing "ship yards, steel mills, air craft plants, oil refineries and always the happy American worker," and as aesthetically vacuous as the boy-meets-girl-meets-tractor sentimentality of Soviet Socialist Realism.[21] But the crisis atmosphere of war, its "liberty or death" finality, brings out in imagery not so much a picturing of fundamental values, more an arrested inventory of those ideological items deemed essential to consensus. No more allusion, indirection, subtle secondary associations: only the austerity of the common absolutes. As so often, Stryker put it most graphically. In a 1940 letter to Jack Delano demanding more "maple syrup" images of an abundant autumn, he exhorts: "Do you think I give a damn about a photographer's soul with Hitler on our doorstep?"[22] The defense bonds photomural posits the ordinary as both basic and ideal; it also asserts it as triumphant. And it does so, finally, in ways which not only summarize the three couplets forming the iconography of mass-production modernity but which also display their incorporation into an imagery of *Life*-style modernity. It is, in this sense, an icon of the modern effect.

The mural resonates with echoes of images and strategies already examined. Its central panel of the mother and the flock of children recalls the *Germination* panels of Rivera's East Wall in Detroit, the industrial plant panel might be a composite of Sheeler's Rouge studies, and the wheat fields below lofty mountains is a favorite FSA image of plenty.[23] The differences are equally marked: not only in the evolution of photographic styles, but in the contextualizing effects of the ensemble itself. Rivera's allegories of mineral, plant, and human birth are replaced by a picture of these existing people posing such that their submerging of individuality to a stereotype conveys the general effect of human continuity. Sheeler's *Criss-Crossed Conveyors* underlies the image of heavy industry: a Kahn-type, single-story frame shed (indeed, it is close to his Glass Plant at the Rouge, 1925, or his Tank Arsenal for the Chrysler Corporation, Warren, 1941)[24] is surmounted by an improbably huge blast furnace and a more proportionally rational set of powerhouse chimneys. Both seem Sheeler images of the Rouge, or closely based on them.[25] Yet the absence of interlocking diagonals, the simple convergence of three, clearly directional elements, and above all, the inclusion of a larger-than-life smiling worker locate this panel in a compositional logic at once more closed (in its interlocking triangles) and more open (in its simple dispersals of evident connections). It also exists in an ideology that acknowledges the power not only of the "great productive machine" but also of those who labor within it. Human work is restored to the couplet: indeed, in this mural, the cloth-capped worker stands in

the donor's position, in the place of ownership. He parallels the farmer on the left, who also carries an implication of ownership: probably residual, given the evident mechanization of the land, itself paralleling machine-based heavy industry.

The play of triangles within the overall mural scheme engenders resolutions rare within the diurnal rush of *Life*-style modernity but crucial to such a summary statement of its underlying structures. The farmer and the factory worker are the cornerstones of the entire edifice. They are foundational to their industries, being shaped by them, and shaping them in turn (so the pictures say). These two panels assert the importance of the land, and of manufacturing industry, with an *equivalence* of emphasis impossible before. In 1936, agriculture was on the edge of natural, economic, and human disaster: this golden harvest declares that those desperate years are behind us. It realizes much of the all-American mural Steichen dreamed of in 1938. Heavy industry would have dominated representations from the 1910s and 1920s (it is still the visual base for the verbal tag "That we may build a better world"), while rural pastoralism led the way before then (its tag is "That we may defend the land we love"). There may also be an FSA-specific message of improvement in the central panel: is not the woman standing tall, against the sky, with the baby cradled in her arms, reminiscent of Lange's icons of faith-breaking despair?[26] Yet here the woman of the High Plains is transformed into the central image of what is being fought for: the crowd of children makes her as fertile as the land, as productive as the factory. She is the home base of normalcy. And more: this shining silhouette of the woman holding one child resonates with allusions to the Virgin Mother, the Holy feminity at once pure yet fertile. Her secular sanctity is the basis of the larger letters in the caption to her panel—"That these may face the future unafraid."

The central panel carries two significant absences: compared to the mountain and the powerhouse stacks, it lacks an upthrusting verticality—from which it is no step at all (just the usual form/content fissure)[27] to noticing the absence of a male figure at the visual heart of the whole. This panel is a feminized space, both comfortingly domestic and a dark, cloudy mystery. It stands, superficially, for keeping the home fires burning, but within the logic of the whole, it cries out for impregnation—which is done, metaphorically and very busily, by the rest of the ensemble, itself the visual embodiment of patriarchy, U.S. style, vintage 1941. The farmer looks across, perhaps at the soldier he might become, perhaps at his progeny. The factory hand looks up, perhaps at the sailor he could become, but also at the huge ship plowing forth above. The soldier and sailor not only defend agriculture, industry and

the home; they are the twin pillars of the defense forces, the human agents of the massive machinery of war.

Tanks and planes dance attendence on the great ship: the play of triangles reaches its peak here, in the power of symmetry. The Law of the Father is made manifest through this appearance in a variety of ways: its bristling brutality, its aggressive armory, its insistent verticality, its prickly immanence, its shining, crowning glory. It is the strongest image of masculinity present, and, by reversing the vertical logic which culminates in it, we suddenly see that it is the essence of the fathering principle absent from the central panel. All the other males in the montage could be fathers, but only within a framework organized and dominated by this figure. The figure is, of course, not a ship per se, but the State, the society as a whole (land, home, factory, armed forces), shaped into a perfectly balanced, yet vibrantly dynamic, war machine. Thus is "government . . . by the people" redefined: the new corporate, welfare state grows strong in adversity by stripping to its essentials and fertilizing itself. And it does so in the most modernizing manner: by merging its often contradictory discourses (farm work, the family, industrial labor, and militarism) as integral equivalents, so the State becomes a war machine, built by heavy industry and fueled by primary products and service by its people, figured here through a visual conjuring of connections, a rapturous yet restrained, awesome yet regulated interpenetration of land, steel, and flesh, of earth, machine, and bodies.

What of the other couplets, proposed earlier as part of the iconology of modernity, along with the industrial plant/factory land conjunction, and its other, the land/farmland, whose fusion arrives so decisively in this mural? The modern city and its crowds are not pictured. Was this because the FSA photographers shared an ethos which regarded Middletown as the generator of the values, or because something of the modern city is implied both in the imagery of the Rouge as a "City of Industry" and in the self-contained, ultramodernity of the battleship? Such speculation is unnecessary. Grand Central Station, site of the mural, was at the heart of the most modern city in the world. Processing crowds for the purpose of traveling (usually to and from work) was its business, its productivity. The other couplet, the consumable object/the consumer, is also not pictured in the way it was so frequently placed in war settings in contemporary advertisements.[28] Yet it is present in the act of looking, for its spectators: the photomural is itself the product, offering itself as seductively as its designers know how, to be consumed by its viewers, above all through their resolving to enact the legend that rules if off, making it the biggest ad in town: "BUY DEFENSE BONDS AND STAMPS NOW!"

The bottom line of all these exchanges is, however, not monetary but symbolic: the State itself stands revealed, a full feast for our eyes, in all its nakedness, as consisting only of its resources, its services, and its people. That these are portrayed as, in turn, limitless, straightforwardly efficient, and already fully committed is, while the primary effect, of secondary significance. The basic message is that, in this nation, there is no center for the eye of power; there is only everybody seeing everybody else, including themselves in their looking, as part of this unity of exchanged gazes, this utterly transparent whole. *Life*-style imagery of modernity, "Made in America" stamped all over it, has finally arrived on Broadway, all decked out as the unchallenged essence of "Modern America," the last scene in the last act, before a curtain that will never fall. The defense bonds mural is unabashedly propagandistic: the needs of war sweep aside the objections about governmental interference that rode so close a watch on official publicity for decades. There is nothing hidden about this persuasion; its very transparency is its rhetorical seduction, its truth-effect, and its conviction as an illusion of reality.

Such a consummation of representation and reality, of sign and referent, amounting to an unmediated display of reference itself, would make the war machine's symbolizing processes unique among the tendencies within the imagery of modernity we have been tracing. Does this climatic amalgamation—more accurately, it was a closing of the parameters between previously contesting extremes—finally transcend the ideological conjuring, the delusory duplicity, and the brutal coercions that we have seen at work, in a variety of ways, in every previous phase? Taylorism stole autonomous work space in the name of rational labor and an equitable solution to the labor problem; the Ford Company created "great productive machines," driven by incessant seesawing between regulation and excess, robotized its workers and mechanized production, while at the same time trumpeting the "$5 day," selling its universality through aestheticized imagery of its plant, and absorbing its others (rurality, the past, history) as pastoral fiction; avant-garde modernism and Deco design remained too expensively craft-based to spread far beyond the subcultures of the rich. These drives to totality imploded, as we saw, in 1929: they failed to work on the ground; they were subject to constant criticism from all sides. The sleights of hand of the next decade had to serve a wounded but resilient corporatism—thus the parasitic "business culture" of *Fortune*. It also had to incorporate the needs of the people: its workers and its consumers. From the FSA's usage of critical reform imagery in removing sharecroppers from the path of monopolizing, mechanized agriculture to the demotic inclusiveness of both *Life* and government publicity, the New Deal double shuffle un-

folded. Similarly, the failing utopian futurama of the World's Fair, the science fiction fantasies of a streamlined society, along with the purist refinements of MOMA formalism and, in certain situations and against its grain, even the radicality of Rivera, Shahn, and the Social Realists, all appear more and more as exaggerations which created, around and between them, a crucial space for compromise. Their combined effect became the message: like this, but less so.

In these ways the war machine completed the monopolizing thrust of each of these two-sided drives, cemented the business-government alliance, smoothing the tensions that still marked the previous decade. Closure occurs precisely in the very illusion of openness in the defense bonds photomural: by the early 1940s, most imagery of modernity, whatever its location, invited ways of seeing that worked, on the model of a Russian doll, as a constant, obsessively repeated demonstration of having nothing to hide. Thus does bourgeois realism secure its effects, by inviting the lifting off of the veil of instant appearance to discover that its replica lies beneath.[29]

The Modernity of Everyday Life

The *Power* series and the defense bonds mural are the barest introduction to the imagery of America, on the edge, then at war. They mark out two positions on a complex perimeter, the outline of which needs careful tracing. They are closer together than many of the key works of the 1930s, but the conditions of their convergence remain to be shown. A profile of the main forms of modern imagery after 1940 also needs to be drawn. The simplification of which Frankl wrote in 1928 seems to lose its modernist purity, the critical connotations of documentary retreat to a disruptive straightforwardness, while the playful fantasies of streamlining and the fairs dissipate rapidly. The practicalities of war organization would have had their impact: an austerity due to shortages, an increase in standardization, an echo of the regulation and watchfulness felt necessary for internal security. At the same time there occurred an acceleration in the technologies of information gathering and communications.[30]

The most evident effect of these—and, I am sure, of many other—factors was that a certain directness of layout, permitting the easy imposition of any other imagery without a sense of excess or conflict, became the design norm in nearly all domains. Obvious exceptions include high-profile corporate architecture, where the International Style created a powerful but limited presence, and, from another trajectory, the spectacular overstatement of tail fins, lights, and other "features" in automobile styling. It may well be that future study of the imagery of mo-

dernity in the 1950s will reveal more continuities than contrasts. Such studies might profitably trace the fate of the three couplets proposed here as ubiquitous in the iconography of modernity between the wars. One surmises that the figuring of work diminishes significantly, and that the consuming couplet comes to the fore (if the archaeology first sketched in *The Mechanical Bride* is accurate).[31] This is relevant to the gestation of the generation, itself a cultural creation of the 1950s in the form of "American youth," currently taking up positions of influence, generating contemporary representations, and consuming them apace.[32] It may also be of interest to explore how persistent are the relations which inflected the iconology of modernity: its ideological conjurings, for example, its sleights of hand, particularly when it came to the crucial questions of power. Does the modern economy of seeing, in evolution since around 1800, move after 1945 into a new phase, as I have shown it to have done around 1910 and again around 1935?

A further aspect of this modern effect worthy of detailed study would seem to be the impact of the exporting of Ford Company and related modernities to what became economic colonies of the United States during these decades—Germany, the United Kingdom, much of South America, Australia, for example. The acceptances and rejections, the cultural overriding and resistances, are bewilderingly complex. To date, if they have received attention at all, it has been mostly in terms of external influences on dependent high cultural forms, such as painting. A quite different picture would doubtless emerge if the exchange were conceived as one working across a broadly spread imagery of modernity. This of course would include the particularities of specific practices. Immediately evident would be a deepening of respect for the resilience of national cultures, however apparently overwhelming the impact of U.S. modernity.[33] Sorting through these relationships with an eye to their current relevance seems to be one of the more important tasks for cultural criticism.

Much that has been raised here remains at the level of suggestion: the complex couplet of the city/crowd, the elusive metaphor of the machine—often spoken, less often visualized, was it so central to modernity?[34] The discussion of advertising imagery, and of industrial design, needs to be more securely located in an analysis of the social psychology of consumerism. Nor can any study of the visual imagery of modernity be thought of as far reaching unless it covers the constructions of meanings in the "image-movement" of film. In this analysis, the displacement of high art by the concentration on the broader imagery of modernity has emphasized certain relationships at the expense of others; needing more exploration are the constructions of sexuality in modernist im-

agery and, quite other, the construction of sociality in American Scene painting, especially in murals. The most obvious understatement has been that of the imagery of resistence: while I have tried to maintain a critical perspective, and to highlight outstanding instances, I have been unable to offer detailed information and fresh insight into, say, the work of the other Mexican muralists in the United States or into Rivera's pictured protests by the Detroit autoworkers and other campaigns by the labor movement at the time.

All these tasks remain before the argument can be seen as fully in place. Nonetheless, I hope that in its present form, this account of the genesis of the U.S. corporate state phase of modernity, and of the visual imagery that was such a significant part of it, suggests a skeptical view of declarations that we have arrived at a condition somehow beyond modernity and its problematics. More importantly, I hope this account will play a part in the emergence of a more realistic, but also more critical, approach to the complex and multiple visual cultures of modernity.[35]

(*Opposite*) Walter Dorwin Teague, interior, Ford Building, New York World's Fair, 1939–40. (The Brooklyn Museum, neg. 8.75)

NOTES

Introduction

1. Konstantin Fedin, *The Conflagration*, trans. Olga Sharise (Moscow: Progress Press, 1968), 280.

2. *New York Times*, May 20, 1919.

3. V. I. Lenin, "The Immediate Tasks of the Soviet Government," in *Collected Works* (Moscow: Foreign Languages Publishing House, 1963), 27:259; also in *Selected Works*, ed. J. Fineberg (London: Lawrence and Wishart, 1937), 7:332.

4. Charles Baudelaire, *The Painter of Modern Life and Other Essays* (London: Phaidon, 1964), 12–15.

5. On Italy, see Umberto da Silva, *Ideologia e arte del fascismo* (Milan, 1974). On Germany, see Barbara Miller Lane, *Architecture and Politics in Germany, 1918–1945* (Cambridge: Harvard University Press, 1968 and 1985); idem, "Architects in Power: Politics and Ideology in the Work of Ernst May and Albert Speer," in Robert I. Rothberg and Theodore K. Rabb, eds., *Art and History: Images and Their Meaning* (Cambridge: Cambridge University Press, 1988), 283–310; and Terry Smith, "A State of Seeing, Unsighted: Notes on the Visual in Nazi War Culture," in Paul Patton and Ross Poole, eds., *War/Masculinity* (Sydney: Intervention, 1985), and in *Block* 12 (Winter 1986–87): 50–70.

Chapter 1. Fordism

1. Louis-Ferdinand Céline, *Journey to the End of the Night* (New York: Penguin, 1966), 195–97.

2. See Julia Kristeva, *The Powers of Horror: An Essay in Abjection* (New York: Columbia University Press, 1972), *passim*.

3. *The Ford Industries: Facts about the Ford Motor Company and the Subsidiaries* (Detroit: Ford Motor Co., 1924), 114.

4. The basic study of Ford Motor Co. (as opposed to the plethora of fabulations about the Ford family) is still the volumes by Allan Nevins and Frank Hill, *Ford: Expansion and Challenge, 1915–1933* and *Ford: Decline and Rebirth, 1933–1962* (New York: Charles Scribner's Sons, 1957 and 1963). Nevins also authored, in collaboration with Hill, *Ford: The Times, the Man, the Company* (New York: Charles Scribner's Sons, 1954). The figures cited in this section are taken from these texts and David A. Hounshell, *From the American System to Mass Production, 1800–1932: The Development of Manufacturing Technology in the United States* (Baltimore: Johns Hopkins University Press, 1984), and Alfred D. Chandler, Jr., *Giant Enterprise: Ford, General Motors and the Automobile Industry* (New York: Harcourt, Brace and World, 1964).

5. *Encyclopaedia Britannica*, 13th ed., s.v. "mass production."

6. Hounshell, *From the American System to Mass Production, 1800–1932*, especially the introduction and chapters 6, 7, and 8. This brilliant study traces closely the contribution of "Yankee" machinist engineers, is carefully skeptical about all previous accounts, and shows unusual sensitivity to visual sources as historical evidence. His account of the emergence of the assembly line is the most finely detailed to date; the following is heavily indebted to his close observation.

7. Charles Sorensen, *My Forty Years with Ford* (New York: Norton, 1956), cited in Hounshell, *From the American System*, 217.

8. Sorensen, *My Forty Years with Ford*, 117–19. This claim of Sorensen's is uncollaborated, although he was involved in the installation of a conveyor-type mold carrier in the Highland Park foundry in February 1913. See Hounshell, *From the American System*, 239. The Ford Company Oral History reminiscences are extensive and housed in the Ford Archives, Edison Institute, Dearborn.

9. Henry Ford, *My Life and Work* (New York: Doubleday, 1922), 81–83. Samuel Crowther was the ghostwriter. Horace L. Arnold and Fay L. Faurote, *Ford Methods and the Ford Shops* (New York: Engineering Magazine Co., 1915).

10. Thomas P. Hughes, *American Genesis: A Century of Invention and Technological Enthusiasm, 1870–1970* (New York: Viking, 1989), 204–5. Chapter 6, "Taylorism + Fordism = Amerikanismus," is an interesting study of the impact of American mass production in Europe, especially Germany and Russia.

11. Colvin was overwhelmed by the plant's productivity, calling its output of over half that of the United States "marvellous," comparable only to the Baldwin locomotive works at Eddystone, Pennsylvania (a specialized batch producer into which mass production methods were slowly, and then only partially, introduced from this period). Fred Colvin, "Building an Automobile Every 40 Seconds," *American Machinist*, May 8, 1913, 757 and 760.

12. See, for example, Fred H. Colvin, "Machining the Ford Cylinders," *American Machinist*, June 12, 1913, 971. Spooner and Wells had been photographing the plant during 1912, and perhaps earlier. Six folders of their images are held in the Ford Archives, Edison Institute, Dearborn. Their photographs were also used by Arnold and Faurote, *Ford Methods and the Ford Shops*.

13. Arnold and Faurote, *Ford Methods and the Ford Shops*, 420.

14. Fred H. Colvin, "Ford Radiators and Gasoline Tanks," cited in Hounshell, *From the American System*, 236.

15. Nevins, *Ford*, ch. 18. This development is echoed in the later Nevins and Hill volumes and in most subsequent accounts.

16. Hounshell, *From the American System*, 237–39.

17. Ibid., 244.

18. Ibid., 247–48.

19. Eugene S. Ferguson, "The Mind's Eye: Nonverbal Thought in Technology," *Science* 197 (Aug. 1977): 827–36. I am indebted to David Hounshell for this reference and to Eugene Ferguson for his comments on this chapter.

20. The concept of the paradigm is drawn from Thomas Kuhn's usage in *The Structure of Scientific Revolutions* (Chicago: University of Chicago Press, 1962).

21. Karl Marx, *Die Grundrisse* ed. and trans. David McLellan (New York: Harper and Row, 1971), selections 5, 12 and 18, being extracts from pp. 80–82, 354–59, and 583–92 of the ms.

22. These observations are based on the analysis by Gilles Deleuze and Felix Guattari, *Anti-Oedipus: Capitalism and Schizophrenia* (New York: Viking Press, 1977), 232ff.

23. Ford, *Life and Work*, 146–47.

24. Closely traced by Hounshell, *From the American System*, in ch. 7, "Cul-de-sac: The Limits of Fordism and the Coming of 'Flexible Mass Production.'"

25. Henry Ford Office Papers, Ac. 2, Misc. Corresp. 1914, box 38, Ford Archives, Edison Institute, Dearborn.

26. Stephen Kern, *The Culture of Time and Space, 1880–1913* (Cambridge: Harvard University Press, 1983), 92.

27. Here I accept Hounshell's distinction between Taylorism and Fordism, and his point about Ford Motor Company absorbing many techniques of scientific management into its machinist orientation (*From the American System*, 249–53). The issue of just how widespread Taylorism was before 1916–18 remains to be resolved. I have stressed, for the purposes of this account, the acceleration of Taylorist spatial controls, including the role of machines, and the next few pages show how Ford developed these into a qualitatively different order, both at Highland Park from 1914 and at the Rouge, Dearborn, Michigan. Other emphases in my account parallel those in Bernard Doray, *From Taylorism to Fordism: A Rational Madness* (Paris: Bordas, 1981; London: Free Association, 1988).

28. *Oxford English Dictionary*, 2d ed., q.v. "machine."

29. Ford Company passenger motor vehicle production for 1909 was 19,000 units; 1911, 39,640; 1912, 78,000; 1913, 182,311; 1915, 342,115; 1917, 740,770; 1919, 664,482; 1921, 845,000; and 1923, 1,669,298. These figures represented the following percentages of total passenger vehicles produced in the United States: 1911, 19.92; 1913, 39.46; 1915, 38.18; 1917, 42.43; 1919, 40.08; 1921, 55.67; 1923, 46.05. In January 1914 a Model T was assembled in 93 minutes, entailing 84 operations to assemble the motor and 45 for the chassis. By February 7, 1920, Model Ts were being produced at the rate of one per minute, and by October 31, 1925, one every ten seconds. A Model T touring car cost $950 in 1909, $550 in 1913, $440 in 1915, $355 in 1921, and $295 in 1923. The runabout model, introduced in 1911, cost between $100 and $50 less. Between 1908 and 1912, Ford Motor Company averaged 118 percent profit per annum. Figures from Nevins and Hill, *Ford: Expansion and Challenge*; Nevins, *Ford*; and Chandler, *Giant Enterprise*, see industry statistics, p. 3, but higher sales figures for the Model T during these years, p. 33.

30. Deleuze and Guattari, *Anti-Oedipus*, 237.

31. Allan L. Benson, *The New Henry Ford* (New York and London: Funk and Wagnalls, 1923), introduction.

32. The title of chapter 2 of Ford's self-published *My Philosophy of Industry*

(Detroit, 1929). On the religious imagery accruing to Ford in the 1920s, see David E. Nye, *Henry Ford: "Ignorant Idealist"* (Port Washington, N.Y.: Kennikat, 1979), ch. 2.

33. See Manfredo Tafuri, *Architecture and Utopia* (Cambridge, Mass.: MIT Press, 1975).

34. John H. Deventer, "Principles and Practice at the River Rouge," *Industrial Management* 114 (Oct. 1922): 196, cited in Nevins and Hill, *Ford: Expansion and Challenge*, 204.

35. Ford, *Life and Work*, 174–75.

36. Lenin's admiration cited above in the introduction, n. 3. In 1938 Ford sent Hitler a $50,000 fiftieth birthday check, along with congratulations on setting the country back on its feet. In *Mein Kampf* Hitler celebrated Ford for standing alone against Jewish financiers, and awarded Ford, on the latter's seventy-fifth birthday in 1938, the Grand Cross of the German Eagle, the highest possible award to a foreigner. See Charles Levinson, *Vodka-Cola* (London: Gordon and Cremonesi, 1978), 212; Albert Lee, *Henry Ford and the Jews* (New York: Stein and Day, 1980), 57–66; Nevins and Hill, *Ford: Expansion and Challenge*, 169.

37. Karl Marx, *Capital* (Moscow: Foreign Languages Publishing House, 1959), 3:249. First published in 1894, edited by Frederic Engels.

38. Ibid., 250.

39. Deleuze and Guattari, *Anti-Oedipus*, 222–62.

40. Mira Wilkins and Frank E. Hill, *American Business Abroad: Ford on Six Continents* (Detroit: Wayne State University Press, 1964); Steven Tolliday and Jonathan Zeitlin, *The Automobile Industry and Its Workers: Between Fordism and Flexibility* (Cambridge: Polity Press, 1986).

41. Victory Lasky, *Never Complain, Never Explain: The Story of Henry Ford II* (New York: Marek, 1981), 39. On industrial spying at Ford during the mid-1920s, see Jonathan Norton Leonard "Only the Emotion of Pity," in John B. Rae, ed., *Henry Ford* (Englewood Cliffs, N.J.: Prentice-Hall, 1969), 110.

42. Arnold and Faurote, *Ford Methods and the Ford Shops*, 33.

43. Ibid., 31.

44. A recent example is Joel Colton and Stuart Bruchey, eds., *Technology, Economy and Society: The American Experience* (New York: Columbia University Press, 1987), 2–4.

45. Chandler's general argument was first put in *The Visible Hand: The Managerial Revolution in American Business* (Cambridge: Harvard University Press, 1971) and updated since in, for example, "Technology and the Transformation of Industrial Organization," in Colton and Bruchey, *Technology, Economy and Society*, ch. 3.

46. Arnold and Faurote, *Ford Methods and the Ford Shops*, 63.

47. Chandler, *Visible Hand*, 302–14. To Chandler, Singer's combination of new technologies and new management "culminates" in Highland Park mass production (Chandler, "Technology and the Transformation of Industrial Organization," 66–67). Hounshell disputes that Singer achieved perfect interchangeability of parts and stresses more its marketing expertise (*From the American System*, ch. 2).

48. Carl G. Barth, cited in George D. Babcock, *The Taylor System in Franklin Management* (New York: Engineering Magazine Co., 1917), 18–19. Franklin made an upmarket car: in 1908, production of less than a hundred per month was adequate, even "thriving," in the view of management. After nine years of the

Taylor system they made forty-five cars a day with a 90 percent wage increase and "no labor trouble of any kind" (29–30).

49. Hugo Diemer, *Factory Management* (New York: McGraw-Hill, 1910).

50. Babcock, *Taylor System in Franklin Management*, 3–5. It has been acknowledged from perspectives as diverse as L. Urwitz, *A Short Survey of Industrial Management* (London: British Institute of Management, 1949), 16–17, and Harry Braverman, *Labor and Monopoly Capital* (New York: Monthly Review Press, 1974).

51. A striking instance is the quite different interpretation of the nature of the input, in 1913, of Walter E. Flanders. To Nevins, he introduced Taylorist time and motion analysis (*Ford*, 466–76), whereas for Hounshell he is the first to introduce the perspectives of the "genuine Yankee mechanic" (*From the American System*, 220–23). My emphasis here accords with that of David H. Noble in both *America by Design: Science, Technology and the Rise of Corporate Capitalism* (New York: Knopf, 1977) and his recent *Forces of Production: A Social History of Industrial Automation* (New York: Knopf, 1984).

52. See Daniel Nelson, *Managers and Workers: Origins of the New Factory System in the United States, 1880–1920*, (Madison: University of Wisconsin Press, 1975).

53. Edwin T. Layton, *The Revolt of the Engineers* (Cleveland, Ohio: Case Western Reserve University Press, 1971).

54. Arnold and Faurote, *Ford Methods and the Ford Shops*, 47.

55. Among many studies of the history of Detroit, Robert Conot's *American Odyssey* (New York: Morrow, 1974) stands out for its emphasis on the human actors, particularly workers. See his chapters 34 and 35 on the $5 day, and treatments of other elements of the Ford saga, such as Ford's corporate style and the Service Department's battles with unionism during the 1930s.

56. Steve Babson, *Working Detroit: The Making of a Union Town* (New York: Adama Books, 1984), 31.

57. Stephen Meyer, *The Five Dollar Day: Labor, Management and Social Control in the Ford Motor Company, 1890–1921* (Albany: State University of New York, 1981).

58. Arnold and Faurote, *Ford Methods and the Ford Shops*, describes categories of workers, 58–61.

59. U.S. Senate, *Report of the Commission on Industrial Relations* (Washington, D.C., 1915), 8:7626, cited in Meyer, *Five Dollar Day*, 126.

60. Undated and unsourced photographs in "Modernization and Home Improvements Sociological Department" folder, Ford Archives, Edison Institute; they show the perspectives discussed below in relation to documentary photography prior to the 1930s. The company perspective is given in, for example, the previously cited *Ford Industries: Facts about the Ford Motor Company and Its Subsidiaries*, 111–23. Meyer's view given in *Five Dollar Day*, 123.

61. Loren Baritz, *The Servants of Power: A History of the Use of Social Science in American Industry* (Middletown, Conn.: Wesleyan University Press, 1960), 33. Basic material on the Sociological Department can be found in Samuel Marquis, *Henry Ford: An Interpretation* (Boston: Little, Brown, 1923); see also Nevins, *Ford*, 550ff.; Keith Sward, *The Legacy of Henry Ford* (New York: Reinhardt, 1943), 58–60; and Meyer, *Five Dollar Day*, ch. 6.

62. Meyer, *Five Dollar Day*, 130.

63. Céline, *Journey to the End of the Night*, 198.

64. Antonio Gramsci, *Prison Notebooks*, ed. Quentin Hoare and Geoffry Nowell-Smith (New York: International, 1971), quotations below from 279–302.

65. Ibid., 305.

66. Stuart Ewen, *Captains of Consciousness: Advertising and the Social Roots of Consumer Culture* (New York: McGraw-Hill, 1976), 24.

67. Edmond Preteceille and Jean-Pierre Terrail, *Capitalism, Consumption and Needs* (Oxford: Blackwell, 1985), 68.

68. Gramsci, *Prison Notebooks*, 285 and 286. These observations prefigure Michel Foucault's conception of the exercise of power in modern societies through the panoptic gaze. See Foucault, *The History of Sexuality: An Introduction* (New York: Vintage, 1980); 1:90–96; idem, *Discipline and Punish: The Birth of the Prison* (Harmondsworth: Penguin, 1979), 187, 200–217; and idem, "The Eye of Power," in Colin Gordon, ed., *Power/Knowledge: Selected Interviews and Other Writings by Michel Foucault, 1972–1977* (New York: Pantheon, 1980).

69. Sward, *Legacy of Henry Ford*, 58; Nevins, *Ford*, 554 and 556.

70. Eugene Ferguson's observation, private communication, March 1990, with reference to Andrew Ure, *Philosophy of Manufactures* (London: Charles Knight, 1835), cited in Friedrich Klemm, *A History of Western Technology* (Cambridge, Mass.: MIT Press, 1964), 294.

71. Sward, *Legacy of Henry Ford*, 293.

72. For example, *Time*, January 3, 1938, 7 and 8 (on the NLRB finding). These are too frequent to cite, especially during periods of public labor agitation, such as 1932, 1934, 1937, and 1941. Usually quick to expose any exaggeration of Sward's, Nevins and Hill support this account of the arrogant exercise of power. For another labor view see Carl Raushenbush, *Fordism, Ford and the Workers, Ford and the Community* (New York: League for Industrial Democracy, 1937); for Harry Bennett's view see *We Never Called Him Henry* (New York: Fawcett, 1951).

73. See Raushenbush, *Fordism*; Sward, *Legacy of Henry Ford*, ch. 24.

74. The Founding Father of Aldous Huxley's island dystopia is named Ford.

Chapter 2. Architecture and Mass Production

1. The significance of the Austin Company of Cleveland was similar to that of Kahn Associates, particularly during and after World War I. Martin Greif's claims that the Austin Company was the originator of steel-frame, standardized factory building and of a fully integrated method of supplying clients with all design, architectural, engineering, and construction services are not fully demonstrated in *The New Industrial Landscape: The Story of the Austin Company* (Clinton, N.J.: Main Street Press, 1978), 57ff. and 34ff. The first steel-frame factory was the Fischer Marble Company, Bronx, by Charles Caldwell in 1902 (*Architectural Review* 126 [Nov. 1959]: 289–90). Kahn used steel framing for the Machine Shop at Highland Park and for the Packard Forge Shop in 1911. His Eagle Plant at the Rouge, 1917–18, is the first of many huge, standardized, and extendible steel-frame factories for Ford and others. These parallel the work of the Austin Company from 1916, when it established offices in other industrial centers, including Detroit (Greif, *New Industrial Landscape*, 59ff.). Austin may well have preceded Kahn in systematizing, by 1911, all factory design, engineering, and construction into one commercial package (34–36).

2. Helen Bennett, "Albert Kahn Gives People What They Want," ms. for *American Magazine*, June 1929, cited by Grant Hildebrand, *Designing for Industry: The Architecture of Albert Kahn* (Cambridge, Mass.: MIT Press, 1974), 51.

3. W. Hawkins Ferry, *The Buildings of Detroit* (Detroit: Wayne State University Press, 1968).

4. Albert Kahn, "Architectural Trend," *Journal of the Maryland Academy of Sciences* 2, no. 2 (Apr. 1931): 125.

5. Hildebrand illustrates and discusses most of the Kahn buildings referred to here and below. A less technical survey is W. Hawkins Ferry, *The Legacy of Albert Kahn* (Detroit: Detroit Institute of Arts, 1970). The company itself published regularly, for example, *Industrial and Commercial Buildings* (Detroit, 1937). Longtime Kahn chairman Sol King authored *Creative—Responsive—Pragmatic: 75 Years of Professional Practice: Albert Kahn and Associates* (New York: Newcomen Society, 1970). Le Corbusier's fascination is evident on pages 37–41 of *Towards a New Architecture* (London: Architectural Press, 1977), particularly pages 38–39, where the *Faguswerke* appears as if it were an American factory. Reyner Banham points out that in other editions this image was replaced with a photograph of nothing less than the Original Building at Highland Park: *A Concrete Atlantis: U.S. Industrial Building and European Modern Architecture* (Cambridge, Mass.: MIT Press, 1986), 215.

6. There is a large literature on this subject. I found useful Paul Mantoux, *The Industrial Revolution in the Eighteenth Century: An Outline of the Beginnings of the Modern Factory System in England* (London: Cape, 1928); Jennifer Tam, *The Development of the Factory* (London: Cornmarket, 1970); Sigfried Gideon, *Space, Time and Architecture* (Cambridge: Harvard University Press, 1941); J. M. Richards, *The Functional Tradition in Early Industrial Buildings* (London: Architectural Press, 1958); H. A. N. Brockman, *The British Architect in Industry, 1841–1940* (London: Allen and Unwin, 1974); John Winter, *Industrial Architecture* (London: Studio Vista, 1970). Kahn is ignored by Gideon, praised by Winter but as a "methods man" in a separate chapter from the modernist architects of Europe and the United States. Recognition of the significance of the "daylight factory" in both architectural and industrial history terms has been very recent: Banham's *Concrete Atlantis* is an instance, as is the fine dissertation by Lindy B. Biggs, "Industry's Master Machine: Factory Planning and Design in the Age of Mass Production, 1900 to 1930," M.I.T., 1987.

7. *Engineering* 26 (July 12, 1878), emphasis in original, cited in Biggs, "Industry's Master Machine," 12.

8. Additional Tax Case, 1913, cited in Nevins, *Ford*, 454. Other notes in Nevins give 1926 and 1927 as the date of the same case.

9. Reyner Banham, *Theory and Design in the First Machine Age* (London: Architectural Press, 1960), 193.

10. Banham's later interpretations of Kahn's factories (in *Concrete Atlantis*) are discussed below.

11. Ferry, *Legacy of Albert Kahn*, 33.

12. The degrees to which the *Faguswerke* was "an American shoe last factory" is extensively discussed by Banham, *Concrete Atlantis*, 181ff.

13. See, for example, Tim Benton, Stefan Muthesius, and Bridget Wilkins, *Europe, 1900–1914* (Milton Keynes: Open University Press, 1975), 51–61, esp. pls. 81–86.

14. His office was connected with it (Nevins, *Ford*, 456).

15. Hildebrand mentions them in *Designing for Industry*, 100; see also Nevins and Hill, *Ford: Expansion and Challenge*, 366ff.

16. Jan.–Feb. 1927; cited in Nevins, *Ford*, 453.

17. Kahn, Address to New York State Association of Architects, Rochester, September 27, 1940, in *Architectural Forum* 173 (Dec. 1940): 501–3.

18. Arnold and Faurote, *Ford Methods and the Ford Shops*, 360.

19. *Architectural Forum* 51 (Sept. 1929): 265–72, cited in Hildebrand, *Designing for Industry*, 157.

20. Hildebrand, *Designing for Industry*, 54, figs. 17–19.

21. George C. Baldwin, "The Offices of Albert Kahn, Architect, Detroit, Michigan," *Architectural Forum* 29 (Nov. 1918): 125–30.

22. Kahn, Address to New York State Association of Architects, 501.

23. Kahn, "Architectural Trend," 133.

24. Nevins, *Ford*, 541.

25. John Burchard and Albert Bush-Brown, *The Architecture of America: A Social and Cultural Survey* (Boston: Little, Brown, 1961), 244ff.

26. Ibid, 238.

27. Ibid., 240, fig. 244.

28. Ibid., 240–41.

29. Ibid., 330.

30. Robert Venturi, Denise Scott Brown, and Steven Izenour, *Learning from Las Vegas* (Cambridge, Mass.: MIT Press, 1972), 91, illustrating the Lady Esther Ltd. plant, Clearing, Illinois, 1938; Ferry, *Legacy of Albert Kahn*, fig. 185.

31. See Edward Lucie-Smith, *Work and Struggle* (London: Paddington, 1977), and Griselda Pollock and Fred Orton, "Les données bretonnantes: La prairie de réprésentation," *Art History* 3 (Sept. 1980): 314–44. There may also be a Sisley (Ferry, *Legacy of Albert Kahn*, figs. 84–88 and 161–64). The modernity of Kahn's summer cottage is, I think, exaggerated, the top floor being divided into rooms; its plan contradicts its open exterior "look" (figs. 124–26).

32. *Detroit News Tribune*, Sunday, September 20, 1908.

33. Flyer for the August 1938 issue, Albert Kahn file, Library, National Museum of American Art, Washington; press stories in this honor in *Detroit Free Press*, August 14, 1938; *Detroit Times*, August 12, 1938. See also George Nelson, *The Industrial Architecture of Albert Kahn Inc.* (New York: Architectural Book Pub. Co., 1939). Two pages are devoted to his Dodge plant, Detroit, in Elizabeth Mock, ed., *Built in USA, 1932–1944* (New York: MOMA, 1944), 94–95.

34. James Marston Fitch, *Architecture and the Esthetics of Plenty* (New York: Columbia University Press, 1961), 14.

35. H. R. Hitchcock, "American Influences Abroad," in Edgar Kaufmann, Jr., *The Rise of an American Architecture* (New York: Metropolitan Museum, 1970; London: Pall Mall, 1970), 8; see also Hitchcock's *Architecture: Nineteenth and Twentieth Centuries* (Harmondsworth: Pelican, 1968), 464.

36. Wayne Andrews, *Architecture, Ambition and Americans* (New York: Free Press, 1964), 258–59.

37. Burchard and Bush-Brown, *Architecture of America*, 242–43, 334–43.

38. Ada Louise Huxtable, Review of *American Architecture and Urbanism* by Vincent Scully, *New York Times Book Review*, November 23, 1969, 7.

39. William H. Jordy, *American Buildings and Their Architects: The Impact of European Modernism in the Mid-Twentieth Century* (New York: Doubleday, 1972), figs. 95 and 96.

40. See n. 9 above. Banham, in *A Concrete Atlantis*, acknowledges the influence of Kahn's office, but regards its work as historically antecedent, and architecturally inferior, to the reinforced concrete structures being introduced in the northeastern United States during the same period. He concentrates on the

Packard No. 10 Building of 1906 (82ff) and on the Original Building at Highland Park, 1908–10 (97ff.). He does not acknowledge the full significance of Kahn's work, especially the architect's quick adoption of steel framing in subsequent industrial building. Nevertheless, we certainly share in a positive revaluation of the achievement of these industrial engineer-architects, although I believe that it extends beyond what he calls the "classic" years 1905–14.

41. See H. J. Kadatz, *Peter Behrens* (Leipzig: Seeman, 1977); T. Buddenseig, *Industriekultur, Peter Behrens und die AEG* (Berlin: Mann, 1981); Lucius Burckhardt, ed., *The Werkbund: Studies in the History and Ideology of the Deutscher Werkbund, 1907–1933* (Edizioni La Biennale di Venezia, 1977; Woodbury, N.Y.: Barron's, 1980); Benton, Muthesius, and Wilkins *Europe, 1900–1914.*

42. See the double-page spread on the tractor factories in the *Detroit News*, Sunday, October 2, 1930; scrapbook of photographs and clippings, Albert Kahn and Associates, Detroit offices. The Austin Company also benefited from this opportunity; see Greif, *New Industrial Landscape*, 97–102. On the larger picture of U.S.-Soviet economic relationships at the time see Hughes, *American Genesis*, ch. 6.

43. Cited in Nevins, *Ford*, 577.

44. Hildebrand, *Designing for Industry*, 71, n. 35.

45. Arnold and Faurote, *Ford Methods and the Ford Shops*, 28.

46. Andrews, *Architecture, Ambition and Americans*, 264; see also Ferry, *Buildings of Detroit*, figs. 373–76.

47. Ferry, *Legacy of Albert Kahn*, figs. 170, 171. This building is also the Ford building closest to Dearborn township, and the museum and Greenfield Village.

48. Ibid., figs. 242–53.

Chapter 3. Henry Ford and Charles Sheeler

1. Sward, *The Legend of Henry Ford*, was first cited in ch. 1, n. 61; David L. Lewis, *The Public Image of Henry Ford: An American Folk Hero and His Company* (Detroit: Wayne State University Press, 1976). Sward was a publicity officer with the CIO in the 1930s; Lewis is professor of business history at the University of Michigan, Ann Arbor.

2. Nevins, *Ford*, appendixes 3–10, has figures re sales, production, profits, etc. On the car models see George H. Damman, *Illustrated History of Ford, 1903–1970* (Glen Ellyn, Ill.: Crestline, 1970); every Ford is illustrated.

3. Arnold and Faurote, *Ford Methods and the Ford Shops*, 22.

4. Remarks about Ford advertising in this and the next section are based on studies such as D. L. Lewis, *The Public Image of Henry Ford*, a thorough survey of the subject up to 1947, and Ralph E. Anderson, *The Story of the American Automobile* (Washington, D.C.: Public Affairs Press, 1950), which surveys early advertising across the industry. The Ford Archives, Edison Institute, Dearborn, contains boxes of advertising tearsheets and agency mockups since 1903, and photographic prints of other advertisements, as well as relevant written documentation. The Automotive History Archives, Detroit Public Library, holds boxes of publicity material distributed to dealers. Other sources include publications such as the *Ford Times*, a dealer-customer magazine, and the journals and newspapers in which the advertisements appeared. The Ford Archives also contains extensive files and photographs relating to the company's participation in promotional activities, including the city, state, national, and international

expositions. Many advertising images appear in popular books about the Ford Company (for example, those of Lorin Sorensen) as well as those on advertising in different countries.

5. Nevins, *Ford*, 345–47.

6. Peter Roberts, *Any Color so Long as It's Black: The First Fifty Years of Automobile Advertising* (New York: Morrow, 1976), 26.

7. See Lewis, *Public Image of Henry Ford*, on price-cutting, 43ff.; on *Ford Times*, 49ff.

8. Abraham Zaleznik, "Preface," in Anne Jardim, *The First Henry Ford: A Study in Personality and Business Leadership* (Cambridge, Mass.: MIT Press, 1970), viii.

9. Nye, *Henry Ford: "Ignorant Idealist,"* 120, citing Marquis, *Henry Ford: An Interpretation*, 4.

10. See Nye, *Henry Ford: "Ignorant Idealist," passim*, esp. ch. 8; Leo Marx, *The Machine in the Garden* (New York: Oxford University Press, 1964); Sward, *Legend of Henry Ford*, is useful on the myth of Ford as a "folk hero," ch. 1; Nevins and Hill, in *Ford: Decline and Rebirth*, devote their conclusion to efforts to reach a positive, "balanced" account.

11. Warren I. Susman "'Personality' and the Making of Twentieth Century Culture," in John Higham and Paul K. Conkin, eds., *New Directions in American Cultural History* (Baltimore: Johns Hopkins University Press, 1979), 223.

12. Nevins and Hill, *Ford: Expansion and Challenge*, 607, on interviews; on letters, see the survey of thousands by Reynold Wik, *Henry Ford and Grass Roots America* (Ann Arbor: University of Michigan Press, 1972). See also Joseph Interrante, "You Can't Go to Town in a Bathtub: Automobile Movement and the Reorganization of Rural American Space, 1900–1930," *Radical History Review* 21 (Fall 1979): 151–70.

13. Upton Sinclair, *The Flivver King: A Story of Ford-America* (Detroit: United Automobile Workers, 1937).

14. David L. Lewis, "Pioneering the Business Film," *Public Relations Journal* (June 1971): 14–17.

15. On Ford advertising during this phase see Lewis, *Public Image of Henry Ford*, 54; Nevins and Hill, *Ford: Expansion and Challenge*, 264–69; Lorin Sorensen, *The Ford Way* (Osceola, Wisc.: Silverado, 1978); tearsheets in Ford Archives, Dearborn; Ford Motor Co. publicity for dealers, Automotive History Archives, Detroit Public Library; N. W. Ayer Advertising Agency Collection 1889–1960, Archives, National Museum of History and Technology, Smithsonian Institute, Washington, D.C.

16. Cited in David L. Lewis, "The Introduction of Henry's Model A No. 2," *Cars and Parts* (Mar. 1974): 121–28.

17. *Reminiscences of Fred L. Black*, March 10, 1951, Oral History Project, Ford Archives, Edison Institute, Dearborn, 179–83. Black was Edsel Ford's personal assistant who also became advertising director of Ford Company from 1927.

18. Ibid., 188.

19. See George Hildebrand, ed., *The Golden Age of the Luxury Car* (New York: Dover, 1980), an anthology from the designer's magazine *Autobody*, 1927–31.

20. "Color in Industry," *Fortune*, February 1930, 86 and 87, 90 respectively.

21. On these questions, see Nevins and Hill, *Ford: Expansion and Challenge* chs. 15–18.

22. See Alfred P. Sloan, *Adventures of a White-Collar Man* (New York: Double-

day, Doran, 1941); idem, *My Life with General Motors* (Garden City, N.Y.: Double-day, 1964).

23. Cited in Nevins and Hill, *Ford: Expansion and Challenge*, 455.

24. And in European study trips, part of the instruction, in 1904 and 1905. Sheeler reminiscences about this period at length in the unpublished 1938 auto-biography, Archives of American Art, microfilm NSH 1.

25. The symbolist reading was initially advanced by John Golding, *Marcel Duchamp: The Bride Stripped Bare by Her Bachelors Even* (London: Allen Lane, 1973).

26. Barbara Zabel, "Louis Lozowick and Technological Optimism of the 1920s," Ph.D. diss., University of Virginia, 1978; her article of the same title, *Archives of American Art Journal* 14 (1974). Other Lozowick material includes Seton Hall University, Student Center Art Gallery, *Louis Lozowick, 1892–1973* (South Orange, N.J., 1973); Robert Hull Fleming Museum, *Abstraction and Realism, 1923–1943, Paintings, Drawings and Lithographs of Louis Lozowick* (Burlington: University of Vermont, 1971); Janet A. Flint, *The Prints of Louis Lozowick: A Catalogue Raisonné* (New York: Hudson Hills Press, 1982). Relevant to this phase of Sheeler's art is Garnett McCoy, "Charles Sheeler: Some Early Documents and a Reminiscence," *Archives of American Art Journal* (April 1965).

27. Compare Ian Jeffrey and David Mellor, *City Scape, 1910–30* (London: Arts Council of Great Britain, 1977–78), to Jane M. Farmer, *The Image of Urban Optimism* (Washington, D.C.: Smithsonian Institution, 1977). On the early 1930s change, see Zabel, "Louis Lozowick" (Ph.D. diss.), ch. 4.

28. Susan Fillin Yeh has done the fundamental work on these relationships in her 1981 City University of New York dissertation, "Charles Sheeler and the Machine Age" (UMI Microfilm, 1983). She cites Josephson in "Charles Sheeler: Industry, Fashion and the Vanguard," *Arts Magazine* 54 (Feb. 1980): 158. A fuller extract is given by Ruth Oldenzeil in an excellent essay which coincidentally raises many of the themes of this book, "The Ford at River Rogue: Artistic Crossings, 1927–1939," in Rob Kroes, ed., *High Brow Meets Low Brow: American Culture as an Intellectual Concern* (Amsterdam: Free University Press, 1988), 37–60. The spectacular Brooklyn Museum exhibition of 1986–87 attests to the continuing impact of these early enthusiasms: Richard Guy Wilson, Dianne H. Pilgrim, and Dickran Tashjian, *The Machine Age in America, 1918–1941* (New York: Abrams, 1986).

29. Charles Millard, "The Photography of Charles Sheeler," in *Charles Sheeler* (Washington, D.C.: National Collection of Fine Arts, Smithsonian Institution, 1968), 82.

30. Martin Friedman, *Charles Sheeler* (New York: Watson-Guptill, 1975), 65.

31. Quotations in Carl Sandburg, *Steichen the Photographer* (New York: Harcourt, Brace, 1929), 51.

32. Yeh, "Charles Sheeler: Industry, Fashion and the Vanguard," 156.

33. Quoted in Geoffry Holme, *Industrial Design and the Future* (New York: Studio Publications, 1934), 43. The contract is not mentioned in Ralph M. Hower, *The History of an Advertising Agency: N. W. Ayer & Son at Work, 1869–1949* (Cambridge, Mass., 1945).

34. Mary Jane Jacob and Linda Downs, *The Rouge: The Image of Industry in the Art of Charles Sheeler and Diego Rivera* (Detroit: Detroit Institute of Arts, 1978), 14.

35. Charles Millard, "Charles Sheeler, American Photographer," *Contemporary Photographer* 6 (1967); Jacob and Downs, *The Rouge*, 13.

36. Bartlett Cowdrey, "Interview with Charles Sheeler, Dec. 9, 1958," ms. Archives of American Art, Washington, D.C., 46–50.

37. Compare Sheeler's *Stamping Press* to the photographs of the Orebreaker and the Punch Press at the Chalmers plant, 1918, by unknown photographers; illus. F. Jack Hurley, *Industry and the Photographic Image* (New York: Dover, 1980), figs. 59 and 60. In fact, engineer-photographers from around 1900 develop the narrative photography of industry to a point of detail, spread, and refinement yet to be fully appreciated. That imagery is a focus of my current research. The paintings of the Rouge seem to have fewer precedents, although there are some in Demuth, Briggs, Hirsch, Crawford, and others; see Marianne Doezema, *American Realism and the Industrial Age* (Cleveland: Cleveland Museum of Art, 1980).

38. This effect is difficult to discern in reproduction. Twelve copy negatives were made in 1929 from original prints and are now in the Ford Archives, Dearborn. My first impressions were based on these. Other original prints remained for many years in a private collection unavailable for exhibition; others were scattered elsewhere. Sheeler's dealer's policy of promoting his painting since 1930 has considerably affected the availability of his photographs. See now Theodore E. Stebbins and Norman Keyes, *Charles Sheeler: The Photographs* (Boston: Little, Brown, 1987), and the associated Boston Museum of Fine Arts exhibition, including the original prints of the Ford photographs.

39. See Constance Rourke, *Charles Sheeler: Artist in the American Tradition* (New York: Harcourt Brace and World, 1938; reprint, 1969), 123–25, for an opposing view.

40. Allan Sekula, "Photography between Labor and Capital," in Benjamin H. D. Buchloch and Robert Wilkie, eds., *Mining Photographs and Other Pictures, 1948–1968: Photographs by Leslie Sheddon* (Halifax, N.S.: Nova Scotia College of Art and Design, 1983).

41. Yeh, "Charles Sheeler," 156, fig. 10, reproduces Sheeler's reference photograph for *American Landscape* in which the railway cars carry the D + IR initials of the Ford-owned local railway company.

42. Rourke, *Charles Sheeler*, 146 and 148.

43. Friedman, *Charles Sheeler*, 44.

44. Jacob and Downs, *The Rouge*, cat. no. 15, *Salvage Ship* photograph.

45. Charles Corwin, *New York Daily Worker*, February 4, 1949, a review which labels Sheeler "The Raphael of the Fords." See chapter 6 of this volume for further discussion of this point.

46. Curiously, the lesser watercolor of 1935 is titled *City Interior No. 2*.

47. Rourke, *Charles Sheeler*, 153.

48. See Patricia Hills, "Phillip Evergood's *American Tragedy:* The Poetics of Ugliness, the Politics of Anger," *Arts Magazine* 54 (Feb. 1980).

49. Nevins, *Ford*, 541.

50. *Classic Landscape* from the Detroit Society of Arts and Crafts show of 1932 (Jacobs and Downs, *The Rouge*, 34); *American Landscape* from the Downtown Gallery, New York, one-man show of November–December 1931. Both paintings have a long history of exhibition and reproduction; see Jacob and Downs, *The Rouge*, 33–35.

51. These sentiments of Sheeler's were conveyed at the time in letters to Walter Arensberg (cited in Yeh, "Charles Sheeler," nn. 6, 7 and 24) and repeated

in his autobiography of 1938 (Archives of American Art, microfilm NSH-1, n.p.), in which he parallels the contemporary artist's duty to express industry to the Gothic cathedral builder's obligation to religion, and in the 1958 interview with Bartlett Cowdrey, 46–47.

52. E. P. Richardson, *Painting in America* (London: Constable, 1956), 377. Richardson was secretary of the Detroit Institute of Arts during this period, later director. See ch. 6.

53. "An Assembly Line of the Ford Motor Company," undated, no authorship known; photofile, Automotive History Archives, Detroit Public Library.

54. Jacob and Downs, *The Rouge*, 22, 33, 34, and 40.

55. Views of the Open Hearth Plant and the blast furnaces were taken for Albert Kahn Associates, and are reproduced in Ferry, *Legacy of Albert Kahn*, figs. 170 and 168; Sheeler's *Ladle Hooks* is in Stebbins and Keyes, *Sheeler: The Photographs*, pl. 51.

56. Copies of the portfolios are in the office of Albert Kahn Associates, Detroit; *Architectural Forum* 1938 was developed into the book *Industrial Architecture of Albert Kahn* by George Nelson.

57. File, Ford Archives, Dearborn; *Reminiscences of Irving Bacon*, Oral History Project, ditto.

58. Walter Dorwin Teague, "Edsel Ford—Designer," *Lincoln-Mercury Times*, May–June 1953; Sheila F. Ford, "Edsel Ford: Artistic Industrialist," *Herald* (Greenfield Village and Henry Ford Museum), vol. 8, no. 2 (Spring 1979): 34–39.

59. See, respectively, Q. David Bowers, *Early American Car Advertisements* (New York: Vestal, 1966), 66; Mary Jane Jacob, "The Modern Art Gallery," in *Arts and Crafts in Detroit, 1906–1976: The Movement, the Society, the School* (Detroit Institute of Arts, 1976), 169.

60. *Detroit Free Press*, May 22, 1933.

Chapter 4. The Garden in the Machine

1. Nevins and Hill, *Ford: Expansion and Challenge*, 490–91; Nevins and Hill, *Ford: Decline and Rebirth*, 71–72; Lewis, *Public Image of Henry Ford*, ch. 8.

2. Major newspapers, May 30, 1932, quoted in *Ford News* 17 (Apr. 1937): 62.

3. Photograph of photomural, Ford Archives, Edison Institute.

4. *Dearborn Independent*, September 1919, cited in Nevins and Hill, *Ford: Expansion and Challenge*, 227.

5. Howard P. Segal, "'Little Plants in the Country': Henry Ford's Village Industries and the Beginning of Decentralized Technology in Modern America," *Prospects* 13 (1988): 181–223. See also Segal's *Technological Utopianism in American Culture* (Chicago: University of Chicago Press, 1985).

6. Cited in Nevins and Hill, *Ford: Expansion and Challenge*, 229.

7. This view of Ford as a beneficient "social engineer" is the basic orientation of the current display of Ford's life and times at the Henry Ford Museum, Dearborn. See Steven K. Hamp, "Subject over Object: Interpreting the Museum as Artifact," *Museum News* 63 (Dec. 1984): 33–37.

8. Leo Marx, *The Machine in the Garden*, 355–60.

9. Segal documents Ford's hatred of the city in "Little Plants in the Country," 3, and shows it to be an instance of a wider feeling, 37–40.

10. Robert Caro, *The Power Broker: Robert Moses and the Fall of New York* (New York: Knopf, 1974), 654; Marshall Berman, *All That Is Solid Melts into Air* (New York: Simon and Schuster, 1982), 304.

11. Ferry, *Buildings of Detroit*, 305.

12. Burchard and Bush-Brown, *Architecture of America*, 247.

13. Nevins, *Ford*, 548ff.; Nevins and Hill, *Ford: Expansion and Challenge*, 479ff.; Ferry, *Buildings of Detroit*, 300.

14. Ferry, *Legacy of Albert Kahn*, figs. 110–20.

15. Sales brochure, cited in Ferry, *Buildings of Detroit*, 300.

16. This pattern was recently repeated, in an even more bizarre way: the Renaissance Center, erected to restore the flagging fortunes of downtown Detroit by a consortium including the Ford Company, is, in terms of its dominant architectural inspiration, the first realization of the visionary project *City of the Future* devised by Yakov Chernikov, student at the Vkhutemas architecture school, Moscow, during the Bolshevik Revolution. Tropes such as these shape Terry Smith, "Black Swan in the City: Detroit, First Week of August, 1986," *Detroit Arts Quarterly* 11 (Winter 1987): 10–11 and 30; also in *Art & Text* 25 (June–Aug. 1987): 2–19.

17. The basic constituents were Greenfield Village and the Edison Institute of Technology, both having museum and educational functions. The latter was subsequently divided, for practical purposes, into the Henry Ford Museum (the major display buildings) and the Edison Institute (an adjacent research and archival facility centered on Lovett hall, built by Ford as part of his old-time dancing revival). William Adams Simonds, *Henry Ford and Greenfield Village* (New York: Stokes, 1938), is an official view, as is Geoffry Upward, *A Home for Our Heritage: The Building of Greenfield Village and Henry Ford Museum, 1929–1979* (Dearborn: Henry Ford Museum, 1979). Other material may be found in H. F. Morton, *Strange Commissions for Henry Ford* (New York: Herald, 1934); Sward, *Legacy of Henry Ford*, ch. 20; Nevins and Hill, *Ford: Expansion and Challenge*, 500ff.; Hamp, "Subject over Object"; Robert Lacey, *Ford: The Men and the Machine* (Boston: Little, Brown, 1986), ch. 14.

18. Having begun on certain heritage-preserving projects in 1919, Ford was approached in 1924 by the Reverend William Goodwin to become the principal sponsor of Williamsburg. Ford wanted something different and closer to home: Lacey, *Ford: The Men and the Machine*, 240–41.

19. Ford, *Life and Work*, 228.

20. Sward, *Legacy of Henry Ford*, 263 and 265. This description precedes the legal separation of the institute from the Ford Company in 1960 and the "modernization" of the museum which began in the mid-1970s; see Hamp, "Subject over Object."

21. *New York Times*, May 20, 1919; see Nye, *Henry Ford: "Ignorant Idealist,"* for detailed account, and Roger Butterfield, "Henry Ford, the Wayside Inn and the Problems of 'History is Bunk,'" Massachusetts Historical Society, *Proceedings* (Boston) 77 (Jan.–Dec. 1965): 53–66.

22. Robert Goldwater, *Primitivism and Modern Art* (New York: Vintage, 1967), 3–14.

23. Cited in Nevins and Hill, *Ford: Expansion and Challenge*, 502.

24. *Reminiscences of Ernest Liebold*, Ford Archives, Dearborn, 890.

25. T. J. Jackson Lears, *No Place of Grace: Anti-Modernism and the Transformation of American Culture, 1880–1920* (New York: Pantheon Books, 1981).

26. Lacey, *Ford: The Men and the Machine*, ch. 14.

27. David Lowenthal, *The Past Is a Foreign Country* (Cambridge: Cambridge University Press, 1985); Patrick Wright, *On Living in an Old Country* (London:

Verso, 1985); Robert Hewison, *The Heritage Industry* (London: Methuen, 1987); and Bob West, "Danger: History at Work: A Critical Consumer's Guide to the Ironbridge Gorge Museum," occasional paper (Birmingham: Centre for Contemporary Cultural Studies, 1985), are all exemplary British studies.

28. C. B. Hosmen, *Presence of the Past: A History of the Preservation Movement in the United States before Williamsburg* (New York: G. P. Putman's Sons, 1965).

29. Donald Horne, *The Great Museum* (London: Pluto, 1984), ch. 7.

30. Michael Wallace, "Visiting the Past: History Museums in the United States," *Radical History Review* 25 (1981). See also Tony Bennett, "Museums and 'the People,'" in Robert Lumley, ed., *The Museum Time Machine* (London: Comedia, 1988), 63–85.

31. Jean Baudrillard, "The Year 2000 Will Not Take Place," in E. A. Grosz, Terry Threadgold, David Kelly, and Alan Cholodenko, eds., *Futur*Fall: Excursions into Post-Modernity* (Sydney: Power Institute of Fine Arts, 1986). On this taking hold of history—"apprehending time"—for present purposes, see also Jacques Donzelot, "L'apprehension du temps," *Critique* (Feb. 1982): 97–119, translated in Don Barry and Stephen Meuke, eds., *The Apprehension of Time* (Sydney: Local Consumption Publications, 1988), which also includes acute interpretive essays by Tony Bennett, Paul Willemen, and Paul Alberts-Dezeeuw. The other, opposite sense of "apprehension"—as fear of time passing in general, and of the determinative, constraining, and perhaps ultimately victorious powers of history—is also evident at Dearborn. In even darker depths, Ford may have glimpsed the unimaginable emptiness that lies on the other side of belief in progress: Greenfield Village might represent a fearful shoring-up against the realization that intense presentness is no substitute for a future in which progress has failed, in which there would be only an always-imploding into the past. For us, it is worse: the postapocalyptic landscape, the land beyond time, might also be a desert dotted with countless Greenfield Villages. We approach the scenario of *Mad Max Three*, of the interminable exchange between Bartertown and Thunderdome. See the coda to Terry Smith, "Modernism Meets Modernity: Great Combusting Conjunctures!" in Grosz et al., *Futur* Fall*, 64–81.

32. *From the Rouge to the Road* (Dearborn: Ford Motor Company, 1935), n.p.

Chapter 5. The Shaping of Seeing

1. Cited in Robert Elson, *Time Inc.: The Intimate History of a Publishing Enterprise, 1923–41* (New York: Atheneum, 1968), 129–30.

2. Michael Schudson, *Advertising: The Uneasy Persuasion* (New York: Basic Books, 1984), 156–57.

3. Uppercase in original Hadden and Luce prospectus, 1921; cited in Elson, *Time Inc.*, 7–8.

4. Steichen's observation, cited ibid., 269.

5. Noel Busch, *Britton Hadden* (New York: Farrar Strauss, 1949), cited in Elson, *Time Inc.*, 82.

6. Cited in William Stott, *Documentary Expression and Thirties America* (New York: Oxford University Press, 1973), 49. His note 7 credits this to Mauritz Halgren, *Seeds of Revolt* (New York, 1933), 5.

7. Cited in Elson, *Time Inc.*, 126–27.

8. Rivera's May Day series was bought by Mrs. Rockefeller soon after completion. In the February 1932 issue, *Fortune* featured Rivera's MOMA show, including a reproduction of *Frozen Assets* (40–41). The closeness of Fortune to the

MOMA program, and the liberal flexibility of both, is indicated here. The Rockefeller Center incident, however, seems to have curtailed the relationship.

9. Fox Film was a spectacular victim of the stockmarket crash and headed the list of *Fortune's* failures, when the magazine finally acknowledged the existence of a crisis, eighteen months later, in April 1931, 89ff.

10. Nevins and Hill, *Ford: Expansion and Challenge*, 572.

11. See Schudsen, *Advertising*, 175–76, for criticisms of Ewan's key points.

12. See Norman Rockwell, *My Adventures as an Illustrator* (New York: Doubleday, 1960), 437ff., and Roger Butterfield and the editors of *Saturday Evening Post*, *The Saturday Evening Post Treasury* (New York: Simon and Schuster, 1954), 14–15.

13. Ewen, *Captains of Consciousness*, 184. On J. Walter Thompson's conscious Social Darwinism, see Stephen Fox, *The Mirror Makers: A History of American Advertising and Its Creators* (New York: William Morrow, 1984), 84–85.

14. See John Kobal, *The Art of the Great Hollywood Portrait Photographers, 1925–1940* (New York: Knopf, 1980).

15. Roberts, *Any Color so Long as It's Black*, 132.

16. Apart from Ewen, *Captains of Consciousness*, and Stuart Ewen and Elizabeth Ewen, *Channels of Desire* (McGraw-Hill, 1982), there seems to be little critical writing on U.S. advertising of this period and few studies of its processes of visualization. Exceptions include Sally Stein, "The Composite Photographic Image and the Composition of Consumer Ideology," *Art Journal* (Spring 1981): 39–44, and idem, "The Graphic Ordering of Desire: Modernization of a Middle-Class Woman's Magazine, 1914–1935," *Heresies* 18 (1984): 7–16. An Australian study with a similar emphasis is Ann Stephen, "Agents of Consumerism: The Organization of the Australian Advertising Industry, 1918–1938," *Media Interventions* (Sept. 1981): 78–96.

17. Cited in Stephen, "Agents of Consumerism," 86.

18. Mary Eagle, "Modernism in Sydney in the 1920s," in Ann Galbally and Margaret Plant, eds., *Studies in Australian Art* (Melbourne: University of Melbourne, 1978), 79–90.

19. Schapiro later distinguishes between "object matter" and "subject matter" to bring out this possibility in his response to the energy of the Abstract Expressionist enterprise, for example, Meyer Schapiro, "The Liberating Qualities of Avant-Garde Art," *Art News*, 56 (Summer 1957).

20. Meyer Schapiro, "The Social Bases of Art," in American Artists' Congress, *First American Artists' Congress* (New York, 1936), 33–36. This volume has been reissued as *Artists against War and Fascism* (New Brunswick, N.J.: Rutgers University Press, 1986), with an introduction by Matthew Baigell and Julia Williams.

21. James Sloan Allen, *The Romance of Commerce and Culture* (Chicago: University of Chicago Press, 1987), 10 and 12.

22. Cited in Fox, *Mirror Makers*, 166.

23. Theodore W. Adorno and Max Horkheimer, "The Culture Industry: Enlightenment as Mass Deception," in *Dialectic of Mass Enlightenment* (London: Allen Lane, 1973), cited in James Curran, Michael Gurevitch, and Janet Woollacott, *Mass Communication and Society* (London: Arnold, 1977), 380.

24. Ibid., 381.

25. Margaret Bourke-White, *Portrait of Myself* (London: Collins, 1964), 56; *Fortune*, May 1947.

26. The 1931 New York Art Center exhibition entitled Foreign Advertising Photography was apparently the first to relate Neue Sachlichkeit photography

directly to advertising; see Herbert Moldering, "Urbanism and Technological Utopianism: Thoughts on the Photography of Neue Sachlichkeit and the Bauhaus," in David Mellor, ed., *Germany: The New Photography, 1927–33* (London: Arts Council of Great Britain, 1978), 93.

27. Sekula, "Photography between Labor and Capital," 241.

28. The first photograph Bourke-White thought well enough of to illustrate it in her autobiography (*Portrait of Myself*, opp. p. 66); the latter is the type of industrial structure which occurs in the work of Rivera, Kahlo, and countless others—simple observation, yes, but selective seeing reinforced as well.

29. Ibid., 66–70.

30. Ibid., 72.

31. Bourke-White, "An Artist's Experience in the Soviet Union," in *First American Artist's Congress*, 17–18. The acute industrial-worker focus is evident in the selection in Sean Callahan, ed., *The Photography of Margaret Bourke-White* (London: Secker and Warburg, 1973).

32. Bourke-White, "Photographing This World," *Nation*, February 19, 1936, cited in Theodore M. Brown, *Margaret Bourke-White, Photojournalist* (Ithaca, N.Y.: Andrew Dickson White Museum of Art, Cornell University, 1972), 125.

Chapter 6. The Resistant Other

1. Paul von Blum, *The Critical Vision* (Boston: South End Press, 1982), 126–27.

2. For example, J. I. H. Baur et al., *New Art in America: 50 American Painters in the 20th Century* (Greenwich, Conn.: New York Graphic Society, 1957). More realistic, if more fearful, was Donald D. Egbert, *Socialism and American Art* (Princeton: Princeton University Press, 1962).

3. For example, Barbara Rose, *American Painting since 1900* (New York: Praeger, 1967); Irving Sandler, *The Triumph of American Painting: A History of Abstract Expressionism* (London: Pall Mall, 1970). The claim regarding the early work of the Abstract Expressionists has not been systematically pursued; it would be an interesting project.

4. For example, Ralph E. Shikes, *The Indignant Eye: The Artist as Social Critic in Prints and Drawings from the Fifteenth Century to Picasso* (Boston: Beacon, 1969); David Shapiro, ed., *Social Realism: Art as a Weapon* (New York: Ungar, 1973).

5. There is a large and persistent literature on this topic. Key texts, representative of various important approaches, include Linda Nochlin, *Realism* (Harmondsworth: Pelican, 1971); T. J. Clark, *Image of the People: Gustave Courbet and the 1848 Revolution* (London: Thames and Hudson, 1973), and idem, *The Painting of Modern Life* (Princeton: Princeton University Press, 1984); John Berger, *Art and Revolution* (Harmondsworth: Penguin, 1969), influentially revived Lukács's realism/naturalism distinction; Brecht's incorporations of modernism into realism (in his reply to Lukács in Ernst Bloch et al., *Aesthetics and Politics* [London: New Left Books, 1971], 82–83) inspired aspects of the *Screen* project (see John Ellis, "Introduction," in *Screen Reader No. 1* [London: British Film Institute, 1977]), leading to studies such as Terry Lovell, *Pictures of Reality* (London: British Film Institute, 1980), and were influential on the relativist position espoused here. For an ideologically quite different relativism about realism see Charles Rosen and Henri Zerner, "What Is, and Is Not, Realism?" *New York Review of Books*, February 18 and March 4, 1982, and their *Romanticism and Realism* (London: Faber and Faber, 1984).

6. Laurance P. Hurlburt, *The Mexican Muralists in the United States* (Albu-

querque: University of New Mexico Press, 1989). The general texts referred to below contain sections on this topic, as do monographs such as Alma Reed, *Orozco* (Dresden: VEB Verlag der Kunst, 1979), and Raquel Tibol, *David Alfaro Siqueiros* (Dresden: VEB Verlag der Kunst, 1966), and exhibition catalogues such as David Elliott, *Orozco, 1883–1949* (Oxford: Museum of Modern Art, 1980), including an essay by Hurlburt.

7. See, for example, Hannes Meyer, ed., *TGP Mexico, el Teller de Grafica Popular* (The workshop for popular graphic art) (Mexico City: La Estampa Mexicana, 1949), a record of twelve years of collective work.

8. Max Kozloff, "The Rivera Frescoes of Modern Industry at the Detroit Institute of Arts: Proletarian Art under Capitalist Patronage," *Artforum* 12 (Nov. 1973): 58–63.

9. Jacob and Downs, *The Rouge,* and Cynthia Newman Helms, ed., *Diego Rivera: A Retrospective* (Detroit: Founders Society, Detroit Institute of Arts, 1986) are the outstanding recent studies.

10. Letter, May 27, 1931, from William Valentiner, director of the DIA, Clyde H. Burroughs Records, Museum Archives, Detroit Institute of Arts, BUR-6-3.

11. Telegram, Hoover to Daly, Department of Justice, New York City, October 15, 1927; "Diego Rivera," New York File #64-31, October 18, 1927, gives a detailed report of the surveillance; both items, File no. HQ100-155423, Federal Bureau of Investigation, Washington, D.C.

12. For example, telegram from the U.S. Embassy in Mexico City to Department of State, Washington, D.C., paraphrased in letter from Kelly, Chief, Division of Eastern European Affairs, to Hoover, August 1, 1928, File no. HQ64-200-211-48, Department of State files, National Archives, Washington, D.C. By the mid-1930s, however, the Communist party grew rapidly, as did Rivera's involvement in political activity: for example, Report by Military Attache, U.S. Embassy, Mexico City, October 26, 1934, no. 5671, Security Classified Correspondence and Reports 1917–1941, Military Reference, National Archives, Washington, D.C., at 10058-0-129.

13. The most thorough treatment of the labyrinthine vicissitudes of Rivera's politics remains Bertram D. Wolfe, *The Fabulous Life of Diego Rivera* (New York: Stein and Day, 1963).

14. Both images occur in the Ministry of Education murals: see *Mural Painting of the Mexican Revolution* (Mexico City: Fondo Editorial de la Plastica Mexicania, 1960), pl. 89, and Wolfe, *Fabulous Life,* fig. 77. The most comprehensive presentation of these murals is Luis Cardoza y Aragón, *Diego Rivera: Los murales en la Secretaría de Educación Pública* (Mexico City: Secretaría de Educación Pública, 1986).

15. Wolfe, *Fabulous Life,* chs. 19 and 20.

16. William Valentiner's vision in a manuscript written in the early 1950s, reproduced in Margaret Sterne, "The Museum Director and the Artist: Dr. William R. Valentiner and Diego Rivera in Detroit," *Detroit in Perspective* 1 (1973), later a chapter in her *The Passionate Eye: The Life of William Valentiner* (Detroit: Wayne State University Press, 1980). Hereinafter cited as "Valentiner." On Edsel Ford's design interests, see ch. 3, n. 58; on Ford's relationship with Rivera, see Linda Downs, "Diego Rivera's Portrait of Edsel Ford," *Bulletin of the Detroit Institute of Arts* 57 (1979): 46–52.

17. "Valentiner," 98: "I felt I had to act quickly before New York and its en-

thusiasts for modern art—whom Rivera had not yet met—captured him." Valentiner did not know that Rivera had met Barr and Abbot in Moscow in January 1928, and may have been invited to show in New York. See Alfred H. Barr, "Russian Diary, 1927–28," *October 7* (Winter 1978): 7–56.

18. Bernard S. Myers, *Mexican Painting in Our Time* (New York: Oxford University Press, 1956), 57; J. Patrick McHenry, *A Short History of Mexico* (Garden City, N.Y.: Doubleday, 1970), 175–78.

19. Wolfe, *Fabulous Life*, 297.

20. Myers, *Mexican Painting*, 81; Wolfe, *Fabulous Life*, 301; Alicia Azuela, "Rivera and the Concept of Proletarian Art," in Helms, *Diego Rivera: A Retrospective*, 125–29.

21. Francis Flynn Paine, "The Work of Diego Rivera," *Diego Rivera* (New York: Museum of Modern Art, 1931), 10–11.

22. Nevins and Hill, *Ford: Expansion and Challenge*, 573–90; Warner Pflug, *The U.A.W. in Pictures* (Detroit: Wayne State University Press, 1971), 23–26; Conot, *American Odyssey*, 283–86.

23. The Fords' roles in the banking collapse is documented in the 1934 Senate Committee on Banking and Currency hearings, and by Francis Pecora, *Wall Street under Oath* (New York, 1939), from which Sward, *Legacy of Henry Ford*, draws for chapter 19.

24. Rivera spoke of Mexico as "a most terrible and beautiful example of the struggle between one class and the other classes" at a meeting of the Committee on Cultural Relations with Latin America (*Detroit Free Press*, June 3, 1932). On Rivera's membership in the League of Mexican Peasants and Workers, and his financing of Mexicans to return home to establish utopian communes, despite his doubts about them, see Mariette Lynn Baba and Malvina Hauk Abonyi, *Mexicans in Detroit* (Detroit: Wayne State University, Center for Urban Studies, 1979), 59.

25. In Valentiner's commissioning letter of May 27, 1931, there is a reference to the Arts Commission seeing and approving the sketches, but Valentiner anticipates "no difficulty in this respect" (see n. 10). Rivera exhibited peasant and nude studies in February 1931 (*Bulletin of the Detroit Institute of Arts* 8 [1931]: 53), giving some drawings to the Detroit Institute in honor of Valentiner's "esthetic authority" in May 1931 (Rivera to Valentiner, Burroughs Records, Museum Archives DIA, BUR-6-2). On the drawings for the mural, exhibited DIA, 1932, see Paul Elitzik, "Discovery in Detroit: The Lost Rivera Drawings," *Americas* 3 (Sept. 1980): 22–27, and Helms, *Diego Rivera: A Retrospective*, 80–83.

26. Kozloff, "Rivera Frescoes," tends to this interpretation; Hurlburt, *Mexican Muralists in the United States*, states it forthrightly, saying that Rivera's celebration of socialism and condemnation of capitalism awaited the Rockefeller Center mural (148). His reading of Rivera's political orientation rests, however, on the level of overt imagery. Yet his chapter on Rivera is open to covert content on other matters, such as the dualities of man-machine and religion-science.

27. I mean a reading of the manifesto as a work of art, of the sort offered by Berman in *All That Is Solid Melts into Air*, part 2.

28. Francis V. O'Connor, "The Diego Rivera Murals," lecture, DIA, March 20, 1977, revised as "An Iconographic Interpretation of Diego Rivera's *Detroit Industry* Murals in Terms of Their Orientation to the Cardinal Points of the Compass," in Helms, *Diego Rivera: A Retrospective*, 215–34.

29. Rivera's wife, Frida Kahlo, suffered a miscarriage early in July; it is likely

Rivera was painting this wall in August. This interpretation was suggested by Linda Downs to Hurlburt, *Mexican Muralists in the United States*, 144–45, n. 101.

30. Berthold Hinz, *Art in the Third Reich* (New York: Pantheon, 1979), ch. 5.

31. Myers's interpretation, in *Mexican Painting in Our Time*, 66–70. See also Antonio Rodriguez, *Canto a la tierra: Los murales de Diego Rivera en la Capilla de Chapingo* (Universidad Autónoma Chapingo, 1986).

32. Diego Rivera, "Scaffolding," *Hesperian*, Spring 1931, cited in Wolfe, *Fabulous Life*, 294–96. Other examples of similar enthusiasms in 1931 are found in Wolfe, 277 and 278, and Rivera, "Dynamic Detroit: An Interpretation," *Creative Art* 12 (Apr. 1933): 289–95.

33. "The two arts working together to create a greater art form, a more complete expression": in Dorothy Punccinelli, "Conversation with Diego Rivera," *California Arts and Architecture* 57 (Aug. 1940): 16. More in this vein appears in the publicity around his 1940–41 San Francisco Junior College mural (for example, *Life*, Oct. 14, 1940, and Mar. 3, 1941).

34. Dos Passos describes the Ford plant in *U.S.A.: The Big Money* (New York: Random House, 1937), 47–57. Céline has been cited above. The effect of being "in" the workplace would have been greater at the time, as a large fountain occupied much of the center of the floor space, obliging viewers to see the mural from either quite close or at considerable distances and angles.

35. Arnold and Faurote, *Ford Methods and the Ford Shops*, 120.

36. Edwin P. Norwood, *Ford Men and Methods* (New York: Doubleday, Doran, 1931).

37. Jacob and Downs, *The Rouge*, 74; Hurlburt, *Mexican Muralistists in the United States*, 154. There is no denying, however, their compositional centrality; see the small *Sketch for North and West Walls* (1932), in Hurlburt, 68.

38. Guy Brett has usefully emphasized Rivera's *strategic* use of sources: "The Mural Style of Diego Rivera," *Block* 4 (1981): 18–29. Rivera may well be paralleling Henry Ford's own use of the past at Greenfield Village, except that he reaches back beyond early industrial pastoralism and emphasizes the value of labor as well as machine power.

39. For a reading of the machines as erotic, see Wolfe, *Fabulous Life*, 307.

40. C. 1487–1521, in the Museo Nacionál de Anthropologia, Mexico City. See Betty Ann Brown, "The Past Idealized: Diego Rivera's Use of Pre-Columbian Imagery," in Helms, *Diego Rivera: A Retrospective*, 142. The same figure appears, with its ancient origins more evident, in the machine image at the center of the 1930–40 *Pan American Unity* mural; see Helms, *Diego Rivera: A Retrospective*, 309–11.

41. Rivera, "Dynamic Detroit: An Interpretation," 289. Rivera went on to characterize the automotive parts specifically as embodying the Pan-American fusion (291).

42. I am indebted to Detroit poet Glen Mannisto for this reading of the absence of the chassis and for many other insights.

43. Punccinelli, "Conversation with Diego Rivera," 16.

44. Hurlburt's observation, *Mexican Muralists in the United States*, 148–50.

45. Elie Faure, "Le peintre murale mexicaine," *Art et Médicine* (Apr. 1934), cited in Wolfe, *Fabulous Life*, 315.

46. See Raphael Samuel, "Editorial," and Eric Hobsbawn, "Man and Woman in Socialist Iconography," *History Workshop Journal* 6 (Autumn 1978), with commentary in Spring 1979 and Autumn 1979.

47. Wolfe, *Fabulous Life*, 306–7.

48. See Sward, *Legacy of Henry Ford, passim;* for an account reflecting contemporary values, see Robert H. Zieger, *American Workers, American Unions, 1920–1985* (Baltimore: Johns Hopkins University Press, 1986), ch. 2, "Rebirth of the Unions."

49. The red star on the worker's glove evokes the Communist symbol, but was also the logo of the glove company which supplied the Rouge, according to Linda Downs, cited in Hurlburt, *Mexican Muralists in the United States*, 148, n. 105.

50. The most thorough study of these panels, the small ones beneath them, and the geological strip panels is Dorothy McMeekin, "The Historical and Scientific Background of Three Small Murals in the Detroit Institute of Arts," *Michigan Academy of Science, Arts and Letters Journal*, 1983, and other studies, drawn upon by Hurlburt, *Mexican Muralists in the United States*, 144 and 150–54.

51. Kozloff, "The Rivera Frescoes," 63, 62.

52. From the voice-over to the film *The Age of Steel* (Ford Fund, 1978).

53. New material on the RCA controversy is in Hurlburt, *Mexican Muralists in the United States*, 159–74.

54. Diego Rivera and Bertram D. Wolfe, *Portrait of America* (New York: Covici, Friede, 1934), 20.

55. Lucienne Bloch, "On Location with Diego Rivera," *Art in America* 74 (Feb. 1986): 114–16.

56. "Valentiner," 101.

57. The *Detroit News, Detroit Free Press,* and *Detroit Times* published daily on the controversy during mid-March. See also "The Rivera Squall," *Art Digest,* April 1 and 15, 1933. The Museum Archives, Detroit Institute of Arts, has extensive documentation; further material is held in the Burton Historical Collection, Detroit Public Library. I also draw on relevant documents in the Ford Archives, Edison Institute, Dearborn. Standard accounts of the controversy can be found in Wolfe, *Fabulous Life*, 311–14; Jacob and Downs, *The Rouge*, 52; and Lacey, *Ford: The Men and the Machine*, 324–26.

58. Letter, January 27, 1931, William R. Valentiner Records, Museum Archives, DIA, Acc. 22/2.

59. *Detroit Times*, March 21, 1933.

60. Lacey, *Ford: The Men and the Machine*, 326: "Edsel Ford did not know how to stand up to his father, but to his eternal credit, he did know how to stand up to Detroit."

61. Nevins and Hill, *Ford: Expansion and Challenge*, 588–89.

62. See n. 22 above; on the Briggs strike and Ford's role in it, see *Detroit News,* February 24, 1933; *Business Week,* February 15, 1933; and Sward, *Legacy of Henry Ford*, 220–22.

63. According to "Valentiner," 106; see also n. 23 above.

64. Letter from DIA Arts Commission to City Council, April 5, 1973; Letter Burroughs to Ford, May 6, 1932: Edsel Ford Papers, Acc. 6, Ford Archives, Edison Institute. Minutes of DIA Arts Commission, April 21, 1931, April 26, 1932, and June 10, 1932.

65. "Valentiner," 103.

66. Letter, November 27, 1932, Edsel Ford Papers, Acc. 6, Ford Archives Edison Institute.

67. Letter, Albert Kahn to Edsel Ford, April 11, 1933, Edsel Ford Papers, Acc. 6, saying Valentiner should not be allowed to resign. Albert Kahn's role within the controversy can be briefly sketched. Also an arts commissioner, he made many contributions of art works to the DIA, and, with Ford and Tannahill, contributed $1,000 to a fund to retain the services of Richardson. But he gave nothing toward either the mural or the architectural work related to it; indeed, he is reported to have not liked it (Interview with E. P. Richardson, DIA Oral History Project). Yet this does not seem accurate. In a letter of December 28, 1932, in which he seeks to persuade Valentiner not to resign, he reports progress, saying that "the large panel on our North wall . . . is turning out just as I expected—perfectly magnificent, full of interest, of wonderful color, excellent in scale and thoroughly satisfactory in every way." However, he went on to say that he found "no relation whatever between the panels above and those below," the intermediate frieze "incongruous" and "of very bad design," adding that Saarinen and others had the same view (William R. Valentiner Records, Museum Archives, DIA, 30/8). During the crisis he spoke strongly in defense of the murals, attacking critics as "provincial and narrow-minded," claiming that the murals "put Detroit on the map artistically" (*Detroit News*, Mar. 22), and seems to have taken a leading role on the commission with Edsel Ford's retreat. His other recorded comments on art are, like Edsel Ford's, virtually nonexistent. It should be said that in 1978, on the instructions of Henry Ford II, lawyers removed from the Ford Archives all material on his father deemed "personal." Arts Commission papers remained, and other minor documents, but some material relevant to Edsel Ford's interest in art seems to have been among that taken.

68. Letters, March 2, 7, and 20, 1933; Edsel Ford Papers, Acc. 6, Ford Archives, Edison Institute.

69. *Industrial Worker*, April 4, 1933, 4.

70. Acc. 33.10, Registrar's Files, "Diego Rivera," Museum Archives, DIA.

71. Wolfe, *Fabulous Life*, 313; Rivera and Wolfe, *Portrait of America*, 20.

72. Aims approved Arts Commission, Minutes, June 14, 1932; story of organization, George F. Pierrot, "Frescoes and Finance at the DIA," *Herald* (Greenfield Village and Henry Ford Museum) 8, no. 4 (Fall 1979): 44–47; membership cards, DIA Archives, PMA 1-2; pamphlet drafts and minutes, PMA 2-1; directors, constitution, Burroughs Records, BUR-4-78, Museum Archives, DIA. Pierrot also wrote on Rivera in *American Heritage*, December 1977, 14–30, and referred to the controversy in the voice-over of the Ford film *The Age of Steel* (1978).

73. "Valentiner," 103.

74. *Reminiscenes of Fred L. Black*, 114–22.

75. Pierrot, "Frescoes and Finance at the DIA," 44–45. The closest approximation to this letter I have sighted is the March 18 *Free Press* editorial, almost the first publication on the matter of a controversial nature. The story about Borth may be a defensive diversion, invented many years later to cover those who actually did incite the controversy. As Pierrot said in 1979, "Trial ballons like this have been accepted practice for many generations. If you want to know what the public will do in a certain situation, create the situation" (45). Pierrot also tried to stir up the controversy again, a month later, to attract tourist attention: *Detroit This Week*, April 23, 1933, 5.

76. Rivera to Valentiner, in Sterne, *Passionate Eye*, 97.

77. It is also unhistorical: the proposal that Rivera paint his desire, Detroit Industry, was introduced *before* any other thought of a mural by anyone on any subject was broached. Had the proposal *then* been modified, the question of other U.S. artists might have come up, and candidates ranging from an Evergood *American Tragedy* panorama to a Sheeler *Industry* photomural would have been available. Yet the 1932 MOMA exhibition of murals and photomurals of New York suitable for Rockefeller Center was steadfastly ignored by the architects and family.

78. Two years later, Edsel Ford invited Sheeler to create the huge photomurals for the Ford Company rotunda at the 1934 Chicago Exposition. Sheeler's dealer, Edith Halpert, insisted that they be paintings—an impractical demand in the time available. As noted above, Ford photographer George Ebling did them in a manner which typifies corporate photography of the 1930s: essentially the engineer's descriptive narrative, augmented by a Sheeler-type emphasis on the abstract processes, a Bourke-White stress on product, and a Rivera-type celebration of the roles of the worker (compare Jacob and Downs, *The Rouge*, 14–15). Kahn's commission to Rivera to do a mural for the General Motors Pavilion at Chicago was withdrawn immediately after the Rockefeller Center controversy erupted.

79. *Reminiscences of Fred L. Black*, 121.

80. Ibid., 122.

81. A controversy such as this occasions many echoes, replays, reconstructions. One which obliged Institute staff to reverse their 1933 tactic of privileging the artist occurred twenty years later, at the depths of the McCarthy moment. In the biography of Valentiner, *The Passionate Eye*, opposite page 202, is reproduced a photograph showing Edgar P. Richardson, then director of the Institute, supervising the installation of a placard beneath the East Wall germination panels, directly opposite viewers entering the Garden Court. Rivera, in Mexico, was striving for readmittance to the Communist party. The Detroit murals now take on yet another life. The banner reads:

> Rivera's politics and his publicity seeking are detestable. But let's get the record straight on what he did here. He came from Mexico to Detroit, thought our mass production industries and our technology wonderful and very exciting, painted them as one of the great achievements of the twentieth century. This came after the debunking twenties when our artists and writers found nothing worthwhile in America and worst of all in America was the Middle West.
>
> Rivera saw and painted the significance of Detroit as a world city. If we are proud of this city's achievements, we should be proud of these paintings and not lose our heads over what Rivera is doing in Mexico today.

Chapter 7. Frida Kahlo

1. Diego Rivera, "Frida Kahlo and Mexican Art," *Bulletin of the Mexican Cultural Seminary*, no. 2 (Ministry of Public Education, Mexico City) (October 1943): 89–101.

2. André Breton, "Frida Kahlo de Rivera," in *Surrealism and Painting*, trans. Simon Watson Taylor (1938) (London: Macdonald, 1972), 144.

3. A draft of this chapter first appeared in *Block* 8 (1983): 11–23; a revised version appeared in *Lip* 8 (1984): 39–59. Apart from my debt to the scholars of Kahlo's work, I thank the following for posing the problems for me: Phil Goodall, Lucy Lippard, Mary Kelly, Alicia Azuela, Virginia Spate, Julie Ewington, Helen Grace, Joyce Kozloff, and Whitney Chadwick.

4. Stresses on Rivera's power and Kahlo's illnesses and sexuality structure Heyden Herrera's *Frida* (New York: Harper and Row, 1983). For more extensive comments on this book and the exhibition *Frida Kahlo/Tina Modotti* (Grey Art Gallery, New York University, Apr.–May 1983), see Terry Smith, "Further Thoughts on Frida Kahlo," *Block* 9 (1983): 34–37. Recent treatments of Kahlo's work include the essay by British novelist Angela Carter accompanying a box of postcards, *Images of Frida Kahlo* (London: Redstone Press, 1989), and the major survey, Helga Prignitz-Poda, Salombu Grimberg, and Andrea Kettermann, eds., *Frida Kahlo: Das Gesamtwerk* (Frankfurt am Main: Verlag Neue Kritik, 1988). The paintings referred to in the text but not illustrated can all be found in these publications.

5. Laura Mulvey and Peter Wollen, *Frida Kahlo/Tina Modotti* (London, 1982), 20. This is the catalogue of the Whitechapel exhibition.

6. Wolfe, *Fabulous Life*, 370–73.

7. Rivera's emphases, *Mexican Folkways* 2 (Apr.–May 1926).

8. While painting this picture, Kahlo was interviewed by a reporter whose profile was headed "Wife of the Master Mural Painter Gleefully Dabbles in Works of Art," *Detroit News*, February 2, 1933.

9. Kahlo's mother actually died in mid-1932, making this painting, in Kahlo's sense, an ex-voto. See Herrera, *Frida*, 156–58.

10. Mulvey and Wollen, *Kahlo/Modotti*, 16.

11. Ibid.

12. *Time* assimilated it too easily in its story "Bomb Beribboned," November 14, 1938.

13. Wolfe's account in *Fabulous Life* includes Rivera's tender care, 309–10; Herrera, *Frida*, 137–46.

14. One of the few surveys is William H. Gerdts, *The Art of Healing* (Birmingham Museum of Art, Ala., 1981). In this volume, subtitled *Medicine in American Art*, the patient's viewpoint is rare indeed, occurring mostly in pictures of wartime casualty stations. Suffering from illnesses of the mind and body is, of course, a major theme in Romantic and Victorian art. In the late 1920s and early 1930s, Alice Neel experienced profound physical and emotional trauma, including the death of her child. Her reminiscences of this period, and the drawings and paintings of hospitalization resulting from it, are in Patricia Hills, *Alice Neel* (New York: Abrams, 1983).

15. Breton, *Surrealism and Painting*, 143.

16. Rivera, "Frida Kahlo and Mexican Art," 89.

17. Heyden Herrera, "Frida Kahlo: Her Life, Her Art," *Artforum*, May 1976, 38; and idem, "Why Frida Kahlo Speaks to the 90's," *New York Times*, October 28, 1990, Arts & Leisure, 1 and 41. Among the responses to the latter article was a letter from Dr. Philip Sandblom, author of *Creativity and Disease: How Illness Effects Literature, Art and Music* (Philadelphia: G. F. Stickley, 1982), claiming that Kahlo's life-long pain and suffering was the result less of her childhood accident than trophic ulcers caused by inherited spina bifida (*New York Times*,

December 23, 1990, Arts & Leisure, 4). I thank Kathryn Gohl for drawing my attention to this letter.

18. Michel Foucault, *The Birth of the Clinic*, trans. A. M. Sheridan Smith (London: Tavistock, 1973), 196.

19. Ibid., 171.

20. Ibid., 109.

21. She apparently did repaint one such accident *retablo* and dedicated it to her own accident, as a "joke," according to her niece. See Herrera, "Kahlo: Her Life, Her Art," 44, n. 10.

22. Frida Kahlo, "Retrato de Diego Rivera" (1940), in *Diego Rivera 50 naos de su labor artistica, Exposition de Homenaje Nacional* (Mexico City, 1951); cited in Wolfe, *Fabulous Life*, 397–98. Kahlo's journal also often addresses Rivera in these terms; Herrera, *Frida, passim.*

23. Jacques Lacan, *The Four Fundamentals of Psychoanalysis* (1973) (New York: Penguin, 1979). See also idem, "The Role of the Mirror-Phase in the Formation of the I," *New Left Review* 51 (Sept.–Oct. 1968), including Jean Roussel's introduction.

24. Laura Mulvey, "Visual Pleasure and Narrative Cinema," *Screen* 16 (Autumn 1975): 7.

25. Ibid.

26. John Berger, *Ways of Seeing* (London: B.B.C. and Penguin, 1972), 47.

27. Sigmund Freud, *Three Essays on the Theory of Sexuality* (1905) (London: Hogarth, 1962); also in the *Standard Edition* (1964), vol. 7.

28. Octavio Paz's account of the symbolic positioning of women in Mexico is relevant here, although limited by its descriptive humanism. See Paz, *The Labyrinth of Solitude* (New York: Grove, 1961), especially "Mexican Masks."

29. Luce Irigaray, "This Sex Which Is Not One" (1977), in *This Sex Which Is Not One* (Ithaca, N.Y.: Cornell University Press, 1985). See also Helen Grace and Ann Stephen, "Where Do Positive Images Come From? (And What Does a Woman Want?)," *Scarlet Woman* 12 (Mar. 1981): 15–21.

30. The constant overturning of "Lacan" by "Kahlo" in this text has the obvious political intention of countering the pessimism engendered by the force of Lacan's account of feminity locked into language as lack. It may be objected that I have not recognized Lacan's struggle with these issues in the last years of his life, as evidenced in Juliet Mitchell and Jacqueline Rose, eds., *Feminine Sexuality: Jacques Lacan and the École Freudienne* (London: Macmillan, 1982). Feminist questioning seemed to move him to a still more extreme concept of the fragmented subject, of the subject's incessant self-construction in all its splits, of sexuality only coming up in this splitting. The Kahlo I am constructing here has already been there. See Smith, "Further Thoughts on Frida Kahlo."

31. Mary Ann Doane, "Film and Masquerade: Theorising the Female Spectator," *Screen* 23 (Sept.–Oct. 1982): 80–82.

32. Elizabeth Cowie, "Woman as Sign," *m/f* 1 (1978): 60.

33. See, for example, Justino Fernandez, *El arte moderno en México* (Mexico City: Antigua Libreria Robredo, 1937).

34. This connection is made by Charles Merewether, "New World Primitivism: Ethnography, Neocolonialism and Minority Discourses," Ph.D., University of Sydney, 1990.

35. Paz, *Labyrinth of Solitude*, chs. 5–8. His essays in *Alternating Current* (New

York: Viking, 1973), sometimes touch on such themes, e.g., 17–21, 40–45, 202.

36. See n. 29 above, and Meaghan Morris, "A-mazing Grace: Notes on Mary Daley's Poetics," *Intervention* 16 (1982); idem, *Lip* 7 (1982–83). Much also remains vexed within the debates around the usefulness/power of psychoanalysis for feminism. Does the concept of the multiplicity of the feminine return the idea of a "universal womanness" in the very contradicting of it, and in a politically more dispersive way? Similarly, the rejection of the anatomical basis for gender in favor of the rule of language or of certain social laws suggests a mobility of sexual construction of an as-yet-unsorted variety: for some it is always in a relation to the given difference; for others it is very free indeed. Finally, Lacan's late undercutting of knowledge and belief as such (the "subject supposed to know") led him to constrast the woman who cannot know (can she at least know that?) to the man who knows nothing precisely because he commands knowing as such, that is, the forming of sexual difference is so fundamental that it destroys conventional knowledge and belief for all. This clearly would also destroy outright my claims for Kahlo's knowing, for her art speaking certain truths. I withdraw none of the claims. (The issues raised here are most cogently canvassed by Jacqueline Rose in Mitchell and Rose, *Feminine Sexuality*, 49–56.)

37. Lucy Lippard, *New York Times Book Review*, April 24, 1983, 10 and 23.

38. Marie de Micheli, *Siqueiros* (Milan: Fratelli Fabri, 1968).

39. Hurlburt, *Mexican Muralists in the United States*, 56–87. See ch. 6, n. 6., this vol., and Antonio Rodriguez, *La pintura mural en la obra de Orozco* (Mexico City, D.F.: Secretaría de Educacíon Pública, 1983).

40. Thus his *Science* and *Mechanical Horse* murals at the Hospicio Cabañas, Guadalajara, his 1932 oil *Queensborough Bridge*, and his portrayal of war as enchaining humanity in a metallic junkyard in *Dive Bomber and Tank* (1940, demountable mural, MOMA); illustrated, Rodriguez, *La pintura mural*, 89, 104, 150.

Chapter 8. Of the People, For the People

1. David Shapiro, *Social Realism*, is the major survey; many artists involved have been treated in monographs; Ilene Susan Ford, "American Social Surrealism," *Archives of American Art Journal* 22 (1982): 8–19. On images of labor in American art see Lois Dinnerstein, "The Iron Worker and King Solomon," *Arts Magazine* 54 (Sept. 1979): 112–17, and Patricia Hills, *The Working American* (Washington, D.C.: District 1199, National Union of Hospital and Health Care Employees, and the Smithsonian Institution, 1979), and idem, *Social Concern and Urban Realism: American Painting of the 1930s* (Boston University Art Gallery, 1983).

2. The latter is illustrated in Hills, *Social Concern and Urban Realism*, 25.

3. On this latter see Charles Pollock's *The Tipple* (1940) and Ceseare Stea's *Relief for Bowery Bay Sewerage Disposal Unit*, both in Francis V. O'Connor, ed., *Art for the Millions* (Boston: New York Graphic Society, 1973), 134 and 82. The National Museum of American Art holds many paintings on this type of theme made under the program, including major works by Douglas Crockwell, Charles Pollock, Louis Guglielmi, Joe Jones, and others. See also Merry A. Foresta, "Federal Art Project Photography," in Pete Daniel, Merry A. Foresta, Maren Stange, and Sally Stein, *Official Images, New Deal Photography* (Washington, D.C.: Smithsonian Institution Press, 1987).

4. Themes in these paintings are traced most thoroughly in Marlene Park

and Gerald E. Markowitz, *Democratic Vistas: Post Offices and Public Art in the New Deal* (Philadelphia: Temple University Press, 1984). See also Greta Berman, *The Lost Years: Mural Painting in New York City under the WPA Federal Art Project, 1935–1943* (New York: Garland, 1978); Karal Ann Marling, *Wall-to-Wall America: A Cultural History of Post Office Murals in the Great Depression* (Minneapolis: University of Minnesota Press, 1982); and Belisaro R. Contreras, *Tradition and Innovation in New Deal Art* (Lewisburg, Pa.: Bucknell University Press, 1983).

5. An interpretation cogently argued by Jonathon Harris, "State Power and Cultural Discourse: Federal Art Project Murals in New Deal USA," *Block* 13 (Winter 1987–88): 28–42. Among these surviving murals are William Gropper's Detroit Post Office mural, now at Case Western Reserve University; Vertis Hayes's *Pursuit of Happiness* (1937), Harlem Hospital, New York; George Biddle's *Society Freed through Justice*, Department of Justice, Washington, D.C.; and Charles Davis, *Progress of American Industry* (1938), Farm Colony, Richmond. Among those destroyed was Biddle's *The SweatShop* (c. 1935), Manhattan, House of Detention for Women. Some sense of the climate of moral-political censure in which the muralists worked, and the not infrequent censorship, can be gained from Joe Jones's list of attacks on muralists in his report in *First American Artists' Congress*, 10–11.

6. Shapiro, *Social Realism*, introduction. See also Rebecca Zurier, *Art for the Masses (1911–1917): A Radical Magazine and Its Graphics* (New Haven: Yale University Art Gallery, 1985).

7. Philip S. Foner and Reinhard Schultz, *Das Andere Amerika* (Berlin: Elefanten Press, 1983). Criticisms of the exhibition are advanced by Ian Burn, "The Other America," *Art Network* 12 (Summer 1984): 18–25.

8. Maren Stange, "'The Record Itself': Farm Security Administration Photography and the Transformation of Rural Life," in Daniel et al., *Official Images, New Deal Photography*, 2 and 4.

9. Even Evans's statement of independence implies an awareness of this: "never make photographic statements for the government or do photographic chores for the government or anyone in government, no matter how powerful—this is pure record, not propaganda. The value and, if you like, even the propaganda value for the government lies in the record which in the long run will prove an intelligent and farsighted thing to have done—NO POLITICS whatever." From a handwritten draft memorandum re Resettlement Administration job, Spring 1935, in Walker Evans, *Walker Evans at Work* (New York: Harper and Row, 1982), 112.

10. William Stott, *Documentary Expression and Thirties America* (New York: Oxford University Press, 1973), 62.

11. See R. J. Doherty, *Social-Documentary Photography in the USA* (Garden City, N.Y.: Amphoto, 1976).

12. Especially Maren Stange, *Symbols of Ideal Life: Social Documentary Photography in America, 1890–1950* (New York: Cambridge University Press, 1989); and Alan Trachtenberg, *Reading American Photographs: Images as History* (New York: Hill and Wang, 1989). For an extensive review of these two books see Terry Smith, *Archives of American Art Journal* 31 (1991): 21–31.

13. Russell Campbell, "America: The (Worker's) Film and Photo League," in *Photography/Politics: One* (London: Photography Workshop, 1970), 92–97; William Alexander, *Film on the Left* (Princeton: Princeton University Press, 1981), chs. 1 and 2.

14. See the varying interpretations of Stott, *Documentary Expression*, concluding chapter; Ian Jeffrey, *Photography: A Concise History* (London: Thames and Hudson, 1981), 173–77; and Trachtenberg, *Reading American Photographs*, ch. 5.

15. The need for the former is raised in John Tagg, "The Currency of the Photograph," in Victor Burgin, ed., *Thinking Photography* (London: Macmillan, 1982); on the latter see the review of Alexander by Stuart Liebman, "Documenting the Left," *October* 23 (Winter 1982): 60–79. The most subtle analysis of all these issues remains Allan Sekula's "Photography between Labor and Capital." On which see Terry Smith, "Photography for and against the Grain: Leslie Shedden and Allan Sekula," *Afterimage* 13 (Summer 1985): 16–19.

16. R. G. Tugwell, T. Munro, and R. E. Stryker, *American Economic Life and the Means of Its Improvement* (New York: Harcourt Brace, 1924). Hine worked generally with the prewar program of gradual social reform promoted by liberals such as Paul Kellogg through magazines such as *The Survey* (later *Survey Graphic*), financed by the philanthropic Russell Sage Foundation. Yet Hine was also a trained sociologist, dedicated photographer, and independent campaigner for reform, working not only for agencies but also doing his own critical photoessays. For accounts of the phases of his political development see Alan Trachtenberg, "Essay," in *America and Lewis Hine: Photographs, 1904–40* (New York: Aperture, 1977); Trachtenberg, *Reading American Photographs*, ch. 4; Stange, *Symbols of Ideal Life*, chs. 2 and 3, is the most critical analysis to date, and includes a close reading of *American Economic Life*.

17. Lewis Hine, *Men at Work* (New York: Macmillan, 1932; reprint, New York: Dover, 1977), n.p.

18. Sekula illuminatingly labels this a "children's book" in "Photography between Labor and capital," 243; Trachtenberg claims it was consciously designed as such, in *Reading American Photographs*, 218. It won the outstanding book of the year award from the Child Study Association.

19. See the Dover reprint, including eighteen extra shots of such subjects. The exclusions cited here are from a set in the Still Pictures Collection, National Archives, Washington, D.C., Hine's Loan Collection of Prints for the National Relief Project 1909–1935, 69-RH-Box 2.

20. Trachtenberg, *Reading American Photographs*, 221. For an argument that Hine had become the eye of management, see Peter Seixas, "Lewis Hine: From 'Social' to 'Interpretive' Photographer," *American Quarterly* 39 (Fall 1987): 405. For an argument that these images were used, against Hine's intentions, by management to compensate workers for their lost autonomy, see Linda Andre, "The Rhetoric of Power, Machine Art and Public Relations," *Afterimage*, 1984, 6.

21. Lewis Hine to Florence Kellogg, February 17, 1933, Elizabeth McCausland Papers, Archives of American Art, Washington, D.C.

22. Trachtenberg, *Reading American Photographs*, 226–30.

23. John Gutman, *As I Saw It* (San Francisco Museum of Art, 1976). See also Benjamin Bloom, *New York Photographs, 1850–1950* (New York: Dutton, 1982). I thank Max Kozloff for drawing my attention to these two texts.

24. Berenice Abbott and Elizabeth McCausland, *Changing New York* (New York: Dutton, 1939); Flint, *Prints of Louis Lozowick*. See also Hank O'Neal, *Berenice Abbott, American Photographer* (New York: McGraw-Hill, 1982).

25. Linda Nochlin noted a similar marked preference in Realist painting in France around 1850, in *Realism*, 45–50, 111–36. There is considerable literature on this question. Prior to Nochlin see R. L. Herbert, "City versus Country: The Rural Image in French Painting from Millet to Gauguin," *Artforum* 8 (Feb.

1970); subsequently T. J. Clark, *The Absolute Bourgeois* (London: Thames and Hudson, 1973), and idem, *Image of the People*. Clark argued that, in painting rural subjects, Courbet and others were intervening, through an indirection obvious to most, in the volatile politics of Paris itself.

26. See Roy E. Stryker Papers, Archives of American Art, Washington, D.C., NDA 8, frame 27ff. for Stryker's comments on captions to publicity photographs in a radio guide; and NDA 4 for press releases, reviews, etc. concerning the exhibition.

27. On the FSA preparation for the New York Exhibition and response to it, see Stryker Papers, NDA 8, frame 1002ff. Examples of articles include *U.S. Camera*, August and October 1941; Robert E. Girvin, "Photography as Social Documentation," *Journalism Quarterly* 24 (Sept. 1947); idem, "The Influence of Roy Stryker on Modern Documentary Photography," *Photographic Society of America Journal* 14 (Nov. 1948).

28. Tagg "Currency of the Photograph," 131–32.

29. Stryker Papers, NDA 8, frame 171. The basic study is F. Jack Hurley's celebratory *Portrait of a Decade: Roy Stryker and the Development of Documentary Photography in the Thirties* (Baton Rouge: Louisiana State University Press, 1972); joined now by Carl Fleischhauer and Beverley W. Brannan, *Documenting America, 1935–1943* (Berkeley: University of California Press, 1988). More interpretative are Stange, *Symbols of Ideal Life*, and her essays cited above.

30. Stryker Papers, NDA 8, frame 16ff.: letter to Personnel Division, 1941, drawn from duties in appointment letter, July 1, 1935, frame 178. The most thorough study of the FSA program is Sidney Baldwin, *Poverty and Politics: The Rise and Decline of the Farm Security Administration* (Chapel Hill: North Carolina University Press, 1968).

31. Last two quotations are from Stryker's notes for the Brehm lecture, Rochester Institute of Technology, June 3, 1950, Stryker Papers, NDA 8, 248ff.

32. Stryker Papers, NDA 8, letter November 1, 1935, re Ford. This is not to deny the significance of his work with Tugwell on *American Economic Life* in 1924, sharply analyzed by Stange, *Symbols of Ideal Life*, 90–105.

33. Julia Peterkin, *Roll, Jordan, Roll* (New York: R. O. Ballou, 1933), and Allen H. Eaton, *Handicrafts of the Southern Highlands* (New York: Russell Sage Foundation, 1937), but from photographs taken three and four years earlier; cited in Jeffrey, *Photography: A Concise History*, 162–64.

34. For example, Nancy Heller and Julia Williams, *The Regionalists* (New York: Watson-Guptill, 1976); and James Dennis, *Grant Wood: A Study in American Art and Culture* (New York: Viking, 1975). The prevailing view of these artists as either despairing deserters of the city and radical politics, such as Thomas Hart Benton, or simple country folk going on with local traditions, such as Grant Wood, is also due for some revision. A satirical, critical content is marked in certain work, and a sense of disquiet, even disruption, pervades other work at the time, for example, that of John Steuart Curry. See Lawrence Alloway's review of Dennis, *Grant Wood*, in *Art in America*, March–April 1976.

35. Clarence Pearce Hornung, *Treasury of American Design: A Pictorial Survey of Popular Folk Arts based on Watercolor Renderings in the Index of American Design at the National Gallery of Art* (New York: Abrams, 1972); see also O'Connor, *Art for the Millions*, 164–75.

36. Bernard McTigue, *FDR and the Arts: The WPA Arts Projects* (New York Public Library, 1983); Stott, *Documentary Expression*, 111–18.

37. Susan Sontag, *On Photography* (Hamondsworth: Penguin, 1978), 56, 54;

see also Roland Barthes, *Camera Lucida* (New York: Hill and Wang, 1981), particularly his concept of the "Flat Death."

38. For example, the 1937 Arkansas-Tennessee flood pictures: which are by Evans and which by Edwin Locke, the least individualized of the FSA photographers? See Gerald C. Maddox, *Walker Evans: Photographs for the Farm Security Administration, 1935–1938* (New York: Da Capo, 1975), nos. 412–50.

39. "Killing" consisted of rejecting the negatives for printing and entry into the file. In the early years this was often done by punching a hole in the negative. After protests by photographers, a more cooperative mode of selection evolved. See Fleischhauer and Brannan, *Documenting America*, 338–40.

40. There are also at least 68,000 negatives. The organization of the prints is further mediated in that they are distributed according to a plan proposed by archivist Paul Vanderbilt in 1942. It was both more formal and more elaborate than that with which Stryker was working six years earlier, but it was developed in consultation with him and broadly speaking follows similar principles. See Stryker Papers, NDA 4, opening frames. Trachtenberg examines Vanderbilt's approach in "From Image to Story, Reading the File," in Fleischhauer and Brannan, *Documenting America*, 52–63. The introduction and appendix to this book are useful introductions to the Library of Congress holdings.

41. The Woodbury County sequence is on microfilm series A11157, Library of Congress. The monograph on Lee is F. Jack Hurley, *Russell Lee, Photographer* (Dobbs Ferry, N.Y.: Morgan and Morgan, 1978). See Stange, *Symbols of Ideal Life*, 123–28, for a more thorough study of this same pairing. Something of Evans's methods of work are sketched in Jerry L. Thompson, *Walker Evans at Work* (London: Thames and Hudson, 1983). Maddox, *Walker Evans*, is, however, more informative.

42. Stange, *Symbols of Ideal Life*, 108.

43. The significance of both the critical economics and the photographs of Lange's husband Paul S. Taylor has been made clear by Richard Steven Street, "Paul S. Taylor and the Origins of Documentary Photography in California," *History of Photography* 7 (Oct.–Dec. 1983): 293–304.

44. Blum, *Critical Vision*, 45: the elision here between an emotion presumably experienced by the viewer and that supposedly experienced by the photographer is typical of the rhetorical imprecision which well-intentioned but misleading readings occasion; each emotion testifies to the other, becoming a circle of communication in which the migrant mother exists only as occasion for the production of a token within a self-servicing circle of "charity." For a more exact analysis see James C. Curtis, "Dorothea Lange, *Migrant Mother* and the Culture of the Great Depression," *Winterthur Portfolio* 29 (Spring 1986): 1–20.

45. Cited in Milton Meltzer, *Dorothea Lange: A Photographer's Life* (New York: Farrar, Straus and Giroux, 1978), 133, from *Popular Photography*, February 1961, 42–43 and 128.

46. George P. Elliott, "Things of the World," *Commentary*, December 1962, 342.

47. Lawrence W. Levine, "The Historian and the Icon: Photography and the History of the American People in the 1930s and 1940s," in Fleischhauer and Brannan, *Documenting America*, 16ff.

48. See Stryker Papers, NDA 4, frame 79; "Russell Lee at Pie Town," *U.S. Camera*, October 1941.

49. Dorothea Lange and Paul Taylor, *An American Exodus: A Record of Human Erosion* (New York: Reynal and Hitchcock, 1939; republication, New Haven: Yale

University Press, 1969), 66. On the conditions of taking this photograph, see Meltzer, *Dorothea Lange: A Photographer's Life*, 172.

50. "Statement of the President," *N.R.A. Bulletin*, June 16, 1933, cited in Persia Campbell, *Consumer Representation and the New Deal* (New York: Columbia University Press, 1940), 24, 27. See also George H. Phelps, *Our Biggest Customer* (New York: Liveright, 1929), for an advertising man's call to turn the worker into a consumer.

51. F. D. Roosevelt, Address at Oglethorpe University, May 1932; cited in Fred Henderson, *Capitalism and the Consumer* (London: Allen and Unwin, 1936), 8.

52. Horace M. Kallen, *The Decline and Rise of the Consumer* (New York: Appleton-Century, 1936), 280–81, for these figures.

53. Ibid., 282; Campbell, *Consumer Representation and the New Deal*, 22.

54. Joseph Gear, *Towards Farm Security: The Problem of Rural Poverty and the Work of the Farm Security Administration* (Washington, D.C.: Department of Agriculture, 1941), see especially "Objectives," 62–63, and "Credo," 66–67.

55. Hurley, *Portrait of a Decade*, 112–16, on photographers' interventions; Nancy Wood, "Portrait of Stryker," in Wood and Stryker, *This Proud Land: America, 1935–1943, as Seen by the FSA Photographers* (London: Seeker and Warburg, 1973), 16.

56. Sally Stein, "Marion Post Wolcott: Thoughts on Some Lesser Known FSA Photographs," in *Marion Post Wolcott* (Carmel, Calif.: Friends of Photography, 1983).

57. Fleischhauer and Brannan, *Documenting America*, 321–29.

58. Alexander, *Film on the Left*, passim. By emphasizing FSA images of industrial work and organization, Foner and Schultz in *Das Andere Amerika* give a misleading sense of the relative political weightings within the program as a whole.

59. Robert Lynd and Helen M. Lynd, *Middletown: A Study in American Culture* (New York: Harcourt, Brace and World, 1929); Hurley, *Portrait of a Decade*, 98.

60. Stryker Papers, NDA 8, Letter to Personnel Division, 1941. See also Fleischhauer and Brannan, *Documenting America*, 331. A contemporary study of the vast range of Roosevelt administration publicity initiatives is James L. McCamy, *Government Publicity* (Chicago: University of Chicago Press, 1939), in which the FSA Historical Section appears as a positive model for other agencies (79–84).

61. Fifty press clippings on this issue, Stryker Papers, NDA 8, 46–123; Arthur Rothstein, "The Picture That Became a Campaign Issue," *Popular Photography*, September 1961, 42ff. On anti-FSA feeling, see Baldwin, *Poverty and Politics*, passim.

62. Alexander, *Film on the Left*, passim.

63. In Hurley, *Portrait of a Decade*, 151.

64. Hurley, *Portrait of a Decade*, 98, a paraphrase; complete text in Thomas H. Garver, ed., *Just before the War; Urban America from 1935 to 1941 as Seen by Photographers of the Farm Security Administration* (New York: October House, 1968), 9.

65. Stryker Papers, NDA 8, frame 941.

66. Ibid., frame 782, 1949 copy.

67. Ibid., frame 786. See also frame 791, "Field notes for John Vachon. Farming." NDA 8 has extensive shooting scripts, frames 764–1001. Others appear in letters to photographers, e.g., NDA 26, Arthur Rothstein and John Vachon; NDA 30, Marion Post Wolcott and Dorothea Lange; NDA 31, Russell Lee; NDA 21, Roy Delano.

68. Stryker Papers, NDA 8, frame 812.

69. Ibid., frame 832.

70. May 13, 1940, ibid., frame 825.

71. August 26, 1939, ibid., frame 798.

72. Hurley, *Portrait of a Decade*, 110–12.

73. See Raymond P. Duggan, *A Federal Resettlement Project, Granger Homesteads* (Washington, D.C.: Catholic University of America, 1937), a comparison of living conditions and attitudes in 1933 and 1936, but too early in the process to produce meaningful results.

74. Quoted in Wood, "Portrait of Stryker," 15.

75. Tagg, "Currency of the Photograph," 139–40. I have taken this interpretation a little further than he does. See also Trachtenberg, in Fleischhauer and Brannan, *Documenting America*, 59–60, on Stryker's search for an abstract value here.

76. Notes on publicity for FSA photographs in the exhibition The Bitter Years: Farm Security Administration Photographs, 1935–41, Museum of Modern Art, New York, October 1962, 57, NDA 8; see also Wood, "Portrait of Stryker," 19.

77. Hurley, *Portrait of a Decade*, 113–16.

78. Or did Tugwell sense already that Greenbelt would remain one of few such model towns, that suburbia based on a war economy would be the form in which the consumer society's housing dreams were made concrete? Is that why he looks like a canvassing politician, like someone telling a lie in which he, too, mostly believes?

79. Tagg compares it to Delano's middle-class couple at *Union Point, Georgia* (1941), in "Currency of the Photograph," 115ff.

80. The Union Point couple are rather more self-conscious; they pose looking at a photo album!

81. Stryker and Wood, *This Proud Land*, 187–88.

82. Levine, "The Historian and the Icon," 39–40.

83. Archie Robertson, typescript, AAA, NDA 4, frame 75.

84. Stryker Papers, NDA 8, 864. In an often-quoted letter of 1940 to Jack Delano he had revved up the ideological demand to exaggerated dimensions: "Emphasize the idea of abundance—the 'horn of plenty'—and pour maple syrup over it—you know, mix well with white clouds and put on a sky-blue platter. I know your photographer's soul writhes, but to hell with it. Do you think I give a damn about a photographer's soul with Hitler at our doorstep? You are nothing but camera fodder to me." Cited in Stryker and Wood, *This Proud Land*, 16.

85. For Stryker's own account of his reasons for leaving, see Stryker and Wood, *This Proud Land*, 124–53; see also Stange, *Symbols of Ideal Life*, 141–46, and Stephen W. Plattner, *Roy Stryker: U.S.A., 1943–1950: The Standard Oil (New Jersey) Photography Project* (New York: International Center of Photography, and Austin: University of Texas Press, 1983).

86. Hurley, *Portrait of a Decade*, 122.

87. These thrusts were noted as early as 1939, by McCamy, *Government Publicity*, 53.

88. Stange, *Symbols of Ideal Life*, 107–14. Vanderbilt claimed that "publisher's demand" was a major force in the spread from rural America and "depressed activities" to the cities and "more sophisticated activities" (117).

89. Ibid., 130.

Chapter 9. Official Images, Modern Times

1. Noted by Stange, *Symbols of Ideal Life*, 89ff.

2. Exhibition Staff, Office of Educational Programs, National Archives and Records Service, *The American Image: Photographs from the National Archives, 1860–1960* (New York: Pantheon, 1979), 95.

3. Record Group 86, National Archives, Washington, D.C.; see, for example, Automobile Industry (Box 1) Folder P, workers at Pierce-Arrow, 1917.

4. The Farm Security and Office of War Information photographs discussed in the last chapter are housed in the Library of Congress. See n. 9 below for further information on National Archives holdings.

5. These observations reflect Allan Sekula's brilliant analysis of the photographic archive, especially his stress on its "contradictory character," wherein an "illusory neutrality" is achieved by isolating images from their "contexts of use," while at the same time the archive as a whole gains authority both from the presumed, although specious, veracity of the camera and, more significantly, from the power of the archive's institutional location (Sekula, "Photograph between Labor and Capital," 193–202). U.S. government photography since the 1860s, but especially from the 1930s, bears out Sekula's supposition: "We might even argue that archival ambitions and procedures are intrinsic to photographic practice" (194). Sekula has developed these insights in relation to the use of photography within the taxonomic disciplines of physiognomy and phrenology, especially their use by police and criminologists in the nineteenth century. All photographic archives participate in this kind of institutionalized informative power, and its potential for control and regression. Actual archives can be the "shadowy source" for heirachies of images that function as indicators of the "look"—in portrait photography, for example—appropriate to class position and social location ("The Body and the Archive," *October* 39 [Winter 1986]: 3–64, esp. 10, 16–19, 55–61). The 1930s photomagazines might be illumatingly seen as open archives of everyday life, an archivizing of life as it happens, a recording of the present in a way that makes it "freely" available to the future as well as an instantaneous transforming of the present into the past. These modernizing drives clearly mark Henry Luce's prospectus for *Life* (June 1936), examined in chapter 5.

6. Alan Trachtenberg, "Introduction: Photographs as Symbolic History," in *American Image*, ix–xxxii, astutely teases out a variety of such instances. He is alert to the factual specificity of that which each image witnesses, and to how this quality can stand either for or against, or stand ambiguously, to such overriding mythologies as a shared "American experience."

7. McCamy, *Government Publicity*, ch. 1.

8. Ibid., ch. 8, esp. tables 6 and 7.

9. Pete Daniel and Sally Stein, "Introduction," in Daniel et al. *Official Images, New Deal Photography*, ix. Apart from the FSA (270,000 images), the authors of *Official images* examine the Department of Agriculture, the Civil Conservation Corps, the National Youth Administration and the WPA, of which, respectively 222,118, 10,850, 20,900, and 122,510 still pictures are on file in the National Archives. Other agencies with major holdings, apart from the armed services, include Fish and Wildlife (52,988), Public Roads (40,650), Social Security Administration (25,600), Food and Drug Administration (19,050), Public Works Administration (9,115), and the Bureau of Prisons (12,000). The Department of Labor is

represented by 19, and the FBI and Department of Justice, none. *List of Record Groups of the National Archives and Records Service* (Washington, D.C.: U.S. General Services Administration, 1984), 22–25. *Official Images* is reviewed by Geoff Batchen, in *Afterimage*, April 1988, 17–18.

10. National Archives, Washington, D.C., Record Group 86, boxes 7 and 2.

11. See Walter Rosenblum, *America and Lewis Hine* (Millerton, N.Y.: Aperture, 1977), 9–11, 23, including reference to Stryker's refusal to employ him at the FSA. Reinforced by Stange, *Symbols of Ideal Life*, 92.

12. Records of the Tennessee Valley Authority, RG 142, National Archives, Washington, D.C.

13. *Lewis Hine Photographs for the National Research Project, 1936–1937*, National Archives, RG 69. For a more positive reading of these photographs, and evidence of Hine's delight in the project, see Judith Mara Gutman, "The Worker and the Machine: Lewis Hine's National Research Project Photographs," *Afterimage*, September 1989, 13–15.

14. McCamy, *Government Publicity*, 22.

15. National Archives, Washington, D.C., Record Group 47.

16. He stamped the backs of his prints: "Lewis W. Hine, Interpretive Photography, Hastings-on-Hudson, New York." See International Museum of Photography, *Lewis Wickes Hine's Interpretive Photography: The Six Early Projects* (Chicago: University of Chicago Press, 1978).

17. Pete Daniel, "Command Performances: Photography from the United States Department of Agriculture," in Daniel et al., *Official Images*, 41.

18. Maren Stange, "Publicity, Husbandry and Technocracy: Fact and Symbols in Civil Construction Core Photography," in Daniel et al., *Official Images*, 66–70. See also Kenneth Holland and Frank E. Hill, *Youth in the Civil Construction Corps* (Washington, D.C.: American Council on Education, 1942).

19. Sally Stein, "Figures of the Future: Photography and the National Youth Administration," in Daniel *Official images*, 92–104.

20. An early fan was, as we have noted, McCamy, *Government Publicity*, 51, 81–84.

21. See Tim N. Gidal, *Modern Photojournalism: Origin and Evolution, 1910–1933* (New York: Macmillan, 1973); Tom Hopkinson, *Picture Post, 1938–50* (Harmondsworth: Penguin, 1970). On the increasing use of photography in women's magazines such as *Ladies Home Journal*, see Sally Stein, "The Graphic Ordering of Desire," *Heresies* 18 (1984): 7–16.

22. Elson, *Time Inc.*, 304.

23. Ibid., 341–42.

24. Carl Mydans, *More Than Meets the Eye* (New York: Harper and Bros., 1959); see also Bourke-White, *Portrait of Myself*, ch. 12.

25. Elson, *Time Inc.*, 306.

26. Ibid., 304.

27. See Terry Smith, "Modernism and Visibility: The Power of Architecture," *Transition* 2 (Sept.–Dec. 1981): 16–22.

28. Roland Barthes, *The Empire of Signs* (New York: Hill and Wang, 1983).

29. Elson, *Time Inc.*, 275 ff.; Bourke-White, *Portrait of Myself*, ch. 12.

30. See Randall Conrad, "Directed and Direct: Changing Conventions in the American Documentary," in *A Symposium on the American Documentary* (Brandeis University Film Study Center Research Program, 1976), supplement to vol. 6, no. 5, 5–14.

31. Stryker Papers, NDA 8, 124–53.

32. *Time*, January 10, 1936, 36.

33. On these phases see Allan Sekula, "The Instrumental Image: Steichen at War," *Artforum*, December 1975, and idem, "The Traffic in Photographs," *Art Journal*, Spring 1981; Steichen's transitions are marked by publications such as *Memorable Life Photographs* (New York: Time Inc. for the Museum of Modern Art, 1951); see also Stange, *Symbols of Ideal Life*, ch. 4.

Chapter 10. Designing Design

1. Stephen Bayley, *In Good Shape: Style in Industrial Products, 1900–1960* (London: Design Council, 1979), 99–213. Similarly, Jay Doblin, *100 Great Product Designs* (New York: Van Nostrand Reinhold, 1970). The products referred to in my text but not illustrated can be found in these two books or in Jeffrey Meikle, *Twentieth Century Limited: Industrial Design in America, 1925–1939* (Philadelphia: Temple University Press, 1979), or Arthur J. Pulos, *American Design Ethic: A History of Industrial Design to 1940* (Cambridge, Mass.: MIT Press, 1983). Further illustrations can be found in Wilson, Pilgrim, and Tashjian, *Machine Age in America*.

2. Nikolas Pevsner, *Pioneers of the Modern Movement* (London: Faber, 1936); revised for publication by the Museum of Modern Art, New York, 1949; further revised as *Pioneers of Modern Design* (Harmondsworth: Penguin, 1960), 38. This publishing history has its own ideological interest. Gideon's work is a parallel effort to secure the same construct.

3. Bayley, *In Good Shape*, 17; presumably he is referring to Daniel Boorstin, *The Americans: The Democratic Experience* (New York: Random House, 1973), and Vance Packard, *The Hidden Persuaders* (New York: McKay, 1957).

4. David Gebhard, "The Moderne in the U.S., 1920–41," *Architectural Association Quarterly* 2 (July 1970): 7.

5. John Heskett, *Industrial Design* (London: Thames and Hudson, 1980); Meikle, *Twentieth Century Limited*, Pulos, *American Design Ethic*.

6. Gebhard, "The Moderne," 6; Meikle, *Twentieth Century Limited* foreword; Donald J. Bush, *The Streamlined Decade* (New York: Braziller, 1975); Syllas promotes a variant—1920s "Stepform" and 1930s "Streamform"—in "Streamform," *Architectural Association Quarterly* 7 (Apr. 1969): 32–41.

7. Richard Pommer, "Raymond Loewy and the Industrial Skin Game," *Art in America* (March/April 1976), 46–47, is a bold, if too brief, exception.

8. See Pulos, *American Design Ethic*, 274–92.

9. Meikle, *Twentieth Century Limited*, 12.

10. Ralph Abercrombie, *The Renaissance of Art in American Business* (New York: American Management Association, 1929), 6–7, cited in Meikle, *Twentieth Century Limited*, 13–14.

11. Ernest Elmo Calkins, "Beauty, the New Business Tool," *Atlantic Monthly*, August 1927, 123. A more thorough-going statement is his "Advertising: Builder of Taste," *American Magazine of Art* 21 (Sept. 1930): 497–502.

12. Pulos, *American Design Ethic*, 296. The *Fortune* advertisement for William F. Wholey office fittings (fig 5.4), discussed in chapter 5, exemplifies this taste.

13. Susan Porter Benson, "Palace of Consumption and Machine for Selling: The American Department Store, 1880–1940," *Radical History Review* 21 (Fall 1979): 199–224. In the exclusive domains of the rich, modernist design was also

displaced by eclectic fantasy tendencies in interior design; see Martin Battersby, *The Decorative Thirties* (London: Studio Vista, 1972), ch. 2.

14. The "generation gap" here was, of course, not so stark, as we saw in the case of Edsel Ford's Cotswolds house and Mrs. Abigail Rockefeller's lively support of Rivera.

15. Official record reprinted by Garland in New York, 1977, in twelve volumes. Victor Arwas, *Art Deco* (London: Academy, 1980), contains superb color reproductions of certain exhibits. It was "a kind of cubist modification of the preceding floral Art Nouveau style" reported Guila Veronesi, *Into the Twenties* (London: Thames and Hudson, 1968), 7.

16. Herbert Hoover, Address to the Fourth Annual Exposition of Women's Arts and Industries, 1925, cited in Pulos, *American Design Ethic*, 304.

17. On the use of the term *modernist* since 1922 see Martin Battersby, *The Decorative Twenties* (London: Studio Vista, 1969), 7, and idem, *Decorative Thirties*, 12.

18. For example, see Humphrey McQueen, *The Black Swan of Trespass: The Emergence of Modernist Painting in Australia to 1944* (Sydney: Alternative Publishing Co-op., 1979); Terry Smith, "Writing the History of Australian Art: Its Past, Present and Possible Future," *Australian Journal of Art* 3 (1983): 10–29; and Ian Burn, Nigel Lendon, Charles Merewether, and Ann Stephen, *The Necessity of Australian Art* (Sydney: Power Institute of Fine Arts, 1988).

19. Raymond Loewy, *Industrial Design* (Woodstock, N.Y.: Overlook, 1979), 59. Ellipses in original.

20. Loewy still uses the suffix to make this taste distinction (ibid., 97); Norman Bel Geddes had done so in *Horizons* (Boston: Little, Brown, 1932; New York: Dover, 1977), 186; for similar mid-1930s usages by Dreyfuss, Loewy, and Teague, see Meikle, *Twentieth Century Limited*, 136, nn. 16 and 17.

21. On Earl, see Meikle, *Twentieth Century Limited*, 12; Heskett, *Industrial Design*, 110; Bayley, *In Good Shape*, 20–21, 222.

22. Jonothan Woodham, "Designs and Empire: British Design in the 1920s," *Art History* 3 (June 1980): 231.

23. Heskett, *Industrial Design*, ch. 4, is the best brief discussion on this point.

24. Bel Geddes, *Horizons*, 271.

25. Stuart Ewan and Elizabeth Ewan, *Channels of Desire: Mass Images and the Shaping of American Consciousness* (New York: McGraw-Hill, 1982), 101. A detailed study is Donald Albrecht, *Designing Dreams: Modern Architecture in the Movies* (New York: Harper and Row, 1986). See also Alan Wykes, *H. G. Wells in the Cinema* (London: Jupiter, 1977).

26. Bel Geddes, *Horizons*, 205–21.

27. Loewy, *Industrial Design*, 61.

28. Bayley, *In Good Shape*, 127.

29. Battersby, *Decorative Thirties*, passim.

30. As we saw in chapter 2, for Albert Kahn, defending at that time a more cautious "modern trend," Mallart-Stevens was not distinguishable from Corbusier; both went too far into faddish excess. By the mid and later 1930s, however, Kahn had evolved a more direct version of symbolic modernity, especially in his exposition designs.

31. "Both Fish and Fowl," *Fortune*, February 1934.

32. Meikle, *Twentieth Century Limited*, 108–10.

33. Harry Braverman, *Labor and Monopoly Capitalism* (New York: Monthly Review Press, 1974), 326–48.

34. Meikle, *Twentieth Century Limited*, 85; Pulos, *American Design Ethic*, 373.

35. See, for example, Bel Geddes, *Horizon*, 225–32; Meikle, *Twentieth Century Limited*, on Geddes' "Taylorism" of office organization, 85–86; Henry Dreyfuss, *Designing for People* (New York: Simon and Schuster, 1955), 226–40.

36. Letter to the *London Times*, November 19, 1945, cited in Bayley, *In Good Shape*, 71–72; on his office, see Meikle, *Twentieth Century Limited*, 87–88.

37. Girvin, "Photography as Social Documentation." Both had been published in *Life*.

38. Bel Geddes describes his design process in detail in *Horizons*, 250–58.

39. Walter Dorwin Teague, *Design This Day* (New York: Harcourt, Brace, 1940), cited in Bayley, 65.

40. Ibid.

41. Bel Geddes, *Horizons*, 225–32.

42. Teague, *Design This Day*, cited in Bayley, 63.

43. Walter Dorwin Teague, "Basic Principles of Body Design Arise from Universal Rules," *Society of Automotive Engineers Journal* 35 (Sept. 1934), supp. 18–19, cited in Meikle, *Twentieth Century Limited*, 139.

44. Harold Van Doren, *Industrial Design: A Practical Guide* (New York: McGraw-Hill, 1940), 137.

45. Although, taking Loewy's life and work as he presents it, it must be said that a sense of irony is perhaps its least conspicious feature.

46. Bush, *Streamlined Decade*, and Meikle, *Twentieth Century Limited*, chs. 7 and 8, are perhaps the best accounts; Bel Geddes' *Horizons* is the most valuable contemporary celebration. Others include Bel Geddes, "Streamlining," *Atlantic Monthly* 154 (Nov. 1934): 553–63, and the valuable survey in the "Design Decade" issue of *Architectural Forum*, October 1940.

47. Julia P. Henshaw and A. D. Miller, eds., *Detroit Style: Automotive Form, 1925–1950* (Detroit: Detroit Institute of Arts, 1985).

48. Sheldon Cheney and Martha Cheney, *Art and the Machine* (New York: Whittlesley House, 1936), 14–15.

49. Meikle, *Twentieth Century Limited*, 138.

50. Pulos, *American Design Ethic*, 393.

51. See, for example, K. S. Plummer, "The Streamlined Moderne," *Art in America*, January–February 1974, 46–54.

52. See below; *Architectural Forum* 69 (Aug. 1938): 97–101, 108; David L. Lewis, "The Ford Pavilion at Chicago's Centenary of Progress Exposition, 1934," *Antique Automobile*, March–April 1975, 7–11.

53. Meikle, *Twentieth Century Limited*, 185.

54. D. Clayton Brown, *Electricity for Rural America: The Fight for the REA* (Westport, Conn.: Greenwood, 1980).

55. Cheney and Cheney, *Art and the Machine*, 20; Lewis Mumford, *Technics and Civilization* (New York: Harcourt, Brace and World, 1963), 357; Meikle, *Twentieth Century Limited*, 186.

56. John Vassos, *Contempo, Phobia and Other Graphic Interpretations* (New York: Dover, 1976) contains reprints of selections from each of the books mentioned. They were all published by Dutton originally, except *Phobia*, which was by published by Covici, Friede, New York.

Chapter 11. "Pure" Modernism Inc.

1. Russell Lynes, *Good Old Modern: An Intimate Portrait of the Museum of Modern Art* (New York: Atheneum, 1973), is the basic survey. Angelica Zander Rudenstine, "The Institutionalization of the Modern: Some Historical Observations,"

in *Post-Modern or Contemporary?* (ICOM Conference Papers, Dusseldorf, 1981), 35–49, usefully covers European precedents. An important critical account is Carol Duncan and Allan Wallach, "The Museum of Modern Art as Late Capitalist Ritual: An Iconographic Analysis," *Marxist Perspectives* (Winter 1978): 28–51.

2. Helen Harrison, ed., *Dawn of a New Day: The New York World's Fair, 1939–40* (New York: Queens Museum, New York University Press, 1980); Meikle, *Twentieth Century Limited*, ch. 9; Pulos, *American Design Ethic*, 411. See also references in next chapter.

3. William S. Lieberman, ed., *Art of the Twenties* (New York: Museum of Modern Art, 1979), 7.

4. Cited in Alfred H. Barr, *Painting and Sculpture in the Museum of Modern Art, 1929–1967* (New York: MOMA, 1967), 620–21.

5. "A New Art Museum," brochure, May 1929, cited ibid., 620.

6. Handbill advertising Barr's lectures, with synopses, Department of Art, Wellesley College (Alfred Barr Papers, MOMA library, courtesy Rona Roob); re Bauhaus, letter to A. Conger Goodyear, cited in Lieberman, *Art of the Twenties*, 7; Barr, "Russian Diary 1927–28." Now see Irving Sandler and Amy Newman, eds., *Defining Modern Art: Selected Writings of Alfred M. Barr Jr.* (New York: Abrams, 1986).

7. In the nose—American, Mexican, French, School of Paris and Rest of Europe; in the center—1875–1900 Postimpressionists, and Homer, Eakins, Ryder; in the tail—Goya to the Impressionists. Cited in A. Conger Goodyear, *The Museum of Modern Art: The First Ten Years* (New York: MOMA, 1943), 85; and Barr, *Paintings and Sculpture*, 623.

8. Alfred H. Barr, *Picasso: Forty Years of His Art* (New York: MOMA, 1939), 60, and idem, *Picasso: Fifty Years of His Art* (New York: MOMA, 1946), 54–57. The best revision of this reading is Leo Steinberg, "The Philosophical Brothel," *Art News* 71 (Sept. and Oct. 1972), two parts. William Rubin attempts to restore it in "From Narrative to 'Iconic' in Picasso: The Buried Allegory in *Bread and Fruitdish on a Table* and the Role of *Les Demoiselles d'Avignon*," *Art Bulletin* 65 (Dec. 1983): 615–48. The *Guernica* bibliography is too extensive for citing here.

9. See Lynes, *Good Old Modern*, 238ff.

10. Duncan and Wallach go on to show how Abstract Expressionism is projected as both continuing and naturalizing (making American) the transference of this experience, in "The Museum of Modern Art as Late Capitalist Ritual." The rehanging of the collection impressed at least one observer as being even more reductive than Barr's: Waldemar Januszcak, "Is There Art after 1960?" *The Guardian*, May 27, 1984.

11. "A Modern Art Questionnaire," August 1927, 85, 96 and 98. In 1927 Loewy was doing at least some Saks advertising. Bel Geddes criticizes the window displays as contradictory and overloaded (*Horizons*, 259–60).

12. Typescript, December 2, 1930, Alfred Barr Papers, MOMA Library, New York.

13. See Meikle, *Twentieth Century Limited*, 103; and Don Wallance, *Shaping America's Products* (New York: Reinhold, 1956), 70–75.

14. "Exhibitions of Industrial Design at the Museum of Modern Art," *MOMA Bulletin* 14 (Fall 1946): 5.

15. Report to the Trustees, November 1933, in Barr, *Painting and Sculpture*, 623.

16. December 4, 1934, cited in Meikle, *Twentieth Century Limited*, 181.

17. Philip Johnson, "History of Machine Art," in *Machine Art* (New York: MOMA, 1934), n.p.

18. Philip Johnson, "The Berlin Building Exposition of 1931," *T-Square*, 1932, and "Architecture in the Third Reich," *Hound and Horn*, 1933; both reprinted in *Oppositions*, January 1974, 86–93, esp. 93.

19. Respectively, Herbert Read, *Art and Industry* (London: Faber, 1934), 55, and Barr, "The Museum Collections: A Brief Report," January 15, 1944, cited in Barr, *Painting and Sculpture*, 630.

20. See Lynes, *Good Old Modern*, 316–24; Monroe Wheeler, "A Report Covering a Proposed Industrial Art Project of the Museum of Modern Art," Research Committee on Industrial Art, MOMA, June 1938, ms. MOMA Library; see also Eliot Noyes's controversial Organic Design exhibition of 1941, and Edgar Kaufmann's many introductory publications.

21. Robert Venturi, *Complexity and Contradiction in Modern Architecture* (New York: MOMA, 1966); Kenneth Frampton, *Modern Architecture: A Critical History* (London: Thames and Hudson, 1980), and idem, *Modern Architecture and the Critical Present* (London: Architectural Design, 1982); Richard Pommer, ed., "Revising Modernist History: The Architecture of the 1920s and 1930s," *Art Journal* 43 (Summer 1983); William J. R. Curtis, *Modern Architecture since 1900* (Oxford: Phaidon, 1982).

22. Tafuri, *Architecture and Utopia*; idem, *Theories and History of Architecture* (London: Granada, 1980); with Francesco Dal Co, *Modern Architecture* (New York: Abrams, 1979); Charles Jenks, *The Language of Post-Modern Architecture* (New York: Rizzoli, 1978), and idem, *Architecture Today* (New York: Abrams, 1982).

23. Gebhard, "The Moderne," *passim*.

24. Henry R. Hitchock and Philip Johnson, *The International Style: Architecture since 1922* (New York: W. W. Norton, 1932; rev. ed., 1966), 20.

25. Ibid., 36–38.

26. Ibid., 13.

27. Ibid., 93.

28. Tom Wolfe, *From Bauhaus to Our House* (New York: Farrar, Straus and Giroux, 1981), *passim*.

29. In this both Read and Pevsner differ. At least in the mid-1930s Pevsner was advocating state socialism as the only way through the design dilemma; *An Enquiry into Industrial Art in England* (Cambridge: Cambridge University Press, 1937), 204. See also Peter Coe and Malcolm Reading, *Lubetkin and Tecton: Architecture and Social Commitment* (London: Arts Council of Great Britain, 1981).

30. Barr, "Preface," in Hitchock and Johnson, *International Style*, 13.

31. Ibid., 37.

32. Hitchock and Johnson, *International Style*, 156–59.

33. Erich Mendelsohn, *Amerika: Bilderbuch eines Architekten* (Berlin: Rudolf Mosse, 1926); Richard J. Neutra, *Wie Baut Amerika?* (Stuttgart: Hoffmann, 1927); and idem, *Amerika: Die Stilbildung des Neuen Bauens Der Vereinigten Staaten* (Vienna: Schroll, 1930).

34. Barr, "Preface," 14.

35. A classic statement is Clement Greenberg's 1939 essay "Avant-Garde and Kitsch," in his *Art and Culture* (Boston: Beacon, 1961). An interesting reevaluation is T. J. Clark, "Clement Greenberg's Theory of Art," *Critical Inquiry* 9 (Sept. 1982): 139–56.

36. Cited in Elsen, *Time Inc.*, 193.

37. Cited in Barr, *Painting and Sculpture*, 626.

38. This was the first of Steichen's theme shows; he became closely associated with the Museum of Modern Art in 1927. See Christopher Phillips, "The Judgment Seat of Photography," *October* 22 (Fall 1982); and Stange, *Symbols of Ideal Life*, 135–40.

39. Tafuri and Dal Co, *Modern Architecture*, 240.

40. Bruno Zevi, *The Modern Language of Architecture* (Canberra: Australian National University Press, 1978).

41. Tafuri and Dal Co, *Modern Architecture*, 240.

42. For much of what follows I am indebted to Tony Fry, "The Photo-Modern," *Transition* 20 (May 1987): 3–7, the first recognition of the significance of this topic.

43. Oswell Blakeston, "Still Camera Today," *Architectural Review* 71 (April 1932): 154.

44. His famous comparisons of the Greek temples and modern cars to make the point about the necessity of standardization are aided by the visual consistency of his photographs (*Towards a New Architecture*, 123–38). The cars were, however, custom-built racing or luxury cars. Corbusier's point was about perfection of engineering design for which standardization is necessary, although not sufficient. Nonetheless, he does not illustrate mass-produced cars, and he seems to think that Kahn-type factory engineering is already near-perfect (37–41).

45. Albert Renger-Patzsch, "Ziele," in *Das Deutsche Lichtbild* (1927), cited in Brian Stokoe, "Renger-Patzsch: New Realist Photographer," in Mellor, *Germany: The New Photography*, 98. On "oestranenie" see Simon Watney, "Making Strange: The Shattered Mirror," in Burgin, *Thinking Photography*, 154–76.

46. Walter Benjamin, "A Short History of Photography" (1931), in Mellor, *Germany: The New Photography*, 72.

47. Cited in Benjamin "Short History of Photography," 73.

48. Walter Benjamin, "The Author as Producer" (1944), in his *Understanding Brecht*, trans. Anna Bostock, ed. Stanley Mitchell (London: New Left Books, 1973), 95.

49. Moderlings, "Urbanism and Technological Utopianism," 93–94.

Chapter 12. Funfair Futurama

1. *New York Times*, March 16, 1937, 25.

2. Eugene A. Santomasso, "The Design of Reason: Architecture and Planning at the 1939–40 New York World's Fair," in Harrison, *Dawn of a New Day*, 33.

3. Joseph P. Cusker, "The World of Tomorrow: Science, Culture and Community in the New York World's Fair," in Harrison, *Dawn of a New Day*, 3.

4. Ibid., 4–14.

5. New York World's Fair 1939–40, Department of Feature Publicity, "Fair-Commissioned Mural Painting," typescript, p. 1, New York Public Library, Archives Branch.

6. *Life*, March 17 and July 13, 1939; Harrison, *Dawn of a New Day*, 111–12.

7. See Archives of American Art, New York Public Library Art Division, New York World's Fair 1939–40 Scrap Book, microfilm N65, for a range of examples.

8. Francis V. O'Connor, "The Usable Future: The Role of Fantasy in the Promotion of a Consumer Society for Art," in Harrison, *Dawn of a New Day*, 57–71.

9. Rem Koolhaas, *Delirious New York* (London: Academy, 1978), 226, 334–36.

10. Ibid., 20.

11. Stanley Applebaum, *The New York World's Fair 1939–40 in 155 Photographs by Richard Wurts and Others* (New York: Dover, 1977), 1–5.

12. Photograph in *Life*, May 15, 1939. The Firestone entry in the *World's Fair of 1940 Official Guide Book* (New York, 1940) read: "You move forward to a modern factory, with chromium-plated streamlined machines, where within a few minutes crude rubber from these assembly-line plantations is turned into automobile tires" (49).

13. Meikle, *Twentieth Century Limited*, 190.

14. *New York Herald Tribune*, April 30, 1939; *New York Times*, July 27, 1938; cited in Koolhaas, *Delirious New York*, 235.

15. About which Le Corbusier crowed—*Paris Soir*, August 25, 1939; cited in Koolhaas, *Delirious New York*, 230. On the utopianism of this fair and Chicago 1933–34 see Folke T. Kihlstedt, "Utopia Realized: The World's Fairs of the 1930s," in Joseph J. Corn, ed., *Imagining Tomorrow: History, Technology, and the American Future* (Cambridge, Mass.: MIT Press, 1986), 97–118. See also Joseph J. Corn and Brian Horrigan, *Yesterday's Tomorrows: Past Visions of the American Future* (New York: Summit, 1984).

16. Harrison, *Dawn of a New Day*, 34–40.

17. Warren Susman, "The People's Fair: Cultural Contradictions of a Consumer Society," in Harrison, *Dawn of a New Day*, 17–27.

18. Helen A. Harrison, "The Fair Perceived: Color and Light as Elements in Design and Planning," in her *Dawn of a New Day*, 43–55.

19. Archives of American Art, microfilm N65.

20. July 1938, cited in O'Connor, "Usable Future," 59.

21. *Life*, March 13, 1939. See also Lorin Sorensen, *The Ford Shows* (Osceola, Wisc.: Silverado, 1976).

22. Stuart Davis, "On Contemporary Painting," in National Art Society, *American Art Today* (New York World's Fair, 1939), 35–37; see also "Art at the Fair," *Art News Annual*, May 25, 1940; Archives of American Art, Elizabeth McCausland Papers, microfilm D-376, frames 561–864.

23. In Harrison, *Dawn of a New Day*, 62–67.

24. See the description by Cusker, "World of Tomorrow," 6–13.

25. Susman, "People's Fair," 26.

26. Umberto Eco, "The Myth of Superman," in *The Role of the Reader* (London: Hutchinson, 1981), 123.

27. Berman, *All That Is Solid Melts into Air*, 168.

28. E. L. Doctorow, *World's Fair* (New York: Random House, 1985), chs. 28, 29, and 31. See also Susman, "People's Fair," on peoples' experiences of the fair.

29. Berman is eloquent on this and other aspects of Moses's energy and his degradations, in *All That Is Solid Melts into Air*, 303.

30. Not, however, without its phenomenally "successful" echoes: it is no coincidence that the overall planning, the site design, many of the themes, and much of the key concepts of the 1940 World's Fair form the basis of the Florida Disneyworld, including Epcot Center. Nothing original, everything new.

Chapter 13. Modernity Becomes Normal

1. Paul T. Frankl, *New Dimensions: The Decorative Arts Today in Words and Pictures* (New York: Payson and Clark, 1928), 17.

2. In this sense only, Klaus Jurgen Sembach is right to propose a "Stil 1930," but he mystifies the content of the fusion and fails to ground it in industrial and commercial avantgardism. Sembach, *Style 1930* (New York: Universe, 1971).

3. Heskett, *Industrial Design*, 137; *New York Times*, March 16, 1937.

4. Manuscript of an article for Stryker by Edwin Locke, for *Popular Photography*, Archives of American Art, Stryker Papers, NDA 8, frame 124ff.

5. For example, Plummer, "Steamlined Moderne," 52.

6. For reproduction and discussion of the photographs see *Charles Sheeler* (New York: Museum of Modern Art, 1939), 117; Stebbins and Keyes, *Sheeler: The Photographs*, 41–43.

7. "Power: A Portfolio by Charles Sheeler," *Fortune*, December 1940, following p. 72.

8. Beginning with the reproduction of *Ladle Hooks* on the cover of *Ford News* (Feb. 15, 1929), with the caption "a cathedral of industry." Stebbins and Keyes echo this in *Sheeler: The Photographs*, 31.

9. He had photographed similar machinery more intensely at the Rouge, for example, *Bar and Billet Mill Motor Room—Ford Plant*, 1927 (Stebbins and Keyes, *Sheeler: The Photographs*, fig. 52).

10. Rourke, *Sheeler: Artist in the American Tradition*, 132–41. Sheeler photographed at New Lebanon, New York, in 1934.

11. Curt Ewald, "Thoughts on the Shape of the Trains," *Die Form* 2 (1927): 227–35, cited in Bayley, *In Good Shape*, 37.

12. While the photograph focused on one of the larger drive wheels and two of the smaller "bogie" wheels, the painting included two of the drive wheels and one of the latter, and thus relates to another photograph in the sequence. See Stebbins and Keyes, *Sheeler: The Photographs*, 57, n. 18.

13. Sheeler, *The Arts*, May 1923, cited in Sheeler, *Charles Sheeler*, 91–93. The police photograph is relevant here, a convergence with a massive use of photography since the mid-nineteenth century, but one not overt in art world contexts, despite its consonance with aspects of the work of such celebrated photographers as August Sander. On which see, for example, Benjamin, "A Short History of Photography," 71; John Tagg, "Power and Photography: Part One. A Means of Surveillance: The Photograph as Evidence in Law," *Screen Education* 36 (Autumn 1980): 17–55; and Sekula, "The Body and the Archive."

14. Rosenblum, *America and Lewis Hine*, 23.

15. Ibid., 57; on the National Research Project, see ch. 9.

16. Stebbins and Keyes, *Sheeler: The Photographs*, fig. 66.

17. Stanley Catlin, "Mural Census," in Helms, *Diego Rivera: A Retrospective*, 308–11.

18. On Siqueiros, see ch. 6, n. 6., and ch. 7, n. 38; on Kahlo's painting see Prignitz-Poda, Grimberg, and Kettenmann, *Frida Kahlo: Das Gesamtwerk*, 165.

19. I am aware that multinational capital finds that wars greatly stimulate productivity and profits, while at the same time presenting problems of public perception of corporate image. Ford Motor Company, for example, motorized much of the German army, stepped back from direct control of its German operations for a few years (G.M. did not), then gained U.S. government compensation for loss of a plant in Germany due to Allied bombing during the war (Levison, *Vodka Cola*, London: Gordon and Cremonesi, 1978), 213–14.

20. There is some difference of opinion as to the date of this work. The caption

to Arthur Rothstein's photograph of the installation, Library of Congress, USF 34-24493D, dates it at 1941. This is accepted by Christopher Phillips in "Steichen's *Road to Victory*," *Exposure* 18 (1981): 41, where he characterizes it as perhaps "the first instance after Pearl Harbor in which documentary photographs were adapted to the purposes of propaganda." Stange cites this opinion in *Symbols of Ideal Life*, 173, but dates the work 1943, as she does in "The Record Itself," 35. Although the fact that the United States entered the war on December 8, 1941, makes a 1941 date for the mural evidence of an instant response, I am disposed to accept the photographer's date in the absence of other evidence or argument.

21. Wood and Stryker, *This Proud Land*, 118; John Vachon, "Tribute to a Man, an Era, an Art," *Harper's Magazine*, September 1973; Stange, "The Record Itself," 4. Steichen was not surprised by this effect, commenting in 1939: "Look at the faces of the men and women in these pages. Listen to the story they tell and it will leave you with a sense of a living experience you won't forget . . . the excellent photographs produced in Soviet Russia impress us at once with the differences between the Russian Official Photographs and the FSA official photography . . . [the Russians] persistently put the Soviet's best foot forward." Ms. by Archie Robertson on the usefulness to the war effort of the FSA Historical Section, Roy E. Stryker Papers, NDA 4, 77, Archives of American Art.

22. Letter, September 12, 1940, cited in a 1965 ms. on the FSA by Richard Doud, p. 62, Archives of American Art, roll 3134. This passage is absent from the same letter in NDA 21, AAA.

23. Coordinated probably by Edwin Rosskam, the mural is an assembly (and assimilation) of the FSA photographers's individual interests and aesthetics. From left to right across the panels we can read Rothstein (mountain), Vachon (fields), Delano or Lange (farmer), Lange, Wollcott or Collier (mother and children), Siegl or Rothstein (plant), Delano (worker). The war personnel and machinery are less individualizable. Yet any of those listed could, by 1938–39, produce any of the images assembled. Some illustrations of the preparation of the mural are in Annette Melville, *Farm Security Administration, Historical Section: A Guide to Textual Records in the Library of Congress* (Washington, D.C.: Library of Congress, 1985).

24. Ferry, *Legacy of Albert Kahn*, figs. 169 and 204; Hildebrand, *Designing for Industry*, figs. 34 and 89.

25. See *Blast Furnace and Dust Catcher—Ford Plant* and *Power House No. 1—Ford Plant*, in Stebbins and Keyes, *Sheeler: The Photographs*, figs. 48 and 44. These images appeared in the *Life* feature on Sheeler's Rouge photographs (Aug. 8, 1938, 42–45), and *Power House* in the MOMA exhibition of 1939 (cat. no. 139). The light on the Ford powerhouse chimneys differs in the two images, as does the angle on the blast furnace.

26. The reference is to Lange's *Woman of the High Plains*, 1938. See Maren Stange, "Symbols of Ideal Life: Technology, Media and the FSA Photography Project," in *Prospects* 11 (1987): 81–104, and idem, *Symbols of Ideal Life*, 120–23.

27. We have frequently noted, in passing, this kind of slippage: in Sheeler's, Rivera's, and Kahlo's imagery, in much advertising, and in streamlining. It might be put, scatalogically, thus: form is foreplay; content is penetration.

28. See, for example, Art Directors' Club of New York, *Twenty-Second Annual of Advertising Art* (New York: Watson-Guptill, 1943).

29. I am pointing here less to Baudrilland's image of ubiquitous simulacra in

a "desert of the real," more to T. J. Clark and John Tagg's recognition that, for bourgeois realism, "reality" is an intertext of constant "reality"-referencing. John Tagg, *The Burden of Representation* (London: Macmillan, 1988), 99–100.

30. Stryker nominates this as the distinctive advance in photography during World War II: notes made June 1950 in preparation for the Brehm Lecture, Rochester Institute of Technology, Stryker Papers, NDA 8, 248, Archives of American Art, Washington, D.C.

31. Marshal McLuhan, *The Mechanical Bride: Folklore of Industrial Man* (New York: Vanguard Press, 1951).

32. Lawrence Grossberg, *It's a Sin: Essays on Post-Modernism, Politics and Culture* (Sydney: Power Publications, 1988), 50–56.

33. Among studies of the export of U.S. modernity, both economic and cultural, are Eva Crockcroft, "Abstract Expression, Weapon of the Cold War," *Artform* 12 (June 1974): 39–41; Levison, *Vodka Cola*; Alain Lipietz, "Toward Global Fordism?" *New Left Review* 132 (Mar.–Apr. 1982): 33–47; Tolliday and Zeitlin, *Automobile Industry and Its Workers*; Jean-Paul de Gaudemar, "The Mobile Factory," *Zone* 1–2 (1986): 284–91; Burn et al., *Necessity of Australian Art*, ch. 7.

34. See Wilson, Pilgram, and Tashjian, *Machine Age in America*. The Brooklyn Museum curated an exhibition from which this book is derived; the volume is beautifully illustrated and contains essays full of suggestion. Nonetheless, the concept "Machine Age" remains too general, open, and partial to satisfy the lack voiced in Barbara Zabel's review of the exhibition, that its "intriguing facts and objects . . . beg for a theoretical framework that would unify all the disparate parts of the show and catalogue." *Archives of American Art Journal* 26 (1987): 36.

35. The account of the evolution of the many-faceted imagery of early twentieth-century modernity given here goes some way, I believe, toward this goal. But it, too, falls short of a fully articulated theory of modernity, and of modern economies of seeing. Such research would have to address a wider sphere than the United States, and a longer trajectory through time. It would need to position itself vis-à-vis the rich veins of speculation about modernity and visuality that run through contemporary philosophy, particularly in Europe. Some rather general beginnings may be found in Hal Foster, ed., *Vision and Visuality*, DIA Art Foundation: Discussions in Contemporary Culture, Number 2 (Seattle: Bay Press, 1988). I address these questions in Terry Smith, *Seeing It Strange: Modernity and Visuality* (forthcoming).

INDEX

All references are to page numbers. Those in italic type refer to illustrations.